CURATION
THE POWER OF SELECTION IN A WORLD OF EXCESS

MICHAEL BHASKAR

piatkus

PIATKUS

First published in Great Britain in 2016 by Piatkus
This paperback edition published in Great Britain in 2017 by Piatkus

A CIP catalogue record for this book
is available from the British Library.

ISBN 978-0-349-40871-2

Typeset in Sabon by M Rules
Printed and bound in Great Britain by
Clays Ltd, St Ives plc

Papers used by Piatkus are from well-managed forests
and other responsible sources.

Piatkus
An imprint of
Little, Brown Book Group
Carmelite House
50 Victoria Embankment
London EC4Y 0DZ

An Hachette UK Company
www.hachette.co.uk

www.improvementzone.co.uk

Praise for *Curation*

'A terrific and important book ... it's a great, fresh take on how the twenty-first century is transforming the way we select everything from food to music' David Bodanis, author of *E=MC²*

'Full of illuminating detail, Bhaskar's writing eloquently confronts problems of excess' *New Statesman*

'In his outstanding new book, Michael Bhaskar reveals that curation, formerly the preserve of art galleries and specialists, has become an essential part of our overloaded lives. Dispelling the old mantra that *more is better*, Bhaskar teaches us that value today lies not in creating more choices, but training ourselves to choose better. Whether operating a business or choosing your own self-identity, *Curation* rightly shifts our focus from producing more and more to finding what matters' Sheena Iyengar, author of *The Art of Choosing*

'This book is a must have ... Bhaskar penetrates to the very essence of man- and machine-made choices' Roman Tschäppeler, co-author of *The Decision Book*

'A fascina Miller, *Spectator*

About the author

Michael Bhaskar is a writer, researcher and digital publisher. He is Co-Founder of Canelo, a new publishing company.

Michael has written and talked extensively about the future of media, the creative industries and the economics of technology for newspapers, magazines and blogs. He has been featured in and written for *The Guardian*, the *Financial Times*, *Wired* and the *Daily Telegraph*, and on BBC 2, BBC Radio 4, NPR and Bloomberg TV amongst others. He has worked as a digital publisher, an economics researcher, a book reviewer, and founded several web initiatives.

Michael has a degree in English Literature from the University of Oxford, where he won the University Gibbs Prize. He has been a British Council Young Creative Entrepreneur and a Frankfurt Book Fair Fellow. He is also author of *The Content Machine* and co-editor of a forthcoming book about publishing. He can be found on Twitter @michaelbhaskar.

Curation: *using acts of selection and arrangement (but also refining, reducing, displaying, simplifying, presenting and explaining) to add value*

Everything in excess is opposed to nature.

<div align="right">HIPPOCRATES</div>

In a few hundred years, when the history of our time will be written from a long-term perspective, it is likely that the most important event historians will see is not technology, not the Internet, not e-commerce. It is an unprecedented change in the human condition. For the first time – literally – substantial and rapidly growing numbers of people have choices. For the first time, they will have to manage themselves. And society is totally unprepared for it.

<div align="right">PETER DRUCKER</div>

Weniger aber besser.

<div align="right">DIETER RAMS</div>

Contents

Introduction

IBM estimates that the world now produces over 2.5 quintillion bytes of data – that is, 2,500,000,000,000 megabytes – every day.[1] If you wrote out all the ones and zeros of just one megabyte in longhand, the line would be five times longer than Mount Everest is high. Facebook alone deals with at least 2.7 billion items of content and 600 terabytes each day. In the past two years humanity has produced more data than the rest of human history combined, and this extraordinary rate of production is still growing by 60 per cent a year. By the time you read this the figures are likely to be bigger. Computation is increasing in parallel. According to McKinsey the world added five exaflops of computational capacity in 2008; in 2014 alone it added forty exaflops.[2]

For comparison, the Library of Congress in Washington DC holds around twenty-three million books. Let's assume the average book is 400 pages long. According to LexisNexis, in its most basic form 677,963 pages of text is equivalent to one gigabyte of data.[3] This means the entire book collection of the Library of Congress holds around 13,570 gigabytes of data or 13.5 trillion bytes, forty-five times less than Facebook's daily churn. Sophisticated new routers can transfer such an amount in seconds. This data

pile represents the accumulated wisdom, knowledge and culture of humanity.

Information used to be rare. Creating, collecting, storing and transmitting data was time-consuming, expensive and difficult. Mostly those processes relied on laborious copying. The materials to do so were fragile and scarce – books were written on clay tablets, papyrus or vellum in isolated islands of learning. Even after the invention of the printing press, books were a relative rarity, and finding, let alone verifying, data was incredibly difficult.

The Library of Alexandria was by far the largest store of information in antiquity. It was the pinnacle of learning for a society that spanned the 'known world', whose trade routes, roads and aqueducts crossed continents, which maintained a standing army over half a million strong and which could mobilise millions more, whose cities were the biggest ever seen, and whose culture, engineering and economy would not be matched for 1,500 years. Based around the Nine Muses, the library was a hotbed of scholarship – here the heliocentric nature of the solar system was discovered many centuries before Copernicus. Containing hundreds of thousands of scrolls, it was invaluable and unrivalled, unique and, when it burnt to the ground, irreplaceable, the very summit, the limit, of what had been thought and known.

Now we carry the equivalent in our pockets, accessible at any second. This is a kind of miracle. It is also a problem.

We have, in the space of a few years, gone from information scarcity to a tsunami of data. Information that used to be private, forgotten, disregarded or simply unknown is instantaneously available and public. But are those 2.5 quintillion bytes worth more than the much smaller collection in the Library of Congress or even the Library of Alexandria? No: much of it is CCTV footage; meaningless keystrokes; spam

emails. We have more than solved the problem of transmitting and recording information. In fact, we've solved it so well there's a new kind of problem: not information poverty, but information overload. The question now isn't about how we can produce or transmit more information – the question is how we will find what matters?

We don't always need more information. Instead, value today lies in better curating information. This is a lesson tech companies have rapidly learned, but one whose ramifications extend far beyond the world of digital media.

Why 'curation'?

Why has curation become a buzzword? Why does it provoke as much eye rolling as enthusiasm? Once the preserve of a few specialists, curation is now applied to practically everything. Music festivals, shops and shopping malls, websites of all kinds, the news, TED conferences, venture capital portfolios, gala openings, dinner parties, music playlists, vacations, personal identities, fashion shows and wine lists all claim to be curated. Curation is ubiquitous.

We're all curators now, whether 'curating' our look, our mini-break, our TV on a night in ... Reporter and investor Robert Scoble calls curation 'the next $1bn opportunity'. Barack Obama is called the 'chief curator' of George W. Bush's legacy, while in very different contexts the power broker of Russian politics and the Italian Prime Minister are also called curators. Pep Guardiola was called the curator of Bayern Munich FC. Leonardo DiCaprio is the curator of a charity art auction. Director Danny Boyle is the curator of a film festival. Satya Nadella, the Microsoft CEO, wants to be the curator of a company culture. A glamorous restaurant doesn't just have a chef, it has a 'chef-curator' (Nuno Mendes of the Chiltern

Firehouse, in case you were wondering). The *Financial Times* has a Head of Curated Content while *Wired* magazine refers to a genetic scientist as 'curator of the gene pool'.

Over the past few years I've collected examples of news-papers or celebrities talking about curation: Gwyneth Paltrow curating her website Goop, Kim Kardashian curating a fash-ion store, Madonna curating Art for Freedom. David Bowie, Pharrell Williams and Johnny Depp have all curated one thing or another. In *Doctor Who*, one of the baddies is known simply as The Curator. The list continues ... open a newspaper or magazine and you will find someone referring to curation.

What's going on?

It's rarely made clear what curation means in these con-texts. Many in its traditional heartlands aren't happy. One top commentator on curation sees it as 'absurd' that the word should be so used.[4] Another famous curator argues that this new use of the word 'has to be resisted'.[5] Yet another argues that more commercial uses are 'corrupting' the original sense.[6] In general the art and museum worlds look on in horror as a prized concept is ripped from their grasp.

At the same time, many of us feel an instinctive distrust. There seems something frivolous and self-indulgent about the idea. The comedian Stewart Lee calls it a 'dead word'.[7] CNBC thought it was one of our most overused words.[8] The spoof news website The Daily Mash ran a brilliant article about some-one curating their tea, getting to the heart of the pompousness that so often seems to accompany curation ('The tea-making process is an ongoing dialogue between water, milk and tea that requires careful curation').[9] In a *Press Gazette* survey of PR terms journalists hate, 'curate' was beaten only by the delight-ful trinity of 'reach out', 'growth-hacking' and 'onboarding'.[10] Caught between some of the more bizarre uses it's popularly ascribed and those in the art world who shun its new-found

popularity, curation presents an easy target: something for people in self-appointed 'creative hubs' like Williamsburg, the Mission District, East London and East Berlin; a self-serving and self-regarding art world reject adding false dignity to a host of everyday practices.

We should change how we think about curation; challenge our easy assumptions and knee-jerk reactions that curation is nothing more than a hipsterish accoutrement. Dismissing or mocking it is all too simple – and tempting. But ... under the surface curation is powerful and interesting – an approach that recognises how our problems have evolved. We've missed too much of this big picture because we've been distracted by the conceptual legacy and all those celebrities. We get that curation is a buzzword. Happens in art galleries and the more modish eateries of San Francisco. But then we ignore the context. We don't join the dots, for example, between the term curation, the wider business environment, the new insights from psychology, science, economics and management, the impact of technologies of all kinds.

The more I looked the more it was apparent that the things we call curation were happening long before we called them that. If we think that curation spread from the art world, we've got it backwards. It was taking place already, in a bewildering variety of contexts. We just started calling those things curation because it was a handy word. Whether we accept it as curation or not, the businesses, trends and activities described here are playing an increasingly prominent role in the economy. Applying the word 'curation', let us catch up with a changing reality. It was a way of encapsulating a newly prominent idea or a loose set of processes and activities. Despite being stretched, scorned and, in the minds of some, misappropriated, for many others it just *worked*.

My view on the word itself is that although we can take

or leave it, the horse has bolted. People already use it in new ways. Language isn't static; words evolve and take on new meanings every day. Rather than resist, we should accept that curation is now a broader and deeper term than it used to be, with relevance beyond the limited contexts of either celebrity stunts or gallery exhibitions. The genie is out of the bottle, and however much we may scoff at what seems like a ridiculous poseur, it's not going to be put back.

Why curation? Because, despite careless and excessive use, it is the best we have. We need to reclaim 'curation' from those who curate their dog's breakfast. It might not always sit right, but curation is the best word available for this ensemble of activities that goes beyond selecting and arranging to blend with refining and displaying, explaining and simplifying, categorising and organising. Those that decry the spread of curation are already much too late: it's at work everywhere, from the art gallery to the data centre, from the supermarket to our favourite social networks. It's to these newer and at times more controversial uses that this book is directed.

A different kind of problem

Curation is misunderstood because it's rarely looked at in its full context. Curation became a buzzword because it was one answer to a new set of problems; the problems caused by having too much. For two hundred years we've lived in a world that champions creativity, pursues growth above all else, relentlessly increases productivity and always wants more: more people, more resources, more data, more everything.

With each passing day though, it's becoming clear we're overloaded. In the West we have everything that previous generations hoped for. Clothes at Primark available for less

than a cup of coffee (itself, of course, once a product only for the wealthy). The world's information at our fingertips. All the gadgets and toys we want. We can raise mountains, go into space and generate nuclear power. Yet we don't know what, or who, to believe; worst of all, we are seemingly incapable of action in the face of our systemic problems from financial crises to environmental catastrophe.

We no longer go hungry, but we face an obesity pandemic. We generate more data but also more noise. We're constantly entertained, but ever more distracted. We are richer, but more indebted, and we are working longer hours. Excess choice is a daily feature of our lives. I used to go shopping at a hypermarket in France so large staff were equipped with rollerskates to get from one end to another. While this profusion of choice may have started with fast-moving consumer goods, really it is the oxygen of capitalism; media, utilities like power and water, our romantic partners, jobs, pensions. Areas like health, finance (insurance, pensions) and education – which carry enormous personal risks and responsibilities – are now based on market choice. In all of them, options have proliferated faster than consumer understanding. Businesses need to find a new way of working.

Luckily, the nature of this problem suggests an answer – we are already seeing a revolution in how we approach value. If value, pecuniary or otherwise, used to be about primary production, now, in a world no longer dominated by scarcity, it has shifted. Value today lies in solving these problems, cutting down complexity. Curation is about how we build companies and economies built on *less* – more tailored, more appropriate – choice. This is the key difference and the big underlying trend that we are still only beginning to understand.

Curation answers the question of how we live in a world where problems are often about having too much. Acts of

selecting, refining and arranging to add value – my working definition of curation – help us overcome overload. This book highlights numerous places in which this simple but forceful definition of curation is increasingly felt: in art and on the web, yes, but also in retail and manufacturing, communications and media, even policy and finance.

It's a way of changing ingrained attitudes to production and creativity in order to allow for a more sustainable future. It's the next roadmap for moving to higher-value areas. It's gone from an afterthought to a prime USP. A response to 'too much' that says let's not just stop, let's not wait for a magical fix, but let's make the job of sorting it valuable in and of itself.

A new generation of web curators and engineers are fixing the problems of information overload. Rather than just putting out more product, mature creative industries are becoming more choosy as a growth strategy. Retail businesses are realising that their value lies in curation, not in stocking and shifting. Consumers don't blindly take whatever's on offer. They want to be curators of their lives. We have built a vast services and financialised economy based on this principle, only we don't realise it. Banks are once again becoming curators of our money, not gamblers with it.

All of this takes place amidst a series of social, business, economic and cultural transformations one commentator has labelled 'the Great Disruption'.[11] They include the advent of a new post-digital era of information abundance, pervasive connectivity and the blurring of offline and online environments; the substantial movement of our culture, business and relationships into this new realm; changing patterns of production and distribution; new economies centred on experiences, luxury goods and high-end services and, above it all, a craving for simplicity. We've heard about them so often it's become a cliché; but it doesn't mean they aren't real.

Curating, doing less, whittling down excess, works because it follows major trends in the economy and argues that market forces will push them on. We have been conditioned for hundreds of years to put primacy on activities and businesses that create more stuff. Where business used to want more, now they should want better. Abundance was the goal, now it's the problem to be solved. When the problems change, so should we.

And we are. Many businesses from bars to banks are already in the business of doing less. But it's only just beginning. We solved the problem of insufficiency, only to find it was replaced by abundance. As a result we'll have to curate far more effectively. In order to prosper we'll start to appreciate the value of less, of simplicity in a complex world. Understood and used correctly, curation can be an essential principle over the coming decades. It will allow organisations to unlock stores of value they never knew they had in saturated markets and a ferociously competitive climate.

About the book

This book discusses both curation as we are familiar with it, and that more hidden, longer-term view. It sees them both as part of the same equation. It wants to get beyond the debates about what is or isn't or should or shouldn't be curation; there have been plenty of those, and meanwhile, people carry on using the word regardless. To understand business and culture in the context of too much. To see how expertise and taste have become new currencies.

Several caveats are in order. This book is by no means comprehensive. Much is left out for the sake of space. It won't convince everyone. For some, the whole idea will be a debasement of an elevated practice from the get-go. For others it will

be the height of pretension to even touch upon the subject. I happen to believe neither is the most useful or interesting path, but readily accept both views will remain.

Nor do I in the slightest see the view of curation offered here as complete and definitive – it's only in the last forty or so years that even art exhibitions were curated, so we really are at the beginning of where this idea is going. Curation is still contested, uncertain and up for grabs. This book is part of a conversation, a series of suggestions that I hope are instructive and useful. Technology and business alike move with unprecedented speed. Today's commonplace wisdom becomes yesterday's naivety. Making predictions is asking for trouble; I am looking for the tendencies.

With all that in mind, the structure is as follows:

Part I looks at how we ended up with problems of too much. It examines the engines of our rising productivity. Digital technology is the most obvious example of abundance today, but in fact most goods are, in some contexts, abundant – material products as well as informational ones. This is the result of a Long Boom beginning with the Industrial Revolution and continuing over the last two hundred years. Beyond that Part I looks at two symptoms of this abundance – the idea of overload, when too much of a good thing causes problems, and the creativity myth, our unwavering faith that creativity is always a positive.

Part II discusses the history of the term curation and looks to define its contemporary use in more detail. Why do I think selection in particular, but also concepts like arrangement, are so significant, the core principles of curation today? What do they mean, and how can we understand them in the context outlined in Part I? Along the way I look at related questions – how the Internet transformed curation and the impact made by algorithmic models of selection; the changing nature of

retail; and then a host of 'curation effects' – both positive side effects and principles of curation. Understanding these principles hints at how curation can be seen as part of the arsenal deployed to combat overload.

Part III surveys prominent examples of businesses, organisations and individuals curating today. Given the sheer range of such activity it makes no claims to be encyclopaedic; instead I want to highlight interesting examples and tease out consequences. It also introduces some refinements and a new vocabulary of curation – implicit and explicit curation, thick and thin curation, a broadcast model and a consumer-curated model of media.

Running a shop or a newspaper has always involved what we now call curation. What has changed is that curation has become ever more central to the activities and identity of those organisations. Hidden from view, even at times to those curating, it has become essential to their bottom lines. How much is curation already within and integral to our business model without us fully acknowledging that fact? How has the world changed so that we need new kinds of cultural and business intermediaries?

We already live in a curated world. Walk around not just Paris or New York, but Buenos Aires, Bangalore and Beijing and you will be surrounded by curation; the shops, galleries, hotels, restaurants of course, but also homes and workspaces, work itself and leisure: if you are lucky enough to be even moderately wealthy in global terms, careful, expert selection is everywhere around you wherever you live. And whoever you are, on the Internet you cannot help but be confronted by a curated offering – of things to read, photos to look at, videos to watch, apps to download or people to follow – and to be a curator yourself in turn.

The Japanese have a word – *tsundoku* – for the act of

constantly buying more books but never actually reading them. Most of us have been there. It's this kind of feeling that is now spreading at a societal level. Typically the Japanese have an answer for *tsundoku*. In Tokyo's Ginza district there is a bookshop that sells only one book at a time.[12] It's a start.

Patterns of selection and arrangement are, gradually, sometimes quietly and sometimes obviously, becoming more prevalent parts of our lives. Ignoring that isn't an option. Mastering it means mastering the context of the twenty-first century.

Part I
THE PROBLEM

First World Problems

Remember #firstworldproblems? Complaints on social media about a minor problem – the difficulty of choosing between the Scottish smoked salmon and the USDA prime steak, the stress of getting dressed for a night out, the affliction of a fundamentally worthless gadget going momentarily wrong – were suffixed with the hashtag #firstworldproblems. It soon became a craze. Buzzfeed catalogued its favourites, which included such gems as 'I can't eat ice cream in my convertible as my hair keeps whipping into it' and 'I spent too long taking a picture of my plate and now my food is cold'. Ah yes, problems indeed. The phrase became so commonplace that it even found its way into the Oxford English Dictionary.

Of course, first world problems are both embarrassing and tongue in cheek. The notion recognises that, for much of the planet, we no longer have to contend with problems such as famine, disease and war, as many still do. It's an attempt to forestall guilt about some of the undoubted nuisances of the modern world, a deflection tactic, the perfect way of balancing those competing contemporary demands of irony and registering annoyance via social media. Now, #firstworldproblems are the faux whining of the overprivileged who know, deep

down, they've won the birth lottery. But there is nonetheless an interesting angle.

For many, the situation has changed. In an age of abundance, #firstworldproblems quite simply *are* the problems some people face. The question with first world problems is, of course, not whether they are ridiculous and self-indulgent – that much should go without saying. The question is how we ended up in a world where, even in jest, these problems could exist at all.

This is uncomfortable but important. It doesn't mean that deep-seated issues to do with poverty and conflict have gone away, although in large parts of the world they are receding, it simply recognises that, although we are living through an age of Great Recessions, austerity and stagnation, it is often the problems of too much, not too little, that define life in the West. It doesn't always feel that way – after all, who doesn't want, even need, more money? – but the reality is that compared to our ancestors we live amidst superabundance.

The psychologist Abraham Maslow's hierarchy of needs makes the point. Maslow argued (see Figure 1) that our needs formed a pyramid.

Each layer in the pyramid rests on those below. So once we've taken care of basic physiological requirements like food and water, we worry about a different set of concerns: are we safe from violence? Do we have the ability to sustain our livelihoods and our health? Then at the top of the pyramid we come to the higher-level functions, self-esteem and making the most of our lives. Do we have control? Can we express ourselves? What Maslow's pyramid indicates is that, in the twenty-first-century West and many other parts of the globe, we aren't principally worried about the lower levels of the pyramid. This isn't to say life is perfect and we can forget

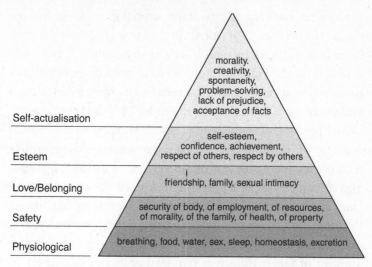

Figure 1. Abraham Maslow's hierarchy of needs

about them, just to point out that for large swathes of the population they are taken for granted. Day-to-day problems have gone upstream.

This then is the biggest irony of all about #firstworldproblems. It's all a big joke and shows quite how vacuous we have become. Yet it also reflects something significant. That problems really have changed. That more is not always more. That there is a tipping point after which simply adding in extra no longer works. This matters. First because for the last two hundred or so years we have engineered society and businesses to keep growing; to keep adding more. Second because we are now reaching overload, when incremental additions cause more harm than good. Lastly it is important as we have an idea, whether in business, the arts or our general lives, that creativity is always a net positive. Perhaps it is. If, however, problems arise from creating more, aren't there grounds to question that assumption?

Let's go back to the tsunami of data we identified in the Introduction. For most of history information was incredibly difficult to find, but even so people still felt there was too much. Plato thought writing would make us lazy thinkers. Seneca the Elder thought books were a distraction and there were too many of them. In 1860 a young doctor called James Crichton Browne spoke to the Royal Medical Society of Edinburgh in language we would recognise today: 'We live in an age of electricity, of railways, of gas, and of velocity in thought and action. In the course of one brief month more impressions are conveyed to our brains than reached those of our ancestors in the course of years, and our mentalising machines are called upon for a greater amount of fabric than was required of our grandfathers in the course of a lifetime.' The roots of information overload run deep.

Yet if people have often felt there was too much data in the past, nothing compares with now. The amount of digital data is doubling every three years or so, growing more than four times faster than the world economy, and the rate of change is constantly increasing. By the end of 2013 there were 1,200 exabytes of stored data in the world. Less than 2 per cent of this was non-digital, whereas in 2000 75 per cent of information was non-digital.[1] As Big Data specialists Kenneth Cukier and Viktor Mayer-Schönberger argue, this is equivalent to the entire USA being covered in fifty-two layers of encyclopaedias. If they were transferred to CD and stacked up the pile would stretch to the moon five times over. Each person alive now has 320 times as much information available to them as in the whole Library of Alexandria which would have so concerned Seneca. If James Crichton Browne worried about information overload in 1860, it's difficult to sense what he would make of it today.

Our technology is a vast machine for creating data. It comes from a huge variety of places – not just tweets, pictures, videos on YouTube, but also sensors (such as humidity sensors in vineyards or temperature sensors in cars), web clicks, company accounts, health data, mobile phone geolocation, streams of CCTV images. The world is being 'datafied', turned into raw data one bit at a time. In practical terms this is both a problem and an opportunity. A problem because all this excess data is unusable in its raw form. An opportunity as companies are learning to process and harness this data into actionable insights.

To get a sense of the problem side of the equation I went to speak to a trader at a major US bank, who had been introduced through a friend. Let's call her Lisa. Dark-haired, expensively accessorised and quick-talking, Lisa gets up every day at 5.30 a.m. and immediately checks her iPhone (back in the day it was a BlackBerry). So begins the overload. She then reads through emails and instant messages (she uses WhatsApp to talk to friends and family), checks any financial data that's come through overnight and scans the news. However, it's at her desk that the overload becomes fully apparent. She has eight screens, like many traders. 'At first I thought it was great,' she tells me, sipping a fizzy water in an anonymous Starbucks. 'This was the real deal. This was trading, it's on the frontline.' Bloomberg fed through real-time market data, emails flooded in, analysts' reports jammed her inbox, the ticker feeds of market movements sped before her eyes. The sheer amount of data the average trader has access to on a second-by-second basis is extraordinary. Moreover they are under great pressure to respond to this data correctly and at lightning speed. Automated trading programmes are able to instantaneously comprehend and act on the total available set of market data. The

NASDAQ stock exchange alone sees over two billion shares traded every day.

The pressure increases. 'The main thing I feel now is ...' she pauses, thinking for the right word, 'paralysis. I guess that's it, paralysis. So much going on, so much to take in that you don't know where to look anymore. Knowing what to pay attention to is my job, but it seems to get more difficult.' She hasn't told anyone else on the trading floor she is seeing a therapist to try and overcome these problems – 'It's not like it's Wolf of Wall Street but it is a tough place.' She strikes me as being hard as nails. Our brains today are roughly the same as those of our ancestors on the savannah. They are designed to hold about seven pieces of information in our working memory at any one time. Beyond that we hit cognitive capacity. With eight screens overflowing with complex information, each catching Lisa's eye, each potentially important, it's no wonder she or anyone else struggles to keep up. And the long days take their toll. Lisa is cash rich in a way few of us ever will be. But she is chronically time poor. Work swallows her entire day and most weekends. Forget about taking a real vacation.

So, how do we tie these strands together? In many respects Lisa is the embodiment of #firstworldproblems. She has a large salary, an enviable apartment and a high-powered job. Yet she is breaking down at work amidst the pressurised flood of data and two relationships ended because she doesn't have the time. No one is crying into their coffee about Lisa's problems and nor should they. But as James Crichton Browne recognised, 'our mentalising machines are called upon for a greater amount of fabric'. This is where the value of curation starts to become clear. In a world of too much data, having the right data is valuable. In a world where we don't have any time, choosing the right thing to do is valuable.

In a world of too much, selecting, finding and cutting down is valuable.

In the context of excess, curation isn't just a buzzword. It makes sense of the world.

But how did we get here in the first place?

1

The Long Boom in Everything

When he died in 1792 Richard Arkwright, the son of a tailor who couldn't afford to send him to school, was the richest non-aristocrat in Britain. His fortune of £500,000 was immense by any standards – but in an age of low social mobility, virtually unheard of. How did this humble Preston-born man generate so much wealth? In answering that question we also begin to answer where the problems of too much came from. As much as any individual, Arkwright was responsible for the Industrial Revolution, an event which fundamentally changed the direction of history and explains the roots of modern excess.

Textiles are a prominent part of any pre-industrial economy – everyone needs clothes and they are labour-intensive to produce. Buying a shirt before the advent of industrial technology was hugely expensive, costing at least $3,500 (or £2,500) in today's money compared with the few dollars we could now spend at a budget store.[1] The problem for consumers was this – home-grown English cotton was high-quality and relatively cheap. But the labour costs of spinning the cotton fibres into threads were prohibitive. The result was that

clothing and other textiles were scarce and expensive. This, then, was the general condition – scarcity defined people's lives. One shirt entailed a significant outlay, with the according ramifications for a household's annual budget.

Arkwright was among those who saw an opportunity. James Hargreaves, a weaver and carpenter from Lancashire, saw his spinning wheel fall over, and, watching it spin on its side, realised that if a spindle could move from vertical to horizontal and back again, it could do the job much more quickly than a human. This insight led to the development by 1764 of the spinning jenny – a seminal instance of machine power augmenting human labour which kick-started a productivity revolution. What's more, by lining up several of these machines in a row, you could increase overall production.

Arkwright himself took a different tack. A born entrepreneur, he sank an enormous amount of money, £12,000, into developing his tech, patenting the spinning frame in 1769 and the carding engine in 1775. The water frame, as the spinning frame was also known, was powered by river water and used a system of rollers to spin its basic material. It could produce a strong twist for the warp threads, which the jenny could not. But it wasn't just the technology that Arkwright envisioned; he also needed a new system of organisation – the factory – to fulfil its potential. At Cromford in Derbyshire from 1771 Arkwright brought all the elements together – the new technology for which he had taken out patents; an army of workers; a factory specially built with machinery in mind, designed to facilitate maximum productivity in design and situation; and a working practice that was dictated not by natural light or the rhythms of the day but by machines (from 1772 they ran twenty-four hours a day). Arkwright even built housing and bussed in workers, thereby creating the template for the industrialised city. The spinning frame was simple to

use and manufactured a high-quality product. By 1785 the factory had been coupled with steam power and the Industrial Revolution was about to hit full swing.

You can still visit Cromford today and see the heavy bricks and orderly ranks of square windows spread throughout the complex. Compared with anything that went before it was the cutting edge. Although it feels quaint now, this was a hard place pioneering new forms of organisation and technology. This grey and huddled ensemble changed the world.

The impact on textiles was dramatic. In the twenty-seven years from 1760 to 1787 imports of raw, unspun cotton leapt from 2.5 million pounds to 22 million pounds. By 1837, when Britain was the workshop of the world and Manchester was becoming 'Cottonopolis', imports of cotton had ballooned to 366 million pounds. As the volumes went up so the prices came down, from 38 shillings per pound in 1786 to just 7 shillings per pound in 1807.

Arkwright became one of the richest men in Britain by doing something new. For most of history, economies had grown slowly. Technology changed at a glacial pace measured in lifetimes. It was Arkwright and those like him, many of them – including industrialists like Matthew Boulton and technologists like James Watt – members of the Lunar Society of Birmingham, an informal but prolific group of likeminded inventors, scientists and business executives, who transformed one of the drivers of the modern world: productivity.

Arkwright combined three things. First he harnessed energy in new ways, converting for his own purposes the water power of streams and then the stored energy in coal. Humankind's capability was immediately improved. By using fossil fuels our capacity for action was transformed. One barrel of oil contains energy equivalent to 25,000 man hours of work. Given

that we have used 944 billion barrels of oil since 1870, that represents an awful lot of work, and it was around this time that the potential of energy resources began to be systematically exploited.[2] Then Arkwright changed the nature of work. For better or for worse, work became regimented, tightly controlled and process-driven. Tasks were divided, rather than lumped together. Lastly Arkwright applied principles of science and engineering to the mass production of objects. Automation and technology would ramp up the productive capacity of the firm.

The Industrial Revolution was a productivity revolution. And it was this change in productivity that meant that shirts could go from being a major purchase in the eighteenth century to a trivial one in the twenty-first. Material objects which had always been scarce started to become widely available. The Long Boom in everything had begun.

The very short answer to the question of how we arrived at a situation where we have too much of everything is that productivity has been growing for over two hundred years. Every year we can make more than the year before. Eventually things accumulate. Eventually the scale tips from scarcity to excess. A new set of problems – and opportunities – arises. Marx and Engels described this change relatively early on and clearly saw its magnitude. The Industrial Revolution

> created more massive and more colossal productive forces than all preceding generations together. Subjection of Nature's forces to man, machinery, application of chemistry to industry and agriculture, steam-navigation, railways, electric telegraphs, clearing of whole continents for cultivation, canalisation of rivers, whole populations conjured out of the ground – what earlier century had even

a presentiment that such productive forces slumbered in the lap of social labour?[3]

Like James Crichton Browne, these mid-Victorians would no doubt have been astonished at the continued transformations since their own time.

Technology has always played a crucial role in change. It was the spinning jenny and the steam engine which kick-started the Industrial Revolution. However the less well known second Industrial Revolution, one hundred years after the first, again underscores how technology constantly transforms productivity. A new set of technologies and the businesses pioneering them would once again reorder the world.

The Bessemer process and then the Siemens-Martin process gave the world steel, and in turn a host of new applications from bridges to skyscrapers. Innovation in this area continued for decades. In 1920, for example, it took three worker hours to produce a ton of steel. By 2000 this was just 0.003 worker hours per ton.[4]

Then came the electrification of factories and goods. Emil Rathenau's AEG pioneered electrical engineering, as did Werner von Siemens, who produced telegraph technology, dynamos, electric trains and light bulbs. Siemens created the self-excited generator – a dynamo that converts mechanical energy to electrical energy. This meant that steam- and water-driven turbines could produce significant amounts of cheap electricity, which could power factories and other innovations in a virtuous circle. Companies like Siemens had their great American counterparts like Edison's General Electric. If one invention, alongside the Bessemer process, could be said to have ignited the second Industrial Revolution, this generator was it.

If Arkwright had applied science, the second Industrial Revolution did so in a far more focused and systematic way. Chemicals and synthetic dyes, for example, were propelled by German firms like BASF and Bayer, who made enormous strides pursuing their own research agendas. By 1914 German firms had nearly 90 per cent of the world market in dyestuffs. A multitude of other technical improvements were happening around the same time: the creation of dynamite; the use of rubber and lubricants to ease and speed up manufacturing; the rollout of nitrogen fertilisers.

There was also a boom in transportation and infrastructure. The 1880s witnessed more rail construction than any decade before or since. Mass adoption of steam shipping and the telegraph shrank the planet. If the first Industrial Revolution had launched the Long Boom, it was the technological innovations of the second – the use of electromagnetism, say – that turbocharged it. A raft of technological improvements led to a clear step change in productivity over those years. The early Industrial Revolution saw productivity growth climb to 0.5 per cent per year. This may sound small, but compared with centuries of near-stagnation it was unprecedented. From 1870 to the present day, however, global productivity growth has been 1.7 per cent per year. According to Jeffrey Kaplan, US productivity per hour worked doubled between 1948 and 1991 and rose a further 30 per cent from 1991 to 2006.[5] The use of technology made the difference.

Since the 1970s there has been some debate about what economists call the secular decline of productivity growth. Put simply, some commentators argue that productivity has stopped growing. As we will see, this does not mean the world economy has stopped growing. Far from it. Nor is it even certain to be the case. Part of the issue is that as productivity grows in manufacturing, so the overall position of

manufacturing shrinks: one factory which used to employ a hundred people now only needs ten. Productivity improvements are harder to achieve in services. The classic example is hairdressing – hairdressers can only give so many haircuts, whereas thanks to technological improvements factories can usually squeeze out additional productivity gains.

Regardless of whether productivity has stalled – and there is evidence that digital technology and the Internet have given it a considerable boost – we are still witness to productive capacity on an awe-inspiring scale. Today the cumulative effects of all those technological improvements are jaw-dropping. Take the Taiwanese manufacturing firm Foxconn.

If you own an iPhone or a BlackBerry, have played on a PlayStation or an Xbox or read on a Kindle, chances are it will have been assembled by Foxconn, quite possibly at their (in)famous Longhua campus in the Chinese city of Shenzhen. If you want to see the frontline of productivity today, this hulking, walled presence is it. Calling it a factory is a stretch. Really Longhua is a kind of city, a sprawling 2.5 square kilometre powerhouse employing up to 300,000 people, housing not just assembly halls but dormitories, kitchens, food halls, banks, bookstores, gyms, playing fields and even an onsite McDonald's.[6] Everything at Longhua is about maximising efficiency and productivity. Foxconn is a manufacturing behemoth, China's largest private employer with 1.4 million employees spread across fourteen sites. Its largest factory at Zhengzhou in Henan province can reportedly make 500,000 iPhones a day in addition to other product lines. Producing millions upon millions of complex consumer goods a year, Foxconn has revenues of above $130bn. The human cost can be high and has not escaped notice.

Yet this is only the beginning. Now the colourful chairman Terry Guo has announced a campaign to build 'one million

robots'. Hiring a team of MIT robotics researchers in 2006, he has set about building the Foxbot, a robotic arm which will theoretically be capable of undertaking the difficult assembly tasks in which Foxconn specialises. This being Foxconn he wants one million of them; one million tireless, precise, incredibly fast robots building phones and tablets twenty-four hours a day. That means a lot of phones and tablets.

Not everything has gone to plan. So far each Foxbot costs around \$20–25,000 to produce and there are only around 30,000 of them.[7] They are only working on a few lines – reports suggest HP's ink cartridges and the iPhone 6 may be among them. They will not replace the human workforce but augment it, reducing costs and increasing productivity. Foxconn pushed the old factory model as far as it would go, building the biggest factories on earth. Like Arkwright or Siemens before them though, they are using technology to boost productivity and profit, the motors of industrialisation. By using new technology Foxconn shows that the secular decline in productivity is not a foregone conclusion. As a leading part of one of the great stories of our time – the opening of the Chinese economy and its vast productive capacity – they are also part of the wider story of how technology has pushed productivity; and how productivity has produced abundance.

The economist W. Brian Arthur argues, 'the economy is an expression of its technologies.'[8] In other words the character, growth and structure of an economy are dependent on its technologies, which goes some way to explaining our present condition. For the past two hundred and fifty years our technologies have been directed at boosting productivity. To producing more. More goods, more food, more data, more stuff.

And the story doesn't end there.

*

Danica May Camacho was born on Sunday 30 October 2011 at Manila's Jose Fabella Memorial Hospital. She was another healthy, happy baby; another human miracle. Except unlike most newborn babies, Danica came into the world amidst the flash of photographers and the world's media. Danica May was, according to the UN, the seven billionth human being alive on planet Earth. By way of congratulations she received a woolly hat and a scholarship fund, although they could equally have gone to another of the estimated 220,000 babies born that day. Twelve years earlier Adnan Nevic was born in Bosnia-Herzegovina. He had the distinction of being the six billionth human being. In twelve years, one billion people had been added to the net total of humans, at a time of rising life expectancy. It's not just productivity that has been growing – so has humanity.

The sheer number of human beings alive has an enormous impact on our economic capacity. Humans at once generate both demand and supply. The more of us there are alive, the more we can consume and produce; the more choice there is and the more our resources are, in theory, stretched. If productivity and technology power abundance, so too does the sheer abundance of people. Around four or five thousand years ago the total population of humanity was still in the tens of millions. By 1700 CE it had climbed to around 600 million, with the one billion figure arriving by around 1820. So it took all of human history up to 1820 before a billion people were alive at one time.

Thereafter things sped up. The geographer Danny Dorling argues that 1851 was the pivotal year, after which the growth rate in the population shot up thanks to rapid industrialisa-tion.[9] It took only 106 years (in 1926) to reach the second billion, hundreds and hundreds of times quicker than the time it took to reach one billion. The third billion was

attained in 1960, just thirty-four years later, while the fourth billion took another fifteen years, coming in 1975; the fifth billion took thirteen years, arriving in 1988. Six billion then took twelve years, coming in 2000; seven billion took a further twelve years. During the twentieth century countries like China or Iran at times pushed the limit of human reproductivity, their populations growing at 4 per cent a year, close to the biological maximum. This rate of growth is unsustainable and there is a large body of evidence to show that the rate of growth has been slowing since the 1970s – but we are still feeling the lag. In countries like Japan, Germany and Italy the slowdown has even turned into a reverse, balancing some of the extraordinary growth seen in places like sub-Saharan Africa. The eighth billionth human will probably be born sometime in 2026, fifteen years after Danica May Camacho. Although forecasting population in the long term is beset with difficulty, many demographers think it likely that the population will reach nine to ten billion by the end of the century.

While indicating a slowdown, that is still an awful lot of people. Most of us have moved from living in societies of at most a few million – and they were a rarity – to living in cities of millions or tens of millions; in societies and international blocs much larger than that; and, to an unprecedented degree, in a single globalised world of billions. Quantitatively speaking the difference is obvious, but it also creates a qualitative difference. The scale and range of human activity is now far beyond our grasp, changing the scope of the economy, the diversity of things on offer and the pressure on resources. All those people have aspirations and needs that drive, power and tax the world.

Technological development and population explosion are obvious manifestations of how we have created conditions of

too much. It's not just about people or technology though, but about the way the two interact.

Take the humble pin. Adam Smith, the great eighteenth-century economist, was extremely interested in this 'very trifling manufacture', as he called it. For Smith pins showed the key to rising wealth by demonstrating the value of the division of labour. Smith saw that by breaking tasks down into small components you could improve them more easily. On a societal level it was much better to have one person focused on making candles and another on making tables, rather than everyone producing their own candles and tables. Moreover, even within an activity like making a pin, you could break the process down into stages to increase efficiency, boost productivity and generate more profits.

Smith argued that discrete tasks could be improved more easily than a bundle of interlinked processes. Workers could become quicker and better. Transition costs of moving from one activity to another could be eliminated. Above all, discrete tasks were much more amenable to automation, as Arkwright, Smith's contemporary, was already showing. One worker alone could produce perhaps twenty pins a day, navigating a series of fiddly tasks in a tricky sequence. But dividing the production into various sub-processes meant that a ten-person unit could produce 48,000 pins in a day – 4,800 per worker, a vast increase. This was the power of the division of labour and technology.

Economist Ha-Joon Chang records what happened next. In 1832, forty-two years after Smith died, the father of computing, Charles Babbage, studied pin manufacture and estimated 8,000 pins could now be produced per worker per day, a near doubling in productivity thanks to improvements in technology *and* workflow.[10] By 1980 a study estimated that modern factories could produce 800,000 pins per worker per

day: a 100-fold increase in productivity over 150 years. Today that figure might be much higher thanks to ever-increasing automation. Here then is where technology meets organisation. Now imagine this applied across almost every area of endeavour and we are starting to see the formula behind the Long Boom.

In the two hundred years after Arkwright built his factory and Smith sketched the division of labour and the foundations of capitalism, methods of organising to increase productivity and wealth underwent continuous refinement. In the early twentieth century Fordism suggested a production-line approach to manufacturing that was far more efficient than the stop-and-go process that came before. Car production stayed on the frontline with, for example, Toyota's *Kaizen* method of continuous improvement and just-in-time logistics. Taylorism sought to make a science of working, supposedly maximising the output of office workers. Today executives and engineers in Silicon Valley spend large amounts of time analysing their own productivity and that of others, the better to build tools and workflows that can be rolled out in-house and offered as services.

Adam Smith laid down the 'Goldilocks' formula of the Long Boom, the elixir of classical economics: technology creates productivity improvements, which then create economic growth, which leads to more demand, more production and further technological change, and so on. Build this on the back of a constantly rising population and an increased emphasis on getting the most out of things and you have the recipe for sustained expansion. Of course there were and are many other elements to economic growth. Access to energy and capital for example, and the infrastructure around them, have been critical to growth of all kinds. Geography has played a role as well, although some countries without natural resources

like Japan have become rich and some with them, like the Democratic Republic of Congo, have ended up poor. Rising wealth meant rising demand and lively markets for all those new goods and services. At the heart of the story, though, is how new technologies and an ever-growing population drive growth. We still see the effects today. China has grown so fast because it has played catch-up by quickly adopting Western technology and methods.

Quantifying the scale of the Long Boom is not easy. We can look at any number of measurements – population is one, productivity another. The size of the global economy is useful as well. Angus Maddison was an economist whose life work was studying long-term trends. Growth used to be very slow, only a tiny fraction of 1 per cent a year, if there was any growth at all. During the period from 1000 to 1500 Western Europe only grew as much as it took China six years to grow between 2002 and 2008.[11] From 1820 growth was super-charged and rose at an annual rate of 1 per cent. However this was put in the shade by the 'Golden Age of Capitalism', the *Trente Glorieuses*, the *Wirtschaftswunder* of 1945–1973, when Western European per capita income grew on average at 4.1 per cent each year. Japan and China have experienced even faster periods of growth. Maddison estimates the global economy grew fifteen-fold in the ninety years between 1913 and 2003.[12] The UK government claims that British productivity grew seven-fold over the twentieth century – an impressive result except that productivity growth was even stronger over the same period in France, Germany, Japan and the United States, for example.[13] Despite recessions, depressions, reversals, revolutions, wars, panics, shocks and slumps, more was produced, whether films or food, in almost every year of the last two hundred than in the preceding year. And this clearly translates into ever more consumption. Jeffrey Kaplan cites

figures suggesting that US household spending in 2005 was twelve times greater than in 1929, while the spending of those same households on durable goods rose thirty-two times over the same period.[14]

Moreover, despite worries about recessions and productivity gains the Long Boom has not slowed down. Indeed since the fall of the iron and bamboo curtains, when Eastern Europe and China opened their economies, the world economy has been boosted by the biggest growth of the labour force and the widest rollout of technology and technological catch-up ever seen. Not just in those nations but everywhere from Mexico to Brazil, Turkey to Indonesia, industrialisation, productivity boosts and labour increases have been enormous – one estimate suggests 1.7bn workers were added to the global labour force in the years 1980–2010.[15] Workers moved from rural areas to cities, family farms to factories, while – as we saw with Foxconn – those factories and businesses reached new levels of productivity. Over the past century transaction costs associated with communication, transport, logistics and tariff barriers have fallen. Investment capital has grown more liquid and mobile. At various times the Long Boom has been powered by financial engineering: the transition to fiat money from the gold standard with the collapse of the Bretton Woods agreement in 1971; creative monetary policy from then on; expansion of business and consumer credit.

We think of digital technology, among other things, as leading to a huge boost in data storage and data creation. This is true, but it is far from the only way digital technology has transformed conditions of scarcity into conditions of abundance. Digital tech has led to vast supply increases and price falls in communications, access to markets, inventory space, content creation and publishing, software, consumer choice, services and processing power. In each of these areas the

past twenty years have seen the dominant trend switch from scarcity to excess. Just think of how Skype has revolutionised international telecommunications. What was once expensive and relatively rare is now routine and virtually free. The so-called sharing economy has unleashed latent supply in areas like short-term rentals (Airbnb), cars and transport (Lyft) and Wi-Fi (Fon).

Data is just one example of how the Internet has completely changed the business environment, but the examples are legion and we have already seen it transform sector after sector which had been optimised for conditions of scarcity. It's also worth remembering that the increase in data and information has deep roots dating back to steam presses, which massively increased print volumes, and before that to one of the earliest industrial technologies, Gutenberg's printing press. The web is still growing. The advent of mobile and wearable technology means digital connectivity is, by the year, becoming more ubiquitous and deeply entrenched across more of the world than ever before. That jejune word 'prosumer' – the idea that consumers are now, thanks to the Internet, producers – may be a commonplace, but it's true. Videos, photos, behavioural data – you name it, it's super-abundant. Productivity growth has always relied on general purpose technologies (GPTs) like steam and electricity to unlock new waves. There is a good argument that computation and connectivity are just such a GPT and that we are currently living through its consequences.

Despite talk of 'secular stagnation' (the generalised slowing of advanced economies) the end is not yet in sight. New technologies including artificial intelligence, the Internet of Things, nanotechnology, bioengineering, super materials like graphene and the widespread rollout of 3D printing (poised to do for objects what the Internet did for data) all mean that

we could be entering an even more intensive phase of this centuries-long process. Meanwhile the shale gas revolution and advances in renewables are securing energy supplies. New organisational forms like the collaborative commons and the sharing economy are unlocking new areas of economic growth. Each of these has the potential to turbocharge new areas of growth and upend entire industries. It's at once exhilarating and unsettling.

If computer technologies represent a third Industrial Revolution, here are the seeds of a fourth. Indeed some thinkers believe this new infrastructure could unleash a wave of productivity so radical it leads to the near-elimination of the marginal costs of production – and in the process to the eclipse of capitalism itself.[16] Imagine if every human being on earth had an advanced 3D printer and the materials to go in it. What would happen to the economy then?

Every day we are still experiencing the full force of the Long Boom.

But what does it have to do with curation? And isn't it a good thing? Broadly, yes, the Long Boom is a good thing. Abundance, it should be stressed, is generally positive. It has given us a formerly undreamt-of quality of life. It gives us the luxury of #firstworldproblems. It means that Danica May Camacho, growing up in a still poor country like the Philippines, should have a much better quality of life than her immediate predecessors. At the same time the Long Boom doesn't mean everything's just fine. Far from it. Billions still live in poverty without medicine or enough to eat, let alone a new phone or this season's fashions.

As we will see, the Long Boom's downsides are making themselves felt. This is where curation comes in. The Long Boom is the business and social context of the twenty-first century. Whether we are talking data or human beings, new

music or plastic trinkets, the Long Boom means that in many areas of our lives, thanks to a combination of economic and technological growth, scarcity has given way to abundance. In short the Long Boom means that many people have too much of one thing or another, not too little. Without the changes described here, I don't believe we would ever have felt the wider need for a term like curation. It's in this context, beyond its home turf of museums and web content, that curation's full impact is felt.

2

Overload

Lisa's problems (sorry Lisa) get to the nub of the kind of issue we see cropping up again and again at this stage of the Long Boom. 'Information, data is the lifeblood of the markets. You can't really get enough. That's the theory.' But in fact, Lisa and others are increasingly overwhelmed by the data on offer. 'Actually it's not just about the volume, it's about having the right data, the stuff that actually matters, and then knowing how to make the best decisions on it. That right there is how you get ahead.' The system generates more and more information about financial markets, whether pricing data, historical data, company reports, news media analyses or write-ups by in-house analysts and all the tantalising and endless information provided by the $24,000-a-year Bloomberg terminal. Simply adding more data isn't necessarily useful. The signal-to-noise ratio for traders is already out of whack; by adding more, you are probably just increasing the level of noise, which will lead to worse outcomes. Instead the trick is to find the right data, that telling piece of actionable information.

Lisa has what I call an overload problem. Overload

problems are when issues occur not because of having too little, but because of having too much.

Even for the simplest financial transaction there is an excess of data – company reports and earnings statements, share and option prices, supplier information, commodities pricing and executive profiles, the macro outlook for the sector and the wider economy. Each contains reams of detail. Simply adding more creates information overload, not enlightenment. In the context of equities trading, information overload is costly. This is why the future of financial information won't simply be about more supply. It will be about building tools that let financial workers sift the data deluge more effectively. Companies that succeed will find willing customers with huge amounts of money on the line.

This is the impact of overload. If businesses exist to solve problems, not only are we now seeing a trend for more companies to solve overload-style problems, but it's a trend that will intensify in the future.

Information overload is the classic case. Lisa swims in a sea not only of financial data, but of information full stop, the great maelstrom of web content from Buzzfeed to the *Wall Street Journal* and the hundreds of TV channels at home, with Netflix piled on top. Like many of us, her attention span is falling to bits. Concentrating on an email let alone a sustained activity is problematic. But overload-style problems are more widespread than that. Despite having everything, I ask Lisa, is she satisfied with her life, is she happy? There is an awkward silence. 'Yes and no,' she answers. 'It feels ungrateful to say no, as I have so much and I've had amazing opportunities. Materially I'm comfortable. But am I happy? Sometimes I don't know. I never feel like I have the time or the space to enjoy anything.'

Statements like this are increasingly a normal part of overload. Adding more isn't going to work.

If we are familiar with information overload, the futurist
James Wallman suggests we are also suffering an overload of
possessions. He calls it 'stuffocation'.[1] Having more things
was always good – hence the demand that powered the Long
Boom. And boy, do we have more things. Americans consume
more than three times what they did fifty years ago. In 1991
they each bought thirty-four new items of clothing a year;
this had risen to sixty-seven new items by 2007. The average
British woman meanwhile buys fifty-eight items of clothing
a year, having almost doubled her spending on clothes in
the fourteen years from 1990 to 2004. In 1995 Americans
bought 188 million toasters and similar devices a year; by
2014 that had risen to 279 million. The Energy Saving Trust
estimates that British households increased their ownership
of electronic consumer gadgets by a factor of eleven in the
period 1970–2009.[2]

Now, Wallman argues, having more simply leads to clut-
ter and excess. It neither serves a purpose nor makes us
happy. Wallman looks at a study from UCLA's Center on the
Everyday Lives of Families. Their report, *Life at Home in the
21st Century*, found a state of 'material saturation' in the lives
of the families they worked with. They had, on average, 139
toys, 438 books and magazines and 39 pairs of shoes each.[3]
Even the smallest home in the study had over 2,260 items
in three rooms. They concluded that Americans are living
amidst 'extraordinary clutter'. Stuffocation even manifests
itself physiologically – the more clutter people, especially
women, had, the higher their stress levels. All that resource
and productivity of the Boom and, after a certain point, all it
does is stress us out.

Overload isn't just about information, but what has been
called 'affluenza', or the challenge of affluence. A grow-
ing body of research looks at how what was once a basic

truth – that having more money and more things is an intrinsic good – is at second view more complex. The classic statement of this was made by the economist Richard Easterlin, who came up with the eponymous Easterlin Paradox. Easterlin argued that although rich people are happier, they are not happier in proportion to how much richer they have become. The argument is that beyond a certain point money doesn't contribute to happiness. While many have always suspected this was true, Easterlin aimed to give it a foundation in social science. Precisely where that point lies, if indeed it exists at all, is subject to debate. One study funded by the French government suggested that national rates of happiness do not really increase after a per capita GDP of around $20,000.[4] Within richer countries Wallman suggests that the effect kicks in at around $75,000. Figures from the World Database of Happiness show that since 1973 UK real per capita GDP has almost doubled; but 'happiness' levels have flatlined.[5]

Regardless of the more arcane political debates around the Easterlin Paradox, the mechanisms behind it are easily understood. There is, for example, the idea of the 'hedonic treadmill'. We quickly get used to new possessions or circumstances and the initial buzz and boost they give us wears thin. We tend to have a kind of emotional ground state to which we return regardless of positive or negative influences. What was once a shiny new coat from the glossy boutique eventually becomes the worn out old coat languishing in the hall. Novelty and excess become the norm and no longer excite us. Moreover, all this wealth increases pressure to keep up with the Joneses. Your Ford, impressive enough last year, loses its lustre now your neighbour owns a Mercedes.

This is the nature of the positional goods which increasingly dominate the economy – goods not purchased for their utility so much as what they say about us. 'Snob goods', for

example, are bought for the claims they make about our taste. This might be a designer coat but it might be, say, education. Parents don't just send their children to Eton for the education, but for what it says about them socially. Veblen goods, named after the economist Thorstein Veblen who coined the phrase 'conspicuous consumption', buck the normal laws of economics and get more desirable as they get more expensive. (Traditional economics argues that as prices go down, demand goes up.) Fine art or wine, rare jewellery, limited edition sports cars – these goods are about showing off how much money you have and so the more they cost, the more effective they are. It's no wonder we don't always feel the benefit of rising wealth when the oligarch on the news is buying cases of Romanée-Conti for fun, or rather, to show off his bank balance.

We also become more impatient. We want things now and in the way we want them. We prioritise immediate and short-term pleasures over long-term goods. As I will discuss in more detail later, we have an excess of choice in almost all areas of our lives and too much choice leaves us feeling overwhelmed and anxious. When survival and subsistence, *pace* Maslow, aren't major problems we find ways of creating new ones. In technical language this is all described as the declining marginal utility of consumption: the more you consume, the more you need to consume to remain happy.

This isn't just a subjective question either. The economist Daniel Alpert argues that the cardinal problem with the global economy today is oversupply. All those consequences of the Long Boom mean supply and demand are out of sync; supply outstrips demand. Supplies of labour, capital and technology are all at unprecedented levels and have led to a situation of oversupply around the world, with worrying consequences. Systemic financial imbalances, for example,

can partly be explained by the enormous reserves of foreign currency held by countries like China and Japan (around $4tn and $1.2tn respectively). Money sloshing around world markets without any generative assets to invest in creates bubbles. Bubbles burst. This kind of oversupply has happened before, in the early twentieth century on the back of the innovations of the second Industrial Revolution. The response then was not just to manufacture more goods but also to create the consumer economy we now inhabit. People were encouraged to buy for the sake of buying, not out of necessity. It's clear that (a) this is no longer available in large portions of the developed world and (b) if everyone on earth lived like this it could, to say the least, create difficult environmental conditions.

It's worth reiterating again that in general overload problems are good problems to have, in that they result from solutions to older problems. When we face overload we are doing it from a position of relative strength and understanding. Yet just because they are good problems, doesn't mean they aren't problems. Deciding which coffee shop to go to or which app to download is laughably trivial. Even calling it a problem, in a world of continuing extreme hardship, verges on the unethical. Yet when we compound all the areas in which we are overloaded it adds up to a situation that requires new ways of working. We should start thinking about approaches to life and business that take a different slant, taking away rather than adding more.

In fact, the nature of overload problems demands that we do this. Let's look in a bit more detail at an overloaded area where there is simply no possibility of adding more. Where we have to find better ways of using what we already possess, something far beyond the usual purview of curation: time.

By definition time, for us, is finite. Trouble is, many of

us feel, as it were, that time is becoming *more* finite. The demands of family and work, let alone leisure, feel all-consuming. Digital technology, tempting us with just one last glance at Facebook, asking us to send that last email, exacerbates the problem. Indeed, our brains secrete an excited little hit of dopamine whenever we get a new message, a pleasurable reward that leaves us craving more. All those extra gadgets, manufactured no doubt at Longhua, make demands. We never switch off.

Worries over our jobs and finances mean we have to work harder than ever just to stand still and pay the mortgage. The cost of everything, but especially health and education, carries on rising. The result is what author and journalist Brigid Schulte calls 'The Overwhelm': the point at which our time management completely breaks down. Part of this is known as 'role overload', the idea that we are taking on too many roles at once (mother, boss, employee, co-worker, wife, friend, sibling, chauffeur, etc.). Having a rich and diversified life is one thing, role overload is when that is taken to an extreme.

A growing body of time-use research supports the thesis that we are overloading our lives. A study carried out by the Oxford University Centre for Time Use Research in 2011 found that despite long working hours, the time parents spent with their children trebled between 1975 and 2000. In US the trend was even more extreme. This contradicts a perception that we are sacrificing childcare for careers. In fact, we really are trying to have it all. A further Oxford study of 20,000 people found that educated women were doing four hours more work a week in 2000 than in the 1970s. As well as spending more time with children there was a universal increase in the amount of time spent watching TV. We are working harder than we have for decades and yet also devoting much more time to our children – and to the TV. More

than half of our waking time, at work or at home, is spent on tech or media products – more time, that is, than we devote to sleeping.[6] It's hard to see how spending more time on child-care is a bad thing, but given the slack hasn't been taken up elsewhere – apart from sleeping less – something is going to hit breaking point.

Schulte reports, from an International Association for Time Use Research conference, further research backing this up: 60 per cent of working parents were cutting down on sleep just to fit things in, while 46 per cent said they had no spare time at all. In the General Social Survey by the National Science Foundation, none of the mothers with a child aged 0–6 said they had spare time and only 5 per cent of fathers felt they had time for leisure. Forty per cent of college-educated American men work over fifty hours a week. Another study found that mothers and fathers in total worked thirteen hours more per week in 2000 than they did in 1970.[7] Meanwhile work itself is getting more intense. One study in a major company found that one weekly meeting of the firm's executive committee generated an eye-watering 300,000 hours of extra work for people across the company. We've all been there. The stats go on: 15 per cent of company time was spent on meetings, many of them not regarded as useful. In the 1970s senior executives would each receive around 1,000 external communications a year. By 2014 this had ballooned to 30,000.[8]

Part of the productivity boost has been about the accelera-tion of flows – flows of capital, ideas, data, products, people and media. It all takes its toll on us as human beings, as well as driving the world into an ever faster, more switched on and more productive engine.

At work and at home time is stretched thin like never before. We have to be incredible parents and model workers; we are expected to helicopter around our children and be ready with

a quick answer for our boss twenty-four hours a day. Time is one of the most precious resources we have, yet our time is overloaded. The demands of the modern world mean that we keep adding to the load. Almost every aspect of our lives has implications for time management that simply exacerbate the problem. Just as having too much stuff shrinks our brains through the activation of stress hormones (yes, that's right – too much stress shrinks our brains and our ability to think clearly), so does having too little time. The stress of having lots to do is compounded by the stress of never having enough time to do it. Then we spend days sitting in meetings that only create unnecessary work. Unless we make what people regard as unacceptable sacrifices, we are on a one-way street to time overload.

Of course, it's not just time that's pressured. The contemporary world produces all kinds of strains, pressures and imbalances. We use too much water, for example, and now face alarming shortages in some of the world's most significant breadbaskets, like California's Central Valley, the Midwest, and the Punjab region spanning India and Pakistan. Snowpacks are run down, aquifers are depleted and seasonal rains like the monsoon become irregular, all compounding the problem of overuse. We have too many cars for the road system we have inherited, resulting in gridlock in the world's major cities. Drivers in Moscow and Jakarta are used to sitting in their vehicles for well over four hours a day, while both São Paulo and Beijing have seen traffic jams in excess of 100km long. Debt levels – government, bank, corporate, personal, secured and unsecured – accumulate to near-record levels, all to underwrite economies built on a model of increasing production and consumption year in year out.

Our society is a great engine wanting more, more, more. Yet we can't just ramp up. We are already overloaded. New

approaches and ways of thinking will, one way or another, have to come into play.

I don't believe 'curation' alone is the answer to macro problems. Curation is clearly not some kind of saviour. Given that many people react badly to seeing curation in contexts outside art galleries, let's give it time! Curation, however, favours an approach that isn't adding to overload, but actively cuts it down. If we started thinking about time as something to be curated, not ransacked, we might approach our lives differently. We can and should make improvements.

If the Long Boom frames our business context, so overload represents the problems that come with it; problems that emerge from the transition from frugality to consumerism that has dominated the last few centuries. For most of us they are still small-scale and relatively harmless – paralysis in the food-store aisle, unable to decide which breakfast cereal to buy; staying up half an hour later than would be ideal just to get everything done. This kind of choice overload is ubiquitous and central to why curation has grown in importance. Then there is the big stuff. We have financial crashes because the debt pile has grown too big and overloads the financial system. We have problems with antibiotic resistance thanks to over-prescription of medicine. A country like Russia has grown much richer over the past twenty-five years, but its happiness levels have not improved and life expectancy, for men, has plummeted.

Overload problems don't mean curation is a magic bullet; curation will be targeted at a subset of those problems. But they do radically change the context in which we conceive and execute business strategy. The Long Boom means there is more of everything, whether data, debt or doughnuts. It doesn't mean life is easier or better. In an overloaded world, the locus of value is shifting. Tech companies have known this

for a while. From their position on the frontline of overload, they realised that taking away, curating, is important. When bewildering choice is the norm, as it is on the web, curating is essential. Hence all the talk from investors about the opportunity in curation and hence, as we will see, the great work being done there. Overload means the methods of the Long Boom are not only faltering, but make the situation worse. As with Big Data, the challenges are about dealing with surplus and severe complexity, not making it worse.

Curation strategies work against the trend towards overload. Curation helps cut through overload and navigate this new economic phase. Sure, it won't do this alone. But because value is increasingly being created in areas and services that alleviate overload, it will be profitable and significant, especially at the consumer end. For organisations of all kinds, then, the nature of the problem indicates that curatorial approaches will play a much greater role in their future. Approaches that don't add more. Approaches that cut things down. That take away. That simplify, contextualise, helping us see and live more clearly. Over the past thirty or so years we have already seen a growth in such approaches. But the scale of the challenge means that we will need to be open about where we find new strategies and models for the future. If it comes from the outliers in art and on the web, so be it. We shouldn't dismiss it.

As for the next thirty-plus years, overload will intensify. Overcoming overload, wherever we find it, in our diaries, shops, national balance sheets or taps, is the great challenge and opportunity of the twenty-first century.

3

The Creativity Myth

The meeting between Beethoven and Goethe, two of history's great creators, was always going to be fun. They were giants of their age, each eager to meet and appraise the other. Eventually, in 1812 in the Bohemian spa town of Teplitz (now known as Teplice), the encounter finally happened. It was by all accounts somewhat awkward. Goethe was a polished courtier, a refined man of learning and manners. Beethoven was wild, difficult, lugubrious and obtuse. In town to recover in the spa waters, beset by deafness, Beethoven was introduced to Goethe by a mutual friend, Bettina von Arnim. On paper they had a lot in common – powerhouses of German culture, they shared the highest aesthetic ideals. They had both admired Napoleon. They were famous and talented. Perhaps for all those reasons they didn't click.

One incident stood out to Bettina.[1] As they walked down one of the picturesque Baroque streets of Teplitz, they noticed royalty ahead. Goethe, ever urbane, did as he was trained to do – doffing his cap to the assembled dignitaries, he politely acknowledged them with due deference and stepped out of the way. Older than Beethoven and from a different world, this

would have been the default setting for even a great artist and intellectual like Goethe. Know thy betters.

Not so Beethoven. Thrusting his hands in his pockets. he marched on without stopping to acknowledge the royals. Instead he stormed through them and then had to wait, dismissively, for Goethe to catch up. Beethoven saw himself as an artist, a creator. Nothing else mattered. Nothing could match that. It was being a creator that set people apart, not wealth or family. This is the difference between the two artists – one chatting amiably, as he was meant to do, head bowed; the other storming off, refusing to stop for anyone. More remarkable still is that such was Beethoven's reputation that the royals saluted him as he went past. Servant had become master. Goethe was shocked by the man he met, writing to his wife that Beethoven had 'an absolutely uncontrolled personality'. Later in the century the artist Carl Rohling depicted the scene (see Figure 2).

Alas, the story is quite possibly apocryphal, a later invention by Bettina. But it's still instructive. At the time there was no doubt that Beethoven was writing revolutionary music, changing the very idea of what an artist could be. 'There will be many princes and emperors,' he wrote, 'but there will only ever be one Beethoven.' For Beethoven the important thing was that he was creating new, unique and extraordinary art. And he really was – composed in a style all of his own, his music is amongst the greatest ever written. No other composer changed music like Beethoven. Yet he also changed how we see creativity. He was part of the Romantic revolution sweeping Europe at the turn of the nineteenth century that put raw and unfettered creativity on a pedestal.

Before then creators had been seen in terms of religion or the aristocracy. For much of history creativity was subordinated to religious concerns – music was in praise of God,

Figure 2. Carl Rohling, *The Incident in Teplitz*

painting and architecture were in the service of religion. Only thanks to the largesse of institutions like the Catholic Church did we have artistic material of any scale. Alongside that, art was funded by patronage. Aristocrats and royalty provided funds that enabled artists to live. In turn artists dedicated their work to the glorification of their patrons. Both ideas of creativity can be seen in those other giants of classical music, Bach and Mozart. Both wrote much of their music for either the Church or grand patrons in the mittel-European courts. Both subordinated their music and creativity to others.

Beethoven wrote for himself.

This was a new conception of creativity and it soon gained wider currency. Poets like Byron and Shelley or painters like

Delacroix and Friedrich spread the doctrine throughout the arts. Creativity was in. As Beethoven said, 'Only art and science can raise men to the level of gods.' Originality, newness, boldness and awe were to be praised. Today we live with Beethoven's legacy. We have inherited the Romantic view of creativity as something to be striven for under all circumstances. We lionise our great creatives, shower them with awards and media coverage. Creativity is seen as the key to business and success. We are addicted to the 'game-changing'. We admire creative entrepreneurs like Henry Ford or Steve Jobs, people who create new things, more than we do rentiers like J.D. Rockefeller or Carlos Slim. Someone like Jobs is a corporate Beethoven – wilful, impulsive and difficult, but also utterly heroic – someone willing to sacrifice everything in the name of creative perfection. Jobs, like Beethoven, refused to compromise in the search for newness. He wasn't interested in focus groups or market research, just as Beethoven wasn't writing for the tastes of a restrictive patron. They bent the world to their will and changed it in the process. And we love them for it.

In almost every area of our lives creativity is seen as desirable. From our schools to our workplaces, creativity is encouraged, in theory at least. It's noteworthy that this idea of creativity came hot on the heels of the Long Boom. Beethoven was only a few years behind people like Arkwright and Smith. When you think about it, they were all doing something similar. Even though Romanticism is often seen as opposed to the industrial mindset, they both were innovative and put a premium on creativity. Factories were not only creating new technologies, but literally creating new products – and lots of them. Arkwright, like Jobs and Beethoven, was a creator. Adam Smith was trying to formulate ways to create wealth. The nascent discipline of

economics was codifying rules for society to become more productive. For Smith and generations of later economists the role of the entrepreneur in the free market, what John Maynard Keynes called 'animal spirits', was a key driver of economic growth. Creativity went hand in hand with prosperity. Economics and industrial technology shared with the Romantics, in a different way, the idea that creativity is a paramount good.

This is the 'creativity myth': the idea that creation and creativity are intrinsic goods. In the present context of overload it may be time to question this assumption – to, as it were, Roll Over Beethoven.

First, let's differentiate between two kinds of creativity. There is the creativity expressed in creative solutions. This entails clever, new and unobvious ways of working. Whatever happens in the future we will always require this kind of creativity. There will always have to be room for the unexpected and brilliant. It would be foolish to jettison this, probably our most vital trait. Then there is the creativity of creating new and more things. This is incremental creativity. Adding more. People like Arkwright, Beethoven and Jobs are, in their differing ways, clearly aligned with the first kind of creativity. The problem is that it's all got bundled into one. Creativity full stop is lauded, when actually creating more, 'being creative', is perhaps not always appropriate.

Nowhere is this more apparent than on the web, the world's largest and most democratic publishing platform. What was once called 'user generated content', initially an exotic idea that anyone could create their own stuff, has become the default. Creativity has gone absolutely mainstream and yet remains lionised, with the result that content has exploded. YouTube tells us that 400 hours of video are uploaded every minute.[2] Adding video to YouTube may indicate mass creativity. But is

it always the best thing to do? On the one hand the web gives us all an outlet for self-expression. On the other, is there any value in yet another cat photo? Democratising creative tools brings a huge range of positives. But it would be crazy to deny it also leads to surplus production. In turn, this crowds out good work. Quantity not only doesn't equal quality, but hampers quality. If we are going to have vast amounts of production we need to build – and value – the mechanisms coping with it. As writer Clay Shirky famously put it, there is no information overload, only filter failure. Whether you agree with that or not, it highlights that as circumstances change, as the Long Boom goes on and we experience more overload, we need better filters.

The flipside of the Creativity Myth is that we devalue the 'non-creative'.

Critics, editors, merchandisers, yes, curators, are all seen as subservient to the creator. These roles are increasingly important, but they are regarded as being below creators in the pecking order. Most of us probably feel that is right. But as we experience more overload I think the balance should shift a little. If we live in a world saturated with images, the value of choosing the right image switches vis-à-vis the value of adding an additional image. Creativity can be exercised in analysis and addition. Just as we gained a brave new creativity in the nineteenth century, we need a brave new creativity for our own age – one that prizes 'second order' roles more highly than our existing, still Romantic concept. This is important because, as the example of Steve Jobs shows, these ideas are deeply enmeshed in our economy. The Long Boom was powered by a model that believed more was more. More was lauded and was what made money.

Now is a pivotal moment. For the first time in history, less *is* more and this means our ideas about economics and creativity

need to evolve. Businesses will lead this change by unlocking new stores of value.

For the past thirty or so years a shift along these lines has been discernible. In many areas there are already signs that the creativity myth is being undermined and overload being countered. Much of this book will go on to explore examples of where acts of secondary creativity are being prioritised – in nightclubs and art galleries, but also in retail, leisure and even the edifice of contemporary finance.

Evidence is mounting that we want to consume less physical stuff. Although total global consumption has continued to rise on the back of growth in new markets, in developed economies it has been tailing off. It might not be the end of stuffocation, but it could be the beginning of the end. The US, for example, exports far more by value today than it did in the late 1970s. Yet the weight of those exports has not increased. Physical stuff has been replaced by non-physical assets like intellectual property, software and entertainment, and services like the law. Energy usage and physical production peaked in the UK in 2001–2003.[3] And of course, growth has slowed since the post-war years to a lower level across developed countries. Indeed, in places like southern Europe and Japan, a return to so-called normal levels of economic growth is a long way off. Meanwhile countries are looking at introducing alternative measures to GDP growth: the Human Development Index is becoming a widely used alternative, the Australian government launched the Measuring Australian Happiness (MAP) initiative and the UK government charged its Office of National Statistics with measuring national happiness. It reflects a recognition that simple measurements of growth – such as GDP – are not, in an age of overload, the only thing worth looking at. Of course production, growth and energy usage are all still rising in most places. And what

was once a physical excess has now only been joined by gains in the intangible world. But it offers an indication that the Long Boom needn't be unidirectional. Growing for ever – in good or in bad ways – is not inevitable.

At the same time we are gaining a better appreciation of how creativity, growth and innovation actually work. Harvard economist Joseph Schumpeter famously characterised the capitalist economy as one of 'creative destruction'. But what if it was really about clever recombination? The image of the creator as a lone genius, a God-like figure, is dated. It might have worked in a more heroic age, but in the jaded, savvy context of the twenty-first century we can do better. The thinker Arthur Koestler wrote an epic treatise on creativity, arguing it is more a function of arrangement than of originality.[4]

Creation, argued Koestler, comes from syntheses of existing ideas; from looking at things in new and different ways. Think about creativity in art. The Renaissance wasn't about the completely new, it was, as the name implied, a rebirth – it changed the world not through unblemished originality but by reinterpreting the art and learning of the ancients. Likewise Picasso's art, that paragon of modernism, drew inspiration from so-called 'primitive' works. Koestler argued that scientific discoveries work in the same way, often using metaphors of ordinary things to make breakthroughs. Think about the water pump which inspired William Harvey's ideas about the circulation of blood, or the strings in string theory. As Newton said: 'if I have seen further it is by standing on the shoulders of giants.'

This also applies to technological innovation. The business thinker Mariana Mazzucato analyses the iPhone in detail.[5] Although we think of it as the classic 'game-changing' device, so new and revolutionary that it has immediately dominated

and transformed an entire sector, this story doesn't stack up. In fact there was very little new about the iPhone at all. The crucial technologies deployed in the iPhone – capacitive touch screens, GPS, solid state memory, internet connectivity, microprocessors, even the 'intelligent personal assistant' SIRI – were not invented for the iPhone but long pre-dated it. Apple brought them together in an attractive easy-to-use package. Seen in this light, Jobs looks less like the Romantic artist and more like one of Koestler's creatives, seeing what's out there on new levels, combining things, mixing them, and so introducing newness. W. Brian Arthur concurs. When you look through the history of technology, he argues, you find it's a dynamic system where parts combine and recombine at new levels of complexity. Technology works by adding to existing assemblies – not by wholesale leaps into new territory. All of this doesn't mean Jobs wasn't a creative visionary. It means that we need to rethink our idea of what creative visionaries are.

Unsurprisingly Jobs himself was the first to admit this, telling *Wired* magazine: 'Creativity is just connecting things. When you ask creative people how they did something, they feel a little guilty because they didn't really do it, they just saw something. It seemed obvious to them after a while. That's because they were able to connect experiences they've had and synthesize new things.'[6]

The creativity myth is seductive. We want to believe it's true. It's romantic as well as Romantic. It's humanity at its best. We like to think that humans can be completely original. Beethoven or Jobs did change the world, just perhaps not in the way we would like to believe. Creativity, when looked at closely, is as much about working with what already exists in new and better ways as it is some kind of divine flame. Romanticism and the rise of the entrepreneur were necessary to shrug off the weighty

hand of social and religious control. Now that battle has been won, we can start to see that creativity always contained elements of what we now call curation.

By the same token, CEOs are seduced by the lure of top-line growth at all costs. Top-line growth is the Romantic way of doing business. Governments think the answer to almost every problem is to boost growth. We've engineered our companies and societies to encourage it. We still to a great extent believe more is more. Despite widespread overload and a context of abundance, we haven't adapted. This is the underbelly of the creativity myth. The 'growth complex', perhaps. Just as creativity doesn't have to be about quasi-divine newness, so growth can work differently. Growth can come from adding value, not adding more. Paradoxically, as the century wears on, we will realise that creating less, indeed, actively cutting down, leads to more prosperity.

The strains of the Long Boom are showing. We've enjoyed the many upsides but overload isn't apparent only in information. It's everywhere. Choice, media and stuff alike have proliferated and continue to proliferate at an ever faster rate. Swathes of life, like leisure, are commoditised and subject to the diktats of mass production. From our water supply to our free time, from rising and complexifying debt to shortages of metals to a break between happiness and wealth, the problems of having more, the results of the creativity myth and the Long Boom, are being felt.

Yet the traditional way of doing business and growing is getting harder. Growing the old-fashioned way won't be an option for some companies. We need to make less from more; to switch from a creativity mindset to a curation mindset. Now that is becoming a reality.

Curation is part of the emerging discipline of 'post-scarcity

economics', a context where the laws of supply and demand are transformed.[7] In the past five hundred years our population has increased fourteen-fold – but our energy consumption has increased by 115 times and the global economy is now 240 times bigger than it was in 1500.[8] In economics, scarcity and value are correlated. Across the global North scarcity no longer holds in media, information and data; for some fortunate individuals it doesn't hold in terms of food or financial products. Consequently, the price of such goods is collapsing. Normal economics breaks down when goods can be infinitely copied and instantly scaled at zero (or very low) marginal cost. You only need to look at a landfill site or visit Freecycle to realise we have a surplus of physical items. The new scarcity is the expertise needed to filter options. The impact of the Long Boom's abundance is creating a new reactive economy. This book should be read with this in mind.

The nature of value is changing. As much as – and often more than – simply adding, value is about taking away. Boosting productivity the old way is insufficient. At the same time we should recognise that some of our beliefs about creativity, innovation and growth also need to change. Curation is not the only or even the main response to these three phenomena. The context of the Long Boom, overload and the creativity myth do however take curation beyond the platitudes, not just culturally but for businesses generally.

I'd been chatting to Lisa for well over an hour. The conversation ranged widely, from the perils of the daily commute to financial technology to the way nobody takes their full vacation allowance. The discussion underlined to me the immense business opportunity available in sorting out overload. People like Lisa at the cutting edge of the modern economy, hardworking and well remunerated, do not feel things function effectively.

As we're leaving I ask one last question. 'Have you ever thought about curation as a business strategy? As something that might help with all of this?' She laughs. 'No! No I haven't.'

Well, here goes.

Part II

THE ANSWER

4

The Origins of Curation

From the Roman senate to a New York urinal

Hans Ulrich Obrist and Stéphanie Moisdon are two of the world's most celebrated curators. Known in the art scene as tastemakers and jetsetters – Obrist alone has made over two thousand trips in the last two decades[1] – they are power curators. The fast-talking and hyperactive Obrist in particular, with his record of 'high impact' shows, series of books and globetrotting agenda, has become the model of a contemporary art curator. Clad in distinctive transparent glasses and scribbling endless notes, Obrist has topped the *ArtReview* Power 100, an influence bellwether. That a curator could top the list is an indication of how far curating has come. No longer niche players, curators are now what the German critic Willi Bongard has called 'Popes of art'.[2]

Obrist and Moisdon co-curated the 2007 Lyon Biennial. Biennials and other international art shows are vast events, with artists, dealers, collectors, curators and perhaps the odd spectator jetting in to see money change hands on

an epic scale. Champagne-fuelled parties are alive with gossip – who is the next big thing? Who's lost it? The top events – Basel, Miami, Venice – are etched into the art calendar.

Art Basel Miami Beach is perhaps the biggest such show in the US. Growing out of the original Swiss fair, it was established as the organisers noticed how many collectors hailed from Miami. Now, amidst the Art Deco sunshine of Miami Beach, distributed through enormous halls, with hundreds of galleries and thousands of premier league visitors, Art Basel Miami Beach is the art fair in its purest form. Having spread from the original Convention Centre to a host of satellite venues, it packs elite hotels with famous artists and, increasingly, celebrities keen to show off their avant-garde credentials. Biennials are the perfect breeding ground for curators as they cram everything into one room – different kinds of art from around the world, different media, different-sized works, all jostling for attention.

But back in Lyon Obrist and Moisdon wanted to be a little different. Rather than selecting and organising artists and artworks, they selected a further sixty people to get involved. Many of these were curators in their own right, and had now been designated players in an intricate art world game. Each of these 'players' would select an artist for inclusion in the programme. Each player chosen by Obrist and Moisdon was a mini-curator. So, effectively what you had is – wait for it – curators curating curators curating. And then, given that they also made artists and critics curators, the whole category of curator had been blown wide open. Everyone was a curator. This was hyper-curation, curation cubed. The thinking behind the show was that, as the world becomes more complex, so no artist or curator can individually represent it. Only by increasing the variety of selection can you ever hope to do

justice to life. Or was it just another art game? It's an open question.

What it undoubtedly showed was that curation had swamped art. Curation was now at the centre of the art world. How did we get there? And how did curation then leap from this context into so many others?

Although the meaning of curation has radically evolved over the last decade, becoming relevant in many new areas, a brief history of the idea is illuminating.

The word itself comes from the Latin *curare*, meaning to take care of. In addition to caring and nurturing, the word had political overtones. *Curatores* were civil servants with responsibility for infrastructure, amongst other things like public games and river traffic on the Tiber. Procurators were responsible for provincial taxation, administration and estate management. This political sense of the word echoed throughout history. Senior politicians in the Venetian Republic, for example, were called procurators. A more familiar usage is that associated with the Church: curates spiritually tended to their flock, an integral part of the ecclesiastical hierarchy registering that old Latin meaning. From the beginning a curator was somewhere between priest and bureaucrat, combining the practical with the otherworldly. Either way curators had access to and mastery over difficult, concealed knowledge.

That sense of 'looking after' was clear in the origins of museum and gallery curators. In the sixteenth and seventeenth centuries rich collectors assembled 'cabinets of curiosities' or *Wunderkammer*, rooms filled with interesting objects from scientific instruments like astrolabes and chemical samples to fragments from the ancient world and mystical relics. Looking after these collections became a full-time job. Elias Ashmole, for example, founder of the eponymous

Ashmolean Museum in Oxford, was the classic Renaissance all-rounder, a scientist, traveller and soldier who built an incredible collection of objects which still stands at the centre of the museum today. Eventually, as such collections grew, so the difficulty in arranging, storing and caring for them increased.

By the eighteenth century a new approach was needed. The British Museum, now the world's second most visited museum, started as the unruly amalgam of three private collections. There was the manuscript collection of the Cotton family, the library of the Earls of Oxford and the collection, or part of it, of Sir Hans Sloane, who had amassed natural history specimens and ancient sculpture.[3] Put together this was the museum. Entrance protocols were uncertain. Staff guided visitors lucky enough to be admitted around the collections on an ad hoc basis. It was far from professional but, thanks to the scale of the collections and the complexity of what was involved, the museum was taking on new form.

Nowhere was this clearer than in what is today the world's most visited museum: the Louvre in Paris. Opened post-Revolution in 1793, the Louvre was from the beginning a new prospect – conceived as a museum for and of the people, it was symbolically placed in the palace at the centre of the *ancien régime*, now given over to the edification of the masses. Its holdings were buoyed by extensive formerly royal collections. Under Napoleon (it was even named the Musée Napoleon in 1803) they were further boosted by booty snatched from the conquered capitals of Europe. Within a short space of time the Louvre's collection was unmatched.

Around this time the director appointed by Napoleon, a colourful character called Dominique Vivant, Baron Denon, responded to the enormous increase in the amount of art in the collection in a new way. Rather than display work in a

great morass, as was normal, Denon organised it. He based displays on chronology and national schools. He looked at art's evolution over time and space. In doing so he not only set the agenda for museum curation throughout the nineteenth century but he changed the Louvre – it was no longer about revolution, but about appreciating and understanding the history of art. Curation, then, wasn't just looking after things. It was selecting with a purpose, then arranging to tell a story.

It might have been rudimentary, but compared with the chaos of most contemporary equivalents it was a step change. By responding to the flood of art and building the modern museum, Denon gestured towards how curators add value amidst excess.

In the nineteenth century a new breed of connoisseur, middle-class and upwardly mobile, found their cultural home in institutions like the British Museum and the Louvre. Both wrestled with the still relevant problem of how to show large collections to broad audiences. At the same time museums became a giant game of imperial one-upmanship; they were an excellent way of proclaiming your national might.

Around the turn of the twentieth century Germany got in on the act. Berlin's great director of museums, and the driving force behind the city's Museum Insel, Wilhelm von Bode, further transformed curating by bringing a new sense of organisational rigour. In the United States, meanwhile, a wave of civic pride saw the foundation of a host of great museums whose immense collections would soon rival and even surpass those of the Old World. Yet curating would spin off at a tangent. While collections kept growing and the challenge of working with them increased – a good case study are the medical collections of pharmaceutical mogul Henry Wellcome, whose mania for collecting saw him accumulate

Figure 3. Marcel Duchamp, *Fountain*

warehouse upon warehouse of arcana, all waiting for diligent curators to eventually sift through – it was the art world that bounced curation out of its museum niche.

Just as the Industrial Revolution changed the meaning of productivity, art was about to change the meaning of meaning. That, in turn, needed new roles to make sense of it all.

Marcel Duchamp was a troublemaker. The artwork

shown in Figure 3 is what it appears to be: a urinal laid on its side, signed *R. Mutt 1917*. Safe to say that when it debuted in that year no one had seen its like. As the first 'readymade', a manufactured object Duchamp called art, it immediately challenged assumptions of what art was and could be.

Called *Fountain*, it was originally 'made' for an exhibition of the Society of Independent Artists in New York. The idea was cooked up by Duchamp in a New York restaurant whilst having lunch with two friends.[4] Although the event was planned as a typical exhibition, for a submission fee the society was obliged to accept entries from members. Duchamp, a board member, was going to have some fun and submitted the work, supposedly by one 'R. Mutt', from a fake address in Philadelphia. Shocked at Duchamp's proposal, the selection board rejected the work. Whereupon Duchamp promptly resigned his position in mock anger. The board claimed to accept work from any qualifying artist! Who were they to legislate what was art? What, exactly, made it unworthy? It didn't help that, as a urinal, it was considered indecent. Duchamp was arguing there was nothing timeless or obvious about art. The artist and the reception, not innate features, made something art. Galleries made art art. In perhaps the greatest irony of all, the original urinal was lost, and now all that exist are lovingly handmade replicas spread around some of the world's most famous galleries.

People read much into the urinal. It's sometimes seen as a body, sometimes as a sensuous, clean sculpture. Or it may just be a urinal. Only when we are told that it's art, when it is positioned as art, do we think of it as such. Duchamp marks the point at which art went on a conceptual journey where it needed further elaboration and contextualisation. It needed

someone to say what it was and why. As art continued on this journey, proliferating along the way, so the role of the curator grew. In the words of the artist Grayson Perry, suddenly art required 'validation'. Now that anything could be art, roles that said what was art in the first place had new power and influence. As Perry argues, even if curators don't create the art, they create the spectacle of art.

Art became increasingly conceptual during the 1960s and the 1970s. No one knew where the boundaries were any more: performance, installation, video, participatory art, architecture, politics and protest, dance, food and digital technology meant that art could be – and often was – anywhere and anything. Art became about the discussion of art. Appreciating art required new levels of knowledge and sophistication. It barely made sense without reference to a body of theory – if at all. At the same time more and more of it was produced as art schools boomed. Simultaneously, exemplified by what had already become the *grande dame* of modern art institutions, MoMA in New York (under the leadership of another famous curator, Alfred Barr), museums were getting into the swing of modern art. As the 1970s became the 1980s the money started to get serious. By 2013 a total of $66bn was spent in the art market and one painting like Cézanne's *Card Players* was sold for $260m.[5] Big business by any standards. Artists like Jeff Koons even celebrated the fact, his works echoing the shininess of the high end luxury goods they were in fact becoming.

So here were the ingredients behind the curation boom that led to events like the 2007 Lyon Biennial: art could be absolutely anything; there was more and more of this stuff that could be anything; and it was all worth more and more money.

Hence the rise of the curator.

The curator tied it all together. The curator said what was art, explained why it mattered and hinted at its value. Iconic and anarchic curator figures like Harald Szeeman emerged in this period. They saw themselves as a new kind of artist, the exhibition as a canvas, the works of art as a kind of paint. Formerly marginal figures, curators were projected by Szeeman and others into the big time. Duchamp hadn't just invented a new kind of art. He necessitated a new kind of role. The character of exhibitions was also changing. In Paris, just shy of 200 years after Denon, the curator Pontus Hultén would, at the newly opened Centre Pompidou, a museum as radical in its own day as the Louvre after the Revolution, attempt a different kind of exhibition. Bode had already pioneered the mixing and matching of different kinds of works – fine art with furniture, say – to illuminate a historical period. Hultén and others went one step further by breaking the boundaries of time and space. Exhibitions featured work from different places and periods, bouncing off against one another. The curator was telling the story here. For better or for worse, curators were now truly the Popes of art. Gallerists, wealthy collectors and, still hanging in there, artists, all remained big. But if one figure defined the new anything-goes jet-setting big-money overly conceptualised steroidal-production art world of the 1990s and 2000s it was the curator.

Which is where things got really interesting.

Around this time the terms curator, curating, curated and curation started becoming more widespread – and changed their meaning. As a Curator of Fashion and Textiles at the V&A, Oriole Cullen told me: 'Anyone can be a curator now, especially as it has come to be understood as personal choice. Today the word curation means personal choice.'

'It's a word that's drifted,' says the art critic Martin

Gayford. 'It originally meant to take care of and preserve. Museums were originally stable and safe environments to keep things. The stress on selecting, arranging and displaying has become more prominent as museums became geared to temporary exhibitions. The curator goes from looking after things to a quasi-artistic role, becoming an impresario, spotting movements and picking stars.' It's a change Gayford has watched from the frontline. 'Curation has become big in the last twenty or thirty years. Being a freelance curator has become a career. Curators are moving up the scale. There is a power grab. They weren't so important fifty years ago. The artists and the collectors are still the powers, but curators are challenging now. Curate became a verb in the last twenty-five years. To curate, I bet, entered general currency in the 1980s.'

This is significant as it also started to enter wider use beyond art. As Gayford puts it, 'All these other kinds of curation are seeping from that [artistic curation]. It's a useful word, there didn't use to be any word for the activity.'

Somewhere along the line curation went from a narrow museum-based activity to something, as Oriole Cullen hints, that is much more about choice, selection, arrangement – something that responds to wider problems of too much. How?

It all started, like so much else, with the invention of the World Wide Web by Tim Berners-Lee in 1990. Before that the Internet was limited. Without an easy-to-use interface, its enormous potential was unlikely to be realised. The web changed that, putting connectivity within reach of millions. Open and low-cost, the web flicked a switch from scarcity to abundance in a host of fields. Suddenly content was everywhere, virtually free and with few barriers to creation. How people interacted with content had to change. Knowingly or unknowingly, the

web was forcing us to act like traditional curators, thinking through the selecting, arrangement, explanation and display of information and other media. Like Denon at the Louvre, ordinary users and companies faced a mass of material which they would have to make sense of – for themselves and for others. If the web made us all creators and publishers, it also made us curators.

Art curation rapidly morphed into 'content curation'.

Take a site which was in its heyday one of the most visited on the web: GeoCities. Today we think of GeoCities, if we think of it all, as emblematic of a certain early era of the web, synonymous with pixel design, bright colours, patterned backgrounds, moving gifs and unfortunate quantities of Comic Sans lettering. Synonymous in other words with awful web design and user experience.

Yet GeoCities was actually an early example of how what would come to be called curation underwrites the new digital age. Users established customisable home pages in areas of interest. GeoCities let people select and display information at will, in an easy-to-use format. Founded in 1994 as Beverly Hills Internet by David Bohnett and John Rezner, the site was divided into 'neighbourhoods' of fan pages or mini-websites. 'Nashville' was about country music, 'Augusta' golf and 'Rodeo Drive' shopping. Users were typically amateur enthusiasts and would filter and carefully curate their pages, collecting links and relevant material from across the web. It was an early example of how the Internet was going to be curated by its users. Even in the earliest days it was clear that a proliferation of information and choice required a behavioural change in Internet users from consumers to curators.

Moreover, a huge business was built on the back of this distributed curating. By the time it was acquired by Yahoo!

at the height of the dotcom bubble, GeoCities was the
third most visited site on the web and went for $3.57bn
in stock. Personal curation was popular and valuable. The
Yahoo! acquisition was when the problems started, how-
ever. Formerly loyal users deserted the site. Never regaining
traction, it was eventually retired in 2009. If GeoCities'
execution was dated, though, its business case was only
getting started. Companies from Google to Facebook would
supersede anything achieved by GeoCities. The model –
allowing users to curate material on the web related to their
interests – proved enduring. Even if nobody saw GeoCities
as a curatorial proposition at the time, in hindsight we can
see it was just that.

It would be a mistake to think of GeoCities as a sudden
break with the world of Jeff Koons and Pontus Hultén. Instead
it was the mass adoption of such an approach, on a scale
that sometimes bewildered and angered those in its original
heartlands.

Curators weren't just widely distributed on these highly
scaled platforms. In another sense the web replicated the old
structure of curators, with some quickly gaining large num-
bers of followers, big ad spends and worldwide status on the
back of their online content curation. As with Hans Ulrich
Obrist, professional curation would prove an attractive career.
A good example is the blog Boing Boing. Originally a fanzine,
arguably itself a classic form of curation, Boing Boing became
a website by 1996.[6] To begin with traffic was modest. Things
really took off once its founder, Mark Frauenfelder, moved
the site to a new platform, Blogger. Boing Boing was now
in a position to redefine itself as one of the first blogs with
significant traction.

Frauenfelder brought in collaborators, editors and writers
who would become famous in their own right, people like

Cory Doctorow, David Pescovitz and Xeni Jardin. With the new team in place traffic grew fast. By the middle of the 2000s Boing Boing was on a roll: one of the most visited websites in the world and the most trafficked blog. It was pulling in millions of readers and making huge amounts from advertising. What started as an amateurish fanzine had become an impressive media outlet setting the online agenda. It did this by linking and sharing. Boing Boing wasn't really in the business of creating content so much as pointing out what was interesting. It maintained a resolutely casual attitude. Despite making millions of dollars a year the site had no office, maintained no structure or staff in the manner of a traditional company and kept the anarchic, open web ethos it developed during the 90s. It was still more fanzine than professional media operation. All the editors continued to work on other projects even as Boing Boing became huge – Frauenfelder worked with *MAKE* magazine and the maker movement, Doctorow continued to work with the Electronic Frontier Foundation and wrote science fiction, while Jardin often commentated on television.

Boing Boing's value came from its editors. Their sheer eclecticism and commitment, and Frauenfelder's early spotting of blogging's potential (he signed on to the platform in early 2000; three years later it would be acquired by Google) as a medium for sharing made the site a success. Jardin has spoken of how they never have a content programme. They run on their instincts and interests. That's it. Yet those instincts and interests, in the pure and unadorned form of Boing Boing, turned the editors into superstar curators analogous to Obrist, with the added bonus that they had built a sustainable business. To this day Boing Boing maintains its commitment to a unique curatorial blend. On a random visit the homepage included a rather horrible jumper based on the computer

game Street Fighter 2, a discussion of racist college admission policies, an advert for free encryption classes and a gallery of '3D tattoos'.

Curation had gone mainstream. Taste and whimsy, operated via underlying platforms, made the web useful and enjoyable rather than a cacophonous mess. It was a new model, creating a new breed of job and celebrity – people like Maria Popova and Jason Kottke, who have built flourishing websites around their identity as curators. As Bobbie Johnson, a journalist and founder of online magazine Matter, put it to me: 'I think the Internet has had a lot to do with it: this idea that we have too much information, too much data – too much good stuff – and we need to sift it to find the real gems. Curation here becomes a sort of wayfinding through a swamp of content. In the early days it was often sifting through user-generated material – sites like Metafilter or Slashdot or Reddit – but increasingly, the media landscape has just become a noisy place. As our attention becomes more pulled-apart, so the curator becomes the person who helps you spend it wisely.' Here is curation as antidote to online overload.

Having lost its original political and religious overtones and made the transition first to museums and then to the art world, curation now found its apotheosis on the sprawling web – both in terms of producing celebrity curators and by making curators of us all. Techniques which reacted to the web's content surplus would soon migrate offline. It turned out that those techniques had value amidst the excess of the Long Boom. Not everyone was happy with it, but curation broke its boundaries, becoming not only the buzzword *du jour* but also something more significant.

Data from Google's Ngram Viewer (see Figure 4) bears out this rise. Looking at word usage in indexed books there is a big spike in the appearance of the words 'curation' and

Figure 4. Mentions of 'curation' and 'curating'
in the Google corpus 1800–2008

'curating' in the 1980s, which corresponds to the boom in the art world. Sadly the Viewer only takes us up to 2008; it's likely that in the years since then curation has spiked even more as writers respond to the growth of web content curation and the increasing uses of the word in areas inconceivable even during the 80s or 90s.

Google Trends (Figure 5) records a similar although less extreme rise, which shows how often curation appears in search engine results pages relative to everything else. There is a notable increase in the middle 2000s, in the wake of Boing Boing's epic traffic growth and that of sites like Popova's.

Google can also tell us what people were searching for. In descending order the most searched items are: curation content; digital curation; data curation; definition curation; social curation; curation tools; what is curation; art curation; museum curation; media curation.

No surprise that on the web content curation dominates art or museum curation, supporting the view that it is the Internet,

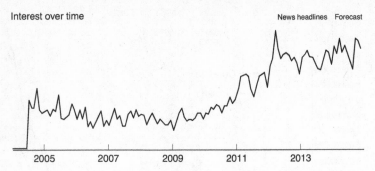

Figure 5. Interest in the word 'curation' on Google Trends 2004–2014

and Internet-based businesses, not art, that have dominated curation over the past decade and are responsible for its recent popularity. More interesting is that many searches display confusion. People are looking for definitions. Lastly, curation here is not just a concept. It's an activity. People want to know about the tools for curating. The curation of content is not, thanks to platforms from GeoCities on, a spectator sport. It's an activity carried out by millions if not billions. Curators, curation, curating aren't static terms. They have histories and, like many words in English, have continuously evolved and changed. Stasis is the exception not the norm and we should expect this evolution to continue. As contexts have changed – because of Denon's Louvre, Duchamp's *Fountain* or Berners-Lee's web – curation has reacted and expanded.

Despite protests, snobbishness and resistance, curation has come a long way from Rome. Now it is entering an exciting, far-reaching phase. From the white cube to the black box and beyond, it has never had wider relevance or more important ramifications. Whether many of its newer uses constitute curation or not is now irrelevant: while what started on the web may not have been immediately recognisable as traditional curation, the word has now travelled, and will continue to

do so. Yet, as those Google searches indicate, a lot of people don't know what it is. Moreover, the examples in this chapter are of what I call explicit curation – but today much curation doesn't go by the name.

So, just what do we mean today by curation?

5

The Principles of Curation

Hidden value

'Trouble with running a business is that whatever you do – whatever targets you hit, however quickly you scale – you always need to do more. There is never a moment when everyone stops and thinks, yup, that's pretty good. It's relentless. That's the deal.'

A friend of mine is the CEO of a large medical information company. He'd flown into London from Massachusetts and we grabbed a beer by the Thames. It was one of those warm summer evenings when the bars are thronged with post-work drinkers. Talk turned to shop, as it inevitably does. My friend's company aggregates research papers, textbooks, clinical reports, reference works, 'how to' guides and interactive materials for healthcare organisations. As the sector has ballooned over the past decade the business has flourished, growing from scrappy start-up to serious player.

My friend was under pressure from the board. Results were impressive – every year registered significant growth, the kind most businesses would kill for. But the board wanted

more. He'd delivered a new technology platform that made the service slicker, easier to use and more reliable. He'd rebranded, bringing the corporate image up to date. He'd massively expanded the sales force, which now landed blue-chip customers on a regular basis. And he'd spearheaded an internationalisation programme, taking the service from its home market in the US into Europe and Asia. While he understood that boards have a duty to keep pushing, it was nonetheless frustrating that there wasn't greater recognition at that level of what had been achieved.

Like most boards (and CEOs) they were obsessively focused on more. More top-line growth. More staff. They bought into the creativity myth. One metric, content uploads, was watched especially closely. Having more content was seen as critical. Their position as market leader was thought to rely on having the most comprehensive set of medical information and so they were in a constant battle to add more. I'd mentioned I was working on a book about curation and we got thinking. Having worked with the company on a project, I was familiar with their content-acquisition process. Although they always wanted more, I also knew they were choosy. A well-drilled content team filtered and carefully selected content. They only wanted material which specifically added value in healthcare terms.

I suggested that far from relying on adding more, his business actually relied on curation. Their proposition to hospitals, businesses and universities was that by subscribing they wouldn't waste time. Everything done on the platform was in the interests of healthcare. Value was predicated on the business offering *Gray's Anatomy*, not *Fifty Shades of Grey*. At a fundamental level this was a business whose sales pitch was really about selection. Technology can be replicated, sales teams hired. But building a corpus of expertly selected information, handpicked by specialists to ensure

health organisations don't waste time and money, well, that is a harder moat to bridge.

So I put it to him: your business isn't based on more. It's based on less. The value you add isn't just about adding. It's about excluding what isn't important or valuable; it's a business that on the face of it looks like technology platform + medical information, but in fact is saturated in curation. Looking at the content growth metric was, then, precisely the wrong way of working. A better indicator of its value to users was the amount of content it excluded, how easy it was to find that must-have piece of material. The selection process was what made it useful.

It got him thinking. When he mentioned it at the next board meeting it got the board thinking too. Thinking in terms of curation helped to refocus the company strategy on what really mattered. It led them to think about what was core to the company's activities, to avoid getting distracted by the trap of adding more in all areas.

Having that beer showed, once again, how curation was happening in more places than might be supposed. But although curation is becoming integral to many businesses, they don't realise it. There is not, in most companies even directly associated with the activity, a Curation Department. My guess is that if there were, it would be laughed out of the office. There is in company accounts no income line attributable to curation. Explaining it to the accountants would be headache enough but truth is, most of us would be hard pressed to join the dots between curating and hard cash receipts. Curation isn't budgeted for and isn't discussed by management.

Curation is more often an emergent property of organisations. Most companies don't have curators. They don't call what they do curation. Nonetheless they are curating. Curation

is integral to their activities. This only becomes a problem when it leads them to miss parts of their value proposition. Given overload, this has immediate force. My friend's medical information company is a perfect example. Much of the information they provide is available online. But has it been peer-reviewed? Is it from a respectable source? On the web you don't always know. Within the platform there is still, as on the web, a great deal of content, but the company spends a huge amount of time organising and presenting it to users, ensuring that despite this profusion they find exactly what they need.

If curation is such a great store of value it makes sense to ask – what do we mean by curation anyway? It's certainly what my friend the CEO asked me. I went to get another beer and explained my thinking.

Curation is where acts of selecting and arranging add value.

Put together, such acts are an extraordinary store of value for an overloaded world. Many curators, especially from the art world, are reluctant to define curation in such bald terms. This allows them nuance. But it means curation gets lost – as another dismissible theoretical construct, an intellectual luxury, a passing fad, not an engaged or practical activity. If we are to take curation seriously, as I believe we should, it needs something more concrete reflecting its widespread use – something to go beyond the much-parodied and obscurantist clichés.

What we have come to call curation is the interface, the necessary intermediary, for the modern consumer economy; a kind of membrane or purposeful filter that balances our needs and wants against great accumulations of stuff. At its broadest curation is a way of managing abundance.

Often it is much more than that. For example, a presentational or performance aspect was long an essential part of curation. It was about putting on a show or display. This is still important, but as I will argue, that element is now often

dropped. While curation is still for the most part directed at audiences as a service, to provide entertainment or education, as it percolates out, as more of us start to resemble traditional curators, so this aspect wanes. I don't expect everyone to agree with or accept this definition; but I think it reflects how people have popularly come to understand curation. It offers a useful template for thinking not only about that new usage, but also the wider context we live in. There will never be a correct or final definition, but we shouldn't shy away from helping to clarify understanding, practice and strategy.

Beyond this definition lie supplementary principles often found in curation. I call these 'curation effects' – refining, simplifying, explaining and contextualising, for instance. Each comes with its own history and practice, explaining its power in a world of too much. Curation combines these effects into one overarching practice.

A good example of how curation underpins entire industries is the app economy.

Apple launched the App Store in July 2008 as part of the iOS 2.0 update to the iPhone (released a year earlier). I remember it well – for those in software and content it was a bombshell. At the publisher I then worked for we quickly partnered with an exciting team of developers based in Texas. Together we managed to release books through the App Store in a matter of weeks. It was frantic and involved many late-night Skype sessions, but we felt exhilarated by the challenge of this new platform. Selling content or software of any kind on the Internet was tough. The App Store promised a controlled retail ecosystem with a simple payment mechanism. All in users' pockets 24/7.

It wasn't long before the number of apps started growing. Fast. By opening the floodgates on mobile application development, Apple unleashed a Cambrian explosion of new material.

Developers realised that they could replicate software to release large numbers of apps. It meant that with enough content and one app framework you could easily release almost limitless numbers of apps. Having launched with only 500, in just a few months the App Store was able to offer thousands upon thousands of apps. Many were high-quality, some revelatory; many, though, were filler.

The problem, for Apple, was clear. By opening the development of apps they had initiated a tidal wave of new product. Broadly speaking this was good for users – never before had so much been available so easily. Yet at the same time, the sheer rate at which new apps were produced threatened to bury good products in a sea of rubbish. Unless you knew exactly what you wanted, finding good apps would become impossible. In other words, making the App Store work required finely balanced curation. Indeed, ensuring the market operated, that users had the best service and that, in a competitive space, good apps were not lost was all a matter of curation.

Apple helped themselves by restricting the platform. Before going live every app requires approval from Apple HQ. The App Store has tough gatekeepers. The approvals process and the rules governing it have constantly been adjusted to reflect Apple's priorities. For example, releasing many apps when one app with further in-app purchases (a later development) would work fine was banned. You couldn't just flood the Store. Technical specs, analysis of the content and rule changes were all used to limit and funnel app creation.

Because of this tight control App Store editors were always close to the process. They saw everything in advance and could pick out promising apps. What constituted a promising app was highly subjective, governed less by download or usage figures and more by what editors perceived as offering originality and quality. Apple have consistently made decisions

that don't maximise profit or sales in the short term, instead looking at the bigger picture of creating lasting value for users, partners and themselves. The App Store has been no exception.

I've seen this curation at work. One app I worked on was picked as an Editor's Choice, the App Store's premium real estate. The same app was later picked as one of the App Store's Games of the Year and was consistently supported in promotions long after launch. Called 80 Days, it retold Jules Verne's *Around the World in 80 Days* as an interactive adventure. For the most part text-based, it was developed on a modest budget by a small team in Cambridge, England (the incredibly talented inkle studios). Mixing steampunk writing with board-game mechanics, this literary product without any backing from games publishers would struggle in most retail environments. Which would be a shame, as the game is brilliant. One early play showed its promise. Unlike anything I had encountered before, 80 Days was utterly original, stylish and absorbing. The hands-on curation of the App Store recognised that. Having picked the game early, the personal attention of App Store editors helped make it a great success. Despite the extraordinary number of apps being launched every week, this attention to curation keeps the App Store interesting and lets work like 80 Days – different but exceptional – find an audience.

Over time the App Store evolved to curate better. Apple understand how our behaviour gets locked into patterns. We download a few apps, play with them for a while and get stuck in a rut. Tweaking design to ensure the right spread of app icons, tailored collections, regular features (like Editor's Choice or New and Noteworthy) and category pages is meant to ensure this doesn't happen. Certainly, compared with Google's Play platform, which is more open and relies

more heavily on algorithms than Apple's, the App Store has a better standard of app. It's still the go-to platform for app launches. And it is still the launch destination for what might be called more artisanal apps – things like 80 Days or Paper or Flipboard or Garageband or The Room or The Elements.

By carefully selecting and arranging apps, Apple ensured that the extraordinary boom in app production didn't lead to overload.

The App Store is a consumer technology, a software and a retail business. But its success is underpinned by an unerring focus on curation. If apps themselves are the explicit value, curation is the implicit addition of value (more on this implicit element later). Take curation away and the app economy would struggle, would not offer the same quality and variety.

Apple's recognition of this is evident in its acquisitions and launches. Despite large capital reserves, Apple notably acquires few businesses. However, it recently bought Booklamp, pitched as Pandora (free, personalised internet radio) for books, for somewhere above $10 million, and Swell, a radio curation service, for around $30 million – not to mention the $3 billion acquisition of Beats Electronics, not just a high-profile consumer brand but a direct rival to music curation sites.[1] Although the sums it paid for Booklamp and Swell weren't huge in terms of Apple's cash pile, the fact they went to the trouble of investing, acquiring and integrating companies in these areas is telling. Subsequently Apple Music and Apple News became key services for the company – and both are built around a large investment in curation. Indeed, when people talk about Apple and curation this is usually what they mean. We should expect many of the lessons from those services to be reverse-engineered into the App Store. Recent adverts for the iPhone have taken to highlighting this feature – that its apps are 'handpicked' is explicitly seen as a sales point.

Yet the battle against app overload isn't over. Many developers and commentators say that Apple isn't doing enough. Once again, the question can be framed in a number of ways but curation is at the heart of it.

The *Financial Times* reports that the top 1.6 per cent of developers make more money than the bottom 98.4 per cent combined.[2] This is a lot of money – in 2015 revenues were up to nearly $2bn a month. Makers of addictive games built around cunningly crafted in-app purchases – Candy Crush or Clash of Clans – reap the rewards. Everyone else sweats it out for meagre sales. Research from Activate suggests that even as the number of apps has continued growing over the last three years or so, the number of downloads has held steady.[3] Apps are, in other words, a highly skewed market, where certain apps claim disproportionately large rewards and the thousands of new apps entering the market are likely to disappear without trace. To some extent this is true of my experience. While I've seen some apps do very well, other excellent products struggle to a surprising degree despite large marketing budgets.

The question for developers is how long is this viable? Yes, one developer in their bedroom can put together a quality app; but more often it needs an expensive team working flat out for months. Thanks to the falling price of apps (free now being the norm), the tech commentator Ben Thompson points out, users benefit from cheap or free services, but the companies behind those services cannot capture that value.[4] He argues that Apple needs to change the App Store, allowing subscriptions and paid updates as part of the mix. Speak to most app developers and they lament that despite all the curation, Apple isn't doing enough to encourage a vibrant ecosystem and stimulate a long tail in app sales. Clearly this isn't happening – once you fall out of the chart's highest echelons, sales drop off a cliff.

Curation helped build the App Store. But its work isn't done.

If Apple want to keep encouraging good apps (and not rely on hype, naivety and expectation) they need to ensure that downloads, usage and revenue accrues to the 98.4 per cent. The bottleneck is the App Store; the solution is good curation.

Apple are curators. My friend and his medical business are curators. Although they don't always talk about curation, that's what they're doing. Curating is about selecting. But also about arranging, refining, simplifying and contextualising. So what does that mean in practice, and why are these activities so important?

Selection

Blockbuster wasn't just a video rental company; it was part of the weekend routine, an iconic part of American culture. Despite its suburban image, there was, in truth, always something exciting about Blockbuster. You'd drive up on a grey Saturday, its strip lights blaring from broad windows, the distinctive blue and yellow livery shining with promise. Inside it smelled like a cinema – of popcorn and sweets. Row upon row of videos were lined up, waiting to be discovered, their loud covers competing for attention. Empty cases – they never actually left the videos in, assuming they'd be immediately stolen – were taken to the counter and filled by bored-looking assistants (see cult film *Clerks*). But this was the weekend! Entertainment! Possibility! Hollywood! In our family, hiring films was part of the Saturday ritual. We'd go for a swim, get a Chinese meal, hire a video and head home to watch it. The movie would inevitably be mainstream, family-friendly, funny and action-packed. It was the week's highlight, and this was a scene replicated in millions of households around the world. Blockbuster was big business, yes. But it was one of those brands that become part of our lives.

Blockbuster specialised in, well, blockbusters. Although there was always a reasonably large selection towards the back, most outlets never had much depth. Instead customers were funnelled towards great front-of-store racks of the latest big-budget releases. Walls of the same film, served straight up. Choices of non-English film, art house cinema or genres outside the mainstream were often hard to find. Blockbuster was about new releases rented en masse in part because this was one of their USPs. You didn't just rent a video because it was cheaper to do so, but because rentals were released earlier than retail versions. It was the next best thing to cinema, smell of popcorn and all. It also heavily promoted those titles because, it was assumed, they were what the audience wanted. And for a long time it appeared they were indeed what the audience wanted. In my family it was the big hits that brought us in. For several years this modus operandi served Blockbuster well: fill stores with the six or seven latest releases, cassette after cassette of the same film dominating prime in-store real estate; leave a short tail of classic fare hidden at the back.

Founded in Dallas in only 1985, Blockbuster grew fast. In the late 1980s it took on games company Nintendo in a battle to hire out video games and won. Through the early 1990s its expansion gathered pace across the US. It bought rivals in a series of ambitious acquisitions before itself being acquired by media giant Viacom for $8.4 billion in 1993. In a display of confidence, its headquarters moved to the showpiece Renaissance Tower in downtown Dallas. Stores were opened abroad. At its height Blockbuster employed over 60,000 people across 9,000 stores; it had achieved high street ubiquity, its name synonymous with media rentals. What could go wrong?

Everything, it turned out. Blockbuster's fall from its 2004 peak was frighteningly fast. By 23 September 2010 it had

filed for bankruptcy. Stores started closing. When it filed for Chapter 11 (the first stage of bankruptcy in the US) the company was experiencing considerable losses and was unable to meet a $42.4 million interest payment on its $900 million debt pile.[5] Blockbuster ran out of road. This was despite the fact that by 2010 it was the only nationwide video rental chain in the US. A buyer, satellite TV network Dish Network, was found but the closures continued. This once mighty empire was bought for only $233 million and Dish was still closing hundreds of stores every year. Eventually, by November 2013, the old model for Blockbuster was dead. The retail model of video and DVD hire it represented was finished and the name, the grand cultural institution, was all but retired.

Blockbuster faced many obstacles. But its biggest mistake would remain hidden for some years. In 2000 it passed up the opportunity to buy a then fledgling start-up for $50 million. At the time the deal must have seemed a waste of good money to Blockbuster executives whose indicators were all positive. As it turned out, the failure to buy the start-up – or recognise the change it represented – sowed the seeds for eventual collapse. Blockbuster failed to see where the media and retail market was going. In 2000 the dotcom boom was coming to a close, but the Internet was still changing people's experiences and expectations. Fast-forward ten years and those changes had solidified. That fledgling had driven them forward. Blockbuster, despite its immense head start and everyday household role, did not evolve and crashed.

That start-up was called Netflix.

Founded just twelve years after Blockbuster by entrepreneur Reed Hastings, Netflix is a textbook example of what Professor Clayton Christensen, of Harvard Business School, calls 'disruptive innovation'.[6] At first Netflix's model would be ignored and even derided by the industry establishment;

before long its hockey stick growth curves would render the old guard obsolete.

Starting with mailed-out DVDs before moving to online streaming, Netflix's proposition was supported on several pillars. First, it was convenient. No more driving to the store. Second, it was cheap. Using a subscription model and removing the overhead of extensive bricks and mortar meant that, especially once postage costs had been eliminated by the online offering, the marginal cost of lending a given film was approaching zero. Third, Netflix offered more choice. Whereas Blockbuster would always be constrained by the limitations of what a store could display, and hence always prioritised those films most likely, in its eyes, to be hired, Netflix could radically expand the catalogue available to any given user. Moreover, from the beginning Netflix wasn't just about having a lot of content; it was about giving users the content they wanted. They also applied the same principles to TV shows. In 1990 about 100 new scripted TV shows aired in the US. By 2015 that figure had grown to over 400.[7] As one network executive put it, 'there is simply too much television'.[8] Netflix wasn't just going to be about more content – that would be counterproductive. It would be about better-curated content.

Over the years Netflix had developed an algorithm called Cinematch to predict viewing preferences. They saw finding movies people would enjoy as a major part of their competitive advantage. Nothing too revolutionary for a tech company, you might think. But then they did something different. In 2007, in an attempt to beat their own algorithm, they launched the Netflix Prize. Teams would create an algorithm that performed better at suggesting films, based on Netflix's film grades and a preordained dataset of films and users. The winner would be the first to cross a 10 per cent improvement threshold and would receive $1m. Until an outright winner was found, an

annual Progress Prize of $50,000 would be awarded for an improvement above 1 per cent. Netflix was inviting anyone with the skill and determination to beat their curation.

Teams from places like AT&T Labs and the University of Toronto applied sophisticated data science techniques to the problem. A start-up, Kaggle, even grew out of the idea.[9] The competition was tough. Throughout 2007 no prize was awarded, but a Progress Prize was given to BellKor, the team from AT&T. In 2008 the story was similar. No outright winner, but a Progress Prize.

Things were getting serious. A flurry of team mergers took place in 2009. The original AT&T team went through several mergers, demergers and permutations but eventually submitted a new algorithm as BellKor's Pragmatic Chaos. It breached the 10 per cent threshold, triggering a 30-day grace period for other teams to submit entries before the final result was announced. Other merged teams scrambled to submit and after tests were run on their great rival, by then known as The Ensemble, BellKor's Pragmatic Chaos was found to have won the $1m prize on 18 September 2009.

By the end over 5,169 teams had taken part. It was a revolutionary new way of selecting films (and doing business), a million miles from Blockbuster. Netflix harnessed the collective wisdom and hard labour of some of the world's best minds and research institutes, all to better curate their movie catalogue. The most remarkable thing was that after all that effort, all the prize money, all the ferocious intellectual competition, all the publicity, Netflix never implemented the new algorithm. Things had changed. Streaming grew faster than expected, mobile tech altered users' behaviour. Netflix now thought the results weren't good enough. Having gone to great lengths to improve its film selection, creating a new method for data science in the process, Netflix were so committed to the

best means of selecting films they abandoned the whole thing.

Another example of how far Netflix has come featured in an investigation by journalist Alexis Madrigal for *The Atlantic*.[10] Like many customers, Madrigal noticed Netflix's baroque film categorisations: Emotional Fight-the-System Documentaries or Foreign Satanic Stories from the 1980s for example. It all seemed weirdly specific. How many categories could there actually be? How the hell did they generate these categories, and what were they doing with them? After some investigation Madrigal found that there were precisely 76,897 discrete categories on Netflix. Suffice to say, this was more categories than anyone had hitherto bothered to contemplate, and explained why Netflix was the destination of choice if you wanted Films With Cool Moustaches or Violent-Nightmare-Vacation Movies. Netflix was using this immense database to build a recommendation engine far superior to the competition, more specific and tailored – eerily so.

Speaking on the record, Netflix's Vice President of Product Innovation, Todd Yellin, confirmed the categories and explained how they worked. In a significant curatorial pattern, Yellin combined cutting-edge algorithmically driven systems with an unmistakable human touch. He called it 'Netflix Quantum Theory'. Every film in Netflix's corpus was watched by a trained viewer (the manual runs to thirty-six pages) and tagged in intricate detail. Moment by moment the film was categorised, often on a five-point scale. Was the ending a happy one? If so, was it a sentimental happy ending? Did such and such character have positive traits by the end (or even, one assumes, a moustache)? The results of this vast tagging process were then computed with reference to every other film to generate categories which could be matched with users – often telling them more about their preferences than they ever would have guessed.

This is a tricky process, combining labour-intensive work – *Wired* claims over 1,000 people work on it at Netflix – with significant investments in R&D and technology.[11] There was no certainty the system would actually work. Yet Netflix persisted and now, according to Madrigal, have one of the most sophisticated media recommendation and categorisation engines ever devised. They can find your filmic doppelganger – the person most similar to you in viewing taste – and suggest things based on their choices. Everything is A/B tested to within an inch of its life. All in the name of helping you choose your next Saturday night movie. They even used all this data when they branched into production – *House of Cards* was made because they knew political thrillers worked well, Kevin Spacey was one of the platform's most popular actors and David Fincher films were watched to the end. *Orange is the New Black* was commissioned because they knew people wanted LGBT content, clever comedy and women-led drama.[12]

The collapse of Blockbuster and the rise of Netflix isn't by a long way just about these two ways of selecting films. But it's part of the story. Standing back from these examples we can see that one way of choosing – Blockbuster's – gave way to a new and more powerful method – Netflix's. If, at most, Blockbuster looked at generic areas or broad demographics, Netflix can respond to and build selections around individuals. It's a pattern we find not only in movies, but across sectors. It's nothing less than a sea change and it responds to the context of overload.

The earlier model is what we might call the Industrial Model of Selection. For most consumers the modern era was dominated by the Industrial Model of Selection. There was choice, but it was circumscribed. Growing up in the 1950s, my parents' generation had, in most consumer decisions, two

or three choices of shampoo, televisions or baked beans. Once mass production had been mastered in the second Industrial Revolution it seemed mass production was enough. Henry Ford is the Industrial Model of Selection's patron saint – you can have any colour, so long as it's black. Here was a model optimised for an affluent and productive world – but not too affluent or productive. It worked when a few Western businesses dominated markets or when product categories and consumer lifestyles were new and unfamiliar. When retail and inventory space were scarce, when distribution and logistics were still being perfected, the Industrial Model of Selection – choice, yes, but limited choice, limited curation, from a narrow range of producers – was enough.

Broadly speaking this was Blockbuster's model: fill key slots with the same film, usually produced by the same Hollywood studios. Sure it had more range, but its selection was limited and most of the time it made money from the narrow hits it stocked in bulk. Put another way, the Industrial Model of Selection was the opposite of a long-tail business.

The Industrial Model of Selection looks something like Figure 6.

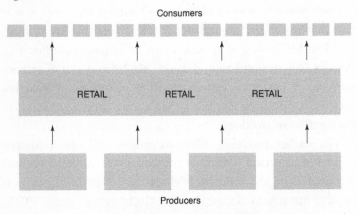

Figure 6. The Industrial Model of Selection

Of course, things changed. The second Industrial Revolution wasn't a one-off, but unleashed waves of development. Productivity and economic growth became the norm. Digital technology supercharged the expansion in choice and consumption. New economies emerged. The result is a consumer landscape offering more choice than was available to our parents in every area of our lives. Movies are only Exhibit A. This explosion in choice leads to what I call the Curated Model of Selection. In essence it means more producers and products, but more expertly matched to consumers. It means Netflix not Blockbuster, and it looks like Figure 7.

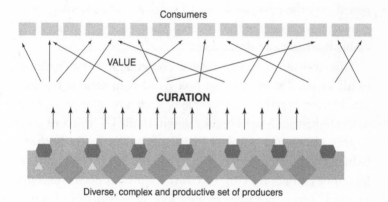

Figure 7. The Curated Model of Selection

Given increased complexity, value accrues not just to retailers, as in the Industrial Model; value also lies in the process of selection for specific consumers. Selection no longer happens wholesale; selection is considered, worked at, constantly improved. Selection isn't just a necessary part of doing business; selection is a primary asset. Selection isn't an afterthought; it's the priority. Selection is no longer a by-product of being a retailer; it is the point of being a retailer.

It means having highly qualified teams of people like Todd Yellin working on ways to match consumer and product.

The Curated Model describes one of the major business transitions of our time. It's not a binary shift but an evolution: usually there is a spectrum, with retail companies lying somewhere between the Industrial and the Curated. If the Industrial Model is exemplified by a Soviet shop, selling one dreary mass-produced product, the perfect Curated Model is the dream of companies like Amazon and Google: you always have the correct product pre-selected from an infinite catalogue. In between is everything else, but companies veer towards one or the other end of the spectrum. What has happened over the past twenty or so years is that technology and growth have rendered the Curated Model not only practically viable but increasingly valued.

This transition has immense consequences for retailers of all kinds. Traditional big box retail is in serious trouble. Blockbuster is only one example of such a retailer going bust as the Industrial Model breaks down. In the US, think of once mighty electronics empires like Circuit City or Radioshack (which filed for bankruptcy in February 2015), brought low by online competition. In the UK this shift has been especially marked. Once familiar names like Woolworth's, Comet, HMV, Borders, Tower Records, MFI, Jessops, Habitat, JJB Sports and Dreams have all either gone bust or drastically shrunk. For years major British supermarket groups like Tesco looked unassailable in their home market. Now they too struggle.[13] These companies are closer to the Industrial than the Curated end of the spectrum.

It would be a stretch to say the Curated Model of Selection finished them – as with Netflix and Blockbuster, convenience and price played a big role. The continued success of Costco and Walmart or European discount grocers like Aldi or Lidl,

businesses that epitomise the Industrial Model, their product ranges coming and going according to availability, is predicated on price. Although they all work hard on selection, it's not their USP – ultra-cheap prices are. Whatever happens to selection, it seems, there'll still be room for a bargain.

It is worth re-emphasising, moreover, that the move from the Industrial to the Curated Model is on a sliding scale, not a binary shift. Blockbuster always had some curation. Many of the old video stores were already curated – and these are the niche and boutique places that today stand the best chance of survival. They were the kind of places that apprenticed great film directors like Quentin Tarantino and Kevin Smith working in video stores before they started directing (just as bookstores helped people like George Orwell, Patti Smith and Jonathan Lethem become the artists we know today). Somewhere like Rocket Video on La Brea Avenue in Hollywood was both a storehouse of cult cinema and part of the Hollywood culture, frequented by 'The Industry'. Like many indie video rental outlets, it's now closed despite all its efforts. And users of Netflix will vouch that neither its range nor selection are perfect. There's still a long way to go.

Yet that sliding scale is moving in one direction – towards the curated model. Somewhere like Netflix has been able to scale up with the abundance of film whilst also offering a more personalised selection.

Blockbuster was a part of our culture, but that culture changed. Selection grew in importance. You started to need not only more selection in absolute terms, but also better individual selection to compensate. Retail, media and consumption generally, more than ever before, were about sophisticated ways of selecting, and not just across ranges, but for specific individuals. All of this equated to success for

those positioned to ride the wave. When Blockbuster passed on buying it, Netflix was still fighting to attract customers. By the middle years of the 2010s it had over 70 million subscribers from Brazil to Germany, its own in-house studio rivalling the production prowess of much-hailed veterans like HBO and billions of dollars in revenue. If Blockbuster had been synonymous with video renting, Netflix became synonymous with video streaming.

Selection matters.

Decisions, decisions

Consider jam.

Jam was the centre of a classic study of choice by Sheena Iyengar, now of Columbia University, and Mark Lepper of Stanford. The study – 'When Choice Is Demotivating' – challenges the idea that more choice is a good thing. Under the old theory of economics, the more chance of finding what you were after, the better. Hence the more choice was available to them, the more it was assumed people would buy. A body of research connected choice to life satisfaction. Not only did more choice lead to a booming economy, but more options meant we were more satisfied with life. No wonder that for most of the twentieth century choice was lionised; an imperative for governments, businesses and individuals.

Iyengar started to wonder. Might choice sometimes have negative consequences? Were we feeling what the futurist Alvin Toffler, at the beginning of the 1970s, had already named 'overchoice' – choice overload? Despite going against the conventional Long Boom wisdom, Iyengar believed our understanding of choice was wrong. The jam experiment came out of her doctoral research studying children and choice. She'd found, contrary to expectations, that children

told to play with one toy appeared to have more engagement and fun than children given freedom to choose their toys.

Enter jam.

For the first part of the study she went to a branch of high-end San Francisco Bay Area supermarket Draeger's. Founded by Prussian immigrants, Draeger's prides itself on choice: they offer 250 kinds of mustard, 75 types of olive oil, no less than 300 varieties of jam and, at Menlo Park, over 3,000 cookbooks and 20,000 kinds of wine. It's the kind of place where customers are willing to spend money trying new, interesting foods. In offering this excess of choice Draeger's is not alone. The average supermarket contained 3,750 items in 1949, twenty-four years after Draeger's first opened. By 2010 this was 45,000 items, while large supermarkets like out-of-town Walmarts had over 100,000.[14] Over consecutive weekends Iyengar used different selections of jam, all from high-end brand Wilkin & Sons (Purveyors to Her Majesty the Queen, no less), to investigate different selections.

As you entered the store there were always tables with goods for customers to try, showcasing the diversity of food on offer. Iyengar set up two tables in that front area to test the idea that excess choice might be 'demotivating'. Customers were used to the idea of sampling new products; it would not be unusual for the open-minded and well-heeled residents of Menlo Park to stop by a table and try something new. On one table six jams were displayed to taste. Another table had twenty-four. In both instances the full range of twenty-four jams was for sale in the shops.

The wider range of jams attracted more people – 60 per cent of passers-by stopped to look at that table, against 40 per cent who looked at the limited selection. But it didn't lead to people trying more jam. Those sampling both the large and the small selections tried about the same number. However, subsequent

purchasing behaviour was seriously altered. Whereas 30 per cent of customers who viewed six jams went on to buy jam, the figure plunged to 3 per cent of those looking at twenty-four jams. In other words, four times the selection resulted in only one-tenth of the eventual sales. The result was that 'consumers initially exposed to limited choices proved considerably more likely to purchase the produce than consumers who had initially encountered a much larger set of options.'[15] Despite the shop priding itself on range, the more focused selection resulted in better sales. Draeger's customers might be offered 300 types of jam, but in fact, that sheer range put them off.

These results were replicated elsewhere. Students wrote more elective essays when offered six topics than when offered thirty – and they were judged to be of better quality. Participants in a study of chocolates (undergraduates at Columbia) were more likely to purchase based on a small set of choices. It was further 'compelling empirical evidence that the provision of extensive choices, though initially appealing to choice makers, may nonetheless undermine choosers' subsequent satisfaction and motivation'. Since the paper was published in 2000 others have come to the same conclusion.

An example cited by academic Barry Schwartz replaced jam with pens.[16] After completing a questionnaire, participants were offered a $1.50 reward or a pen worth $2. Seventy-five per cent duly chose the pen. More choice changed the calculation. A new set of participants were offered either $1.50, the $2 pen or two felt-tip pens worth about $2 between them. After being offered a further choice only 50 per cent of people went for pens, even though they were clearly more valuable. Introducing more choice made people not want to choose. Rather than allowing people to maximise their gains, as traditional economics suggests, choice had the opposite effect.

Astoundingly Schwartz also cites studies of this same effect occurring in healthcare. Faced with more medical options, doctors would abrogate the choice. Iyengar's research has subsequently looked at how her conclusions can be applied to areas like pensions and health insurance.

So what's going on? Why would more jam attract more interest but result in less jam being bought?

It's what Schwartz calls the 'tyranny of choice'. Understanding this tyranny takes us further into psychology and the behavioural economics challenging the view of *Homo economicus* as a rational being.

For a start, thanks to the complexity engendered by the Long Boom, many of us don't have the expertise to make choices. Moreover, our ability to know is complicated by advertising, which activates our 'availability heuristic': the more we encounter something, the more it is 'available' or easily remembered.[17] The more available something is, the more significance we ascribe to it. The more we see mobile phone x, the more we are likely to choose mobile phone x regardless of whether it makes sense to do so.

Too much choice overwhelms us. The responsibility of making the 'right' choice quickly becomes a burden. It creates conflict and indecision. Plurality of choice leads to one choice only – the decision not to choose! We have, no doubt, all experienced this in the supermarket aisles, staring at hot sauce or soft drinks rooted to the spot, overcome with trivial indecision. One principle behind this feeling is known as loss aversion. We feel losses more acutely than gains. Choosing immediately opens the possibility of loss – the possibility that we could have chosen better, and so have missed out. We'd rather not choose than make the wrong choice.

Choice forces us to trade off. Every choice comes with an opportunity cost, the idea that every choice we make closes off

the possibility of all the others. Knowledge of those opportunity costs impacts on our ability to choose and our satisfaction with the choices we make. For example, say I choose mobile phone x and it repeatedly goes wrong. I immediately think back to other choices and how much less frustration I would be experiencing had I made one of them. The more options you have, the more opportunity costs you have incurred, psychologically speaking. We don't just experience regret after the event either – we anticipate regret. We ruin our own pleasure anticipating regret we might feel about other choices we could make! Which again impedes our ability to choose, inhibiting our desire to make a choice in the first place. This spills over into our work and our everyday lives – the tens, hundreds, thousands of unanswered emails we have to parse and prioritise; the impossible to-do list; the endless choices about not just jam but our insurance, electricity, Internet providers, our children's education.

Returning to jam, if we think we'll regret buying Jam A because of the opportunity costs of not buying Jam B, we are more likely to buy no jam than Jam A. Given the confluence of this effect with the sheer rise in choice and a market system, the prevalence of a Curated Model of Selection is predictable and understandable.

A further consideration is that the existence of an excessive range of parameters for decision making again impairs our ability to decide.[18] Say you are purchasing a car. There are any number of possible parameters to consider – colour, brand, top speed, safety record in side impact collisions, in-car stereo quality and so on. When spending significant sums most of us believe the availability of more parameters leads to better decisions. More information, we assume, means we're better prepared. Yet this isn't true. After considering about ten parameters our ability to make decisions is impaired. We get

confused and lose sight of our priorities. Even ten is a stretch and many psychologists argue anything beyond five is suboptimal. Saturated not just in choices but in information about choices – from the fuel efficiency of an engine to the size of the boot – we struggle to grasp what we want and why we want it. When buying a car we shouldn't take in every factor – we should choose five and focus on them.

Our choices define us. Likewise businesses and organisations are defined by their choices, which speak more clearly than any advertising campaign. The long-running Whitehall Study by Professor Michael Marmot of University College London indicates that it is the feeling of choice, rather than anything else, that promotes wellbeing.[19] Our wellbeing is dependent on the ability to exercise choice, but too much choice backfires. The feeling of choice, rather than its reality, is what we want.

Curation's role should be clear. In Western markets we have choice saturation – whether it's dating options or mobile phones or jam. The old theory said this was virtuous: good for us, good for everybody. But evidence suggests that there comes an all too familiar point when choice flips from positive to negative. Presenting the six best or most interesting jams leads to more sales than a table that's overflowing with variety. Pre-selecting which information is important about a given product helps us make better decisions. To put it bluntly, having jam today means curated jam.

Schwartz's solution to what he calls the paradox of choice is that we 'learn to love constraints'. Although we think of constraints as negative they can be helpful, even liberating. Curation produces such constraints. It limits us, but productively. Arbitrary and unthinking constraint, or the kind of constraints that come from scarcity, are unproductive. Curation, in contrast, frees us from the tyranny of small – and

large – choices. Curation allows us to focus on what matters. It takes the chore away but leaves us with the benefits; curated selection leaves us with choice, but better choice. In a time-scarce world it saves time. In tough markets where 80 or 90 per cent of products fail, curation helps focus on what works. It's why, for example, companies like Proctor and Gamble are rolling back the long-term strategy of product creation to focus on a smaller number of better-defined products and why Tesco, the world's fifth-largest retailer, is slashing its product range by a third.

When it comes to selection, curation is how we can have our cake and eat it. How we can have unprecedented production and multiplying choice without the associated anxiety, confusion and tax on our cognitive resources. Prior selections – curated selections – are needed. If we carry on expanding choice, the conclusion Iyengar suggests is that we will only grow more demotivated, whether in our desire to see masterworks in a gallery or buy breakfast condiments.

Yes, selection matters.

Platform says this

During my conversations with curators, one topic came up again and again. It's not just that curators are selectors; they're expert selectors. They have studied or practised for years to build a body of knowledge. Their curation is based on judge-ments and instincts honed by tens of thousands of hours of learning and immersion. Good taste, one diffuse but central idea behind curated selections, is carefully cultivated.

The value of curation is never *just* about selection. It's about knowledgeable selection, knowledge you can't fake. It's this mastery which makes curation so significant. Typically a museum curator will have both undergraduate

and postgraduate degrees, supplemented by globe-trotting museum placements. But the blues fan running an amateur blog and collecting old records has probably spent similar amounts of time immersing themselves in the sound of the Delta. Either way, their choices are worth following because of that deep expertise.

Comparisons are easier when in-depth knowledge is available. Curators automatically know which features are important, what fundamentals are at play and why. They parse irrelevant information faster. Experts cut options down to manageable levels without breaking sweat. Without expertise, one has to evaluate in detail, on a case-by-case basis, rather than zeroing in with an instantaneous glance. When buying that car, an expert can, choosing from thousands of criteria, instantly home in on the right model, saving you months of stress.

Yet expertise is never static. In an age of technological transformation, what it means to be an expert, and how that impacts selection, changes. This doesn't mean old-fashioned virtues of learning are becoming irrelevant. As we will see, curation straddles the new and the old, each complementing the other. But the issue is this: on the Internet, machine-driven curation, based on sophisticated algorithms and data mining, has increasingly replaced human curation. Is the expertise behind curated selection becoming more about coding and designing software than a rich understanding?

The answer is yes – and no.

Amazon is in some ways the bookish analogue of Netflix. While bookselling was always closer to the Curated Model of Selection than, say, Blockbuster, Amazon had at least a ten-fold advantage in total product stock: while the biggest bricks-and-mortar bookstore could support around 100,000 titles, from the beginning Amazon had no effective cap on

range. Choice was unlimited. As always, this created problems as well as opportunities.

Two early Amazon employees illustrate the shifting fortunes of machine and human curation. Back in 1997 Greg Linden was a 24-year-old artificial intelligence expert living in Seattle. He got a job working for the local book retail start-up. James Marcus was a cultural critic for the *Village Voice* – someone steeped in the world of bookish culture.[20] Like Linden, he took a job with Amazon, working as a site editor. In those days Amazon employed people to post reviews and provide recommendations. They were, like Marcus, from literary backgrounds. Marcus wrote hundreds of reviews and edited the home page, which reached millions of people a day. He had a column called 'Book Favourites' which built audiences for worthwhile books. His job was to slot Amazon into the book world, to give it the feel of a local indie. The editors had real power. Their curation could make or break books. 'The very early history is that Amazon,' Linden tells me, 'had a very strong human editorial voice back in early 1997. It was a bookstore only at this time and had editors and reviewers crafting the front page, much like the reviews you see if you go into a good small bookstore today.'

But Amazon's founder, Jeff Bezos, was a hedge-fund analyst and engineer: a numbers man. He felt more at home with hard metrics than the luvvie atmosphere of Manhattan publishing. Written material, Marcus told the *New Yorker*, was dismissed as 'verbiage'.[21] Bezos wanted to change the messy, subjective, Old World curation of the site – the curation that first attracted editors like Marcus. The mood was frenetic: 'The company was chaotic and growing fast, we could barely keep the wheels on,' says Linden. 'Our work was mostly trying to keep up and scale with the rapid growth, with some big projects to expand into new product lines (music, movies)

or internationally.' Despite Amazon's focus on data, he tells me, 'Any breakthroughs or innovation on things like personalisation happened as side projects, totally unplanned and unsanctioned by management.' It was becoming obvious to those on the engineering side that the site was growing too fast to maintain the hands-on, boutique approach. 'With millions of books in the catalogue, millions of customers with widely different tastes, and soon expanding into music, movies and many other product categories, a handcrafted approach couldn't keep up.'

Amazon knew what products people were buying – couldn't it also automatically recommend products based on this dataset? Their dream, and that of engineers like Linden, was to offer the customer only one book – the next book they wanted to buy.

At first the systems were crude and couldn't match human curation. If you bought a book about cooking, you then only got more of the same. It wasn't subtle.

In 1998 Linden saw a way to use the data more effectively. It was called 'item to item collaborative filtering'. It looked only at the relationships amongst products. Linden's insight was that if you just compared product correlations (ignoring a customer's individual buying history) – noticing that product *a* was often bought with product *b* – and if you had a large enough dataset, the system could suggest goods with uncanny accuracy. Enough correlations and you could safely assume that almost anyone buying product *a* would also want product *b*. It meant that all products could be included. Relationships were already in place. It noticed hidden nuances without getting distracted by odd juxtapositions. Linden had hit on a new way of auto-curating retail. Within Amazon the process was known as 'personalisation' and soon had its own dedicated team, P13N.

They tested the system against human recommendations. It won decisively.

Editors couldn't compete with the algorithms. Unlike editors, the system couldn't understand *why* a book was desirable. But the aggregated data didn't lie; correlations between products were clearly useful to consumers. Some estimates claim that a third of Amazon purchases now arise from the recommendation system. The MBA suits triumphed over old-fashioned curators like Marcus. As the dotcom boom ended, most of the site's editors were let go.

Today it's a constant process of refinement. Amazon can't just rely on its stock of data – data ages. Just because products were correlated in 2001, doesn't mean they will be correlated fifteen or twenty years later. If recommendations are wrong, the system is undermined. So there is a constant balancing act between harnessing historical data and discarding what isn't useful. Amazon has built sophisticated techniques for guessing the 'depreciation' of its data. It has systems that analyse whether consumers' tastes have changed, and whether recommendations are likely to be inaccurate.

Linden, who as much as anyone pioneered machine-driven curation, changed retail for ever. Marcus was out of a job. Linden himself places recommendations as part of a wider change at Amazon, but all of these changes were built on automation and the empirical evidence of traffic: 'Experiments showed that the editorial content could be outperformed by machine-generated content – personalised recommendations, top N lists, crowdsourced reviews – and quickly the front page and other pages on the website became automated.'

Since the late 90s machine-driven curation, fed by the enormous datasets that have sprung up in the interim, has grown. Companies like Amazon and Netflix that mastered this shift flourished. Meanwhile researchers at McKinsey

estimated that such personalisation had a return on invest-
ment of five to eight times.[22] It became clear that the Curated
Model of Selection would at least in part be the domain of
algorithms.

Yet that isn't the whole story. On the App Store, as well as
in iBooks, iTunes, News and Music, Apple hadn't abandoned
human curators. In fact, it was doubling down on them.
Indeed, even as the big platforms powered onwards, the rise
of curation was happening on a micro scale. Sites like Boing
Boing weren't growing fast on the back of machine learning,
but on editor taste. In millions of niches individual curators
were carving audiences. Even Amazon eventually changed
course and started to rehire human editors.

What's more, others saw an opportunity to reverse engi-
neer human selection back into the former poster child for
automated selection. Amazon's range is so vast that while
recommendation systems are essential, they far from exhaust
the potential for curation on the site. Canopy.co is built
around Amazon. Everything for sale on Canopy is supplied
via Amazon. In effect, Canopy exists on top of Amazon – a
version where designers and creatives spend hours deliberating
over each item. On Amazon you can buy any item of furniture
you want. On Canopy you will find only that perfect piece,
otherwise buried deep in the system.

'We all liked shopping on Amazon,' says co-founder Brian
Armstrong when I ask him about how they got started.
'But we didn't really discover new products there. We often
learned about great products from our friends, through word
of mouth.' Working in a design studio at the time, Brian and
his co-founders decided to do something about it. They set up
Canopy to curate Amazon using their design expertise. 'As
product designers, we know the importance of maintaining a
high level of quality on our storefront,' he tells me. 'Amazon

sells practically everything, but not everything in their catalogue is worth buying.'

I ask Brian about the place of hands-on curation in a world of machines and Big Data. His response is worth quoting at length: 'We've only seen the very beginning of machine-driven curation – it's still super-early in the game. People have been hand-picking things for thousands of years in their homes and shops, so human curation has a huge head start. Even though it's becoming more and more pervasive, algorithmic curation is not yet a solved problem. Algorithmic curation will definitely get better, but it won't ever have discerning taste or a unique point of view. People can perceive and appreciate the human thought that goes into manual curation. They pick up on the time and effort that's been invested, in the same way that with a well-designed object you can see the fingerprints of a designer who thought deeply about the problem and came up with a unique solution. This human quality is also behind the appeal of "artisanal" goods and services.'

Canopy has gone back to the Amazon of James Marcus. Armstrong's answer tells us why. Part of curation's appeal is an unmistakable personal touch. A qualitative dimension stemming from an individual's style, taste, learning or opinion, interesting and useful precisely because of quirks and insights deriving from what makes that person unique. Curation is, in part, about what machines cannot do. Think back to Netflix. While they use data-processing systems, every film is watched, tagged and reviewed by a film buff. Why? Because they are grading things like a film's sentiment, humour and any number of subjective factors beyond the modelling capacity of software. If machine-driven curation was the pinnacle of selection, there would be no room for a site like Canopy or Boing Boing or Wanelo or countless other human-curated concerns. We would fire all the visual

merchandisers. Get rid of the magazine editors. Gallery exhibitions could be fed into an app.

But that doesn't happen. People still enjoy the experience of bricks-and-mortar bookstores, in part because of their curation by booksellers. Selection is about finding the right things. Defining what is 'right' in any given context can't be boiled down to the information analysed by a machine. Which is not to say machines aren't valuable – they are, and will be a massive part of curatorial business over the next century.

But we will see a balance.

Human and algorithmic curation working together, complementing each other. Linden, the original architect of retail selection by personalisation algorithms, agrees: 'On the balance of algorithmic versus human selection, the short answer is that, with millions of items in the catalogue and millions of customers, you can't do anything but algorithmic. Nothing else can get coverage over enough of it. Nothing else scales. The longer answer is that the algorithms entirely depend on human selection – it's human actions of buying, looking, searching and reviewing that the algorithms are surfacing to other humans to help them – so the reality is that the algorithms are helping humans help other humans, not replacing humans at all.'

Search indexing means we have become very good at finding things we know we want. It's usually just a brief enquiry away. But faced with abundance – millions of books, say – we often don't know what we want in the first place. In the words of the technology analyst Benedict Evans, 'Google is very good at giving you what you're looking for, but no good at all at telling you what you want to find, let alone things you didn't know you wanted.'[23] If search algorithms fixed the problem of finding things on the Internet, curation, in its myriad forms, is what helps address the latter – what is it you want to find

in the first place? It's altogether a subtler and more nuanced question and plays on the uncertainties we experience when faced with enormous choice.

Whether it's driven by machines or humans, curation goes beyond 'I want/need this' to ask more fundamental questions. If you want to find something, search is the key; if you want to *discover*, then it's about curation. This distinction rests at the heart of all web curation and goes a long way to explaining its power in a world where consumers are overloaded with options.

While algorithms are very good at analysing some things, they are terrible at others. For example, algorithms may be able to tell us we might like to watch a particular film, or even whether a film is likely to succeed at the box office (there is in fact a company that specialises in this) – but they can't tell us whether a film is any good.[24] Beyond statistical correlations, they can't explain why we might like it. They can't create random, dimly felt linkages. The Netflix Prize offered no marks for judgement on quality; no criteria for aesthetics or taste. Whether it's books, films or anything at all, to an algorithm it's just data. No one can deny their power – not just to sort our media, but, for example, to find directions, fly drones or even predict terror attacks and outbreaks of disease – but at the same time we often want more. We don't yet have an algorithm that truly understands meaning beyond a set of heuristics; that sees beyond data. Google's Deepmind division are said to be developing artificial intelligence software capable of (something like) this, but for the time being algorithms don't have the meaning-rich quality of subjective judgement.

Expertise, then, is not a matter of old learning giving way to new; they reinforce one another. In an age of web-based platforms like Amazon, the process of selection can be depicted as in Figure 8.

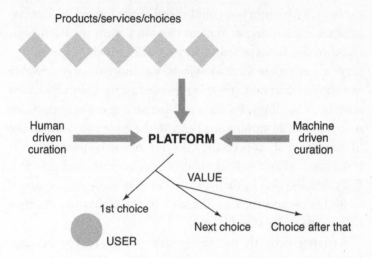

Figure 8. How platforms curate

The best selection makes the most of both human and machine curation to offer bespoke choices. This is how the Curated Model of Selection will develop. It's how we will manage the enormous proliferation of choices available to us and cut them down to a manageable number. The arts of connoisseurship aren't dead in the age of algorithmic selection – they're augmented.

Expert selection is a core principle of curation. The examples I've given here are mainly from retail and illustrate how central selection has become to overloaded consumers. But they need not be retail. Going back to that earlier use of curation, in museums, centuries of collecting have resulted in unmanageable collections which need sifting by curators.

If you were in London for the weekend I'd suggest you visit the British Museum in Bloomsbury and the Natural History Museum in South Kensington, two of the city's – and the world's – most visited and impressive tourist attractions. At

the British Museum you could spend hours behind its neoclassical facade looking at ancient treasures from the Parthenon frieze to the Rosetta Stone. In total the British Museum displays an awesome 80,000 objects. Far more than is viewable in a single afternoon. Yet this represents only 1 per cent of the museum's holdings. Its eight million strong collection, much of it kept in 194 storerooms beneath the main site, would take lifetimes to truly appreciate. Like our industrial production, it is the accumulated heritage of centuries of work (and plunder). Curators, experts in their field, take that eight million down to 80,000 – and then to direct us to the eighty objects they believe we really should view.

Arriving beneath the neo-gothic towers of the Natural History Museum you witness, aside from the dinosaurs, an even more extraordinary process of selection. The Natural History Museum's life and earth science collections amount to over eighty million items, including a giant squid, extinct species of insect, records from Darwin's voyage on the *Beagle* and over 5,000 meteorites. There are seven million fossils alone, some of them dating back 3,500 million years. Most importantly the museum holds over 850,000 'type' specimens – the first identified instance of a species and its benchmark thereafter. While some specimens choose themselves, it takes an enormous process of selection, underpinned by world-leading knowledge, to curate this immense collection. You can glean at least a sense of its scale and mission from just a day in its galleries.

Both the Natural History Museum and the British Museum, of course, do far more than merely select objects to display, just as Amazon doesn't only help select your next book. But without serious selection, Netflix and the Natural History Museum alike would long ago have been overloaded by their sheer quantity of material. They are both curating,

selecting, choosing. As institutions they derive enormous value from their vast holdings. But they wouldn't if there wasn't a knowledgeable, extensive process of selection at work. The chance of finding that one must-see piece, or that extraordinary specimen, would be vanishingly small.

The displays, in contrast, are curated and because they are curated, selected, they help us navigate the collections. They take over-abundance and make it work. As the nineteenth-century mathematician Augustus de Morgan put it: 'Take the library of the British Museum ... what chance has a work of being known there merely because it is there? If it be wanted, it can be asked for; but to be wanted it must be known.' Selection is the difference between known and unknown, overload and balance, chaos and value. Put simply, the more we have in any given area, the more we need selection to make it manageable.

Given the growth in productivity and hence in choice, the Industrial Model of Selection is, in many instances, struggling. Selection is no longer an unexciting business necessity but an important USP in its own right. When that happens you move towards the Curated Model of Selection, offering both a wider and a more tailored choice, now a major part not just of museums, but of the wider retail and business environment. If too much choice overwhelms us, curated selection reins it back in.

Selection might be the central principle of curation. But as any curator will tell you, selection is still only the beginning.

Arrangement

Mass mourning broke out on the MIT campus as the demolition squad rolled in. It was the end of an era. Starchitect Frank Gehry had designed the new $300m Stata Center – a

state-of-the-art research facility designed to project MIT's path into the twenty-first century. Limned in the trademark Gehry style – with protruding windows and a mash of collapsing angles and jagged planes – the building was described by its architect as looking like a party of drunken robots gathered to celebrate. The Stata Center was meant to change the way people worked. By combining different disciplines and labs, the idea was that new forms of knowledge would be created. Arranging the offices, departments and research spaces in an open and fluid way would itself generate new thinking. It would be 'hackable', 'post-disciplinary'; innovative inside and out.

The ironic thing, and the reason for mass mourning, was that the building the Stata Center replaced had already done these things. Building 20, the long, hulking block that previously occupied the site, had a reputation as the most innovative space on earth. Nicknamed the 'magic incubator,' it showed that a different arrangement was, sometimes, all that is needed.

Building 20, or 18 Vassar Road, was never given a formal name because it was never meant to last. Hastily thrown up in 1943 at the height of the Second World War, it was designed, allegedly in one afternoon, to house the Rad Lab – a radar laboratory helping the Allies identify Nazi planes. A sprawling 25,000 square metre structure, it was three storeys of rickety wood (which was why it was temporary – Cambridge fire regulations wouldn't allow wooden buildings on that scale). At its peak it housed some 4,000 radar researchers. The Rad Lab developed radar not just for planes but also for navigation, understanding the weather and spotting submarines. In 1945 the Department of Defense claimed its work would have taken twenty-five years in peacetime. As with other Second World War research centres like Oak Ridge or Los Alamos it

held a curious mix of characters and disciplines from maths, science and technology, experimentalists and theoreticians thrown together in the deep end. It's fair to say that if radar wasn't invented in Building 20 it was perfected there.

After the war Building 20 was scheduled for demolition. Yet despite – or because – of its jerry-built structure it became one of the most iconic structures not just on the MIT campus but in research. Post-war it became a home for random departments of MIT. Before long this assortment of misfits would change the world.

The first interdisciplinary research lab at MIT, the Research Laboratory of Electronics, was founded in Building 20. Noam Chomsky began his research into the structure of linguistics there, drawing on fields as diverse as biology and computer science. The MIT machine shop was moved there, along with a particle accelerator. Harold Edgerton created underwater photography there. The first computer hackers, members of the Tech Model Railroad club, based in E Wing, found a home there. Companies like the Digital Equipment Corporation, once one of the world's leading computer producers, were formed there. Nuclear science, systems control, new electronics, advanced acoustics technology (Amar Bose, founder of audio equipment manufacturer the Bose Corporation, was playing with speakers), the first atomic clock and microwave physics were all incubated in the space. In C Wing walls were painted with lurid murals to test the effects of LSD. There was even a room for repairing pianos.

Building 20 was, in many ways, inadequate. Ugly, featureless and cold, it lacked the creature comforts of modern buildings. Its humidity gave it a musty smell. The inside was dark. It didn't have a disciplinary identity. But it all worked. Why?

Because it was jerry-built and always supposed to go,

Building 20 was, unlike a permanent brick structure, endlessly and easily reconfigurable. If you wanted to take down a wall, you did. If you wanted more height, you'd knock through the ceiling. If you wanted to chat to someone down the hall – as often as not there was no hall. People met in new ways. There was no real sequence to the numbering of rooms and wings, which meant everyone got lost. As it was a horizontal space, getting lost took you past potential new colleagues. Groups could form and share information in ways impossible in the segregated offices and labs that characterised most research buildings of the time. Departments, research groups and oddballs from across campus came to Building 20 because there was nowhere else to go. Once there they started talking and thinking together, knocked through walls, embarked on joint projects from backgrounds no one had ever thought of combining. In Building 20 they were free – free to change the building and free to work differently.

Most buildings and offices limit rearrangement. They set patterns of work literally in stone. Some buildings like old warehouses and factories do the opposite. They allow constant rearrangement. It makes them more durable and adaptable and explains why, in cities around the world, these once derelict spaces have become so desirable. Their inherent capacity for the productive reconfiguring of space means that, unlike most offices from the 1950s with their walls and elevators, they leapt from industrial to digital revolution without breaking sweat.

A 1978 press release from the MIT museum puts it well:

Unusual flexibility made the building ideal for laboratory and experimental space. Made to support heavy loads and of wood construction, it allowed a use of space which accommodated the enlargement of the working

environment either horizontally or vertically. Even the roof was used for short-term structures to house equipment and test instruments. Although Building 20 was built with the intention to tear it down after the end of World War II, it has remained these thirty-five years providing a special function and acquiring its own history and anecdotes. Not assigned to any one school, department or center, it seems to have always have had space for the beginning project, the graduate student's experiment, the interdisciplinary research center.[25]

Building 20 bucked the dominance of planned, top-down research programmes. Want to research something? Build a building, hire a team, do the work. It was an additive, linear process. Instead Building 20 took existing university assets and allowed them to flexibly rearrange themselves. It wasn't a process of addition so much as recombination. By arranging work spaces differently, MIT harnessed more overall value than virtually any research programme in history. By making a space that rearranged both itself and the disciplines and research groups within it, the Stata Center only aped the old building.

Informed by these lessons, architects and office designers are approaching layout anew. When Pixar needed a new office Steve Jobs was insistent that it had to bring people together.[26] As a blend of creatives, artists and technologists, this intermixing of minds, not just hiring more people, would make Pixar a success. The same principles are found in new laboratories like the Crick Institute in London, a $1bn medical research facility. Both Pixar and the Crick are built around large, open atria designed to facilitate chance meetings and foster internal relationships. They have open stairways and bridges, numerous casual meeting places that allow

serendipitous conversations, 'breakout spaces', entrances used by everyone, openness to the main space from surrounding galleries. At Pixar the mailboxes, the cafeteria, a gift shop and, most importantly of all, the bathrooms were all placed in the atrium, necessitating visits there. You couldn't avoid running into your colleagues even if you wanted to. Tech companies from Airbnb to Facebook now design their offices like this as standard.

Physical connections still matter. Our interaction with space is a function of its arrangement. After crunching the data on peer-reviewed papers, Isaac Kohane, a Harvard Medical School researcher, found that the co-authors of the most cited papers usually worked within ten metres of each other. The authors of the least cited were usually over a kilometre apart.[27] The buildings that really work, like Building 20, are those that blend people and ideas in the best ways. A simple matter of arrangement can, in short, change everything. MIT didn't need the Stata Center to change the world. All it needed was the freedom and self-arrangement of Building 20.

If a central part of curation is selecting, what you do with those selections – how you arrange, organise, display, juxtapose and order them – is utterly crucial. As Building 20 suggests, some forms of arrangement or organisation are more generative than others – sometimes by an order of magnitude. In an overloaded world, rather than incrementally adding, perhaps we should re-examine what we already have and use it better. Understand that recombining can be recreating. That seeing and drawing out existing patterns, amplifying and altering them, is often a wiser and more valuable approach than creating more. Perhaps you don't need a new building – you just need to use the one you have more intelligently.

As online curator Maria Popova puts it: 'The art of curation isn't about the individual pieces of content, but about how

these pieces fit together, what story they tell by being placed next to each other, and what statement the context they create makes about culture and the world at large.'[28] This is, she argues, a process of 'pattern recognition'. Seeing how things fit together, understanding connections (which multiply in a networked environment), but then also, crucially, creating new ones by recombining them, is a massive part of curation.

Building 20's success was about relationships between people and ideas. By arranging and allowing them to combine in new, previously unthought-of ways it produced more than the sum of its parts – albeit, unlike curation, at random. We even see this at the level of individual relationships. Building 20 was full of people sparking off each other in what are known as 'creative pairs'.[29] Relationships like that between Noam Chomsky and Morris Halle fundamentally changed at least one aspect of knowledge and probably many more. This is the power of the creative pair, whether in music (Lennon and McCartney), science (Marie and Pierre Curie), business (Charlie Munger and Warren Buffett) or technology (Larry Page and Sergey Brin), a species of relationship with outsized impact.

Life throws these things into place. Curation cultivates them into being. Arrangement, and by extension curation, is about the transforming impact of relationships – not just amongst people but images, words, ideas, groceries, historical curios, anything at all. Curators find and establish relationships. They are matchmakers, contrasters, minglers, pattern spotters and pattern producers – people who can see, understand and interpret the *gestalt* and in doing so create a new one.

After selecting, the question becomes – what do you do with those selections? How do you arrange them? How do you make sure you have Building 20? How can you make the most of what you already have? What you do alongside selecting makes all the difference.

Sum of parts

If supermarkets teach us about selection, they also tell us about the power of arrangement. Cornell University's Brian Wansink spent years studying consumer behaviour and the way we eat. His investigations show how simple matters of arrangement influence it to an extraordinary degree. In one experiment he wanted to encourage students to eat more healthily at a college canteen.[30] Changing ingrained habits is difficult. Students knew what they wanted and it didn't involve vegetables. Rather than go about this the traditional way – by changing the menu – he wanted to achieve the same effect simply by rearranging the canteen.

Wansink moved broccoli to the beginning of the line. The first thing hungry students now saw wasn't fast food. Fruit was taken out of functional containers and put in an attractive wooden bowl. The salad bar went in front of the tills, making it more prominent, something you couldn't avoid. The ice cream freezer went from invitingly transparent to opaque. Buying sugar-rich desserts was made more complex, requiring additional calculations. Wansink hadn't actually added anything, the food on offer was the same, but he rearranged the process. The results were clear.

Broccoli consumption increased by 10–15 per cent. Fruit sales from the wooden bowl doubled. Sales of salad tripled. The percentage of students buying ice cream fell from 30 per cent to 14 per cent. In general the composition of meals was far healthier.[31] Arrangement, not any other inducement, led to healthy eating. Wansink studied other instances of how food's presentation and arrangement affects our relationship with it. We get full faster from eating off small plates, for example, because the smaller plate frames our expectations to make us feel we have eaten enough. Even a plate's colour changes how we eat.

Just as behavioural sciences are teaching us about choice and selection, so they are teaching us that arrangement shapes how we behave and how business works. Simple cues or ordering have marked consequences. Supermarkets have known this for some time. It's why they put chocolates at the till and their own brands at eye level. It's why fruit and vegetables are usually near the entrance. They realised that changing in-store arrangement was more valuable than building more outlets. Lower risk and higher return, patterning and merchandising became a central strategy.

Old business models were about crude expansion. This was based on making existing assets work more intelligently. Just as at MIT, supermarkets understood that what you had was potentially a rich source of value. Which isn't to say they didn't pursue linear growth – most of them did and now they're running into headwinds. They went for both, but now, in more difficult circumstances, once again working the arrangement to the maximum will be key to their future prospects. Virtually all placements in supermarkets are based on these insights.

Noticing that British consumers drank far fewer cocktails than Americans, Sainsbury's, the UK's second- or third-largest supermarket chain, partnered with Diageo, the drinks giant. In British supermarkets accoutrements like limes were at the opposite ends of the store to spirits. Consumers weren't thinking cocktails because the ingredients were so dispersed. Once people reached spirits they no longer wanted to trek back for limes. By putting a new space in the spirits section selling ice, fruits and mixers they increased sales of spirits by 9 per cent.[32] Complementary goods were allowed to complement one another.

Unilever found sales of its Peperami brand disappointing. Having secured space next to the checkout, they were confident it would sell. No luck. Instead Unilever found that sales

of Peperami increased when it was put in the chilled snack section. That it didn't need to be chilled was supposed to be a benefit; but consumers expected meat-based snacks to be chilled and weren't buying Peperami, or noticing it, out of context. Everyone in FMCG (fast-moving consumer goods) businesses has a similar story.

Where things come in a sequence and how they are framed influences our decisions. If we're hungry and see broccoli before anything else, we want it. If apples look better in a bowl, we want apples.

Decision science is often based on arrangement – and it is a key tool to guide people in overloaded contexts. The principle here is known as framing. We don't approach things neutrally. Everything we encounter and experience is, in one way or another, framed by its surroundings. Our behaviour and how we understand the world is a result of how the world is framed to us. When plates are smaller they frame portion size to make us eat less. When fruit sits in a nice bowl, its framing, its context and situation, makes us want to eat it.

Figure 9 illustrates how simple yet forceful this can be.

Figure 9. Which centre dot is bigger?

Looking at the two centre dots, most of us would immediately claim the central dot on the left is bigger than the one on the right. But of course it isn't. They're the same size. Our brains process the size of the centre circles only in contrast to the surrounding circles. It's that contrast, that framing, that makes us judge size. It's also true of properties like colour – colours appear to change depending on which colours are shown around them.

It's why we spend good money on bottles of mineral water with a funky-shaped bottle. And it's why we spend even more money on a glass bottle of mineral water with grand lettering on the front. The product is the same, but the framing – the packaging in this case – shapes our expectations. Illusionists Penn and Teller once put on a show called *Bullshit!* In one feature they went around New York City testing bottled waters, discovering in the process that in a water 'taste test' 75 per cent of people preferred the refined taste of ... regular tap water. They pulled the same trick in a high end restaurant, complete with fancy names, notional health benefits and an on-hand 'water steward'. It was, again, from a tap. We're all suckers. If a product is framed in the right way, we are willing to pay thousands of times more for it.

As the circles demonstrate, framing is far from limited to commercial transactions – everything from our day-to-day relationships to our most difficult life challenges is framed, and that framing shapes how we engage with them.

One aspect of framing, again discussed by behavioural scientists and economists (Kahneman and Tversky foremost amongst them), is anchoring. If you walk into a budget supermarket and see a loaf of bread for sale at £2 you might think that's expensive compared with the surrounding loaves, which cost £1. All that cheap bread frames the £2 and, by being half the price, 'anchors' your expectations about the cost of bread

at a lower level. Similarly, if you walk into your local 'artisanal' bakery that £2 loaf starts looking cheap next to a £5 rustic sourdough. Your expectations have been anchored up. It's why in negotiations first movers have the advantage – they anchor expectations about the final settlement.

Price, as much as any rational process or idea of 'real value', is a function of context. Value accrues through contrast, immediate comparison; it's implicit in given contexts and frames, not out there as a fact. Change the frame and you change the value proposition.

Curation uses all these techniques. Twentieth-century works from an artist like Matisse can look radical, daring and unconventional when placed in a gallery full of Renaissance masterpieces. They stand out and break the rules. Yet put those same Matisses in a room full of Damien Hirst vitrines or next to a Marina Abramović performance and they start to look quite traditional. They're still paintings, still depicting the human form. Curators play on these effects, contrasting works, shaping and upsetting our expectations. Just as price and value are produced through framing and anchoring, so the avant-garde is an expression of arrangement. No art *is* avant-garde, in the same way that no bottle of mineral water *is* worth $20; in both cases context imparts the property.

From Denon at the Louvre through Bode and Hultén, curators haven't just selected which works to display; they've hung them as well, helping to explain and appreciate the art or challenge and provoke the viewer. If the neuroscience and behavioural economics are by now well known, the connection to curatorial practice is less widely discussed. The same techniques are present in the work of Wansink and Hans Ulrich Obrist. We just don't really talk about curating supermarkets because it sounds ridiculous. But both use arrangement to achieve precise goals. Whereas an art curator

might, say, change our opinion on an aspect of visual culture, a shop might guide us to buy more baked beans; both achieve this through framing.

Frames are so powerful because we aren't generally aware of them. When going to the college canteen most of those students weren't thinking about how their food was presented. They were hungry, loading up on what seemed easy. Unless we are serious connoisseurs we tend not to think about the hanging of paintings in an exhibition – we just take it in. And we don't think about how companies steer us in their shops, or about the increasingly sophisticated marketing techniques which play off these insights.

One study conducted by the University of Newcastle shows how this works.[33] Taking a random sample of students, the researchers wanted to see what would affect whether they paid into an honesty box when taking tea or coffee. Students received emails reminding them to pay and a notice was put up reminding them to do so. On alternate weeks the researchers put another image in the room – either a control image or a pair of eyes. This was very subtle, simply a photocopied picture in both cases. No one really looked at it. Yet on those weeks when the eyes were present they collected on average 2.76 times what they did when the control image was on display. The study concluded that 'the images exerted an automatic and unconscious effect on the participants' perception they were being watched.' In other words, even if students weren't consciously aware of eyes in the room, the poster nonetheless changed behaviour by reframing a private activity as public. Whether it's in a clothing store, on a cruise ship or in a school textbook, our experience is conditioned by carefully constructed frames we don't realise are there. The more we understand how this works, the better we can understand our interactions with the world.

Arrangements are never *just* background. Or rather, background creates foreground. How things are arranged changes our actions. It makes us eat differently, spend more money or see art anew. At MIT a new approach to the arrangement of research kick-started revolutions in science and technology.

Just as selection is the obvious counterbalance to overwhelming choice, arrangement, patterning, makes the most of what we already have. Curators arrange; they frame, creating context through contrast. Selecting and arranging between them are, thanks to the results of the Long Boom, in an overloaded world and because of some deep properties of our minds, a way of recreating our culture, media and business for the twenty-first century.

So arrangement isn't only for florists and composers. Arrangement is one of the most powerful tools we have.

Artful arrangements

For most of human history recorded information was scarce. In ancient Mesopotamia this changed with the advent of a breakthrough technology used to record debts: writing. The increasing availability of information is one of the Long Boom's central planks and key to the overload we now experience. From the beginning of textual abundance in the wake of Gutenberg's press to its full realisation with the print factories and mass media of the twentieth century, culminating in the unprecedented inflation of the digital era, information has become more widespread and available in almost every one of the last 500 years. In recent times, thanks to the mass adoption of digital media like smartphones, this has been true on an eye-popping scale.

Information overload is commonly accepted. The question is not whether it exists (given that our conscious brain can

process something like sixty bits at a time and the amount of information now available is such that each American consumed the equivalent of 175 newspapers per day in 2011[34]) but rather, what is the best way of handling it? Information is a good thing; how we ensure it remains a good thing in an era of overload is the real issue. Selection will, of course, have a huge part to play. Selecting the right piece of information, the critical piece of the puzzle that makes the difference between profit and loss, victory and defeat, has enormous significance. But selection alone is not enough. How you arrange information matters as well. As it has become abundant, the need for arranging information has become pressing.

Today a whole industry is devoted to the presentation, visualisation and organisation of data. Information designers create new ways for us to see information. Data scientists help process swathes of data into manageable insights. How we arrange and consume information has become big business. But this is an industry that dates back further than we might suppose.

Charles Joseph Minard (1781–1870), from Dijon, France, was one of the first to perfect data visualisation: the art of representing the world in abstract. A civil engineer, he changed how we see information – and hence how we understand the world. Having spent a long career building bridges and dams he approached information in the same way, as flows that could be visually represented. His image, the *Carte figurative des pertes successives en hommes de l'Armée Française dans la campagne de Russie 1812–1813* (see Figure 10), has been called the best statistical graphic of all time by modern information designers.[35]

Minard's map depicts Napoleon's disastrous Russian campaign of 1812. The Grande Armée set out for Moscow as one of the largest and most successful forces ever assembled – 442,000 men with a string of famous victories behind them.

Nations lay at Napoleon's feet as his attention turned to the vast power on Europe's eastern flank. It was to be his crowning glory. But then history intervened: the Russian winter, the immense size of the country itself, the huge Russian army and their scorched-earth policy ensured the invasion became a rout of epic proportions.

Minard's map immediately makes clear the scale of Napoleon's catastrophe. The lighter band represents the army, numerically, heading east. As it gets thinner it shows the force being whittled down. The black band is the retreat from Moscow through the Russian winter. In all the map condenses into a simple two-dimensional image six metrics: the numerical size of the army; the distance and course they travelled; the temperature; latitude and longitude; and the location by date, including cities and geographical features. By the time they had taken the abandoned, still smouldering ruins of Moscow, Napoleon's force was reduced to 100,000 men. When they finally left Russia it was with just 10,000. At one stage the black line abruptly halves as the Armée crosses the Berezina river under attack. Over 20,000 troops are lost.

Understanding the scale of what happened to the Grande Armée is difficult. Many in France were shocked, struggling for years to comprehend the historic calamity of this seemingly invincible force. It involves huge numbers and distances, played out over a long timescale. There are numerous data points, difficult to entertain all at once. The complexity of warfare, then as now, was challenging. Arranging information graphically – and really it is an arrangement – Minard revealed the disaster with extraordinary clarity. At a glance we understand. Tables of data would be information overload; one well-executed image is information perfection. Arranging information changes how we look at the world; it shapes our understanding, deepens our experience, reveals trends and

Figure 10. Minard's map of Napoleon's 1812 Russian campaign

tendencies we would otherwise miss. Minard wasn't an artist in the traditional sense. Instead he arranged data.

What Minard (and others) pioneered in the nineteenth century is now becoming routine. Newspapers have whole departments whose role is to produce such diagrams. Information companies work with corporate clients to produce graphs, animations and videos designed to help them understand themselves, boiling down the confusion of modern business into digestible packages. I've worked with animators who specialise in internal coms for big companies – so complex are these multinational, many-layered organisations that they need to be graphically reinterpreted for their own executives. Anyone who has worked in an organisation of some size can testify to the bewildering nature of corporate structures. Project managers create Gantt charts or use tools like Trello to map and arrange workflows. Intricate projects employing diverse workers, dependencies and processes are made possible through clear visual arrangement. Visualising (and organising) data in every sense is a huge part of our world, from the Dewey Decimal System to computer programming ontologies.

If one company exemplifies this trend it's Google, the information business *par excellence*. With its mission to sort the world's information, Google's obvious pitch is selection: we'll give you the best possible search results. We'll whittle down the information maelstrom into manageable and accurate answers. The fabled Google algorithm, with its hundreds of variables and ever-changing parameters, is above all the world's most valuable selection engine. But Google is more than just a selector. Eric Schmidt himself acknowledges as much in his co-written book *How Google Works*, saying that Google 'curates' the Internet.[36] If curation is where selection and arrangement add value, then how Google arranges information must play a big part in its user proposition.

When Google was founded in 1998, search engines like AltaVista and Excite were already popular. Google was the scrappy start-up. It won the search battle for two reasons. First, other search engines used basic Bayesian analysis to deliver results; they looked at the frequency of search terms. Google went one better with its PageRank system (named after co-founder Larry Page). Google looked beyond the density of words to the inbound links coming to a website. Not only would it analyse the number of such links, but it would rank their importance. A link from a website which itself was heavily linked to was worth more than a link from websites with few inbound links of their own. Each inbound link was seen as a kind of vote for the significance of a page's content. PageRank was an immediate success. While there is no 'right' way to shuffle the Internet, Google's results felt relevant and intelligent. With PageRank Google nailed selection.

Second, Google changed the design of search-engine interfaces. The competition had cluttered search and results pages, stuffed with information and news. GeoCities-style design might be fine for your website; not for a search engine. Google went minimal – a search bar, the logo and a list of links. The number of words on the home screen was and is rigorously policed. This design was user-friendly, an attempt to deliver well-chosen information and nothing more. When Google first launched they made the copyright notice at the bottom of the screen more prominent to let users know the page had finished loading. People were so used to overstuffed pages that they couldn't believe the simplicity of the Google homepage. It is basically a bar, or part of the URL field – simpler than virtually any other interface. Arranging the requested information efficiently and cleanly has always been the design priority.

So it continues. Knowledge Graph, for example, was launched in May 2012. Again this is not just about selection

but also arrangement. A wholesale redesign of the basic search concept, display boxes differentiate Knowledge Graph from the body of search. They cluster information including pictures, links and excerpts in a tightly bundled hierarchy. The boxes act as a search page within a search page. With just a single glance they convey rich information. If I'm looking for a product they have links to buy, reviews and information on related products. If I'm looking for a person they have a biography and birth dates. If I look for a company they have a snapshot of the business and their current market cap. It's only designed as an introduction, but it complements the main results, acting as a gateway. The box itself separates and highlights the digested information.

Moreover, Figure 11 shows how Google has evolved. Knowing Oxford is a place, it breaks out both news and longer-form arti-cles ('In the news' and 'In-depth articles' respectively). These are inserted into the search engine results page (or SERP), briskly showing the variety of information available, breaking it down according to relevance and, in those sections, how new it is. In general it shows how Google has constantly tweaked the arrangement of its pages. Selection is Google's USP. But how selections are then arranged on screen is the hidden source of Google's success and the reason it invests in new programs and design concepts like Knowledge Graph. All this information is in

Figure 11. An early 2015
Google SERP for Oxford

the system, but its arrangement makes it doubly useful. With its interface design, Google nailed arrangement.

As Schmidt himself says, PageRank and clean design are about curating the Internet. What Minard did for the Russian campaign, Google does on a macro scale for the web. Both take large volumes of information and, by appropriate arrangement, overcome overload. Just as supermarkets understand that selection and arrangement are key in crowded markets, so Google understood they would be decisive advantages in the digital world.

Selection works by taking away. Arrangement is a subtler shift; it makes the most of what you have. Outside Qatar most art galleries can't simply buy any painting they need to fill gaps in their collection. They must tell the stories using what they already have. Hanging makes the most of existing holdings. In the digital world, where we are not limited by inconvenient atoms, we can go even further. What David Weinberger calls miscellaneous organisation (things like tagging) allows – unlike paintings in a gallery, which can only have one arrangement at a time – near-infinite and productive recombination. We can arrange and catalogue things in multiple ways simultaneously. The scope and force of arrangements is duly increased.

The new value is, as often as not, latent – it's already there, waiting to be unlocked. Arranging requires us to shift our view. To understand the hidden frames that structure our world. To go from the specific to the general. To become pattern spotters and pattern creators.

There isn't a best way of arranging. What works for Google won't work for Walmart or Minard or MoMA. The challenge of curation isn't just about building expertise in order to choose well, it's also about building the understanding to arrange for the task at hand. There isn't a rule book.

Instead curation demands hard work. Not everyone will be able to curate properly in any given area. Supermarkets and Google are both investing in insight teams to ensure arrangements are based on sound principles and have the required impact.

Search results are based on decisions in systems design. Select information the user wants and arrange it legibly. In other words, curate. And what about the value? As of 2015 Google's parent company, Alphabet, had a market capitalisation of above $525bn, not to mention the value, financial or otherwise, created through its free services.

Here's a small example of how arrangement changes everything. It's a classic from the field of user experience (UX). Jared Spool, a UX specialist, was working for an ecommerce client whose business was struggling.[37] After researching the problem, watching how users interacted with the site in his lab, Spool thought he had identified the answer.

It all rested on a web form. All it wanted were two fields – an email address and a password – and it had two buttons – Login and Register. There was a link to Forgot password. That was it. Fairly standard.

Users went to the site and shopped as usual, filling up a basket with goods. When they were done, having spent time choosing what they wanted, they hit Checkout. Then the form came up. In theory this was good for customers. By creating accounts, repeat purchases would be easier. For first-timers it was a tiny inconvenience that, in future, would make life better. It seemed like a great idea and was at the time standard procedure.

Spool's analysis showed, however, that the form was a big issue. Some customers couldn't remember if it was their first time on the store. Others typed the wrong password and

gave up in frustration. Registration was almost universally seen as an unnecessary chore. Some customers didn't want to share personal data. Indeed, Spool's analysis showed that 45 per cent of customers had multiple registrations and some had up to ten different accounts. Of those requesting password reminders, 75 per cent would never go on to purchase.

The solution was simple – they removed the Register button. In its place was Continue, with the message 'You do not need to create an account to make purchases on our site. Simply click Continue to proceed to checkout. To make future purchases even faster, you can create an account during checkout.' Customer purchasing leapt 45 per cent. In the first week this meant $6m in extra revenue. In the first year the company made an additional $300m. All they had done was rearrange the process. That Continue is now called the $300m button. One small change in the arrangement of our interaction with a single site was worth $300m.

How we arrange things – experiences, merchandise in shops, forms, gallery exhibitions, web pages, information, food on a plate – makes a big difference. This is true at the deepest level. In the words of the information theorist César Hidalgo, 'Our world is different from that of early hominids only in the way in which atoms are arranged.'[38] Or think about the innumerable forms that result from recombining strands of DNA. Good arrangement or organisation is also in the spirit of *curare* – it means making the absolute best of what you have.

Curation is the best umbrella term we have for how we select and then arrange. It's no surprise that the art of arrangement as a professional discipline started in museums and galleries, where things required arrangement according to complex schemas. But now arrangement is needed

everywhere. We have so much stuff that just as we must select, we must arrange it more effectively and more efficiently.

Selection and arrangement are the two central principles of curation. They have spread to new sectors in myriad ways and found millions of new outlets. But they are still only the beginning.

6

Curation Effects

Curation can be hard to grasp because its borders are diffuse and shifting. What is or isn't curation, or curated, is never quite clear. It might be just a bunch of stuff thrown together; it might be painstakingly arranged. In the middle is a grey area, where isolating curated elements, and finding the added value, aren't always obvious. It's one of the reasons curation is easy to dismiss. It's just too wishy-washy, too vague for organisations that need quick and tangible results.

But this is also a strength.

Putting selection and arrangement at the centre of curation gives us an easily identifiable basis for curatorial activity. Around that is a loose but powerful penumbra of what I call curation effects – both principles and side effects of curation whose impact, when properly understood and seen within the wider framework of curation and overload, can be immense. They reach into sectors and problems usually considered far from curation, liberally borrowing ideas and techniques. They add value, whether we are choosing our pensions or organising our homes. Curation effects are where curation overlaps with other techniques, strategies and

disciplines from product design to text editing, biological taxonomy to good old-fashioned storytelling. The dividing lines between such phenomena and curation are never clear. But it's precisely this chameleon quality that makes curation so useful.

Curation effects are the positive externalities or beneficial side effects that arise when we curate. But they are also principles to apply to our curation. Saying that we should select and arrange is one thing – saying *how* and *why* we should select and arrange is another. Curation effects are the results that we want to get, the goals of curation, but also the motivation, the route, and the crossover into other areas. Both why you select and what happens when you do.

These curation effects are by no means exhaustive. To some extent each curator will find and chase their own specific subset of curation effects. What follow are some examples of curation effects and why they matter more than ever.

Reducing and refining

Recall that in the British Museum's collection are some eight million objects, of which roughly 80,000 are on display at any one time. Clearly, seeing eight million objects is out of the question, even during a lifetime of looking. But for the average visitor to the museum, appreciating even 80,000 objects is a remote possibility indeed. On your London city break, if you spent just ten seconds looking at each item on display, that would take you 222 hours. Even the most enthusiastic museum-goer would, one imagines, get rather jaded. So even the selection process that arrives at 80,000 objects is incomplete. In fact the average visitor probably wants to seriously engage with something like eighty exhibits per visit. But they don't want to see just any eighty

objects – they often want to see the best, most important, most famous, most exemplary and rarefied eighty objects in the collection (agreeing what these are and why is the difficult bit).

Herein lies a key principle and effect of selection. By selecting you automatically reduce. You cut things down, you exclude and say no. Crucially, this isn't a directionless process. By cutting things down you are making them better. Curated selections are never just about reducing – they are about refining as well.

We've all got used to the mantra that less is more. Business books, articles, conferences and symposia tell us that a vital principle of the modern world is that we should be doing less. This book agrees. But less on its own is not necessarily better. Only a process like curation, involved with refinement through selection, can ensure that. It's no good exhorting the world to less, if you don't consider what that less should consist of. There is little point reducing if you aren't also refining. Because curation is built around expert selection with concrete goals, curation ensures that reduction and refinement happen in lockstep.

Less isn't just more. Curation *makes* less more.

Curators at the British Museum use their expertise to say, if you're only going to look at eighty, or even eight, items, look at these, the exhibits found nowhere else: displays that take your breath away or spark your imagination. Here are the greatest examples of their kind. Don't worry about those common shards of pottery found all over Europe – look instead at the Easter Island statue or the Lewis Chessmen. The curators aren't just selecting to make the collection manageable. They aren't reducers pure and simple. The process is one of enormous distillation, a hard, fine-grained process of filtering which makes the visitor experience.

It's not just museum curators who now operate on these principles. When the team behind the Flip camera or the iPhone designed those devices, they spent months removing buttons. What, they asked, was the minimum number a device could support? Reducing the number of buttons made devices easier to use. This isn't just about getting rid of buttons for its own sake. Both devices made revolutionary refinements to the user experience in product categories whose interfaces were often difficult to navigate, and traditionally put off many potential customers. Taking away was market-making – it created demand for the products.

Curation fits into a wider economic pattern of reduction and refinement. Over the past few decades we have begun to appreciate and build businesses around what isn't there. In California, for example, the energy market has been redesigned to calculate unused energy – 'negawatts' – as an incentive. Negawatts accumulate when every household installs energy-saving light bulbs, for example. Most energy companies generate profits from increased consumption and so encourage greater energy usage. Negawatts flip the standard equation, rewarding those companies for the energy they save. Using an elegant solution, the Californian energy market, along with markets in Texas, Connecticut and Georgia, rewards both consumers and energy companies for their restraint. We have started to measure energy by what isn't there in order to make our energy use better.

The owners of luxury goods brands have become ever more conscious of how those brands' value is predicated on exclusivity. Chasing top-line growth is a constant temptation. Sell more handbags and shoes, make more money. But pushed a little too far, this model becomes toxic. Brands flip from desirable to ubiquitous. Suddenly they aren't desirable any more. For the most elite brands, every product that isn't

made has value in shoring up the brand image. It's why, for instance, a company like Ferrari would actively scale back production. When the chairman, Luca di Montezemolo, announced in 2013 that they would reduce production from 7,318 units per year to less than 7,000, he did the opposite to every other motor executive. He made his reasoning clear: 'The exclusivity of Ferrari is fundamental for the value of our products,' he told journalists. 'We don't sell a normal product. We sell a dream.'[1] And that dream is based on cars that will never exist.

One of my favourite examples of this principle comes from dishwasher tablets. We used to buy big cardboard packs of dishwasher powder. Then product designers hit on a cunning wheeze. Instead of selling the powder they put it into small tablets, separated into two differently coloured layers, each of which did a different job. Going to town, they put a little red ball on top of the tablet. The net result was that for more money they were selling far less product. But by repackaging that reduced amount of raw material, they made it more expensive. Selling less was worth more even in something as functional and un-aspirational as washing dishes. These tactics and innovations are instructive.

Curation is part of this economy of less. Refinement through reduction often sees some form of curation at work. Whether it's motivated by the drive to sustainability, the desire for exclusivity, simple efficiencies or the restless quest to improve, reducing and refining is a feature of modern business that's impossible to ignore.

As a publisher, I see the value of reducing and refining every day. We call it editing. Countless books come in with incredible potential. But they can be baggy, overlong, over-written and stuffed with unnecessary asides (at this stage apologies are offered to the editor ...). Editors' value lies in

what they take away from books. Books usually don't require rewriting or even major reworking – they just need whittling down to the good bits. It's almost impossible for authors themselves to have the objectivity to see what needs to be done. Which is where editors step in. Moreover editing is a skill that takes time to perfect. There is no shortcut – editors have to get stuck in close to the text, read it many times, think it through, and have a facility for the wider structural questions as well the detailed mechanics of a sentence or phrase.

Today the publishing industry faces the huge challenge of self-publishing and the Internet. In effect the Internet means that publishers can be circumvented by channels like Amazon's Kindle Direct Publishing – as early as 2013 a quarter of bestsellers on the platform were apparently self-published. Even if they no longer control market access, though, publishers have an ace up their sleeve: experienced and expert editors. To date no one has found a way of replicating that relationship. Trusted editors kill your darlings like no one else. They know which cuts will improve, which will impair. If publishing as a whole is about curating a list, making the catalogue into a statement, then editing is a kind of micro-curation, selecting passages to cut, refining the book, and arranging the remaining pieces for maximum impact. Editing is perhaps a cousin to curation, but one who often stops by for a chat.

Editing is an industry in its own right. Beyond freelancers and professional editorial businesses, a new breed of company like GetAbstract or Blinkist is based on reducing books (and other media) to their essence. Blinkist parses books to fifteen minutes' reading. Take Thomas Piketty's *Capital in the 21st Century*: according to data released by Amazon, more readers have failed to finish this groundbreaking work

of economics than almost any other book. Although Piketty's book has changed perceptions of inequality and wealth, the data suggests most readers stop around page 26 of 700.[2] Only 2.4 per cent get to the end. Blinkist's team of trained readers digest the information into a short burst, a fifteen-minute reading experience that reduces those 700 pages to its main messages. Cheating, maybe, but to Blinkist's time-pressured readers invaluable. They produce hundreds of summaries a year which are then bundled as a subscription service on the web or in mobile apps. They claim millions of summaries have been downloaded since launch and have ambitious plans to grow. Revision series like CliffsNotes have long understood this model.

Beyond the book industry, new kinds of editing are being industrialised. Outside Manila in the Philippines, banks of anonymous offices house thousands of workers staring at insalubrious images for hours on end. They see the worst of humanity. Not just a bit of pornography, but truly disturbing images of extreme violence and gore which they can never know are real or fake. They scan content which is racist, inflammatory and abusive, working long hours for derisory pay by Western standards – $300–$500 a month. These workers are editors. Employed, according to *Wired*, by the major social networks – including Facebook, YouTube, Twitter and Instagram – they ensure the content of uploads remains within service guidelines.[3]

Scrolling through one image after another, fed to them in real time, the office workers, English speakers with Westernised sensibilities, identify and remove images deemed inappropriate. Anything from stray nudity to public executions and snuff movies can be flagged as offensive by users around the world. The results are then fed to Filipino 'content moderators' on long shifts who have to make difficult

judgements about what does and doesn't breach the guide-
lines. Quite often it's not clear. But equally it can be all too
clear and beyond shocking. It's relentless and desensitising.
They think through the context and intention of marginal
cases to see whether they comply with the guidelines.
Facebook has, for example, attracted trouble for removing
images of breastfeeding mothers (it has a much discussed 'no
nipples' rule). In spite of the toll, the jobs are still considered
desirable.

For the social networks this policing, which despite the low
wages paid incurs a huge cost given the volume of material
involved, is essential. Websites aren't just defined by their
content, but also by what is edited out. Parents have to trust
that their children won't find disturbing or lewd images on
Facebook. If this happened on a regular basis Facebook would
lose trust, children would be taken off the site, the user base
damaged. Taking away, reducing and refining, is as important
to YouTube as it is to a book publisher. Just as Western busi-
nesses send offshore unpleasant work from rubbish disposal to
mass manufacturing of garments, so they do with this indus-
trialised and harrowing editing. Although those tropical office
parks might seem a world away from the book-lined study
of an editor, their value proposition is remarkably similar.
Nimble hyper-growth businesses like Instagram are usually
contrasted with sclerotic 'old media' firms like publishers, but
both still need to be curators and editors. In both cases value
is created by taking away.

People like to know that their selection has been worked
on. That the millions have been whittled to the few dozen;
that the few dozen has been narrowed to this one selection;
that effort and knowledge has gone into what is presented.
What's more, this isn't just a pleasant side effect; for those
who do it well, it's a major competitive advantage. Selecting

and arranging also means reducing and refining. Doing less is meaningless unless it also means doing better. That happens because of good curation.

Simplifying

One way of describing the Long Boom, and the development of civilisation itself, would be to do so in terms of increasing complexity. Complexity is a good indicator of development. To make big, new and difficult things happen, complexity is often a prerequisite. You can't have cars, or microwave meals, or holidays in the Maldives, or nuclear submarines, or contemporary art without a huge dollop of complexity on the side. Inasmuch as it gives us things we want, complexity is necessary and good.

Over recent decades, though, we've started to understand the costs as well as the benefits of complexity. We've begun to see how complexity drives overload. Complexity theory tells us that complexity overload is not just disadvantageous, but potentially catastrophic. Take the Mayans, a society studied by one of the pioneers of complexity theory, the anthropologist Joseph Tainter.

Leaving their monuments and cities still standing in the jungles of the Yucatan peninsula and the Petén of northern Guatemala, the Classic Maya of the Southern Lowlands are one of the most famous civilisations to have collapsed – other examples include ancient Mesopotamia, the Minoans, the Hittites, the Chou Empire in China and, of course, the Romans.

Having started in hamlets, they began to form larger groupings like city states and regional powers. For nearly a millennium up to 800 CE the Mayan population grew. Their cities expanded and they built great temples and palaces.

Their learning increased – agriculture and the arts grew more sophisticated and intensive, which boosted the population, in turn necessitating a further intensification of agriculture. Some evidence suggests the Southern Lowlands was one of the most densely populated regions of the preindustrial world.[4] They created a system of astronomy and science and developed an advanced logographic script, to date the only Mesoamerican script to be deciphered (which was done as recently as the 1970s and 80s). Elaborate ceremonies were conducted according to an intricate calendar. Mighty pyramids were constructed, along with canals, raised fields, crop terraces, military fortifications and reservoirs. Archaeological evidence shows a society becoming more status-driven and hierarchical: ruling elites and priests were supported by bureaucrats and artisans. Within each class there were many further gradations. A tiered system of cities emerged whereby major administrative centres were surrounded by second-tier sites in evenly spaced clusters.

Yet within a short time, a period so quick Tainter calls it 'shocking', Mayan civilisation fell apart. The population collapsed from around three million to 450,000 in seventy-five years. At one major city, Tikal, it is estimated the population declined by 90 per cent or more. Writing and calendrical systems were lost. New building of temples and monuments abruptly ceased. What happened?

The Mayans didn't have enough energy to sustain the complexity they had created. Maintaining complex societies uses energy. That dense population and intensive agriculture, those costly ceremonies and bureaucracy, that building work – it all created complexity that sucked up scarce resources without contributing in return. If that energy use can't be sustained it makes a society vulnerable to external shocks like invaders, disease or natural disasters:

More complex societies are more costly to maintain than simpler ones, requiring greater support levels per capita. As societies increase in complexity, more networks are created among individuals, more hierarchical controls are created to regulate these networks, more information is processed, there is more centralization of information flow, there is increasing need to support specialists not directly involved in resource production, and the like. All of this complexity is dependent on energy flow.[5]

The key point about collapse is that 'investment in socio-political complexity as a problem-solving response often reaches a point of declining marginal returns'.[6] This is true of information processing in most societies – the more information there is, the more diminishing marginal returns can be seen in the processing and use of that information, all of which requires energy, all of which adds to the complexity, so requiring more energy in turn.

There comes a point when the costs of complexity outweigh the benefits, and this is what happened to the Maya. Their rainforest environment meant any dip in productivity could not be easily alleviated – instead it led to vicious competition for resources. This created a feedback loop between productivity, competition and complexity, with each needing to increase to maintain some kind of balance. Sculptures, monuments and standing armies were symptoms of the battle for prestige and dominance, deterring warring neighbours and attracting allies and securing servants. Building work and cultural sophistication didn't provide more nutrition, but boy did it use it up. The population wasn't large enough nor the resources plentiful enough to support the social structure that had arisen to secure resources in the first place. Wars and disasters that the society would normally shrug off became

critical. All that late investment had shown a declining marginal return.

Complexity theory is the branch of science and social science that tries to understand the impact of complexity on any system or situation. It could be the weather or the financial markets, but we all experience complex systems in our day-to-day interactions with the world. The Long Boom and overload can be seen in this light.

Two questions spring to mind. Haven't we got over this sort of thing by now? And what the hell have the Mayans got to do with curation? The financial crash and Great Recession of 2008 show how it fits together.

If we thought we'd mastered complexity, the financial crash was a wake-up call. In the years leading up to it, the global financial system was on a bull run, yielding massive returns for those close to the action on the trading floors of London and New York. Much of it was based on the burgeoning field of credit derivatives – financial instruments existing at a level of remove from primary economic activity. Even in the most benign conditions the world economy is an extraordinarily complex system, far beyond the modelling power of any computer. The sheer range of possible inputs and causal factors at any given stage encompasses, pretty much, the sum of possibilities on earth. Derivatives took this complexity and supercharged it. They came as a blizzard of acronyms: collateralised debt obligations (CDOs), mortgage-backed securities (MBS), credit default swaps (CDS), in China 'wealth management products' (WMPs). Debt was recycled and repackaged, 'securitised', to produce derivatives, which in turn produced more opacity and complexity in the financial system. Despite the crash they remain a vast industry – the derivatives currently in circulation are worth $650 trillion, or nine times global GDP.[7]

All that complexity and opacity meant that, in an echo of the Mayans, the whole system was vulnerable when a shock came. Shocks that would usually be tough – like a dip in demand for Sunbelt real estate, the initial US trigger for the 2008 crisis – became critical. The system was too complex for the 'quants' and economics PhDs to predict or manage. As with the Mayans, a complex superstructure teetered on a base that couldn't support it. Complexity, which had driven such outsized rewards for bankers and hedge-fund managers, turned into the enemy. Thanks to a poorly regulated system, coupled with the opacity of financial instruments and the offshore system of shadow banking, financial contagion spread to the real economy of wages, jobs and tax receipts. In the end complexity and overleveraging did for Lehman Brothers what it did for the Mayans. However smart we think we are, we haven't beaten complexity. Quite the opposite.

There was another way. Canada was the only G7 nation to avoid a government bailout of the financial sector. As an Ottawa official told the *Financial Times*, Canadian bankers are 'boring, but in a good way'[8] (no snickering please). The bankers on Toronto's Bay Street stuck to tried and tested models. The management of risk, not the manufacturing of complexity, was adhered to. Compare Wall Street or City banks with Canada's largest by market capitalisation, TD Bank. While TD Bank emerged without a meltdown, many of its Anglo-American counterparts went bust. While the Royal Bank of Scotland required an unprecedented bailout from the UK government, the Royal Bank of Canada simply carried on.

The straight-talking head of TD, Ed Clark (who publicly said bank bosses earned too much), had a rule for selling financial products: Would you sell it to your mother-in-law?

The mother-in-law test harked back to a different era. But it helped his bank remain solvent. Anything dodgy or difficult to understand was out. Unlike US banks, Canadian banks were tightly regulated. They had tough capital requirements (7 per cent of tier one capital in common stock) and leverage ratios (1 to 20, whereas those of Bear Stearns and Morgan Stanley were both above 1 to 30). It meant they couldn't indulge in the casino tactics of other financial centres. Moreover the mortgage market was well regulated. Those mortgages were not securitised as much as in the US – in 2007 only 27 per cent of Canadian mortgages were securitised, as against 67 per cent in the US. There was less complexity in the system.

In all, it meant Canadian banks were forced to have simpler – but more robust – business models. They had to choose what they did more carefully. Moreover the regulatory environment was itself simple and transparent for those involved in financial activity to understand. It's clear that solving the riddle of complexity is one of the most important challenges we face today, but how does curation come in?

First, let's be honest. Curation alone isn't going to save the world from the perils of complexity. Frankly, complexity needs everything we've got. The point is not that curation would have saved the Mayans – of course it wouldn't. The point is that we need multiple ways of managing complexity; curation is another weapon in the arsenal of simplicity, an element of the antidote to complexity. The more complexity we encounter, the more simplification matters. By selecting and arranging, curation takes what is complex and while keeping the essential elements, makes the whole simpler. This is the balancing act of curation – to keep what is important and valuable about complexity, without the overwhelming, overleveraged and overloaded aspects of it.

If banking before the crash is an excellent example of an overloaded complex system, Canadian banking was a better-curated version. It kept many of the key elements, but dispensed with many of the bad. The Canadian approach to money was curatorial in that it was selecting investments better, and arranging them better (all those capital rules). Its custodial element stayed true to the spirit of *curare*. And the way it approached customers was better curated as well. A rigorous process of selection decided which products the bank would sell (the mother-in-law test). Safe to say, not many on Wall Street filtered their offerings with a mother-in-law test. Curated banking? It's not a phrase we ever hear and not one I am suggesting. The point is that we need organisations and business models that work towards simplicity, not the reverse. That, for example, select only appropriate investments and arrange them in a stable manner. Iyengar, Schwartz and others have studied how choice affects our attitude to banking. As we saw, the more choice – the more investment options, say – the less able we are to make wise decisions or even decide at all.

This kind of thinking can be scaled up and out. Complexity causes problems across the board and a new wave of businesses are figuring out how to combat it. Global just-in-time supply chains collapse if one element goes wrong. Now a new generation of process experts are re-localising and onshoring production in order to take complexity out of the supply chain. Individual products from pharmaceuticals to machine tools get more complex in operation and production by the year. Yet it also means that when they go wrong, it's a nightmare. That added complexity piles on cost. In response, the new movement of frugal innovation – applied to everything from cars to medical tech – retains the benefits of advanced technology but, by going back to first principles, strips out

complexity, making the products more robust, easier to operate and cheaper.

Over the years the cockpits of planes grew encrusted with gadgetry. Eventually the sheer operational complexity became a hazard even for experienced pilots. The response was the 'glass cockpit', an overhaul of the in-flight interface to make it simple – choosing the most important parts of the display and arranging them intuitively. As data has become a more everyday part of the corporate environment, so management dashboards have proliferated. Procter and Gamble, for example, have a 'cockpit' analogous to the glass cockpit of aeroplanes designed to streamline decision making. Similarly, over the years legal documents get longer and more difficult to understand. Alan Siegel, a pioneer of simpler business, has redrafted many of them, selecting only the most salient points, rewriting the copy in a straightforward manner and redesigning the layout.[9] Complex legal agreements are boiled down to a single, readily comprehensible page. Arguably WhatsApp became so valuable so fast because it took out anything extraneous. It went back to the simplest fundamentals of communication.

Just as we are building an economy out of what isn't there, so the increase in complexity means we are building an economy to make things simpler. Selection removes the number of elements in play. There are fewer actors and fewer relationships. Arranging makes things more transparent and easy to use. Expert sets of selecting and arranging, even in areas as large as financial products, help us retain the benefits of complexity while mitigating the risks. Most of the time, curation helps simplify on a micro scale – in our day-to-day transactions and encounters. Given the growth in complexity, anything that helps, however small, should be given a space.

As the eighteenth-century English painter Joshua Reynolds put it, 'Simplicity is an exact medium between too little and too much.' Curation helps ensure that exact medium.

Categorisation

Carl Linnaeus (1707–78) is one of the greatest scientists in history. He didn't discover a new law. He didn't make new theories. He is not known for a breakthrough experiment or as the builder of new technologies. Yet as much as anyone Linnaeus changed science. How did he do it?

By labelling, naming and, above all, categorising. Modern biology is built on categorisation.

The son of a botanist and church minister in Sweden, the young Linnaeus showed an early interest in the diversity of species. At the time there was no real means of cataloguing them. Biology was a mess. During his studies Linnaeus realised that without a common understanding of species and their distinctions, those discussing the study of life would always talk at cross purposes. There would be no disciplinary foundation. Deciding to change this, he wrote the *Systema Naturae* (first published in 1735 and revised many times). In doing so he created the system of 'binomial nomenclature' that still governs how we name species in biology.

Linnaeus' scheme divided the world into three kingdoms (animal, vegetable, mineral). These were then further subdivided into classes, followed by orders, families, genera and finally species. Even if the system has since been revised, for example to encompass an understanding of evolution and genetics or the inclusion of new kingdoms like fungi (and the exclusion of minerals), it created the framework that made understanding possible. So for example humans are categorised in binomial nomenclature as *Homo sapiens*,

their unique binomial identifier. *Homo* is the genus, *sapiens*
the species. Neanderthals are called *Homo neanderthalensis*
as they share the genus of human beings, but are a different
species.

Not only did Linnaeus' work give each species a unique
name but, because it worked, it was stable and made the
exchange of information easy. Categorisation meant every-
one talking about the same flower was on the same page.
Before Linnaeus, learning to remember the names of species,
especially plants, was a long and difficult process. At school
Linnaeus made a point of memorising as many as he could,
but later Linnaean categories made it easier. Such classifi-
cation wasn't invented by Linnaeus, and nor has it stood
still. But he was the first to make sense of biodiversity –
Linnaeus alone categorised 12,000 species of plants and
animals.[10] A clear, hierarchical classification made biology
intelligible, bringing order to the chaos of nature. Biology
rests on a process of categorisation – which is in turn about
selecting and arranging based on sets of features. In his own
lifetime Linnaeus was feted by the intellectuals of Europe
as heralding a revolution; in our own, *Time* hailed him as
the fifth most influential scientist in history. Not bad for a
categoriser.

Linnaeus reminds us how important categorisation actually
is. Without categories, we struggle. When we select, we select
for. We select into. In the early days of curation, much of what
a curator did was categorising. Categories were still being
created and understood. What kind of painting was this?
What kind of fossil? By using their expertise to place objects
in categories still being finalised, curators helped build our
understanding of the world. Just as biology needed categories,
so every area of knowledge and activity – from art history to
film subscriptions to selling medical insurance – requires a

prior process of categorisation. Imagine trying to navigate a library without the Dewey Decimal System or equivalent. It would be impossible.

Curators create, manage and sift categories. Facets and features lost on you or me are clear to a curator familiar with the field. Those categories tell us what experts think are important, relevant or useful characteristics.

Categorisation augments our minds. It's expertise outsourced and stored. Linnaeus' classification is his biological knowledge crystallised and made shareable. But it also works on a more local level. We sort our kitchens and our computer files into categories so we don't have to remember where everything is – just the categories. We don't search all over the place for knives and forks – we have a category, cutlery, and a cutlery drawer embodying that category, externalising our mental organisation. The more there is to remember, the more we need to externalise. To do so, we must create categories. Even arranging spaces like our homes is based on a series of implicit categories without which we'd struggle to get by (things to bake with, clothes for special occasions). Making our house a place of physical categories is what psychologist and neuroscientist Daniel Levitin calls 'cognitive prosthetics'.[11]

Categories simplify the world into meaningful and useful chunks – we don't see individual blades of grass, just the generalised category we call grass.

As we have seen, how stores are arranged, and what they select, is a huge and often critical part of their success. US DIY retailer Ace Hardware specialises in categorisation that makes life easier and more manageable for consumers. CEO John Venhuizen studies how our brains make categories in order to perfect both selection and arrangement. The chain has a stockholding of 83,000 items and any given store has

between 20,000 and 30,000 items available. This is a huge amount for both the chain and the customer to process. A dedicated category-management department steps in. Their job is to rationalise the range of products in such a way that the categories will be logical and natural for most consumers.

Part of this entails creating normal hierarchical systems. Starting with Gardening, you then go to Fertilisers, then to different brands of Fertilisers. But it also extends to thinking through how people interact with products. If you're building, say, a cupboard, you might want drills, nails, wood and handles to be located together. Or if you want fertiliser, you might want gardening tools nearby as well. It's not just about having electronics as a category – it's thinking about the use of the items within it. So you don't just find drills – you find a section for putting up shelves. When you have so many products, they can and should exist in multiple categories to help you shift through them. The department curates both the categories and the things included within them to make our navigation of those 30,000 items seamless.

We tend to take categories as natural – for example, in clothing stores clothes are for the most part sorted by clothing type rather than size. But they could be the other way round. I could walk into a section that had all the items already there in my size. It might save time and make comparing things easier. Curators create new categories that make sense of the world – things that make us smile, people we call friends, novels that end wistfully, tools for putting up shelves, types of fungi. New categories create new angles on the world. Understanding, building and using them requires creativity and imagination.

Curators, then, don't just select. They select for and into. Netflix don't just select films for you – they first categorise

them with those lengthy names. Melvil (*sic*) Dewey knew that for libraries to work, librarians needed a standardised system to put books in. Linnaeus didn't arbitrarily select species. He selected them within a framework of knowledge which was not only produced by selection, but also aided that selection down the line.

Reducing, refining, simplifying and categorising are all curation effects: principles and by-products of curation. They all have growing value. But we needn't stop there – we could have explored:

- **Displaying and presenting:** a visual or performative element was always at the heart of curation. It put on a show. Curation then has a long-running history with the visual. This continues today, not least because of the prevalence of visual culture. 'Design thinking' has, moreover, leapt from the explicitly visual to all areas of our lives. Experience designers, for example, think through how we interact with anything from a theme park to our office. Having a sense of presentation, and an understanding of the nuances within it, is important not just for gallerists, but anyone organising a conference or show, delivering a presentation (let alone a TED talk) or building a customer-focused environment. The visual matters.
- **Explaining and storytelling:** everyone from great religions and nation states to individuals feels the need for a defining story. Selecting and arranging always creates an implicit or explicit story, context or explanation. In virtually all of my conversations with curators, some variant on this theme has been acknowledged. Curators have a highly developed sense of pattern

recognition, and it's that ability to not just see the patterns but pull them out, make them comprehensible, accentuating important aspects, that they work on. In putting together an exhibition, a curator is generally telling a story about a period, a culture, an artist, as much as presenting their works.

- Businesses realise this power. It's no surprise, for example, that companies like Budweiser or the British retailer John Lewis abandoned traditional advertisements in favour of miniature narratives – generally involving animals like Clydesdale horses, bears, hares and penguins. In order to counteract media saturation, advertisers have become purist storytellers. We are overloaded with adverts. We don't remember them, we don't care. Let's face it, they're annoying. Budweiser, John Lewis and their agencies use storytelling to go beyond the ennui, connecting with audiences above the media haze. Stories capture and retain attention otherwise lost in the deluge. As Peter Guber, former CEO of Sony Motion Pictures and one of America's best-connected executives, says: 'For too long the business world has ignored or belittled narrative, preferring soulless PowerPoint slides, facts, figures, and data. But as the noise level of modern life has become a cacophony, the ability to tell a purposeful story that can truly be *heard* is increasingly in demand.'[12]

- **Preserving and nurturing:** in museums curators are charged with caring for their exhibits, whether they're Cretaceous fossils, fragile reams of papyrus or Tracey Emin's bed. They must safely store, preserve and document their collections. This element of stewardship is often lost in the quick-fire world of online curation,

but it shouldn't be; as I will later argue, having some idea of preserving or nurturing is what will stop curation disappearing down its own self-indulgence. When I asked Oriole Cullen, the V&A curator, what she did, her answer was clear: 'In museums we take care of the collections. It's about cataloguing, databasing, physical care of the collection, adding to the collection, access to the collection and putting on exhibitions.' Taking care was still at the top. This sense of caring, not just choosing, helps explain why curation has such an important role today – but it's often glossed over in the newer sense of the word.

We could have continued with distilling, juxtaposing, clarifying, narrating, contextualising, filtering, connecting, elevating … Curation effects are widespread and powerful. They connect with us at a deep level – we like order, narrative, care, clarity and ease. If Buzzfeed has taught us anything, it's that we have a predisposition for lists. The more we understand how curation coheres with a network of new skills, strategies and capabilities, the better prepared we will be for thriving in the age of excess that is changing forever how we live and work. There isn't one way of curating, or one set of effects than can be mechanically applied. Instead curation is a basket of approaches we can select from, as illustrated in Figure 12.

Businesses solve problems. By solving problems they make money. Businesses make mistakes when they misunderstand the nature of the problem they are trying to solve.

At this juncture in history, with overload spreading and the creativity myth running out of fuel, we are starting to see a grand shift in the problem set. If business used to address problems of scarcity with the solution of production, or services that enabled production, the principles outlined in this

Figure 12. Approaches to curation

chapter – primarily selecting, but also arranging and all those secondary curation effects – address what happens when the problems are of abundance. When the problems change, the answers have to change as well. Business and organisational assumptions fit for the twentieth century are becoming redundant. The answer is to adapt.

Curation helps solve the problems of today and tomorrow. It's the mass sourcing of the expertise needed to navigate and comprehend the saturated, complex markets of the twenty-first century.

There isn't a cookie-cutter approach. You can't take a business or sector and say it requires curation in this, this and that way. Instead, we need to get to grips with the principles and think them through in each particular scenario. How can selecting solve problems? Might a change of arrangement be better? In the next chapter we will see how curators are already reacting to this change, improving lives and altering business and transforming assumptions. They do it by realising that the principles of curation help with (for example):

- **Saving time.** Recall the Oxford study of time pressure. Selecting and arranging can free up time to focus on what we want.
- **Freeing cognitive resources.** Excess choice and research about such choice saps mental energy. The more we have to decide, the less we are able to decide. By outsourcing these processes, curation lets us get back to what matters.
- **Sparing us anxiety.** The more there is to do, and the more chaotic our lives, the more stressed we get. Curation can provide an antidote, from making a trip to the supermarket more pleasant to creating a more stable banking system.
- **Maximising utility.** Think about water crises in places like California. This is never framed in the language of curation. But solving the problem will depend on making better selections about where water is used and managing the existing supplies of that water better. The water crisis has a familial resemblance to a host of problems we think of as closer to curation. In both cases maximising the utility of what is already there and allocating resources wisely is enabled by curation.
- **Cutting down complexity.** On both the macro and micro levels complexity is a problem. Having fewer elements in play makes a critical difference.
- **Finding quality.** Separating the wheat from the chaff has never been more important because there has never been more chaff.
- **Overcoming information overload.** Selection goes beyond filtering. It's a proactive, intelligent, expert filtering – the essential ingredient to beating the cardinal problem of the information age.

- **Creating contrast.** Homogeneity is a by-product of excess; curation can make the world interesting again.
- **Redefining creativity.** The more we appreciate the skills and personality behind good curation, the better we can move beyond the dated Romantic idea of what creativity can be.
- **Channelling attention.** Media and goods are ubiquitous; human attention is finite. Power has already shifted to those who can broker attention (look at tech company valuations). Curators do this – they say, look at this, not that.
- **Providing context.** Exhibitions let us understand a painting by putting it in the context of the painter's life, the period in which it was made or even the trans-historical theme the painting addresses. A playlist lets us understand a song. Curators, through intelligent arrangement, help us make sense of things when making sense of things gets harder.
- **Beating overproduction.** Not only does curation make the most of existing resources, but it provides a new paradigm for generating wealth beyond simply having more of everything (whether more mobile phones or more debt).

Curation is part of the answer to the question: how will we live and work today?

Back on the banks of the Thames, discussing curation and my friend's company, I ordered another round and settled in. Business was indeed relentless, the emails were still coming in, content needed wrangling but, for a few hours, that could wait. For my friend, selecting the most important medical information, and arranging it in the most efficient and clear manner, underpinned a business that was now worth

hundreds of millions of dollars. They'd never thought about this as curation; they'd thought about it as a service, as being the best company they could be. In future, rather than only looking at the metrics of more, they could also look at the metrics of less – this as much as any growth figure was a sign the service was working.

'So if we're curators, does that mean basically everyone is a curator?' he asked.

Well, I replied, you might be surprised.

hundred-in-millions of dollars. They'd never thought about
it that way before. They'd known that it ... again ... being
below expenses they couldn't ... In the meantime they could
... ing at the mercy of their ... They couldn't go back on the
decision ... there their decision was a sign
... what they'd already ...

"... it's no longer here than it's high. It's a moment
... until," he said.

"Well," he said, "you must be starved."

Part III
THE REALITY

7

Curate the World

Building the curation economy

Off the coast of Abu Dhabi a new city is rising. Even by the grandiose standards of Middle Eastern megaprojects, it's ambitious. Saadiyat Island covers 27 square kilometres. The bridge from the mainland, the Sheikh Khalifa Bridge, is in its own right one of the world's largest infrastructure projects: 1.4 kilometres long, ten lanes wide, built using 15,500 tons of reinforced steel.[1] Eventually Saadiyat Island will be home to at least 150,000 new residents, living in a green, oasis-like environment minutes from one of the world's most punishing deserts. Divided into 'districts' – a beach district, a marina district and so on – the island comes richly appointed with the amenities of modern life, from five-star hotels to a fully fledged campus of New York University. There will be schools and parks, music and science centres, a theatre, shopping malls. Unlike many such projects, these will be built on a human scale – the goal is to create genuine neighbourhoods of reasonably sized flats and villas rather than the ranks of skyscrapers so often found in the boomtowns of the new global economy.

Abu Dhabi is going for the big league; it wants to become, in the words of its promotional literature, 'a nucleus of global culture'. It's partnered with some of the world's most famous museums to build a vast new Saadiyat Cultural District, 'a new urban landscape made of *archi-sculptures*, characteristic of the dialogue between architecture and sculpture'. There will be, for example, the Sheikh Zayed Museum designed by Norman Foster. Over 66,000 square metres in area and partnered with the British Museum, it will focus on themes including the Environment, Heritage and Education. Then there will be the Guggenheim Abu Dhabi. Again a huge project, again from a serious player, the Guggenheim Abu Dhabi will focus on twentieth-century and contemporary art, with a special focus on visual arts from the Middle East. Bigger still than the Sheikh Zayed Museum, it is hoped that it will bridge Western and Islamic artistic practice.

Perhaps the biggest coup is that Abu Dhabi will open the first foreign Louvre, the world's most visited and perhaps most richly endowed museum. Designed as a vast dome by the Pritzker Prize-winning architect Jean Nouvel, this is a partnership not just with the Musée du Louvre but with Agence France-Muséums, the government agency responsible for museums across France including the Musée d'Orsay, the Centre Pompidou and the Bibliothèque Nationale. In its first year the Louvre will loan its Emirati cousin 300 works, many amongst its most precious – shown in the Middle East, or for that matter beyond Europe, for the first time. For the most part, though, Louvre Abu Dhabi will display works it has itself acquired. For years Abu Dhabi has, like its neighbour Qatar, acquired a lavish permanent collection, which will form the centrepiece of the museum: a glittering display of world culture, it will be the linchpin of this grand infrastructural theatre the *Wall Street Journal* has called, even before its

completion, one of the top ten sights of the world. For once the press release doesn't overplay its hand when it claims Saadiyat Cultural District is 'unprecedented in size or scope'.

Welcome to the curation economy.

At one level this is a superficial change: a classic case of curation as a light dusting on top of the real economy; a plaything for billionaires and trend-chasers, while the hard work goes on elsewhere. This is partly true. Much curation isn't integral to the economy and has only limited impact, usually amongst cultural elites in areas of questionable significance. This is why curation is so easily mocked; sure, curate this or that, but really it doesn't matter. Curation, though, actually goes much deeper. Patterns of selection and arrangement are having a more fundamental impact on the world's businesses, and curation can change the way we work right down the value chain. We tend to think that curation is only happening in a few isolated places like the Louvre Abu Dhabi, where money is no object and culture is a toy of state. This is wrong. And it also misunderstands exactly what is happening in the Arabian Gulf.

Saadiyat Cultural District can only properly be understood in the wider regional context. Abu Dhabi is part of the United Arab Emirates, a group of states collectively about the size of Maine or Ireland. Until recently, it was a hard place. Abu Dhabi's neighbouring emirate, Dubai, only got its first electricity and paved street in 1961. This former British protectorate was a backwater of desert wastes. Bedouin tribes lived lives of timeless austerity. Then Abu Dhabi discovered oil. Beneath the dunes are 9 per cent of the world's proven oil reserves, some ninety-eight billion barrels, worth trillions of dollars.[2] With a tiny population of native Emiratis it means every citizen in Abu Dhabi is a paper millionaire many times over. Yet for many years the Nahyan Sheikhs of Abu Dhabi remained

conservative. The trappings of modern life came late. Sheikh Zayed, the long-time ruler, was a beloved figure, charismatic and generous, but traditional – riding a white stallion, he followed traditional Bedouin pursuits like falconry and roving the deserts. While things carried on and revenue continued rising comfortably, it was his neighbours, the Maktoums of Dubai, that hogged global attention.

Soon after the discovery of oil, Sheikh Rashid of Dubai realised his supplies would run dry far sooner than those of Abu Dhabi. He and his sons consciously pursued a different strategy to Zayed – aggressive growth and development. They built ports at breakneck pace, even when everyone thought they were mad. They constructed giant luxury hotels, opening their country to Western tourists and business people, Iranian émigrés and merchants and labourers from the Indian subcontinent. They made Dubai the most cosmopolitan place in the Gulf and the region's air, distribution, finance and trade entrepôt. But above all the Maktoums, with their desert ski slopes, floating skyscrapers, record-breaking builds, district making and fake archipelagos, put Dubai on the map.

A classic example of their pharaonic attitude was the region's first skyscraper, the Dubai World Trade Center, built on an empty stretch of land in 1978. It was speculative, daring and assumed to be a folly – until it worked. Even more ambitious was Jebel Ali port; with sixty-six berths, the largest dry dock in the world and, now, the world's largest man-made harbour, it was originally dismissed as a barmy vanity project. Dubai's strategy was to build big and gamble. It has worked, more or less – at least if you forget the autocratic rule, the environment, the terrible working conditions for builders and some bumpy credit conditions. Dubai moved itself up the value chain. Whereas Abu Dhabi or Saudi Arabia were reliant on crude oil exports, Dubai built a modern economy which

included strengths in aviation, banking and (increasingly) the creative industries.

The Maktoums gambled their dirhams on an epic scale; the Nahyans doubled down on drilling. Dubai, with limited natural resources, turned itself into a sophisticated player. Abu Dhabi pumped the barrels. Like other resource-rich countries it was a one-dimensional economy. So Sheikh Khalifa, Abu Dhabi's ruler, decided to emulate Dubai. This has now happened with waves of investment in hotels like the $6bn Emirates Palace, a tie-up with NYU, a Formula One circuit and Ferrari theme park, the Masdar environmental project in the desert and, above all, Saadiyat Island. And Saadiyat Island shows that Abu Dhabi is setting its sights even higher up the value chain than Dubai. If Dubai does glitz, it says, Abu Dhabi does class. The context of the Cultural District is then twofold – at one level it is, as the press officer told me, about building 'a universal museum in the Middle East translating the spirit of openness and dialogue of cultures'. But, again according to the press officer, they also hint at a greater ambition:

Abu Dhabi's Saadiyat Island creates the perfect location as a natural crossroad for history, art, tourism, development and a diverse population. Building a cultural ecosystem is key to Abu Dhabi's cultural ambitions: with a rich cultural programme including exhibitions, workshops, talking platforms, an international annual art fair, as well as tailored initiatives for students, collectors and tourists. These draw a range of visitors of all ages and backgrounds from all over the world.

In other words the Cultural District spearheads Abu Dhabi's move into higher value sectors; curation reorients

Abu Dhabi. Building museums and curating unprecedented displays, collected on the back of immense wealth, is, in fact, part of a wider programme of building a diversified, post-oil economy. Curation isn't just a facile display of pomp; it's more considered and formidable. Yes, this is an old ruse. The Bilbao effect, whereby a sparkling museum drives urban regeneration, is well known. But rarely has it been tried on this scale, and rarely has curation been so central. In the marketing material emphasis is placed on specific curatorial points – what has been acquired and why, how, where and when it will be displayed, what those displays, galleries and exhibitions are trying to achieve.

Abu Dhabi, one of the world's richest states, is diving wholesale into curation. It's doing this as part of a local race to develop and curatorial practice is at the heart of it.

Gold collar workers

Economists traditionally divide activity into fundamental sectors. At the bottom are primary activities, based on natural resources, like agriculture. Before anything else you must eat. For most of history the primary sector dominated; most people worked in the fields and most wealth was tied to the ownership of arable lands. It extended to the harnessing of raw materials like minerals. But it could also be seen to encompass hunting and gathering, fishing, forestry and mining.

Then came secondary activities, principally manufacturing: classic blue collar jobs. Raw materials extracted and produced by primary activity were transformed, augmented, packaged, assembled and processed. Anyone from BMW to a blacksmith was part of the secondary economy.

Beyond that was the tertiary sector, better known as the service sector: white collar jobs. Facilitating exchange or

communication are tertiary activities, as are transport, tourism, clerical work and legal services. Neither plumbers nor hairdressers nor accountants produce anything material; they produce a service. From this outline the general direction of travel is clear: technology-driven productivity gains mean the primary and secondary sectors become more efficient and shrink in terms of their overall proportion of the economy. In tandem the tertiary sector balloons. Policy makers saw this as a good thing – tertiary sector jobs are often more highly paid, higher-status and regarded as 'better' by governments, business and employees alike.

Such is the size and differentiation of the tertiary sector, however, that economists have added two refinements taking us further up the value chain: the quaternary and quinary sectors. It's here we find curation. Quaternary sectors relate to knowledge work, or intellectual services. The staff of universities, for example, would be a good example, as would management consultants or many technology and IT firms. When a pharmaceutical company invests in researching a new drug, in creating the engines of future revenue, this is quaternary work.

Beyond quaternary lies the quinary level; so-called 'gold collar workers', 'rainmakers', knowledge superstars, economic power brokers. In the words of one article this is about 'the creation, re-arrangement and interpretation of new and existing ideas'.[3] Quinary workers are decision makers in the command centres of global trade; equivalent to what Italian economist Vilfredo Pareto called 'the vital few'. They work across disciplines in transnational fields, connecting disparate areas of activity as the nodal points of our networked system. From government to media, they are taste makers, key influencers, paladins of knowledge work or 'info-capitalism', the most advanced forms of added value available.

Curation straddles the quaternary and quinary fields, where learning and expertise drive decisions, selections and arrangements of goods, ideas and capital. It's far removed from primary and secondary work, which in part explains why we don't always have the tangible sense that it's making a contribution. Management consultants will be familiar with the problem. But shifts at the quinary level have ramifications all the way down to major alterations in the primary sector (which still dominates large parts of the world).

As nations recalibrate their economies, they are looking at expanding to higher levels. Primary economies, like raw materials exporters in Africa, want to build a secondary base; secondary economies like China want knowledge-intensive industry. And developed economies like the USA are trying to find ways of supporting the premium sectors and enabling them to grow. Regional associations like ASEAN, Mercosur or the EU, for instance, are largely based around trying to collectively push their regions up the chain. Everyone is trying to turbocharge the drift of history by moving up through the economic gears.

In Russia the government is building a huge research and development area called Skolkovo, in partnership with companies including Microsoft, Siemens and EADS. Divided into major clusters, featuring grand architecture, visa waivers for key workers and an eye-watering budget from the federal government, Skolkovo is part of the Kremlin's strategy to move the Russian economy forward. Largely dependent on raw materials, notably energy, Russia wants to become more knowledge-intensive. In South Korea the government supported the development of industry, helping build manufacturing giants like Daewoo, Hyundai and Samsung – the *chaebols*. But faced with awesome competition from China the government started backing cultural products, switching its successful

industrial policy from the secondary to the tertiary sector. Today Korean soaps are watched by hundreds of millions and the musical phenomenon that is K-pop has gone supernova.

Abu Dhabi's strategy can be seen in this context. By installing a Cultural District as their flagship project, rather than say, an entertainment complex, as might be built in Dubai, Abu Dhabi is setting its sights on the quaternary and quinary sectors. If Dubai achieved the unusual feat of leapfrogging from a primary to a tertiary economy, Abu Dhabi, as usual, wants to go one better.

Economic and industrial policy are substantially directed at moving industrial activity towards areas where curation-style activities play a significant role. They probably don't know it and are unlikely to admit it, but governments love curation!

The slow collapse of the Industrial Model of Selection and the rise of a Curated Model is also part of this picture. Consumer preferences, the mechanics of retail, the macro picture of value generation – all are moving, and all are moving in a direction that means we have to better select and arrange.

One way of thinking about this change, well demonstrated by the case of Saadiyat Island, is to see curation as twofold. We have both *explicit* and *implicit* curation:

- **Explicit curation:** the curation of art galleries, biennials and museums. It's thick black glasses and white cubes; it's the mushrooming numbers of curation postgrads. Its roots are in the great museums of the eighteenth, nineteenth and twentieth centuries. But it's also curation centred on the world's fashion and tech capitals: of celebrities curating Instagram feeds and music festivals; boutique pop-ups and fashion blogs. It's when a friend curates his playlist. It's a buzzword, a prominent phenomenon; but it's also a bit of a joke,

a touch glib, applying the po-faced seriousness of contemporary art to some of our least pressing and apparently superficial problems. Explicit curation makes the web more interesting and makes our nights out more fun – but it is also open to the kind of Daily Mash spoof we saw in the Introduction. Explicit curation walks the tightrope between creating new forms of value and descending into, well, silliness. Saadiyat Island is clearly a case of explicit curation, inasmuch as Abu Dhabi is investing in classic curatorial practice.

- **Implicit curation:** where patterns of selection and arrangement are quietly reordering industries. We've already seen this at work in the last chapter. It's about new high-end services. It's intensive knowledge work requiring deep expertise. It responds to plurality, excess choice. It's about a post-manufacturing economy and a new kind of retail model, where asset bases consist of knowledge, taste and expertise rather than tangible goods; it's about repositioning to higher-margin activities as underlying productivity increases. It's the macro to the micro of explicit curation. By building Saadiyat Island, Abu Dhabi ultimately wants to encourage this kind of curation. Having great museums is obviously a worthy goal and a good way of attracting tourists. But shifting the economy upwards is the great prize.

Explicit and implicit curation can often be found in similar areas. But it's easy for us to miss the implicit curation because we are too busy sniggering at the antics of moustachioed 'explicit' curators. Design blogs distract us from how retail buyers, investors and property managers, for example, must all now be curators. As we will see in the next chapter, explicit curation is transforming culture. But the rise of implicit

curation, that underlying trend exemplified in Abu Dhabi's moves, means we aren't just curating galleries – we're curating the world. This lasts. In the language of economic policy, the change is structural, not cyclical.

As discussed in Part I, since the 1970s and 80s, the value of US exports has greatly increased according to the US Department of Commerce, growing from $364bn in 1989 to $1,579bn in 2013.[4] The physical weight of those exports, meanwhile, hasn't grown at all. As early as 1973 the legendary sociologist Daniel Bell was talking about the 'post-industrial' society or what has been dubbed 'cognitive capitalism'. For economies like the US and the UK it's now taken for granted that knowledge drives growth – advanced technology, intellectual property and imaginative, expert services provide the value. Curation is part of this change, one which some thinkers regard as being on a par with the transition from an agrarian to an industrial model. More importantly it's part of the next evolution of post-industrial work, where the next thirty years of growth will come from. As commodities undergo a downturn, it's a reminder that sources of value change and move. The message for both small and big business is clear: follow value, find curation.

Even at the most basic level curation is transforming the world with those most necessary of goods: food and drink.

The food chain of the future

It was the last straw for Carlo Petrini: a McDonald's had just opened next to Rome's iconic Spanish Steps. A seasoned campaigner and revolutionary, Petrini saw the triumph of fast food and didn't like it one bit. Tired of watching as his beloved gastronomic heritage was sidelined, he decided to do something – and set up Slow Food. As the name suggests, Slow Food

was conceived as everything fast food was not. Local, artisanal, natural, rooted in tradition, Slow Food was against monoculture, homogeneity and the extensive use of chemicals. Petrini's fellow Piedmontese, Oscar Farinetti, would, nearly twenty years after Slow Food began, take the concept to the masses.

Farinetti wasn't the obvious candidate. Having inherited his father's supermarket he built it into a consumer electronics chain, UniEuro. It was successful, if dull. Farinetti himself is anything but – charismatic, far-sighted, he always knew that he wanted to go beyond selling electrics. His father, after all, hadn't just been an entrepreneur – he was also a partisan fighting the Nazis in the Second World War. Surely, Farinetti thought, I should have a mission as well? Could this be it?

Eventually selling UniEuro for around half a billion euros, Farinetti found his mission in Slow Food. He saw an opportunity to remake what a supermarket could be; to radically shorten the time spent by produce in transit between farm and store; to build links with the best producers, working hard to find them; to provide an outlet that blended food markets like Barcelona's La Boqueria with a restaurant complex, a wine cellar and educational institution, all built around the best produce sold at reasonable prices. Localism and environmentalism would – at last – get exciting. Eataly, which he founded in 2004, was to be that place, and its first store opened in 2007.

If you want to see where the supermarket of the future began, go to Turin. Taking the Linea 1 to Lingotto I went to the first Eataly on a day of thunderstorms and torrential rain. Nestled beneath Alpine massifs, Turin was once home to the Italian automotive industry. Eataly itself resides in an old vermouth factory, directly opposite the hulking mass of the former Fiat plant, once the largest on earth. A walk around its famous rooftop track is one of the unforgettable

experiences of twentieth-century manufacturing. Now, in a neat illustration of the often painful transition from secondary to tertiary industries, the factory has been converted into a shopping, leisure and exhibition complex. Like its American twin, Detroit, Turin is having to build a new post-industrial identity, and it's epitomised by Eataly.

For a gourmand Eataly is thrilling. These shops are big, bazaar-like spaces – the Turin shop is 118,000 square feet. Rome, in an abandoned air terminal, is a whopping 170,000 square feet and includes a coffee roastery, a brewery, eighteen restaurants and even a travel agency for booking gastronomic holidays. Everything is light, spacious, carefully designed, neither kitsch historical pastiche nor *echt* modernity. Above all everything is meticulously selected and arranged.

In the Salumeria (the cured meats section), racks of Parma ham hang overhead, while downstairs rows of them mature. Next to them, ageing, are great wheels of Parmigiano Reggiano. Beneath the hams sit piles of *salumi*, cut and aged on site. There is Salumi Nostrano Lodigiano, the finest Gran Bresaola at €43.90 per kilo, San Daniele prosciutto from the *prosciuttificio* Dok Dall'ava in Friuli and fiery *nduja di spilinga* from producer Luigi Caccamo in Monte Poro, Calabria. The cheese section has thick, melting wedges of Gorgonzola Dolce DOP, fat cuts of Cremonese Gran Padano, Parmigiano Reggiano aged for a minimum of fifteen months, most for more than thirty (anything else is infanticide, says the blurb), and tubs of bobbing *burattina* from producer Domenico Romagnuolo of the Campania, made from pure buffalo milk in the traditional manner. If you want tomatoes you can have Piccadilly, *grappolo*, *allungato* and *marinda* tomatoes – each of which looks stunning. Eataly knows all the producers of this food. Every one is artisanal, examined in detail to be the best examples of that product.

Farinetti's devotion to finding the best ingredients (along with his deep pockets) means he even buys some favoured producers. At Eataly you can buy plenty of Pasta Artigianale Gragnano (Gragnano in the Campania, with its perfect microclimate of sea and mountain air, centuries of experience, and the finest flour, is the area known for producing Italy's best dried pasta). You can specifically buy from the Pastificio Afeltra, a pasta maker dating from 1848. Farinetti liked it so much he bought the company. Their stately building, on the street that has always been the centre of pasta making, combines the best of that traditional craftsmanship with up-to-date technology. Made from the finest fully organic durum wheat semolina, all Afeltra pasta is slowly extruded through bronze, giving the correct porosity and roughness, then dried in wooden cells, regularly checked for everything from humidity to microbiological quality. In total Eataly stocks over 200 shapes of pasta including paccheri, vesuvio, bucatini, casarecce and calamari as well as the more familiar pennes and spaghettis – each one exhaustively, expertly selected.

Eataly is also full of restaurants. The arrangement of these and of all the goods is well thought through, never overwhelming despite the profusion. Antipasti are near each other, and at the opposite end of the store to the gelato counter and espresso bar. There is a natural order bringing out the classical rhythms of *cucina Italiana*. A large bookshop can be found on the right when you enter. Information about slow food, seasonal foods, ingredients and techniques is cleverly integrated into the space.

Eataly stocks thousands of items and serves a large menu across its restaurants. But the care with which they are selected is extraordinary. All the suppliers have rigorous standards. Everything is chosen to be the best possible example. It's all about curating the rich, locally complex heritage

of Italian cuisine and ingredients. Eataly contains a lot – but it's a tiny fraction of the possible produce and it's militantly filtered. Even the hand washes in the bathrooms are specially selected. Water, given free at the restaurants, Lurisia, is again controlled by Farinetti. The bottles are glass because Farinetti believes it makes the water taste better.

Eataly is curated through and through. There are no corporate brands, no industrially processed products, no complex supply chains. Food is highlighted as coming from individual farms, co-operatives and even fields. Eataly represents choice – but all those tomato sauces have already been through a vast process of pre-selection. They represent only the pinnacle, the best possible choice. Inasmuch as it represents the future of food retail – and it's hard not to hope that there might be an element of truth in that – Eataly's attention to selection and arrangement is key. As one of the principal investors in the NYC branch, Mario Batali, told the *New York Times*: 'Customers believe they are getting something highly edited.'[5]

Batali argues that Eataly is not an everything store. It's part supermarket, part food court; but, he added, 'it all works together'. It's not a restaurant or set of restaurants; it's not a shop or set of shops. It's not a market, an institute, a cookery school, a philosophy of producing, selling and eating: it's all of them at once, underpinned by an unerring focus on selection that makes a new way of growing, Slow Food, possible. Eataly is the curated antidote to agribusiness; it's where curation changes aspects of primary production. Eataly shows how not only is the future of food retail likely to be one of more curation, but how that future impacts right through the supply chain to the growers.

None of it came cheap. The Turin store was underwritten by at least €20m of investment from Farinetti. In New York it may have been even more. But the results are stunning.

New York's opening was attended by then Mayor Michael Bloomberg and had queues for weeks. Two years later it was taking $1,700 per square foot per year compared with $350 to $500 at even the most lucrative malls. With eight to thirteen thousand visitors a day, by some measures it's the third most popular attraction in New York after the Statue of Liberty and the Empire State Building.[6] Eataly expanded to places like Chicago, Istanbul and Tokyo without sacrificing its values, vision, and curatorial proposition. Now plans are afoot for the next wave of expansion in cities like Boston, Moscow, Munich and Sydney.

Agriculture is the most fundamental industry. Food production, like almost everything else, has continued increasing. Today 40 per cent of the world's land surface is given over to agriculture. The 'Green Revolution' of the 1950s and 1960s ensured that even as the global population swelled, so did our food supply. Pesticides, herbicides, nitrates, fertilisers and breeding kept productivity ticking up, although many experts now fear we will start to suffer adverse consequences. A combination of climate change, soil degradation and water stress will mean growing food becomes harder, but for now the problem is managed. According to conservative estimates from Oxfam research, the world produces 17 per cent more food per head of the population than it did thirty years ago.[7] We have enough food, if anything we have too much – it's just not equally distributed. Food is no more separate from the abundance of our era than most goods.

Foods are also complex. Eataly manages to condense the bewildering complexity of Italian food, where every village has a different culinary tradition with different ingredients and recipes, into one shop, which gives you the full breadth of produce and cooking from the mountains of Lombardy to the coast of Sicily.

Wine is a good example. Burgundy alone has 4,300 growers, most of them with less than ten hectares under vine. While it accounts for only 3 per cent of French production, it has nearly a fifth of the *Appellations d'Origine Contrôlée* which govern the tight regional identity of French wine. Even seasoned wine experts find mastering the intricacies of Burgundy a challenge. Over centuries viticulture has encompassed a bewildering span of grape varietals and growing conditions. It explains why wine has long been curated – why there have always been sommeliers in restaurants, and local wine merchants who would help navigate for casual drinkers.

So we curate wine. I am a member of a not-for-profit wine organisation called The Wine Society which is built around a team of expert buyers, many of whom have the rare Master of Wine status – the organisation's pitch is one of exceptional selection for everyday drinkers. In London I drink at a bar called Sager + Wilde, whose choice of wine is always impeccable. Now they have taken to curating the wine lists for other restaurants. If we didn't curate wine, there is no way we would have the differentiated global marketplace for wine we currently enjoy, a market supporting a dizzying array of tiny producers from the Napa Valley to the Western Cape.

Curation isn't just a nice addition to the global wine market; curation is a structural necessity. The more wine we have, the more countries, chateaux and winemakers that produce it, the more innovation, the longer and richer the heritage of the old world classics, the more complex is the business and the higher the value of curation vis-à-vis the value of producing another bottle.

You might think this is all very agreeable but without serious economic consequences (although in fact the wine industry is worth billions, The Wine Society is growing faster than at any time in its 141-year history and Sager + Wilde are

expanding into new bars). But it has enormous ramifications. Wine may be big, but coffee is bigger. Every day over 2.1bn cups of coffee are drunk.[8] After oil, coffee is the world's most traded commodity, meaning that for major producers like Brazil, Colombia, Vietnam and Indonesia it is a critically important export. So any significant trends have serious repercussions for millions of producers. And of the many trends in coffee, none is more significant than the 'third wave'.

In the US the first wave of coffee dates back to the nineteenth century. Major brands like Folgers, founded in 1850, brought it to the masses. From the 1960s to the 1980s there was a change in coffee culture – coffee bars, epitomised by the classic second-wave brand, Starbucks, changed the way people drank coffee. Then in the 1990s and early 2000s came the third wave. Outlets like Stumptown Coffee Roasters from Portland, Oregon, and Counter Culture Coffee from Durham, North Carolina, set about making coffee with a new sense of mission. Coffee was to be treated more reverentially, like wine, with correct methods of preparation, growing and sourcing. In the UK, traditionally a tea-drinking nation, the waves came later. Coffee became popular in the 1960s with the wider adoption of instant coffee. Then came the second wave in the 1990s – Starbucks sprang up in town centres alongside British brands like Costa and Nero. By the late 2000s, starting in London but rippling out around the country, came the third wave.

Third-wave coffee is much more carefully selected than what came before. Roasters and baristas genuinely spend hours looking at, testing and thinking about beans. Third-wave is about plantations. It is about elevation and soil, national and local traditions of coffee growing. Beyond selection, it focuses on improving roasting techniques and places a premium on coffee art.

A big part of third-wave coffee is not only the scientific

approach to production and the connoisseur selection but that connection, like Slow Food, between supplier and end retailer. Often the best coffee comes from micro-holdings, places with, dare one say it, *terroir*. These coffees are incredibly labour-intensive, often needing quadruple picking, by hand, because the beans ripen at different times. It's only by focusing on the details of selection that this is possible, however; bulk and careless purchasers will never make that link. Curating the product brings primary and quinary closer together.

James Simmons of Stumptown Coffee's Greenwich Village outlet tells me about the process of buying: 'It's a considerable amount of curatorial work. All of the coffee our Green Buyers [so called because the beans are bought green, direct from the plantations] secure for us comes through close relationships to producers which take years and a great deal of energy to grow.' He talks about the attention paid to quality – 'Our quality plays an inextricable role in how we grow our business and we wouldn't have high-quality coffee if our Green Buyers didn't have direct relationships with producers.' One example he cites is Stumptown's continuing relationship with the Aguirre family of Guatemala, who not only grow some of the world's best coffee, but actively support their local community.[9] In Simmons' words it takes buyers with 'the highest level of expertise in the coffee industry' to identify and build these relationships.

In London I visited a third-wave coffee shop called, aptly, Curators Coffee. A refined modern space, part coffee shop, part demure fashion boutique, part laboratory, it's one of many third-wave outlets thriving amidst the city's new coffee culture. Over a cup of delicate, almost floral coffee, Catherine Seay, the co-founder, spoke to me about their approach.

'In terms of food and coffee shops,' she said, 'you can walk into the big high street stores, ask for anything and they will just produce it. People don't even want to know or look at the

menu at those places. They'll ask for an Earl Grey tea and they get it. But we might only have one single estate Darjeeling on our tea menu. For me, I want someone to sort out the stuff that isn't interesting, to present a few options that are really appealing.' It's an approach where every single thing in the shop is exhaustively selected. They ensure that of the few items they sell, they only have the best, produced to the highest standard. At Curators Coffee the drink is closer to fine wine than the sludgy work-fuel we all know (yes, OK, and love).

But this is a business strategy. According to the *Financial Times* sales of specialist coffee are up 300% since 2002.[10] Seay knows that Curators Coffee, which is expanding, builds customer loyalty through its curation: 'When it comes to new coffees we get customers to trust us – we complement coffees with flavours on a month-by-month basis and customers come in and follow that. They will come specifically to try that one combination.' Sometimes customers just want a cup of coffee without fuss – which is fine by Seay, that's what they'll get, no questions. Because of the selection, they know it will be good. But if they want to spend half an hour discussing origins, permaculture, shade-grown beans, brewing temperatures and all the rest of it, great.

Thinking about the dangers of explicit curation, I ask Seay if this could go too far. Are we making things too complicated, too silly? Her answer gets to the heart of good curation: 'There might be some wild curated food businesses in the future. But I hope it doesn't go too far to the ridiculous side. It should be about mastery of the craft. That's what a curator brings: knowledge. The more I can find out about coffee, the better I can choose it.'

At the explicit level third-wave coffee involves scenesters talking about blueberry and vanilla notes in their single-grower flat white. But it changes the way coffee is grown,

distributed, made and consumed. For that single grower, such coffee rather than bulk buys is the difference between good prices and bad; it's the difference, for them as for the drinker, between a mass product and a crafted item. Aesthetically as well as economically it's a different world. And here's the kicker: the curated version makes more money, for the grower, the distributor and upstream for the shop. People will pay for curated experience. Without curation – that new focus on selection – they'd just have another boring, bland coffee.

Instead, entrepreneurs like Seay grow by offering curated choices. Their suppliers then double down on making the best possible product. New businesses like Pact Coffee are scaling the model up to deliver curated coffee to your home. Starbucks is starting to realise they need better options. Even going back to the first wave, something like Nespresso is more select than a jar of generic instant coffee. Third-wave may be elitist and faddish – but it's spearheading a wider change in how we drink *and* produce those 2.1bn cups a day. If enough people choose third-wave, as they have been, the ramifications spread throughout the entire supply chain.

This is the pattern across the food and drink sector. At the explicit level there is a new approach. Menus shrink – it's now perfectly normal, indeed fashionable, for restaurants to have three starters and three mains. Indeed, many restaurants now specialise in one thing only. This was always the norm in Tokyo, where a restaurateur would choose one dish to cook exceptionally well, but is increasingly common in the West. When going out for dinner we don't want excessive choice; we want a curated experience.

Then at the implicit level we see a new approach to the whole business. The network of Slow Food and its retailers is about taking care in choosing what food goes where. The rise of farmers' markets is a related phenomenon. In the UK a

service like Abel & Cole and in the US Community Supported Agriculture deliver pre-selected, seasonal, local food to your door. A litany of new food services do the same – not just vegetables, but beers, wines, coffees, even bacon (really), are selected and delivered. Blue Apron not only sends you the food weekly, but also the recipes to go with it. The pitch for such companies isn't about price; they tend to be expensive. Instead it's about choosing the best from a complex field. If I want generic beer it's cheap from a supermarket; if I want hand-selected craft beer then I go to DeskBeers. Beneath these are changes to how the major suppliers and retailers do business. They are forced to react, to more proactively curate their offering. Sainsbury's for example, the UK's third-largest supermarket, has trialled an Eataly-style market store. Whole Foods, a more curated experience than Walmart, has boomed.

Our attitude to food has changed. Where once we stuck within the boundaries of national cuisines, now we pick and choose. And it's not just Chinese one day Mexican the next; it's more specific, Sichuan hot pot and Oaxacan mole. Where once we were limited by local ingredients, now the world's produce comes to our door. Hence the need for a curated approach. Companies like Eataly and Curators Coffee are the thin end of a wedge in our relationship with the most primary of economic activities. I'm not arguing that Eataly will replace Walmart – it won't. But I am saying that in future Walmart is likely to look a little more like Eataly. Well-heeled customers aren't paying because of a food shortage; they pay to have their choices pre-selected so that they are offered only the very best.

Curating our food, our wine, our coffee might sound like (might indeed be) the height of pretentiousness. But when it transforms the most fundamental economic sector and perhaps the most basic activity of them all, we should pay

attention. Yes, these examples are cosseted and middle-class. It's rich and often Western consumers who feel the benefit the most. But the world is adding middle-class consumers faster than ever before: 500m in China by 2020 according to Jack Ma.[11] Indonesia alone will add 68m people to its middle class in the next five years – more than the population of France or the UK.[12] Above 2bn will be middle-class at the end of the decade. If curation remains centred on smallish elites, it is rippling out. So it's not just preposterous indulgence, it's the most significant consumer trend; and while there is a fine line between market trend and pointless fad it can't be ignored.

We curate the world. We do it because there is too much stuff but also because there is opportunity in doing so. Curation is a response to overload, but as Abu Dhabi and Oscar Farinetti realised, it's the kind of knowledge-intensive work that's driving the next waves of growth. Curation effects have strayed far from the old heartlands. We are seeing them in:

- **Data.** Such is the supply spike that data management is everywhere – even in places like medicine.[13] As health data becomes more prevalent the conclusions it's possible to draw from it are less obvious. Information about conditions and their associated symptoms is growing more complex and ambiguous. Clinicians find that increasingly there is no 'right' treatment; instead they are required to pick and choose from a menu of options. As the data available from medical and wearable technology grows, so the field becomes ever more about the management of information.
- **Homes.** Marie Kondo has sold millions of books with a straightforward piece of advice: choose your possessions carefully.[14] Be ruthless, and get rid of

most of what you own. Kondo believes in decluttering everything that doesn't 'spark joy'. It's part zero-tolerance approach to tidying up, part Zen philosophy of domestic space; either way, her advice has been taken up on a mass scale. It reflects a more curated attitude to our homes, one that has been developing over many years. Arguably, our homes are both the earliest curated spaces and the most curated spaces. The emphasis on clearing out the crap should not come as a surprise.

- **Reputation.** As *The Chronicle of Higher Education* argues, academics have to curate their online identity.[15] Getting tenure is a matter of curating your work and reputation. Beyond this, again, the prevalence of data means that meta-studies, the choosing and organisation of existing research, is becoming more important than ever. This applies to all of us. We are judged by what we share and post. The Internet is a reputational minefield where we have to edit and construct our image.

- **Nations.** Several years ago Sweden set up Curators of Sweden. Every week it lets different Swedish citizens control the @sweden Twitter account. It recognises that national identity isn't fixed; that to some extent we all pick and choose and curate from the mass of traditions, stories, beliefs, customs, laws, cultures, languages, places and histories that make up every country's identity. Each Swede has their own curated version of what Sweden is, and the national identity emerges from that multiplicity of versions. It's a branding exercise but it hints at a deeper truth about nationhood. So on the explicit level this is about curating a Twitter feed and marketing; at the implicit level

it points to the ways in which we all have to select and arrange elements of our national identity.

Curation is relevant to us all. For sheikhs in the Gulf and coffee growers on the Central American isthmus, it changes patterns of work, creation, consumption, strategy and experience. Selecting and arranging are fundamental activities. They've always been with us. What's changed is their relative position in the value chain. They're more significant now than ever.

Our cultural life is not immune from the Long Boom and overload.

8

Curate Culture

Musical mixology

1970s, the South Bronx

Kool Herc was a Jamaican living in New York in the early 1970s. At 1520 Sedgwick Avenue, amidst urban poverty and gang violence, he invented hip hop.

Kool Herc's innovation was to take the beats in hard funk records, and using two turntables to mix them so songs would consist exclusively of beats. He'd noticed the 'break', the beats that set up a song, were the most popular parts of songs on club dancefloors. Splicing two copies of the same record extended the break, forming a new sound called breakbeat. By looping old tracks Kool Herc was making a new kind of music. It was a sound *sui generis* – but it wasn't about creating new music in the sense of writing and recording new songs. It was about mixing.

At first Kool Herc was known mainly on the rough streets of the Bronx. Before long others were getting in on the scene, adding rapping to the beats. By the late 1970s names like

Afrika Bambaataa and Grandmaster Flash were taking the sound to a new level. Hip hop would go on to conquer the world, becoming the signature sound for a generation, the planet's best-selling music genre. But Kool Herc hadn't just invented hip hop – he'd helped redefine the terms of musical creativity; selecting tracks and combining them in original ways to produce new experiences. The age of hip hop also gave birth to superstar DJs bigger than the artists they worked with: first Pete Tong, Carl Cox, Judge Jules and Fatboy Slim and then the EDM superstars of the present like Calvin Harris, David Guetta, Avicii and Armin van Buuren came to dominate music.

1990s, London

One of those DJs was Richard Russell. Russell wanted to do more than just DJ; he'd realised record labels held the power. He joined the A&R department of a fledgling label, XL Recordings, in 1991. Within three years he was running the show. Over the following decades, as the music industry descended into crisis and consolidated into the Big Three majors, he would transform XL into the most iconic and successful indie label of its time.

As everyone went for scale, Russell tacked in the opposite direction: signing new artists wasn't his priority. Russell and XL developed a model built around an unerring selection of brilliant music. Every year they would only sign one or two new artists. Moreover these wouldn't be from one genre – unlike other famous labels, XL never specialised in a particular sound. As he told *The Guardian*: 'We get offered 200,000 unsolicited demos a year and yet only sign about one artist a year. We're basically saying no to everything, lots of big artists as well. You need an element of fearlessness to do that.'[1]

In the process they signed acts including The Prodigy, Radiohead, The xx, Dizzee Rascal, Basement Jaxx, Jack White, Vampire Weekend, Devendra Banhart and Adele, becoming one of the most profitable labels around. It was all based on a relentless focus on the artist. Russell looked at the integrity and vision of artists and let this guide him. Selection, not scale, would create the defining label of the past ten years.

2000s, Berlin

Perhaps the most iconic nightclub of the early twenty-first century is Berghain in Berlin, named after its location between the districts of Kreuzberg and Friedrichshain. Set in a vast Soviet-era power plant, the club features reputedly the world's best sound system, a huge Funktion One rig, and has developed a signature sound of brooding techno. Just as legendary as the darkrooms and beats, however, is the notorious door policy.

Getting into Berghain is a rite of passage in itself. Early into the morning long queues snake around the building. Hopeful entrants wait hours only to be told *nein* by the club bouncer, a pierced and tattooed legend of German nightlife called Sven Marquardt. It's become something of a journalistic trope to attempt entry. Entry tactics form a Berghainology of what to wear (black) and what to say (not a lot, and not in English). There's even an app to help. Marquardt for the most part remains inscrutable. Releasing his memoirs, however, he gave an insight into the reasoning behind the entry policy. It was, he said, about selecting the 'right mix' of people on any one night.[2] Sometimes a rash of designer labels will get you turned away; on another night it might be part of the vibe.

Berghain's atmosphere and mystique rests not just on the music, the DJs, the goings on – it rests on this infamous implicit curation of the audience. It's the same principle

behind the Soho House group's 'no bankers' policy. If anyone got into Berghain whenever they wanted there would be no *Rolling Stone* profiles, no underground myth. Nightclubs select and mix the 'right' people as well as the right music.

In different ways these examples show how the drift of musical culture has gone from primary production to various forms of secondary activity. At its height, DJing is a new form of creativity altogether, a claim few would make about night-club door policy. But at another level the direction of travel across musical culture puts a premium on curation of one kind or another, explicit and implicit.

Both the production and the experience of culture is ever more curated.

But what should I listen to next?

If you want an excellent illustration of the Long Boom, you can do a lot worse than music. Music used to come in two forms: the music that was performed live and the music stored in people's heads. While some music was written down, mostly it consisted of folk songs and memorised performances. With the invention of the printing press there came a step change. Printers in places like Venice started printing written music on a scale impossible in the scribal age. In the nineteenth century industrial printing and instrument making meant that the middle classes could own and learn instruments. On New York's Tin Pan Alley songwriters made fortunes penning dit-ties that were instantly rushed into print. Music was breaking its bonds, being stored and performed more widely.

Thomas Edison's invention of the phonograph in 1877 changed everything. Recorded music meant that physical performance and the experience of music were separated. Sound itself was now copiable and replayable. No longer an

upper-class luxury, music became a ubiquitous presence in homes, bars and shops. Music wasn't just noise, it had become a locus of culture, a centre of personal identity and a vast global industry. The high water mark of physically stored musical data was the CD. They were cheaply mass-produced, and music fans couldn't get enough. The industry peak was epitomised by the $10.8bn acquisition of Polydor by Seagram in 1998 to form what would become Universal Music.

Then, from an industry perspective, things tanked, thanks to MP3s, Napster, the digitisation and mass piracy of music. Seagram's acquisition now appeared the height of hubris. But consumer abundance reached a whole new level: if music had seemed plentiful in the era of records and CDs, it was nothing to the new digital reality. Music's copiability was no longer predicated on a complex and resource-intensive industrial process – it was instantaneous and free. Once again, digital technology supercharged the long-term tilt towards abundance.

Now, with Spotify, the Swedish music subscription and streaming service, I have access to thirty million songs, with 20,000 new ones added every day. Users of Spotify have created over 1.5 billion playlists.[3] Then there are the radio stations, music videos, rival services and podcasts competing for our ears. YouTube and Soundcloud let anyone upload their songs and have tens, if not hundreds, of millions of unique records. The problem for connected listeners isn't scarcity. The problem is knowing what to listen to. Even before the change we'd spend hours choosing songs or putting together mixtapes. In a relatively short space of time the entire customer proposition around music has been transformed. The music industry has started to make the shift from technologies of production to technologies of curation. If music today has a problem it is about discoverability: how in the endless sea

of available music will people ever find what they want, or discover something new?

Thanks to this aural overload we are in the midst of a curation arms race. Spotify started as a response to piracy. Their pitch to record labels and users was simple: you will have the best of both worlds. Listeners could access all the music they wanted, the signature shift of the digital age; record companies would monetise those ears. The problem for Spotify was that, despite its fast growth, users found the service difficult to navigate. As on the App Store, as in the supermarket, they would get into grooves – they'd get stuck in a rut. Literally millions of songs and artists had never once been listened to on the service.

Spotify piled resources into curation. It redesigned the site to make browsing more prominent. It hired experts to produce playlists in genres, for different moods, contexts and times of day, from morning commute to teenage house party. It became more social, allowing users to share and build playlists more easily – everyone could help curate music. Then in 2014 it acquired a company called The Echo Nest for a reported $100m. Spun out from the MIT Media Lab, The Echo Nest had pioneered a technique called audio fingerprinting. Examining billions of data points across a catalogue of sixty million songs, researchers synthesised the information into intelligence readily usable by music services. If you liked song x, it would find you song y with extraordinary accuracy.

The Echo Nest have, for example, a danceability index that, they allege, transcends genre. They have a side project called Every Noise At Once, which is building a complete profile of the world's music genres. Unlike other data-analysis firms they focus only on music; their clients include MTV, Vevo and Spotify rival Rdio. Earlier services like Pandora and Last.fm had developed sophisticated audio fingerprinting,

but with this acquisition Spotify was aiming to take the lead. Founder Daniel Ek made clear the reason for the acquisition: 'You will see the quality of our recommendations increase,' he said.[4] Before long Spotify launched 'Discover Weekly', a new service that, every Monday, sent users a new batch of songs tailored to their listening habits.[5] Playlists have become sophisticated, knowledgeable explorations of micro-styles and offbeat genres. They are also influential: playlist Rap Caviar has 2.1m followers.

But others weren't standing still. Pandora's Music Genome Project continued to innovate, looking at between 400 and 2,000 traits per track to identify what people might like. Soon after Spotify bought The Echo Nest, Google, moving rapidly into music streaming, bought a start-up called Songza which examined contextual data relating to users to suggest tracks. Apple had bought Beats and started piling into the space. They hired DJs like Trent Reznor of Nine Inch Nails and Zane Lowe from BBC Radio 1 to build playlists and run a new station, Beats 1, 'the world's local station', operating from London, New York and Los Angeles. As the *Financial Times* argues, although music now only makes a small proportion of Apple's revenues it has a symbolic place in the company. Competing on streaming means competing on curation: 'One of the features that will be retained [from the Beats app] is designed to elicit as much information as possible about a user's individual music tastes by asking them to select favourite genres and musical styles when signing up to the service. It is hoped that this personalisation, alongside recommendations from artists, will help overcome difficulty in choosing what to listen to from a library of millions of tracks.'[6] In just three months the number of Apple Music users grew to eleven million, and the service epitomised the company's renewed focus on curation. Artists including Jay Z, Coldplay and Madonna

launched their own competing service, Tidal. New entrants like Slacker Radio, Hype Machine, Patreon or evening DJing apps added to the mix, each with their own take on how to find and recommend songs.

In a little over a decade the business and consumption of music had become a space of competing curation, driven by the supply shock of the digital era. Whoever 'owned' music wouldn't just be the cheapest or most attractive service – they would solve the question of musical excess.[7] The precise tactics, metrics and outcomes are, for our purposes, less significant than the terrain of battle itself.

Nor is this only a question of tech giants playing DJ. Smaller services are finding a place. Ambie supplies music to commercial premises. Based on the assumption that most players use crude, one-size-fits-all selection models, Ambie instead tailors offerings for each client. 'We founded Ambie under a different approach,' says founder Gideon Chain. 'We brought together a unique blend of music experts and tastemakers with real tech superstars ... and all geared towards building a curated music service, that could scale.'

Ambie's competitive advantage is quite simply better curation: the opposite of Muzak. All music is chosen by experts for the client's space. This human curation is augmented by in-house technology. Combining the two means that every customer has the best experience while the service remains scalable. But crucially everyone gets an expert. While the competition sells pre-prepared packages, Ambie can offer something unique while still keeping costs down.

For Chain, this aspect, reflected in Apple's hires or Spotify's social emphasis, is critical: 'Our belief is that machine-driven curation can achieve a fair amount – essentially reducing the amount of work required by each curator. However, music is too subjective to be compiled by computers alone. There are

aspects of curation (sequencing, brand-specific guidelines, elements of mood) that computers still find very difficult. At the same time, our music experts are tastemakers in their own fields, immersing themselves in the world of music on a daily basis.'

Ambie works with a strong sense of place and brand. How does this song work in this room? What brand considerations are needed? That's not just about filtering swearing, for example; it's engaging with the whole tenor of a track to see if it aligns with the client's expectations. 'Everyone thinks they can make great playlists but the ability to accurately source, process and sequence tracks for a specific brand or space is actually incredibly difficult,' says Chain. 'Good curation covers many different elements but always begins with an incredibly detailed profile of the customer or space the music is being curated for. This includes brand values, customer demographic, interior design and specific zones, trading patterns, price point, competition, desired ambience/s and other key factors. Then there is the balance between contemporary and traditional music and the balance between familiar, mainstream music versus unknown, underground or emerging sounds.'

Ambie's sales proposition is based purely on their ability as tastemakers, expert selectors, influencers and technologists. Businesses can easily source music; finding music to play in your bar or shop isn't the problem. Ambie is specifically designed to solve the inverse equation, to find the *right* music.

Music today is curated. First we simply listened. Albums gave us a set order and selection. Then we created mixtapes for our friends. Now we share playlists. Once we listened to bands; now we listen to DJs. We used to create all our sounds from scratch; now we pick and sample from old songs. DJ Mark Ronson even argues we live in the 'sampling era' of music, where sounds are heard and reincorporated over and

over again.[8] One track, 'Amen, Brother' by The Winstons, has been sampled on a further 1,687 songs.[9] This may not be curation as such but it shows the extent to which the old creativity myth is breaking down and how far a more curatorial mindset has become embedded. The sampler or DJ is half creator, half curator. In music and across cultural forms, first- and second-order creative acts are becoming increasingly blurred.

When the tools to make music are everywhere and music itself, in its extraordinary scope and diversity, is a click away, curation isn't a luxury add-on – it's a necessary component.

Play it again

What are the implications for culture?

First. The Broadcast Model of culture and media is dying. Earlier we saw how the Industrial Model of retail ceded ground to a Curated Model. The cultural and media corollary is the Broadcast Model giving way to a Consumer-Curated Model. In music the system of a few radio stations, labels and shops, which collectively dictated what was listened to, has given way to a complex mixture of algorithms and curated playlists. In television the shift is just as noticeable. Mid-twentieth-century America had a network oligopoly of NBC, ABC and CBS: The Big Three. In Europe state television predominated. As recently as the 1970s a British viewer would have chosen from three channels. Over time, with the satellite revolution, more and more channels came on screen. Television became abundant. VHS gave viewers more freedom. Then came the Internet: YouTube, peer-to-peer file-sharing networks, Netflix, Hulu, BBC iPlayer, all meant that the traditional model of scheduled broadcasts started to crumble. While the Broadcast Model was itself curated, what has changed is that we all now curate.

The power to decide who watches what and when has flipped from broadcasters to audience. Now we have to decide what we want to watch – from a vast menu. The same goes for reading, listening, playing, viewing. In museums the old style of exhibition started to give way to more interactive and collaborative programming. Albums and radio are Broadcast; playlists are Consumer-Curated. TV schedules are Broadcast; your to-watch list is Curated.

In publishing editors and imprints once held power. Then booksellers and review pages became key intermediaries. All of them lost ground to readers. You and I are now the most important suggesters and curators of books. Books don't correlate exactly to Broadcast, but the pattern is the same. In contemporary culture and media, sequencing and discovery are devolved away from old power bases. We don't listen to the radio as scheduled; we catch up at will on our podcast player. Young audiences find the idea of cinematic release schedules in different territories baffling and frustrating. Individual tracks – not albums – are the prime unit of musical consumption. We're as likely to listen to a playlist assembled by ourselves, our friends, a celebrity or a site like Pitchfork as one from a band or record label. We no longer expect news to be parcelled into a complete package, delivered at the same time every day. We dictate which video games get distribution through user-driven services like Steam Greenlight. The shift from top-down industrialised organisation to a user-centric Consumer-Curated Model is here.

This 'post-broadcast' media is hardly news. But its ramifications are still playing out. Cultural scarcity is not the problem. Adapting to the new reality is. Organisations that cling on to the old will see their influence, popularity and market share eroded.

It's not plain sailing. In the Broadcast Model we had no

choice but to enjoy a shared culture. In the Consumer-Curated world that's impossible. Moreover as we curate our own media, and choose the curators we will allow to help us, the potential for disappearing down the rabbit hole of our own tastes, beliefs and preferences increases.

It's a risk, and it highlights one of the differences between good and bad curation. Good curation helps the new, the unexpected; bad curation just confirms what you already want. This is why tastemakers have started to make a come-back against personalisation algorithms. Good curation is about adding value – not appropriating it.

Nevertheless, gatekeepers are not going away. Despite the rise in Consumer Curation, and contrary to popular myth, gatekeepers of all kinds are still around. In fact, they may be more important than ever before. It's easy to believe that because power has been devolved, gatekeepers are becoming redundant. They aren't – but their role is changing.

If gatekeepers used to be dictatorial figures, now they're guides. The fact that choice is so overwhelming, that every time we look for content, media or culture we are bombarded with options, means that despite Consumer Curation we still want trusted guides. Trusted is the operative word – one that explains why so many legacy brands have, despite the gleeful predictions of the digerati, managed to thrive.

XL Recordings, like many in the creative industries, made gatekeeping an integral part of their business model. The art-ists whose music they put out are worth considering because of all the others who were rejected. While XL would never put their own brand at the centre of a marketing campaign, because they focus on so few artists they are able to fully support everything those artists do. Their selection has a meaningful impact on the presentation of the artists and, in turn, on the likelihood of those artists being listened to.

Many traditional newspaper brands have found new online audiences. Publishers have not disappeared but become part of a validation process for writers: writers crave recognition; readers crave trusted signposts suggesting what to read.

Of course, gatekeepers aren't just legacy organisations. New gatekeepers spring up all the time. Spotify and the other music sites are as much gatekeeper as a traditional radio station or MTV. Vice, inasmuch as they direct attention here and not there, are gatekeeping as much as *The Washington Post*. Influential individuals who send tweets are still gatekeeping. New niches and gatekeeping roles are evolving all the time. The question for these new gatekeepers changes: how do you become trusted as a curator?

The truth is there is no shortcut. Authenticity, consistency, excellent selections – it's very hard to fake. It's why so many corporate attempts to become media curators fail. Gatekeepers of any kind have to be patient. They need a clear vision and they have to stick to it. The best legacy organisations have spent decades or even centuries building and augmenting that vision. Which is why the *Financial Times* and Penguin, Gagosian and William Morris Entertainment are all gatekeepers that remain influential, profitable and relevant. For the new emerging gatekeepers, building credibility is the challenge – but they do, and that's why we have things like Laughing Squid, Vox Media and Wattpad.

Cultural and media gatekeepers saw their old Broadcast Model crumble. But this didn't mean they were useless. Such is the excess of material available, they still have a role, no longer as the monopolists but as partners. In the attention economy, the key is who controls our attention. While gatekeepers are more numerous and no longer have total control, they still funnel attention, the oxygen of culture.

The change in creativity is part of a wider pattern: creativity

is shifting from its mythical phase towards curation. By now the line between the two is ever more indistinct. Moreover – and surprisingly – it's broadly accepted.

Perhaps the roots of this change lie in the move towards what in the 1970s was termed postmodernism. Whereas previous art movements had distinct features, postmodernism, whether in art, fashion, literature, architecture or philosophy, was built around a playful, magpie attitude to the very idea of distinct features themselves. Bricolage and recombination would be the hallmarks. While this was once considered advanced, we now take it for granted.

Architecture, for instance. Postmodern architecture was a reaction to the modernist formalism of the mid-twentieth century. Modernism had a functional aesthetic – the so-called International Style, a visual language of severe blocks. It was arrestingly up to date and serious. Against the militant purity of modernism, postmodernism would playfully combine historical forms, cheekily picking motifs from across the architectural lexicon.

The classic case is New York's Sony Building (see Figure 13), originally the AT&T Building. Designed by Philip Johnson, begun in 1978 and completed in 1984, it was controversial from the start. Unlike modernist skyscrapers it used classical forms on a grandiose scale; where they rejected historical decoration, Johnson supersized it. The idea of putting a 'Chippendale'-style bookcase on a skyscraper seemed outrageous to Manhattanites used to crisp right angles and sleek monoliths. Moreover Johnson himself had once been an arch-modernist, working with Ludwig Mies van der Rohe on the Seagram Building, an iconic functionalist skyscraper in the International Style which eschewed ornamentation. For much of his career, history wasn't part of Johnson's design.

Like fellow postmodernists James Stirling and Robert

Venturi, Johnson neither bought into a single school nor rejected history – instead he and his contemporaries saw schools and periods alike as a menu. The giant pediment, the granite cladding, an enormous seven-metre arched entrance – these were taken from classical buildings, while the boxy form stayed true to the International Style. This visual sampling was echoed in Johnson's One Detroit Centre (again see Figure 13). Constructed on a similar scale to the Sony Building, it had over-elaborated Flemish-style gables – 1990s meets 1690s. PPG Place in Pittsburgh was another skyscraper, this time with spires reminiscent of a Gothic castle. Facades and

Figure 13. Left, the Sony Building; right, One Detroit Center

rooftops became spaces for decoration. By being too rigidly defined, modern architecture had become boring. Now columns and plinths, gables and spires were back – but as things to be chosen and combined, not stylistic essentials as they would once have been. Adherence to one doctrine was replaced by a whimsical medley of form.

Postmodern architecture then was, more than ever before, a curatorial exercise. It was perhaps another curation effect, another familial resemblance to the creativity of DJs and sampling or the rise of the curator as the central figure in the art world. We have an entire culture based on the referencing and reuse of cultural memes. Creativity as a force of originality is decentred, unmoored. What constitutes a classic second-order practice like curation is complicated as core tenets of the activity are brought into the heart of what it means to produce.

The modernists had, in the words of the poet Ezra Pound, wanted to 'Make It New'. Although they often reused old fragments of culture, there was something radically original about their literature, dance, music, visual art, architecture and cinema. Now the postmodernists wouldn't even try to Make It New. They'd just Make It. If the modernists were already living in an age when the encrusted layers of older culture meant the possibility of newness was difficult, they still wanted to challenge it. By the time we got to the age of postmodern architects, megastar DJs and curators curating curators at biennials, no one was even pretending 'pure' creativity was a possibility any more.

We have undoubtedly gone beyond the identifiable artistic movement of postmodernism prevalent in the 1970s, 80s and 90s. Yet nothing particularly definable has emerged to replace it – indeed, postmodernism even predicted this situation when it talked of the breakdown of 'grand narratives', including, one supposes, that of postmodernism itself.

Postmodernism is gone, is now a historical relic, but its legacy of 'neo-eclecticism' – anything goes, pick and choose, mix everything – is still here. Its mode of recycling bits and pieces of culture has apparently become permanent. Emotionally we may still be attached to the creativity myth – but in practice it seems we've already left it far behind. Today memes are recycled through every area of our culture: films are endlessly remade, books rewritten; TV programmes reference other TV programmes; remixes and samples dominate the charts. Pop Art self-consciously took its forms from mass consumer culture. Now art self-consciously takes from Pop Art.

This is not an unprecedented state of affairs. Shakespeare didn't write the plots for most of his plays *ex nihilo*; he recomposed them from a medley of sources. This was regarded as normal. Only when Shakespeare was later deified by a generation of writers, poets, actors and publishers as the epitome of creative genius would this be seen as somehow odd. Until the Romantic era, to emulate classical or religious sources of perfection was often more of an imperative than originality.

But, nonetheless, are we devaluing creativity? Producing a weakened, emaciated version of creativity where the critic, the curator, rather than the original is the hero? We can see these trends playing out in that media staple – the news.

The new news

In the first weeks of 2011 events that became known as the Arab Spring burst into the world's consciousness – and nowhere more so than in Egypt. Ruled for decades by Hosni Mubarak, Egyptians, inspired by their neighbours, started to protest. Then on 25 January, the situation intensified. Cairenes in their hundreds of thousands descended on Tahrir Square at the city's heart – a huge traffic intersection and

ceremonial space surrounded by national museums and party headquarters. Chaos ensued. Tahrir Square itself became a giant encampment. Violence was never far from the surface as protesters, armed militias and the police engaged in shadowy running battles. By 1 February, Al-Jazeera reported, there were one million people in the square. During the protests, which eventually resulted in the collapse of the Mubarak regime when the army refused to intercede, there were thousands of deaths. Ninety police stations were burned to the ground.

Three years later the situation in Kiev, Ukraine, was equally combustible. As in Egypt, tension had been rising for years. In Ukraine it centred on the country's direction – would it turn west, towards the EU, or east, to Russia? After President Viktor Yanukovych pivoted towards Russia widespread protests sprang up, activists descending on Kiev's main civic space, the Maidan. Protesters were based there from December 2013, but vicious clashes between police and demonstrators in February 2014 became pitched battles. At first police fired rubber bullets but soon they moved to live ammunition, tear gas and flash grenades. There were even snipers on surrounding buildings. Events were complex, involving columns of protesters, behind-the-scenes political machinations, street clashes, subterfuge and a lack of 'objective' reporting. The timeline for 18 February alone is still hotly disputed.

In both Tahrir Square and the Maidan, traditional news operations struggled to stay on top of events. Both situations were immensely dangerous for reporters. In the fissile atmosphere of revolution, it was never clear who was on which side, who might present a violent threat, or what might happen next. Both situations were also complex, with both sides making the most of propaganda and the participants, dispersed across massive cities, becoming

entangled in webs of enmity and allegiance. In previous years journalists would have done what they could – but this would have been after the fact, partial and incomplete. Only in hindsight would it have been possible to properly understand historical events.

Now journalists could try a different approach. Social media offered the possibility of citizen journalism – ordinary people recording the news. While citizen journalism never took off as its proponents had hoped, connected devices meant that more information than ever before was emerging from dangerous, complex events. Status updates and, perhaps most powerfully, mobile video were now in protagonists' hands. On-the-ground journalists would still be essential, but news desks could sift through a mass of uploads, verifying and collating material before inserting it as part of their own coverage. In Cairo and Kiev, as well as in even more difficult situations like the Syrian conflict, the character of journalism changed from writing the narrative to weaving the narrative from existing sources: amateur footage, once the supporting act, became the main event. If news organisations wanted to keep up, they needed new models of news gathering in which piecing together existing sources played a greater role than finding those sources in the first place. CNN no longer needed to shoot the footage itself, always a partial process using as it did single camera crews; it needed to find material for recomposing into its stories. And of course, this did not mean news organisations were redundant. Finding, verifying and contextualising the mass of information that was emerging in real time on the ground took authority, expertise, infrastructure and an existing audience. When CNN quoted a tweet or embedded mobile footage, we wanted to know what was happening, who was speaking and why; we still wanted the news to give us a coherent narrative of what was

occurring, but the means to do so was shifting from reportage to collage.

The Egyptian and Ukrainian revolutions show how news is changing. It used to be about collecting and transmitting information. Now it is about parsing vast amounts of noise for the signal. It's what a report on the future of news from Columbia University's Tow Center calls 'post-industrial journalism': journalism not oriented to churning out mass product, but more focused, niche, flexible and curated.[10] A journalism where journalists will look more like editors – or curators.

Xavier Damman, the founder of curation service Storify, told me that 'In a world where everyone can publish, curation is an important part of making sure that real information isn't just data.' This distinction is crucial to reporting today. Storify is one example of a company built around helping others manage it. But unlike many digital entrepreneurs, Damman recognises this is a necessary but also an evolutionary trend, building on an existing base: 'Journalism has always been about curating sources, packaging them as a story and then distributing them to people. Now witnesses and experts – those same sources – are on social networks. We still need to listen to repackage them. But before journalists would have access to twenty sources – now it's two thousand. We need these people – journalists, bloggers, curators of any type – I call them information engineers – to optimise this output for large audiences, to filter through all the noise.'

One obvious change is that news sites link to each other as never before. This started with the new breed that began in the 1990s and 2000s: outlets like The Huffington Post, The Drudge Report and Slate. Whereas traditional news focused on being a complete package, these websites faced outward. They didn't see themselves as monolithic slices of content so much as connectors to the growing mass of interesting

material on the web. Then the second generation of news sites like Buzzfeed and Quartz came along. Whereas the HuffPo's linking was innovative, for the new breed of 'digital journalism' it was standard. Floating on a sea of content, we dart in and out of publications.

Indeed, Buzzfeed, which was recently hiring for the new position of News Curation Editor, often consisted of embedded tweets, gifs and photos from elsewhere on the web. Its signature form, the 'listicle', was simply a selection and arrangement of existing material. Half of Quartz's famous daily email consists of links. The value proposition went from writing and delivering the news, to finding the most interesting content. What Quartz discovered and linked to was almost as important as what it produced. Before long embedded tweets, links to other sites and YouTube films were filling up pages on the sites of *The Guardian*, the *New York Times* and every major news outlet. The idea of the single story started to give way to rolling coverage composed from a mosaic of sources. On the margins of journalism and the web a new breed of business was finding space to grow. TheSkimm created detailed newsletters; This was building a social network that forced users to choose carefully what they shared; Longreads selected the best longer writing from 'hundreds of publishers'.

None of this should be a surprise – we can hardly expect the information explosion to leave activities like journalism, information provision and non-fiction writing and entertainment unscathed.

Partly this reflected the explosion in the amount of material. Everyone was now a 'content producer' and so the original content producers – news and media – had to adapt. Transaction costs associated with the production and distribution of content (of all kinds, of course, not just journalism) plummeted. Now in almost any niche there were clusters of

published expertise outside industry confines. Companies and brands, personal blogs, influential tweeters, non-profit organisations, NGOs and university research centre newsfeeds all started producing high-quality material. The well-regarded SCOTUSblog had more in-depth coverage of the United States Supreme Court than traditional media. Britain's Westminster political bubble was covered with verve and scurrilousness by upstarts like the Guido Fawkes blog. Quite often, it was realised, a random tweet or a bystander with a smartphone encapsulated a situation better than any journalist – so why not co-opt them?

Not only was there more comment, but there was more potential news in the first place. A connected world bred stories. Then there were new models, goals and media for journalism: philanthropic and profit-driven; online and offline; crowd-sourced and professionally edited; video, audio, interactive and text-based. It meant more need for curation and more curation, that core interdependence we see time and again.

It means gatekeepers are still there. Their importance is reflected by the careers of two stars of the new journalism environment, Ezra Klein and Nate Silver. Klein left *The Washington Post*'s Wonkblog and Silver left the *New York Times*'s The Upshot; they went to start Vox and FiveThirtyEight. Both indicate that individual curation of the news is becoming more important in that both considered they had sufficient audience, clout and expertise to leave their institutions and start from scratch. Yet both Wonkblog and The Upshot have carried on, expanded and, according to the *New York Review of Books,* doubled in readership in the years since their two superstars left.[11] The value of big old gatekeepers, just like the value of new forms and superstar curators, has risen. Again this goes back to a familiar motif:

the amount of news information has increased so much we need more filters than ever before, trusted brands *and* new start-ups, those professionally produced *and* those devolved to us. We want new and personalised filters like Klein and Silver; we also want great legacy brands. In the new information environment, the more curators the better.

News organisations must also curate themselves. In their leaked Innovation Report, the *New York Times* claimed to publish well over 300 new URLs every day. Even the most ardent readers would struggle to keep up. The report also argues that the homepage has declining importance in funnelling readers to stories – they are coming from elsewhere (from links on social media for example). They manage this with projects like NYT Now, an app that presents a small, selected dose of *Times* stories. Hence there is a dual curation: the *New York Times* curates the news through its editorial selections. Then it curates itself. The use of the moniker NYT rather than *New York Times* is part of a push towards brevity and completeness often missing in the content abundance of the web. It gives the online news the feeling of what Craig Mod calls 'edges'.[12] NYT Now reintroduces a hierarchy; it's about summing up and categorising. The same impulse is behind new algorithmically driven services like Summly that digest the news.

News today means curating people out in the field, in the squares, on the ground of the revolution, not airlifted into it business class. It means wading through published material, much of it brilliant, at least as much awful, irrelevant or misleading, to present us with content that is varied, interesting and informative. And it means self-curation – selecting the most essential snippets for busy readers. This then is the new news: journalism in an information-rich era.

But it is not without serious problems. A Gallup report

concludes that trust in the news media has declined for decades and is plumbing new lows. In 1979 51 per cent had confidence in newspapers; by 2014 that had plunged to 22 per cent.[13] Those questions about ethics and curation are keenly felt here. Does the person adding the link garner more benefit than the producer? Do aggregators from Google to Flipboard appropriate the value of those creating the content? When your video of the revolution is on CNN, who benefits? Companies like Prismatic are able to data-mine the news for actionable investment insights – but again, the value of production is questioned.

In news, amongst certain of our cultural producers and on the Internet, some claim this shift in the locus of value actively harms production. Whether this is the self-interested squawking of an elite unwilling to adapt or a serious threat to free and accurate reporting remains to be seen. Either way, it needs monitoring.

No one can have missed the curatorial drift in culture and media. A process of cultural accumulation dates back centuries. The weight of culture, of media overload – their sheer copiousness, accessibility and diversity – creates a qualitative change in our interactions with the multifarious cultural forms that surround us. Our relationship becomes disaggregated, democratically splintered. Moreover, the convergence of those forms onto screen-based media only compounds the issue – the sum of it all competes for attention on nothing more than a small piece of glass.

Where once we created and consumed, intermediary roles are now legion, more visible, more structurally integral to our interactions with cultural products. Aesthetic, ethical and economic considerations aside, this is the reality of our cultural life. Down to our operating notions of creativity, our

culture is geared towards second-order roles: DJs, A&R execs and even bouncers; editors, critics and curators; remixers, bloggers and commissioners. How to navigate the new reality? Taste and sensibility will play ever larger roles. The ethics of culture and the economics of media will continue to be challenged. Whether you are a publisher, an art gallery, a music platform or a digital journalism start-up the best curation will be a leading competitive advantage – especially for those, like Spotify or Apple Music, who effectively blend technological prowess with personal and aesthetic judgements.

Curation began with art and museums, as a property of culture, before spreading to the Internet. And it was on the Internet, rather than in culture, that it went global.

9

Curate the Internet

The world beyond marketing

However large you think the Internet is, it just keeps getting bigger. Just as we get comfortable with the idea of petabytes we find ourselves entering the Yottabyte Age, having skipped the intervening exabyte in the rush. The Internet only recently received a new IP (Internet Protocol) standard, IvP6, without which it would have ground to a halt – for the mathematically inclined IvP6 has $7.9 \times 1,028$ more locations than the previous standard, IvP4. This is all underwritten by a staggering and fast-growing physical infrastructure. Writing on *The Economist* website, Virginia Rometty, CEO of IBM, claims that 'There are more than a trillion interconnected and intelligent objects and organisms – including a billion transistors for every person on the planet.'[1] Moreover vast regions of the web remain hidden. The Deep Web, that portion beyond the purview of search indexing, represents up to 96 per cent of all digital data, whether it's company intranets, the anonymous Tor communication system or the 'darknet' of criminal transactions. Social, mobile and wearable technology have all

exacerbated the ballooning of the Internet, as do the growing range of connected devices that form the nascent Internet of Things. As the cost of producing, publishing and storing data of any kind collapsed, so they flourished (thank you Moore's Law, thank you Tim Berners-Lee).

The Internet is now vast beyond comprehension. The story of Silicon Valley and its so-called Unicorns, all those billion-dollar start-ups, is the story of services that navigate the infinitude. These are the master aggregators who, by making the Internet work, by managing this excess, command our attention: and by commanding our attention, they command advertising dollars.

It's easy to see why curation became part of the Internet. Of all the overload we experience, the Internet, with its explosion of data and information, its density of connections, its speed, is the most obvious.

Nor is it solely a matter of volume. It's about the curious flattening of information. If the President of the United States sends a tweet, it is no different in form than an utterance sent by you or me. If the President of the United States gives a speech it happens in a vastly different context than if you or I did. Sure, the impact of the tweets will be different, but their substance is equivalent, unlike in the bumpy offline world. Online curation isn't just about whittling things down, it's also a qualitative parsing amidst far finer distinctions.

Earlier on I described curation as a kind of interface. On the Internet this is literally true – all our interactions have to be mediated through interfaces, and this involves necessary patterns of selection and arrangement. If curation has become so prominent in recent years, it's in large part down to this process; humans on one side of the screen, a mass of data on the other. Throughout this book many examples have already been web-based, and that should be no surprise.

The Internet's curatorial mix is multifaceted. Individuals,

services and protocols all play a role. At the higher levels new disciplines of curating build reputations and market companies. New kinds of celebrity, known for their sharing, dominate new media. And new kinds of business facilitate curation on an industrial scale.

One of the best known is Paper.li, a start-up which grew out of the Swiss Federal Institute of Technology. Co-founded by Edouard Lambelet, Paper.li lets users filter the Internet and repackage its contents in a digestible form. Every day they process 144 million websites. Their users collect what's interesting, helped by Paper.li's technology which does the heavy lifting and then publishes their choices.

When I spoke to Lambelet he explained the reasoning behind the site: 'The idea is to facilitate the discovery of the long tail of content. We all have this feeling of content overwhelming us, of drowning in content and information, in the news. I believe people are part of the solution.' Lambelet's vision of curation is one of a human process built on top of their technology. He sees this as integral – in that long tail human whims can find something different, something unexpected and worth sharing. The fusion is key: 'A lot of people don't actually want to create content, but they are engaged enough to recommend it. If they need to spend three hours a day in order to do that though, they can't, it's too much – so we bring web technology and semantic technology to make the job of curation easy on a daily basis.'

Ultimately Lambelet is building a business based on information overload and its solution. He recognises this, and indeed the way both have formed a central dynamic of the Internet: 'Because of this massive noise we are experiencing on the Internet, content filtering is more and more valuable to users. If I find someone who can help me filter this noise out, I will. Consumers are concerned by the noise. So it's not just about

the creation of content – content filtering is also of value. From the beginning of the Internet we have always needed filtering – from portals and directories to websites and pages and then to search engines. Now it's overwhelming again, with social media and the nomadicity of content, we need to filter again – and this time the filtering is crowdsourced and curated.'

Dedicated curation services have found their place. Damman's Storify and Lambelet's Paper.li have both gained considerable traction. But we could equally have discussed Curata or Trap.it, Scoop It or Swaay, enterprise-level software aiming to turn businesses into worthwhile curators.

Paper.li and the others specialise in 'Content curation'.[2] This has become a discipline in its own right, a method built around the content-curation life cycle. Loosely, the process works as follows:

- **finding** content (from newspapers, Twitter, email newsletters, feed readers, keyword monitoring, the trade and speciality press, power social media users and influencers);
- **selecting** and organising the content. This often includes commenting on the work or excerpting, putting into context or collections;
- **sharing** it with others.

Most explicit web curation is based on this pattern, although as we will see, the implicit curation of the web is altogether more complex. What's striking about the discussion around content curation is how much of it comes down to marketing.

Marketers see content curation as a way of pulling in new audiences, establishing credibility, creating deeper engagement with existing customers and even boosting search engine optimisation – SEO – and return visits. Once, marketers typically

saw themselves as media producers. They wanted to funnel everything on to their own products and spaces – not other people's. Content curation feels radical as a marketing strategy because it overturns both maxims.

Curation marketing recognises that buyers have changed – they don't expect marketing to be simple messages broadcast through the obvious channels. It doesn't work. Information about products used to be scarce and markets were less saturated with product. Purchasers have grown more discriminating; they don't want crude sales messages, they want high-value content.

It's also part of a change in marketing: an evolution from straightforward sales to the building of brand affinity and customer retention: 'thought leadership', not just the generation of leads. It's marketing-as-a-service, useful and interesting in its own right. It also comes back to that perennial of curation – expertise. Good content curation demonstrates expertise and builds trust. Lastly, content curation may take a lot of intelligent selection, which itself is a resource, but it requires less up-front spend than classic advertising.

So businesses from Microsoft to Lego to, famously, America's oldest flour mill, King Arthur's, have self-consciously become curators. I've followed O'Reilly Radar for years, a regular dose of curated links from the technology publisher O'Reilly Media.

But the term is often used weirdly. Websites advise people to 'curate in the morning' or curate their way to success. Curation is seen as a shortcut, a defined thing, not a process. Curata, for example, have a twelve-step checklist for content marketing. It makes sense on one level, but reduces curation to a formula. Content curation isn't that simple, can't be slotted in as another routine task. Good curation is more difficult and subtle than that. This is why many such strategies feel

hollow. Curation felt radical and different to some marketers, hence the understandable focus. But equating curation with marketing misses not only all the worthwhile curation beyond marketing (e.g. much of it) but also how integral curation has become to a wide variety of activities.

This isn't to deny that curation can form part of an effective strategy for marketing and community building. It absolutely can, and it is an essential ingredient. By some measures content marketing is the fastest-growing marketing segment for consumer brands.[3] At its best content curation marketing builds trust, is useful and interesting, and demonstrates that companies are working unselfishly as part of a wider conversation. But at its worst it's a meaningless buzzword trotted out to fill blanks in corporate strategy meetings.

We need to go beyond the idea of content curation – which is fine for describing newsletters, blogs, and playlists on Spotify, but doesn't really encapsulate what curation means on the Internet.

Instead we should look at it all as part of a Curation Layer.

The Internet is often regarded as a stack consisting of layers, from the physical layer of cables and servers, through various protocols up to the application layer – the bit we users generally encounter in the form of web browsers and so on. The Curation Layer doesn't sit formally within this framework, but in its spirit, alongside other layers like the content layer, the social layer or even the game layer. Given the limited amount of information any human can engage with, there are always filtration and selection mechanisms. Collectively these filters form the Curation Layer.

We are cloaked in curation and everywhere encounter the Curation Layer. It's just that it's much easier to spot in the digital world.

Perhaps one reason why curation is regarded with such

suspicion is the so called 'stack fallacy', the mistake of believing that the layers above yours are easy to build. It's just curation, choosing; it's easy, anyone can do it. This rarely proves to be the case. Just because you're good at building databases, distribution centres or even web platforms doesn't mean you're good at expert selection.

How do we work with and in the Curation Layer? Businesses use it as part of their marketing offering in the form of content curation. Curators like Maria Popova, Matt Drudge or Jason Kottke develop sizeable audiences through idiosyncratic curation. Start-ups like Paper.li or Bundlr develop tools to augment the curation of others. Websites like Pinterest make everyone a curator of cakes, cats and, for me, book jackets. The point is that Internet curation happens on a grand scale. Not only is it concentrated in pockets of content curation, but it's also something much bigger – an integral part of our core technology, business and informational environment.

It does however beg a further question. Throughout this book I have looked at algorithmic and human curation together. Large web services have been called curators. Can we really talk about these as curation, or is that stretching the term beyond breaking point?

Of machines and men

Sitting in his office at Oxford University's Internet Institute, Luciano Floridi, Professor of Philosophy and Ethics of Information, is quite clear: speaking with rapid clarity, he argues curation cannot be ascribed to the big web platforms. 'Curation implies responsibility for what you curate,' he says. Responsibility is a human trait. 'Curators are experts – you have to have a say to be a curator. There is a practical side to curation that means algorithmic curation should be joined by

a sense almost of ownership or custodianship. The ability to intervene, to follow on, to ensure your curation has an impact, is key. It is a pragmatic relationship.' The point for Floridi is that curation has ethical overtones that go back to its root *curare*. Curation doesn't just mean selecting and arranging, it means doing those things for a purpose grounded in helping.

We broadly agree on why curation matters. 'Curation comes as a consequence of abundance,' he says. 'You don't need to curate papyrus or rolls of script.' But Floridi sees curation as having a very specific role. 'It puts the entity, the thing curated, at the centre. The curator has a mentality, a sensitivity that looks at what is good for something. The good of the entity comes first, before the curator.' Curation, he argues, 'is altruistic towards what is being curated'. And this is where the idea of machine-driven curation runs into problems. Automated programs that simply direct users elsewhere, that don't have custody of information or content, cannot do this. Floridi argues that Google is more likely to curate advertising, of which it is a direct custodian, than content, which it merely pushes people towards. It's what author Carmen Medina calls curation's 'moral lens'.[4]

There is then a big question about what constitutes curation. This is more than just a semantic question – it is about the economy's direction, business strategies that will succeed or fail. Throughout this book I have looked at algorithmic and human curation side by side, arguing that both should be seen as part of the curatorial drift. However, many assume that curation is explicitly human, while the plainer 'aggregation' is machine-driven. Most discussions of content curation, for instance, rest on this distinction.

Content farming, mass aggregation – these don't have the unmistakable human touch which curation seems to imply. That touch which becomes so valuable in a world governed by machine-made systems.

David Byrne, the musician and commentator, makes a similar point in an article about curation for the *New Statesman*: 'What I and other "experts" offer is surprise,' he writes.[5] Byrne argues that his experiences 'being a wee bit outside the norm, are a little more biased, skewed, pre-edited and peculiar than what those herd-based and algorithmic services come up with'. The result is that it helps people in 'encountering an idea, an artist or a writer outside the well-trodden and machine-predictable paths'. This person-centric curation is 'a potlatch process', a 'social glue', an exchange of information among friends. Byrne, like Floridi, makes the point that perhaps curation is valuable precisely because it avoids the algorithmic and the aggregative and is instead imbued with human values, quirks and all.

So why do I see curation as spanning both the algorithmic and the personal? Before I answer, one proviso: the dividing line between curated and not curated is still fluid and malleable. It's not always clear and will take time to settle.

But the reason I think both work is that, first, this is how we use the word. Some discussions assume curation can never be performed automatically, others assume it can and is. As with the word curation generally, the genie is out of the bottle and attempting to legislate language is pointless. Follow the trends out there, on blogs and social media, in the traditional media, in books and podcasts, and plenty of people are comfortable using the word with the suggestion that algorithms suffice as curation. It's not neat, and it raises all kinds of conceptual difficulties; but for better or for worse this is how the English language moves forward.

Second, I think it applies as there is no neat divide between what people and machines do. Every time we use the Internet our interactions are substantially guided and governed by programs and protocols. Yet they themselves are ultimately created and controlled by people. Something as basic as a search

enquiry is a complex dialogue of human decision making and automation. At one end are the decisions of users; at the other those of search engineers. In between lie various technologies that mediate between the two with a dizzying level of complexity. Automated processes now offer experiences and selections so advanced they go far beyond what we commonly label a filter. And we saw earlier how, at Amazon, Apple and Netflix, machine-driven and human-driven curation dovetailed. While many Big Data processing tasks would be impossible if done by humans, these systems are still designed, maintained, monitored, governed, changed and consumed by people.

Indeed, while tech companies are known for pushing machine-driven systems, Google will use personal recommendations in highlighting restaurants on its explore feature in Google Maps and Samsung is, like Apple, employing editors (and partnering with Axel Springer) for its news aggregation app. The service will be divided into a 'Need to know' section curated by an editorial team and a 'Want to know' section driven by algorithms.[6] Algorithms factor in human 'up votes' or engagement metrics; and we respond to these and shape them in turn. When discussing curation we have to acknowledge this complementary reality, seeing the blend as one of the signature forms of our time. We should recognise that there are now no hard and fast lines between what is machine-driven or algorithmic and what is human. In the words of the investor and technologist Peter Thiel: 'Computers are tools, not rivals.'[7] Just as we use all manner of machines when we put together a new building but don't say the building is 'machine-made', so curation often happens in amalgams of the automated and the personalised. Moreover we are still interested in the subjective; just because automation is required, doesn't mean we don't want extra, personal filters layered on top. Serendipity has not been retired. As one of the

leading writers on web curation, Steven Rosenbaum, puts it: 'In an era of data abundance, the thing that is scarce is taste.'[8]

The next book you read may well have been recommended to you not by a person, and not by an algorithm – but by a strange emergent cyborg that combines the two ... However this isn't to say that distinctions don't exist. Along with the axis of explicit and implicit curation is a further distinction within the Curation Layer. There isn't a uniform level of curation. In some areas curation is especially thick or dense; and in other areas it is much lighter, the layer is thin:

- **Thick curation:** by and large this is what marketers talk about when they discuss curation. It's about humans; it's the curation of Canopy.co or Boing Boing; Instagram and O'Reilly Radar; a store on Etsy or the front page of Arts and Letters Daily. It's the Discover section on Kickstarter or the Public Domain Review. It's intense, fully realised, based on detailed personal choices, often for smaller audiences; it discusses its choices and comments on them, adding extra spin to its decisions. It works as an additive part of the Curation Layer.

- **Thin curation:** a lighter, often machine-driven form of curation – the network of cataloguing and filtration mechanisms, recommendation and discovery algorithms, that we find throughout the Internet. We wouldn't necessarily always call it curation as it works automatically or semi-automatically, generally without commenting on or explaining its processes. At its fringes it melds with tagging systems and folksonomies (the results of social tagging), search indexing and retrieval algorithms, database architectures and version control systems like Git. It is the underlying and necessary curation of the Internet, the suite of

systems that by deep selection and arrangement make
managing the superabundance of information a prac-
tical possibility.

As with the Curated and Industrial Models of Selection,
there isn't a hard divide between the two – it's again a spec-
trum. Thick curation is often explicit curation, thin curation
often implicit curation. But this needn't be the case. Retailers
like Eataly, for example, don't explicitly call themselves cura-
tors but they are undoubtedly an example of thick curation.
Pinterest is much closer to explicit than implicit curation. But
Pinterest is, like most such services, a composite – people's
personal curation fills their own boards, while the site as a
whole uses various machine-driven mechanisms for finding,
recommending and sorting that material. So its users make
Pinterest a thickly curated space; but Pinterest has built its
own thin curation to help. And for those who might think
Pinterest a trivial example, it has seventy-three million users,
a valuation of around $11bn and an application program-
ming interface – API – for major business users.[9]

Moreover, while this division of thick and thin works most
obviously in digital environments, it's a general phenomenon.
Art galleries, boutique record stores, specialist cycle cafés,
libraries, brand-name hotels, film sets, festivals and even invest-
ment portfolios are thickly curated. Meanwhile department
stores, sculpture parks, shopping malls, trade fairs, markets
and even some neighbourhoods (think New York's Nolita or
London's Marylebone) are still curated, but more thinly.

The two are also complementary. Thin curation makes
the Internet governable and its content discoverable. Thicker
curation breaks beyond search. It answers subjective ques-
tions, the questions you didn't even know you wanted to
ask. By introducing random human elements, it bursts the

'filter bubbles' of automated systems, taking us beyond what Upworthy CEO and writer Eli Pariser calls the 'search and retrieval Web': an echo chamber of our own preferences augmented through behaviour-tracking recommendation algorithms.[10] That mesh of machine-driven filtering technology creates a 'city of ghettos' to which thick curation, of wide-ranging material, is one answer. Unpredictable, messy and strange, human judgement can go beyond this canalised, automated version of the web. It leaves room for random epiphanies and takes us beyond our blind spots. We need algorithms, but we still need ourselves.

On a wider level, without a blend and balance of different kinds of curation we will fall into self-reinforcing loops of taste and opinion. Rather than open up and explore the world, curation would close it down. One form of curation – let alone one curator – represents a totalitarian vision. A diversity of models and curators mitigates the risk. It opens rather than closes.

As with the move from the Industrial to the Curated Model of Selection, so we are seeing the 'thickening' of the Curation Layer. Internet businesses understand that more curation offers more value to users. This tendency to move towards more curated experiences and denser discovery protocols is one of the long-term trends of the Internet.

Prizefight: Facebook v. Twitter

Take those giants of social media, Facebook and Twitter. Big Curation. Their respective strategies and performance over their maturing years (roughly 2010–2016) encapsulate this movement towards thicker curation. By looking at them I am not trying to pick winners or suggest who will do well in future – the sector moves much too fast for that. I'm looking backwards to see what happened.

Twitter CEO Dick Costolo was worried. It wasn't meant to be like this. When Twitter debuted on the NASDAQ its market capitalisation was a hefty $24bn. Despite making a loss, Twitter was worth more than most media businesses in the United States. But Costolo's earnings calls with Wall Street investors were taking on an uneasy tone. Metrics were bad. User growth had stalled. New people were turning away in droves, alienated by a system that seemed incomprehensible and stacked in favour of existing super-users.

Since launching in 2006 Twitter had enjoyed massive growth. In 2007 it hosted around 5,000 tweets a day; by 2013 that figure was approaching 500 million. But the fundamental interface remained the same: it was still an unending 'firehose' of real-time tweets in a single feed. The mechanism for finding content hadn't evolved. What's more, the three most significant user interface touches designed to help manage this – the @ sign to signify someone, # to denote tweets around a topic, retweeting to share someone else's tweet – had been driven by users. Only later were they formally adopted. All of which meant that despite becoming one of the largest and most active sites on the Internet, Twitter devolved curation to its users.

Journalist Nick Bilton's account of Twitter's history hints at why. From the start Twitter suffered from a confused identity. Each of the four co-founders had a different vision, resulting in years of internecine squabbling that hobbled efforts to build a workable product (early users will remember the Fail Whale which featured on regular outages). Ev Williams, the imaginative Nebraskan who had previously founded Blogger before selling it to Google, saw Twitter as a communications network. He thought Twitter should be a place to share news and find out what was happening. Meanwhile the first pro-grammer, and later CEO, Jack Dorsey, thought it should be personal – about what you were doing. Dorsey was wilful

and intense, a match for Williams. The other founders could barely keep the peace. Even when they had all moved on, Twitter was stuck between competing imperatives and there was a certain stasis in product development. Was it an evolved RSS feed and syndication platform? A chat system and social network? A real-time opinion aggregator?

Then, once the company had gone public, came the increasingly awkward investor discussions. On one such call even the Chief Financial Officer at the time, Anthony Noto, confessed that the site 'isn't the most relevant experience for a user'.[11] He went on to admit that 'putting [interesting] content in front of the person at that moment in time is a way to organize that content better' as against the firehose, where it's lost. It was an admission from the top that, for many, spewing 350,000 tweets a minute needed better curation.

Down the road in Palo Alto things couldn't have been going better for Mark Zuckerberg and Facebook. Having made a rocky start, Facebook shares performed strongly after the company went public. Their value quadrupled between July 2013 and July 2015, by which time the business was worth \$245bn – the world's seventeenth-largest by market capitalisation, increasingly seen as an essential part of advertising and with user numbers continuing to grow. At the time of writing Facebook has 1.5 billion users, meaning if it were a country it would easily be the largest on earth. Twitter meanwhile has a shade fewer users than the population of the US, around 315 million. Starting around 2009–10 Twitter's user growth has been stalling, while Facebook's powers ahead. Facebook realised much earlier that a more curated experience was essential. Curation would make Facebook friendly; the lack of it made Twitter intimidating.

One pivotal change was the introduction of a filtered News Feed, a controversial measure pushed through by Zuckerberg himself. Facebook users would no longer see everything

posted, but instead would have a more managed experience. Engineer Lars Backstrom explained Facebook's reasoning on the company blog:

> The goal of News Feed is to deliver the right content to the right people at the right time so they don't miss the stories that are important to them. Ideally, we want News Feed to show all the posts people want to see in the order they want to read them. This is no small technical feat: every time someone visits News Feed there are on average 1,500 potential stories from friends, people they follow and Pages for them to see, and most people don't have enough time to see them all.[12]

Backstrom claimed that those 1,500 stories were digested to 300 pieces of content per user per day. For heavy users of the site, these numbers would be blown out of the water – without the new system they might be exposed to 15,000 posts per day. Moreover Backstrom reported that because of better targeting, posts that had previously been viewed only 43 per cent of the time were now viewed 70 per cent of the time.

While (like the Google search algorithm) Facebook's News Feed examines thousands upon thousands of factors, at its core the process is quite simple. Something is likely to be shown on your feed roughly according to the following:

interest in the poster

x

track record of the post

x

track record of the poster

x

type of post (status update, image)

x

when it was posted

=

likelihood of appearing on your feed

This is thin curation indeed. But, crucially, compared with Twitter, it gave users a curated experience beyond their own decisions.

The algorithm is constantly evolving powered by detailed qualitative research, Facebook's enormous dataset and rigorous testing. One addition (along with recording likes, shares, comments and so on) was factoring in the time users spent looking at particular posts. Even this has an algorithm that ensures you really are looking at the site and not waiting for it to load or wandering off. It's part of Facebook's battle to stay ahead. At times this has backfired – when they were found conducting a study into the emotional impact of curation, which included seeing if they could alter people's emotions, there was an outcry. But experimentation continues. Facebook Moments, launched in 2015, auto-curates photos (say from a family party). Time stamps and facial-recognition software build profiles of who was at an event and then aggregate and share associated pictures. Facebook Instant Articles works with news providers like the BBC and *Der Spiegel* to select quality content targeted at individual users – all hosted by Facebook.

At an extreme Facebook are building a walled-garden Internet – neater, safer and more curated, with all the positive and chilling aspects that implies. As its growth shifted to emerging markets, Facebook realised it had a pivotal role to play in shaping the Internet's future. In Asia, Africa and Latin America it launched internet.org, for example, a charitable push for cheap data and a simplified web enabling more people to access the Internet.

As part of internet.org users have free access to services like Wikipedia and health information – and also of course to

Facebook and Facebook Messenger. There are Facebook-only data plans, while countries like Ghana and the Philippines have hugely discounted Facebook data plans (e.g. you pay very little or even nothing for using Facebook). The upshot is that in parts of the world people use Facebook without realising they are on the Internet. In Asia and Africa researchers noticed an interesting trend: surveys of Internet use showed people claiming not to use the Internet. Yet when followed up in focus groups, they would claim to use Facebook. News site Quartz investigated further and found that 11 per cent of Indonesians and 9 per cent of Nigerians on Facebook claimed never to use the Internet.[13]

This, then, is the Internet of the next four billion. People gravitate towards the dually curated world of Facebook – curated by their friends and curated by Facebook itself. Highly curated walled gardens were already the trend with apps, but Facebook, as the super app, intensifies that trend. What's more this system wasn't just easier for new users but it seemed to work especially well in mobile, which had rapidly become the most important segment in tech. It takes us back to the portals of the early web, like AOL, which featured a vanishingly small button called 'Go to internet'. Not only does it make the Internet more palatable, but it has helped them better target adverts. They know more about users and how best to target material. Whether you think this is good or not it's certainly been good for someone – Facebook.

Twitter had to respond. On one investor call Costolo acknowledged that Twitter needed to 'curate' more. One idea was the logged-out homepage – a curated version of the site. Another was the 'While You Were Away' feature, which aimed to take the best tweets people might have missed. They added an Instant Timeline feature for new users. They even launched a new product for media publishers – curator.twitter. com. It was a mixture of their most advanced filtering technology, a mechanism for building new Curated Collections, a

way of curating multimedia content including Vines, real-time data insight into what was happening on Twitter and a broadcasting channel Tweets. Another innovation is the Highlights feature – this updates twice a day and creates a feed of twelve or so tweets the algorithm thinks will interest you. Bloomberg called it 'a significant step outside Twitter's comfort zone in pursuit of new users' – and one towards Facebook.[14]

Perhaps the most significant venture is Moments – a move into direct curation. Twitter builds collections of Tweets, Vines and Periscopes around live events. These include both scheduled events – the Superbowl or Glastonbury, say – and breaking news like natural disasters or election results. Or it could just be interesting stuff – they envisage a channel for 'Throwback Thursday', but also focus on big-ticket headlines like Business and Sport. Users swipe through narratives built in real time around these events, looking at one Tweet (or Vine or Periscope) at a time. Moments is meant to distil the best content – and few now deny there is a mass of great stuff on Twitter – into coherent, easily digestible packages for basic users of the site.

What's more, there is a human element to decision making – collections are curated by a team with newsroom experience. Those editors will be able to embed relevant tweets into people's timelines. In addition Twitter is partnering with trusted brands like the *Washington Post*, *Vogue* and NASA to select content. Twitter is turning itself from a quasi-random firehose into an edited media outlet. This is new – how will they deal with atrocities? To what extent will paid events gain prominence? This needs new competencies. Twitter are pushing the service hard, integrating it into their desktop and mobile interfaces. But they also want to decentralise it – the tool could be pushed out to all Twitter users, allowing them to better curate their output. Indeed, the launch of Moments came with an explicit 'Moments curation policy' on the main Twitter website.

There is no easy fix. Twitter haven't solved all their problems. When in early 2016 a rumour spread that Twitter might transition to an algorithmically driven timeline, there was an immediate and ferocious backlash. The company backed down from wholesale change but, still facing the wrath of growth-hungry investors, persisted in attempts to create more algorithmically filtered experiences. Suddenly not only the financial future of Twitter but its passionate relationship with millions of users was at stake – over the issue of curation.

Twitter, having fallen behind, is now aiming for thick curation. Facebook has built tools and programs to curate itself. The direction of travel for both has been to add more and more into the Curation Layer; to offer users more value through more curation; to respond to the overload enabled by their own platforms; and to use curation as a means to better understand those users. Corporate strategy in big West Coast tech (but also in the phenomenal success of a product like WeChat from China's Tencent) can be read through the prism of curation as finding more ways to let people curate and find better-curated environments amidst the excess.

Take Yahoo!, a company whose relationship to curation – explicit and implicit, thick and thin – has been inconsistent. They haven't been sure where or how they should fit into the Curation Layer. Founded by Jerry Yang and David Filo, Yahoo! was originally a hand-selected directory of links, the original web-curation site. In those feverish early days it was enough to get them noticed. Led by the energetic Jeff Mallett, Yahoo! enjoyed a rollercoaster few years, building an early search engine and riding the dotcom bubble like almost no one else: its share-price spike on going public was, at the time, the third-largest in history.[15] They also bought GeoCities, as we saw earlier, the idea being that Yahoo! would become synonymous with managing the Internet.

But it went wrong. Yahoo! tanked in the dotcom crash. So began twelve years of soul searching and a succession of CEOs (from Hollywood, from the tech industry, Yang again). Missed opportunities became commonplace: the times they failed to buy Facebook, the bungled acquisition by Microsoft, bad deals with Google. Under the leadership of Terry Semel Yahoo! expanded into a direct media company. Unlike Google or Facebook, which had clear missions (to manage the world's information, to connect people), Yahoo! now had a conflicted identity – was it about search or media, technology or content?

Despite failing to keep pace with Google's search and advertising technology, Yahoo! made some astute acquisitions in the mid-2000s that should have put it in the curatorial vanguard. Del.icio.us and especially Flickr, sites for storing and sharing links and pictures respectively, were at the time hot property and pioneers of the new system of distributed tagging that let users produce taxonomies and cataloguing mechanisms for large datasets. They were early and successful examples of how web platforms grew powerful by enabling users to become curators in their own right. I recall Flickr's tag cloud as a revelation, a whole new way of engaging with content that made maximum use of what was hyperbolically (but not incorrectly) known as 'the wisdom of crowds'.

Yet even these services never reached their full potential. Del.icio.us was spun out of the business some years later. Flickr remained in the stable, but was eclipsed by other photo-sharing sites, often better optimised for mobile. That classic of web curation – photos – may have started on Flickr but it quickly moved elsewhere. Meanwhile Yahoo! relied increasingly on its legacy users, its large Yahoo! Mail base and a fortuitous investment in Alibaba, a ferociously expansive Chinese web business whose rising value undergirded precarious Yahoo! stock.

Then in July 2012 they hired Google executive Marissa
Mayer as the new CEO. Mayer was one of the earliest and
most influential Google employees. She pioneered data-driven
user experience, relentlessly focusing on making the interface
simple and backing it up with hard facts (recall the signifi-
cance of Google's arrangement of information). Mayer's pitch
was based on her vision, her tech experience and her leading
sense of platform and product. Mayer would have two years
before Alibaba went public. Two years when a floor was
placed on Yahoo! stock; two years to turn the business round
and fashion a consumer technology company to rival Google
or Facebook. What would she do?

Mayer was going to remake Yahoo! as a product not a
media company – the latter being the favoured approach of
the internal candidate she pipped to the post. Having started
with hand-curated links, Yahoo! had lost out as one of the
Internet's curators in chief. All those missed opportunities
and lack of focus meant they had time and again misunder-
stood the direction and significance of curation on the web.
Mayer would change that. She had some quick successes –
award-winning apps; product teams working on great stuff;
a turnaround in aspects of the culture; thousands of job
applications. But saving Yahoo! required much more.

So she embarked on a two-year acquisition binge. Tumblr
was founded by David Karp, a young New York-based CEO.
He had a huge audience of young people, billions of page views
a month, high user engagement. Above all Tumblr was part of
the new way of curating the Internet. While earlier blogging
platforms let users produce their own content, on Tumblr it
was more common for users to repost videos, images and text
from elsewhere in a kind of endless collage. In response to the
growth of web content, services like Tumblr were offering
a personalised curation of all those trillions of images and

minutes of film. Mayer went in big, for $1.1bn. Like Flickr it was going to have in Tumblr a focused, grounded curation at the heart of its new strategy. Tumblr acted as the filter for a generation. While its audience was valuable, the curatorial aspect, getting back into being part of the Internet's curatorial mix at the social level, made sense in terms of the wider corporate strategy.

Mayer acquired over sixty companies in that time, the vast majority of them based on curation. They included, for $30m, Summly, a start-up founded by seventeen-year-old Briton Nick d'Aloisio, Snip.it, which allowed people to make collections of links, and social recommendation services like Jybe, Alike and Stamped. The product revamps, from new weather apps to new 'digital magazines' led by famous names like former *New York Times* tech correspondent David Pogue, curated sites built into verticals on top of Tumblr, were about curation – if Yahoo! was to stay in media and keep pursuing a Janus-faced tech/media strategy, the media element would also be highly curated. Search technology and user interface (or selection and arrangement) were back as an in-house priority. Mayer wanted Yahoo! to reclaim a central role in selecting and arranging the Internet. At the time of writing, the omens aren't looking great.

What happens next is an open question. There are reports Yahoo! could be broken up or sold.[16] It isn't the point. Mayer's career, Yahoo!'s history, strategy and future all hinge on working within the Curation Layer – how well they do it, whether people like it and how many users they can empower to curate in their own right. The value of the web today is contingent on the tools and capabilities available to curate it. It's not only why Mayer will spend $1.1bn on Tumblr but why she would want to methodically re-gear the whole company around curation.

Curator takes all

So much value has been created by the technology boom that difficult ethical, legal and financial questions about how that value gets shared are unavoidable. Curation has become so central to how we navigate the web, and the value of attention it attracts and enables so great, that we should question whether the skew has gone too far. Are we disproportionately rewarding curators over creators? It's the same question that dogged the cultural debate, but here writ large – tech companies are so vast that entire sectors are impacted by their whims; the value of creation itself is potentially eroded by business models. How can that be a good thing?

What are the ethics of this new reality? For example, how credit and reward are apportioned might increasingly be out of whack – hence the outsized rewards that go to curators and gatekeepers, whether that's Hans Ulrich Obrist rather than new artists or Eataly rather than micro Slow Food producers. The Copyright Wars and debates around the apportionment of revenue from digitised culture have been done to death, but the issue doesn't go away.[17]

A few years ago Maria Popova launched online the Curator's Code – an attempt to ensure that fair deserts were shared. Using new Unicode symbols, the code indicated links of direct and indirect discovery – the equivalent of acknowledging 'via' and giving a 'hat tip'. Attribution would be universal and clear; boundaries between creator and curator respected; the 'creative and intellectual labor' of both acknowledged.

Only it immediately ran into controversy. Commentators objected, as they often do, to the use of the word curation. But beyond that they claimed that not only was the code unnecessary, since typing *via* was easy enough, but that it didn't go far enough: curators were still leeching off the production of

others.[18] The writer and technologist Jaron Lanier has written extensively about the problem.[19] For him the issue is quite clear, and is financial in nature: in this great curatorial edifice creators no longer see the full monetary rewards because they get creamed off whilst descending through the Curation Layer.

I well understand this problem. As someone who earns a living producing books and apps in the expectation of selling them, making any kind of money, let alone luxuriating in non-financial attribution, is difficult. The more people need to be supported by an individual product or service, the greater difficulty there is in making the numbers add up. Unless you hit a gusher, factoring in each cost layer of production and the newer additional curatorial layers is tough. A $10 cheque from Google Ads or Spotify doesn't a new economy make.

Yet somehow we have to find ways of squaring the excess production and its declining yields. Somehow we have to navigate the overload; to make things discoverable. Those people that do inevitably create and appropriate value. To rail against this, to think it is the height of decadence, parasitism, piracy, pretentiousness, is all very well – but it solves nothing when production itself is often not the problem. Selecting and arranging from it is.

We need to find an accommodation that remunerates creators – rewarding them with more than just a hat tip – but also produces the full diversity of thick and thin curation we need to operate. Part of this will involve an evolving appreciation of creativity as a second-order activity. Again, I don't expect this to be popular.

We all want to buy into the creativity myth and I for one hope it never goes away. Ours would be a grey and shoddy world without its romance. But as the context changes, so must our concepts. Over the next decades the challenge for

Internet curation – from Facebook down – is to share value. Even if we don't call it curation, patterns of selection and arrangement dominated the Internet's early years; they've driven our experience.

The Argentinian writer Jorge Luis Borges wrote a story about the Library of Babel. His library was composed of a near-infinite labyrinth of hexagonal rooms, which contained every possible combination of a 416-page book, randomly sorted. Yes, somewhere in the library was every useful and brilliant possible book. But in reality the library was endless and entirely useless. Without curation, or aggregation, or filtering, the Internet would be such a Borgesian nightmare. The overload would render all production and creativity pointless – it would be lost, undiscoverable and buried. We should remember the Internet isn't just an evolutionary stage of the gathering excess but a radical inflection point that completely alters the terms of engagement. To use another literary example, the critic Neil Postman contrasted two dystopian visions of the future, those of George Orwell and Aldous Huxley:

> Orwell feared those who would deprive us of information. Huxley feared those who would give us so much we would be reduced to passivity and egoism. Orwell feared the truth would be concealed from us. Huxley feared the truth would be drowned in a sea of irrelevance.[20]

The future we have come to inhabit is Huxley's. The question is not whether or not curation is needed. It's how we build a system that financially accommodates the new diversity of activity.

And we shouldn't forget that the creativity myth *is* a myth – creativity has always involved recombination. There has never

been a clean division between creativity and what we now call curation. Negotiating the two has always been complex.

Curation will remain central. It will encompass a series of interlocking or nested interfaces, from the most refined human judgements to great underlying architectures that govern all our digital interactions. Over time the drift within the Curation Layer has been towards thicker curation. This is why, despite powerful technologies, human curation has a place. While many believe curation precludes machine-based mechanisms, thin and thick allow us to have both.

While the examples here happen to be businesses, of course, swathes of curation, perhaps even the majority, happen in nominally non-market, personal activities. More of which soon. Yet, it is striking how businesses of all kinds have become selectors and arrangers – implicit curators.

10

Curate Business

The commanding heights

Next to Hong Kong Island's Star Ferry terminal is the International Finance Centre. At 412m its Tower 2 is the second-tallest building in the Special Administrative Region and an instantly recognisable landmark. Nestled beneath it, part of a complex including blue-chip offices and a Four Seasons hotel, is a shopping mall, the IFC Mall.

This is not your run-of-the-mill emporium.

With many of the world's biggest-spending consumers on its doorstep, the IFC Mall sees sales numbers most retail businesses would kill for. For the upmarket brands packed into the mall this is amongst their most important outlets. When I speak to the bullish general manager, Karim Azar, he tells me many of the shops sell double their counterparts in New York. 'The saturation of brands is high in Hong Kong,' he says. 'But the most successful stores for many brands are in Hong Kong. For Chanel or Ferragamo or Armani – for any shop on the Canton Road for example – it will be the number one in the world for that brand.'

Hong Kong is a ruthlessly competitive retail market. As late as the mid-90s China was a backwater for luxury goods firms. Twenty years later, China was, in many cases, their most valuable market and the largest luxury goods market on earth – by some estimates up to half the global market consists of Chinese consumers, although much of this is money spent abroad.[1] With its longstanding *laissez-faire* philosophy, frothy stock market and Rolls-Royce-driving super-rich, Hong Kong is the luxury entrepôt to China and Asia – their first port of call, where reputations are made and unmade. In turn, Hong Kong views itself as being at the apex of fashion and taste. Azar says: 'The Hong Kong consumer is the most sophisticated in Asia and most Asians are emulating Hong Kong. They [people from Hong Kong] have been exposed to fashion for longer than any other Asian nation and so the brands are developed here.' It all means that when it comes to fashion, luxury and high-end retail, Hong Kong – with its elite shopping malls like the IFC and equivalents of Bond Street like Canton Road, is where the action is.

Azar knows his business has to be cutting-edge. Anyone visiting Hong Kong can testify it's not short of places to buy luxury goods. If you haven't bought your Ferragamo shoes or Hermès tie at your hotel or in the mall beneath your office, don't worry! There's one just next to your departure gate at Chek Lap Kok. When Azar uses the word 'saturation' he means it. If IFC wants to maintain its position as the leading destination in the territory, it can't just follow the old real estate strategy of going to the highest bidder and jamming shops in. Azar may speak the hard-and-fast talk of a classic businessman, but his business shades surprisingly close to the work of a curator.

'I am very fussy. I travel the world looking for the coolest brands, the next big thing. I get hundreds of requests from

brands looking for space. We meet with the CEOs of the biggest and the best and we tell them what we want. We say no to people all the time.' With the pick of the world's brands at his feet, Azar's job is to identify those that are newest, the most different, interesting and valuable. Those putting in extra to create an amazing experience; the brands of tomorrow on the bleeding edge of global culture, not two steps behind the West. 'We can pick and choose the brands we work with – we want to keep it very selective, we were the mall that brought tons of new things to Hong Kong. Tom Ford, Zara, Club Monaco, Zanotti, Givenchy, Tory Burch, Moncler – we brought more than fifty brands to Hong Kong, including cosmetics brands like Estée Lauder who never had a standalone presence before.' Azar's point is that IFC isn't just a place for spending large quantities of money on luxury goods – it's about pioneering taste on the whole continent.

While Hong Kong's retail market is uniquely ('fiercely') competitive, with some of the highest rents per square foot to be found anywhere, the wider regional context is also in play. Sitting at the foot of the Pearl River Delta, Hong Kong forms part of the world's largest urbanised region. Between sixty and one hundred million people live there. Moreover this area was the initial engine of capitalism in China and today has the second-highest per capita GDP of the People's Republic after Shanghai. The upshot is serious regional competition.[2] Across the mouth of the delta lies that other Special Administrative Region and former colony, Macau, with its glittering casinos. Just across Hong Kong's mainland border lies Shenzhen, the original Special Economic Zone and now a sprawling megacity and manufacturing hub, home – as we saw earlier – to a vast Foxconn plant. Then there is Guangzhou, capital of Guangdong province, a wealthy mercantile city of some eleven million. Even lower-tiered cities like Dongguan or Foshan

have populations equivalent to large European capitals. As some of the richest and most developed cities in China, they are racing to catch up with Hong Kong.

Which means that, more than ever, Azar's proposition of IFC as the area's leading shopping mall relies on a considered curation. If everyone has the latest luxury brand, Azar wants to find the next big thing and put it in a new context. He won't let stores get complacent. They have to constantly refresh their offering and keep their premises looking sharp.

'We want to enrich the retail experience. It's about visiting eight shops the customer enjoys, rather than just three big shops,' he says. Much of this involves making the retail experience as attractive as possible. He cites huge investment in stores, elaborate plans from the top architects. Shops go to lengths they never normally would to get into the IFC. They produce unique goods for that store. For them it's status and access to top consumers; for IFC everything is about an offering that will keep them at that apex. In Azar's words, this is about 'chasing everything' – finding the cutting edge and then shaping the selection and arrangement of shops around it.

Hong Kong's government is alive to the dynamic as well. It's part of the reason why, like Abu Dhabi, they are investing in large cultural infrastructure projects like the West Kowloon Cultural District. Situated on the harbour waterfront, this will be an arts complex of seventeen institutions including museums, concert halls and theatres. If Guangzhou can have a shiny new opera house, Hong Kong can go one better.

We wouldn't usually think of a real estate and retail manager as a curator. Yet what Azar does bears an uncanny relationship to curation. In the super-saturated world of Hong Kong's high-end retail the value is shifting from supply (owning a mall, opening a store) to curation. As work

changes, this pattern is becoming increasingly prevalent in unexpected places.

Like Hong Kong, Silicon Valley is a focus of abundance. Change, innovation, a multitude of start-ups, talented engineers, exciting ideas, media gossip, billions of dollars of venture capital (VC) money and numberless data collide at the digital world's nerve centre. We tend to think VC firms are making mega-bucks. This is a myth. A few VCs, like Sequoia Capital, Kleiner Perkins Caufield & Byer or Andreessen Horowitz, take an outsized chunk of the rewards. They make selections that beat the competition amidst mass uncertainty and information overload. Many VCs only track the S&P 500 – if they are lucky. Many go bust.

Sequoia are one of the oldest firms in the region and have a near-unrivalled reputation. Perhaps their most legendary VC is the Welsh-born Sir Michael Moritz. Moritz was there in the dotcom boom. He considered dozens of investments on a weekly basis. He would look at areas that were already crowded. When he invested in Google, the space was already busy. Firms had billions in cash and all the market share. Getting in late, like he was, is not the classic VC strategy – which aims to be ahead of the curve, investing in nascent sectors and riding their growth from risky early foundations. When Moritz looked at Google he would have seen a college-based and inexperienced management team, a crowded sector and a garage operation. Numerous Valley VCs had already passed.

Moritz bucked the trend and invested $12.5m. This stake would, in just a few years, be worth billions.

Moritz is different in the Valley. He is not a Stanford computer science PhD. Instead he has a history degree. Moritz doesn't start with technology, so much as with the overall situation and how a company slots in. It's not just this or that

tech – but how is the market moving? What are the founders like? What's that design movement? What's the price of processing power? Where are consumers spending their time? What are the problems people face? Where might software be in ten years' time? Moritz adjusted his companies to the reality as he saw it. He realised that you shouldn't just select the right start-up, you then needed to continuously mould, adjust, rearrange it for reality, for constant change. You didn't just invest in Google, you worked with the company to help it *become* Google.

Moritz realised that blind faith in technology led to bad investment decisions. He developed an investment philosophy that was flexible, not a mechanical process but one that grew from deep expertise, experience and consideration of the environment. Moritz reads voraciously around his investments. He wants to know everything. It's understanding in the round, iterating, pushing, pivoting, that makes those investments a success. It is an art. Moreover, as he tells Joshua Cooper Ramo, most of his best investments have come from a profound ability to empathise with the hopes, dreams and fears of the founders – he fully admits that investments that didn't work or were missed came from a lack of empathy.[3]

Moritz's approach to VC is different. In the process he has become a billionaire. Sequoia's investments are worth 20 per cent of the value of the entire NASDAQ.[4]

Moritz resembles a curator as much as an old-style investor. The skills involved substantially overlap. In a complex scenario he found a new way of doing business that reacted to change. It's a skill replicated by the best investors like Warren Buffett. Moritz claims it's hard to find new VCs. It's an exceptional skill set of selecting and arranging that is not easily replicable. Understanding the tech or having a Harvard MBA doesn't mean you see things in the round. Many VCs,

unlike Moritz, did not survive the dotcom crash. If the tech boom pops, many more will go to the wall.

Moritz and Azar occupy quinary roles – roles in the commanding heights of the world economy. They are superstars influencing global trends. While neither would be called a curator, what they do, the skill set they share, has a close familial resemblance. Their ability to select in crowded fields and to add value by doing so; to follow up and carefully arrange those selections for maximum success; their expertise and understanding of their fields; all these make them irreplaceable.

When jobs get pushed upstream in crowded, difficult markets, they become curatorial. Whether it's luxury brand outlets or tech investments, distilling complex, overloaded markets into clear and successful selections is one of the defining abilities of our time. Understanding this change explains how work has already altered over the last thirty or so years – and will continue to alter. Sure, such jobs have always existed. Newspaper editors, interior designers and retail buyers, for example, have always worked by selecting and arranging. It's their increased prevalence, scope and potential to create value that has changed. And if for the time being they are concentrated in privileged but significant enclaves, they will, I believe, rapidly percolate into more business sectors and geographical areas.

Whenever I spoke to art or museum curators, the suggestion that venture capitalists might be family was anathema. That, they scoffed, isn't curating. Speaking to a lecturer teaching a master's degree course in curation, I argued that surely this was great for curating? Curating has become a kind of advanced prototype for the future of work. Curators' core skills have never been more desirable. Isn't this something to embrace? The business of art and the art of business have never been closer.

Shut up and take my money!

Piggly Wiggly changed retail forever. It may have been incongruously named but the Memphis, Tennessee store founded in 1916 by Clarence Saunders ushered us out of the formal nineteenth-century world where goods were kept behind counters into a brave new twentieth-century reality: self-service shopping. Saunders let customers browse and pick items at will, rather than wait for harried assistants to pluck them off segregated shelves. They then took the goods to a centralised cash desk and paid. Walking through those turnstiles customers had agency; they walked into a new kind of experience. Suddenly layout, mix and brand communication took centre stage. These new stores spread through America and hit Europe in the 1950s. This was when shoppers became shoppers as we know them today.

Saunders created a new model of shopping for a new kind of industrialised economy and consumer. His template would reign for a century.

Now that model is crumbling. Driven by overlapping trends – the supply shock from China and new technologies; the extraordinary expansion in stock availability engendered by ecommerce; the dramatic growth of luxury as a retail force, with its high margins and greater vertical integration; changing consumer preferences and purchasing behaviour – the experience of shopping is undergoing a shift comparable to that of the early twentieth century. We have already seen this: the shift from an Industrial Model of Selection to a Curated Model. It's worth exploring in more detail.

Imagine an Industrial Model fashion store. It has a reasonable selection. At most there may be a few thousand different lines in the store, but most likely there will be fewer.

Contrast this with shopping online. A search for 'dress' on

Amazon returns 947,000 results; narrowing this to 'black dress' returns 244,000 (numbers which, if anything, clearly indicate the extent of the Long Boom's legacy). If shopping on the Internet had a killer app, it was this – everything was available. But of course, in the familiar pattern, that expansion required an overlaid compression of choice: 947,000 dresses is of use to no one. Size of catalogue becomes irrelevant compared to finding people the right garment; a more difficult task as options proliferate. This is one reason why Amazon hasn't (to date) dominated fashion, that most personal and self-expressive of categories. In contrast, think about a company like Opening Ceremony. In the words of the *LA Times*, 'if there is one store that has shaped fashion retail in the 21st century, it's Opening Ceremony.'[5]

Founded by Carol Lim and Humberto Leon in New York's SoHo in 2002, Opening Ceremony was inspired by a visit to Hong Kong, that same retail pressure cooker Karim Azar works so hard to maintain. Their idea was to show brands from all over the world, featuring a given country every year. At the same time they would break and showcase new American designers. Every item was carefully chosen and each new store opened after careful thought. It's always blended styles, from the high to the low, from the utterly exclusive to the offbeat and punk. They work with mainstream brands like Vans or Topshop, artists, film stars and directors; they revive tired old labels; and they discover completely new designers. Installations and collaborations are key.

Opening Ceremony became the ultimate in a new kind of fashion store that was global, almost like an art gallery, built around its selections and partnerships. It's no accident that Opening Ceremony became an icon just as fashion became infinitely available. As designers spring up; as clothing factories increase production, often in terrible conditions for the

workers; as clothing becomes something we can order at the click of the button; the value, aesthetic and pecuniary, moves into Opening Ceremony territory: the curation of the offering. Let's face it. The average Opening Ceremony customer willing to spend $500 on a shirt doesn't want for clothes, or for places to buy clothes. These privileged consumers want only for the latest and best fashions.

Saunders and other retailers expanded customer choice so much that a renewed and strengthened intermediary process is now required. What's changed is not that retailers are curating, for at some level they have always done so; it's the focus on curation as retail's *raison d'être*. Production, supply chains and logistics have all been to some extent 'solved'. While admittedly still complex and difficult, they aren't the central challenge or purpose for a retailer (although for ecommerce companies, solving the 'last mile' question of getting goods into people's hands quickly is still a defining task).

Earlier we saw how a new kind of 'box subscription' food business enables you to have selections sent to you. The model is spreading. OwlCrate sends a monthly delivery of hand-selected young adult books, while Faithbox sends out Christian-influenced products and materials. My Little Box selects lifestyle goods. Not Another Bill picks surprise gifts. Cratejoy, based in Austin, Texas, is a company designed to provide the infrastructure for such box subscription businesses in anything from toys to T-shirts. Birchbox, one of the leaders in the area, does something similar in cosmetics. For $10 a month users sign up to receive five new samples. On signup the customer inputs their preferences and requirements and subsequent packages are carefully chosen based on their 'beauty profile'. This service is invaluable for niche or start-up luxury brands. Birchbox is, around this curated offering, building both a media business, creating content, and a traditional retail business.

Birchbox and Opening Ceremony embody many of the most important trends in retail. They both have a curated offering at their heart. This means they not only select intensively, but they talk about it. Opening Ceremony is producing more videos for its websites and Birchbox has become an online publication. Customers want more information about the products they buy. The 'research phase' before purchasing has increased dramatically. People are more likely to turn to trusted curators, especially those that discuss products and processes in detail.[6] Getting the balance right is crucial. Retailers have seconds to win or lose a customer. Much rests on how information is displayed. Are there price comparisons? If so, how many? Do you need to put not just badges and reviews but a physical location (even if just the head office) on every single page? Is there information about the packaging? Do you link to other sites' reviews? How many off-site reviews do you need? Do you have a downloaded data sheet and if so, what data does it include? Is there background product information and technical specs?

They also combine ecommerce with bricks and mortar. Birchbox is, on the face of it, an ecommerce business. But it has segued into the physical realm, opening an outlet in Manhattan. At a Fast Company conference, Birchbox co-founder Katia Beauchamp estimated that the lifetime value of a customer who visited the store was two and a half times greater than that of an online-only customer. The opposite trend applies for Opening Ceremony – its chic stores are replicated by a substantial online presence. This is what Professor Scott Galloway of New York University's Stern Business School calls the end of 'pure play'.[7] He argues that it's no longer viable to be purely a physical or ecommerce retailer. You need both. Ecommerce transmits rich content and information, lets you maximise range. But you also need a physical store. In part they are convenient, flexible warehouses, but

they also force you to narrow the range. Galloway's research shows that most in-store purchases have been researched online anyway. Hence the necessity of a multichannel offering.

Getting the curatorial mix right across physical and digital environments will be a key competence for retailers. Moreover, he believes the 'vanity economy' of luxury, beauty and apparel will be at the forefront of further changes in retail – exactly as might be expected from Birchbox and Opening Ceremony.

Recently I attended a talk by James Daunt, boss of the UK's largest dedicated book chain, Waterstones. Going into the 2010s, Waterstones was in trouble. The high street generally had been hit hard by recession and digital commerce. For retailers trading on price, new discounters and the Internet had proved painful. In books the challenge was particularly acute. Amazon's market share had grown rapidly as it became the dominant force in bookselling. Already operating on thin margins, Waterstones was in a battle for survival. Its loss would be more than a shame – it would be a catastrophe for writers, British publishing and the book-buying public.

Parachuted in after a Russian takeover in 2011, Daunt, who previously ran an upmarket chain of eponymous bookshops, set about reconfiguring the business. He realised it could never compete with Amazon on range or price. Instead he had to capitalise on Waterstones' existing strengths.

Waterstones' range went from passive to actively chosen; every book is judged, selection size and arrangement is constantly changing, driven by expert choice rather than publisher payments. Staff are empowered to choose, display and engage with books. Centralised buying has been banished in favour of selections made by individual stores. Daunt sees curation as the breakthrough change. Waterstones is happy to stock fewer books, but they should be finely chosen. Booksellers have accountability as curators, rather than passive receivers

of orders. Making bookstores interesting and having their selection based on judgement, rather than what publishers pay, for example letting booksellers and not publishers dictate the front of store, was how Waterstones fought back against a 25 per cent collapse in sales in favour of the Amazon Kindle. Even where central buying remained important, it was better allocated, recognising that different geographical areas and shops had different requirements.

In other words, personal curation and bookselling, beautiful environments, the chance of serendipitous discovery or conversation – these are what give Waterstones a fighting chance in the digital age. They have, in other words, moved from an Industrial Selection Model driven from HQ and by supplier contributions to a more Curated Selection Model, buttressed by the humanity and diversity of their physical stores and booksellers. In Daunt's presentation he reported a significant uplift in sales and a return to profit. The business was secure. It again shows the complex relationship between machine-driven and human-driven curation. Amazon pioneered algorithmic recommendations ... but years later Waterstones is building a great business on the back of human, personal selections, carving a niche against the Seattle behemoth through explicit and thick curation based on its legion of passionate booksellers. What's more, as Amazon piles into same-day delivery, urban lockers for after-work collection and even swarms of delivery drones, the physical convenience argument disappears and all that's left is curation. Curation may have grown on the web, but its impact spreads far beyond. After all, even Amazon responded to the landscape with an old-fashioned bricks-and-mortar bookstore, Amazon Books, which opened in Seattle in late 2015. This is just the start of a plan to roll out hundreds of such bookstores.[8]

The Curated Model is still in its infancy. But start-ups

indicate the direction of travel. Lyst, for example, is a popular retail aggregator that lets users browse among 11,500 designers and stores from Alexander McQueen to Valentino. They then create, share and purchase from 'lysts'. Lyst extensively mixes algorithmic recommendation with personal curation, is growing fast and has raised over $60m in financing from luxury goods giant LVMH and venture capitalists Accel Partners, amongst others.[9] If you want furniture the curated model can be found in start-ups like made.com and Dot and Bo. Electronics? Have a look at Grand St. Talk about fashion and cosmetics? Tech? A little over eighteen months since going live, the brilliant Product Hunt was sending 2.5 million users a month to new launches. Kit.com was designed to change the way we discover 'things worth getting'. We've not even mentioned the merged fashion giant of Italian ecommerce star Yoox and Net-A-Porter, or Refinery29 – places that seamlessly combine content, curation and retail.

Nonetheless it would be a mistake, as Waterstones and any number of retailers illustrate, to elide the Curated Model with start-ups. Galloway cites companies like Gap and Apple – vertically integrated, selective with their product, seamlessly crossing digital and physical retail – as great examples of companies who have succeeded in the new retail landscape by doing both. Both in a sense curate themselves – at the level of manufacturing *and* retail. Shopping mall company Westfield has opened a large Labs operation in the Bay Area to build the new technologies retailers will need – as have Walgreens, Walmart, Target and American Eagle Outfitters, among many others.[10] So-called 'legacy' retailers have been growing their ecommerce efforts at a phenomenal pace for years. The truth is that in today's world there is no online or offline. There is a blend.

High-end retail was always curated – these were always

pleasant, hushed environments, museum-like in their selection and presentation. Now the new dynamic pushes mass access to the Curated Model of Selection, out from its deluxe redoubts and on to the high street.

For most of the twentieth century the way we shopped remained consistent. Producers made goods; shops sold them. We browsed freely, discovering products through shop aisles but also via advertising or word of mouth. Clarence Saunders created a robust system that delivered enormous rewards. But, faced with an increase in possible supply and the new content environment, retail is changed. Utilising to maximum benefit the mix of digital and physical, providing information around selections and products, building trust as a curator and recognising that how we discover, recommend and filter goods in abundant markets is irrevocably altered – these are the rules of curated retail. Neither Walmart nor a small boutique on the Marais's Rue des Francs-Bourgeois will duck the challenge: that discovery, not supply, is now the major obstacle in the consumer economy.

Bazaars, now and then

What we have come to call curation isn't some recent innovation. It has existed for centuries. The innovation is that we have come to label it curation. The word has travelled, the activity has always been present and it's carried on evolving – yes, becoming more prevalent with time, but coming from a clear lineage of practice. In what might be called the bazaar economy – the world of markets – curation has always held a key role. In any market, price competition is always going to be important. But beyond that comes the selection and arrangement of goods. What you have; whether it is exclusive or not; how finely sourced; where it sits in the market; how

the wares are displayed – long before there were any ideas of curation these were day-to-day concerns.

Take that classic of world trade – the Silk Road. While it is usually associated with Chinese traders, Indian merchants also played a prominent role. Before the Industrial Revolution, India and China dominated world commerce. Up to 1750, they controlled just over 40 per cent of global wealth. All merchants on the Silk Road faced enormous challenges, but for those from India they were acute – not only did Indian merchants face deserts and bandits but this was a trans-Himalayan trade, traversing the highest and remotest mountain fastness on earth. To reach their markets, for millennia caravans travelled from the subcontinent, across the Indus and Oxus rivers, over the Hindu Kush mountains and through the Khyber Pass.

Textiles were the most significant items to be traded, but there were also spices (pepper, cinnamon, nutmeg, cloves, ginger and mace), jewels, dyestuffs like indigo, weapons, sugar, rice (Indian rice was considered superior) – travelling hundreds, even thousands of miles to the markets of central Asia in Bukhara, Samarkand, Tashkent or Isfahan. Roman togas and Turkic turbans alike were made from Indian cloth (Indian cotton was cooler than wool and was considered a mark of exotic distinction). India's advantage was that, compared with the arid steppe, it was a fertile land that could support a large population which in turn produced plentiful cloth. Ancient Greece and Rome were already major export markets for Indian cottons; Pliny the Elder claimed that 550 million sesterces were sent to India by Romans every year.[11] In return traders would travel back from Inner Asia with thousands of steppe-bred horses, but also with leather and wool, furs from Siberia, paper, silks and porcelain from China triangulated through Inner Asia.

Indian merchants, living in their caravanserais, were at the heart of an integrated transcontinental network of trade and banking. Multan, in modern-day Pakistan, was a key hub city located between the mountains and the riverine plains, the Islamic and Hindu worlds. Under the Mughal Empire (1526–1707) this trade flourished from northern India, the Punjab in particular. In the early modern period, Scott C. Levi estimates, there were 35,000 Indian merchants working the Silk Road; Isfahan in Persia alone had an Indian population of around 12,000 in the late seventeenth century. From there merchandise could be sent to the Mediterranean or the Caucasus and Muscovy.

There was an infrastructure not only of caravanserais but of roads and passes, trees for shade, wells, bridges, fortresses to suppress armed attacks. The Mughal emperor Akbar the Great alone ordered the construction of 1,700 caravanserais and worked with his Persian Safavid counterpart, Shah Abbas, to protect the trade routes even during times of conflict. Caravans needed unloading every evening and reloading in the morning, the work being managed by Afghan nomads. The process became so efficient that fresh fruit from Central Asia could be carried as far as the Deccan plateau in the heart of the Indian subcontinent.

Caravan merchants nevertheless had to be careful. Their journey was arduous. They faced cold, heat, shortages of food and water, bandits and wars as they traversed the barren mountain passes. Everything was strapped to camels or loaded onto precarious carts. By the late seventeenth century up to 30,000 animals were each carrying 180 kilos of merchandise. Each caravan transported hundreds or thousands of bolts of cloth, to be sold in stages so as not to flood the market.

By the eighteenth century, fuelled by European bullion plundered from the New World, a quarter of the world's

textiles were produced in India. This created jobs for farmers growing cotton, skilled spinners, weavers, dyers, printers, artists, logistics specialists and, at the fulcrum of it all, wholesalers. The Punjab in particular became a global centre of textile production, but Sind, Gujarat and Bengal were also significant producers. There were many different kinds of cloth. Basic materials, but also cotton blended with linen and silk. There were calicoes, chintzes and muslins; Kashmiri shawls, turbans and towels; numerous patterns, prints and colours. India had an edge in production and hence price; but then it also had the diversity and quality of product to go with it.

Indian merchants had to carefully select what they were going to take. Due to the means of transport and the terrain there were huge limits on what could be packed. Although some intelligence was available from their network, information about distant markets was often a matter of guesswork. Logistics, fulfilment and financing were core areas of competence for the merchants – the indispensable basis of their trade. But success also required two further elements: having the right balance of goods in the limited space of the caravan, and the ability to sell them effectively at the other end. Matters of selection were, then, critical to the operation of the trans-Himalayan Silk Road. Balancing the selection of goods was central to the success or failure of these enterprises. Get the mix right – one blend of textiles, spices and weapons for this town, another for that – and the rewards were enormous. Get it wrong and years', even decades' worth of work and capital would be wasted.

This then is the truth of the merchant. They either compete on price or they compete on their selection and arrangement. Or more likely both. This is true of the caravan merchants of Mughal India; the Renaissance cloth traders of Florence or Leipzig; in the Grand Bazaar of Istanbul; or at contemporary

markets from London's Columbia Road flower market to Tokyo's Tsukiji seafood market to wares on Etsy.

What has changed is that as time goes on, the elements of selection and arrangement become ever more central. The Multani merchants of the seventeenth century faced a Herculean challenge in moving their produce to market. Choosing the balance of spice and calico – which quantities, which products – was always bounded by the incredible difficulties not only of production but of distribution. Today, in a world of just-in-time integrated supply chains, that element is less important. Being able to access textiles is no longer a competitive advantage; choosing them is.

All of this can still be found today in India's burgeoning economy. While it's a truism that, since the so-called Licence-Permit Raj was lifted in 1991 with a raft of economic liberalisation, the Indian economy has been growing fast – at an average rate of 6.8 per cent for 1991–2011[12] – it's also true that India, like most of the world, is seeing a shift in the nature of value towards curation-style activities. This isn't to deny or even underplay the challenges – for most of India's population life is still crushingly hard. It is nevertheless a recognition of how growth is occurring in the world's second-largest country by population.

Today it is a mistake to think of India's population simplistically as a mass market. In fact, focusing in this way on the country's 1.2 billion people, up to 300 million of whom are middle-class consumers (and 56 million of whom own a car), creates an error. For example, Tata launched the Nano – a people's car designed to be cheap enough for millions. But it didn't catch on. The market simply didn't want a one-size-fits-all car. People would either stick with motorbikes or wanted to trade up and have more of a differentiator. It was, argues analyst Dheeraj Sinha, a misunderstanding of Indian consumers to think of them as an undifferentiated mass.[13] A focus on

cost at the expense of aspirational and other higher-end values was a category error. Stripping things down to the bare minimum, thinking only about cost, was a strategy that failed to win converts. Moreover it meant that focus moved away from careful curation and differentiation, which harmed brands in the affluent areas as well as those attempting to move upmarket. While the Nano failed, Mahindra and Mahindra, which focused on well-fitted SUVs, continued to flourish.

Indian consumers are, after two decades of growth, on the upgrade cycle – of their phones and cars for example. While the 1990s were about rolling out products like TVs, fridges, microwaves and cars in ever greater numbers, more sophisticated consumers are now becoming the norm, with the associated offerings and retail environments. Shopping malls, retail chains, experts and consumer spending have all mushroomed. A curation-oriented approach is proving more successful in India than the mass market many businesses thought they would find. In Dheeraj Sinha's words: 'The Indian consumer is done with the expected stuff. He wants some shock value – a break away from the routine. He wants bang for his buck, he wants his money to show itself. The desire cuts across social strata.'[14]

Because of the size of its market, scale was prioritised over differentiation in India – whether in telecoms, airlines or retail. This is now changing. Picking up on the bazaar theme, the retail chain Big Bazaar launched by the Mumbai-based Future Group (India's second-largest retail conglomerate) was an attempt to create a mass-market Indian retail destination – its slogan *Isse Sasta Aur Achcha, Kahin Nahin* translates as 'nowhere is cheaper and better than this'. Big Bazaar was an attempt to create a 'carefully curated' version of the street market. It was an attempt to bring the best of the old together with the best of the new in a highly curated setting. This is

also the driver behind initiatives like Foodhall. While it hasn't been plain sailing and the group has more recently hit trouble, it shows how those at the forefront of Indian business are going for curated approaches to what was traditionally seen as the definitive mass audience.

Many of the largest Indian businesses are themselves highly curated entities. Conglomerates are a common form, often built up around powerful business dynasties from traditional groups like the Parsis of Mumbai or the Marwaris from rural Rajasthan. Marwari families like the Birlas grew up in and through the bazaar economy; today they manage vast diversified portfolios of businesses. The Hinduja brothers, who own assets amounting to around \$35bn, are descended from Indian traders who worked in Iran. The trick with such groups, now aped by the founding of a portfolio business like Alphabet, the parent of Google, is to balance elements within the whole; to have hedges built into the mix to ensure overall flourishing is possible. Moreover, such businesses can, thanks to their mix, be resilient. While Western firms have often pursued a strategy of divestment and focus, these sprawling familial empires are growing on the back of melding elements together.

And of course at the grandest level India is an act of managing diversity, of language (thirty languages and thousands of dialects), religion and culture. A new breed of Indian entrepreneur is putting together pan-regional versions of fashions and food. The salwar kameez has spread to south India, while dosas can be found in the north. The need for Indian businesses to micro-target is growing and is becoming ever more possible. This explains the flourishing of a website like Craftsvilla, India's largest ethnic crafts marketplace, which retails unique handcrafted items from sarees to candles. It can match diversity with scale, targeted curation with the mass and complexity of Indian produce. A complex interplay

between regionalism and the national is creating a series of overlapping, nested and interlocuting markets. Weddings for example have become a $40bn industry where every element – themes, Bollywood-style dances and costumes, sangeet ceremonies (like a wedding shower) – is pored over in great detail, and a different regional elements are spreading throughout the country.

Bazaars – markets – are a constant of history. They remain as relevant today as ever. Throughout history we have expected to find curators of various kinds. The librarians who organised information; the critics who picked out and praised works that stood out from the crowd; the collectors who amassed work and the custodians who looked after it. But there were also the merchants, wholesalers and buyers. These roles have never been synonymous with curators, but they always shared much of the skill set. Curation is not the explicit goal of these businesses; it's folded into them, a vital part of the proposition but not its most obvious aspect. This was true in the time of the Mughals and it remains true. India's economy today has a large element that is living in poverty; a large middle that is getting used to consumer life; and a fast-growing upper segment that is redefining itself around curation.

Curation-type skills are not as limited by time and space as we might be inclined to believe.

The curation scientific

Information businesses of any kind are also transformed. We've already seen this at work in our cultural life and on the Internet. But, thanks to that incredible increase, it reaches everywhere that touches information.

Scientific enquiry is one such area. The journal *Nature* is

today the world's most highly cited, according to Thomson Reuters.[15] For researchers, having their name in the journal can make careers. When epochal discoveries are made – anything from the ozone hole to cloning Dolly the sheep or sequencing the human genome – *Nature* publishes the findings.

From the seventeenth century science became more formalised, its newly established methods at last enabling humankind to understand the world. As the nineteenth century began, most scientific apparatus and infrastructure was still that of the late Renaissance – a realm of amateur experimentalists and dilettantes. Even great names like Humphry Davy, Michael Faraday or Antoine Lavoisier, for example, effectively worked on their own, outsiders ploughing their own furrow. As the nineteenth century wore on, however, things began to change. German university research laboratories were increasingly professionalised and their American cousins began to catch up. But scientific communication was run by bodies like Britain's Royal Society. Attempts at new journals tended to fail.

Founded in 1869, *Nature* reflected the new reality of science as an increasingly professionalised and socially significant discipline (just ten years earlier Darwin had forever changed humanity with the publication of his *On the Origin of Species*). Norman Lockyer, its founder, was a scientist and thinker jointly credited with the discovery of helium. A member of the exclusive X Club, a group of liberal thinkers aiming to modernise science and the popular mind, he formed a coterie that would contribute extensively to the new journal. Published by the Macmillans, *Nature*'s stable backing and prominent researchers, guided adroitly by Lockyer, ensured it quickly became a settled part of the scientific firmament.

Its mission was simple. First, to 'place before the general public the grand results of Scientific Work'. Second, 'to aid

Scientific men themselves, by giving early information of all advances made in any branch of Natural knowledge throughout the world'.[16] Although the first aim was fairly normal for a publication, the second was (perhaps unsurprisingly) forward-thinking: *Nature* wasn't just a publisher, it wanted to integrally support, 'aid' the work of science. It gave them room to go beyond publishing.

Nature soon cemented itself as the foremost scientific journal. Meanwhile science, the original progenitor of the Long Boom, was undergoing a huge inflation. The number of articles published in scientific journals has been doubling every thirteen years. By the mid-2000s over 1.35 million peer-reviewed articles were published every year. In 1950 there were around 60,000 recorded journals. Fifty years later it was one million.[17] *Nature* itself has recorded even more bullish figures, talking about a 9 per cent trend growth rate in articles, which equates to a doubling of global output every nine years.[18] On top of this, innovative means of publishing science have been established, bypassing the slow pace of traditional peer review and dissemination – in physics, for instance, the repository arXiv lets researchers post work (early stage, pure data) inadmissible in *Nature*. The situation is just as bad in the humanities: research suggests that 93 per cent of humanities journal articles are never cited.[19]

Scientists have an abundance problem. Wading through even a fraction of the available research is impossible. Long gone are the days of an Aristotle or Erasmus, when one individual could master the entire field of knowledge. Staying abreast of material even in your niche is difficult. Moreover, as the speciality and the depth increase, so does the complexity of the work.

Which is where *Nature* comes in. *Nature* is the arch-curator of science. As the most trusted and prestigious

curatorial brand in the game (although the journal *Science* might object), its selections for inclusion in the main journal are arbiters of quality and significance. As science grows, far from losing their importance top-end journals like *Nature* have only seen it increase. Its editors, a phalanx of scientists armed with PhDs from the world's top institutions, decide what matters and why. As with curation everywhere, the value of a good curator increases with production. *Nature* remains a flourishing business, premised on expert curation, the jewel in the crown of the newly merged Holtzbrinck and Springer group.

But there is now another angle to this story. *Nature*'s parent company had been busy in areas that highlighted another trend within curation, one that has been apparent throughout this book. They set up Digital Science, a cross between an old-fashioned VC and an incubator for scientific communications technology. *Nature* is an old-fashioned curator, still a publisher at its heart. Digital Science would try something new: it would build a new suite of tools allowing scientists themselves to become curators. So, for example, they created products for managing data; for producing and sharing references; for sifting through the welter of citations; for publishing and filtering scientific work in new ways. The mission, note, still chimes with *Nature*'s original purpose – aiding scientists. Digital Science is a recognition that adding journals to boost top-line growth is a strategy that is running out of road; instead, providing people on the frontline of information overload with imaginative tools offers a better opportunity. Others agree – Mendeley, for instance, a London-based start-up which aimed to transform scientific communication, was snapped up by journals giant Elsevier.

Today we see two parallel tracks of curation. First there is the model of the firm itself as curator. *Nature* curates scientific

research; Opening Ceremony curates fashion; Ambie curates music.

Then there is the firm as an enabler of others' curation. Companies build tools allowing – empowering – people to become curators in their own right. Spotify spends vast amounts improving its own curation, but, through its play-lists and sharing of functionality, allows anyone to create and broadcast their musical taste. Facebook has in place thin films of curation – but the whole point is that it's we ourselves who curate it, through our connections and what we choose to post. WeChat, Tumblr and Pinterest all enable others to be curators. It's what powers the self-curation of sites like Wikipedia or TripAdvisor – powerful curators in their own right, but driven by a distributed curation amongst the users.

Creating means for others to *curare* is a signature business model of the digital age.

Magazines more widely, for example, are changing. At some level they were always curators. Now a company like Stack curates them, sending out different magazines to users. And then comes the next level – distributing that curation everywhere. Flipboard makes selections, but it also disaggregates content and lets users rearrange it into collections of their own making. Flipboard shifts magazine curation from editors to readers; from Broadcast to Curated. Having raised hundreds of millions of dollars, the expectation of investors is that, one day, this combination of Flipboard and reader-centred curation (or its equivalents like promising Dutch start-up Blendle) will be worth more than magazine giants like Hearst or Condé Nast.

Having a strategy for letting others curate, for outsourcing to those on the frontlines, will be more and more essential. It's a model we have seen time and again on the web and it's not going away. Social media relies on networks of trust,

intimacy and knowledge, amplified by connectivity – given how much curation is about personality and connection, it's hardly surprising this model is so prevalent.

Again, this needs to be placed in the wider context. That the locus of value has moved is recognised by those suffering the consequences. The boss of Taiwanese electronics manufacturer Acer, Stan Shih, coined the term 'smiling curve' to describe the problem facing his business. If the curve represented value, he could see a depression in the middle of the supply chain among producers, a depression creating the 'smile'. Upstream intellectual property owners like chip designers and downstream sellers with consumer brands and access were hogging value. Middling players like Acer were trapped between them, their margins squeezed. Manufacturing alone, without those benefits of IP or glossy brand, wasn't cutting it any more. It lost value. Apple and Gap experienced the reverse. Likewise, in educational or scientific publishing, value is shifting from the middle of the curve – that great mass of journals – to high-level curators like *Nature* or tools enabling others to curate. We saw in Part II how many retailers were struggling, caught in their own version of the smiling curve. At the same time a new generation of retailers who understand the curatorial landscape is emerging, and platforms like Etsy, Popshops and Datafeedr drive highly curated niche offerings.

Science generally is tending towards curation. Biocurators, for example, continue the legacy of Linnaeus in curating the natural world, now at the level of genetics. Finance too is becoming richly informationalised. Earlier we saw how Lisa's problems boiled down to an excess of information. Everything from a Bloomberg terminal to new offerings like StockTwits (which aims to derive market data from Twitter) or Symphony provide tools for traders to sift the maelstrom of information, with greater and lesser levels of success. Look through the

promotional literature of venture capital or private equity funds and you'll notice the word 'curated' with surprising regularity.

And at a high level there are curious echoes between finance and art. Both, for example, revolve as much around secondary selections as primary productions. In the late nineteenth and early twentieth centuries, art became ever more self-involved – successive waves of art grew more abstracted, commenting on themselves. In the same way, towards the close of the twentieth century finance became abstracted and self-referential; derivatives, securities based on other securities, were, like movements in art, built on top of one another, getting further and further away from the underlying reality they were meant to describe. At the same time art became ever more lucrative, traded as just another fungible asset by a breed of wealthy buyers looking for good returns. Deloitte's Art and Finance Report claims that three-quarters of art buyers made their purchases for investment purposes.[20] Firms like Cadell & Co are art advisers, but are regulated as financial advisers: their brief is to combine collection know-how with market savvy. Deutsche Bank has extensive collections and an in-house art department. I hesitate to draw any conclusions from this, but it's an interesting parallel.

Curation, as a word, may have started far from business. But its attributes have long been central to many companies and roles. Now, in a world where services and intangibles play ever more central roles in the generation and distribution of wealth, they are integral.

Many nineteenth-century economists believed in something called Say's Law, named after the French economist Jean-Baptiste Say. Roughly speaking his law suggested that production equalled demand; that the more was produced in

an economy, the more demand and consumption there would be. Production created wealth, which created demand. John Maynard Keynes and others disputed this. In blunt form Say's Law fell out of favour. But it's nonetheless true that we have an extraordinary capacity to soak up, manage and profit from rising production. Even if Say's Law doesn't hold at the macro level, close up we can see how rising production has spawned new industries designed to manage and modulate growth. Business is creating what I call ecosystems of curation. These are new networks where a multitude of specialised firms collectively curate a sector. That these ecosystems have grown so much, and support such a diversity of commercial life, is testament to the change discussed in this book.

Centuries ago fashion was governed by the twin poles of artisan producers and local gossip – who was wearing what in Florence, what the lord and lady stepped out in and so on. As time went on further elements were added – shops and media. They became key filters and trend setters. By the middle of the twentieth century, fashion was dominated by powerful designers and ateliers, the growth of influential magazines like *Vogue*, and retail outlets on the smart streets of global fashion capitals. Today all this still exists, but has become vastly more complex – and the complexity has become more intermediated in order to manage it. For a start, the differentiation within each category has been immeasurably increased. We have a huge range of designers from global brands to tiny experimental boutiques. Then there are the new curatorial roles – fashion bloggers, amateur and professional photographers, trend watchers (one firm alone employs 3,000 of them),[21] personal shoppers, stylists, brand strategists, retail architects, algorithm coders. Even shopping mall managers! Just as human and algorithmic curation work together, so in

these ecosystems do we also see the coexistence of professional and amateur, big brand and local niche.

As the rag trade grew and diversified, more elements of the industry, which was always amongst the most intensively curated, came to involve curation. Together it now produces an intricate network, linking producers and reporters, online and offline, selecting and arranging the right garments for the right people. Localised regions of the broader Curation Layer involve overlapping curation ecosystems whose increase in size and diversity is underwritten by significant economic and social change. It reflects the fact that searching for what you know you want has, in this arena as in so many, become trivial. Finding what you don't know you want has, conversely, become ever more valuable. The ecosystem – whether in food, or news, or scientific communication – is the difference.

The question for many businesses is, I believe, now about their strategy for navigating the ecosystem they are entering. If you are an established player, how can you entrench your position or diversify into new parts of that ecosystem? And if you are new, where do you fit into the elaborate existing structures? Getting the answer right is one of the business challenges of our time.

The distributed Curation Model indicates something vital. It is now we, you, I, everyone, who are the most important curators of all.

11

Curate Yourself

I, Curator

For most of human history identity hasn't been up for grabs – it's been foisted upon us. Where you grew up, your gender, race and class all effectively channelled your options, your projection of and sense of self. Identities were taken off the shelf: the peasant or the knight, the dowager or the besuited banker, the coal miner or even the consumptive poet, were all archetypes people could readily buy into. This isn't to say people had no agency – of course they did. But their social identity was more often than not, wherever they were, quite clearly laid down, something they had to buy into and live completely. With many large caveats and exceptions, we tended to receive our identities direct from our parents and our place in society.

Over the past fifty or so years, for the first time in history, this doesn't hold. Earlier on I spoke about how curation usually has a performative or service role; how it is directed out, towards an audience. Now we reach the limits of this interpretation, the frontier of curation: ourselves.

There has been a dramatic qualitative shift in how we approach the tricky business of being. Where we used to take identities off the shelf, now we delicately pick and choose those elements we like and want. We make ourselves up. In the words of the novelist Neal Stephenson, 'Our cultures used to be almost hereditary, but now we choose them from a menu as various as the food court of a suburban shopping mall.'[1] For want of a better word, and at the risk of sounding ridiculous, we curate our identities. Curation is no longer directed solely towards others as a performance or presentation; it's internalised. This marks not only a change in how we relate to our lives, but also a further shift in what it means to curate.

This works on two levels. First we curate ourselves outwardly. This isn't simply having certain clothes and being seen at the right parties. It's about subtle, tacit signals composed as a signifying mosaic drawn from the rich and varied sources of the contemporary world. Second, we curate our experiences. We don't want to lead linear and predictable lives – instead, the very stuff of reality is treated by the modern consumer like an art exhibition, a series of contrasting, surprising, thrilling and thought-provoking items whose uniqueness and sequence give meaning to the whole.

This might sound highfalutin', but really it breaks down into a concrete sense most of us have experienced: the craving for variety, newness and difference amply catered for in the modern economy, whether it's literally entry to an exhibition, adventure holidays or a new kind of work. In short, our attitude to ourselves internally and externally has been caught up in the same dynamic we've been looking at all along. As might be expected, this has positive and negative dimensions.

In the last chapter – as we have done throughout the book – we saw how businesses empower people to curate

for themselves. This would never have come about had not there not been a willing audience, keen to share and curate their music or photos. For this model to work, there had to be demand – one that often appears madly self-absorbed and absurd, but whose influence and reach is growing even as it is decried.

Choose life

Over the twentieth century children took their cues less and less from their parents. Where once this would have been a near-automatic process, by the middle of the century, with the dawning of specific and mainstream youth cultures, the hold of previous generations was loosening. New subcultures emerged: mods and rockers, punks and skinheads, rastas and metallers, goths and New Romantics. Each had an internally coherent look and cultural form. It would be wrong to say that these cultures were not a hotch-potch – they were. Teddy Boys, for instance, took Edwardian suits and combined them with intense rhythm and blues music.

Punk was one of the most easily identifiable such subcultures. It first hit Britain in the heatwave summer of 1976. Mired in widespread unemployment, the country struggled to comprehend the depths of its post-war decline. By 1977 punks had exploded into the mainstream, causing consternation among the respectable classes. Punks were angry, alienated, nihilistic and profane. They were, ironically, the perfect dramatisation of a country in crisis; the symptom of an ongoing slow-motion collapse, designed to provoke a reaction. Punks were recognisable above all for their stylistic challenge – like the mods and rockers before them, their very look was meant as a challenge and an appropriation of the dominant forms.[2] They cut up the Union Jack and spliced it about their

person. With its quiffs, leather jackets, drainpipes, skinhead overtones, denim and 'bovver boots', punk was a medley of post-war styles literally held together by safety pins. The point about punk, as with all those post-war movements, is that for the first time on a mass scale people were choosing entirely new identities for themselves, and that moreover, those very new looks and identities were themselves carefully selected composites.

But there were nonetheless clear boundaries. It would be difficult to be a punk, for example, if you wore a plain business suit, had a conservative haircut, went home to the suburbs every evening and listened mainly to Bach. Punk was never as simple as we remember, but it nonetheless came as an internally coherent package, certain elements of which were necessary. Even rebellion, let alone the many more 'acceptable' identities, was carefully codified and consistent. Being a punk was a strange assemblage of self-selection, screw-the-system aggression and box-ticking exercise.

Compare this with that much maligned, possibly retired, contemporary subculture: the hipster. Originally hipsters were another post-war subculture, a 1950s movement like the Beats. Typically they were working-class to the Beats' middle class, dandyish in zoot suits, drapes, quiffs and attitude. They were the white working-class side of the vibrancy of black musical culture. They were identifiable.

Today we can still identify hipsters. We see them with their elaborate beards, fixed-gear bicycles, predilection for the bars of Brooklyn ... (where they are possibly drinking third-wave coffee). Yet the essential elements of hipsterism are non-existent. There is no set of defining traits. Instead, the defining trait is a kind of self-conscious curation of the self (and forgive me if that sounds like an incredible hipsterism). Take the attitude to vintage clothing. Whereas a Teddy Boy

or punk sampled from specific eras, the hipster liberally takes from across the spectrum: a 1950s jacket, 1920s trousers, sneakers from the 1980s, a T-shirt emblazoned with a 1990s cartoon. There is no governing narrative, image or identity beyond the mash-up of them all; beyond the ability to choose and recombine there is nothing that necessarily defines the hipster. In the 1970s both the accountant and the punk had clear expectations of their image and demeanour; they understood who they were and how they fitted into a picture of the world. With the hipster this disappears. They are people of pure bricolage – assemblages self-consciously picked from across the entire spectrum, artfully, ironically put together into a globalised kind of non-identity whose shared elements are more in the spirit of curation than any of the things that go into them.

Before you scoff, and yes, well you might, like third-wave coffee this is the thin end of a wedge whose significance extends beyond its metropolitan roots. To some extent the last fifty years have seen all of our identities take this curatorial turn. We make things up far more than we used to. The guy sitting next to you at the football in jeans is probably an investment banker about to fly off to his yacht. The woman in pearls sitting next to you at the opera is a nurse just finished her shift. We all have more freedom and opportunity to make up who we are going to be; to put together different contrasting elements.

This all goes back to the expansion of choice. There are *tout court* more options. We can all find products from across the spectrum – vintage, high-street, ultra-cheap, luxury. The media is always on, beaming us images of lifestyles and cultures. No sooner has a subculture developed than it has been globalised and co-opted by major brands. Again, this is a qualitative shift. Think of fan culture. To be a fan in the

pre-Internet days took devotion. If you were collecting Star Wars figurines say, you'd have to laboriously hunt them down. You'd make contacts at your local shop, around which you'd spend inordinate amounts of time. Tracking down new titbits of knowledge took time and effort. On the Internet it's easy to be a fan. You can find those models, rare comics or costumes with ease. Arcane information is a few clicks away. Everyone can be a fan whenever they want. Fan culture, as a result, has boomed: just look at the growth of events like Comic Con in San Diego.

The curation of identity is built on growing individualism. But it is all undergirded by the growth in choice. The fact that we can pick clothes from across the decades, that we have so many films, games and TV shows, means that we are forced to select. In the face of the slowly accreted accumulation of personal choices, the kind of complete social forms and identities which used to predominate break down. In their place comes the Curated Model of Selection and its personal equivalent. When consumerism, pluralism and selection are foundational, we become curated entities. In this way – I'm sorry to tell you – we are all hipsters now.

As consumerism continues its march, so it spreads. In Eastern Europe and large parts of Asia, what were until recently collectivist societies have given way to individualism. In a single generation choice has gone from limited luxury to ubiquitous presence. For older generations in China, their experience was rooted in communism. Within living memory they experienced the deprivations of the Great Famine and forced collectivisation; they went through the extremities and violence of the Cultural Revolution. They lived lives of brutal sparseness where any kind of choice was a rarity. Fast-forward to their children and grandchildren and, for the middle classes at least, things couldn't be more different. Until recently

consumerism in China had a near-transgressive aspect that demarcated the generations. Young Chinese consumers were a new breed, smothered in love from the so-called 4-2-1 structure of a typical family (thanks to the one-child policy, every child is the focus of attention for their two parents and four grandparents). In the words of one commentator, 'competitive and lonely, wealthy and not afraid to flaunt it, this generation of children began to define themselves and their position through their consumption choices'.[3]

Young Chinese are, unlike their elders, able to sample from the global menu just as much as their Western peers. They too are used to eating McDonald's one day, traditional Chinese the next, just as their equivalents do in Los Angeles or Milan. They too will happily select from this or that musical tradition, cinematic genre or stylistic mode; for them too the world, its history, culture and art is a grand shopping mall to be sampled from at will. Maoism this is not.

Club Tropicana

Several years ago I watched a programme about the hotel Claridge's. The manager said something interesting. His guests, he implied, wanted to 'curate their experiences' – and this was where Claridge's came in. Once this grand hotel, marked at every turn by deep layers of decorum and the kind of understated elegance for which English brands are known, was the natural habitat for its guests – everyone would have felt quite comfortable and at home. His throwaway comment revealed a change; now few of his guests would feel quite at home. Instead, for them, it was an experience; one that formed part of the 'curated' whole which was their lives; that fitted into a rich blend, rather than being a seamless part of a coherent whole. Claridge's recognised that it was a particular

kind of experience for a particular kind of experience-chasing consumer.

Tourism trades in experiences. Inasmuch as it is about consumption of a good, we should expect to find here the familiar pattern of curation. And vacations, like fashion, like our consumer lives, reflect who we are – they are not only about what we like and choose but what we wish others to perceive us liking and choosing. We have now built a marketplace for experiences that reflects a change in how people want to parcel their experience.

Tourism too has been part of the Long Boom – and has hit overload. Tourism was once a set of clearly defined experiences. Everyone knew what tourism consisted of, and who would experience it. The Grand Tour around southern Europe specialised in sights from antiquity and the Renaissance – the perfect education for louche aristocrats keen to explore the continent's classical heritage and have some adventure. In the later nineteenth century those same aristocrats began travelling instead to the beaches and waters of the French Riviera – the Promenade des Anglais in Nice, for example, was built for wealthy English tourists. Spa towns had always been tourist destinations; places like Bath or Baden-Baden were frequented by those looking for recuperation. For most, tourism happened to other people.

In a clear echo of the post-war period's changing identities, and as a result of the strong growth of those years, tourism became available to a wider group. Relatively affluent northern Europeans started visiting places like mainland Spain, Majorca and Rimini in Italy. Britons, Germans and Scandinavians soon descended in their millions: the number of international tourists in Spain grew from six million in 1960 to thirty million by 1975.[4] From Iberia and the Balearics tourism spread fast, in the process enabling previously isolated

and impoverished communities in remote coastal areas of the Canary Islands, Greece, the former Yugoslavia and Turkey to develop.

Such tourism was based around the charter tour week: a structure designed to fill northern European aeroplanes flying to a limited number of sure-fire destinations. The planes would take out one load and pick up another on the way back, a weekly tempo that became part of the social fabric of tourism in the Mediterranean. It worked well for the tourists: guaranteed flights and hotels made for low prices, which expanded the numbers who could afford to go. The week had a rhythm: tour guides, local fiestas, standardised excursions to local sights, sunbathing and organised barbecues on the beach. It even explains why, despite cosmetic differences, almost all Mediterranean hotels look the same: they are designed to be functional and cheap, while directing as many rooms and balconies towards the sun as possible. Companies like Club Med and the tour operators have become much slicker and more sophisticated, but many elements of their holidays would be recognisable to a packager of the late 1960s and early 70s.

Orvar Löfgren argues that the Mediterranean, from the Grand Tour to the package holiday, created the modern tourism archetype: sun, sea, sand and sex, coupled with some 'sights' and culture.[5] Clichés of the Med sunbelt became the tourist ideal from Thailand to the Caribbean, in the process reshaping poor and distant parts of the world into hub destinations and motors of national growth. Like identity, tourism was taken off the shelf. It meant offering a limited range of known elements. Tourism's transition to mass activity rode on the same tide of increasing wealth, rising choice and widening options. A new breed of discerning consumer, less interested in traditional holidays than in new experiences, arrived just

as computerised booking systems liberated them from the constraints of the packaged tour, the falling price of air travel threw open the map and, later, Airbnb and others strapped rocket boosters to room supply.

Packaged holidays began to suffer: overhasty development, overcrowding and badly behaved tourists created the so-called Torremolinos Effect, tourism's particular species of overload named after the Costa del Sol resort that suffered from loutish Brits, a crippled infrastructure, pollution and homogeneity, where old cultures and cuisines were elbowed aside in favour of crowded beaches and cheap booze. This was precisely what the new breed – who called themselves travellers as much as tourists – didn't want.

Now people wanted something unique, secluded, 'unspoilt' and original. An experience. So began the boom in niche and experiential travel. 'Travellers' weren't content seeing the Eiffel Tower; they wanted, with only traces of self-awareness, a tour round a Rio favela. They didn't want to roast on a beach; they wanted to scuba-dive a shipwreck. They wanted to go clubbing in Ibiza one weekend and have tea at Claridge's the next. Tourism was unbundled. Places and experiences were now to be curated, not taken as a generic package. Over the last thirty years the old pattern of tourism gave way to the independent traveller, the backpacker, the explorer. Traditional resorts started to lose out – rather than go clubbing in Magaluf people wanted to run with the bulls at Pamplona's San Fermin festival; rather than sunbathe in Benidorm they wanted to attend the Tomatina, that extraordinary food fight in the Valencian town of Buñol. While, say, Thomas Cook was always curated, the trend is yet again evolutionary, towards a more prominent and intense curation.

Tourism is big business. Every year over 1.1 billion people (up from only twenty-five million in 1960) travel for pleasure,

in an industry supporting up to one in eleven jobs worldwide.[6] Tourism has a huge impact on the economy, the environment and local culture. Changes in tourism, as in many of the industries we have examined, have a larger ripple effect than might be supposed. Travel agents have, for instance, by and large given way to aggregated review sites like TripAdvisor (which acquired the curated travel site Wanderfly). While they may have disappeared from the middle of the market they have reappeared strongly at the top. Tourism is no longer packaged. Rather it is designed, or 'tailor-made', in the industry parlance; from something we passively accept to something we actively curate; from a limited set of clearly defined experiences to a kaleidoscope of options. In London an agency like Black Tomato will design your holiday down to the T – turning it into a curated series of bespoke experiences. Australian firm ATP offers trips that are, according to the *Daily Telegraph*, 'curated to the nth degree'.[7] Meanwhile a new service called Peek has backing from Jack Dorsey and Eric Schmidt amongst others. As its founder Ruzwana Bashir (echoing the usual mantra of curation businesses) told Fast Company: 'We're not showing you absolutely everything. We are showing you the best things.'[8] As we have seen time and again, the pattern is for new curatorial positions to open at the top of the market, selecting and arranging for, in this case, a new nomadic elite hungry for exclusive experiences, before rippling out through wider contexts.

As adventure sports and ashrams, yoga retreats and mountain hikes ease their way into the traditional sun and sea mix, new infrastructures of hospitality, entertainment and transportation are needed. In parallel new breeds of experiential businesses and cultural forms are emerging. These aren't just bungee jumps for student backpackers in New Zealand. Cinema and theatre have both, for instance, been changed

by the advent of immersive versions like Secret Cinema or Punchdrunk. Watching a film is transformed into a live, interactive experience – you are thrown into the fiction. It's memorable, different, absorbing and exciting. It's cinema for people saturated in cinema; for people whose Netflix habit means that choice of films is less important than choice of experience.

The new market for experiences means that we prize those brokers who can get us tickets for Bayreuth, Wimbledon or the Kentucky Derby; who can arrange for us to visit the Venice Carnivale or Coachella. These days corporate lawyers are more likely to talk about their weekend endurance sailing than afternoons on the golf course. Just as we view culture as a tapestry from which to sample at our leisure, so we regard leisure itself. Sophisticated event discovery services like YPlan and Dojo, or new offerings from Time Out Labs, are built to cater for this trend, using data around location, preferences, timing and a multitude of event-creation and indexing tools to wade through the thousands and millions of events put on each year. YPlan pitch themselves as curators for the wealth of experiences offered by modern life; the idea being there is so much happening, discovering it all is impossible. Live events are a \$22bn-a-year industry in the US alone, while the share of expenditure on live events relative to general consumer spending has risen 70 per cent since 1987.[9] What we want even more than the latest designer outfit (incredible, I know) is the latest designer experience, whether it's Punchdrunk's production in a half-forgotten warehouse or a one night only pop-up bar. Experience itself slots into the pattern of Long Boom and overload, and, just as we have seen elsewhere, it's developed its own Curation Layer, its own ecosystem for managing it.

This isn't a bad thing and taps into several significant trends. As we saw in Part I, James Wallman, author of *Stuffocation*,

argues we already own too much stuff and it doesn't make us happy.[10] The trouble with new things is that we quickly adapt; the initial boost wears off. What's more, things degrade. Meanwhile experiences have a host of benefits – far from getting worse over time, they only become more burnished in the memory. That disastrous camping trip? Character-building! Unlike material goods, experiences are difficult to compare, so they don't make us feel inadequate. You could spend a fortune on a fortnight in the Maldives and for all I know my wet week in a tent was more fun. Not only are our experiences objectively harder to measure, but research shows we are much less inclined to do so in the first place.[11] Experiences, unlike material things, tend to be inherently social – they get us out of the house and let us meet new people.

Experiential purchases are also at the forefront of the economy. Eventbrite, a live event discovery and ticketing platform with annual sales of over $1.5bn, conducted research suggesting that, driven by the 'sharing' opportunities afforded by social media, 78 per cent of millennials (18–34 year olds) would choose desirable experiences over desirable material products.[12] A report from the Boston Consulting Group concluded that experiences were growing 4 per cent faster than goods purchases at the upper end of the market.[13] Worth $1.8 trillion and $1 trillion respectively, over the long term experience will overtake goods in the higher-end bracket and it's likely a similar pattern will play out throughout the wider consumer economy.

All of this equates to a change in the tenor of the self and of experience. It's a subtle change. I'm not arguing that until recently people didn't pick and choose the elements that went into their holiday; or didn't piece together experiences for the way they contrasted. People have always done these things. Yet again what's changed is the prevalence and intensity. As

with everything about this book, it's less about sudden pivot points and more about the larger-scale direction of travel.

Making a statement

Like retail, entertainment, information, consumer goods and art exhibitions, the self is curated. None of those businesses devolving curation to distributed groups would ever have got off the ground had they not found willing participants. These are the people – us – who spend hours carefully constructing a social media profile, choosing this and that photo, video or article to share. And then measure the results on Klout. The people for whom all aspects of our life, from our walk to work onwards, are measurable – and then compared with others, with Fitbit or our smart watch. We work for companies who employ someone to find and repackage the most interesting news in our sector, all in the name of brand building. We are even the people whose attitude to finding partners has become one of filtration systems, whether that's a swipe to the left on Tinder or complex and allegedly scientific mechanisms. Even romance is overloaded and requires curation, and before we get too upset it's we the users who asked for it.

Throughout this book we have seen the 'menuification' of the world – everything becomes a series of too many choices that require management. Overall I am neutral on the desirability or otherwise of this. It's the society and economy we have ended up with, and compared to having too little it's an excellent place to be. It provides new, interesting, fruitful opportunities for leisure and employment alike.

But one does have to raise a sceptical glance at this curatorial turn in our sense of self. It can lead to a flat, deracinated version of what it means to be. It's painfully self-conscious. Experiences and identity become calculations. The great

narrative arcs that once defined our lives are now chopped up into unrelated sequences – what the author Douglas Coupland calls 'denarration'[14] and the digital writer Douglas Rushkoff calls 'present shock'.[15] Again, it should be stressed that I don't see this as anything particularly new; just as more widespread, more prominent.

The sociologist Pierre Bourdieu argued that all matters of taste are matters of distinction: our tastes, judgements and choices don't stem from any 'natural' or 'superior' aesthetic or cultural preferences.[16] Rather, our tastes serve to define us in relation to others. In his epic study of the French middle class, Bourdieu saw even the smallest examples – the food people ordered in a restaurant, the songs they would listen to at home – as powerfully connected to class and what he called cultural capital. It is those with such capital who define what serves as good taste. Good taste is naturalised by those with cultural capital. Taste is not about judgement; it's about separation. About making statements that distinguish us from those 'above' or 'below' us in the perceived hierarchy. Much of the class system is built from aesthetic decisions. Having internalised various elements of taste, we then 'self-select' into a certain class.

So what happens now, when everything is on the table, when the billionaire in a private jet wears jeans and a T-shirt? When we approach our lives like a greatest hits playlist? Despite widening inequality, the spread of a curation mindset that deliberately picks from across the spectrum of options changes the power relations implicit in our choices. We still don't understand what it means when everyone is a curator. I believe we are entering a new phase where curation itself becomes cultural capital. The more curated a person is, the more they are able to weave eclectic, rare and differing elements into their own life as experiences, as goods, the more

of a new kind of cultural capital they enjoy. It's no longer about eating this or that food in a restaurant; it's about how those restaurants blend together. Of course this is still about money – the more money you have, the more you can curate your life.

To quote another Left Bank thinker, Michel Foucault, we have become 'entrepreneurs of the self'.

It is often noted of Internet businesses, particularly ones that are free to use, that the user is the product. Just as those services enable us to become curators, so they turn us into a product for advertisers. So targeted are these systems, built on reams of personal data and sophisticated technology, that it's no stretch to say we are curated; we are carefully selected and unwittingly arranged for advertisers. As a publisher I've found these services very useful. But again, it all feeds into a changing dynamic of who we are and how we live.

The philosopher Matthew Crawford isn't the first to wonder whether all this is leading to a crisis of attention so severe it's undoing our sense of personhood, but he sums the problem up excellently:

> We are living through a crisis of attention that is now widely remarked upon, usually in the context of some complaint or other about technology. As our mental lives become more fragmented what is at stake often seems to be nothing less than the question of whether one can maintain a coherent self. I mean a self that is able to act according to settled purposes and ongoing projects, rather than just flitting about.[17]

No one has the answer to this. But I suspect that it will involve more curation and not less; that, as a society, we have gone too far down the road towards overload; that,

quite simply, not curating is not an option. Whether we like it or not, whether we choose to call it curation or not, the modern world forces us to be curators. We will have to get used it.

Conclusion

A cabinet of curiosity

One of the most famous Renaissance *Wunderkammer* – literally wonder rooms – was that of the singularly named Dane, Ole Worm, a naturalist and antiquary born in Aarhus in 1588. A restless and lifelong learner, Worm travelled Europe studying in Germany, Switzerland and England before settling at the University of Copenhagen, where he entered the service of King Christian IV as his physician.

A polymath, Worm taught the arts and natural history, making advances in anatomy and identifying the small parts of the cranium now known as the Wormian bones. He was also a linguist, collecting and preserving runic scripts from ancient Scandinavia. But today he is best known for his *Wunderkammer* (see Figure 14), one of the most renowned of the early modern period. Here was Worm the natural philosopher, collecting arcane artefacts brought back from exploratory missions to the New World. Stuffed animals were blended with turtle shells; racks of antlers with totems and statues; mineral specimens with vials of potions. Squid, fossils, reptiles, skeletons and furs jostled for space in his

Figure 14. Ole Worm's cabinet of curiosity
from the mid-seventeenth century

bestiary. Worm collected clockwork mechanisms and automata including a mechanical duck: so-called 'artificialia'. His research strayed from the natural world into ethnographic and numismatic collections. One legendary piece was the remains of a plant–animal hybrid called the 'Scythian Lamb' or 'Vegetable Lamb of Tartary' – a woolly fern of Central Asia that supposedly came alive as a kind of sheep tethered to the plant and its roots.

But his collection was also used for empirical research – Worm famously concluded that the long horn in his collection was not that of the mythical unicorn, but from a narwhal. He did this by poisoning his pets and then feeding them ground-up horn – when they failed to recover this was, he argued, because the horn was not bestowed with the magical restorative properties expected of a unicorn. Worm spent

years not only collecting the most interesting specimens, but also cataloguing them, studying them, arranging them. He would personally guide visitors around the collection and claimed it was built so that people could learn. As a figure he stands at the junction of an extraordinary range of disciplines: anthropology and ethnography, biology and taxonomy, museology and archaeology, medicine and anatomy, classics and linguistics.

On his death in 1654 the collection was subsumed into that of the Royal Danish Kunstkammer. Posthumously published as the *Museum Wormianum* in 1655, a catalogue of engravings provides a rich insight into this unusual collection. It was the stepping-off point for further scientific advancements. *Wunderkammer* were strange menageries that came about at a time when the boundaries between art and science, the occult and the factual, enlightenment clarity and good old-fashioned kleptomania were still loosely drawn. They connected the new world of scientific learning, cataloguing, making sense of things, to an older world of hoarding and mysticism; they were part biological lab, part anthropological museum, part wizard's chamber.

Yet curating this display firmly pointed in the direction of modernity. The process of selection led Worm to think through what was important or unique. What was worth preserving and including? It led to a sense of expertise, history and empirical experimentation. *Wunderkammer* allowed for juxtaposition. They allowed people to focus on finding new and interesting things and then to compare them, study them. This helped them find analogies, discover order in the chaos of the natural world and parallels in the messy world of human culture. It created ideas of pedagogical display. As a contemporary of Galileo, Descartes and Sir Francis Bacon, Worm and other curators were helping to forge scientific understanding.

The process of creating the cabinet of curiosity – its curation – was closely intertwined with the development of a modern world view.

Curation became central to museums because, as a process, it required intense focus and wide knowledge. Curation, through its basic attributes, helped make sense of the world. It's still doing so to this day. Curation may be a second-order activity, but it's one whose reach and impact shouldn't be underestimated.

How curation works

Unfortunately there is no shortcut to good curation. It's always specific and rooted in trust and knowledge. You can't click your fingers and make it happen; it's hard work, an ongoing activity. Not curating, just letting things spill out and pile on one another, is in many ways the easy option; curating well is tough, patient stuff. There are however some messages worth keeping in mind:

- Whatever we call it, curation is already happening. It's a label that's been adopted for existing trends as much as a practice that spread. Getting het up about whether something is curation or not is a waste of time; while the term is often used carelessly, it's here.
- Nonetheless much curation is still unrecognised. Many businesses are predicated on curation-style activities – only they don't name it as such. Even in something like publishing, for example, it's rare indeed to find commissioning editors and publishers who call themselves curators.
- This ties into the concepts of explicit and implicit curation. We all know explicit curation, and can see the

fashion blogs and designer cocktail bars where something along those lines is obviously going on. But beneath lie swathes of implicit curation; curation going by any other name, helping to make the world manageable.

- To understand why curation shouldn't be dismissed as another pointless fad, we have to see its core tenets in the context of long-term rising productivity, the explosion of the digital revolution and the related phenomena of overload. This new environment requires a change in orientation for businesses and individuals alike.

- Older models, like the Industrial Model of Selection or the Broadcast Model of Culture, have been seriously destabilised in this scenario. In their place Curated Models, that go beyond basic search, optimised for complex and saturated markets, are taking over.

- Expertise, understanding and judgement have never been more important. But we are also seeing new assemblages of automated and algorithmically driven processes. Figuring out how best to combine the two is a major part of effective curation in the twenty-first century.

- Everywhere the direction of travel is towards greater levels of curation. Curation is becoming thicker. If this book could be summarised in an image it would look like this:

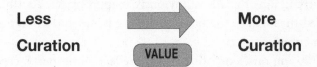

Less Curation → VALUE → **More Curation**

- We only appreciate the power of selection when we look at the full range of associated curation effects.

Whether it's about refining large sets, simplifying complexity while keeping nuance, contextualising and explaining, or bringing out the full innate power of things through clever arrangements, these curation effects have outsized impact.

- Gatekeepers are not going away – but they are changing.
- One of today's most important business models is creating the tools and means for others to curate. While boosting one's own (for want of a better word) brand as a curator will always be important, building platforms that empower others to become curators has started to take precedence as one of the signature business forms of our time.
- This new centrality of curation changes our attitudes to businesses like retail, indeed, even our attitudes to what businesses do. The firm as a curator is not a recent idea, but remains a force. But the changes go deeper – it changes our relationship to our cultures, to the idea of creativity and even to ourselves.

The bad and the ugly

Suggesting that all is well, that thanks to curation we are entering a Utopian world of excellent coffee, plentiful art and absorbing jobs for all, is obviously inappropriate. As I have hinted throughout the book, there are issues and limitations with curation.

Curation raises questions over intellectual property, credit and the apportionment of rewards, especially on the Internet. Curators cannot ignore the fact that they are, at some level, making a living or gaining an audience through the work of others. This is less the case now we have started curating for

an audience of one – but all those presentational forms of curation are gaining through the work of others. Systems of distributing credit like the Curator's Code are on balance to be welcomed, despite the carping. They are better than nothing. But as Jaron Lanier and others point out, no one can eat on retweets. Lanier's own solution is to develop a new system of micropayments that allows for a better-distributed system of rewards; something that means the Siren Servers, Lanier's name for the big curatorial powerhouses from Google to Facebook et al., don't just clean everything up.

It's not hard to get behind Lanier's proposal, but it's a million years from becoming a reality. In the meantime creators have never had it harder, and even the long tail of curators find actually earning a living as opposed to gaining followers is difficult. Not curating isn't the answer – our world would quickly become unnavigable. But apportioning rewards correctly remains difficult.

The case for curation's place in the modern economy should not be overstated. My argument is that it's growing fast, but this still means it's limited. Look at the Fortune 500 and you will find a fair number of companies for whom curation is a major part of their proposition: retailers, technology companies, media businesses. But you will find many more that exist in realms far from those I have discussed here – energy, banking, pharmaceuticals, automotives. The truth is the world's biggest companies still look more like ExxonMobil and J.P. Morgan than Amazon or News Corp. However it is worth noting that most of these companies are locked into straightforward additive growth models and are hence compounding rather than alleviating the symptoms of overload. This creates opportunities for those businesses willing to tack the other way.

There are also question marks as to what kind of jobs

curation creates. On the one hand it should be an undiluted positive. Here should be the next generation of jobs, tailored to the new reality, suitable for the attention spans and habits of media-rich Gen Yers. These are jobs countries from Russia to Abu Dhabi are trying to create. Yet technology can change everything; the idea of the 'second machine age' that is upending our ideas of work and creating a new era of machine-dominated jobs has gained currency.[1] The authors of a book on the topic point out that in the mid-2000s self-driving cars were a joke; no one could make them work and the idea itself felt like science fiction. Ten years later they are becoming a common sight on the streets of California. What seems like a safely 'human' activity can quickly, in this environment, become technologised. The authors point out that communication and pattern recognition are, for example, now firmly the province of machines. Curation is meant to be at least partly human and this makes it valuable. But what if we realise we prefer the curation of ultra-advanced AIs that find us things and manage the world with uncanny accuracy and efficiency?

We just don't know where this is going. While we can be confident that the need for curation will increase, we don't know whether curation will hold out the promise of good new jobs or if a few dominant technology platforms will accrue all the rewards. As skilled and subjective labour, curation should be an employment redoubt in this emerging techno-economic nexus. But, since we have already come to rely on machine-driven mechanisms, nothing is certain. Even while it's unlikely we will need to create jobs that boost supply, will we create jobs that manage it?

Indeed, at one level curation has opened up a new and more democratic vista, in that being a curator has lower barriers to entry than being a creator. Sure, it doesn't mean

everyone will be a good curator, but as the scales tip towards over-production it should create opportunities for new kinds of business or new forms of cultural engagement. Yet it's often remarked that inequality is on the increase – especially in places like the US and the UK, as well as being deeply entrenched in emerging economies. Pretty much everywhere, we are heading back to, if not already arriving back at, inequality levels last seen in the 1920s and before.[2] Curation may slot neatly into this dynamic. Certainly, the experience of the art world suggests that even as the number of curators booms, a few lucky individuals at the top rack up air miles and prestigious commissions while everyone else ekes out a meagre living. Superstar curators, whether in the art world or a Silicon Valley Unicorn like Pinterest, may take massively outsized rewards as, thanks to network effects and a star system, small opening advantages grow into unbridgeable gulfs.

Curators have power. And never more so than when attention itself is becoming the most valuable currency of all. There is no code though for how they exercise this power. There is no rulebook, no real laws, no governing structure or professional body for curation. It's too slippery and widespread for that.

So is this the nightmare? That we live in a world where creativity is devalued? Where not only do all the rewards go to second-order activities, but they go disproportionately to a small few, a small few who have survived or ridden a wave of extinction thanks to the frontiers of new technology? Yes, it's the nightmare. But it needn't happen.

Taking care

Curation is not without issues. Few things are. However, we cannot simply ignore it, or pretend it's not here, and that it's

not already working. Curation is a structurally necessary part of contemporary life whose significance and value is growing.

What we shouldn't forget though is *curare*, curation in the sense of taking care of. Curation capable of incorporating a moral dimension, that has, as Professor Floridi indicated, a sense of custodianship. Whether that's through digital means or otherwise, it will, I believe, make a crucial difference. Curation that doesn't have the sense of taking care, preserving, nurturing is more likely to lead to negative outcomes. Having credibility and expertise may be necessary for good curation; but it's all too easy to forget about this side as well.

The ultimate question is not where curation is happening or what it is, but what's the difference between good and bad curation? Whether curation is explicit or implicit, thick or thin, is less important than whether it's useful.

Good curation, as we have seen, involves expertise, taste, judgement. But it also involves trust, empathy and considerations beyond itself. When curation is devoid of these elements, it descends into irrelevance. How we manage overload requires a sense of curation far beyond that of cupcake photos. But when curation is built around a sense of what others want, imbued with a service ethic, when it cares about what it curates more than the curation itself, those charges are unfair – curation here is rightly valuable. It becomes, to paraphrase the economist E.F. Schumacher, business as if people mattered.

We are only at the beginning of where these ideas could take us. Whether we get there or not depends on the choices of millions of curators large and small, traditional and new, professional and amateur, online and offline; but the opportunity is enormous if we are willing to go beyond our comfort zones and think big. Curation is adaptive, what Nassim Nicholas Taleb calls antifragile – the more you load onto it the stronger

it gets.[3] The more stuff we as a society produce, the more we are overloaded and so the more valuable curation becomes. If our present trajectory continues we should, then, expect to see more of the kind of activity we have come to call curation.

It would astonish our ancestors that today we can build companies, institutions and livelihoods from the sifting and organisation of the sheer mass of material we produce. But this is the world we have come to inhabit. Selection and arrangement, refinement, display – these aren't afterthoughts or sideshows in the modern world; they at the vanguard of a practice whose roots run deep but whose future is more significant than ever. Learning how to make the most of them, to work with them effectively, to broaden and deepen their impact, is one of the core principles of working effectively in an age of too much and we'll be all the better for it.

From humming data centres to the trillions of hours spent in front of screens; from dusty street markets to glistening marble-clad shopping malls; from the logistics of the new tourism to prestige projects on newly minted islands; from Amazon engineers to fashion designers, Silicon Valley VCs to drinks entrepreneurs, sales assistants to CEOs, in all of it curation is here, it's happening and it's changing how we work and live, how we engage with the sprawling and multitudinous world we have created.

Thinking through careful selections. Cutting down the problems. Growing people's chances of understanding, or purchasing, or finding, or simply appreciating. Arranging to maximise – getting the most out of everything. Understanding how curation effects are diffused throughout our culture. Using that understanding to make wise choices on behalf of others: welcome, once again, to the curation economy.

Author's Note

History never slows down. The pace of social, economic and technological evolution feels relentless and dizzying. We all experience its impact every single day. The danger for a writer is that, once you finish typing, things move on, facts on the ground change, your examples and arguments no longer hold.

It's been some time since I wrote *Curation*, and it's interesting to go back and see what has changed. My hope when writing the book was that by looking at the big picture, the deep underlying shifts, it would to some extent insulate the ideas from fickle and fast moving shifts.

In general I think the argument holds; the trends identified have, if anything, intensified. The message still needs hammering home. Of course, not everything has stayed the same and some things in particular are worth commenting on in more detail. As the context changed, so some elements of curation came into a new significance.

Since I first wrote the book, the march of algorithmic digital curation has grown even clearer. Machine learning has become the essential discipline of digital technology, a corporate and research priority for major tech companies and academic computer science departments alike. The ever increasing power and sophistication of machine learning

techniques has enabled and powered the spread of algorithmic curation into more and more areas.

Just over a decade ago, a form of artificial intelligence known as connectionism began to re-enter the academic mainstream. This was in fact one of the earliest forms of machine learning, dating back to the 1950s. It aims to replicate the structures of the brain, producing 'neural networks' capable of learning through a process akin to trial and error. Such neural networks fell out of favour by the late 1960s and entered the academic wilderness. What changed was the growth of enormous datasets and the raw computing power to process them. Neural networks struggled in data impoverished environments, but now companies like Google and Facebook have sufficient reserves to make them work. Big data and cloud computing meant neural networks once again had purchase. Machine learning was back in fashion and by 2015 it started to pay off for the tech giants. Automated image recognition and translation are just two areas which have been transformed in a matter of years.

At the same time, advances were being made in other areas. Bayesian machine learning models, based on work in probability of the eighteenth-century English statistician Thomas Bayes, started making huge gains. So-called 'nearest-neighbour' methods were notable in builder recommendation systems, including the Netflix example cited in the book. Reinforcement learning became much more powerful, echoing how we humans develop and acquire our faculties.

All of this is only getting more effective by the year, even by the month. I don't believe it will ever render human curation obsolete – and it's fascinating to note that even as tech companies invest in artificial intelligence teams they continue to hire human editors and curators in greater numbers than ever. But it shows how algorithmic curation is rapidly changing,

spreading and increasing in scope. Yet in one huge area, this algorithmic filtering reached its limits: politics, news and, above all, what counts as truth.

Last year's political earthquakes in the US and UK had one unexpected side-effect: they put previously esoteric debates about online curation front and centre of public discussion. What had been a matter for developers and web marketers suddenly had immense geopolitical significance.

Phrases like 'fake news' and 'post-truth' became watchwords of an unusually turbulent era. As the single biggest distribution hub of news in the world, Facebook found itself in the eye of the storm. Questions about who controls its content became widespread. At one stage Facebook was accused of liberal bias and, in response, fired all its human editors. The result was chaos on the News Feed. The algorithm was good; but not that good.

Before long Facebook was accused of spreading fake stories that swung the US election. It got into trouble for broadcasting a shooting in real time of its Live service. It was alleged that both the Brexit and Trump campaigns scored considerable success by targeting stories to specific users through advanced audience segmentation techniques. Mark Zuckerberg, the Facebook Founder and CEO, was even moved to write a kind of manifesto for facing these challenges in early 2017.

This was a debate about who sees what, where and when; who has the power to verify and disseminate; who defines what is true and what deserves to be seen. It was a debate about who builds the algorithms that govern the world's attention, and so govern the world's media. It spans continents and impacts all our lives. It comes with the knowledge that curation of news and social networks is intensely political. Here was something perhaps unexpected: a debate about curation that electrified the world.

Everyone has a stake here and it begs a question I have often been asked: how do we stop things like 'fake news'? How do we break out of the filter bubbles it is increasingly apparent we all inhabit?

The answer has to be a distinction between good and bad curation. This is something that needs more exploration. Does good curation mean the kind that smashes open our filter bubbles, exposes us to the new and different, shows us that the world beyond our pre-occupations and pre-existing beliefs is diverse and rich and worth knowing about? Or actually, should we follow the path of technology as it has generally been built: systems that keep us happy and satisfied by serving up precisely what we want and expect. Systems that, in other words, reflect ourselves. Sure we might say we want a diversity of opinions, but actually what keeps us coming back is the safe knowledge we'll be given more of what we like. We vote with our feet and 'good' curation follows.

For me, we need to make a strong case for the former. Now more than ever, we need to argue that good curation takes us beyond our comfort zones. Good curation gives us more than the obvious, more than what our friends like, more than our existing sum of opinions, preferences and habits. Good curation takes risks. The expertise of good curation is and must be the antidote to a post-truth, relativist world. Curators can and should manage our ever more complex informational and media ecosystems to guard against the spread of the perniciously untrue.

A big part of this is to encourage greater curatorial literacy. We all need to understand how and why we get shown a certain article; what kind of validation, or absence of validation, was involved. How does Facebook influence political culture through curatorial design? What does it mean to have such a concentration of power in the hands of one company, one

algorithm, a concentration of power with the proven ability to dictate the course of history? Answering these questions is central to building a curation that works for everyone.

Defining and arguing for good curation is, then, one thing. Teaching ourselves to recognise it is another. Both will be essential. This is most obviously true in the media and political realm, but it applies –to everything from music playlists to museum exhibits. The difficulty is in the big tech groups themselves. These are companies with sky high valuations based in large part on their enormous and still growing-user numbers. How can we square the circle of their continued growth with the needs of what I call good curation, a curation that isn't always easy, might be unpopular, that challenges and provokes and isn't content to take the easy path? How do we square this process, which will not only need the development of new technologies as well as the hiring and training of vast numbers of new employees, with the constant temptation to take the path of least resistance? How can we reconcile curation with quick ad-money?

There isn't a precedent for the level of control and audience scale enjoyed by a Facebook or Google, but there may be precedents for how we can make this work. Regulation, either legislative or voluntary self-governance, is one obvious step. Building human safeguards into the procedures will be critical at some points; and removing them at others will be just as critical. Some things need a fine grained judgement ultimately attached to a clear line of responsibility; other things need to be dealt with by code. However recognising, publicising and where necessary amending the inevitable biases of code is essential. And ultimately that is a judgement that people, not algorithms, will have to make. We need to think more creatively and expansively about how big tech companies are owned, managed and developed. It's clear now that major

platforms aren't just any other business and shouldn't be treated as such.

Lastly there is someone who can influence them: us, the users. Collectively it's our laziness or our activism, interest and alertness that will govern the future of mass digital curation. If we don't want to live in a world of fake news, pointless videos and relentless ads we need to do something about it; switch off or switch over. Ridesharing platform Uber is already changing tack on a number of fronts thanks to the stirrings of a user boycott. Facebook obsessively tweaks its algorithms to ensure people don't leave the site; even including higher quality, 'aspirational' material people don't click but like the idea of. Just so we don't delete the app, fed up of intellectual dreck. Building a world of 'good curation' as an urgent societal priority sounds almost like a self-indulgent joke. But it's not. The stakes couldn't be higher.

One word in the book needs a little more comment: value. It's worth emphasizing how non-reductively it was intended. Yes, there are undoubtedly financial rewards for those individuals and businesses that curate well. But seen in these terms alone we have an impoverished view.

As I argued in the book, curation is 'folded' into other activities. Shops make money from selling things, not from curating them; yet their curation is now an important part of their overall proposition, just as the quality of recommendation algorithms is an important part of the proposition for Amazon or Spotify, even if it's not generally the thing customers pay for. This hints that much of the financial value of curation is veiled. Economists at Google and elsewhere argue that we systematically underestimate the impact of technology in recent GDP figures. This is because so many services are now free that they don't show up as GDP. The point is, then, that a lot of value is created but not officially registered

thanks to such technology. But really my argument is much broader than this.

We should value news curation because it's about the integrity of our public sphere in an information-saturated world. We should value the curation of an exhibition because it enriches our lives. We should value the curation of a bookshop because it breaks through the noise and finds us a book we'll never forget; a book that changes us. A book that without that intervention, we would never have found. We should value curation because it makes the vibrant, complex, multi-faceted world we have grown used to possible, navigable, enjoyable, comprehensible, whether it makes money or not. Curation is about selecting and arranging to add value – defined in the broadest possible sense.

We live in a time when these patterns of selection and arrangement have incredible power. That is even more true now than when I started writing the book. So is the corresponding answer: that one of the most essential skills of our era will be to master, recognise and influence those patterns wherever we find them.

Michael Bhaskar
2017

Notes

INTRODUCTION

1 http://www-01.ibm.com/software/data/bigdata/what-is-big-data.html

2 http://www.mckinsey.com/~/media/mckinsey/dotcom/insights/strategy/mckinsey%20quarterly%2050th%20anniversary%20issue%20overview/mckinsey_quarterly_q3_2014.ashx

3 http://www.lexisnexis.com/applieddiscovery/lawlibrary/whitepapers/adi_fs_pagesinagigabyte.pdf

4 http://www.theguardian.com/books/2015/apr/18/david-balzer-curation-social-media-kanye-west

5 Obrist (2014), p. 24

6 https://www.youtube.com/watch?v=X4TuPAlQLcg

7 http://uk.phaidon.com/agenda/art/articles/2011/september/09/a-brief-history-of-the-word-curator/

8 http://www.forbes.com/sites/stevenrosenbaum/2014/03/29/is-curation-over-used-the-votes-are-in/

9 http://www.thedailymash.co.uk/news/society/tossers-curating-everything-2015041697425

10 http://www.pressgazette.co.uk/content/going-forward-here-are-ten-bits-jargon-journalists-would-most-prs-de-layer-their-ecosystem

11 Wooldridge (2015)

12 http://ebookfriendly.com/tokyo-bookshop-one-book-week-pictures/

First World Problems

1 Mayer-Schönberger and Cukier (2013), p. 9

1 The Long Boom in Everything

1 http://www.sleuthsayers.org/2013/06/
 the-3500-shirt-history-lesson-in.html
2 See https://www.newscientist.com/article/mg22029430.400-
 primeval-planet-what-if-humans-had-never-existed/
3 From *The Communist Manifesto*
4 Smil (2005)
5 Kaplan (2008)
6 http://www.economist.com/news/business/21568384-can-foxconn-
 worlds-largest-contract-manufacturer-keep-growing-and-improve-
 its-margins-now
7 http://english.caixin.com/2013-05-14/100527915.html
8 Arthur (2009), p. 193
9 Dorling (2013)
10 Chang (2014)
11 Figures from Prasad Rao and van Ark, eds (2013)
12 Ibid.
13 https://www.gov.uk/government/uploads/system/uploads/
 attachment_data/file/443898/Productivity_Plan_web.pdf
14 https://orionmagazine.org/article/the-gospel-of-consumption/
15 Alpert (2013), p. 11
16 Rifkin (2014); Mason (2015)

2 Overload

1 Wallman (2014)
2 Simms (2014)
3 Figures from Wallman (2014)
4 http://www.voxeu.org/article/gdp-and-life-satisfaction-new-evidence
5 Skidelsky (2013)
6 http://www.slideshare.net/ActivateInc/activate-tech-and-media-
 outlook-2016/8-The_total_tech_and_media
7 All figures from Schulte (2014)
8 Nisen (2014)

3 THE CREATIVITY MYTH

1 For more detail, see for example http://www.gramophone.
co.uk/features/focus/a-meeting-of-genius-beethoven-and-goethe-
july-1812?pmtx=most-popular&utm_expid=32540977-5.-
DEFmKXoQdmXwfDwHzJRUQ.1

2 https://www.youtube.com/yt/press/en-GB/statistics.html

3 http://static1.squarespace.com/static/545e40d0e4b054a6f8622bc9/t/
54720c6ae4b06f326a8502f9/1416760426697/Peak_Stuff_17.10.11.pdf

4 Koestler (1975)

5 Mazzucato (2013)

6 http://archive.wired.com/wired/archive/4.02/jobs_pr.html

7 See for example http://lareviewofbooks.org/essay/
post-scarcity-economics/

8 Harari (2014), p. 275

4 THE ORIGINS OF CURATION

1 http://www.newyorker.com/magazine/2014/12/08/art-conversation

2 Perry (2014)

3 For more on this and the history of curation in museums, see
Schubert (2000)

4 http://www.telegraph.co.uk/culture/art/3671180/Duchamps-Fountain-
The-practical-joke-that-launched-an-artistic-revolution.html

5 Perry (2014)

6 For more, see http://www.fastcompany.com/1702167/
inside-wild-wacky-profitable-world-boing-boing

5 THE PRINCIPLES OF CURATION

1 http://techcrunch.com/2014/07/28/
apple-to-buy-swell-for-30-million-per-report/

2 http://www.ft.com/cms/s/2/d72f0e14-27ab-11e4-be5a-
00144feabdc0.html#axzz3fgNqiHFu

3 http://www.slideshare.net/ActivateInc/activate-tech-and-media-
outlook-2016/120-120THE_APP_ECONOMY
wwwactivatecomDespite_massive_number

4 https://stratechery.com/2014/business-models-2014/

5 http://www.hollywoodreporter.com/news/
blockbuster-delays-424-mil-debt-25172

6 Christensen (1997)
7 https://redef.com/original/age-of-abundance-how-the-content-exp losion-will-invert-the-media-industry
8 http://variety.com/2015/tv/news/tca-fx-networks-john-landgra f-wall-street-1201559191/
9 http://mashable.com/2012/03/26/kaggle/
10 Mentioned in http://www.theatlantic.com/technology/ archive/2014/01/how-netflix-reverse-engineered-hollywood/282679/
11 http://www.wired.co.uk/magazine/archive/2015/02/features/ do-adjust-your-set/page/2
12 Ibid.
13 http://www.theguardian.com/commentisfree/2014/oct/26/ supermarkets-reign-is-over-hail-the-independents
14 Iyengar (2011), p. 187
15 Iyengar and Lepper (2000)
16 Schwartz (2004)
17 Superbly summarised in Kahneman (2011)
18 Levitin (2015)
19 http://unhealthywork.org/classic-studies/the-whitehall-study/
20 Discussed in http://www.newyorker.com/magazine/2014/02/17/ cheap-words
21 http://www.newyorker.com/magazine/2014/02/17/cheap-words
22 https://hbr.org/2015/11/how-marketers-can-personalize-at-scale
23 http://ben-evans.com/benedictevans/2015/6/24/ search-discovery-and-marketing
24 Dormehl (2014)
25 Quoted in Brand (1994)
26 Catmull (2014)
27 Cited in http://www.newyorker.com/magazine/2012/01/30/ groupthink
28 Quoted in http://www.neboagency.com/blog/ art-curation-interview-maria-popova/
29 Shenk (2014)
30 Barden (2013)
31 Ibid.
32 Ibid.
33 Bateson, Nettle and Roberts (2006)
34 Levitin (2015), p. 6
35 See http://www.edwardtufte.com/tufte/posters and http://www. edwardtufte.com/tufte/minard

36 Schmidt, Rosenberg and Eagle (2014)
37 For more detail see https://www.uie.com/articles/
 three_hund_million_button/
38 Hidalgo (2015), p. 178

6 CURATION EFFECTS

1 http://www.telegraph.co.uk/finance/newsbysector/
 transport/10044827/Ferrari-tries-to-cut-car-sales-to-protect-brand-
 exclusivity.html
2 http://www.wsj.com/articles/
 the-summers-most-unread-book-is-1404417569
3 http://www.wired.com/2014/10/content-moderation/#slide-id-
 1593139&sref=https://delicious.com/ajaxlogos/search/wired
4 Tainter (1988), p.160
5 Ibid., p. 91
6 Ibid., p. 93
7 Richards (2014)
8 http://www.ft.com/cms/s/0/db2b340a-0a1b-11df-8b23-
 00144feabdc0.html#ixzz3V8OJ6Oaa
9 Siegel and Etzkorn (2014)
10 http://www.linnean.org/Education+Resources/who_was_linnaeus
11 Levitin (2015)
12 Guber (2011), p. ix

7 CURATE THE WORLD

1 All figures taken from an Abu Dhabi Tourism and Culture
 Authority press release and interview
2 Krane (2009)
3 http://www.clearias.com/sectors-of-economy-primary-secondary-
 tertiary-quaternary-quinary/
4 http://www.census.gov/foreign-trade/index.html
5 http://www.nytimes.com/2012/08/29/dining/eataly-exceeds-
 revenue-predictions.html?_r=0
6 http://www.entrepreneur.com/article/238389
7 http://www.oxfam.ca/there-enough-food-feed-world
8 http://www.britishcoffeeassociation.org/about_coffee/coffee_facts/
9 https://www.stumptowncoffee.com/producers/
 arturo-aguirre-sr-and-jr

10 http://www.ft.com/cms/s/0/bfce2878-c691-11e5-b3b 1-7b2481276e45.html
11 http://www.forbes.com/sites/bruceupbin/2015/06/09/jack-ma-says-alibaba-has-no-plans-to-invade-america-its-the-other-way-around/
12 Wooldridge (2015), p. 14
13 http://www.wired.co.uk/magazine/archive/2014/06/ideas-bank/ vinod-khosla
14 Kondo (2014)
15 http://chronicle.com/article/How-to-Curate-Your-Digital/151001/

8 CURATE CULTURE

1 http://www.theguardian.com/business/2011/feb/16/ richard-russell-xl-recordings-dizzee-rascal-prodigy
2 http://www.theguardian.com/world/2014/aug/15/ berghain-club-bouncer-sven-marquardt-memoirs-berlin
3 https://press.spotify.com/uk/information/
4 http://www.billboard.com/biz/arti- cles/news/digital-and-mobile/5930133/ business-matters-why-spotify-bought-the-echo-nest
5 http://www.theverge.com/2015/7/20/9001317/ spotify-discover-weekly-poersonalized-playlist-deep-cuts
6 http://www.ft.com/cms/s/f1d6e2ce-0b6b- 11e5-994d-00144feabdc0,Authorised=false. html?_i_location=http%3A%2F%2Fwww.ft.com%2F- cms%2Fs%2F0%2Ff1d6e2ce-0b6b-11e5-994d-00144feabdc0. html%3Fsiteedition%3Duk&siteedition=uk&_i_refer- er=http%3A%2F%2Fwww.ft.com%2Fhome%2Fuk#axzz3cHpJzizM
7 And not everyone will survive; see http://qz.com/232834/ streaming-music-has-become-a-pawn-in-a-high-stakes-chess-match- who-will-win-and-why/
8 https://www.ted.com/talks/ mark_ronson_how_sampling_transformed_music?language=en
9 http://www.whosampled.com/most-sampled-tracks/1/
10 Anderson, Bell and Shirky (2015)
11 http://www.nybooks.com/articles/archives/2015/jun/25/ digital-journalism-next-generation/
12 https://medium.com/message/coming-home-nyt-now-e3fc26f60a59
13 http://www.gallup.com/poll/171740/americans-confidence-news- media-remains-low.aspx

9 Curate the Internet

1 http://www.economist.com/news/21589108-new-model-firm-its-way-says-virginia-rometty-chief-executive-ibm-year

2 For more see Rosenbaum (2011), Curata (2015)

3 See https://www.youtube.com/watch?v=grU0xJ7JwLs

4 https://twitter.com/milouness/status/178595970639081473

5 http://www.newstatesman.com/2015/05/man-versus-algorithm

6 http://www.androidauthority.com/samsung-curated-news-app-europe-638460/

7 Thiel (2014), p. 144

8 Rosenbaum (2011), p. 13

9 http://techcrunch.com/2013/11/14/pinterest-launches-its-first-apis-partners-with-zappos-walmart-disney-nestle-random-house-hearst-on-first-rollout/?ncid=twittersocialshare

10 Pariser (2011)

11 http://www.theguardian.com/technology/2014/sep/04/twitter-facebook-style-curated-feed-anthony-noto

12 https://www.facebook.com/business/news/News-Feed-FYI-A-Window-Into-News-Feed

13 http://qz.com/333313/milliions-of-facebook-users-have-no-idea-theyre-using-the-internet/

14 http://www.bloomberg.com/news/articles/2015-04-23/twitter-tries-to-tone-down-the-chirping

15 Carlson (2015)

16 http://www.theguardian.com/technology/2016/feb/19/yahoo-sale-goldman-sachs-jp-morgan-marissa-mayer-alibaba

17 See e.g. Taylor (2014)

18 See e.g. http://designnotes.info/?p=6823

19 Lanier (2011, 2013)

20 Postman (2005), p. xix

10 Curate Business

1 http://www.economist.com/blogs/economist-explains/2014/04/economist-explains-17

2 http://cdn2.vox-cdn.com/uploads/chorus_asset/file/664128/pearl_river_large.0.jpg

3 Ramo (2009)

4 According to Sequoia themselves, at least: https://www.sequoiacap.

com/us/about/dentmakers

5 http://www.latimes.com/travel/fashion/la-ig-0907-opening-
ceremony-20140907-story.html#page=1

6 See research from Interbrand cited by Jones (2014)

7 Ibid.

8 http://www.wsj.com/articles/amazon-plans-hundreds-of-brick-and
-mortar-bookstores-mall-ceo-says-1454449475

9 https://angel.co/lyst

10 https://www.linkedin.com/pulse/20140619151046-6907-retail-
innovation-labs-in-the-bay-area-indiana-seattle-illinois-austin-
new-york-city and http://www.fastcompany.com/3039608/
most-innovative-companies-2015/westfield-labs

11 Levi (2015)

12 Goyal (2014), p. 8

13 Sinha (2015)

14 Ibid., p. 117

15 http://www.nature.com/nature/about/

16 http://www.nature.com/nature/about/mission.pdf

17 All figures from Larson and Ins (2010)

18 http://blogs.nature.com/news/2014/05/global-scientific-output-
doubles-every-nine-years.html

19 http://www.vox.com/2015/11/30/9820192/
universities-uncited-research

20 https://www2.deloitte.com/content/dam/Deloitte/
es/Documents/acerca-de-deloitte/Deloitte-ES-
Opera_Europa_Deloitte_Art_Finance_Report2014.pdf

21 http://trendwatching.com/

11 Curate Yourself

1 Stephenson (2013), p. 265

2 For more see Hebdige (1979)

3 http://luckypeach.com/how-mcdonalds-started-in-china/

4 Löfgren (1999)

5 Ibid.

6 http://media.unwto.org/press-release/2015-01-27/
over-11-billion-tourists-travelled-abroad-2014

7 http://www.telegraph.co.uk/travel/travelnews/10474809/
Telegraph-Travel-Awards-2013-Favourite-escorted-tour-operator.
html

8 http://www.fastcompany.com/3002093/jack-dorsey-eric-schmidt-
 back-peek-another-beautiful-curated-travel-startup

9 http://www.hughmalkin.com/blogwriter/2015/9/23/
 why-no-one-has-solved-event-discovery

10 Wallman (2014)

11 http://www.theatlantic.com/business/archive/2014/10/
 buy-experiences/381132/

12 http://eventbrite-s3.s3.amazonaws.com/marketing/Millennials_
 Research/Gen_PR_Final.pdf

13 https://www.bcgperspectives.com/content/articles/
 consumer_products_retail_shock_new_chic_dealing_with_new_
 complexity_business_luxury/

14 Obrist, Coupland and Basar (2015)

15 Rushkoff (2013)

16 Bourdieu (2010)

17 Crawford (2015), p. ix

CONCLUSION

1 Brynjolfsson and McAfee (2014)

2 Piketty (2014)

3 Taleb (2013)

Acknowledgements

As someone who works with books and writing every day, I well know how much work goes into making a book. Thanks are owed to too many people to list here, and apologies to those not thanked by name or who I have missed out.

First Alex Christofi and then Sophie Lambert have been incredible agents. Alex refined the proposal with a brilliant touch and placed the book; Sophie took things up without missing a beat and has been the sort of wonderful confidante, support and adviser that every author relies on to an almost crazy degree. Many thanks too to the wider team at Conville & Walsh. It's a huge privilege to work with them and I am incredibly grateful.

From the first meeting Tim Whiting of Little, Brown absolutely got the book and the ideas; it all clicked into place. He and Meri Pentikäinen have been the ideal critics, shepherds and visionaries that every book needs. Thanks to all of the wider team at Little, Brown and Piatkus for their hard work in bringing the book out. On all fronts it has been superb. Steve Gove did a brilliant job on the copyedit and greatly improved the book throughout.

There were many people I spoke to when writing the book. Huge thanks to all of them, in no particular order: Edouard

Lambelet, Xavier Damman, Gideon Chain, Lily Booth, Brian Armstrong, Daniel Kaplan, Shannon Fox, Karim Azar, Daniel Crewe, Emma Cantwell, 'Lisa' (you know who you are), Catherine Seay, Bobbie Johnson, Martin Gayford, Molly Sharp, Oriole Cullen, Simon Sheikh, Greg Linden, James Simmons, Luciano Floridi and the staff of the British Library and the Bodleian Library. On a wider level curation is now a much commented upon phenomenon and I have relied on the huge body of work represented in the bibliography and web links – this book would have been impossible without it.

Comments on the draft were immensely useful and have made it a much, much better book. For all their careful reading and attention – which blew me away – thanks are owed to Julian Baker, George Walkley, Anna Faherty, James Bullock and Stephen Brough. It should go without saying that all errors and infelicities are mine alone.

My co-founders at Canelo, Iain Millar and Nick Barreto, should also be thanked for putting up with me working on this book while we were also launching a new business. It's not a combination I would recommend if you value free time, but their support was invaluable.

Lastly, and above all, thanks to Dani for absolutely everything. It would take volumes to even begin. And I promise not to spend all weekend writing any more. For a month or two at least . . .

Bibliography and Further Reading

Alpert, Daniel (2013), *The Age of Oversupply: Overcoming the Greatest Challenge to the Global Economy*, London: Portfolio Penguin

Anderson, Chris (2013), *Makers: The New Industrial Revolution*, London: Random House Business Books

Anderson, Chris, Emily Bell and Clay Shirky (2015), *Post Industrial Journalism: Adapting to the Present*, New York: Tow Center for Digital Journalism

Arthur, W. Brian (2009), *The Nature of Technology: What It Is and How It Evolves*, London: Allen Lane

Balzer, David (2014), *Curationism: How Curating Took Over the Art World and Everything Else*, Toronto: Coach House Books

Barden, Phil (2013), *Decoded: The Science Behind Why We Buy*, Chichester: Wiley

Bateson, Melissa, Daniel Nettle and Gilbert Roberts (2006), 'Cues of being watched enhance cooperation in a real-world setting', *Biology Letters*, The Royal Society

Bilton, Nick (2013), *Hatching Twitter: How a fledgling start-up became a multibillion-dollar business & accidentally changed the world*, London: Sceptre

Borges, Jorge Luis (1970), *Labyrinths*, London: Penguin

Bourdieu, Pierre (2010), *Distinction: A Social Critique of the Judgement of Taste*, Oxon: Routledge

Brand, Stewart (1994), *How Buildings Learn: What Happens After They're Built*, London: Phoenix

Brynjolfsson, Erik, and Andrew McAfee (2014), *The Second Machine Age: Work, Progress and Prosperity in a Time of Brilliant Technologies*, New York: W. W. Norton

Carlson, Nicholas (2015), *Marissa Mayer and the Fight to Save Yahoo!*, London: John Murray

Catmull, Ed, with Amy Wallace (2014), *Creativity, Inc.: Overcoming the Unseen Forces That Stand in the Way of True Inspiration*, London: Bantam Press

Chang, Ha-Joon (2014), *Economics: The User's Guide*, London: Pelican Books

Christensen, Clayton M. (1997), *The Innovator's Dilemma: When Technologies Cause Great Firms to Fail*, Boston MA: Harvard Business School Press

Coyle, Diane (2011), *The Economics of Enough: How to Run the Economy As If the Future Matters*, Princeton: Princeton University Press

Crawford, Matthew (2015), *The World Beyond Your Head: How to Flourish in an Age of Distraction*, London: Viking Penguin

Curata (2015), *The Ultimate Guide to Content Curation*, Boston MA: Curata

Dobelli, Rolf (2013), *The Art of Thinking Clearly: Better Thinking, Better Decisions*, London: Sceptre

Dorling, Danny (2013), *Population 10 Billion: The Coming Demographic Crisis and How to Survive It*, London: Constable and Robinson

Dormehl, Luke (2014), *The Formula: How Algorithms Solve All Our Problems ... And Create More*, New York: Perigee

Economist, The, Introduction by Zanny Minton Beddoes (2014), *Debts, Deficits and Dilemmas: A crash course on the financial crisis and its aftermath*, London: Profile Books

Emmott, Stephen (2013), *10 Billion*, London: Penguin

Goyal, Ashima, ed. (2014), *The Oxford Handbook of the Indian Economy in the 21st Century*, Oxford: Oxford University Press

Guber, Peter (2011), *Tell to Win: Connect, Persuade, and Triumph with the Hidden Power of Story*, London: Profile Books

Harari, Yuval Noah (2014), *Sapiens: A Brief History of Mankind*, London: Harvill Secker

Hebdige, Dick (1979), *Subculture: The Meaning of Style*, London: Methuen

Hidalgo, César (2015), *Why Information Grows: The Evolution of Order, from Atoms to Economies*, London: Allen Lane

Johnson, Steven (2013), *Future Perfect: The Case for Progress in a Networked Age*, London: Penguin

Iyengar, Sheena (2011), *The Art of Choosing*, London: Abacus

Iyengar, Sheena S., and Mark R. Lepper (2000), 'When Choice is Demotivating: Can One Desire Too Much of a Good Thing?', *Journal of Personality and Social Psychology*, vol. 76, no. 6, American Psychological Association

Jarvis, Jeff (2009), *What Would Google Do?*, New York: Collins Business

Jones, Graham (2014), *Click.ology: What Works in Online Shopping*, London: Nicholas Brealey

Kahneman, Daniel (2011), *Thinking, Fast and Slow*, London: Penguin

Kasarda, John D., and Greg Lindsay (2011), *Aerotropolis: The Way We'll Live Next*, London: Allen Lane

Koestler, Arthur (1975), *The Act of Creation*, London: Picador

Kondo, Marie (2014), *The Life-changing Magic of Tidying Up: The Japanese Art of Decluttering and Organizing*, New York: Ten Speed Press

Krane, Jim (2009), *Dubai: The Story of the World's Fastest City*, London: Atlantic Books

Krogerus, Mikael, and Roman Tschäppeler (2012), *The Change Book: Fifty Models to Explain How Things Happen*, London: Profile Books

Kunkel, Benjamin (2014), *Utopia or Bust: A Guide to the Present Crisis*, London: Verso

Lanier, Jaron (2011), *You Are Not a Gadget: A Manifesto*, London: Penguin

Lanier, Jaron (2013), *Who Owns The Future?*, London: Allen Lane

Larson, Peder Olesen, and Markus von Ins (2010), 'The rate of growth in scientific publication and the decline in coverage provided by the Science Citation Index', *Scientometrics*, vol 84, no. 3, Springer

Leslie, Ian (2015), *Curious: The Desire to Know and Why Your Future Depends On It*, London: Quercus

Levi, Scott C. (2015), *Caravans: The Story of Indian Business*, New Delhi: Allen Lane

Levitin, Daniel J. (2015), *The Organized Mind: Thinking Straight in the Age of Information Overload*, London: Penguin Viking

Lindstrom, Martin (2008), *Buyology: How Everything We Believe About Why We Buy is Wrong*, New York: Doubleday

Löfgren, Orvar (1999), *On Holiday: A History of Vacationing*, Berkeley and Los Angeles: University of California Press

Lovell, Nicholas (2013), *The Curve: From Freeloaders Into Superfans: The Future of Business*, London: Portfolio Penguin

MacCannell, Dean (2013), *The Tourist: A New Theory of the Leisure Class*, Berkeley: University of California Press

Martin, James (2006), *The Meaning of the 21st Century: A Vital Blueprint for Ensuring Our Future*, London: Eden Project Books

Mason, Paul (2015), *PostCapitalism: A Guide to Our Future*, London: Allen Lane

Mayer-Schönberger (2013), Viktor, and Kenneth Cukier, *Big Data: A Revolution That Will Transform How We Live, Work and Think*, London: John Murray

Mazzucato, Mariana (2013), *The Entrepreneurial State: Debunking Public vs. Private Sector Myths*, London: Anthem Press

McKeown, Greg (2014), *Essentialism: The Disciplined Pursuit of Less*, London: Virgin Books

Mullainathan, Sendhil, and Eldar Shafir (2013), *Scarcity: Why Having Too Little Means So Much*, London: Allen Lane

Obrist, Hans Ulrich (2011), *A Brief History of Curating*, Zurich: JRP Ringier

Obrist, Hans Ulrich (2014), *Ways of Curating*, London: Allen Lane

Obrist, Hans Ulrich, Douglas Coupland and Shumon Basar (2015), *The Age of Earthquakes: A Guide to the Extreme Present*, London: Penguin

Offer, Avner (2006), *The Challenge of Affluence: Self-Control and Well-Being in the United States and Britain since 1950*, Oxford: Oxford University Press

O'Neill, Paul (2012), *The Culture of Curating and the Curating of Culture(s)*, Cambridge, MA: MIT Press

Pariser, Eli (2011), *The Filter Bubble: What the Internet is Hiding from You*, London: Viking

Perry, Grayson (2014), *Playing to the Gallery: Helping Contemporary Art in its Struggle to Be Understood*, London: Particular Books

Piketty, Thomas (2014), *Capital in the Twenty-First Century*, Cambridge, MA: Harvard University Press

Postman, Neil (2005), *Amusing Ourselves to Death: Public Discourse in the Age of Show Business*, 2nd edition, New York: Penguin

Prasad Rao, D.S., and Bart van Ark, eds (2013), *World Economic Performance Past, Present and Future: Essays in celebration of the life and work of Angus Maddison*, Cheltenham: Edward Elgar

Ramo, Joshua Cooper (2009), *The Age of the Unthinkable: Why the New World Order Constantly Surprises Us and What to Do About It*, London: Little, Brown

Rickards, James (2014), *The Death of Money: The Coming Collapse of the International Monetary System*, London: Portfolio Penguin

Rifkin, Jeremy (2014), *The Zero Marginal Cost Society: The Internet of Things, the Collaborative Commons, and the Eclipse of Capitalism*, New York: Palgrave

Rosenbaum, Steven (2011), *Curation Nation: How to Win in a World where Consumers are Creators*, New York: McGraw Hill

Rushkoff, Douglas (2013), *Present Shock: When Everything Happens Now*, New York: Penguin Current

Salecl, Renata (2010), *Choice*, London: Profile Books

Schmidt, Eric, and Jonathan Rosenberg, with Alan Eagle (2014), *How Google Works*, London: John Murray

Schubert, Karsten (2000), *The Curator's Egg: The Evolution of the Museum Concept from the French Revolution to the Present Day*, London: One-off Press

Schulte, Brigid (2014), *Overwhelmed: Work, Love and Play When No One Has the Time*, London: Bloomsbury

Schumacher, E.F. (1993), *Small is Beautiful: A Study of Economics as if People Mattered*, London: Vintage

Schwartz, Barry (2004), *The Paradox of Choice: Why More Is Less: How the Culture of Abundance Robs Us of Satisfaction*, New York: Harper Perennial

Shenk, Joshua Wolf (2014), *Powers of Two: Finding the Essence of Innovation in Creative Pairs*, London: John Murray

Siegel, Alan, and Irene Etzkorn (2014), *Simple: Conquering the Crisis of Complexity*, London: Random House Business Books

Simms, Andrew (2014), *Cancel the Apocalypse: The New Path to Prosperity*, London: Abacus

Sinha, Dheeraj (2015), *India Reloaded: Inside India's Resurgent Consumer Market*, New York: Palgrave Macmillan

Skidelsky, Robert, and Edward Skidelsky (2012), *How Much Is Enough?: The Love of Money and the Case for the Good Life*, London: Allen Lane

Smil, Vaclav (2005), *Creating the Twentieth Century: Technical Innovations of 1867–1914 and Their Lasting Impact*, New York: Oxford University Press

Stephenson, Neal (2013), *Some Remarks*, London: Atlantic Books

Studwell, Joe (2013), *How Asia Works: Success and Failure in the World's Most Dynamic Region*, London: Profile Books

Tainter, Joseph A. (1988), *The Collapse of Complex Societies*, Cambridge: Cambridge University Press

Taleb, Nassim Nicholas (2013), *Antifragile: Things That Gain From Disorder*, London: Penguin

Taylor, Astra (2014), *The People's Platform: Taking Back Power and Culture in the Digital Age*, London: Fourth Estate

Thiel, Peter (2014), *Zero to One: Notes on Startups, or How to Build the Future*, London: Virgin Books

Timberg, Scott (2015), *Culture Crash: The Killing of the Creative Class*, New Haven: Yale University Press

Timberg, Thomas A. (2014), *The Marwaris: The Story of Indian Business*, New Delhi: Allen Lane

Tripathi, Dwijendra, and Jyoti Jumani (2007), *The Concise Oxford History of Indian Business*, New Delhi: Oxford University Press

Wallman, James (2014), *Stuffocation: Living More With Less*, London: Portfolio Penguin

Weatherall, James Owen (2013), *The Physics of Finance: Predicting the Unpredictable: Can Science Beat the Market?*, London: Short Books

Weinberger, David (2007), *Everything is Miscellaneous: The Power of the New Digital Disorder*, New York: Times Books

Wooldridge, Adrian (2015), *The Great Disruption: How business is coping with turbulent times*, London: Economist Books

Wright, Alex (2007), *Glut: Mastering Information Through the Ages*, Washington, DC: Joseph Henry Press

Web links

'A Meeting of Genius: Beethoven and Goethe, 1812', *Gramophone*, http://www.gramophone.co.uk/features/focus/a-meeting-of-genius-beethoven-and-goethe-july-1812?pmtx=quarterly-dd (accessed 8 November 2014)

Allison, Chris, 'The Art of Curation: An Interview With Maria Popova of BrainPickings', Nebo (2010), http://www.neboagency.com/blog/art-curation-interview-maria-popova/ (accessed 14 October 2014)

'An Interview with Hans-Ulrich Obrist', *The Believer* (2012), http://logger.believermag.com/post/28845125847/an-interview-with-hans-ulrich (accessed 8 August 2013)

Ankeny, Jason, 'Eataly Elevates Food Retail, Tastes Success. What's Next?', *Entrepreneur* (2014), http://www.entrepreneur.com/article/238389 (accessed 12 July 2015)

Antonelli, Paola, 'A Curator's Tale', *Moma Salon: 1* (2014), https://www.youtube.com/watch?v=X4TuPAlQLcg (accessed 14 October 2014)

'Arturo Aguirre, Sr and Jr', *Stumptown Coffee*, https://www.stumptowncoffee.com/producers/arturo-aguirre-sr-and-jr (accessed 20 July 2015)

Auerbach, David, 'Twitter at the crossroads', Slate, 2015, http://www.slate.com/articles/technology/bitwise/2015/04/twitter_earnings_and_acquisitions_the_company_s_in_

trouble_and_its_options.html?wpsrc=fol_tw (accessed 3 May 2015)

Backstrom, Lars, 'News Feed FYI', Facebook (2013), https://www.facebook.com/business/news/News-Feed-FYI-A-Window-Into-News-Feed (accessed 16 June 2015)

Battan, Carrie, 'Johnny Depp Curates Pirate-Themed Compilation', Pitchfork (2012), http://pitchfork.com/news/48833-tom-waits-teams-with-keith-richards-patti-smith-teams-with-johnny-depp-courtney-love-teams-with-michael-stipe-for-depp-helmed-compilation/ (accessed 20 May 2013)

Blythman, Joanna, 'No wonder superstores are dying – we're sick and tired of their culture', *The Guardian* (2014), http://www.theguardian.com/commentisfree/2014/oct/26/supermarkets-reign-is-over-hail-the-independents (accessed 1 November 2014)

Bond, Paul, 'Blockbuster delays $42.4m debt payment', *The Hollywood Reporter* (2010), http://www.hollywoodreporter.com/news/blockbuster-delays-424-mil-debt-25172 (accessed 20 July 2015)

'Bowie to Curate New NYC Festival', *Billboard* (2006), http://www.billboard.com/articles/news/58498/bowie-to-curate-new-nyc-festival (accessed 20 May 2013)

Bradshaw, Tim, 'Apple looks beyond iTunes with launch of its streaming service', *Financial Times*, 2015, http://www.ft.com/cms/s/f1d6e2ce-0b6b-11e5-994d-00144feabdc0,Authorised=false.html?_i_location=http%3A%2F%2Fwww.ft.com%2F-cms%2Fs%2F0%2Ff1d6e2ce-0b6b-11e5-994d-00144feabdc0.html%3Fsiteedition%3Duk#axzz3cHpJzizM&sref=https://delicious.com/ajaxlogos/curation (accessed 6 June 2015)

Bradshaw, Tim, 'Growing Pains', *Financial Times* (2014), http://www.ft.com/cms/s/2/d72f0e14-27ab-11e4-be5a-00144feabdc0.html#axzz3fgNqiHFu&sref=https://delicious.com/ajaxlogos/curation (accessed 12 July 2015)

Bustillos, Maria, 'Why We Need Curators', Buzzfeed (2012), http://www.buzzfeed.com/mariabustillos/rise-of-the-net-jockey-why-we-need-curators#.brp04DYWnl (accessed 2 April 2013)

Byrne, David, 'Man vs Algorithm', *New Statesman* (2015),

http://www.newstatesman.com/2015/05/man-versus-algorithm (accessed 16 June 2015)

Chen, Adrian, 'The laborers who keep dick pics and beheadings out of your Facebook feed', *Wired*, 2014, http://www.wired.com/2014/10/content-moderation/#slide-id-1593139&sref=https://delicious.com/ajaxlogos/curation (accessed 29 October 2014)

Cheredar, Tom, 'NPR launches NPR One', VentureBeat (2014), http://venturebeat.com/2014/07/28/npr-launches-new-npr-one-mobile-app-for-curating-public-radio-news/ (accessed 29 July 2014)

'China's addiction to luxury goods', *The Economist* (2014), http://www.economist.com/blogs/economist-explains/2014/04/economist-explains-17 (accessed 18 July 2015)

'Coffee Facts', British Coffee Association, http://www.britishcoffeeassociation.org/about_coffee/coffee_facts/ (accessed 29 July 2015)

Collins, Glenn, 'At Eataly, the Ovens and Cash Registers Are Hot', *The New York Times*, 2012, http://www.nytimes.com/2012/08/29/dining/eataly-exceeds-revenue-predictions.html (accessed 16 May 2015)

Constine, Josh, 'Why Is Facebook Page Reach Decreasing?', *TechCrunch* (2014), http://techcrunch.com/2014/04/03/the-filtered-feed-problem/ (accessed 3 July 2015)

Crook, Jordan, 'Apple to Buy Swell for $30m', *TechCrunch* (2014), http://techcrunch.com/2014/07/28/apple-to-buy-swell-for-30-million-per-report/ (accessed 28 July 2014)

Curtis, Nick, 'Entrepreneur Kate MacTiernan on Danny Boyle's new film festival', *Evening Standard* (2013), http://www.standard.co.uk/goingout/film/entrepreneur-kate-mactiernan-on-danny-boyles-new-film-festival-shuffle-and-restoring-a-derelict-8673990.html (accessed 27 June 2013)

DeMers, Jayson, 'What Google's Knowledge Graph Means for the Future of Knowledge', *Forbes* (2014), http://www.forbes.com/sites/jaysondemers/2014/10/28/what-googles-knowledge-graph-means-for-the-future-of-search/2/ (accessed 8 February 2015)

Deshpande, Pawan, 'The Definitive Guide to Content Curation', Curata (2015), http://www.curata.com/blog/the-definitive-guide-to-content-curation/ (accessed 1 July 2015)

Doctorow, Cory, 'Clay Shirky on information overload and filter failure', Boing Boing (2010), http://boingboing.net/2010/01/31/clay-shirky-on-infor.html (accessed 17 February 2014)

Dredge, Stuart, 'Twitter boss confirms plan to expand curated experiences to all', *The Guardian* (2015), http://www.theguardian.com/technology/2015/apr/29/twitter-boss-curated-experiences-timeline (accessed 3 May 2015)

Dugan, Andrew, 'Americans' Confidence In News Media Remains Low', Gallup (2014), http://www.gallup.com/poll/171740/americans-confidence-news-media-remains-low.aspx (accessed 25 February 2015)

Ellenberg, Jordan, 'The Summer's Most Unread Book Is …', *The Wall Street Journal* (2014), http://www.wsj.com/articles/the-summers-most-unread-book-is-1404417569 (accessed 3 April 2015)

'Ethos', Sequoia Capital, https://www.sequoiacap.com/people/ethos/ (accessed 18 July 2015)

Evans, Benedict, 'Search, discovery and marketing', Ben-Evans (2015), http://ben-evans.com/benedictevans/2015/6/24/search-discovery-and-marketing?utm_content=buffer8ce71 (accessed 19 July 2015)

'Ferrari tries to cut car sales to protect brand exclusivity', *Daily Telegraph* (2013), http://www.telegraph.co.uk/finance/newsbysector/transport/10044827/Ferrari-tries-to-cut-car-sales-to-protect-brand-exclusivity.html (accessed 3 April 2015)

Fisher, Eve, 'The $3500 Shirt', Sleuthsayers (2013), http://www.sleuthsayers.org/2013/06/the-3500-shirt-history-lesson-in.html (accessed 18 July 2015)

Foster, Hal, 'Exhibitionists', *London Review of Books*, 2015, http://www.lrb.co.uk/v37/n11/hal-foster/exhibitionists (accessed 27 June 2015)

Freeland, Chrystia, 'What Toronto Can Teach London and New York', *Financial Times* (2010), http://www.ft.com/cms/s/db2b340a-0a1b-11df-8b23-00144feabdc0,Authorised=false.html?siteedition=uk&_i_location=http%3A%2F%2Fwww.

ft.com%2Fcms%2Fs%2F0%2Fdb2b340a-0a1b-11df-8b23-00144feabdc0.
html%3Fsiteedition%3Duk&_i_referer=&classification=con-
ditional_standard&iab=barrier-app#axzz3V8OFKGzd&s-
ref=https://delicious.com/ajaxlogos/curation (accessed 22
March 2015)

Galloway, Scott, 'The death of pure-play retail and impulse buys', L2
(2015), https://www.youtube.com/watch?v=grU0xJ7JwLs&-
feature=youtu.be (accessed 17 July 2015)

Gayford, Martin, 'Duchamp's Fountain', *Daily Telegraph*
(2008), http://www.telegraph.co.uk/culture/art/3671180/
Duchamps-Fountain-The-practical-joke-that-launched-an-
artistic-revolution.html (accessed 15 November 2014)

Good, Robin, 'Content Curation Visualized', Pinterest, https://
www.pinterest.com/robingood/content-curation-visualized/
(accessed 17 June 2013)

Goodhall, Chris, 'Peak Stuff' (2011), http://static1.squarespace.
com/static/545e40d0e4b054a6f8622bc9/t/54720c6ae4b-
06f326a8502f9/1416760426697/Peak_Stuff_17.10.11.pdf
(accessed 20 July 2015)

Groys, Boris, 'The Curator As Iconoclast', Bezalel (2006), http://
bezalel.secured.co.il/zope/home/en/1143538156/1143802471_
en (accessed 31 July 2013)

Hamblin, James, 'Buy Experiences, Not Things', The Atlantic
(2014), http://www.theatlantic.com/business/archive/2014/10/
buy-experiences/381132/ (accessed 29 July 2015)

'Henry Holland to curate Trinity Leeds launch', *Retail Gazette*
(2013), http://www.retailgazette.co.uk/blog/2013/03/23200-
henry-holland-to-curate-trinity-leeds-launch (accessed 20 June
2013)

Hern, Alex, 'End of the timeline? Twitter hints at move to Facebook-
style curation', The Guardian, http://www.theguardian.com/
technology/2014/sep/04/twitter-facebook-style-curated-feed-
anthony-noto (accessed 27 August 2014)

Honan, Mat, 'This is Twitter's Top Secret Project Lightning',
Buzzfeed (2015), http://www.buzzfeed.com/mathonan/twitters-
top-secret-project-lightning-revealed#.qkARmj57z&sref=https://
delicious.com/ajaxlogos/curation (accessed 20 June 2015)

'How Many Pages In A Gigabyte?', LexisNexis, http://www.lexisnexis.com/applieddiscovery/lawlibrary/whitepapers/adi_fs_pagesinagigabyte.pdf (accessed 13 February 2014)

Hudgins, Coley, 'Complexity Theory and System Collapse', The Resilient Family (2012), http://www.theresilientfamily.com/2012/03/complexity-theory-and-system-collapse/ (accessed 16 April 2014)

'Information', Spotify, https://press.spotify.com/uk/information/ (accessed 12 July 2015)

Ingram, Matthew, 'Twitter acquisition confirms that curation is the future', Gigaom (2012), https://gigaom.com/2012/01/20/twitter-acquisition-confirms-that-curation-is-the-future/ (accessed 23 January 2012)

Iyengar, Sheena, 'The art of choosing', TED (2010), https://www.ted.com/talks/sheena_iyengar_on_the_art_of_choosing#t-1378263&sref=https://delicious.com/ajaxlogos/curation (accessed 16 June 2014)

Johnson, Bobbie, 'Yuri Milner: Genius Investor or King of the Gold Rush', Gigaom (2011), https://gigaom.com/2011/03/16/yuri-milner-genius-investor-or-king-of-the-gold-rush/ (accessed 20 March 2013)

Jones, Dan, 'English clubs are left dazzled', *Evening Standard* (2014), http://www.standard.co.uk/sport/dan-jones-like-mowgli-as-he-faces-the-snake-our-english-clubs-are-left-dazzled-9141385.html (accessed 22 February 2014)

Jonze, Tim, 'XL Recordings, the record label that's tearing up the rule book', *The Guardian* (2011), http://www.theguardian.com/business/2011/feb/16/richard-russell-xl-recordings-dizzee-rascal-prodigy (accessed 6 June 2015)

Kaplan, Jeffrey, 'The Gospel of Consumption', *Orion Magazine* (2008), https://orionmagazine.org/article/the-gospel-of-consumption/ (accessed 15 October 2015)

Kaplan, Marcia, 'Celebrity Curators Help Personalize Ecommerce', Practical Ecommerce (2011), http://www.practicalecommerce.com/articles/3178-Celebrity-Curators-Help-Personalize-Ecommerce?SSAID=314743 (accessed 20 May 2013)

Karlsson, Per, 'The world's wine production 2000–2012', *BK*

Wine Magazine (2013), http://www.bkwine.com/features/winemaking-viticulture/global-wine-production-2000-2012/ (accessed 3 May 2015)

Kessler, Sarah, 'How Kaggle Solves Big Problems With Big Data Competitions', Mashable (2012), http://mashable.com/2012/03/26/kaggle/#C3APzntNGkqq (accessed 20 July 2015)

Kessler, Sarah, 'Jack Dorsey, Eric Schmidt Back Peek, Another Beautiful Curated Travel Startup', *Fast Company* (2012), http://www.fastcompany.com/3002093/jack-dorsey-eric-schmidt-back-peek-another-beautiful-curated-travel-startup (accessed 28 July 2015)

Kowalcyzk, Piotr, 'This unique Tokyo bookstore offers one book title a week', Ebook Friendly (2015), http://ebookfriendly.com/tokyo-bookshop-one-book-week-pictures/ (accessed 14 September 2015)

Kummer, Corby, 'The supermarket of the future', The Atlantic (2007), http://www.theatlantic.com/magazine/archive/2007/05/the-supermarket-of-the-future/305787/ (accessed 16 May 2015)

Kusinitz, Sam, 'An Exhaustive List of Google's Ranking Factors', Hubspot Blogs (2014), http://blog.hubspot.com/marketing/google-ranking-algorithm-infographic (accessed 7 July 2014)

Langer, Matt, 'Stop Calling It Curation', Gizmodo (2012), http://gizmodo.com/5892582/stop-calling-it-curation (accessed 19 February 2013)

Lawrence, Robert Z., 'An Analysis of the 1977 Trade Deficit', *Brookings Institution*, http://www.brookings.edu/~/media/Projects/BPEA/1978%201/1978a_bpea_lawrence_smeal_vonfurstenberg_gordon_houthakker_krause_cline_kareken_maclaury.PDF (accessed 30 April 2014)

Lehrer, Jonah, 'Groupthink', *The New Yorker* (2012), http://www.newyorker.com/magazine/2012/01/30/groupthink (accessed 8 February 2015)

'Lyst', *AngelList*, https://angel.co/lyst (accessed 20 July 2015)

Madrigal, Alexis C., 'How Netflix Reverse Engineered Hollywood', The Atlantic (2014), http://www.theatlantic.com/technology/archive/2014/01/

how-netflix-reverse-engineered-hollywood/282679/ (accessed 10 January 2014)

Madrigal, Alexis C., 'I Loved You, Blockbuster', The Atlantic (2013), http://www.theatlantic.com/technology/archive/2013/11/i-loved-you-blockbuster/281213/ (accessed 1 January 2015)

Malkin, Hugh, 'Why no one has solved event discovery', Hugh Malkin (2015), http://www.hughmalkin.com/blog-writer/2015/9/23/why-no-one-has-solved-event-discovery (accessed 12 October 2015)

'Malleable Malls', The Economist (2013), http://www.economist.com/news/britain/21571926-shopping-centres-are-proving-well-suited-digital-age-malleable-malls (accessed 22 January 2014)

Marshall, Kelli, 'How to Curate Your Identity as an Academic', The Chronicle of Higher Education (2015), http://chronicle.com/article/How-to-Curate-Your-Digital/151001/ (accessed 23 February 2014)

Massing, Michael, 'Digital Journalism', The New York Review of Books (2015), http://www.nybooks.com/articles/archives/2015/jun/25/digital-journalism-next-generation/ (accessed 7 July 2015)

Max, D.T., 'The Art of Conversation', The New Yorker (2014), http://www.newyorker.com/magazine/201–4/12/08/art-conversation (accessed 20 July 2015)

Mayer, Marissa, 'Tumblr + Yahoo!: It's Officially Official', Yahoo! (2013), http://yahoo.tumblr.com/post/53441093826/tumblr-yahoo-its-officially-official (accessed 20 June 2013)

McDuling, John, 'An epic battle in streaming is about to begin', Quartz (2014), http://qz.com/232834/streaming-music-has-become-a-pawn-in-a-high-stakes-chess-match-who-will-win-and-why/ (accessed 26 July 2014)

'Millennials', Eventbrite, http://eventbrite-s3.s3.amazonaws.com/marketing/Millennials_Research/Gen_PR_Final.pdf (accessed 12 October 2015)

Mirani, Leo, 'Millions of Facebook users have no idea they're using the Internet', Quartz (2015), http://qz.com/333313/millions-of-facebook-users-have-no-idea-theyre-using-the-internet/ (accessed 16 June 2015)

'Mission Statement', *Nature*, http://www.nature.com/nature/about/mission.pdf (accessed 27 July 2015)

Mod, Craig, 'Coming Home', *The Message* (2014), https://medium.com/message/coming-home-nyt-now-e3fc26f60a59#.frm70bk3c (accessed 20 May 2015)

Moore, Booth, 'Opening Ceremony Possibility', *Los Angeles Times* (2014), http://www.latimes.com/travel/fashion/la-ig-0907-opening-ceremony-20140907-story.html#page=1&sref=https://delicious.com/ajaxlogos/curation (accessed 20 July 2015)

Morton, Tom, 'A brief history of the word curator', Phaidon (2011), http://uk.phaidon.com/agenda/art/articles/2011/september/09/a-brief-history-of-the-word-curator/ (accessed 13 March 2013)

'Most Sampled', Who Sampled, http://www.whosampled.com/most-sampled-tracks/1/ (accessed 18 July 2015)

Munger, Michael, 'Market Makers or Parasites?', *Library of Economics and Liberty* (2009), http://www.econlib.org/library/Columns/y2009/Mungermiddlemen.html (accessed 7 July 2014)

Nisen, Max, 'Companies have turned killing time into an art form', Quartz (2014), http://qz.com/200725/companies-have-turned-killing-time-into-an-art-form/ (accessed 6 May 2014)

Nordmark, Jon, '14 retail innovation labs in the Bay Area and 5 other cities', Pulse LinkedIn (2014), https://www.linkedin.com/pulse/20140619151046-6907-retail-innovation-labs-in-the-bay-area-indiana-seattle-illinois-austin-new-york-city (accessed 20 July 2015)

Oltermann, Philip, 'Berghain club bouncer launches memoirs about life as Berlin doorman', *The Guardian* (2014), http://www.theguardian.com/world/2014/aug/15/berghain-club-bouncer-sven-marquardt-memoirs-berlin (accessed 15 August 2014)

'Over 1.1 billion tourists travelled abroad in 2014', World Tourism Organization (2015), http://media.unwto.org/press-release/2015-01-27/over-11-billion-tourists-travelled-abroad-2014 (accessed 5 August 2015)

Owens, Simon, 'One way in which Facebook is just like 1990s era AOL', Simon Owens (2015), http://www.simonowens.net/

one-way-in-which-facebook-is-just-like-1990s-era-aol (accessed 21 February 2014)

Packer, George, 'Cheap Words', *The New Yorker* (2014), http://www.newyorker.com/magazine/2014/02/17/cheap-words (accessed 27 September 2014)

'Parents treble time they spend on childcare since the 1970s', University of Oxford, 2010, https://www.ox.ac.uk/media/news_stories/2010/paren100407.html (accessed 6 May 2014)

Pasori, Cedar, 'Leonardo di Caprio Talks Art', *Complex Style*, 2013, http://uk.complex.com/style/2013/04/leonardo-di-caprio-talks-saving-the-environment-with-art-collecting-basquiat-and-being-named-after-da-vinci (20 May 2013)

Phillips, Matt, 'The slow sad decline of Radioshack', Quartz (2014), http://qz.com/263841/the-slow-sad-decline-of-radioshack-one-of-the-great-brands-of-the-80s/ (accessed 14 September 2014)

Popova, Maria, 'Curators Code', Curators Code (2012), http://www.curatorscode.org/ (accessed 12 March 2013)

Proto, Eugenio, and Aldo Rustichini, 'GDP and Life Satisfaction: New Evidence', *Vox*, 2014, http://www.voxeu.org/article/gdp-and-life-satisfaction-new-evidence (accessed 3 February 2014)

Rometty, Virginia, 'The year of the smarter enterprise', *The Economist* (2013), http://www.economist.com/news/21589108-new-model-firm-its-way-says-virginia-rometty-chief-executive-ibm-year (accessed 4 July 2015)

Ronson, Mark, 'How Sampling Transformed Music', TED (2014), https://www.ted.com/talks/mark_ronson_how_sampling_transformed_music?language=en#t-17584&sref=https://delicious.com/ajaxlogos/curation (accessed 29 May 2015)

Rosenbaum, Steven, 'Innovate – curation!', TEDxGrandRapids (2011), https://www.youtube.com/watch?v=iASluLoKQbo (accessed 27 May 2013)

Rosenbaum, Steven, 'Is Curation Overused?', *Forbes* (2014), http://www.forbes.com/sites/stevenrosenbaum/2014/03/29/is-curation-over-used-the-votes-are-in/ (accessed 31 March 2014)

Rowan, David, 'What do you do for the data disenfranchised?', *Wired UK* (2013), http://www.wired.co.uk/magazine/

archive/2013/04/ideas-bank/what-did-you-do-for-the-data-disenfranchised (accessed 3 June 2013)

Sargent, Mikah, 'Yahoo!, the Genghis Khan of the tech world', Medium (2013), https://medium.com/@ mikahsargent/yahoo-the-genghis-khan-of-the-tech-world-66082ebcc1db#.7o6qkzbdw (accessed 5 August 2013)

Sawers, Paul, 'Blinkist for Android gives you the gist of books in 15 minutes', The Next Web (2014), http://thenextweb.com/ apps/2014/09/01/blinkist-android-gives-gist-non-fiction-books-15-minutes/ (accessed 18 September 2014)

Seifert, Dan, 'Spotify's latest trick is a personalized weekly playlist of deep cuts', The Verge (2015), http://www. theverge.com/2015/7/20/9001317/spotify-discover-weekly-poersonalized-playlist-deep-cuts (accessed 20 July 2015)

'Shock of the New Chic', Boston Consulting Group (2014), https://www.bcgperspectives.com/content/articles/ consumer_products_retail_shock_new_chic_dealing_with_ new_complexity_business_luxury/ (accessed 29 July 2015)

Silver, James, 'Meet Netflix Founder Reed Hastings', Wired (2015), http://www.wired.co.uk/magazine/archive/2015/02/features/ do-adjust-your-set/page/2 (accessed 12 July 2015)

Spool, Jared M., 'The \$300m Button', User Interface Engineering (2009), https://www.uie.com/articles/three_hund_million_ button/ (accessed 24 March 2014)

Starr, Oliver, '3 Reasons Curation is Here to Stay', ReadWrite (2011), http://readwrite.com/2011/05/09/3_reasons_curation_ is_here_to_stay (accessed 20 March 2013)

'Statistics', YouTube, https://www.youtube.com/yt/press/en-GB/ statistics.html (accessed 20 July 2015)

Stibel, Jeff, 'The Web is dead and the app killed it', Wired (2013), http://www.wired.co.uk/magazine/archive/2013/09/ ideas-bank/the-web-is-dead-and-the-app-thankfully-killed-it (accessed 18 November 2013)

Streams, Kimber, 'Grand St, A Curated Online Consumer Electronics Store', Laughing Squid, 2013, http://laughingsquid. com/grand-st-a-curated-online-consumer-electronics-store/ (accessed 18 July 2013)

Streihorst, Tom, 'Post-Scarcity Economics, *LA Review of Books* (2013), https://lareviewofbooks.org/essay/post-scarcity-economics/ (accessed 5 August 2013)

Surtees, Michael, 'Curator's Code – No Thanks', Design Notes (2012), http://designnotes.info/?p=6823 (accessed 12 March 2013)

'The Pearl River Delta Megacity', Vox, http://cdn2.vox-cdn.com/uploads/chorus_asset/file/664128/pearl_river_large.0.jpg

'There is enough food to feed the world', Oxfam, http://www.oxfam.ca/there-enough-food-feed-world (accessed 3 May 2015)

Thompson, Ben, 'Business Models for 2014', Stratechery (2014), https://stratechery.com/2014/business-models-2014/ (accessed 6 November 2014)

'Tossers Curating Everything', The Daily Mash, 2015, http://www.thedailymash.co.uk/news/society/tossers-curating-everything-2015041697425 (accessed 29 July 2015)

Triggs, Rob, 'Samsung to launch curated news app for its Galaxy phones', Android Authority (2015), http://www.androidauthority.com/samsung-curated-news-app-europe-638460/ (accessed 12 October 2015)

Tufekci, Zeynep, 'Why Twitter Should Not Algorithmically Curate the Timeline', The Message (2014), https://medium.com/message/the-algorithm-giveth-but-it-also-taketh-b7efad92bc1f#.it5584ghn (accessed 14 September 2014)

Tufte, Edward, 'Minard Sources', Edward Tufte (2002), http://www.edwardtufte.com/tufte/minard (accessed 6 November 2014)

Upbin, Bruce, 'Jack Ma Says Alibaba Has No Plans to Invade America', *Forbes* (2015), http://www.forbes.com/sites/bruceupbin/2015/06/09/jack-ma-says-alibaba-has-no-plans-to-invade-america-its-the-other-way-around/ (accessed 20 July 2015)

Vanhemert, Kyle, 'Canopy: A Curated Site That Finds the Best Stuff You Can Buy On Amazon', *Wired* (2014), http://www.wired.com/2014/04/canopy-a-curated-select-of-amazons-most-awesome-products/ (accessed 18 September 2014)

Van Noorden, Richard, 'Global scientific output doubles every nine

years', *Nature* (2014), http://blogs.nature.com/news/2014/05/global-scientific-output-doubles-every-nine-years.html (accessed 27 July 2015)

Vogel, Carol, 'At $142.4 Million, Triptych Is the Most Expensive Artwork Ever Sold at an Auction', *New York Times* (2013), http://www.nytimes.com/2013/11/13/arts/design/bacons-study-of-freud-sells-for-more-than-142-million.html?ref=international-home (accessed 13 November 2013)

Walker, Rob, 'Inside the Wild, Wacky, Profitable World of Boing Boing', Fast Company (2010), http://www.fastcompany.com/1702167/inside-wild-wacky-profitable-world-boing-boing (accessed 20 November 2014)

Warwick, Joe, 'Foxlow Review', *Metro* (2013), http://metro.co.uk/2013/11/21/the-hawksmoor-team-hits-another-high-with-neighbourhood-restaurant-foxlow-4194067/ (accessed 22 November 2013)

'West Kowloon Cultural District', Foster + Partners (2011), http://www.fosterandpartners.com/projects/west-kowloon-cultural-district/ (accessed 31 July 2013)

'What is Big Data?', IBM, http://www-01.ibm.com/software/data/bigdata/what-is-big-data.html (accessed 8 August 2015)

'When workers dream of a life beyond factory gates', *The Economist* (2012), http://www.economist.com/news/business/21568384-can-foxconn-worlds-largest-contract-manufacturer-keep-growing-and-improve-its-margins-now (accessed 22 September 2014)

'Who was Linnaeus?', The Linnean Society of London, http://www.linnean.org/Education%20Resources/who_was_linnaeus (accessed 20 July 2015)

Wigger, Erin, 'The Whitehall Study', Unhealthy Work (2011), http://unhealthywork.org/classic-studies/the-whitehall-study/ (accessed 19 July 2015)

Wolf, Gary, 'Steve Jobs', *Wired*, http://archive.wired.com/wired/archive/4.02/jobs_pr.html (accessed 18 July 2015)

Xuena, Li, 'Why Foxconn's Switch to Robots Hasn't Been Automatic', Caixin (2013), http://english.caixin.com/2013-05-14/100527915.html (accessed 22 September 2014)

Picture Credits

Index

KU-407-093

Black sand beach, Jökulsárlón,
Iceland
MATT MUNRO/LONELY PLANET ©

Plan Your Trip
Scandinavia's Top 12

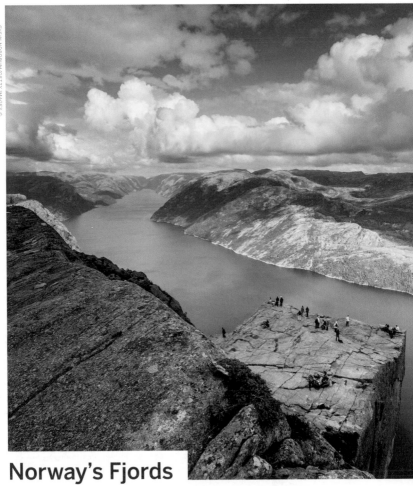

SVEIN NORDRUM/GETTY IMAGES ©

Norway's Fjords
Landscapes of unrivalled and dramatic beauty

Norway's fjords (p214) cut deep gashes into the interior, adding texture and depth to the map of northwestern Scandinavia. Sognefjorden and Hardangerfjord are extensive fjord networks, but Nærøyfjorden, Lysefjord (pictured above) and Geirangerfjord (pictured right), with their quiet, precipitous beauty, are possibly Scandinavia's most beautiful corner.

1

MU YEE TING/SHUTTERSTOCK ©

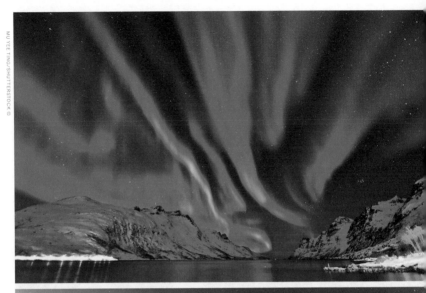

SIMON'S PASSION 4 TRAVEL/SHUTTERSTOCK ©

Aurora Borealis

Nature's most extraordinary night-sky spectacle

Whether caused by the collision of charged particles in the upper atmosphere, or sparked, as Sami tradition tells, by a giant snow fox swishing its tail in the Arctic tundra, the humbling splendour of the northern lights is unforgettable. The further north you go, such as the Lapland region of Finland (p154), Norway (p214) or Sweden (p236), the better your chances of gazing on nature's light show.

MATT MUNRO/LONELY PLANET ©

Lofoten Islands, Norway

Islands whose peaks reach for the sky

Few forget their first sighting of Lofoten Islands (p167; above: Reine, Lofoten Islands), laid out in summer greens and yellows or drowned in the snows of winter, their razor-sharp peaks dark against the sky. In the pure, exhilarating air, there's a constant tang of salt and a whiff of cod – staple of the seas. A hiker's dream and nowadays linked by bridges, the islands are simple to get to.

3

Design Shopping
Go to the heart of Scandinavian style

Elegant, innovative yet functional takes on everyday items have made the region's creativity world-famous and mean that you won't have to look far before you experience an 'I need that!' moment. There are great design and handicrafts across the region, but Copenhagen and Helsinki (p126), closely followed by Stockholm, are where modern flagship stores, such as Hay House (pictured right), can be found alongside quirky boutiques that present edgier new ideas.

Sami Culture
Draw near to Scandinavia's first people

The indigenous Sami have a near-mystical closeness to the natural environment – the awesome wildernesses of Lapland. Reindeer-herding is still a primary occupation, yet the Sami are a modern people still in touch with their roots. Check out the great museums (p162), the parliament buildings and craft workshops in Inari and Karasjok, and try to coincide with a festival or cultural event, whether reindeerracing (pictured) or *'yoiking'* (traditional singing).

Viking History

Learn more about the iconic seafaring Norsemen

Mead-swilling, pillaging hooligans or civilising craftspeople, poets and merchants? A series of memorable burial sites, rune stones, settlements and museums – the Vikingskipshuset in Oslo (pictured; p198) is perhaps the best – across the region brings the fascinating Viking Age to life. Gods and beliefs, their stupendous feats of navigation, customs, trade, longships, intricate jewellery, carvings and the wonderful sagas – it's all here.

Sledding

Explore the icy wastes at a husky's pace

A classic winter experience (p164) is to hitch up a team of reindeer or husky dogs to a sled and swish away under the pale winter sun. Short jaunts are good for getting the hang of steering, stopping and letting the animals know who you think the boss is; once your confidence is high, take off on an overnight trip, sleeping in a hut in the wilderness and thawing those deserving bones with a steaming sauna. Pure magic.

National Park Hiking

Hike out into pristine wilderness

If you like dark pine forests populated by foxes and bears, head for northeastern Finland's Karhunkierros trail (pictured). Norway's Jotunheimen National Park encompasses hundreds of lofty mountain peaks and crystal-blue lakes. Lying inside the Arctic Circle, Abisko National Park in Sweden is at one end of the epic 440km Kungsleden hiking trail. And walkers will never forget the bleak volcanic slopes, steaming pools and mossy valleys of Iceland's Landmannalaugar to Þórsmörk trek (p104).

Old Town, Tallinn
Medieval architecture and wonderful views

Tallinn's Unesco-protected Old Town (p287) is a 14th- and 15th-century twin-tiered jumble of turrets, spires and winding streets. Most experiences of Estonia's capital begin and end with the cobblestoned, chocolate-box landscape of intertwining alleys and picturesque courtyards. Enjoy the postcard-perfect vistas from one of the observation towers, refuel in one of the cosy vaulted-cellar bars and cafes, or simply stroll, soaking up the medieval magic.

VVORONOV/SHUTTERSTOCK ©

Historic Wooden Towns

Traditional buildings as backdrop to city life

Wooden buildings are a feature of Scandinavia, and towns and cities were once built exclusively from timber. But 'great fires' were common and comparatively few historic districts remain. They are worth seeking out for their quaint, unusual beauty; among others, Bergen (pictured top; p218) and Stavanger in Norway, Rauma (pictured abov in Finland and Gothenburg in Sweden preserve excellent 'timbertowns', perfect for strolling around.

10

Stockholm, Sweden

Scandinavia's stately belle in a lovely setting

Sweden's capital (p236) is the aristocrat among Scandinavian cities, with an imposing architecture of stately buildings arrayed across a complex, scarcely intelligible geography of islands and waterways. Noble museums, palaces and galleries dignify this former seat of empire with plenty of contemporary innovation to balance it out.

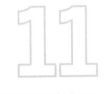

Denmark's Food Scene

The source of New Nordic cuisine

Copenhagen's (p34) culinary prowess is a byword these days. Once known for smørrebrød (open sandwiches) and *frikadeller* (meatballs), Denmark's capital has led the development of New Nordic cuisine, and further innovations are always on the go. The Nordic forage ethos, looking for naturally occurring local ingredients, has had worldwide culinary influence.

Plan Your Trip
Need to Know

When to Go

Warm to mild summers, cold winters
Mild year round
Mild summers, cold to very cold winters
Polar climate

Svalbard
GO Mar–Aug

Iceland
GO Jun–Aug

Lapland
GO Feb–Apr,
Aug–Sep

Fjords
GO Mar–Sep

Helsinki/
Tallinn
GO May–Jul

Copenhagen
GO May–Oct, Dec

High Season (Jun–Aug)

- All attractions and lodgings are open.

- Hotels in many parts are often substantially cheaper.

- Winter sports high season is January to March.

Shoulder (Apr, May, Sep & Oct)

- Expect chilly nights and even snow.

- Not the cheapest time to travel as summer hostels and camping grounds have closed.

- Many rural attractions close or shorten opening hours.

Low Season (Nov–Mar)

- Hotels charge top rates except at weekends.

- January to April is busy for winter sports.

- Short, cool or cold days.

Currency

Denmark: Danish krone (kr; DKK)
Finland & Tallinn: euro (€; EUR)
Iceland: Icelandic króna (kr; ISK)
Norway: Norwegian krone (kr; NOK)
Sweden: Swedish krona (kr; SEK)

Language

Danish, Estonian, Finnish, Icelandic, Norwegian and Swedish
English is widely spoken.

Visas

Generally not required for stays of up to 90 days; some nationalities need a Schengen visa.

Money

ATMs are widespread. Credit/debit cards are accepted everywhere

Mobile Phones

Local SIM cards cheap, widely available. Need an unlocked phone.

Time

Iceland: Western European Time (GMT/UTC plus zero hours)
Denmark, Norway & Sweden: Central Europ & Tallinn: Eastern European Time (GMT/UTC plus two hours)
All but Iceland use summer time from late March to late October.

Daily Costs

Budget: Less than €150

- Dorm bed (HI membership gets you good discounts): €15–40

- Bike hire per day: €10–25

- Lunch specials: €10–18

- National parks: free

Midrange: €150–250

- Standard hotel double room: €80–160

- Week-long car hire per day: €35–60

- Two-course meal for two with wine: €100–150

- Museum entry: €5–15

Top end: More than €250

- Room in boutique hotel: €150–300

- Upmarket degustation menu for two with wine: €200–400

- Taxi across town: €20–40

Useful Websites

Lonely Planet (www.lonelyplanet.com/scandinavia) Destination information, hotel bookings, traveller forum and more.
Go Scandinavia (www.goscandinavia.com) Combined tourist board website for the four mainland Nordic countries.
Direct Ferries (www.directferries.com) Useful booking site for Baltic and Atlantic ferries.

What to Take

- HI membership card, towel and sleep sheet for hostels.

- Tent and sleeping bag for hiking – huts fill fast.

- Powerful insect repellent in summer.

- Eye mask for the never-setting summer sun.

- Swimsuit – there are lots of hot springs, hotel spas and lakes to jump in.

Arriving in Scandinavia

Copenhagen Kastrup Airport The metro and trains run very regularly into the centre (15 minutes). Around 300kr for the 20-minute taxi ride.
Stockholm Arlanda Airport Express trains run all day to Stockholm; airport buses are cheaper but slower. Think 500kr for the 45-minute taxi drive.
Oslo Gardermoen Airport Regular shuttle buses make the 40-minute journey to the centre. Trains run from the airport into the centre of Oslo in 20 minutes. A taxi costs 700kr to 900kr.
Helsinki Vantaa Airport It's a half-hour train ride from the airport to the centre. Local buses and faster Finnair buses do it in 30 to 45 minutes. Plan on €45 to €55 for the half-hour taxi trip.
Keflavík Airport (Reykjavík) Buses run the 45-minute journey into Reykjavík. Taxis charge around kr16,000.

Getting Around

Getting around Scandinavia's populated areas is generally a breeze, with efficient public transport and snappy connections. Remote regions usually have trustworthy but infrequent services.

Bus Comprehensive network throughout region; only choice in many areas.

Train Efficient services in the continental nations, none in Iceland.

Car Drive on the right. Hire is easy but not cheap. Few motorways, so travel times can be long. Compulsory winter tyres.

Ferry Great-value network around the Baltic; spectacular Norwegian coastal ferry, and service to Iceland via the Faroe Islands.

Bike Very bike-friendly cities and many options for longer cycling routes. Most transport carries bikes for little or no charge. Hire widely available.

Planes Decent network of budget flights connecting major centres. Full-fare flights comparatively expensive.

For more on **getting around**, see p305

Plan Your Trip
Hot Spots for...

Beautiful Landscapes

There are few more beautiful corners of Europe, with dramatic landscapes of astonishing variety across the region.

NICK TSIATINIS/GETTY IMAGES ©

Norway's Fjords (p214)
Norway's fjords have to be seen to be believed, with vertiginous rock walls rising above ice-blue waters.

Geirangerfjorden
Norway has many amazing fjords, but none can rival this one (p220).

Southeastern Iceland (p94)
A haunting world of stark volcanoes and black beaches, and vast, empty landscapes of rare, singular beauty.

Jökulsárlón Glacial Lagoon
The gravitas of glaciers is nowhere more accessible than here (p98).

Lakeland, Finland (p134)
There are few more splendid lake landscapes on earth than the Lakeland district.

Seal Lakes
Kolovesi and Linnansaari National Parks are the prettiest (p138).

Activities

Hike the high country in summer or dog-sled across the ice in winter. Scandinavia has numerous opportunities to get active and explore.

V. BELOV/SHUTTERSTOCK ©

Vatnajökull National Park (p102)
All of Iceland's beauty is found within the boundaries of this park, especially epic ice-caps and fiery volcanoes.

Hiking
Fabulous trails that take you beyond the crowds (p102).

Tromsø (p160)
Whatever the season, Tromsø is one of Scandinavia's most appealing places for getting out into the wilds.

Dog-sledding
Let a husky team pull you across a frozen wilderness (p170).

Voss (p230)
Voss is filled with adventure-sport possibilities, and the backdrop is guaranteed to be breathtaking.

Kayaking
Paddle quiet fjord waters beneath soaring rocky cliffs (p231).

Urban Style

Scandinavia's countries have a particular flair for design. The results are ubercool, from shopping possibilities to cutting-edge architecture.

ANDREY SHCHERBUKHIN/SHUTTERSTOCK ©

Helsinki (p114)
Exemplifying Scandinavia's style aesthetic, with its designer boutiques, design districts and daring architecture.

Design District
A museum and neighbourhood devoted to creativity (p120).

Stockholm (p236)
With stunning traditional architecture wedded to contemporary innovation, this is one of the world's most stylish cities.

Skansen
Proof Swedes have been style leaders for centuries (p247).

Tallinn (p258)
A northern European gem of cohesive, uniformly beautiful architecture in a lovely setting by the Baltic Sea.

Old Town
Tallinn's medieval core is like an open-air museum (p266).

Nordic Cuisine

In keeping with Scandinavia's devotion to improving the important things in life, the region's cuisine is both trailblazing and rooted in tradition.

JOANNE MOYES/ALAMY STOCK PHOTO ©

Copenhagen (p34)
If one city epitomises the daring nature of Scandinavia's culinary revolution, it's Copenhagen.

Höst
Affordable New Nordic menus and gorgeous interiors (p49).

Stockholm (p236)
Combining the freshest culinary ingredients of the highest quality with an avant-garde mindset.

Kryp In
Innovation in classy surrounds with no pretensions (p252).

Bergen (p222)
As with most good things in life, Bergen does culinary with freshness and flair.

Torget Fish Market
Finest seafood ready to eat, old-style, right by the water (p227).

Plan Your Trip
Local Life

Activities

Scandinavia is ripe for exploration, and the opportunities to do so in the great outdoors are many and varied. Of the summer activities, hiking is easily the pick, with trails crossing the region within sight of Icelandic volcanoes and glaciers and Norwegian fjords. Boat trips, too, are a fabulous way to see the region's most extraordinary scenery, from glacial lagoons in Iceland to the abundant lakes of Finland's Lakeland district. In winter, dog-sledding is something of a Scandinavian specialty and a marvellous way to experience ice-bound wilderness areas in the high Arctic. And then there's Voss, Scandinavia's adventure-sports capital.

Shopping

Even if you're not normally the shopping kind, Scandinavia may just convince you to make an exception to the habits of lifetime. 'Design' is a much-hyped part of the Scandinavian experience – and with

very good reason. From homewares and furnishings (so much more than Ikea) to fashion in all its forms, the region's designers are world leaders, with a particular leaning towards the clean lines and minimalist sensibilities so associated with the Nordic aesthetic. Another must-shop experience is gourmet foods and markets, the perfect complement to the region's restaurant culinary excellence, and as good for buying gifts as for planning a picnic.

Entertainment

Nights in Scandinavia are, at least in urban centres, lively and long-lasting, and much of the nightlife centres around live music. All cities of the region have their particular favourites, from the hard-rock temples of Bergen to the Icelandic pop of Reykjavík, while Copenhagen, Helsinki and Stockholm all have their devotees. Excellent classical music venues and programs, as well as theatre, where you can see works by local

luminaries such as Ibsen, ensure that most tastes are catered for.

Eating

Scandinavian cooking, once viewed as meatballs, herring and little else, has wowed the world in recent years with New Nordic cuisine, a culinary revolution that centred on Copenhagen. While the crest of that wave has now passed, the 'foraging' ethos it championed has made a permanent mark here. It showcases local produce prepared using traditional techniques and contemporary experimentation, and clean, natural flavours.

In the wake of Copenhagen's Noma, which became known as the world's best eatery (but is temporarily closed), numerous upmarket restaurants opened and have flourished across the region's capitals, which are now a foodie's delight. Traditional eateries still abound, however, and are focused on old-school staples.

★ Best for Architecture

Oslo Opera House (p203)

Göteborgs-Utkiken (p181)

Old Town, Tallinn (p287)

Sami Parliament (p162)

Arctic Cathedral (p160)

Drinking & Nightlife

Scandinavians are enthusiastic drinkers, although strong alcohol in Sweden, Norway and Finland can only be bought in state stores. Beer is ubiquitous, and the microbrewery and boutique beer phenomenon has deep roots in the Scandinavian psyche. Each nation also has its own favourite shot to clear the head. Coffee is also an obsession, especially in Norway, and a refined yet casual cafe culture is a deeply ingrained feature for locals and travellers alike.

From left: Ibsen Museet (p202), Oslo; Foraging, Denmark

Plan Your Trip
Month by Month

February
🎪 Rørosmartnan, Norway
An old-fashioned and traditional winter fair (http://rorosmartnan.no) livens the streets of the historic Norwegian town of Røros.

👁 Jokkmokk Winter Market, Sweden
The biggest Sami market (www.jokkmokks marknad.se) of the year, with all manner of crafts for sale, preceded by celebrations of all things Sami, featuring reindeer races on the frozen lake.

March
🛷 Sled Safaris & Skiing, Northern Norway, Sweden & Finland
Whizzing across the snow pulled by a team of huskies or reindeer is a pretty spectacular way to see the northern wildernesses. Add snowmobiling or skiing to the mix and it's a top time to be at high latitude.

☆ Reindeer Racing, Finland
Held over the last weekend of March or first of April, the King's Cup (www.siida.fi) is the grand finale of Finnish Lapland's reindeer-racing season and a great spectacle.

April
🎪 Sami Easter Festival, Norway
Thousands of Sami participate in reindeer racing, theatre and cultural events in the Finnmark towns of Karasjok and Kautokeino (www.samieasterfestival.com). The highlight is the Sami Grand Prix, a singing and *yoiking* (traditional singing) contest attended by artists from across Lapland.

☆ Jazzkaar, Tallinn
Late April sees jazz greats from all around the world converge on Estonia's picturesque capital for this series of performances (www.jazzkaar.ee).

Above: Roskilde Festival (p24), Denmark

MATT MUNRO/LONELY PLANET ©

May
🎊 Aalborg Carnival, Denmark
In late May, Aalborg kicks up its heels hosting the biggest Carnival (www.aalborgkarneval.dk) celebrations in northern Europe, when up to 100,000 participants and spectators shake their maracas and paint the town red.

🎊 Bergen International Festival, Norway
One of the biggest events on Norway's cultural calendar, this two-week festival (www.fib.no), beginning in late May, showcases dance, music and folklore presentations – some international, some focusing on traditional local culture.

June
☆ Stockholm Jazz Festival, Sweden
Held on the island of Skeppsholmen in the centre of Stockholm, this well-known jazz fest (www.stockholmjazz.com) brings artists from all over, including big international names.

★ Best Festivals
Midsummer, June

Sled safaris & skiing, March

Roskilde Festival, June & July

Aurora Watching, November

Christmas, December

🎊 Midsummer, Denmark, Norway, Sweden & Finland
The year's biggest event in continental Nordic Europe sees fun family feasts, joyous celebrations of the summer, heady bonfires and copious drinking, often at normally peaceful lakeside summer cottages. Held on the weekend between 19 and 26 June.

🎊 Frederikssund Vikingespil, Denmark
Held in Frederikssund over a three-week period (late June to early July), this Viking

Above: Midsummer, Sweden

festival (www.vikingespil.dk) includes a costumed open-air drama and a banquet with Viking food and entertainment.

July

☆ Copenhagen Jazz Festival, Denmark

The capital's biggest entertainment event of the year offers 10 days of music at the start of July. The festival (p47) features a range of Danish and international jazz, blues and fusion music, with more than 500 indoor and outdoor concerts.

☆ Roskilde Festival, Denmark

Northern Europe's largest music festival (www.roskilde-festival.dk) rocks Roskilde each summer. It takes place in early July, but advance ticket sales are on offer around October and the festival usually sells out.

☆ Ruisrock, Finland

Finland's oldest and possibly best rock festival (www.ruisrock.fi) has top local and international acts, in early July on an island just outside the southwestern city of Turku.

☆ Wife-Carrying World Championships, Finland

The world's premier wife-carrying event (p153) is held in the village of Sonkajärvi in early July. Winning couples (marriage not required) win the woman's weight in beer as well as significant kudos.

☆ Moldejazz, Norway

Norway has a fine portfolio of jazz festivals, but Molde's version (www.moldejazz.no) in mid-July is the most prestigious. With 100,000 spectators, world-class performers and a reputation for high-quality music it is easily one of Norway's most popular festivals.

August

✥ Þjóðhátíð, Iceland

Held over the first weekend in August, this festival (www.dalurinn.is) on the Vestmannaeyjar islands is Iceland's biggest knees-up, with three days of music, fireworks and frivolity. It's a big thing for young Icelanders; an enormous bonfire is a focal point.

☆ Smukfest, Denmark

This midmonth music marvel (www.smukfest.dk) in Skanderborg bills itself as Denmark's most beautiful festival, and is second only to Roskilde in terms of scale. It takes place in lush parkland in the scenic Lake District and attracts up to 40,000 music fans.

✥ Copenhagen Cooking & Food Festival, Denmark

Scandinavia's largest food festival (p48) focuses on the gourmet. It's a busy event that lets you see presentations from top chefs, go on food-oriented tours of the city and taste produce.

September

☆ Reykjavík International Film Festival, Iceland

This annual event (www.riff.is) right at the end of September sees blockbusters make way for international art films in cinemas across the city, as well as talks from film directors from home and abroad.

November

☉ Aurora Watching, Iceland, Norway, Sweden & Finland

Whether you are blessed with seeing the aurora borealis is a matter of luck, but the further north you are, the better the chances. Dark, cloudless nights, patience and a viewing spot away from city lights help.

☆ Stockholm International Film Festival, Sweden

Screenings of new international and independent films, director talks and discussion panels draw cinephiles to this important annual festival (www.stockholmfilmfestival.se).

December

✥ Christmas, Region-wide

Whether visiting Santa and his reindeer in Finnish Lapland, admiring the magic of Copenhagen's Tivoli at night or sampling home-baked delicacies, Christmas, especially if you know a friendly local family, is a heart-warming time to be here.

Plan Your Trip
Get Inspired

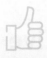

Read

Njál's Saga (Anonymous; 13th century) Gloriously entertaining Icelandic story of a bloody family feud.

A Death in the Family (Karl Ove Knausgaard; 2009) First of six searingly honest autobiographical novels.

Kalevala (Elias Lönnrot; 1849) Finland's national epic is a wonderful world of everything from sorcerer-shamans to saunas and home-brewing.

The Emperor's New Clothes (Hans Christian Andersen; 1837) One of Andersen's most famous tales.

The Girl with the Dragon Tattoo (Stieg Larsson; 2005) The first book of the Swedish noir trilogy that captured the world.

Watch

Wild Strawberries (1957) Ingmar Bergman's sensitivity comes to the fore in this masterpiece.

The Man without a Past (2002) Quirky Finnish brilliance from Aki Kaurismäki.

Dancer in the Dark (2000) Provocative director Lars von Trier and Björk combine in this melodramatic but masterful film.

The Bridge (2011) This excellent series takes place between Sweden and Denmark.

Let the Right One In (2008) Superb vampire romance in a northern town.

Sameblod (2016) A stark reminder of historic attitudes to the Sami.

Listen

Máttaráhku Askái (Ulla Pirttijärvi; 2002) Haunting title track from the yoik-inspired Sami artist.

Ghost Love Score (Nightwish; 2004) Epic track from Finland's symphonic metal masters.

Cocoon (Björk; 2001) Among the Icelander's most intimate songs.

In the Hall of the Mountain King (Edvard Grieg; 1875) Brilliant soundtrack to *Peer Gynt's* troll scene.

The Final Countdown (Europe; 1986) You know you love it.

Best of ABBA (ABBA; 1975) It's impossible to pick a favourite.

Barbie Girl (Aqua; 1997) Denmark's all-time No 1.

Above: Sculpture of Hans Christian Andersen in Kongens Have (p45), Copenhagen

Plan Your Trip
Five-Day Itineraries

Nordic Cities

This intense five-day itinerary will allow you to savour the buzz of Scandinavia's stylish and happening cities, even as it will leave you longing for more – this is a taster and a fine first foray into the region.

Seal Lakes (p138) Kolovesi and Linnansaari National Parks to showcase the Lakeland region at its best.

Savonlinna (p144) Explore the castle, take a boat trip and seek out the New Valamo Monastery, all in a day. Take a day tour 🚍 or 🚗 1½ hrs to Seal Lakes

Helsinki (p114) Revel for a day in the design-rich environment where art nouveau meets Soviet functionalism. 🚍 4½ hrs to Savonlinna

Tallinn (p258) Estonia's capital is easy to reach from across Europe and the reward is a medieval gem (one day). ✈ 30 mins or 🚢 2 hrs to Helsinki

FROM LEFT: KAVALENKAU/SHUTTERSTOCK ©, ILOZAVR/SHUTTERSTOCK ©

Echoes of the East

With Russia looming large to the east, Scandinavia's eastern Baltic regions feel like nowhere else. Beyond the cities, you'll leave behind one expanse of water for another, for the lakes that are such a feature of Finland.

Bergen (p222)
Fly into Bergen and spend a day exploring one of the most beautiful small cities on earth.
✈ 1¼ hrs to Copenhagen

Copenhagen (p34)
Spend a couple of days exploring the Danish capital with an emphasis on taking in its culinary, design and architectural offering.
✈ 1¼ hrs to Stockholm

Stockholm (p236) Soak up the style, views and ambient buzz of urban Scandinavia with a couple of days in this elegant city.

Plan Your Trip
10-Day Itinerary

Nature's Canvas

The formerly Viking lands of Iceland and Norway are intense rivals when it comes to choosing the most beautiful country on earth. Then again, if you've ten days up your sleeve, why not visit both and make up your own mind?

Vatnajökull National Park (p102) A day's hiking here is like a crash course in wild Iceland.
🚗 1 hr 40 min

Jökulsárlón Glacial Lagoon (p98) Spend a day on boats and on foot in one of Iceland's star attractions. 🚗 1¼ hrs to Vatnajökull National Park

Viðey (p74) Echoes of the past dominate the ruins of this uninhabited island.
⚓ 1¼ hrs, then 🚗 6 hrs

Höfn (p106) This Southeast harbour town is a good stopover on the way to see Jökulsárlón.
🚗 1 hr 5 min

Vík (p100) Otherworldly black beaches in a strange and wonderful land. 🚗 2½ hrs, then ✈ 1 hr 10 min to Bergen

Reykjavik (p72) Iceland's capital is a fascinating city and the gateway to all things Icelandic. ⚓ day trip

Aurlandsfjorden (p221) A front-row seat to some of Norway's best fjord views.
🚗 ¼ hrs to Flåm

Bergen (p218) Explore this stunning harbourside town and fjord gateway. 🚗 2 hrs 45 mins to Aurlandsfjorden

Flåm (p221) A good base for accommodation and supplies while visiting the Norway fjords.

Plan Your Trip
Two-Week Itinerary

Scandinavia Grand Tour

Sophisticated cities, wild landscapes, soulful indigenous inhabitants. You'll need to keep on the move, but you can experience all of these in two relentlessly pleasurable weeks, visiting Norway, Finland and Denmark along the way.

Tromsø (p160) Visit the museums, take the cable car and get active hiking or dog-sledding ✈ 1 hr 10 min from Bodø

Karasjok (p162) Immerse yourself in Sami culture through museums, a theme park and architecture (one day). 🚗 7 hrs from Tromsø

Lofoten Islands (p167) Fly to Bodø, then transfer by ferry to the Lofoten Islands. ⚓ 3 hrs

Bodø

Inari (p162) Experience the Finnish side of Sami life with top-notch cultural attractions for a day. 🚗 1½ hrs from Karasjok

Rovaniemi (p158) Say hi to Santa Claus, visit the museum and explore the hinterland (two days). 🚗 4 hrs from Inari

Oslo (p194) Norway's capital, and increasingly an icon of Scandi cool, is worth at least a couple of days. ✈ 1½ hrs to Lofoten Islands

Helsinki (p114) Fly to Helsinki and marvel at the spectacular architecture & local design. ✈ 1¼ hrs from Rovaniemi to Helsinki

Copenhagen (p34) Enjoy the urban sophistication of Scandinavia's coolest city. ✈ 1½ hrs from Helsinki

Bornholm (p54) Explore remote Baltic reaches and seek out the curious round churches (two days). ✈ 40 min from Copenhagen

Plan Your Trip
Family Travel

The Low-down

Most of Scandinavia is very child-friendly, with domestic tourism largely dictated by the needs of those travelling as families. Theme parks, amusement parks, zoos and child-friendly beaches and activities are just part of the story, and although there are exceptions, businesses go out of their way to woo families, and children are rarely made to feel unwelcome. Most sights and activities are designed with kids in mind, with free or reduced admission for under-18s and plenty of hands-on exhibits. And what other region of the world can possibly claim such an iconic place to fuel a child's imagination as the home of Santa Claus?

Accommodation

Bigger camping grounds and spa hotels are particularly kid-conscious, with heaps of facilities and activities designed with children in mind. Cots (cribs) are standard in many hotels but numbers may be limited.

Activities

In Denmark, Finland, Norway and Sweden you'll find excellent theme parks, waterparks and holiday activities. Many museums have a dedicated children's section with toys, games and dressing-up clothes.

Iceland is something of an exception: children are liked and have lots of freedom, but they're treated as mini-adults, and there aren't many attractions tailored specifically for kids.

Resources

For all-round information and advice, check out Lonely Planet's *Travel with Children*.

Practicalities

○ Baby food, infant formula, soy and cow's milk, disposable nappies (diapers) etc are widely available in Scandinavian supermarkets.

○ Car-rental firms hire out children's safety seats at a nominal cost, but advance bookings are essential.

○ High chairs are standard in many restaurants but numbers may be limited.

○ Restaurants will often have children's menu options, and there are lots of chain eateries aimed specifically at families.

○ Breastfeeding in public is common and often officially encouraged.

○ Many public toilets have baby-changing facilities.

○ Remember that distances in Scandinavia are vast and careful planning is required. Try not to cover too much ground (so as to avoid spending too much time in the car) and consider flying where possible.

When to Go

Easily the best time to travel in Scandinavia with children is the main tourist season that runs from mid-June to mid-August – this is when hotels offer the best deals for families, all sights and attractions are open and the weather is more conducive to a happy family holiday.

★ Best Child-friendly Attractions

Liseberg (p183)

Olavinlinna (p138)

Dog-sledding (p170)

Vikingskipshuset (p198)

Aurora Borealis (p6)

If you've come to Scandinavia for the northern lights or winter activities such as dog-sledding, don't be put off by the bitterly cold weather. It's all about coming prepared with the appropriate clothes (Scandinavian families don't hide in their homes for 10 months of the year!) and winter can be a magical time to be here.

From left: Liseberg (p183), Gothenburg, Sweden; Aurora Borealis, Norway

De Kongelige
Repræsentationslokaler
(p45)

Arriving in Copenhagen

Copenhagen Airport (p52) is Scandinavia's busiest hub (in Kastrup, 9km southeast of the city centre) with direct flights to cities in Europe, North America and Asia, plus a handful of Danish cities. It has good eating, retail and information facilities.

Long-distance trains arrive at **Københavns Hovedbanegård**, a 19th-century, wood-beamed hall with currency exchange, a post office, left-luggage facilities and food outlets.

Where to Stay

Copenhagen's accommodation options range from high-end design establishments to excellent budget hotels and hostels, which are mostly on the western side of the Central Station. Reserve well in advance, especially hostels, during the busy summer season.

The **Copenhagen Visitors Centre** (p52) can book rooms in private homes. Depending on availability, it also books unfilled hotel rooms at discounted rates.

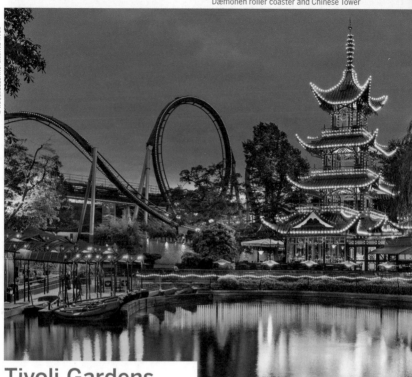

Dæmonen roller coaster and Chinese Tower

Tivoli Gardens

The country's top-ranking tourist draw, tasteful Tivoli Gardens has been eliciting gleeful thrills since 1843. Whatever your idea of fun – hair-raising rides, twinkling pavilions, open-air stage shows or alfresco pantomime and beer – this old-timer has you covered.

Great For...

Don't Miss

The city views, taken at 70km/h, from the Star Flyer, one of the world's tallest carousels.

Roller Coasters

The Rutschebanen is the best loved of Tivoli's roller coasters, rollicking its way through and around a faux 'mountain' and reaching speeds of 60km/h. Built in 1914, it claims to be the world's oldest operating wooden roller coaster. If you're after something a little more hardcore, the Dæmonen (Demon) is a 21st-century beast with faster speeds and a trio of hair-raising loops.

The Grounds

Beyond the carousels and side stalls is a Tivoli of landscaped gardens, tranquil nooks and eclectic architecture. Lower the adrenalin under beautiful old chestnut and elm trees, and amble around Tivoli Lake. Formed out of the old city moat, the lake is a top spot to snap pictures of Tivoli's commanding Chinese Tower, built in 1900.

Tivoli Gardens entrance gate

❶ Need to Know

Tivoli Gardens (☎33 15 10 01; www.tivoli.dk; Vesterbrogade 3; adult/child under 8yr 120kr/free, Fri after 7pm 160kr/free; ⊙11am-11pm Sun-Thu, to midnight Fri & Sat early Apr-late Sep, reduced hours rest of year; 🚼; 🚌2A, 5C, 9A, 12, 14, 26, 250S, Ⓢ København H)

✕ Take a Break

Jolly **Grøften** (www.groeften.dk; ⊙noon-11pm Sun-Thu, to midnight Fri & Sat early Apr-late Sep; 🛜) is a local institution.

> ★ **Top Tip**
> Rides cost 25kr to 75kr; a multiride ticket is 220kr.

Pantomime Theatre

Each night during the summer this criminally charming theatre presents silent plays in the tradition of Italy's Commedia dell'Arte. Many of the performers also work at the esteemed Royal Ballet.

Illuminations & Fireworks

Throughout the summer season, Tivoli Lake wows the crowds with its nightly laser and water spectacular. The Saturday evening fireworks are a summer-season must, repeated again from 26 to 30 December for Tivoli's annual Fireworks Festival.

When to Go

After dusk Tivoli is at its most enchanting when the park's fairy lights and lanterns are switched on.

Friday evenings From early April to mid-September, the open-air Plænen stage hosts free rock concerts from 10pm – go early if it's a big-name act.

Halloween Tivoli opens for around three weeks. See the website for details.

Christmas From mid-November to early January, Tivoli hosts a large market with costumed staff and theatre shows. There are fewer rides, but the gløgg (mulled wine) and æbleskiver (small doughnuts) are ample compensation.

Live Performances

The indoor **Tivolis Koncertsal** (Concert Hall; www.tivoli.dk; Tietgensgade 30; 🚌1A, 2A, 5C, 9A, 37, 250S, Ⓢ København H) hosts mainly classical music, with the odd musical and big-name pop or rock act. All tickets are sold at the **Tivoli Billetcenter** (☎33 15 10 01; Vesterbrogade 3; ⊙10am-10.45 Sun-Thu, to 11.45pm Fri & Sat summer, 10am-6pm Mon-Fri rest of year; 🚌2A, 12, 14, 26, 250S, Ⓢ København H) or through the Tivoli website.

EVIKKA/SHUTTERSTOCK ©

Designmuseum Danmark

Don't know your Egg from your Swan? What about your PH4 from your PH5? For a crash course in Denmark's incredible design heritage, make an elegant beeline for Designmuseum Danmark.

Great For...

Don't Miss

The iconic 1959 vintage poster 'Wonderful Copenhagen' – a duck and her little ones stopping traffic.

Housed in a converted 18th-century hospital, the museum is a must for fans of the applied arts and industrial design. Its booty includes Danish silver and porcelain, textiles and the iconic design pieces of modern innovators such as Kaare Klint, Poul Henningsen, Arne Jacobsen and Verner Panton.

20th-Century Crafts & Design

The museum's main permanent exhibition explores 20th-century industrial design and crafts in the context of social, economic, technological and theoretical changes. The collection displays celebrated furniture and applied arts from Denmark and abroad.

PERNILLE KLEMP/DESIGNMUSEUM DANMARK ©

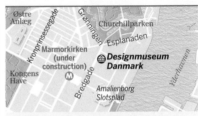

ℹ Need to Know

Designmuseum Danmark (www.designmuseum.dk; Bredgade 68; adult/child 100kr/free; ◷11am-5pm Tue & Thu-Sun, to 9pm Wed; ☒1A, Ⓜ Kongens Nytorv) is 250m north of Marmorkirken.

✕ Take a Break

The museum's Klint Cafe, just off the lobby, serves Danish classics and has a fine outdoor courtyard.

★ Top Tip

The museum shop is one of the city's best places to pick up savvy gifts and easy-to-carry souvenirs.

Fashion & Fabric

This permanent exhibition showcases around 350 objects from the museum's rich textile and fashion collections. Spanning four centuries, the collection's treasures include French and Italian silks, ikat and batik weaving, and two extraordinary mid-20th-century tapestries based on cartoons by Henri Matisse. As would you expect, Danish textiles and fashion feature prominently, including Danish *hedebo* embroidery from the 18th to 20th centuries, and Erik Mortensen's collection of haute couture frocks from French fashion houses Balmain and Jean-Louis Scherrer.

The Danish Chair

An ode to the humble chair and an exploration of what goes into making a 'good' one, this permanent exhibition displays more than 100 beautifully designed chairs, including some international guests. Standing room only.

Porcelain

This detailed exhibition celebrates European porcelain and its journey from initial attempts through to the current day.

Danish Design Now

Showcasing contemporary fashion, furniture and products, this captivating exhibition focuses on 21st-century Danish design and innovation.

Central Copenhagen

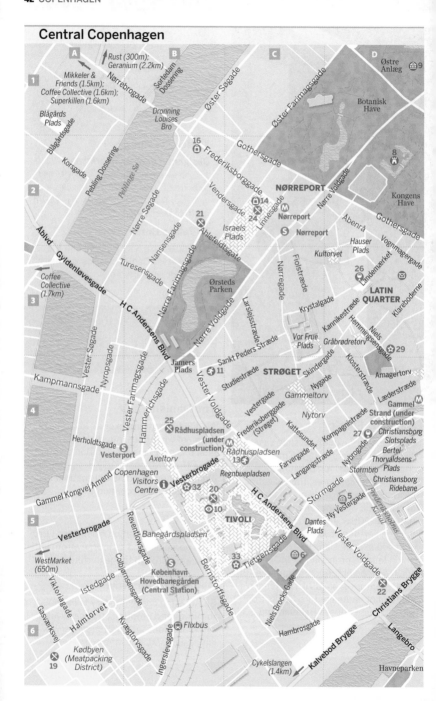

Rust (300m);
Geranium (2.2km)

Mikkeler &
Friends (1.5km);
Coffee Collective (1.6km);
Superkillen (1.6km)

Blågårds
Plads

Nørrebrogade

Sortedam Dossering

Øster Søgade

Øster Farimagsgade

Østre
Anlæg

9

Botanisk
Have

8

Blågårdsgade

Korsgade

Dronning
Louises
Bro

16

Frederiksborggade

Gothersgade

NØRREPORT

Kongens
Have

Pebling Dossering

Peblinge Sø

Vendersgade

21

Israels
Plads

14

24

Linnésgade

Nørreport

Nørre Voldgade

Abenrå

Gothersgade

Ablvd

Gyldenløvesgade

Nørre Søgade

Nansensgade

Ahlefeldtsgade

Nørreport

Hauser
Plads

Vognmagergade

Coffee
Collective
(1.7km)

Turesensgade

H C Andersens Blvd

Nørre Farimagsgade

Ørsteds
Parken

Nørregade

Fiolstræde

Kultorvet

26

Møntergade

LATIN
QUARTER

Vester Søgade

Nørre Voldgade

Larslejsstræde

Krystalgade

Kannikestræde

Niels
Hemmingsensgade

Klareboderne

Nyropsgade

Kampmannsgade

Vester Farimagsgade

Jarmers
Plads

11

Sankt Peders Stræde

Studiestræde

Vor Frue
Plads

Gråbrødretorv

29

Vester Voldgade

STRØGET

Skindergade

Klosterstræde

Amagertorv

Herholtsgade

Hammerichsgade

25

Rådhuspladsen
(under
construction)

Vestergade

Frederiksberggade
(Strøget)

Gammeltorv

Nytorv

Kattesundet

Vesterport

Axeltorv

Rådhuspladsen

Farvergade

Kompagnistræde

Nygade

Nybrogade

27

Læderstræde

Gammel
Strand (under
construction)

Christiansborg
Slotsplads

Bertel
Thorvaldsens
Plads

Gammel Kongevej Amend

Copenhagen
Visitors
Centre

Vesterbrogade

32

20

Regnbuepladsen

13

Løngangstræde

Stormbro

Stormgade

Christiansborg
Ridebane

10

TIVOLI

Dantes
Plads

5

Ny Vestergade

Vester Voldgade

Vesterbrogade

Reventlowsgade

Banegårdspladsen

H C Andersens Blvd

Frederiksholms Kanal

Christians Brygge

WestMarket
(650m)

Colbjørnsensgade

Bernstorffsgade

33

Tietgensgade

6

Langebro

Istedgade

Viktoriagade

Gasværksvej

Halmtorvet

Kvægtorvsgade

København
Hovedbanegården
(Central Station)

Niels Brocks Gade

Vester Voldgade

22

Kødbyen
(Meatpacking
District)

19

Ingerslevsgade

Flixbus

Hambrosgade

Cykelslangen
(1.4km)

Kalvebod Brygge

Havneparken

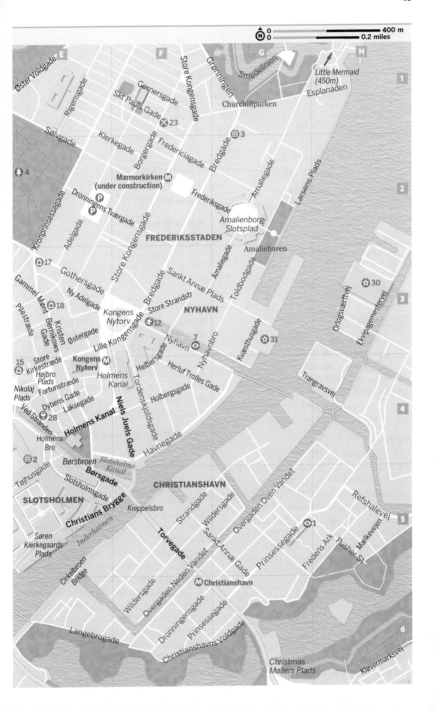

Central Copenhagen

SIGHTS

One of the great things about Copenhagen is its size. Virtually all of Copenhagen's major sightseeing attractions are in or close to the medieval city centre. Only the perennially disappointing **Little Mermaid** (Den Lille Havfrue; Langelinie, Østerport; ☐1A, 🚢Nordre Toldbod) lies outside the city, on the harbourfront.

Nyhavn
Canal

(Nyhavn; ☐1A, 26, 66, 350S, Ⓜ Kongens Nytorv) There are few nicer places to be on a sunny day than sitting at the outdoor tables of a cafe on the quayside of the Nyhavn canal. The canal was built to connect Kongens Nytorv (Copenhagen's largest square) to the harbour and was long a haunt for sailors and writers, including Hans Christian Andersen, who lived there for most of his life at, variously, No. 20, 18 and 67.

Nationalmuseet
Museum

(National Museum; ☎33 13 44 11; www.natmus. dk; Ny Vestergade 10; adult/child 75kr/free; ☺10am-5pm Tue-Sun, also open Mon Jul & Aug; ♿; ☐1A, 2A, 9A, 14, 26, 37, ⓈKøbenhavn H) For a crash course in Danish history and culture, spend an afternoon at Denmark's National Museum. It has first claims on virtually every antiquity uncovered on Danish soil, including Stone Age tools, Viking weaponry, rune stones and medieval jewellery. Among the many highlights is a finely crafted 3500-year-old Sun Chariot, as well as bronze *lurs* (horns), some of which date back 3000 years and are still capable of blowing a tune.

Ny Carlsberg Glyptotek
Museum

(☎33 41 81 41; www.glyptoteket.dk; Dantes Plads 7, HC Andersens Blvd; adult/child 95kr/free, Tue free; ☺11am-6pm Tue-Sun, until 10pm Thu; ☐1A, 2A, 9A, 37, ⓈKøbenhavn H) Fin de siècle architecture dallies with an eclectic mix of art at Ny Carlsberg Glyptotek. The collection is divided into two parts: Northern Europe's largest trove of antiquities, and an elegant collection of 19th-century Danish and French art. The latter includes the largest collection of Rodin sculptures outside France and no less than 47 Gauguin paintings. These are displayed along with works by greats like Cézanne, Van Gogh, Pissarro, Monet and Renoir.

An added treat for visitors is the August/ September Summer Concert Series (admission around 75kr). Classical music is performed in the museum's concert

hall, which is evocatively lined by life-size statues of Roman patricians.

De Kongelige Repræsentationslokaler Historic Building

(Royal Reception Rooms at Christiansborg Slot; www.christiansborg.dk; Slotsholmen; adult/child 90kr/free; ⊙10am-5pm daily May-Sep, closed Mon Oct-Apr, guided tours in Danish/English 11am/3pm; 🚌1A, 2A, 9A, 26, 37, 66, 🚢Det Kongelige Bibliotek) The grandest part of Christiansborg Slot is De Kongelige Repræsentationslokaler, an ornate Renaissance hall where the queen holds royal banquets and entertains heads of state. Don't miss the beautifully sewn and colourful wall tapestries depicting Danish history from Viking times to today. Created by tapestry designer Bjørn Nørgaard over a decade, the works were completed in 2000. Look for the Adam and Eve–style representation of the queen and her husband (albeit clothed) in a Danish Garden of Eden.

Rosenborg Slot Castle

(☑33 15 32 86; www.kongernessamling.dk/en/rosenborg; Øster Voldgade 4A; adult/child 110kr/free, incl Amalienborg Slot 145kr/free; ⊙9am-5pm mid-Jun–mid-Sep, reduced hours rest of year; 🚌6A, 42, 184, 185, 350S, 🅼Nørreport, 🆂Nørreport) A 'once-upon-a-time' combo of turrets, gables and moat, the early-17th-century Rosenborg Slot was built in Dutch Renaissance style between 1606 and 1633 by King Christian IV to serve as his summer home. Today, the castle's 24 upper rooms are chronologically arranged, housing the furnishings and portraits of each monarch from Christian IV to Frederik VII. The pièce de résistance is the basement Treasury, home to the dazzling crown jewels.

Statens Museum for Kunst Museum

(☑33 74 84 94; www.smk.dk; Sølvgade 48-50; adult/child 110kr/free; ⊙11am-5pm Tue & Thu-Sun, to 8pm Wed; 🚌6A, 26, 42, 184, 185) 🆓 The National Gallery straddles two contrasting, interconnected buildings: a late-19th-century 'palazzo' and a sharply minimalist extension. The museum houses medieval and Renaissance works and impressive collections of

Dutch and Flemish artists including Rubens, Breugel and Rembrandt. It claims the world's finest collection of 19th-century Danish 'Golden Age' artists, among them Eckersberg and Hammershøi, foreign greats like Matisse and Picasso, and modern Danish heavyweights including Per Kirkeby.

Kongens Have Park

(King's Gardens; http://parkmuseerne.dk/kongens-have; Øster Voldgade; ⊙7am-11pm Jul–mid-Aug, to 10pm May–mid-Jun & mid-late Aug, reduced hours rest of year; 🚼; 🚌26, 🅼Nørreport, 🆂Nørreport) 🆓 The oldest park in Copenhagen was laid out in the early 17th century by Christian IV, who used it as his vegetable patch. These days it has a little more to offer, including immaculate flower beds, romantic garden paths and a marionette theatre with free performances during the summer season (2pm and 3pm Tuesday to Sunday).

Superkilen Park

(Nørrebrogade 210, Nørrebro; 🚌5C, 🆂Nørrebro) This fascinating 1km-long park showcases objects sourced from around the globe with the aim of celebrating diversity and uniting the community. Items include a tile fountain from Morocco, bollards from Ghana and swing chairs from Baghdad, as well as neon signs from Russia and China. Even the benches, manhole covers and rubbish bins hail from foreign lands.

🅶 TOURS

You can't visit Copenhagen and not take a canal boat trip. Not only is it a fantastic way to see the city, but you get a perspective that landlubbers never see. Be aware that in most boats you are totally exposed to the elements (even during summer).

Bike Copenhagen with Mike Cycling

(☑26 39 56 88; www.bikecopenhagenwithmike.dk; Sankt Peders Stræde 47; per person 299kr; 🚌2A, 5C, 6A, 14, 250S) If you don't fancy walking, Bike Mike runs three-hour cycling tours of the city, departing Sankt Peders Stræde 47 in the city centre, just east of Ørstedsparken (which is

southwest of Nørreport station). Mike is a great character and will really give you the insider's scoop on the city. Book online.

Copenhagen Free Walking Tours
Walking

(www.copenhagenfreewalkingtours.dk; Rådhuspladsen) Departing daily at noon from outside Rådhus (City Hall), these free, three-hour walking tours take in famous landmarks and include interesting anecdotes. Tours are in English and require a minimum of five people. Free 90-minute tours of Christianshavn depart at 4pm Friday to Monday from the base of the Bishop Absalon statue on Højbro Plads. A tip is expected.

Canal Tours Copenhagen
Boating

(☑32 96 30 00; www.stromma.dk; Nyhavn; adult/child 80/40kr; ☺9.30am-9pm late Jun–mid-Aug, reduced hours rest of year; 🚼; 🚌1A, 26, 66, 350S, Ⓜ️Kongens Nytorv) Canal Tours Copenhagen runs one-hour cruises of the city's canals and harbour, taking in numerous major sights, including Christiansborg Slot, Christianshavn, the Royal Library, Opera House, Amalienborg Palace and the Little Mermaid. Embark at Nyhavn or Ved Stranden. Boats depart up to six times per hour from late June to late August, with reduced frequency the rest of the year.

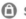 SHOPPING

Most of the big retail names and homegrown heavyweights are found on the main pedestrian shopping strip, Strøget. The streets running parallel are dotted with interesting jewellery and antique stores, while the so-called Latin Quarter, to the north, is worth a wander for books and clothing. Arty Nørrebro is home to Elmegade and Jægersborggade, two streets lined with interesting shops.

Bornholmer Butikken
Food & Drinks

(☑30 72 00 07; www.bornholmerbutikken.dk; Stall F6, Hall 1, Torvehallerne KBH; ☺10am-7pm Mon-Thu, to 8pm Fri, to 6pm Sat, 11am-5pm Sun; 🛜; 🚌15E, 150S, 185, Ⓜ️Nørreport, Ⓢ Nørreport) The 'Bornholm Store' in Torvehallerne Market offers a range of tasty take-home specialties from the Danish island of Bornholm, which is famed for its incredible local products. Tasty treats to bring home include honeys, relishes and jams, Johan Bulow liquorice, salamis, cheeses, herring, liquors and beers.

Operaen

SHE/SHUTTERSTOCK ©

Maduro
Homewares

(📞33 93 28 33; www.maduro.dk; Frederiksborggade 39; ⏰11am-6pm Mon-Fri, 10am-4pm Sat; 🚇5C) The motto of Maduro owner Jeppe Maduro Hirsch is that 'good style is more than decor and design.' His small shop is an eclectic mix of lovely products, including ceramics, posters and jewellery. The style ranges from sleek to traditional to quirky, and the selection of children's items is especially charming.

Posterland
Gifts & Souvenirs

(📞33 11 28 21; www.posterland.dk; Gothersgade 45; ⏰9.30am-6pm Mon-Thu, to 7pm Fri, to 5pm Sat; 🚇350S, Ⓜ Kongens Nytorv) Posterland is Northern Europe's biggest poster company, and is the perfect place to find something to spruce up your walls. The wide selection includes art, travel and vintage posters, as well as Copenhagen posters of every description including Danish icons Hans Christian Andersen, Tivoli Gardens and the Carlsberg Brewery. You can also pick up souvenirs like postcards, maps, calendars and magnets.

Hay House
Design

(📞42 82 08 20; www.hay.dk; Østergade 61; ⏰10am-6pm Mon-Fri, to 5pm Sat; 🚇1A, 2A, 9A, 14, 26, 37, 66, Ⓜ Kongens Nytorv) Rolf Hay's fabulous interior design store sells its own coveted line of furniture, textiles and design objects, as well as those of other fresh, innovative Danish designers. Easy-to-pack gifts include anything from notebooks and ceramic cups to building blocks for style-savvy kids. There's a second branch at Pilestræde 29-31.

Wood Wood
Fashion & Accessories

(📞35 35 62 64; www.woodwood.dk; Grønnegade 1; ⏰10.30am-6pm Mon-Thu, to 7pm Fri, to 5pm Sat, noon-4pm Sun; 🚇1A, 26, 350S, Ⓜ Kongens Nytorv) Unisex Wood Wood's flagship store is a veritable who's who of cognoscenti street-chic labels. Top of the heap are Wood Wood's own hipster-chic creations, made with superlative fabrics and attention to detail. The supporting cast includes solid knits from classic Danish brand SNS Herning, wallets from Comme des Garçons, and sunglasses from Kaibosh.

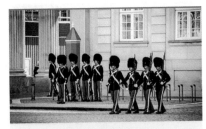

🚶 Changing of the Guard

The Royal Life Guard is charged with protecting the Danish royal family and their city residence, Amalienborg Palace. Every day of the year, these soldiers march from their barracks through the streets of Copenhagen to perform the **Changing of the Guard** (www.kongehuset.dk/en/changing-of-the-guard-at-amalienborg; Amalienborg Slotsplads; ⏰12pm daily; 🚇1A) **FREE**. Clad in 19th-century tunics and bearskin helmets, their performance of intricate manoeuvres is an impressive sight. If Queen Margrethe is in residence, the ceremony is even more grandiose, with the addition of a full marching band.

If you miss out on the noon ceremony, a smaller-scale shift change is performed every two hours thereafter.

Guards march near Amalienborg Palace

✪ ENTERTAINMENT

Copenhagen is home to thriving live-music and club scenes that range from intimate jazz and blues clubs to mega rock venues. Blockbuster cultural venues such as **Operaen** (Copenhagen Opera House; 📞box office 33 69 69 69; www.kglteater.dk; Ekvipagemestervej 10; 🚇9A, 🚢Operaen) and **Skuespilhuset** (Royal Danish Playhouse; 📞33 69 69 69; https://kglteater.dk; Sankt Anne Plads 36; 🚇66, 🚢Nyhavn, Ⓜ Kongens Nytorv) deliver top-tier opera and theatre. The **Copenhagen Jazz Festival** (www.jazz.dk; ⏰Jul), the largest jazz festival in northern Europe, hits the city over 10 days in early July.

 Christiania

Escape the capitalist crunch at Freetown **Christiania** (www.christiania.org; Prinsessegade; ⊞9A, ⊞Christianshavn), a free-spirited, eco-oriented commune with various beer gardens, communal eateries and live-music venues. Explore beyond the settlement's infamous 'Pusher St' and you'll stumble upon a semi-bucolic wonderland of whimsical DIY homes, cosy gardens and craft shops, eateries, beer gardens and music venues.

Before its development as an alternative enclave, the site was an abandoned 41-hectare military camp. When squatters took over in 1971, police tried to clear the area. They failed. Bowing to public pressure, the government allowed the community to continue as a social experiment. Self-governing, ecology-oriented and generally tolerant, Christiania residents did, in time, find it necessary to modify their 'anything goes' approach. A new policy was established that outlawed hard drugs, and the heroin and cocaine pushers were expelled.

The main entrance into Christiania is on Prinsessegade, 200m northeast of its intersection with Bådsmandsstræde. From late June to the end of August, 60- to 90-minute guided tours (40kr) of Christiania run daily at 3pm (weekends only September to late June). Tours start just inside Christiania's main entrance on Prinsessegade.

Freetown Christiania
SERG ZASTAVKIN/SHUTTERSTOCK ©

Jazzhouse
Jazz

(☎33 15 47 00; www.jazzhouse.dk; Niels Hemmingsensgade 10; ⊗from 7pm Mon-Thu, from 8pm Fri-Sat; 🛜; ⊞1A, 2A, 9A, 14, 26, 37) Copenhagen's leading jazz joint serves up top Danish and visiting talent, with music styles running the gamut from bebop to fusion jazz. Doors usually open at 7pm, with concerts starting at 8pm. On Friday and Saturday, late-night concerts (from 11pm) are also offered. Check the website for details and consider booking in advance for big-name acts.

⊗ EATING

Copenhagen remains one of the hottest culinary destinations in Europe, with more Michelin stars than any other Scandinavian city. **Copenhagen Cooking** (www.copenhagencooking.dk; ⊗Aug), Scandinavia's largest food festival, serves up a gut-rumbling program.

Lillian's Smørrebrød
Danish €

(☎33 14 20 66; www.facebook.com/lillianssmorrebrod; Vester Voldgade 108; smørrebrød from 17kr; ⊗6am-2pm Mon-Fri; ⊞1A, 2A, 9A) One of the best, the oldest (dating from 1978) and least costly smørrebrød places in the city, but word is out so you may have to opt for a takeaway as there are just a handful of tables inside and out. The piled-high, open-face sandwiches are classic and include marinated herring, chicken salad and roast beef with remoulade.

Chicky Grill
Danish €

(☎33 22 66 96; Halmtorvet 21, Vesterbro; mains from 65kr; ⊗11am-8pm Mon-Sat; ⊞10, 14, ⊟København H) Blend in with the locals at this perennially popular bar and grill in hip Kødbyen (the 'Meatpacking District'). It has decor that is more diner than 'dining out', but prices are low and portions are huge, with a menu of predominantly grilled meats, fried chicken, burgers and that all-time popular Danish speciality, *flæskesteg* (roast pork).

Torvehallerne KBH
Market €

(www.torvehallernekbh.dk; Israels Plads, Nørreport; dishes from around 50kr; ⊗10am-7pm

Mon-Thu, to 8pm Fri, to 6pm Sat, 11am-5pm Sun; ☐15E, 150S, 185, ⓂNørreport, ⓈNørreport) Torvehallerne KBH is an essential stop on the Copenhagen foodie trail. A delicious ode to the fresh, the tasty and the artisanal, the market's beautiful stalls peddle everything from seasonal herbs and berries to smoked meats, seafood and cheeses, smørrebrød, fresh pasta and hand-brewed coffee. You could easily spend an hour or more exploring its twin halls.

WestMarket Market €

(☑70 50 00 05; www.westmarket.dk; Vesterbrogade 97, Vesterbro; meals from 50kr; ☉bakeries & coffee shops 8am-7pm, food stalls 10am-10pm; ☎📶; ☐6A) Copenhagen's newest foodie hotspot, WestMarket is both a traditional market and a hip street-food emporium. The range of cuisines is impressive: visitors can sample offerings from all over the world, from Danish smørrebrød at Selma to Ugandan egg wraps at Ugood. Treat yourself to sinfully delicious desserts at Guilty.

Nyboders Køkken Danish €€

(☑22 88 64 14; www.nyboderskoekken.dk; Borgergade 134; lunch 58-148kr, dinner mains 128-189kr; ☉noon-4pm & 5-11.30pm; ☎; ☐1A, ⓂKongens Nytorv) Located in an affluent neighbourhood with a fashionably chic feel, Nyboders Køkken's menu is purposefully deeply traditional; if you are Danish, grandma's kitchen may come to mind. Think apple charlotte, classic wienerschnitzel, prawn cocktail and Danish junket with cream. Among the mains, the roasted slices of pork with parsley sauce has had local food critics swooning.

Höst New Nordic €€€

(☑89 93 84 09; www.hostvakst.dk; Nørre Farimagsgade 41; 3-/5-course menu 350/450kr; ☉5.30pm-midnight, last order 9.30pm; ☐37, ⓂNørreport, ⓈNørreport) Höst's phenomenal popularity is a no-brainer: warm, award-winning interiors and New Nordic food that's equally fabulous and filling. The set menu is superb, with three smaller 'surprise dishes' thrown in and evocative creations like beef tenderloin from Grambogaard with onion compote, gherkins, cress and smoked cheese. The 'deluxe' wine menu is significantly

Torvehallerne

CAROLINE HADAMITZKY/LONELY PLANET ©

Coffee shop in Torvehallerne

better than the standard option. Book ahead, especially later in the week.

Uformel
New Nordic €€€

(☑70 99 91 11; www.uformel.dk; Studiestræde 69; dishes 120kr; ☺5.30pm-midnight Sun-Thu, to 2am Fri & Sat; 🛜; 🚌2A, 10, 12, 250S, 🅂Vesterport) The edgier younger brother of Michelin–starred restaurant Formel B, Uformel ('Informal') offers a more casual take on New Nordic cuisine. The restaurant serves up an ever-changing menu featuring local, seasonal ingredients to create its mouth-watering dishes. Diners can choose several small plates to create their own tasting menu, or opt for the set menu of four courses (775kr).

Geranium
New Nordic €€€

(☑69 96 00 20; www.geranium.dk; Per Henrik Lings Allé 4, Østerbro; lunch/dinner tasting menu 2000kr, wine/juice pairings 1400/700kr; ☺noon-3.30pm & 6.30pm-midnight Wed-Sat; 🛜☑; 🚌14) 🌿 Perched on the 8th floor of Parken football stadium, Geranium is the only restaurant in town sporting three Michelin stars. At the helm is Bocuse d'Or prize-winning chef Rasmus Kofoed, who transforms local ingredients into edible Nordic artworks like venison with smoked lard and beetroot, or king crab with lemon balm and cloudberries.

Kroner-conscious foodies can opt for the slightly cheaper lunch menus, while those not wanting to sample the (swoon-inducing) wines can opt for enlightened juice pairings. Book ahead.

🍸 DRINKING & NIGHTLIFE

Copenhagen is packed with a diverse range of drinking options. Vibrant drinking areas include Kødbyen (the 'Meatpacking District') and Istedgade in Vesterbro, Ravnsborggade, Elmegade and Sankt Hans Torv in Nørrebro, and especially gay-friendly Studiestræde.

Coffee Collective
Coffee

(www.coffeecollective.dk; Jægersborggade 57, Nørrebro; ☺7am-8pm Mon-Fri, 8am-7pm Sat & Sun; 🚌8A) In a city where lacklustre coffee is as common as perfect cheekbones, this micro-roastery peddles the good stuff – we're talking rich, complex cups of caffeinated magic. The baristas are passionate about

their beans, and the cafe itself sits on creative Jægersborggade in Nørrebro. There are two other outlets, at food market Torvehallerne KBH (p48) and in **Frederiksberg** (☑60 15 15 25; https://coffeecollective.dk; Godthåbsvej 34b, Frederiksberg; ⏰7.30am-6pm Mon-Fri, from 9am Sat, from 10am Sun).

Ved Stranden 10 Wine Bar

(☑35 42 40 40; www.vedstranden10.dk; Ved Stranden 10; ⏰noon-10pm Mon-Sat; 🛜; 🚌1A, 2A, 9A, 26, 37, 66, 350S, Ⓜ Kongens Nytorv) Politicians and well-versed oenophiles make a beeline for this canalside wine bar, its cellar stocked with classic European vintages, biodynamic wines and more obscure drops. Adorned with modernist Danish design and friendly, clued-in staff, its string of rooms lend the place an intimate, civilised air that's perfect for grown-up conversation and vino-friendly nibbles like cheeses and smoked meats.

Ruby Cocktail Bar

(☑33 93 12 03; www.rby.dk; Nybrogade 10; ⏰4pm-2am Mon-Sat, from 6pm Sun; 🛜; 🚌1A, 2A, 14, 26, 37, 66) Cocktail connoisseurs raise their glasses to high-achieving Ruby. Here, hipster-geek mixologists whip up near-flawless libations such as the Green & White (vodka, dill, white chocolate and liquorice root), and a lively crowd spills into a maze of decadent rooms. For a gentlemen's club vibe, head downstairs into a world of Chesterfields, oil paintings and wooden cabinets lined with spirits.

Lo-Jo's Social Bar

(☑53 88 64 65; www.lojossocial.com; Landemærket 7; ⏰bar 11.30am-midnight Mon-Wed, to 2am Thu-Sat; 🚌350S, Ⓜ Nørreport, Ⓢ Nørreport) It's all in the name: colourful Lo-Jo's is a place to be social, with a range of tasty cocktails available for sharing for up to five people. Wines are largely organic or bio-dynamic, and for something a bit different, there is a bubbly spritz menu and a refreshing apple press menu, using fresh apple juice as a base.

Mikkeller & Friends Microbrewery

(☑35 83 10 20; www.mikkeller.dk/location/mikkeller-friends; Stefansgade 35, Nørrebro; ⏰2pm-midnight Sun-Wed, to 2am Thu & Fri, noon-2am Sat; 🛜; 🚌5C, 8A) This uniquely-designed

 Cykelslangen

Two of the Danes' greatest passions – design and cycling – meet in spectacular fashion with **Cykelslangen**, aka Cycle Snake. Designed by local architects Dissing + Weitling, the 235m-long cycling path evokes a slender orange ribbon, its gently curving form contrasting dramatically against the area's block-like architecture. The elevated path winds its way from Bryggebro (Brygge Bridge) west to Fisketorvet Shopping Centre, weaving its way over the harbour and delivering a whimsical cycling experience. To reach the path on public transport, catch bus 30 to Fisketorvet Shopping Centre. The best way to reach it, however, is on a bike, as Cykelslangen is only accessible to cyclists.

Cykelslangen
GERARD PUIGMAL/GETTY IMAGES ©

beer geek hotspot offers 40 kinds of artisan draft beers from local microbreweries and 200 varieties of bottled beers, ciders and soft drinks. Patrons can snack on gourmet sausages and cheese while enjoying their beer.

Rust Club

(☑35 24 52 00; www.rust.dk; Guldbergsgade 8, Nørrebro; ⏰hours vary, club usually 8.30pm-5am Fri & Sat; 🛜; 🚌3A, 5C, 350S) A smashing place attracting one of the largest, coolest crowds in Copenhagen. Live acts focus on alternative or upcoming indie rock, hip hop or electronica, while the club churns out hip-hop, dancehall and electro on Wednesdays and house, electro and rock on Fridays and Saturdays.

Designer Danes

As wonderful as Danish design-focused shops, museums, hotels and restaurants are, the very best place to see Danish design is in its natural environment: a Danish home. To the Danes, good design is not just for museums and institutions; they live with it and use it every day.

Visit a Danish home and you'll invariably find a Bang & Olufsen stereo and/or TV in the living room, Poul Henningsen lamps hanging from the ceiling, Arne Jacobsen or Hans Wegner chairs in the dining room, and the table set with Royal Copenhagen dinner sets, Georg Jensen cutlery and Bodum glassware.

From 11pm Friday and Saturday, entrance is restricted to over-20s.

 INFORMATION

EMERGENCY & IMPORTANT NUMBERS

Dial 112 to contact police, ambulance or fire services; the call can be made free from public phones.

DISCOUNT CARDS

The **Copenhagen Card** (www.copenhagencard.com; adult/child 10-15yr 24hr 389/199kr, 48hr 549/279kr, 72hr 659/329kr, 120hr 889/449kr), available at the Copenhagen Visitors Centre or online, gives you free access to 72 museums and attractions in the city and surrounding area, as well as free travel for all S-train, metro and bus journeys within the seven travel zones.

MONEY

Banks are plentiful, especially in central Copenhagen. Most are open from 10am to 4pm weekdays (to 5.30pm on Thursday). Most have ATMs that are accessible 24 hours per day.

POST

Post Office (70 70 70 30; www.postnord.dk; Pilestræde 58; 8.30am-7pm Mon-Fri, to 2pm Sat; 350S, Kongens Nytorv) A handy post office near Strøget and the Latin Quarter.

There is also a post office in Central Station.

TOURIST INFORMATION

Copenhagen Visitors Centre (70 22 24 42; www.visitcopenhagen.com; Vesterbrogade 4A, Vesterbro; 9am-8pm Mon-Fri, to 6pm Sat & Sun Jul & Aug, reduced hours rest of year; 2A, 6A, 12, 14, 26, 250S, København H) Copenhagen's excellent and informative information centre has a superb cafe and lounge with free wi-fi; it also sells the **Copenhagen Card**.

 GETTING THERE & AWAY

AIR

If you're waiting for a flight at **Copenhagen Airport** (32 31 32 31; www.cph.dk; Lufthavnsboulevarden, Kastrup; Lufthavnen, Københavns Lufthavn), note that this is a 'silent' airport and there are no boarding calls, although there are numerous monitor screens throughout the terminal.

BUS

Eurolines (www.flixbus.com; København H) Operates buses to several European cities. The ticket office is behind Central Station. Long-distance buses leave from opposite the DGI-byen sports complex on Ingerslevsgade, just southwest of København H (Central Station). Destinations include Berlin (329kr, 7.5 hrs) and Paris (699kr, 19 to 22¼ hrs).

TRAIN

DSB Billetsalg (DSB Ticket Office; 70 13 14 15; www.dsb.dk; Central Station, Bernstorffsgade 16-22; 7am-8pm Mon-Fri, 8am-6pm Sat & Sun; København H) is best for reservations and for purchasing international train tickets.

Rust (p51)

ℹ️ GETTING AROUND

TO/FROM THE AIRPORT

The 24-hour metro (www.m.dk) runs every four to 20 minutes between the airport arrival terminal (Lufthavnen station) and the eastern side of the city centre. It does not stop at København H (Central Station) but is handy for Christianshavn and Nyhavn (get off at Kongens Nytorv for Nyhavn). Journey time to Kongens Nytorv is 14 minutes (36kr).

By taxi, it's about 20 minutes between the airport and the city centre, depending on traffic. Expect to pay between 250kr and 300kr.

Trains (www.dsb.dk) connect the airport arrival terminal to Copenhagen Central Station (København Hovedbanegården, commonly known as København H) around every 12 minutes. Journey time is 14 minutes (36kr). Check schedules at www.rejseplanen.dk.

BICYCLE

Copenhagen vies with Amsterdam as the world's most bike-friendly city. The superb, city-wide rental system is **Bycyklen** (City Bikes; www.bycyklen.dk; per 1hr 30kr). Visit the Bycyklen website for more information.

CAR & MOTORCYCLE

Except for the weekday rush hour, when traffic can bottleneck, traffic in Copenhagen is generally manageable. Getting around by car is not problematic, except for the usual challenge of finding an empty parking space in the most popular places.

PUBLIC TRANSPORT

Copenhagen has an extensive public transport system consisting of a metro, rail, bus and ferry network. All tickets are valid for travel on the metro, buses and S-tog (S-train or local train), even though they look slightly different, depending on where you buy them. The free Copenhagen city maps that are distributed by the tourist office show bus routes (with numbers) and are very useful for finding your way around the city. Online, click onto the very handy www.rejseplanen.dk for all routes and schedules.

WALKING

The best way to see Copenhagen is on foot. There are few main sights or shopping quarters more than a 20-minute walk from the city centre.

BORNHOLM, DENMARK

Bornholm, Denmark at a Glance...

The sunniest part of Denmark, Bornholm lies way out in the Baltic Sea, 200km east of Copenhagen (and closer to Sweden and Poland than to mainland Denmark). But it's not just (relatively) sunny skies that draw the hordes each year. Mother Nature was in a particularly good mood when creating this Baltic beauty, bestowing on it rocky cliffs, leafy forests, bleach-white beaches and a pure, ethereal light that painters do their best to capture.

Two Days on Bornholm

Divide your first couple of days between **Rønne** (p60), **Dueodde** (p64) and **Gudhjem** (p66). While at Rønne, don't miss the Nylars Rundkirke, and at Gudhjem, leave ample time to explore the Bornholms Kunstmuseum and linger over its contents. If the weather's warm, go for a swim at Dueodde beach.

Four Days on Bornholm

Days three and four on Bornholm – you lucky soul! – will see you exploring the windmills and lovely architecture of **Svaneke** (p65), the mix of architecture and nature at **Sandvig** (p69) and then falling off the map at **Christiansø** (p68). If you've time, return to **Gudhjem** (p66) and take one of the lovely walks in the area.

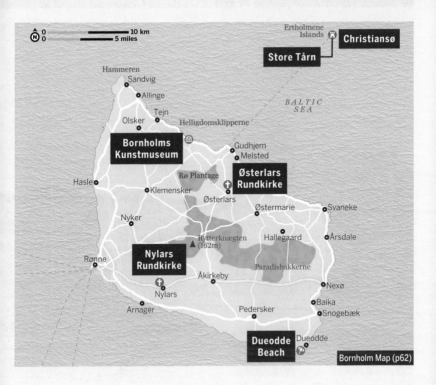

Arriving on Bornholm

The island's airport, Bornholms Lufthavn, is 5km southeast of Rønne. Bus 5 connects the airport with Rønne.

Where to Stay

There's a good mix of camping grounds, hostels and hotels around the island, plus plenty of holiday houses and apartments for rent. Hotels span the spectrum from traditional *badehoteller* (bathing hotels by the seaside) to ultramodern and stylish. The five Danhostels are outlined at www.danhostel-bornholm.dk.

You'd be wise to book well ahead for visits in summer, especially July and August.

Store Tårn

VOYAGERIX/SHUTTERSTOCK ©

Historic Bornholm

Bornholm's human footprint includes medieval fortresses, thatched fishing villages, iconic rundekirke (round churches) and more. Historic smokehouses, too, are a charming feature.

Store Tårn

Built in 1684, Christiansø's **Store Tårn** (Great Tower; adult/child 40/20kr; ⊘11am-6pm Tue-Thu, to 4pm Fri-Mon mid-Jun–mid-Aug, 11am-4pm Tue-Sun Easter–mid-Jun & mid-Aug–mid-Oct) is an impressive structure measuring a full 25m in diameter, and the tower's 100-year-old lighthouse offers a sweeping 360-degree view of the island. After major restoration work, the tower reopened in June 2017 with new exhibits on local history and birdlife.

Bornholms Kunstmuseum

Occupying a svelte, modern building and overlooking sea, fields and (weather permitting) the distant isle of Christiansø, **Bornholms Kunstmuseum** (🖉56 48 43 86;

Great For...

Don't Miss

The round churches that are so distinctive of Bornholm.

Nylars Rundkirke

ⓘ Need to Know

Bornholm can be reached by plane, ferry or a ferry-bus-train combination via Sweden.

✕ Take a Break

Fru Petersens Café (📞21 78 78 95; www.frupetersenscafe.dk; Almindingensvej 31, Østermarie; cake buffet incl drinks 145kr; ⊘noon-6pm Jun-Aug, to 5pm Wed-Sun Apr, May, Sep, Thu-Sun Oct) is a gorgeous little place with wonderful cakes.

★ Top Tip

Look closely and you'll find a rune stone dating back to the mid-11th century at the Østerlars Rundkirke entrance.

www.bornholms-kunstmuseum.dk; Otto Bruuns Plads 1; adult/child 70kr/free; ⊘10am-5pm Jun-Aug, closed Mon Apr, May, Sep & Oct, shorter hours rest of year) echoes Copenhagen's Louisiana. Among its exhibits, the museum displays paintings by artists from the Bornholm School, including Olaf Rude, Oluf Høst and Edvard Weie, who painted during the first half of the 20th century.

Østerlars Rundkirke

The largest and most impressive of Bornholm's round churches, Østerlars Rundkirke dates to at least 1150, and its seven buttresses and upper-level shooting positions give away its former role as a fortress. The roof was originally constructed with a flat top to serve as a

battle platform, but the excessive weight this exerted on the walls saw it eventually replaced with its present conical one. The interior is largely whitewashed, although a swath of medieval frescoes has been uncovered and restored.

Nylars Rundkirke

Built around 1150, **Nylars Rundkirke** (www.nylarskirke.dk; Kirkevej 10K, Nylars; ⊘7am-6pm Apr-Sep, 8am-3.30pm Oct-Mar) is the most well-preserved and easily accessible round church in the Rønne area. Its central pillar is adorned with wonderful 13th-century frescoes, the oldest in Bornholm. The works depict scenes from the creation myth, including Adam and Eve's expulsion from the Garden of Eden. The cylindrical nave has three storeys, the top one a watchman's gallery that served as a defence lookout in medieval times.

Rønne

Rønne is Bornholm's largest settlement and the main harbour for ferries. The town has been the island's commercial centre since the Middle Ages, and while the place has expanded and taken on a more suburban look over the years, a handful of well-preserved quarters still provide pleasant strolling. Especially appealing is the old neighbourhood west of Store Torv with its handsome period buildings and cobblestone streets, among them Laksegade and Storegade.

◉ SIGHTS

Bornholms Museum Museum

(☑56 95 07 35; www.bornholmsmuseum.dk; Sankt Mortensgade 29; adult/child 70kr/free; ◷10am-5pm Jul–mid-Aug, closed Sun mid-May–Jun & mid-Aug–late Oct, shorter hours rest of year) Prehistoric finds including weapons, tools and jewellery are on show at Bornholm's museum of cultural history, which has a surprisingly large and varied collection of local exhibits, including some interesting Viking finds. A good maritime section is decked out like the interior of a ship, and there's a hotchpotch of nature displays, antique toys, Roman coins, pottery and paintings.

Erichsens Gård Museum

(☑56 95 07 35; www.bornholmsmuseum.dk; Laksegade 7; adult/child 50kr/free; ◷10am-4pm Fri & Sat mid-May–mid-Oct) Pretty in pink, this merchant's house from 1806 is a photogenic half-timbered idyll on a cobbled lane. There are short opening hours, when you can view the rooms and lovely garden.

Mølgaard & Marcussen Gallery

(☑81 75 48 67; www.mølgaard-marcussen.dk; Raadhusstræde 1A; ◷10am-4pm Mon-Fri, to 1pm Sat) Bornholm overflows with creative types and has a long tradition of ceramics. The two friendly owners of this studio gallery and store are great proponents of the art, and their pastel-hued creations are truly covetable.

✖ EATING

Hasle Røgeri Seafood €

(☑56 96 20 02; www.hasleroegeri.dk; Søndre Bæk 20, Hasle; dishes 58-115kr; ◷10am-9pm

Rønne

Jul-late Aug, to 5pm May, Jun & late Aug-Oct) The closest traditional smokehouse to Rønne is by the water in Hasle, about 11km north of town. This century-old place has the iconic square chimneys, lots of outdoor seating and a super spread of smoked-fish goodness (herring, salmon, mackerel, eel, prawns) in a 149kr lunch buffet.

Torvehal Bornholm Food Hall €
(☑ 31 43 72 00; www.torvehalbornholm.dk; Gartnervangen 6; mains from grill 145-190kr; ☺10am-5pm Wed & Thu, to 8pm Fri-Sun Jun-Aug, shorter hours rest of year) While food elsewhere on the island went gangbusters, Rønne's food scene lagged – but the summer 2017 opening of this food hall in the town's north changed that. In a former slaughterhouse, peruse the output of some of Bornholm's finest producers, nibble on snacks from a food truck, sample beer brewed on site and dine on meat fresh off the grill.

🍷 DRINKING & NIGHTLIFE

Take a wander around Store Torv to find drinking spots.

ℹ️ INFORMATION

Tourist Office (Bornholms Velkomstcenter; ☑ 56 95 95 00; www.bornholm.info; Nordre Kystvej 3; ☺9am-5pm Jul-mid-Aug, to 4pm Mon-Fri rest of year, hours vary Sat) is a few minutes' walk from the harbour, this large, friendly office has masses of information on all of Bornholm and Christiansø.

ℹ️ GETTING THERE & AWAY

BOAT
The **ferry terminal** (Findlandsvej) is by the harbour. There is a large car park and a ticket office, plus a bus stop next door.

BUS
There's a bus stop by the ferry terminal, and a busy **bus stop** on Snellemark, close to Store Torv.

The Round Churches of Bornholm

As the windmills are to Mykonos or the stone heads are to Easter Island, so are the four 12th-century round churches *(rundekirke)* to Bornholm. The churches are symbols of the island, immediately familiar to every Dane. Each was built with 2m-thick whitewashed walls and a black conical roof at a time when pirating Wends from eastern Germany were ravaging coastal areas throughout the Baltic Sea. They were designed not only as places of worship but also as refuges against enemy attacks – their upper storeys doubled as places to fire arrows from. They were also used as storehouses to protect valuable possessions and trading goods from being carried off by the pirates.

Each church was built about 2km inland, and all four are sited high enough on knolls to offer a lookout to the sea. These striking and utterly distinctive churches have a stern, ponderous appearance, more typical of a fortress than of a place of worship. All four churches are still used for Sunday services. You'll find them at Østerlars (p59), Olsker (p70), Nyker and Nylars (p59).

Østerlars Rundkirke (p59)

ℹ️ GETTING AROUND

There are loads of places across the island renting bikes, and many hotels and hostels also offer rental.

Bornholm

N

5 miles

10 km

Ertholmene Islands

Græsholm

Frederikso

Christiansø

Baltic Sea

Ferry to Christiansø

Gudhjem

Gudhjem Harbour

Bus Stop

GUDHJEM

Ejnar Mikkelsensvej

Løkkegade

Brøddegade

Åbogade

Holkavej

Bokulvej

Nørresand

Helligdomsvej

21

25

16

2

33

19

200 m

0.1 miles

Svaneke

Fiskergade

Peter F. Heerings Gade

Gruset

Baltic Sea

Munken

Storegade

Svaneke Torv

Østergade

Vestergade

Tempelvej

26

28

8

27

400 m

0.2 miles

Hammeren

Sandvig

Allinge

Hasle

Olsker

Tejn

Klemensker

Helligdomsklipperne

Rø Plantage

Gudhjem

Melsted

Østerlars

See Gudhjem Enlargement

158

158

159

9

31

23

30

13

24

10

15

32

11

4

5

17

1

22

See Svaneke
Enlargement

Svaneke

Årsdale

158

Nexø

Balka

Snogebæk

158

Hallegaard

Dueodde

18

3

Østermarie

20

38

Pedersker

Rønnevej

Almindingen

Åkirkeby

38

Rytterknægten
(162m)

Nylars

14

Nyker

Arnager

Rønnevej

Bornholms
Lufthavn

159

38

Rønne

29

7

6

12

Sweden

Germany

Poland

5

6

7

8

A

B

C

D

E

F

Bornholm

Dueodde

Dueodde, the southernmost point of Bornholm, is a vast stretch of breathtaking beach backed by deep green pine trees and expansive dunes. Its soft sand is so fine-grained that it was once used in hourglass-es and ink blotters.

There's no real village at Dueodde – the bus stops at the end of the road where there's a hotel, a steakhouse restaurant, a couple of food kiosks and a boardwalk across the marsh to the beach. The only beachside 'sight' is a **lighthouse** on the western side of the dunes; you can climb the 197 steps for a view of endless sand and sea. For more views, head 1km back to the main road to visit **Bornholmertårnet** (🖉40 20 52 40; www.bornholmertaarnet.dk; Strandmarksvejen 2; adult/child 75/50kr; ☉10am-5pm May-Oct).

ACTIVITIES

Dueodde Beach Beach

() Dueodde's beach is a fantastic place for children: the water is generally calm and is shallow for about 100m, after which it becomes deep enough for adults to swim. During July and August it can be a crowded trek for a couple of hundred metres to reach the beach. Once there, simply head off to discover your own wide-open spaces.

⊗ EATING

You'll find a cheesy themed steakhouse and a couple of stock-standard kiosks selling ice cream, hot dogs and snacks at the end of the road by the bus stop.

For better food choices (and a super-market), head to nearby Snogebæk.

 GETTING THERE & AWAY

Two access roads head to Dueodde south from Strandmarksvejen. Bus 7 runs here.

Svaneke

Svaneke is a super-cute harbour town of red-tiled 19th-century buildings that has won international recognition for maintaining its historic character. Popular with yachters and landlubbing holidaymakers, its pretty harbourfront is lined with mustard-yellow half-timbered former merchants' houses, some of which have been turned into hotels and restaurants.

Svaneke is also home to plenty of fab island flavours: a renowned smokehouse a notable microbrewery, and beloved makers of gourmet liquorice, caramels and chocolates – all of which are highly recommended.

 SIGHTS

Glastorvet Square
If you're interested in crafts, there are a number of ceramics and handicraft shops dotted around town, and at Glastorvet in the town centre there's a workshop of renowned local designer Pernille Bülow, where you can watch glass being melted into orange glowing lumps and then blown into clear, elegant glassware. This is a lovely spot to explore local flavours and artisans.

 EATING

Røgeriet i Svaneke Seafood €
(☑56 49 63 24; www.roegerietsvaneke.dk; Fiskergade 12; snacks & meals 40-120kr; ⊙from 10am Apr-Oct) You'll find a fine selection of excellent smoked fare at the long counter here, including smørrebrød (Danish open

sandwiches), mackerel, trout, salmon, herring, shrimp and *fiskefrikadeller* (fish cakes). Sit inside with a view of the massive, blackened doors of the smoking ovens or at the outdoor picnic tables overlooking the old cannons, with a view of the five iconic chimneys.

Svaneke Chokoladeri Sweets €
(☑56 49 70 21; www.svanekechokoladeri.dk; Svaneke Torv 5; flødeboller from 20kr; ⊙10.30am-5.30pm Mon-Fri, to 5pm Sat, 11am-5pm Sun; 🚼) Located at the entrance to Bryghuset is one of Bornholm's top chocolatiers. Made on the premises, the seductive concoctions include a very Bornholm *havtorn* (sea buckthorn) dark-choc truffle, and gourmet *flødeboller* (try the raspberry and liquorice combo).

There's also a store on Rønne's Store Torv.

Svanereden International €
(☑50 50 72 35; www.svanereden.dk; Gruset 4; mains 75-120kr; ⊙10am-9pm mid-May–mid-Sep; 🚼) When the weather gods are smiling, this casual outdoor restaurant positioned above the harbour is a great spot to dine and unwind. The choices are simple and good (from champagne brunch to tapas platters to wok-fried dishes and stews cooked over an open fire). Kids are actively welcomed, and the views and atmosphere are tops.

 DRINKING & NIGHTLIFE

Bryghuset Microbrewery
(☑56 49 73 21; www.bryghuset-svaneke.dk; Svaneke Torv 5; lunch 79-139kr, dinner mains 169-299kr; ⊙11am-midnight, kitchen closes 8.30pm; 🚼) This is one of the most popular year-round dining and drinking hotspots on the island, known through-out Denmark for its excellent beers brewed on the premises. It also serves decent, hearty pub grub that pairs well

with its brews. Danish lunch classics include smørrebrød, *fiskefrikadeller* and a fine burger. Dinner mains are mostly juicy, fleshy affairs.

ℹ️ INFORMATION

Tourist Office (📞56 95 95 00; Peter F Heerings Gade 7; 🕙10am-4pm Tue-Sat mid-Jun–late Sep) is by the harbour.

ℹ️ GETTING THERE & AWAY

There are bike-rental places in town. Buses 3, 5, 7 and 8 pass through.

Gudhjem & Melsted

Gudhjem is the best-looking of Bornholm's harbour towns. Its rambling high street is crowned by a squat windmill standing over half-timbered houses and sloping streets that roll down to the picture-perfect harbour. The town is a good base for exploring the rest of Bornholm, with cycling and walking trails, convenient bus connections, plenty of places to eat and stay, and a boat service (p68) to Christiansø.

Melsted blends into Gudhjem just a short walk southeast of the town centre.

⊙ SIGHTS

The area around Gudhjem harbours a number of cultural riches, including the island's impressive art museum (p58), it's most striking round church Østerlars Rundkirke (p59), and an intriguing medieval re-creation at Bornholms Middelaldercenter (p67).

Oluf Høst Museet Museum

(📞56 48 50 38; www.ohmus.dk; Løkkegade 35; adult/child 75kr/free; 🕙11am-5pm Jun-Aug, Wed-Sun Sep & Oct; 👶) This wonderful museum contains the workshops and paintings of Oluf Høst (1884–1966), one of Bornholm's best-known artists. The museum occupies the home where Høst lived from 1929 until his death. The beautiful back garden is home to a little hut with paper, paints and pencils for kids with a creative itch.

Røgeriet i Svaneke (p65)

MIŁOSZ MAŚLANKA/SHUTTERSTOCK ©

Bornholms Middelaldercenter — Museum

(☑56 49 83 19; www.bornholmsmiddelalder-center.dk; Stangevej 1, Østerlars; adult/child 140/70kr; ☺hours vary Easter–Oct; 🖼) This 'Medieval Centre' re-creates a medieval fort and village, and gives the Danes another chance to do what they love best: dressing up in period costume and hitting each other with rubber swords. They also operate a smithy, tend fields, grind wheat in a water mill and perform other chores of yore throughout the summer months. In July the activity schedule is beefed up to include archery demonstrations and hands-on activities for children.

Baltic Sea Glass — Gallery

(☑56 48 56 41; www.balticseaglass.com; Melstedvej 47; ☺10am-5pm) Wherever you travel on Bornholm you will come across small independent ceramicists' and glass-blowers' studios. A couple of kilometres south of Gudhjem is one of the best: Baltic Sea Glass. It's a large, modern workshop and showroom with regularly changing exhibitions.

ACTIVITIES

Gudhjem's shoreline is rocky, though sunbathers will find a small sandy **beach** at Melsted, 1km southeast.

A 5km **bike path** leads south from Gudhjem to the thick-walled, stoutly buttressed Østerlars Rundkirke (p59), the most impressive of the island's round churches.

M/S Thor — Boating

(☑56 48 51 65; www.ms-thor.dk; Gudhjem Havn; one-way/return 100/125kr; ☺from Gud-hjem 11.30am May-Sep) Take a cruise along the coastline west of Gudhjem to view the rugged rock formations of Helligdom-sklipperne. You can stay on the boat and return to Gudhjem, or disembark at the landing place by the cliffs and walk up to visit Bornholms Kunstmuseum (p58).

There are additional sailings in July and August.

Walks Around the Gudhjem Area

A short five-minute climb up **Bokul,** the heather-covered hill, provides a fine view of Gudhjem town's red-tiled rooftops and out to sea.

From the hill at the southeastern end of Gudhjem harbour you'll be rewarded with a harbour view. You can continue along this path that runs above the shoreline 1.5km southeast to Melsted, where there's a little sandy beach. It's a delightful **nature trail**, with swallows, nightingales and wildflowers.

Heading west for around 6km takes you along the scenic elevated coastline of **Hellig-domsklipperne** and to the excellent Bornholms Kunstmuseum (p58). The path (sti) heads along the coast from Nørresand.

View of Gudhjem from Bokul
BILDAGENTUR ZOONAR GMBH/SHUTTERSTOCK ©

🍴 EATING

Norresan — Cafe €

(☑20 33 52 85; www.facebook.com/norresand; Nørresand 10; cake/sandwich 35/70kr; ☺11am-9pm Jul, shorter hours Apr-Jun & Aug-Oct) In a beautiful old smokehouse by the water (close to Oluf Høst Museet (p66)), this whitewashed cafe wins over visitors with views, home-baked cakes and cookies, tasty ice cream and a sweet ambience. Check its Facebook page for opening hours, and for details of visiting food trucks for sunset-watchers.

Gudhjem Røgeri — Seafood €

(☑56 48 57 08; www.smokedfish.dk; Ejnar Mik-kelsensvej 9; dishes 64-115kr; buffet 130-185kr;

Christiansø Wildlife Refuge

Græsholm, the island to the north-west of Christiansø, is a wildlife refuge and an important breeding ground for guillemots, razorbills and other seabirds.

Together, Christiansø, Frederiksø and Græsholm are known as the Ertholmene Islands, and they serve as spring breeding grounds for up to 2000 eider ducks. The ducks nest near coastal paths and all visitors should take care not to scare mothers away from their nests because predator gulls will quickly swoop and attack the unattended eggs.

The islands also attract a colony of seals.

Guillemots and razorbills on Græsholm island
JOHNNY MADSEN/ALAMY STOCK PHOTO ©

⏱from 10am Apr-Oct) Gudhjem's popular smokehouse serves deli-style fish and salads, including the classic smørrebrød topping known as Sol over Gudhjem (Sun over Gudhjem: smoked herring topped with a raw egg yolk, chives and radish on rye bread). There's indoor and outdoor seating, and live music most nights in July and August.

Stammershalle Badehotel
Danish €€€

(Lassens; ☎56 48 42 10; www.stammer shalle-badehotel.dk; Søndre Strandvej 128, Stammershalle; small/large tasting menu 450/595kr; ⏱6-10pm May-Oct, Wed-Sat Mar & Apr) An ode to relaxed Scandi elegance, the restaurant at **Stammershalle Badehotel** (s/d incl breakfast from 700/900kr; ⏱May-Oct, Wed-Sat Mar, Apr & Nov; P🛜♨) is a local foodie hotspot. Service is knowledgeable and personable, and the sea-and-sunset panorama as inspired as the kitchen's creations. Bookings are essential.

ℹ INFORMATION

Tourist Office (☎56 95 95 00; Ejnar Mikkelsens-vej 27; ⏱10am-3.30pm Mon-Fri Jun-Aug) is a small building right by the harbour. It's staffed in summer, and open for self-service (brochures etc) for a few hours in the morning daily from mid-April to mid-October.

ℹ GETTING THERE & AWAY

BOAT

Christiansøfarten (☎56 48 51 76; www.chris tiansoefarten.dk; Ejnar Mikkelsensvej 25; Chris-tiansø return adult/child 250/125kr; ⏱hours vary) operates passenger ferries to Christiansø from Gudhjem. From July to late August, ferries depart Gudhjem daily at 10am, 12.30pm and 3pm; return ferries depart Christiansø at 2pm, 4.15pm and 7.30pm. Sailing time is around an hour. Note that there are fewer sailings outside peak summer.

In a gorgeous gesture, 10am sailings in summer are serenaded from Gudhjem's harbour by the local choir.

BUS

The main **bus stop** (Ejnar Mikkelsensvej) in Gudhjem is near the harbour. There are good bus links to other parts of the island.

Christiansø

If you think Bornholm is as remote as Denmark gets, you'd be wrong. Even further east, way out in the Baltic, is tiny Christiansø, an intensely atmospheric 17th-century island fortress about 500m long. It's an hour's sail northeast of

Bornholm (departing from Gudhjem), and makes a lovely and idyllic day-trip destination.

There is something of the Faroe Islands about Christiansø's landscape (on a much less epic scale, of course), with its rugged, moss-covered rocks, historic stone buildings and even hardier people. There is a real sense, too, that you are travelling back in time when you visit here.

⊚ SIGHTS

The main sightseeing on Christiansø is provided by the walk along the fortified **stone walls** and cannon-lined batteries that mark the island's perimeter.

There are reefs with nesting seabirds and a couple of secluded swimming coves on Christiansø's eastern side. On the western side, a footbridge links Christiansø with the small neighbouring island of **Frederiksø**. Frederiksø's west coast has a swimming jetty and bird-watching spots.

⊗ EATING

Christiansø Gæstgiveri (☑ 56 46 20 15; www.christiansoekro.dk; s/d 1150/1250kr; ⊙ closed late Dec-Jan) serves meals, and there's a snack kiosk next door selling hot dogs and ice cream (open May to September).

ⓘ INFORMATION

Information is online at www.christiansoe.dk.

Dogs or other pets are forbidden on Christiansø.

ⓘ GETTING THERE & AWAY

Christiansøfarten (☑ 56 48 51 76; www. christiansoefarten.dk; return ticket adult/child 250/125kr; ⊙ mid-Apr–late Oct) operates passenger ferries to Christiansø from Gudhjem.

Sandvig & Allinge

Sandvig is a genteel seaside hamlet with storybook older homes, many fringed by

Christiansø

VOYAGERIX/SHUTTERSTOCK ©

12PHOTOGRAPHY/SHUTTERSTOCK ©

Hammershus Slotsruin

rose bushes and flower gardens. It's front-ed by a gorgeous sandy bay and borders a network of walking trails throughout the Hammeren area and southwest to Hammershus.

Allinge, the larger and more developed half of the Allinge-Sandvig municipality, is 2km southeast of Sandvig.

◎ SIGHTS

Hammershus Slotsruin · Ruins
(Slotslyngvej) **FREE** The impressive ruins of Hammershus Slot, dramatically perched on top of a cliff 74m above the sea, are the largest in Scandinavia. The castle was thought to have been built in the early 1300s, and a walk through the evocative site, enjoying the views, is a must for Bornholm visitors. The grounds are always open and admission is free. A smart new **visitor centre** is being built, sympathetic to the surrounds (opening 2018; likely with an admission fee for exhibits).

Hammeren · Nature Reserve
Hammeren, the hammerhead-shaped crag of granite at the northern tip of Bornholm, is criss-crossed by **walking trails** leading through hillsides thick with purple heather. Some of the trails are inland, while others run along the coast. The whole area is a delight for people who enjoy nature walks.

Olsker Rundkirke · Church
(Sankt Ols Kirke; Rønnevej 51, Olsker; 10kr; ◷10am-5pm Mon-Fri May-Oct) Five kilo-metres south of central Allinge, on the southern outskirts of the small village of Olsker, is the highest (26m) and most slender of the island's four round church-es. If you take the inland bus 1 between Rønne and Allinge, you can stop off en route.

ENTERTAINMENT

Gæsten Live Music

(www.gaestgiveren.dk; Theaterstræde 2,
Allinge; ticket prices vary; ⊗bar from 5pm,
concerts from 8pm Mon-Sat Jul-early Aug) This
summertime institution offers live music
six nights a week in peak summer; see the
program and buy tickets online, or tickets
are generally also available at the door.
There's usually a party atmosphere in the
courtyard, and also a fine vegetarian buffet
from 6pm (160kr; meat and fish dishes
available too).

EATING

Kalas-Kalas Cafe €

(☑60 19 13 84; www.kalasbornholm.dk;
Strandpromenaden 14, Sandvig; 2/3 ice-cream
scoops 34/44kr, coffee 30-40kr; ⊗11am-10pm
late Jun–mid-Aug, shorter hours rest of year)
The perfect island combination: great
coffee, handmade ice cream the locals
queue for, picture-perfect rocky coastline
out the windows, and beanbags on the
terrace for sunset cocktails. Ice-cream
flavours come courtesy of local gardens
and fields: elderflower, rhubarb, redcur-
rant, various berries. Ask here about boat
trips and snorkelling tours run by the
owners' sons (www.boatingbornholm.
dk). Check the website for hours.

Nordbornholms Røgeri Seafood €

(☑56 48 07 30; www.nbr.dk; Kæmpestranden
2, Allinge; dishes 60-115kr, buffet 189kr;
⊗11am-10pm; 🔊) Several of Bornholm's
top chefs praise this smokehouse as
the island's best. Not only does it serve
a bumper buffet of locally smoked fish,
salads and soup (ice-cream dessert
included), but its waterside setting makes

The Windmills of Denmark

The easternmost town in Denmark,
Svaneke is quite breezy and has a number
of windmills. To the northwest of town,
around Møllebakken, you'll find an old
post mill (a type of mill that turns in its
entirety to face the wind) and a **Dutch
mill**, as well as an unusual three-sided
water tower designed in the 1950s by
architect Jørn Utzon (of Sydney's Opera
House fame).

On the main road 3km south of Svaneke
in the hamlet of **Årsdale**, there's a working
windmill where grains are ground and sold.

Årsdale windmill
MILOSZ MASLANKA/SHUTTERSTOCK ©

it the perfect spot to savour Bornholm's
Baltic flavours.

INFORMATION

Tourist Office (☑56 95 95 00; Sverigesvej 11,
Allinge; ⊗11am-5pm Mon-Fri, 10am-4pm Sat &
Sun Jul & Aug, shorter hours rest of year) is a
helpful spot, by the harbour in Allinge.

GETTING THERE & AWAY

There are decent bus connections: bus 1 runs
frequently from Rønne, bus 4 from Gudhjem.

REYKJAVÍK

Reykjavík at a Glance...

Reykjavík is loaded with captivating art, rich cuisine and quirky, creative people. The music scene is epic, with excellent festivals, creative DJs and any number of home-grown bands. Even if you come for a short visit, be sure to take a trip to the countryside. Tours and services abound, and understanding Reykjavík and its people is helped by understanding the vast, raw and gorgeous land they anchor. The majority of Icelanders live in the capital, but you can guarantee their spirits also roam free across the land. Absorb what you see, hear, taste, smell – it's all part of Iceland's rich heritage.

Two Days in Reykjavík

Spend the morning exploring historic **Old Reykjavík** (p85) and afternoon shopping and sightseeing along arty **Skólavörðustígur** (p84). Head to **Laugavegur** (p84) for dinner, drinks and late-night dancing.

On day two, catch a **whale-watching cruise** (p85) or explore the **Old Harbour** (p85) and its museums in the morning. While away the afternoon at **Laugardalur** (p87) and your evening at a top Icelandic restaurant (p87).

Four Days in Reykjavík

On day three, rent a bike at the Old Harbour and ferry out to historic **Viðey** (www.videy.com), heading back for last-minute shopping in **Laugavegur** (p84) and **Skólavörðustígur** (p84). Sample the area's seafood then catch a show, an Icelandic movie or some live music.

On day four take a trip to the **Golden Circle** (p80). Visit the **Blue Lagoon** (p78) later in the evening, after the crowds have dwindled.

Reykjavík Map (p82)

Arriving in Reykjavík

Keflavík International Airport Iceland's primary international airport is 48km west of Reykjavík.

Reykjavík Domestic Airport Only a 2km walk into town.

Smyril Line (www.smyrilline.com) operates a pricey but well-patronised weekly car ferry from Hirtshals (Denmark) through Tórshavn (Faroe Islands) to Seyðisfjörður in East Iceland. It's possible to make a stopover in the Faroes.

Where to Stay

Reykjavík has loads of accommodation choices, with hostels, midrange guesthouses (often with shared bathrooms, kitchen and lounge) and business-class hotels galore, and top-end boutique hotels and apartments seem to be opening daily. Reservations are essential from June through August and prices are high. Plan for hostels, camping or short-term apartment rentals to save money. Most places open year-round and offer discounts online.

VLADIMIR KOROSTYSHEVSKIY/SHUTTERSTOCK ©

National Museum

Iceland's premier museum is packed with artefacts and interesting displays. Exhibits give an excellent overview of the country's history and culture, and the audio guide (kr300) adds loads of detail.

Great For...

Don't Miss

The gaming pieces made from cod ear bones, and the wooden doll that doubled as a kitchen utensil.

The superb National Museum beautifully displays Icelandic artefacts from settlement to the modern age, providing a meaningful overview of Iceland's history and culture. Brilliantly curated exhibits lead you through the struggle to settle and organise the forbidding island, the radical changes wrought by the advent of Christianity, the lean times of domination by foreign powers and Iceland's eventual independence.

Settlement Era Finds

The premier section of the museum describes the Settlement Era – including how the chieftains ruled and the introduction of Christianity – and features swords, meticulously carved **drinking horns**, and **silver hoards**. A powerful **bronze figure of Thor** is thought to date to about 1000. The priceless

ⓘ Need to Know

National Museum (Þjóðminjasafn Íslands; ☏530 2200; www.nationalmuseum.is; Suður-gata 41; adult/child kr2000/free; ⊙10am-5pm May–mid-Sep, closed Mon mid-Sep–Apr; 🚌1, 3, 6, 12, 14)

✕ **Take a Break**

The ground-floor **Museum Café** (National Museum, Suðurgata 41; snacks kr600-1800; ⊙10am-5pm May–mid-Sep, 9am-5pm Tue-Fri, 11am-5pm Sat & Sun mid-Sep–Apr; 🛜) offers wi-fi and a welcome respite.

★ **Top Tip**

Free English tours run at 11am on Wednesday, Saturday and Sunday, May to mid-September.

13th-century **Valþjófsstaður church door** is carved with the story of a knight, his faithful lion and a posse of dragons.

Domestic Life

Exhibits explain how the chieftains ruled and how people survived on little, lighting their dark homes and fashioning bog iron. There's everything from the remains of early *skyr* (yoghurt-like dessert) production to intricate pendants and brooches. Look for the Viking–era **hnefatafl game set** (a bit like chess); this artefact's discovery in a grave in Baldursheimur led to the founding of the museum.

Viking Graves

Encased in the floor are Viking–era graves, with their precious burial goods:

horse bones, a sword, pins, a ladle and a comb. One of the tombs containing an eight-month-old infant is the only one of its kind ever found.

Ecclesiastical Artefacts

The section of the museum that details the introduction of Christianity is chock-a-block with rare art and artefacts such as the priceless 13th-century **Valþjófsstaður church door**.

The Modern Era

Upstairs, collections span from 1600 to today and give a clear sense of how Iceland struggled under foreign rule, finally gained independence and went on to modernise. Look for the **papers and belongings of Jón Sigurðsson**, the architect of Iceland's independence.

PURIPAT LERTPUNYAROJ/SHUTTERSTOCK ©

Blue Lagoon

In a magnificent black-lava field, this scenic spa is fed water from the futuristic Svartsengi geothermal plant. With its silver towers, roiling clouds of steam and people daubed in white silica mud, it's an other-worldly place.

Great For...

Don't Miss

A bike or quad-bike tour in the lava fields.

A Good Soak

Before your dip, don't forget to practise standard Iceland pool etiquette: thorough, naked pre-pool showering.

The super-heated spa water (70% sea water, 30% fresh water) is rich in blue-green algae, mineral salts and fine silica mud, which condition and exfoliate the skin – sounds like advertising speak, but you really do come out as soft as a baby's bum. The water is hottest near the vents where it emerges, and the surface is several degrees warmer than the bottom.

Towel or bathing-suit hire is €5.

Explore the Complex

The lagoon has been developed for visitors: there's an enormous, modern complex of changing rooms (with 700 lockers!), restaurants and a gift shop. It is also

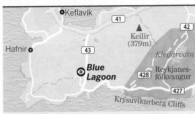

ℹ Need to Know

Blue Lagoon (Bláa Lónið; ☑420 8800; www.bluelagoon.com; adult/child from kr6990/free; ☺7am-midnight Jul–mid-Aug, 7am-11pm mid-May–Jun, 8am-10pm Jan–mid-May & mid-Aug–Sep, 8am-9pm Oct-Dec)

✗ Take a Break

Try on-site **Blue Café** (snacks kr1000-2100; ☺8am-midnight Jun–mid-Aug, reduced hours mid-Aug–May; 🛜) or **LAVA Restaurant** (mains lunch/dinner kr4500/5900; ☺11.30am-9.30pm Jun-Aug, to 8.30pm Sep-May; 🛜).

★ Top Tip

In summer avoid from 10am to 2pm – go early or after 7pm.

landscaped with hot-pots, steam rooms, a sauna, a silica-mask station, a bar and a piping-hot waterfall that delivers a powerful hydraulic massage. A VIP section has its own interior wading space, lounge and viewing platform.

Massage

For extra relaxation, lie on a floating mattress and have a massage therapist knead your knots (30/60 minutes €75/120). Book spa treatments well in advance; look online for packages and winter rates.

Guided Tours

In addition to the spa opportunities at the Blue Lagoon, you can combine your visit with package tours, or hook up with nearby **ATV Adventures** (☑857 3001; www. atv4x4.is) for quad-bike or cycling tours

(kr9900 from the Blue Lagoon through the lava fields) or bicycle rental. The company can pick you up and drop you off at the lagoon.

Planning Your Visit

Many day trips from Reykjavík tie in a visit to the lagoon, which is 47km southwest of the city. It's also seamless to visit on your journey to/from Keflavík International Airport (there's a luggage check-in in the car park, kr600 per bag, per day).

You should book ahead or risk being turned away. On a tour, always determine whether your ticket for the lagoon is included or if you need to book it separately.

Reykjavík Excursions (Kynnisferðir; ☑580 5400; www.re.is; BSÍ Bus Terminal, Vatnsmýrarvegur 10) and **Bustravel** (☑511 2600; www.bustravel.is) connect the lagoon with Reykjavík and the airport.

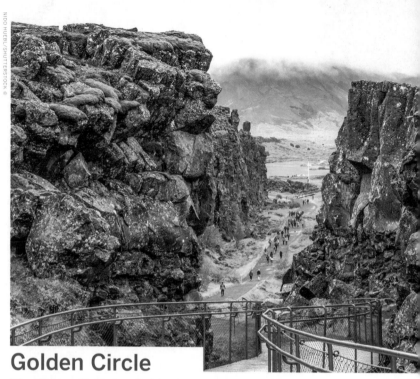

Þingvellir National Park

Golden Circle

The Golden Circle is a beloved tourist circuit that takes in three popular attractions all within 100km of the capital: Þingvellir, Geysir and Gullfoss.

Great For...

Don't Miss

The Sigríður memorial near the foot of the stairs from the Gullfoss visitors centre.

The Golden Circle offers the opportunity to see a meeting-point of the continental plates and the site of the ancient Icelandic parliament (Þingvellir), a spouting hot spring (Geysir) and a roaring waterfall (Gullfoss), all in one doable-in-a-day loop.

Visiting under your own steam allows you to visit at off-hours and explore exciting attractions further afield. Almost every tour company in the Reykjavík area offers a Golden Circle excursion, which can often be combined with virtually any activity, from quad-biking to caving and rafting.

If you're planning to spend the night in the relatively small region, **Laugarvatn** is a good base with excellent dining options.

Þingvellir National Park

Þingvellir National Park (www.thingvellir.is), 40km northeast of central Reykjavík,

Strokkur geyser

Golden Circle

❶ Need to Know

Tours generally go from 8.30am to 6pm or from noon to 7pm. In summer there are evening trips from 7pm to midnight.

✕ Take a Break

Eateries, mini-marts and grocery stores dot the route.

★ Top Tip

To go on to West Iceland afterwards, complete the Circle backwards, finishing with Þingvellir.

is Iceland's most important historical site and a place of vivid beauty. The Vikings established the world's first democratic parliament, the **Alþingi**, here in AD 930. The meetings were conducted outdoors and, as with many Saga sites, there are only the stone foundations of ancient **encampments**. The site has a superb natural setting, with rivers and waterfalls in an immense, fissured rift valley, caused by the meeting of the North American and Eurasian **tectonic plates**.

Geysir

One of Iceland's most famous tourist attractions, **Geysir** FREE (*gay*-zeer; literally 'gusher') is the original hot-water spout after which all other geysers are named. Earthquakes can stimulate activity, though eruptions are rare. Luckily for visitors, the very reliable **Strokkur** geyser sits alongside. You rarely have to wait more than five to 10 minutes for the hot spring to shoot an impressive 15m to 30m plume before vanishing down its enormous hole. Stand downwind only if you want a shower.

At the time of writing, the geothermal area containing Geysir and Strokkur was free to enter, though there is talk of instituting a fee.

Gullfoss

Iceland's most famous waterfall, **Gullfoss** (Golden Falls; www.gullfoss.is) FREE is a spectacular double cascade. It drops 32m, kicking up tiered walls of spray before thundering away down a narrow ravine. On sunny days the mist creates shimmering rainbows, and it's also magical in winter when the falls glitter with ice.

A tarmac path suitable for wheelchairs leads from the tourist information centre to a lookout over the falls, and stairs continue down to the edge. There is also an access road down to the falls.

Reykjavík

Reykjavík

◉ SIGHTS

◉ Laugavegur & Skólavörðustígur

Hallgrímskirkja — Church

(☏510 1000; www.hallgrimskirkja.is; Skólavörðustígur; tower adult/child kr900/100; ☉9am-9pm Jun-Sep, to 5pm Oct-May) Reykjavík's immense white-concrete church (1945–86), star of a thousand postcards, dominates the skyline, and is visible from up to 20km away. Get an unmissable view of the city by taking an elevator trip up the 74.5m-high **tower**. In contrast to the high drama outside, the Lutheran church's interior is quite plain. The most eye-catching feature is the vast 5275-pipe **organ** installed in 1992.

Harpa — Arts Centre

(☏box office 528 5050; www.harpa.is; Austurbakki 2; ☉8am-midnight, box office 10am-6pm) With its ever-changing facets glistening on the water's edge, Reykjavík's sparkling Harpa concert hall and cultural centre is a beauty to behold. In addition to a season of top-notch shows (some free), it's worth stopping by to explore the shimmering interior with harbour vistas, or take one of the guided tours and visit areas not open to the general public (see website for daily times and prices).

Culture House — Gallery

(Þjóðmenningarhúsið; ☏530 2210; www.culturehouse.is; Hverfisgata 15; adult/child incl National Museum kr2000/free; ☉10am-5pm May–mid-Sep, closed Mon mid-Sep–Apr) This superbly curated exhibition covers the artistic and cultural heritage of Iceland from settlement to today. Priceless artefacts are arranged by theme, and highlights include 14th-century manuscripts, contemporary art and items including the skeleton of a great auk (now extinct). The renovated 1908 building is beautiful, with great views of the harbour, and a cafe on the ground floor. Check website for free guided tours.

National Gallery
of Iceland Museum
(Listasafn Íslands; ☑515 9600; www.listas
afn.is; Fríkirkjuvegur 7; adult/child kr1500/
free; ◷10am-5pm daily mid-May–mid-Sep,
11am-5pm Tue-Sun mid-Sep–mid-May) This
pretty stack of marble atriums and
spacious galleries overlooking Tjörnin
offers ever-changing exhibits drawn
from the 10,000-piece collection. The
museum can only exhibit a small sample
at any time; shows range from 19th- and
20th-century paintings by Iceland's
favourite sons and daughters (including
Jóhannes Kjarval and Nína Sæmunds-
son) to sculptures by Sigurjón Ólafsson
and others.

◎ Old Harbour
Saga Museum Museum
(☑511 1517; www.sagamuseum.is;
Grandagarður 2; adult/child kr2100/800;
◷10am-6pm; ☐14) The endearingly blood-
thirsty Saga Museum is where Icelandic
history is brought to life by eerie silicon
models and a multi-language soundtrack
with thudding axes and hair-raising
screams. Don't be surprised if you see
some of the characters wandering around
town, as moulds were taken from Rey-
kjavík residents (the owner's daughters
are the Irish princess and the little slave
gnawing a fish!).

There's also a cafe, and a room for pos-
ing in Viking dress.

Whales of Iceland Museum
(☑571 0077; www.whalesoficeland.is; Fiskislóð
23-25; adult/child kr2900/1500; ◷10am-5pm;
☐14) Ever stroll beneath a blue whale?
This museum houses full-sized models
of the 23 species of whale found off Ice-
land's coast. The largest museum of this
type in Europe, it also displays models
of whale skeletons, and has good audio
guides and multimedia screens to explain
what you're seeing. It has a cafe and gift
shop, online ticket discounts and family
tickets (kr5800).

◎ Old Reykjavík
Settlement Exhibition Museum
(Landnámssýningin; ☑411 6370; www.reykjavik
museum.is; Aðalstræti 16; adult/child kr1600/
free; ◷9am-6pm) This fascinating archae-
ological ruin/museum is based around a
10th-century **Viking longhouse** un-
earthed here from 2001 to 2002, and the
other Settlement Era finds from central
Reykjavík. It imaginatively combines tech-
nological wizardry and archaeology to give
a glimpse into early Icelandic life.

Tjörnin Lake
This placid lake at the centre of the city is
sometimes locally called the Pond. It ech-
oes with the honks and squawks of more
than 40 species of visiting birds, including
swans, geese and Arctic terns; feeding
the ducks is a popular pastime for the un-
der-fives. Pretty sculpture-dotted parks like
Hljómskálagarður FREE line the southern
shores, and their paths are much used by
cyclists and joggers. In winter hardy souls
strap on ice skates and turn the lake into an
outdoor rink.

✪ ACTIVITIES
Literary Reykjavík Walking
(www.bokmenntaborgin.is; Tryggvagata 15;
◷3pm Thu Jun-Aug) FREE Part of the Une-
sco City of Literature initiative, free liter-
ary walking tours of the city centre start
at the main library and include the Dark
Deeds tour focusing on crime fiction.
There is also a downloadable Culture
Walks app with several themes.

Elding Adventures at Sea Wildlife
(☑519 5000; www.whalewatching.is; Ægis-
garður 5; adult/child kr11,000/5500; ◷har-
bour kiosk 8am-9pm; ☐14) ✔ The city's most
established and ecofriendly outfit, with an
included whale exhibition and refresh-
ments sold on board. Elding also offers
angling (adult/child kr13,800/6900)
and puffin-watching (adult/child from
kr6500/3250) trips and combo tours,

and runs the ferry to Viðey. Offers pick-up.

Haunted Iceland Walking
(www.hauntedwalk.is; adult/child kr2500/free; ☺8pm Sat-Thu Jun–early Sep) Ninety-minute tour, including folklore and ghost spotting, departing from the Main Tourist Office.

🔒 SHOPPING

Laugavegur and Skólavörðustígur are the central streets of Reykjavík's shopping scene. You'll find them densely lined with everything from stereotypical souvenir shops (derisively called 'Puffin Shops' by Reykjavikers) to design shops and galleries selling beautiful handmade Icelandic arts and crafts, couture clothing lines and cool outdoorwear.

Geysir Clothing
(☎519 6000; www.geysir.com; Skólavörðustígur 16; ☺10am-7pm Mon-Sat, 11am-6pm Sun) For traditional Icelandic clothing and unique modern designs,

Geysir boasts an elegant selection of sweaters, blankets, and men's and women's clothes, shoes and bags.

KronKron Clothing
(☎561 9388; www.kronkron.com; Laugavegur 63b; ☺10am-6pm Mon-Thu, to 6.30pm Fri, to 5pm Sat) This is where Reykjavík goes high fashion, with the likes of Marc Jacobs and Vivienne Westwood. But we really enjoy its Scandinavian designers (including Kron by KronKron) offering silk dresses, knit capes, scarves and even wool underwear. Its handmade shoes are off the charts; the shoes are also sold down the street at **Kron** (☎551 8388; www.kron.is; Laugavegur 48; ☺10am-6pm Mon-Fri, to 5pm Sat).

Orrifinn Jewellery
(☎789 7616; www.orrifinn.com; Skólavörðustígur 17a; ☺10am-6pm Mon-Fri, 11am-4pm Sat) Subtle, beautiful jewellery captures the natural wonder of Iceland and its Viking history. Delicate anchors, axes and pen nibs dangle from understated matte chains.

Skúmaskot

Skúmaskot — Arts & Crafts

(☏663 1013; www.facebook.com/skumaskot.art. design; Skólavörðustígur 21a; ☺10am-6pm Mon-Fri, to 5pm Sat) Ten local designers create these unique handmade porcelain items, women's and kids' clothing, paintings and cards. It's in a recently renovated large gallery beautifully showcasing their creative Icelandic crafts.

Kolaportið Flea Market — Market

(www.kolaportid.is; Tryggvagata 19; ☺11am-5pm Sat & Sun) Held in a huge industrial building by the harbour, this weekend market is a Reykjavík institution. There's a huge tumble of second-hand clothes and old toys, plus cheap imports. There's also a food section that sells traditional eats like *rúgbrauð* (geothermally baked rye bread), *brauðterta* ('sandwich cake', a layering of bread with mayonnaise-based fillings) and *hákarl* (fermented shark).

Kirsuberjatréð — Arts & Crafts

(Cherry Tree; ☏562 8990; www.kirs.is; Vesturgata 4; ☺10am-6pm Mon-Fri, to 5pm Sat & Sun) This women's art-and-design collective in an interesting 1882 former bookshop sells weird and wonderful fish-skin handbags, music boxes made from string, and, our favourite, beautiful coloured bowls made from radish slices.

✖ EATING
✖ Laugavegur & Skólavörðustígur

Bakarí Sandholt — Bakery €

(☏551 3524; www.sandholt.is; Laugavegur 36; snacks kr600-1200; ☺7am-9pm; 🛜) Reykjavík's favourite bakery is usually crammed with folks hoovering up the generous assortment of fresh baguettes, croissants, pastries and sandwiches. The soup of the day (kr1540) comes with delicious sourdough bread.

Gló — Organic, Vegetarian €

(☏553 1111; www.glo.is; Laugavegur 20b; mains kr1400-2000; ☺11am-9pm Mon-Fri, 11.30am-9pm Sat & Sun; 🛜🍴) Join the cool cats in this

🌿 Laugardalur: Hot-Springs Valley

On a verdant stretch of land 4km east of the city centre, **Laugardalur** (🚌2, 5, 14, 15, 17) was once the main source of Reykjavík's hot-water supply, and relics from the old wash house remain. It's a favourite with locals for its huge **swimming complex** (☏411 5100; www. reykjavik.is/stadir/laugardalslaug; Sundlaugavegur 30a, Laugardalur; adult/child kr950/150, suit/towel rental kr850/570; ☺6.30am-10pm Mon-Fri, 8am-10pm Sat & Sun; 🐾), fed by the geothermal spring, alongside a **spa** (☏553 0000; www.laugarspa.com; day pass kr5500; ☺6am-11pm Mon-Fri, 8am-9.30pm Sat & Sun), a skating rink, botanical gardens, sporting and concert arenas, and a kids' zoo and entertainment park.

Stop by the sun-dappled tables of **Café Flóra** (Flóran; ☏553 8872; www.floran.is; Botanic Gardens; cakes kr10,000, mains kr1500-3100; ☺10am-10pm May-Sep; 🍴) 🍃 for lovely food made from local ingredients, some from the park's own gardens. Soups come with fantastic sourdough bread, and snacks range from cheese platters with nuts and honey to pulled-pork sandwiches. Weekend brunch, good coffee and homemade cakes round it all out.

Nearby are **Frú Lauga farmers market** (☏534 7165; www.frulauga.is; Laugalækur 6; ☺11am-6pm Mon-Fri, to 4pm Sat; 🍴) 🍃 and **Reykjavík Art Museum – Ásmundarsafn** (Ásmundur Sveinsson Museum; ☏411 6430; www.artmuseum.is; Sigtún; adult/child kr1600/free; ☺10am-5pm May-Sep, 1-5pm Oct-Apr; 🚌2, 4, 14, 15, 17, 19).

Café Flóra
EGILL BJARNASON/LONELY PLANET ©

Partying in Reykjavík

Reykjavík's renowned *djammið* is the lively surge of drinkers and partyers through central Reykjavík's streets, pubs and dance clubs. Thanks to the high price of alcohol, things generally don't get going until late. Icelanders brave the melee at government alcohol store **Vínbúðin** (www.vinbudin.is; Austurstræti 10a; ⊙11am-6pm Mon-Thu & Sat, to 7pm Fri), then toddle home for a pre-pub party before hitting the streets.

upstairs, airy restaurant serving fresh, large daily specials loaded with Asian–influenced herbs and spices. Though not exclusively vegetarian, it's a wonderland of raw and organic foods with your choice from a broad bar of elaborate salads, from root veggies to Greek. It also has branches in **Laugardalur** (⌨553 1111; www.glo.is; Engjateigur 19; mains kr1250-2000; ⊙11am-9pm Mon-Fri; 🛜🚲) 🌿 and **Kópavogur** (www.glo.is; Hæðasmári 6; mains kr1300-2300; ⊙11am-9pm Mon-Fri, 11.30am-9pm Sat & Sun; 🛜🚲) 🌿.

Ostabúðin Deli €€

(Cheese Shop; ⌨562 2772; www.ostabudin.is; Skólavörðustígur 8; mains kr3750-5000; ⊙restaurant noon-10pm, deli 10am-6pm Mon-Thu, to 7pm Fri, 11am-4pm Sat) Head to this gourmet cheese shop and deli, with a large dining room, for the friendly owner's cheese and meat platters (from kr1900 to kr4000), or the catch of the day, accompanied by homemade bread.

You can pick up other local goods, like terrines and duck confit, on the way out.

Dill Icelandic €€€

(⌨552 1522; www.dillrestaurant.is; Hverfisgata 12; 5-course meals from kr12,000; ⊙6-10pm Wed-Sat) Top New Nordic cuisine is the major drawcard at this elegant yet simple bistro. The focus is very much on the food – locally sourced produce served as a parade of courses. The owners are friends with Copenhagen's famous Noma clan, and take Icelandic cuisine to similarly heady heights. Reservation is a must.

Þrír Frakkar Icelandic, Seafood €€€

(⌨552 3939; www.3frakkar.com; Baldursgata 14; mains kr4000-6000; ⊙11.30am-2.30pm & 6-10pm Mon-Fri, 6-11pm Sat & Sun) Owner-chef Úlfar Eysteinsson has built up a consistently excellent reputation at this snug little restaurant – apparently a favourite of Jamie Oliver's. Specialities range throughout the aquatic world from salt cod and halibut to *plokkfiskur* (fish stew) with black bread. Non-fish items run towards guillemot, horse, lamb and whale.

Old Harbour

Sægreifinn Seafood €

(Seabaron; ⌨553 1500; www.saegreifinn.is; Geirsgata 8; mains kr1350-1900; ⊙11.30am-11pm mid-May–Aug, to 10pm Sep–mid-May) Sidle into this green harbourside shack for the most famous lobster soup (kr1350) in the capital, or to choose from a fridge full of fresh fish skewers to be grilled on the spot.

Coocoo's Nest Cafe €€

(⌨552 5454; www.coocoosnest.is; Grandagarður 23; mains kr1700-4500; ⊙11am-10pm Tue-Sat, to 4pm Sun; 🛜) Pop into this cool eatery tucked behind the Old Harbour for popular weekend brunches (dishes kr1700 to kr2200; 11am to 4pm Friday to Sunday) paired with decadent cocktails (kr1300). Casual, small and groovy, with mosaic plywood tables;

the menu changes and there are nightly themes, but it's always scrumptious.

Matur og Drykkur Icelandic €€

(☑571 8877; www.maturogdrykkur.is; Grandagarður 2; lunch mains kr1900-2700, dinner mains/tasting menus kr3700/10,000; ☺11.30am-3pm & 6-10pm Mon-Sat, 6-10pm Sun; 🚌14) One of Reykjavík's top high-concept restaurants, Matur Og Drykkur means 'Food and Drink', and you surely will be plied with the best of both. The brainchild of brilliant chef Gísli Matthías Auðunsson, who creates inventive versions of traditional Icelandic fare. Book ahead in high season and for dinner.

❌ Old Reykjavík

Stofan Kaffihús Cafe €

(☑546 1842; www.facebook.com/stofan.cafe; Vesturgata 3; dishes kr1500-1700; ☺9am-11pm Mon-Wed, to midnight Thu-Sat, 10am-10pm Sun; 🛜) This laid-back cafe in a historic brick building has a warm feel, with its worn wooden floors, plump couches and spacious main room. Settle in for coffee, cake or soup, and watch the world go by.

Messinn Seafood €€

(☑546 0095; www.messinn.com; Lækjargata 6b; lunch mains kr1850-2100, dinner mains kr2700-4100; ☺11.30am-3pm & 5-10pm; 🛜) Make a beeline to Messinn for the best seafood that Reykjavík has to offer. The speciality is amazing pan-fries where your pick of fish is served up in a sizzling cast-iron skillet accompanied by buttery potatoes and salad. The mood is upbeat and comfortable, and the staff friendly.

Grillmarkaðurinn Fusion €€€

(Grill Market; ☑571 7777; www.grillmarka durinn.is; Lækargata 2a; mains kr4600-9900; ☺11.30am-2pm Mon-Fri, 6-10.30pm Sun-Thu, to 11.30pm Fri & Sat) From the moment you enter the glass atrium here, high-class dining is the order of the day. Service is impeccable, and locals and visitors alike rave about the food: locally sourced Icelandic ingredients prepared with culinary imagination by master chefs. The tasting menu (kr10,400) is an extravaganza of its best dishes.

Coocoo's Nest

MIKAEL AXELSSON /MIKKELLER & FRIENDS REYKJAVIK ©

Mikkeller & Friends

Fiskmarkaðurinn Seafood €€€

(Fishmarket; ☏578 8877; www.fiskmarkadurinn.
is; Aðalstræti 12; mains kr5100-8900; ☺5-
11.30pm) This restaurant excels in infusing
Icelandic seafood and local produce with
unique flavours like lotus root. The tasting
menu (kr11,900) is tops, and it is renowned
for its excellent sushi bar (kr3600 to
kr4600).

🍷 DRINKING & NIGHTLIFE

🍸 Laugavegur & Skólavörðustígur

Laugavegur is the epicentre of Reykjavík's
nightlife and you could begin (and end) a
night here. Bar-hop until the clubs light up
for dancing (late), then wander home under
the early-morning sun.

Kaffi Vínyl Cafe

(☏537 1332; www.facebook.com/vinilrvk; Hver-
fisgata 76; ☺8am-11pm; ☎) This new entry on
the Reykjavík coffee, restaurant and music
scene is popular for its chill vibe, great mu-
sic, and delicious vegan and vegetarian food.

Mikkeller & Friends Craft Beer

(☏437 0203; www.mikkeller.dk; Hverfisgata
12; ☺5pm-1am Sun-Thu, 2pm-1am Fri & Sat;
☎) Climb to the top floor of the building
shared by excellent pizzeria Hverfisgata
12 and you'll find this Danish craft-beer
pub; its 20 taps rotate through Mik-
keller's own offerings and local Icelandic
craft beers.

Kaffibarinn Bar

(☏551 1588; www.kaffibarinn.is; Bergstaðas-
træti 1; ☺3pm-1am Sun-Thu, to 4.30am Fri &
Sat; ☎) This old house with the London
Underground symbol over the door
contains one of Reykjavík's coolest bars;
it even had a starring role in the cult
movie *101 Reykjavík* (2000). At weekends
you'll feel like you need a famous face or
a battering ram to get in. At other times
it's a place for artistic types to chill with
their Macs.

Kaldi — Bar

(☎581 2200; www.kaldibar.is; Laugavegur 20b; ⊗noon-1am Sun-Thu, to 3am Fri & Sat) Effortlessly cool, with mismatched seats and teal banquettes, plus a popular smoking courtyard, Kaldi is awesome for its full range of Kaldi microbrews, not available elsewhere. Happy hour (4pm to 7pm) gets you one for kr700. Anyone can play the in-house piano.

Old Reykjavík

Austurstræti is lined with big venues that pull in the drinking crowd. As the night goes on, some of the capital's best dance clubs and late-night hangs can be found around Naustin St.

Micro Bar — Bar

(☎865 8389; www.facebook.com/MicroBarIceland; Vesturgata 2; ⊗4pm-12.30am Sun-Thu, to 1.30am Fri & Sat) Boutique brews are the name of the game at this low-key spot in the heart of the action. Bottles of beer represent a slew of brands and countries, but more importantly you'll discover 10 local draughts on tap from the island's top microbreweries – one of the best selections in Reykjavík. Happy hour (5pm to 7pm) offers kr850 beers.

Loftið — Cocktail Bar

(Jacobsen Loftið; ☎551 9400; www.facebook.com/loftidbar; 2nd fl, Austurstræti 9; ⊗4pm-1am Sun-Thu, to 4am Fri & Sat) Loftið is all about high-end cocktails and good living. Dress up to join the fray at this airy upstairs lounge with a zinc bar, retro tailor-shop-inspired decor, vintage tiles and a swanky, older crowd. The basic booze here is the top-shelf liquor elsewhere, and jazzy bands play from time to time.

Paloma — Club

(http://palomaclub.is; Naustin 1-3; ⊗8pm-1am Thu & Sun, to 4.30am Fri & Sat; ☝) One of Reykjavík's best late-night dance clubs, with DJs upstairs laying down reggae, electronica and pop, and a dark deephouse dance scene in the basement. It's in the same building as the Dubliner.

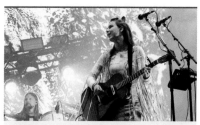

Icelandic Pop

Iceland's pop music scene is one of its great gifts to the world. Internationally famous Icelandic musicians include (of course) Björk and her former band, the Sugarcubes. Sigur Rós followed Björk to stardom; their concert movie *Heima* (2007) is a must-see. Indie-folk band Of Monsters and Men stormed the US charts in 2011 with *My Head Is an Animal;* their latest album is *Beneath the Skin (2015)*. Ásgeir had a breakout hit with *In the Silence* (2014).

Reykjavík's flourishing music landscape is constantly changing – visit www.icelandmusic.is and www.grapevine.is for news and listings. Just a few examples of local groups include Seabear, an indie-folk band, which spawned top acts like Sin Fang (*Flowers;* 2013) and Sóley (*We Sink;* 2012). Árstíðir record minimalist indie-folk, and released Verloren Verleden with Anneke van Giersbergen in 2016.

Other local bands include GusGus, a pop-electronica act, FM Belfast (electronica) and múm (experimental electronica mixed with traditional instruments). Or check out Singapore Sling for straight-up rock and roll. If your visit coincides with one of Iceland's many music festivals, go!

Of Monsters and Men
DFP PHOTOGRAPHIC/SHUTTERSTOCK ©

ENTERTAINMENT

Bíó Paradís Cinema

(☏412 7711; www.bioparadis.is; Hverfisgata 54; adult kr1800; 🛜) This totally cool cinema, decked out in movie posters and vintage officeware, screens specially curated Icelandic films with English subtitles. It has a happy hour from 5pm to 7.30pm.

Húrra Live Music

(www.facebook.com/pg/hurra.is; Tryggvagata 22; ⊗6pm-1am Mon-Thu, to 4.30am Fri & Sat, to 11.30pm Sun; 🛜) Dark and raw, this large bar opens up its back room to make a concert venue, with live music or DJs most nights, and is one of the best places in town to close out the night. It's got a range of beers on tap, and happy hour runs till 9pm (beer or wine kr700).

ℹ INFORMATION

DISCOUNT CARDS

Reykjavík City Card (www.citycard.is; 24/48/72hr kr3700/4900/5900) offers admission to Reykjavík's municipal swimming/thermal pools and to most of the main galleries and museums, plus discounts on some tours, shops and entertainment. It also gives free travel on the city's Strætó buses and on the ferry to Viðey.

EMERGENCY NUMBERS

Ambulance, fire brigade & police 112

TOURIST INFORMATION

The **Main Tourist Office** (Upplýsingamiðstöð Ferðamanna; ☏411 6040; www.visitreykjavik.is; Ráðhús City Hall, Tjarnargata 11; ⊗8am-8pm) has friendly staff and mountains of free brochures, plus maps, Reykjavík City Card and Strætó city bus tickets. It books accommodation, tours and activities.

ℹ GETTING THERE & AWAY

Iceland has become very accessible in recent years, with more flights from more destinations. Ferry transport makes a good alternative for people wishing to bring a car or camper from mainland Europe.

Flights, tours and rail tickets can be booked online at www.lonelyplanet.com/bookings.

ℹ GETTING AROUND

The best way to see compact central Reykjavík is by foot.

TO/FROM THE AIRPORT

The journey from Keflavík International Airport to Reykjavík takes about 50 minutes.

Flybus (☏580 5400; www.re.is; 🛜) meets all international flights. One-way tickets cost kr2200. Pay kr2800 for hotel pick-up/drop-off, which must be booked a day ahead. A separate service runs to the Blue Lagoon (from where you can continue to the city centre or the airport; kr3900).

Airport Express (☏540 1313; www.airportexpress.is; 🛜) Operated by Gray Line Tours between Keflavík International Airport and Lækjartorg Sq in central Reykjavík (kr2100) or Mjódd bus terminal, or via hotel pick-up/drop-off (kr2700; book ahead). Has connections to Borgarnes and points north, including Akureyri.

Airport Direct (☏497 5000; www.reykjaviksightseeing.is/airport-direct; 🛜) Minibuses operated by Reykjavík Sightseeing shuttle between hotels and the airport (kr4500, return kr8000).

Taxis cost around kr15,000.

BUS

Strætó (www.bus.is) operates regular, easy buses in the city centre and environs, running 7am until 11pm or midnight daily (from 11am on Sunday). A limited night-bus service runs until 2am on Friday and Saturday.

 Where to Stay

Demand always outstrips supply in Reykjavík. Try to book your accommodation three to six months ahead.

Neighbourhood	Atmosphere
Old Reykjavík	Central, easy with higher-end options. Can be crowded, busier and expensive.
Old Harbour	Less busy once back from the harbour. Guesthouses and hostels are more affordable, but it is slightly less central.
Laugavegur & Skólavörðustígur	Perfect for shopping and partying. Good range of options with certain quiet pockets. It's touristy on the main streets.
Hlemmur & Tún	Loads of high-rise hotels are popping up here. The areas are on the bland side and a bit far from the city centre.
Laugardalur	Near large park and swimming complex. New high-rise hotels. Further from the city centre.

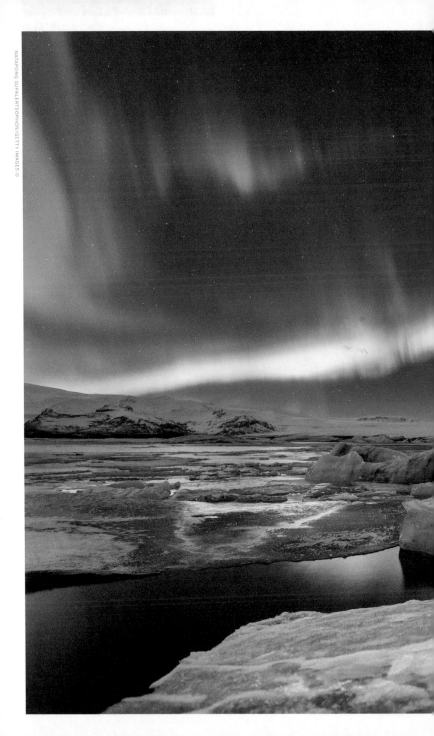

Aurora Borealis over Jökulsárlón Glacial Lagoon

SOUTHEASTERN ICELAND

Southeastern Iceland at a Glance...

The 200km stretch of Ring Road from Kirkjubæjarklaustur to Höfn is truly mind-blowing, transporting you across vast deltas of grey glacial sand, past lost-looking farms, around the toes of craggy mountains, and by glacier tongues and ice-filled lagoons. The only thing you won't pass is a town.

The mighty Vatnajökull dominates the region, its huge rivers of ice pouring down steep-sided valleys towards the sea. Jökulsárlón is a photographer's paradise, a glacial lagoon where wind and water sculpt icebergs into fantastical shapes.

Two Days in the Southeast

Spend a day just driving the ring road, letting the extraordinary scenery and lonely views wash over you. On day two, spend a day in and around the **Jökulsárlón Glacial Lagoon** (p98), including at least one boat trip and one hike. Base yourself in **Höfn** (p106), and get to know a remote southern Icelandic settlement.

Four Days in the Southeast

On day three, spend as much time as you can getting to know the black beaches of **Vík** (p105). On day four, devote all your energies to hiking in **Vatnajökull National Park** (p102), taking in some of Iceland's most iconic vistas. If you've any time left, devote it to exploring **Landmannalaugar** and **Fjallabak Nature Reserve** (p110).

Hágöngulón

Kvíslavatn

Stafafell

●Versalir
Kjalvötn

Vatnajökull
National
Park

Bjarnanes
Þveit ●

Höfn

Heinabergslón

Stokksnes

Þórisvatn

Vatnajökull

Önýtavatn
Fjallabak
Nature
Reserve

Fögrufjöll
▲(1090m)

Grænalón

Laki
▲(818m)

Lómagnúpur
(767m)

●Landmannalaugar

Laufsalavatn

Skaftafell

●Hali

Jökulsárlón

Jökulsárlón

Fjallsárlón

Hvannadalshnúkur
(2110m)

Jökuldalur

▲Gjátindur

Kalfafell●

▲Torfajökull

Kirkjubæjarklaustur

Öræfi
Skeiðarársandur

Hof

Mýrdalsjökull

▲
Katla
(1250m)

Hrífunes

Eldhraun

Álftaver
●●

Mýrdalssandur

Þykkvabæjarklaustur

●Vík

**Vík
Beaches**

0 — 40 km
0 — 20 miles

Southeastern Iceland (p104)
Höfn Map (p107)

Arriving in the Southeast

Buses drive the Ring Road (Rte 1), connecting Reykjavík and popular towns in Iceland's Southwest with destinations further east along the south coast.

Vík is a popular departure point for Kirkjubæjarklaustur; it's then 200km east to the next town, Höfn – and along the way the primary stops for buses are Skaftafell and Jökulsárlón. Your own wheels allow a more in-depth exploration.

Where to Stay

There are hotels and guesthouses scattered throughout the region, but not nearly enough to satisfy demand. Our advice: book early, and be prepared to pay high rates (some of the country's highest).

The areas around Kirkjubæjarklaustur and Höfn have the most choice; options are very limited around Skaftafell and Jökulsárlón.

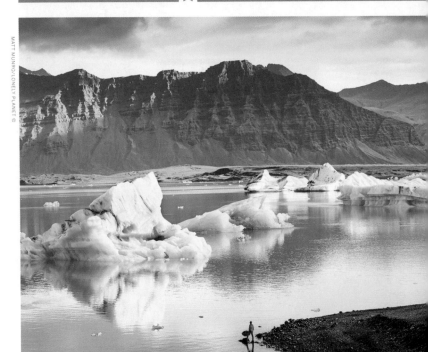

MATT MUNRO/LONELY PLANET ©

Jökulsárlón Glacial Lagoon

A host of spectacular, luminous-blue icebergs drift through Jökulsárlón glacial lagoon, right beside the Ring Road between Höfn and Skaftafell. It's one of Iceland's most memorable sights.

Great For...

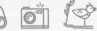

Don't Miss

When walking along the shore, taste ancient ice by hauling it out of the water.

This is nature at its most dramatic. The icebergs calve from Breiðamerkurjökull, an offshoot of Vatnajökull, crashing down into the water and drifting towards the Atlantic Ocean. They can spend up to five years floating in the 25-sq-km-plus, 260m-deep lagoon, melting, refreezing and occasionally toppling over with a mighty splash, startling the birds. They then move out to sea via Jökulsá, Iceland's shortest river.

Lagoon History

Although it looks as though it's been here since the last Ice Age, the lagoon is only about 80 years old. Until the mid-1930s Breiðamerkurjökull reached the Ring Road; it's now retreating rapidly (up to a staggering 500m per year), and the lagoon is consequently growing.

ⓘ Need to Know

Don't try to do a trip from Reykjavík to the lagoon and back in one day.

✕ Take a Break

The year-round **cafe** (snacks kr400-2000; ⊘9am-7pm) beside the lagoon is a good pit stop for information and a snack.

★ Top Tip

It's worth spending at least a couple of hours here.

Lagoon Boat Trips

Take a memorable 40-minute trip in an **amphibious boat,** (☑478 2222; www.icelagoon.is; adult/child kr5500/2000; ⊘9am-7pm Jun-Sep, 10am-5pm May & Oct) which trundles along the shore like a bus before driving into the water. On-board guides regale you with factoids about the lagoon, and you can taste 1000-year-old ice. There is no set schedule; trips run from the eastern car park (by the cafe) regularly – up to 40 a day in summer.

Zodiac Boat Trips

Ice Lagoon (☑860 9996; www.icelagoon. com; adult/child kr9500/6000; ⊘9am-5.30pm mid-May–mid-Sep) deals exclusively with

Zodiac tours (an inflatable boat) of the lagoon. It's a one-hour experience, with a maximum of 20 passengers per boat, and it travels at speed up to the glacier edge (not done by the amphibious boats) before cruising back at a leisurely pace. It pays to book these tours in advance, online; minimum age six years.

Lagoon Hikes

The new **Breiðármörk Trail** has been marked from the western car park at Jökulsárlón, leading to Breiðárlón (10km one way) and Fjallsárlón (15.3km) lagoons. It is classified as challenging. In time, there is a plan to build out this walking route from Skaftafell in the west to Lónsöræfi in the east. The visitor centre at Höfn sells a trail map (kr250).

Puffin on Dyrholaey Peninsula

CHRISTIAN SCHWEIGER/500PX ©

Vík Black Beaches

Images of the black, basalt beaches at Reynisfjara and nearby are among Iceland's most beautiful. Coming here is an opportunity to sample the country's strange, haunting beauty.

Great For...

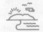 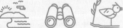

Don't Miss

Katla Track (p105) runs tours of the area that take in local landmarks and get to the edge of Mýrdalsjökull.

Reynisfjara

On the west side of Reynisfjall, the high ridge above Vík, Rte 215 leads 5km down to black-sand beach **Reynisfjara**. It's backed by an incredible stack of basalt columns that look like a magical church organ, and there are outstanding views west to Dyrhólaey. Surrounding cliffs are pocked with caves formed from twisted basalt, and puffins belly flop into the crashing sea during summer. Immediately offshore are the towering Reynisdrangur sea stacks. At all times watch for rogue waves: people are regularly swept away.

Reynisdrangur

ROEL SLOOTWEG/SHUTTERSTOCK ©

❶ Need to Know

Vík is a major stop for all Reykjavík–Höfn bus routes; buses stop at the N1 petrol station.

✕ Take a Break

At Svarta Fjaran (p105), black volcanic cubes house this contemporary cafe-restaurant.

★ Top Tip

The beach can get busy in high season, so try to come early in the day or late in the evening.

Reynisdrangur

Vík's most iconic cluster of sea stacks is known as **Reynisdrangur**, which rise from the ocean like ebony towers at the western end of Vík's black-sand beach. Folklore says they're masts of a ship that trolls were stealing when they got caught in the sun. The nearby cliffs are good for puffin watching. A bracing walk up from Vík's western end takes you to the top of Reynisfjall ridge (340m), offering superb views.

Dyrhólaey

One of the south coast's most recognisable natural formations is the rocky plateau and huge stone sea arch at **Dyrhólaey** (deer-lay), which rises dramatically from the surrounding plain 10km west of Vík, at the end of Rte 218. Visit its crashing black beaches and get awesome views from atop the promontory. The islet is a nature reserve that's rich in bird-life, including puffins; some or all of it can be closed during nesting season (15 May to 25 June). The archway itself is best seen from Reynisfjara.

Skaftafellsjökull glacier

MARCO BOTTIGELLI/GETTY IMAGES ©

Hiking in Vatnajökull National Park

Skaftafell, the jewel in the crown of Vatnajökull National Park, encompasses a breathtaking collection of peaks and glaciers. It's the country's favourite wilderness.

Great For...

Don't Miss

Atlantsflug (☑854 4105; www.flightseeing.is) offers eye-popping scenic flights with six choices of routes.

Thundering waterfalls, twisted birch woods, the tangled web of rivers threading across the sandar, and brilliant blue-white Vatnajökull with its lurching tongues of ice, dripping down mountainsides like icing on a cake.

Svartifoss

Star of a hundred postcards, Svartifoss (Black Falls) is a stunning, moody-looking waterfall flanked by geometric black basalt columns. It's reached by an easy 1.8km trail leading up from the visitor centre via the campsite. To take pressure off the busy trail to Svartifoss, park staff recommend you take an alternative path back to the visitor centre.

Svartifoss waterfall

KAVRAM/SHUTTERSTOCK ©

ℹ Need to Know

The park produces good maps outlining shorter hiking trails (kr350).

✕ Take a Break

Glacier Goodies (www.facebook.com/glaciergoodies; mains kr2200-2700; ◷11.30am-7pm mid-May–Sep), close to the visitor centre, does dishes made from local ingredients.

★ Top Tip

To take pressure off the busy trail to Svartifoss, take an alternative path back to the visitor centre.

Skaftafellsjökull

A very popular trail is the easy one-hour return walk (3.7km) to Skaftafellsjökull. The marked trail begins at the visitor centre and leads to the glacier face, where you can witness the bumps and groans of the ice (although the glacier is pretty grey and gritty here). The glacier has receded greatly in recent decades, meaning land along this trail has been gradually reappearing.

Skaftafellsheiði Loop

On a fine day, the five- to six-hour (15.5km) walk around Skaftafellsheiði is a hiker's dream. It begins by climbing from the campsite past Svartifoss and Sjónarsker,

continuing across the moor to 610m-high **Fremrihnaukur**. From there it follows the edge of the plateau to the next rise, **Nyðrihnaukur** (706m), which affords a superb view of Morsárdalur, and Morsárjökull and the iceberg-choked lagoon at its base.

Morsárdalur & Bæjarstaðarskógur

The seven-hour hike (20.6km return) from the campsite to the glacial lake in Morsárdalur is ordinary but enjoyable. Alternatively, cross the Morsá river at the foot of Skaftafellsheiði and make your way across the gravel riverbed to the birch woods at Bæjarstaðarskógur. The return walk to Bæjarstaðarskógur takes about six hours (13km return). This is also the trail to follow if you're exploring on mountain bike (BYO bike).

Southeast Iceland

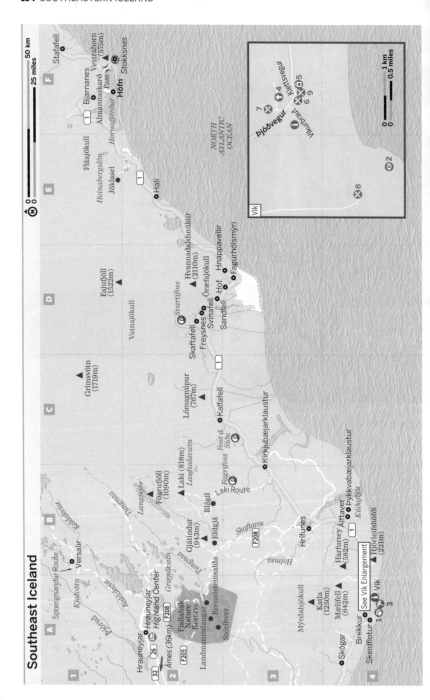

0 25 miles

0 50 km

VIK

Þjóðvegur

Víkurbraut

Klettsvegur

NORTH ATLANTIC OCEAN

0 0.5 miles

0 1 km

Stafafell

Bjarnanes

Almannaskarð Vestrahorn (575m)

Hornafjörður Pass

Höfn Stokksnes

Fláajökull

Heinabergslón

Jöklasel

Hali

Öræfajökull

Hvannadalshnúkur (2110m)

Hnappavellir

Fagurhólsmýri

Hof

Sandfell

Svínafell

Öræfajökull

Skaftafell

Freysnes

Esjufjöll (1522m)

Svartifoss

Vatnajökull

Grímsvötn (1719m)

Lómagnúpur (767m)

Kálfafell

Foss á Síðu

Kirkjubæjarklaustur

Fagrifoss

Laki (818m)

Laki Route

Laufsalavatn

Fögrufjöll (1090m)

Langisjór

Tungnaá

Gjátindur (943m)

Eldgjá

Bláfjall

Skaftáróss

F208

Hrífunes

Hólmsá

Kúðafljót

Þykkvabæjarklaustur

Hjörleifshöfði (221m)

Hafursey (582m)

Álftaver

Brennisteinsalda

Stórihver

Landmannalaugar

Fjallabak Nature Reserve

Fjallabak Highland Center

Hrauneyjar

Árnes (36km)

F208

F225

32

26

Sprengisandur Route

Versalir

Hrauneyjar

Þjórsá

Kaldakvísl

Kaldakvísl

Tungnaá

Greendavatn

Myrdalsjökull

Katla (1250m)

Mælifell (642m)

See Vik Enlargement

Vík

Skógar

Brekkur

Skeiðflötur

8

2

7

4

5

6 9

3

1

Vík

The welcoming little community of Vík (aka Vík í Mýrdal) has become a booming hub for a very beautiful portion of the south coast. Iceland's southernmost town, it's also the rainiest, but that doesn't stop the madhouse atmosphere in summer, when every room within 100km is booked solid. With loads of services, Vík is a convenient base for the beautiful basalt beach Reynisfjara and its puffin cliffs, and the rocky plateau Dyrhólaey (both just to the west) and for the volcanoes running from Skógar to Jökulsárlón glacier lagoon and beyond. Along the coast, white-capped waves wash up on black sands and the cliffs glow green from all that rain. Put simply, it's gorgeous.

◎ SIGHTS

Víkurkirkja Church

(Hátún) High above town, Vík's 1930s church has stained-glass windows in spiky geometrical shapes, but we like it most for its village views.

◉ TOURS

Skógar (33km west of Vík) and Hvolsvöllur are the hubs for activity tours on the south coast. In Vík, you can check with the hostel for tours to Mýrdalsjökull. Many Reykjavík tour companies also make the long haul out here.

Katla Track Driving

(✆849 4404; www.katlatrack.is) Katla Track runs tours of the area (kr29,900, from Reykjavík kr44,900) that take in local landmarks and get to the edge of Mýrdalsjökull.

🔒 SHOPPING

Víkurprjón Gifts & Souvenirs

(✆487 1250; www.vikwool.is; Austurvegur 20; ⊗8am-7pm) The big Icewear souvenir and knitwear shop next to the N1 station is a coach-tour hit. You can peek inside the factory portion to see woollen wear being made.

Southeast Iceland

🍴 EATING

Víkurskáli International €

(✆487 1230; Austurvegur 18; mains kr1400-3000; ⊗11am-9pm) Grab a booth and a burger at the old-school grill inside the N1 with a view of Reynisdrangur. Daily specials from casserole to lamb stew.

Suður-Vík Icelandic, Asian €€

(✆487 1515; www.facebook.com/Sudurvik; Suður-víkurvegur 1; mains kr2250-5350; ⊗noon-10pm, shorter hours in winter) The friendly ambience, from hardwood floors and interesting artwork to smiling staff, helps elevate this restaurant beyond the competition. Food is Icelandic hearty, and ranges from heaping steak sandwiches with bacon and Béarnaise sauce to Asian (think Thai satay with rice). In a warmly lit silver building atop town. Book ahead in summer.

Ströndin Bistro International €€

(✆487 1230; www.strondin.is; Austurvegur 18; mains kr2000-5000; ⊗6-10pm; 🛜) Behind the N1 petrol station is this semi-smart wood-panelled option enjoying sea-stack vistas. Go local with lamb soup or fish stew, or global with pizzas and burgers.

Svarta Fjaran Cafe €€

(Black Beach Restaurant; ✆571 2718; www.svartafjaran.com; Reynisfjara; snacks kr990, dinner mains kr2500-6000; ⊗11am-10pm; 🛜) Black volcanic cubes, meant to mimic the nearby black beach Reynisfjara with its famous basalt columns, house this contemporary

restaurant that serves homemade cakes and snacks during the day and a full dinner menu at night. Plate-glass windows give views to the ocean and Dyrhólaey beyond.

INFORMATION

Tourist Information Centre (☎487 1395; www.visitvik.is; Víkurbraut 28; ◷10am-7pm Mon-Fri, 11am-5pm Sat & Sun Jun-Aug; ☎) Inside Brydebúð.

GETTING THERE & AWAY

Vík is a major stop for all Reykjavík–Höfn bus routes; buses stop at the N1 petrol station.

Strætó (☎540 2700; www.bus.is) services:

○ Bus 51 Reykjavík–Vík–Höfn (Reykjavík–Vík kr5880, 2¾ hours, two daily) If you take the early bus you can stop in Vík then continue on to Höfn on the later bus; however, from September to May service is reduced and you can't count on that connection.

Sterna (☎551 1166; www.icelandbybus.is) services:

○ Bus 12/12a Reykjavík–Vík–Höfn (Reykjavík–Vík kr5600, 4¼ hours, one daily June to mid-September).

Reykjavík Excursions (☎580 5400; www.re.is) services:

○ Bus 20/20a Reykjavík–Skaftafell (Reykjavík–Vík kr7500, four hours, one daily June to early September).

○ Bus 21/21a Reykjavík–Skógar (Reykjavík–Vík kr7500, 3¾ hours, one daily June to August) One of the two services to Skógar goes as far as Vík each day.

Höfn

Although it's no bigger than many European villages, the Southeast's main town feels like a sprawling metropolis after driving through the emptiness on either side. Its setting is stunning; on a clear day, wander down to the waterside, find a quiet bench and just gaze at Vatnajökull and its guild of glaciers.

Höfn simply means 'harbour', and is pronounced like an unexpected hiccup (just say 'hup' while inhaling). It's an apt name – this modern town still relies heavily on fishing and fish processing, and is famous for its *humar* (often translated as lobster, but technically it's langoustine).

Bus travellers use Höfn as a transit point, and most travellers stop to use the town's services, so pre-book accommodation in summer. On bus timetables and the like, you may see the town referred to as Höfn í Hornafirði (meaning Höfn in Hornafjörður) to differentiate it from all the other *höfn* (harbours) around the country.

SIGHTS

If you're interested, there are various museum-style exhibitions around town, including a rock collection and an old stockfish shed with displays on fishing and seafaring.

Gamlabúð Notable Building, Museum (☎470 8330; www.vjp.is; Heppuvegur 1; ◷9am-7pm Jun-Aug, to 6pm May & Sep, to 5pm Oct-Apr) FREE The 1864 warehouse that once served as the regional folk museum has been moved from the outskirts of town to a prime position on the Höfn harbour front. It's been refurbished to serve as the town's visitor centre, with good exhibits explaining the marvels of the region's flagship national park (including flora and fauna), as well as screening documentaries.

Seamen's Monument Monument (Óslandsvegur) This monument stands on Ósland, the bird-filled promontory south of the harbour. Head here for good walks and views.

ACTIVITIES

Activities that explore Vatnajökull's icy vastness – such as glacier walks, super-4WD tours, lagoon kayaking and snowmobile safaris – are accessed along the Ring Road west of Höfn.

In town, there are a couple of short **waterside paths** where you can amble and gape at the views – one by Hótel Höfn and another on Ósland.

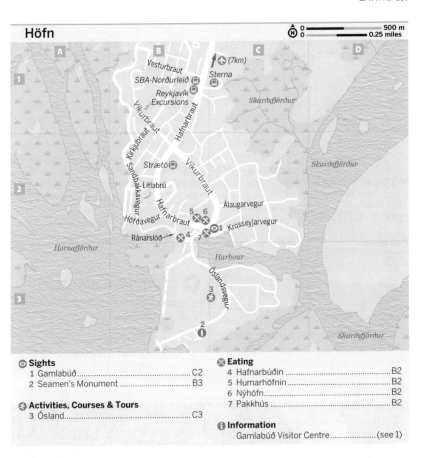

Höfn

Ósland Walking

This promontory about 1km beyond the
harbour – head for the seamen's monument
on the rise – boasts a walking path round
its marshes and lagoons. The path is great
for watching seabirds, though be wary of
dive-bombing Arctic terns.

From the seamen's monument, you can
follow a nature trail that has been set up to
model the solar system – it's been 'scaled
down 2.1 billion fold', and has its sizes and
distances in correct proportion.

✖ EATING

Humar (langoustine) is the speciality on
Höfn menus – tails or served whole and
grilled with garlic butter is the norm, and
prices for main dishes range from kr7000
upwards. You'll find cheaper crustacean-
centric options too: bisque, sandwiches or
langoustine-studded pizza or pasta.

Look out for the **Heimahumar** food
truck, parked out front of Nettó in the
summer, for the cheapest lobster wraps
and panini in town (around kr1850).

Hafnarbúðin Fast Food €

(☑478 1095; Ránarslóð 2; snacks & meals
kr400-2800; ⊙9am-10pm Mon-Fri, 10am-
10pm Sat & Sun, shorter hours in winter) A
fabulous relic, this tiny old-school diner
has a cheap-and-cheerful vibe, a menu of
fast-food favourites (hot dogs, burgers,

toasted sandwiches) and a fine *humarloka* – langoustine baguette – for kr2000. There's even a drive-up window!

Nýhöfn Icelandic €€

(☎865 2489; www.nyhofn.is; Hafnarbraut 2; mains kr2900-5900; ⊙noon-10pm mid-May–mid-Sep) This sweet 'Nordic bistro' is in the home that Höfn's first settler built in 1897, and still retains its refined, old-world atmosphere. The menu spotlights local produce, but is an interesting nod to influences near and far, from langoustine bruschetta to Peruvian ceviche by way of organic vegetarian barley burgers. There's a small bar in the cellar, too.

Pakkhús Icelandic €€€

(☎478 2280; www.pakkhus.is; Krosseyjarvegur 3; mains kr3200-6850; ⊙noon-10pm mid-May–mid-Sep, 5-9pm mid-Sep–mid-May) Hats off to a menu that tells you the name of the boat that delivers its star produce. In a stylish harbourside warehouse, Pakkhús offers a level of kitchen creativity you don't often find in rural Iceland. First-class local langoustine, lamb and duck tempt taste buds, while

clever desserts end the meal in style: who can resist a dish called '*skyr* volcano'?

No reservations taken – you may have to wait for a table, but there is a bar area downstairs.

Humarhöfnin Icelandic €€€

(☎478 1200; www.humarhofnin.is; Hafnarbraut 4; mains kr2900-8400; ⊙noon-10pm May-Sep, to 9pm Oct-Nov) Humarhöfnin offers 'Gastronomy Langoustine' in a cute, cheerfully Frenchified space with superb attention to detail: herb pots on the windowsills, roses on every table. Mains centred on pincer-waving critters cost upwards of kr7000, but there are also more budget-friendly dishes, including a fine langoustine baguette (kr4300) or pizza (kr2900).

🍺 DRINKING & NIGHTLIFE

Höfn goes to bed early (there are activities to get to early in the morning!), but drinking can be done at most restaurants. Kaffi Hornið has a particularly good beer selection, while Nýhöfn boasts a small cellar bar.

Skyr volcano dessert served at Pakkhús

CAROLYN BAIN/LONELY PLANET ©

ℹ️ INFORMATION

Gamlabúð Visitor Centre (📞470 8330; www.
visitvatnajokull.is; Heppuvegur 1; ⏰9am-7pm
Jun-Aug, to 6pm May & Sep, to 5pm Oct-Apr)
sits inside a harbour-front Gamlabúð house
and has excellent exhibits, plus local tourist
information. Ask about activities and hiking
trails in the area.

ℹ️ GETTING THERE & AWAY

Höfn is about 6km south of the Ring Road on
Rte 99. The nearest towns in either direction
are Kirkjubæjarklaustur, 200km west, and
Djúpivogur, 105km east.

AIR

Höfn's airport is 6.5km northwest of town. Eagle
Air (www.eagleair.is) flies year-round between
Reykjavík and Höfn (one way from kr18,600).

BUS

Bus companies travelling through Höfn have differ-
ent stops, so make sure you know what operator
you're travelling with and confirm where they pick
up from.

Buses heading from Höfn to Reykjavík stop
at all major towns and landmarks, including
Jökulsárlón, Skaftafell, Kirkjubæjarklaustur,
Vík, Skógar, Hvolsvöllur, Hella and Selfoss. See
websites for up-to-date rates and schedules.

Note that there is no winter bus connection be-
tween Egilsstaðir and Höfn (ie bus 62a doesn't run).

SBA-Norðurleið (📞550 0700; www.sba.is)
services (stop at N1 petrol station):

- Bus 62a to Egilsstaðir (kr9400, five hours,
one daily June to mid-September; stops at
Djúpivogur, Breiðdalsvík and fjords along Rtes
92 and 96).

- Bus 62a to Mývatn (kr15,500, 7½ hours, one
daily June to mid-September).

- Bus 62a to Akureyri (kr19,000, 9¼ hours, one
daily June to mid-September).

Sterna (📞551 1166; www.icelandbybus.is) servic-
es (pick-up/drop-off at campground):

- Bus 12a to Reykjavík (kr11,600, 10¼ hours,
one daily June to mid-September).

 Smartphone Apps

Useful and practical smartphone apps
include the vital 112 Iceland app for
safe travel, Veður (weather), and apps
for bus companies such as **Strætó**.
Offline maps come in handy.

There are plenty more apps that cover
all sorts of interests, from history and
language to aurora-spotting, or walking
tours of the capital. Reykjavík Grapevine's
apps (Appy Hour, Craving and Appening)
deserve special mention for getting you
to the good stuff in the capital.

VITALII MATOKHA/SHUTTERSTOCK ©

Strætó (📞540 2700; www.straeto.is) services
(pick-up/drop-off out front of the swimming
pool):

- Bus 51 to Reykjavík (kr12,180, 7¼ hours, two
daily June to mid-September, one daily Sunday
to Friday the rest of the year).

Reykjavík Excursions (📞580 5400; www.re.is)
services (stop at N1 petrol station):

- Bus 19 to Skaftafell (kr5500, 4¼ hours,
one daily June to mid-September). Stops at
Jökulsárlón for 2½ hours. Can be used as a
day tour returning to Höfn (with 5¼ hours at
Skaftafell).

ℹ️ GETTING AROUND

Without your own transport in this area, getting
around can be tricky. **Vatnajökull Travel** (📞894
1616; www.vatnajokull.is) is a year-round agency
that works with some of the region's tour opera-
tors and can shuttle you around.

Icelandic Culture

Iceland blows away concerns such as isolation, never-ending winter nights and its small population with a glowing passion for all things cultural. The country's unique literary heritage begins with high-action medieval sagas and stretches to today's Nordic Noir bestsellers. Every Icelander seems to play in a band, and the country produces a disproportionate number of world-class musicians. The way of life and grand landscapes inspire visual artists who use film, art and design to capture their unique Icelandic perspectives.

Harpa (p84), Reykjavík's art centre
BRIAN MAUDSLEY/SHUTTERSTOCK ©

Stokksnes

About 7km east of the turn-off to Höfn, just before the Ring Road enters a tunnel through the Almannaskarð pass, a signposted road heads south to headland Stokksnes. After 4.5km, there's an opportunity for refreshments; pull in for some coffee or cakes at the Viking Cafe. The farm-owner runs the cafe, and he charges visitors kr800 to explore his incredible property, including a photogenic Viking village **film set** and miles of **black-sand beaches**, where seals laze and the backdrop of Vestrahorn creates superb photos.

Note that the film set (built in 2009 by Icelandic film director Baltasar Kormákur) may finally see action soon, when Baltasar directs *Vikings*, a long-gestating film project he started writing more than a decade ago. The set will hopefully remain in place after its film duties are done.

EATING

Viking Cafe Cafe €
(www.vikingcafe.is; waffles & cake kr900; ⊘9am-7pm May-Oct) In a wild setting under moodily Gothic Vestrahorn mountain, you'll find this cool little outpost, where coffee, waffles and cake are served.

ⓘ GETTING THERE & AWAY
You'll need your own wheels to get here.

Landmannalaugar & Fjallabak Nature Reserve

Mind-blowing multicoloured mountains, soothing hot springs, rambling lava flows and clear blue lakes make Landmannalaugar one of Iceland's most remarkable destinations, and a must for explorers of the interior. It's a favourite with Icelanders and visitors alike... as long as the weather cooperates.

Part of the Fjallabak Nature Reserve, Landmannalaugar (600m above sea level) includes the largest geothermal field in Iceland outside the Grímsvötn caldera in Vatnajökull. Its multihued peaks are made of rhyolite – a mineral-filled lava that cooled unusually slowly, causing those amazing colours.

The area is the official starting point for the famous Laugavegurinn hike, and there's some excellent day hiking as well. The day-use fee for the facilities at Landmannalaugar is kr500.

⊙ ACTIVITIES

There's plenty to do in and around Landmannalaugar, though many hikers skip the area's wonders and set off right away for their Laugavegurinn hike. If you plan to stick around, you'll be happy to know that the crowds dwindle in the evenings and, despite the base's chaotic appearance, you'll find peace in the hills above.

Hiking

If you're day-hiking in the Landmannalaugar area, stop by the information hut to

purchase the useful day-trip map (kr300), which details all of the best hikes in the region. Guided hikes (through operators from Hvolsvöllur to Skógar areas) can also be a great way to explore the area.

The start of the Laugavegurinn hike is behind the Landmannalaugar hut, marked in red.

Frostastaðavatn Hiking
This blue lake lies behind the rhyolite ridge immediately north of the Landmannalaugar hut. Walk over the ridge and you'll be rewarded with far-ranging views as well as close-ups of the interesting rock formations and moss-covered lava flows flanking the lake. If you walk at least one way on the road and spend some time exploring around the lake, the return trip takes two to three hours.

Brennisteinsalda Hiking
When the weather is clear, opt for a walk that takes in the region's spectacular views. From Landmannalaugar climb to the summit of rainbow-streaked Brennisteinsalda – covered in steaming vents and sulphur

deposits – for a good view across the rugged and variegated landscape (it's a 6.5km round trip from Landmannalaugar). From Brennisteinsalda it's another 90 minutes along the Þórsmörk route to the impressive **Stórihver** geothermal field.

Hot Springs
Follow the wooden boardwalk just 200m from the Landmannalaugar hut, to find a steaming river filled with bathers. Both hot and cold water flow out from beneath Laugahraun and combine in a natural pool to form an ideal hot bath. Landmannalaugar could be translated as the People's Pools...and here they are.

Horse Riding
Landmannalaugar has on-site **horse-riding tours** (📞868 5577; www.hnakkur. is; 1/2hr tour kr9000/12,500) from July to mid-August. The horse farms on the plains around Hella also offer riding (usually longer trips) in and around the Landmannalaugar area.

Stokksnes

Landmannalaugar

Shopping

Mountain
Mall
Food & Drinks, Clothing

(www.landmannalaugar.info) The Mountain
Mall on the Landmannalaugar grounds
is set up inside two buses, selling basic
supplies from hats, long johns, hot tea and
maps to beer (kr1000), soup (kr1000) and
fresh fish from the nearby lakes. It also sells
fishing licences.

☒ EATING

There are no restaurants at Landman-
nalaugar; bring all of your own food. The
Mountain Mall shop sells some basic food
supplies at a premium, and the huts have
cooking facilities for guests.

ℹ INFORMATION

The Landmannalaugar hut wardens can answer
questions and provide directions and advice on
hiking routes. They also sell a map of day hikes
(kr300) and the Laugavegurinn hike (kr1700), as
well as a booklet in English and Icelandic on the

hike (kr3000). Note that wardens do not know
if it will rain (yes, this is the most frequently
asked question here). At the time of writing there
was no wi-fi, but there was some mobile-phone
reception.

ℹ GETTING THERE & AWAY

BUS

Landmannalaugar can be reached by rugged,
semi-amphibious buses from three different
directions. They run when the roads are open to
Landmannalaugar (check www.road.is).

From Reykjavík Buses travel along the western
part of the Fjallabak Rte, which first follows Rte
26 east of the Þjorsá to F225.

From Skaftafell Buses follow the Fjallabak Rte
(F208).

From Mývatn Buses cut across the highlands via
Nýidalur on the Sprengisandur Rte (F26).

It's possible to travel from the capital and be
in Landmannalaugar for two to 10 hours before
returning to Reykjavík, or three to five hours be-
fore going on to Skaftafell. That's about enough
time to take a dip in the springs and/or a short

walk. Schedules change, but morning buses usually reach Landmannalaugar by midday. Alternatively, stay overnight and catch a bus out when you're done exploring.

Reykjavík Excursions (p106) services:

- Bus 10/10a Skaftafell–Landmannalaugar (kr9000, five hours, one daily late June to early September).

- Bus 11/11a Reykjavík–Landmannalaugar (kr8000, 4¼ hours, three to four daily mid-June to mid-September).

- Bus 14/14a Mývatn–Landmannalaugar (kr16,500, 10 hours, one daily late June to early September).

Sterna (p106) services:

- Bus 13/13a Reykjavík–Landmannalaugar (kr8000, four hours, one daily late June to early September).

Trex (☎587 6000; www.trex.is) services:

- Bus T21 Reykjavík–Landmannalaugar (kr7900, 4¼ hours, two daily mid-June to early September).

CAR

Roads to Landmannalaugar are open in summer only (approximately late June to September) depending on weather and road conditions (check www.safetravel.is and www.road.is). There are three routes to Landmannalaugar from the Ring Road, all requiring a minimum of a 4WD. Driving from Mývatn to Landmannalaugar takes all day along the Sprengisandur Rte route (4WD only). If you have a small 4WD, you will have to leave your vehicle about 1km before Landmannalaugar, as the river crossing here is too perilous for little cars, and cross by footbridge. Two-wheel-drive rentals are not allowed to drive on F roads to Landmannalaugar.

There's no petrol at Landmannalaugar. The nearest petrol pumps are 40km north at **Hrauneyjar** (Hotel Highland; ☎487 7782; www.hrauneyjar.is; Hrauneyjar; guesthouse s/d incl breakfast from kr19,900/22,500, hotel s/d incl breakfast kr32,050/36,250; [P] [📶]), close to the beginning of the F208 and also in the Fjallabak Reserve; and 90km southeast at Kirkjubæjarklaustur, but to be on the safe side you should fill

 ## Ring Road from Skógar to Vík

As the Ring Road arcs east from Skógar to Vík, the haunches of the foothills rise to the glaciers, mountain tops and volcanoes inland, while rivers descend from mysterious gorges and course across the broad sweep of pastures to black-sand beaches and the crashing ocean. This rural area may be dotted with farmhouses (many of which have guesthouses), but considering the volume of summertime visitors, it still feels alternately dramatic and pastoral.

Ring Road, Iceland

up along the Ring Road if approaching from the west or the north.

F208 Northwest You can follow the west side of the Þjórsá (Rte 32), passing Árnes, then take Rte F208 down into Landmannalaugar from the north. This is the easiest path to follow for small 4WDs. After passing the power plant, the road from Hrauneyjar becomes horribly bumpy and swerves between power lines all the way to Ljótipollur ('Ugly Puddle').

F225 On the east side of the Þjórsá, follow Rte 26 inland through the low plains behind Hella, loop around Hekla, then take Rte F225 west until you reach the base. This route is harder to tackle (rougher roads).

F208 Southeast The hardest route comes from the Ring Road between Vík and Kirkjubæjarklaustur. This is the Skaftafell–Landmannalaugar bus route.

You can also take a super-4WD tour with local tour operators, which will take you out to Landmannalaugar from Reykjavík, or from anywhere in the south.

HELSINKI, FINLAND

In this Chapter

Helsinki, Finland at a Glance...

Spectacularly entwined with the Baltic's bays, inlets and islands, Helsinki's boulevards and backstreets are awash with magnificent architecture, intriguing drinking and dining venues and ground-breaking design – its design scene is one of the most electrifying in the world today. Fresh Finnish flavours can be found all over Helsinki, from the historic kauppahalli (covered market) to venerable restaurants, creative bistros and Michelin–starred gastronomy labs. Helsinki is surrounded by a sublime natural environment that's easily reached from all across the city.

Two Days in Helsinki

Nearby Helsinki's iconic art-nouveau **train station** (p132) are outstanding galleries **Kiasma** (p124) and **Ateneum** (p124). Shop-stroll **Esplanadin Puisto** (p130) and Kaisaniemi, then catch a show at **Musiikkitalo** (p128).

On day two, visit **Tuomiokirkko** (p124) and **Uspenskin Katedraali** (p125), then explore **Suomenlinna** (p119), before a meal at **Suomenlinnan Panimo** (p129)

Four Days in Helsinki

Start day three at **Seurasaaren Ulkomuseo** (p125). After a picnic lunch, make for **Temppeliaukion Kirkko** (p125), wander through **Kansallismuseo** (p125) then explore **Helsinki Art Museum (HAM)** (p125). Dine at **Saaga** (p129) before trying Finnish craft beer at **Birri**.

Day four begins at **Vanha Kauppahalli** (p128) followed by the **Design Museum** (p125) and the **Museum of Finnish Architecture** (p125). Explore the Design District shops, then dine at the **Savoy** (p129).

Arriving in Helsinki

Helsinki-Vantaa Airport The airport-city rail link (www.hsl.f; €5, 30 minutes, 5.05am to 12.05am) serves Helsinki's train station. The airport is also linked to central Helsinki by fast Finnair buses (€6.30, 30 minutes, every 20 minutes, 5am to midnight). A Taksi Helsinki cab costs around €45 to €50.

Helsinki Train Station Helsinki's central train station, serving international and domestic trains, is linked to the metro (Rautatientori stop).

Where to Stay

Helsinki is dominated by chain hotels, particularly Sokos and Scandic, but there are some boutique and designer gems, too. Budget accommodation is in short supply. Apartment rentals range from one-room studios to multiroom properties ideal for families. Often you'll get use of a sauna, parking area and other facilities.

From mid-May to mid-August book well ahead, though July is quieter for business and high-end hotels.

Suomenlinna castle

WESTEND61/GETTY IMAGES ©

Suomenlinna

Suomenlinna, the 'fortress of Finland', straddles a cluster of car-free islands connected by bridges, and is a marvellous place to spend an afternoon or morning.

This Unesco World Heritage site was originally built by the Swedes as Sveaborg in the mid-18th century. Several museums, former bunkers and fortress walls, as well as Finland's only remaining WWII submarine, are fascinating to explore; its tourist office (p126) has info.

Great For...

Don't Miss

The most atmospheric part of Suomenlinna, Kustaanmiekka, is at the end of the blue trail.

Jetty Barracks

At Suomenlinna's main quay, the pink Rantakasarmi (Jetty Barracks) building is one of the best preserved of the Russian era. It holds a small exhibition and a helpful, multilingual tourist office, with downloadable content for your smartphone. Guided tours (p126) of Suomenlinna depart from here.

Suomenlinna fortress walls

RISTO0/SHUTTERSTOCK ©

ℹ Need to Know

Suomenlinna (Sveaborg; www.suomen linna.fi)

✕ Take a Break

Suomenlinnan Panimo (p129), by the main quay, brews excellent beers and offers good food to accompany them.

★ Top Tip

At around 5.15pm it's worth finding a spot to watch the enormous Baltic ferries pass through the narrow gap between islands.

Russian Orthodox Church

Near the tourist office you'll find Suomenlinna's distinctive **church** (www.helsing inkirkot.fi; Suomenlinna; ⊙noon-4pm Wed-Sun, plus Tue Jun-Aug). Built by the Russians in 1854, it served as a Russian Orthodox place of worship until the 1920s when it became Lutheran. It doubles as a lighthouse.

Suomenlinna-Museo

Suomenlinna-Museo (adult/child incl Vesikko €7/4; ⊙10am-6pm May-Sep, 10.30am-4.30pm Oct-Apr) is a two-level museum covering the history of the fortress. Displays include maps and scale models. A helpful 25-minute audiovisual display plays every 30 minutes.

Bunkers & Beyond

Exploring the old bunkers, crumbling fortress walls and cannons will give you an insight into this fortress, and there are plenty of grassy picnic spots. Monumental King's Gate was built in 1753–54 as a two-storey fortress wall, which had a double drawbridge and a stairway added. In summer you can get a waterbus back to Helsinki from here, saving you the walk back to the main quay.

Getting There

Ferries (www.hsl.fi; single/return €3.20/5, 15 minutes, four hourly, fewer in winter) depart from the passenger quay at Helsinki's **kauppatori**.

From May to September, **JT-Line** (www.jt-line.fi; return €7) runs a waterbus from the kauppatori, making three stops on Suomenlinna (20 minutes).

Art & Design Walking Tour

Helsinki is renowned for its architecture, and this walk takes in many exemplars of the city's dramatically varying styles. It reveals the city's evolution from market town to the cutting-edge capital it is today.

Start Vanha Kauppahalli
Distance 3.2km
Duration 3 hours

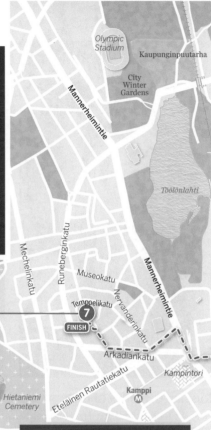

7 Continue walking northwest then west through leafy backstreets to the **Temppeliaukion Kirkko** (p125), an extraordinary rock-hewn church.

6 National Romantic splendour reaches its peak at Helsinki's spectacular **train station** (p132), topped by a copper-caped clock tower.

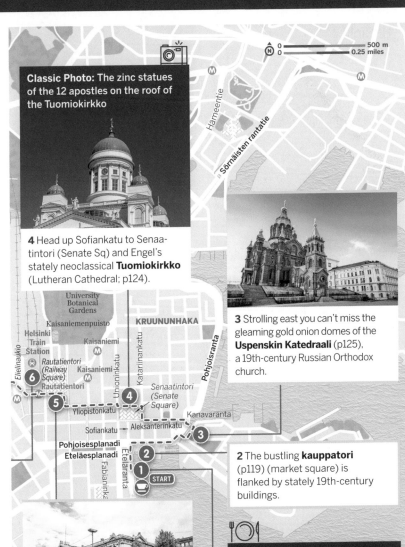

Classic Photo: The zinc statues of the 12 apostles on the roof of the Tuomiokirkko

4 Head up Sofiankatu to Senaatintori (Senate Sq) and Engel's stately neoclassical **Tuomiokirkko** (Lutheran Cathedral; p124).

3 Strolling east you can't miss the gleaming gold onion domes of the **Uspenskin Katedraali** (p125), a 19th-century Russian Orthodox church.

2 The bustling **kauppatori** (p119) (market square) is flanked by stately 19th-century buildings.

Take a Break...
Fuel up first with coffee and a pastry at the **Vanha Kauppahalli** (p128).

1 Helsinki's traditional market hall, **Vanha Kauppahalli** (p128), was built in 1888 and remains a traditional Finnish market

5 Walk west to the country's finest art museum, the **Ateneum** (p124), in a palatial 1887 neo–Renaissance building.

0 ——— 500 m
0 ——— 0.25 miles

University Botanical Gardens
Kaisaniemenpuisto
KRUUNUNHAKA
Kaisaniemi
Helsinki Train Station
Rautatientori (Railway Square)
Kaisaniemi
Rautatientori
Yliopistonkatu
Senaatintori (Senate Square)
Sofiankatu — Aleksanterinkatu
Kanavaranta
Pohjoisesplanadi
Eteläesplanadi
START
Hämeentie
Sörnäisten rantatie
Katariinankatu
Unioninkatu
Pohjoisranta
Eteläranta
Fabianinkatu
Elielinaukio

6 LEONID ANDRONOV/SHUTTERSTOCK ©, 7 TRABANTOS/SHUTTERSTOCK ©
3 ORSHA BRILEV/SHUTTERSTOCK ©, 4 ANDREY BRASOV/SHUTTERSTOCK ©

Helsinki

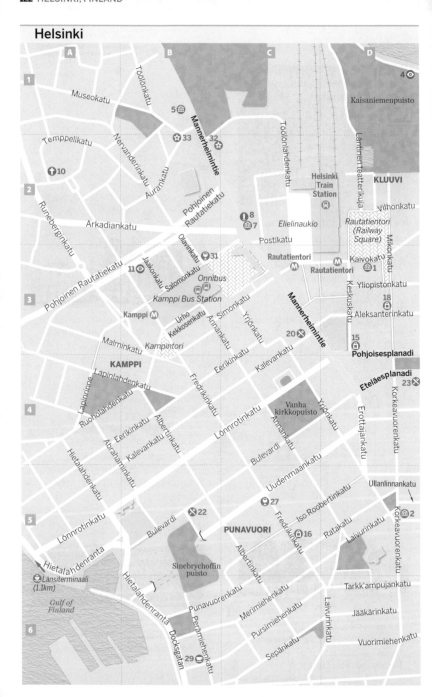

0 500 m
0 0.25 miles

Kaisaniemenlahti **E** **F** **G** **H**

1

Kaisaniemenranta

↑ *Hakaniemen*
Kauppahalli (450m);
Teurastamo (2.3km);
Arabiakeskus (4.3km)

Kristianinkatu

Pohjoisranta

Liisankatu

17

Tervasaarenkannas

Tervasaari

Mariankatu

Meritullinkatu

2

Kaisaniementie

KRUUNUNHAKA

Kaisaniemi

Unioninkatu

Vironkatu

Gulf of
Finland

Kaisaniemi

Fabianinkatu

Rauhankatu

Snellmaninkatu

Kirkkokatu

Pohjoisranta

Kluuvikatu

Vuorikatu

12

Hallituskatu

3

University
of Helsinki

Senaatintori
(Senate
Square)

Sofiankatu

Aleksanterinkatu

Kanavaranta

19

Helsinki
City Tourist
Office

21

28 13

Laivastokatu

3 30

Pohjoisesplanadi

Eteläesplanadi

JT-Line 6 *Local*
Ferries

Kanavakatu

Satamakatu

Luotsikatu

KATAJANOKKA

4

Kasarmikatu

Fabianinkatu

26

Kauppatori
(Market Square)

14

Katajanokanlaituri

Kauppiaankatu

Kruunuvuorenkatu

Vyokatu

24

Pohjoinen
Makasiinikatu

Eteläranta

25

Kanavakatu

9

Makasiiniterminaali

Eteläsatama

Katajanokan
Terminaali

5

Laivasillankatu

Kasarmikatu

Tähtitorninvuoren
puisto

Tähtitorninkatu

Olympia
Terminaali

6

Vuorimiehenkatu

Ehrenströmintie

Laivasillankatu

Eteläinen Puistotie

ULLANLINNA

Tehtaankatu

Suomenlinna
(1.7km)

Helsinki

◎ SIGHTS

Helsinki has more than 50 museums and galleries, including many special-interest museums that will appeal to enthusiasts. For a full list, check the tourist office website (www.visithelsinki.fi), or pick up its free *Museums* booklet.

Ateneum Gallery

(www.ateneum.fi; Kaivokatu 2; adult/child €15/ free; ⊙10am-6pm Tue & Fri, to 8pm Wed & Thu, to 5pm Sat & Sun) Occupying a palatial 1887 neo–Renaissance building, Finland's premier art gallery offers a crash course in the nation's art. It houses Finnish paintings and sculptures from the 'golden age' of the late 19th century through to the 1950s, including works by Albert Edelfelt, Hugo Simberg, Helene Schjerfbeck, the von Wright brothers and Pekka Halonen. Pride of place goes to the prolific Akseli Gallen-Kallela's triptych from the Finnish national epic, the *Kalevala*, depicting Väinämöinen's pursuit of the maiden Aino.

Kiasma Gallery

(www.kiasma.fi; Mannerheiminaukio 2; adult/child €14/free, 1st Sun of month free; ⊙10am-5pm Tue & Sun, to 8.30pm Wed-Fri, to 6pm Sat) Now one of a series of elegant contemporary buildings in this part of town, curvaceous and quirky metallic Kiasma, designed by Steven Holl and finished in 1998, is a symbol of the city's modernisation. It exhibits an eclectic collection of Finnish and international contemporary art, including digital art, and has excellent facilities for kids. Its outstanding success is that it's been embraced by the people of Helsinki, with a theatre and a hugely popular glass-sided cafe and terrace.

Tuomiokirkko Church

(Lutheran Cathedral; www.helsinginseurakunnat. fi; Unioninkatu 29; ⊙9am-midnight Jun-Aug, to 6pm Sep-May) FREE One of CL Engel's finest creations, the chalk-white neoclassical Lutheran cathedral presides over Senaatintori. Created to serve as a reminder of God's supremacy, its high flight of stairs is now a popular meeting place. Zinc statues

of the 12 apostles guard the city from the roof of the church. The spartan, almost mausoleum-like interior has little ornamentation under the lofty dome apart from an altar painting and three stern statues of Reformation heroes Luther, Melanchthon and Mikael Agricola.

Uspenskin Katedraali Church

(Uspenski Cathedral; www.hos.fi/uspenskin-kat edraali; Kanavakatu 1; ⊘9.30am-4pm Tue-Fri, 10am-3pm Sat, noon-3pm Sun) FREE The eye-catching red-brick Uspenski Cathedral towers above Katajanokka island. Built as a Russian Orthodox church in 1868, it features classic golden onion-topped domes and now serves the Finnish Orthodox congregation. The high, square interior has a lavish iconostasis, with the Evangelists flanking panels depicting the Last Supper and the Ascension.

Kansallismuseo Museum

(National Museum of Finland; www.kansallis museo.fi; Mannerheimintie 34; adult/child €10/ free, 4-6pm Fri free; ⊘11am-6pm Tue-Sun) Built in National Romantic art nouveau style and opened in 1916, Finland's premier historical museum looks a bit like a Gothic church, with its heavy stonework and tall square tower. A major overhaul is under way until 2019, but the museum will remain open throughout. Already-completed sections include an exceptional prehistory exhibition and the Realm, covering the 13th to the 19th century. Also here is a fantastic hands-on area for kids, Workshop Vintti.

Temppeliaukion Kirkko Church

(☎09-2340-6320; www.helsinginseurakunnat. fi; Lutherinkatu 3; adult/child €3/free; ⊘9.30am-5.30pm Mon-Thu & Sat, to 8pm Fri, noon-5pm Sun Jun-Aug, shorter hours Sep-May) Hewn into solid stone, the Temppeliaukio church, designed by Timo and Tuomo Suomalainen in 1969, feels close to a Finnish ideal of spirituality in nature – you could be in a rocky glade were it not for the stunning 24m-diameter roof covered in 22km of copper stripping. Its acoustics are exceptional; regular concerts

take place here. Opening times vary depending on events, so phone or search for its Facebook page updates. There are fewer groups midweek.

Helsinki Art Museum Museum

(HAM; www.hamhelsinki.fi; Eteläinen Rautatiekatu 8; adult/child €10/free; ⊘11am-7pm Tue-Sun) Inside the **Tennispalatsi** (Tennis Palace;), Helsinki's contemporary-art museum oversees 9000 works, including 3500 city-wide public artworks. The overwhelming majority of its 20th- and 21st-century works are by Finnish artists; it also presents rotating exhibitions by emerging artists. Exhibits change every seven weeks. There's always at least one free exhibition that doesn't require a ticket to the museum's main section.

Design Museum Museum

(www.designmuseum.fi; Korkeavuorenkatu 23; combination ticket with Museum of Finnish Architecture adult/child €10/free; ⊘11am-6pm Jun-Aug, 11am-8pm Tue, to 6pm Wed-Sun Sep-May) An unmissable stop for Finnish design aficionados, Helsinki's Design Museum has a permanent collection that looks at the roots of Finnish design in the nation's traditions and nature. Changing exhibitions focus on contemporary design – everything from clothing to household furniture. From June to August, 30-minute tours in English take place at 2pm on Saturday and are included in admission. Combination tickets with the nearby **Museum of Finnish Architecture** (Arkkitehtuurimuseo; ☎045-7731-0474; www.mfa.fi; Kasarmikatu 24; adult/child €10/free, combination ticket with Design Museum €12/free; ⊘11am-6pm Tue & Thu-Sun, to 8pm Wed) are a great-value way to see the two museums.

Seurasaaren Ulkomuseo Museum

(Seurasaari Open-Air Museum; www.kansal lismuseo.fi/en/seurasaari-openairmuseum; Seurasaari; adult/child €9/3; ⊘11am-5pm Jun-Aug, 9am-3pm Mon-Fri, 11am-5pm Sat & Sun mid-late May & early–mid-Sep) Situated 5.5km northwest of the city centre, this excellent

island-set museum has a collection of 87 historic wooden buildings transferred here from around Finland. There's everything from haylofts to a mansion, parsonage and church, as well as the beautiful giant rowboats used to transport church-going communities. Prices and hours refer to entering the museum's buildings, where guides in traditional costume demonstrate folk dancing and crafts. Otherwise, you're free to roam the picturesque wooded island, where there are several cafes.

🏴 TOURS

Happy Guide Helsinki
Walking, Cycling

(☎044-502-0066; www.happyguidehelsinki. com; walking/bike tours from €20/55) Happy Guide Helsinki runs a range of original, light-hearted but informative cycling and walking tours around the city. Just some of its bike-tour options include berry-picking or a sunset sauna tour; walking tours range from an old-town tour to food

tours and craft-beer tours. Meeting points are confirmed when you book.

Suomenlinna Guided Tours
Walking

(☎029-533-8420; www.suomenlinna.fi; Rantakasarmi, Suomenlinna; adult/child €11/4; ⏰up to 3 times daily Jun-Aug, 1.30pm Sat & Sun Sep-May) Guided tours of Suomenlinna (p119) lasting one hour depart from the **Rantakasarmi Information Centre** (☎029-533-8420; www.suomenlinna.fi; Suomenlinna; ⏰10am-6pm May-Sep, to 4pm Oct-Apr). Tours cover the fortress' main sights, with informative explanations in English.

🛍 SHOPPING

Helsinki is a design epicentre, from fashion to furniture and homewares. Its hub is the Design District Helsinki (https://designdistrict.fi), spread out between chic Esplanadi to the east, retro-hipster Punavuori to the south and Kamppi to the west. Hundreds of shops, studios and galleries are mapped on its website; you can also pick up a map at the tourist office.

Artek

Artek Design

(www.artek.fi; Keskuskatu 1B; ⊘10am-7pm Mon-Fri, to 6pm Sat) Originally founded by architect and designers Alvar Aalto and his wife Aino in 1935, this iconic Finnish company maintains the simple design principle of its founders. Textiles, lighting and furniture are among its homewares. Many items are only available at this 700-sq-metre, two-storey space.

Tre Design

(www.worldoftre.com; Mikonkatu 6; ⊘11am-7pm Mon-Fri, to 6pm Sat) If you only have time to visit one design store in Helsinki, this 2016-opened emporium is a brilliant bet. Showcasing the works of Finnish designers in fashion, jewellery and accessories, including umbrellas, furniture, ceramics, textiles, stationery and art, it also stocks a superb range of architectural and design books to fuel inspiration.

Lasikammari Antiques

(www.lasikammari.fi; Liisankatu 9; ⊘noon-5pm Tue, Wed & Thu, to 2pm Mon, Fri & Sat) Vintage Finnish glassware from renowned brands such as Iittala, Nuutajärvi and Riihimäki, and individual designers such as Alvar Aalto and Tapio Wirkkala, make this tiny shop a diamond find for collectors. Along with glasses, you'll find vases, jugs, plates, bowls, light fittings and artistic sculptures. Prices are exceptionally reasonable; international shipping can be arranged on request.

Awake Design

(www.awake-collective.com; Fredrikinkatu 25; ⊘12.30-6.30pm Tue-Fri, 11am-4pm Sat) 🍴 At this super-minimalist art gallery–concept store, changing displays of handmade, Finnish–only designs range from men's and women's fashion and accessories, including watches, jewellery, bags and shoes, to birch plywood furniture and homewares such as rugs, carpets, sheets and blankets. Everything is ecologically and sustainably produced. Regular evening art and fashion shows are accompanied by champagne – check the website for announcements.

 Brunssi

Finns like a lie-in on the weekend, after the excesses of Friday and Saturday nights, so *brunssi* (brunch) was sure to catch on. Usually offered as a fixed-price buffet with everything from fruit and pastries to canapes, salads and pasta, it's so popular that you'll often have to book or wait. It's typically served from around 10.30am to 3.30pm, weekends only.

MAISICON/SHUTTERSTOCK ©

Arabiakeskus Design

(www.arabia.fi; Hämeentie 135, Toukola; ⊘noon-6pm Tue, Thu & Fri, to 8pm Wed, 10am-4pm Sat & Sun) Arabia refers to a whole district where the legendary Finnish ceramics company has manufactured its products since 1873. The complex, 5km north of Helsinki, includes a design mall, with a large Arabia/Iittala outlet. Run by Helsinki's Design Museum (p125), the free **Iittala & Arabia Design Centre museum** tells of the brand's history. Take tram 6 or 8 to the Arabiankatu stop.

⚙ ENTERTAINMENT

Catching live music – from metal to opera – is a highlight of visiting Helsinki. The latest events are publicised in the free *Helsinki This Week* (http://helsinkithisweek.com). Tickets for big events can be purchased from Ticketmaster (www.ticketmaster.fi), Lippupiste (www.lippu.fi), LiveNation (www.livenation.fi)

👍 The Call of Kallio

For Helsinki's cheapest beer (around €3 to €4 a pint), hit working-class Kallio (near Sörnäinen metro station), north of the centre. Here, there's a string of dive bars along Helsinginkatu, but it, the parallel Vaasankatu and cross-street Fleminginkatu are also home to several more characterful bohemian places: go for a wander and you'll soon find one you like.

and Tiketti (www.tiketti.fi), which also has a booking office in Kamppi.

Musiikkitalo · Concert Venue

(Helsinki Music Centre; ☎020-707-0400; www. musiikkitalo.fi; Mannerheimintie 13; tickets free-€30) Home to the Helsinki Philharmonic Orchestra, Finnish Radio Symphony Orchestra and Sibelius Academy, the glass-and copper-fronted Helsinki Music Centre, opened in 2011, hosts a diverse program of classical, jazz, folk, pop and rock. The 1704-capacity main auditorium, visible from the foyer, has stunning acoustics. Five smaller halls seat 140 to 400. Buy tickets at the door or from www.ticketmaster.fi.

Storyville · Jazz

(☎050-363-2664; www.storyville.fi; Museokatu 8; ⊙jazz club 7pm-3am Thu, to 4am Fri & Sat, bar 7pm-2am Tue, to 3am Wed & Thu, to 4am Fri & Sat) Helsinki's number-one jazz club attracts a refined older crowd swinging to boogie woogie, trad jazz, Dixieland and New Orleans most nights. As well as the

performance space, there's a stylish bar that has a cool outside summer terrace, restaurant and outdoor charcoal grill in the park opposite, where some summer concerts also take place.

❌ EATING

Vegan and vegetarian cafes are especially well represented in this hip city, along with art-filled hangouts and some great independent restaurants and bistros serving gastropub-style fare. The former slaughterhouse complex **Teurastamo** (https:// teurastamo.com; Työpajankatu 2; ⊙9am-9pm Mon & Tue, to 10pm Wed-Sat, to 8pm Sun) has a fantastic smokehouse, Asian food and much more. Look out for Finnish staples and snacks at the traditional market hall **Hakaniemen Kauppahalli** (www.hakaniemenkauppahalli.fi; Hämeentie 1; ⊙8am-6pm Mon-Fri, to 4pm Sat; ☑) ✐.

Vanha Kauppahalli · Market €

(www.vanhakauppahalli.fi; Eteläranta 1; ⊙8am-6pm Mon-Sat, plus 10am-5pm Sun Jun-Aug; ☑) ✐ Alongside the harbour, this is Helsinki's iconic market hall. Built in 1888 it's still a traditional Finnish market, with wooden stalls selling local flavours such as liquorice, Finnish cheeses, smoked salmon and herring, berries, forest mushrooms and herbs. Its centrepiece is its superb cafe, **Story** (www.restaurantstory.fi; Vanha Kauppahalli, Eteläranta; snacks €3.20-10, mains €12.80-17; ⊙kitchen 8am-3pm Mon-Fri, to 5pm Sat, bar to 6pm Mon-Sat; ☑) ✐. Look out too for soups from **Soppakeittiö** (www.katijafille. fi/soppakeittio/; Vanha Kauppahalli; soups €9-10; ⊙11am-5pm Mon-Sat; ☑).

Karl Fazer Café · Cafe €

(www.fazer.fi; Kluuvikatu 3; dishes €4-12; ⊙7.30am-10pm Mon-Fri, 9am-10pm Sat, 10am-6pm Sun; 🛜☑👪) Founded in 1891 and fronted by a striking art deco facade, this cavernous cafe is the flagship for Fazer's chocolate empire. The glass cupola reflects sound, so locals say it's a bad place to gossip. It's ideal, however, for buying dazzling confectionery, fresh bread, salmon

or shrimp sandwiches, or digging into towering sundaes or spectacular cakes. Gluten-free dishes are available.

Suomenlinnan Panimo Finnish €€

(☑020-742-5307; www.panimoravintola.fi; Suomenlinna C1; mains €15-30; ☺noon-10pm Mon-Sat, to 6pm Sun Jun-Aug, shorter hours Sep-May) By the main quay, this microbrewery is the best place to drink or dine on Suomenlinna. It brews three ciders and seven different beers, including a hefty porter, plus several seasonal varieties, and offers good food to accompany it, such as pike-perch with mustard tar sauce, or a game platter, smoked reindeer and wild pheasant rillettes.

Saaga Finnish €€

(☑09-7425-5544; www.ravintolasaaga.fi; Bulevardi 34; mains €22-27, 3-course menus €49-65; ☺6-11pm Mon-Fri late May-Aug, 6-11pm Mon-Sat Sep & Oct) Chandeliers made from reindeer antlers and split-log benches lined with reindeer furs adorn this rustic timber-lined Lappish restaurant. Specialities from Finland's far north include chargrilled whitefish with sour milk sauce, and roast elk with juniper berry sauce, followed by desserts such as Lappish squeaky cheese with sea buckthorn cream or liquorice cake with birch ice cream and cloudberries.

Olo Finnish €€€

(☑010-320-6250; www.olo-ravintola.fi; Pohjois-esplanadi 5; 4-course lunch menu €53, dinner tasting menus short/long from €79/109, with paired wines €173/255; ☺6-11pm Tue-Sat Jun–mid-Aug, 11.30am-3pm & 6-11pm Tue-Fri, 6-11pm Sat mid-Aug–May) At the forefront of new Suomi cuisine, Michelin–starred Olo occupies a handsome 19th-century harbourside mansion. Its memorable degustation menus incorporate both the forage ethos and molecular gastronomy, and feature culinary jewels such as fennel-smoked salmon, herring with fermented cucumber, Åland lamb with blackcurrant leaves, juniper-marinated reindeer carpaccio, and Arctic crab with root celery. Book a few weeks ahead.

Savoy Finnish €€€

(☑09-6128-5300; www.ravintolasavoy.fi; Eteläesplanadi 14; mains €37-44, 3-course lunch

Musiikkitalo

Karl Fazer Café (p128)

menu €63; ☉11.30am-3pm & 6pm-midnight Mon-Fri, 6pm-midnight Sat) Designed by Alvar and Aino Aalto in 1937, this is one of Helsinki's grandest dining rooms, with birch walls and ceilings and some of the city's finest views. The food is a modern Nordic tour de force, with the 'forage' ethos strewing flowers and berries across plates that bear the finest Finnish game, fish and meat.

🍷 DRINKING & NIGHTLIFE

Diverse drinking and nightlife in Helsinki ranges from cosy bars to specialist craft-beer and cocktail venues, and clubs with live music and DJs. In summer early-opening beer terraces sprout all over town. Some club nights have a minimum age of 20 or older; check event details on websites before you arrive.

Kappeli Bar
(www.kappeli.fi; Eteläesplanadi 1; ☉10am-midnight; 📶) Dating from 1867, this grand bar-cafe opens to an outdoor terrace seating 350 people and has regular jazz, blues and folk music in the nearby bandstand in

Esplanadin Puisto (Esplanadi Park) from May to August. Locals and visitors alike flock here on a sunny day.

Steam Hellsinki Cocktail Bar
(www.steamhellsinki.fi; Olavinkatu 1; ☉4pm-4am Mon-Sat; 📶) A wonderland of steampunk design, with futuristic-meets-19th-century industrial steam-powered machinery decor, including a giant Zeppelin floating above the gondola-shaped bar, mechanical cogs and pulleys, globes, lanterns, radios, candelabras, Chesterfield sofas and a Zoltar fortune-telling machine, this extraordinary bar has dozens of varieties of gin, and DJs spinning electro-swing. Ask about gin-appreciation and cocktail-making courses in English.

Kaffa Roastery Coffee
(www.kaffaroastery.fi; Pursimiehenkatu 29A; ☉7.45am-6pm Mon-Fri, 10am-5pm Sat; 📶) Processing up to 4000kg of beans every week, this vast coffee roastery supplies cafes throughout Helsinki, Finland and beyond. You can watch the roasting in progress

through the glass viewing windows while sipping Aeropress, syphon or V60 brews in its polished concrete surrounds. It also stocks a range of coffee grinders, espresso machines and gadgets.

Birri Microbrewery

(Il Birrificio; http://ilbirri.fi; Fredrikinkatu 22; ⊙11am-11pm Mon-Thu, to 1am Fri & Sat, to 4pm Sun) Birri brews three of its own beers on-site at any one time, stocks a fantastic range of Finnish–only craft beers and also hand-crafts its own seasonally changing sausages. The space is strikingly done out with Arctic–white metro tiles, brown-and-white chequerboard floor tiles, exposed timber beams and gleaming silver kegs.

Holiday Bar

(http://holiday-bar.fi; Kanavaranta 7; ⊙4-11pm Tue-Thu, to 2am Fri, noon-2am Sat; 🛜) Even on the greyest Helsinki day, this colourful waterfront bar transports you to more tropical climes with vibrant rainforest wallpapers and plants such as palms, tropical-themed cocktails like frozen margaritas and mojitos (plus two dozen different gins) and a seafood menu that includes softshell crab. A small market often sets up out front in summer, along with ping-pong tables.

ℹ️ INFORMATION

DISCOUNT CARDS

The **Helsinki Card** (www.helsinkicard.com; one/two/three day pass €46/56/66) gives you free public transport around the city and local ferries (Kauppatori) to Suomenlinna, entry to 28 attractions in and around Helsinki and a 24-hour hop-on, hop-off bus tour.

The **Helsinki & Region Card** (one/two/three day pass €50/62/72) offers the same benefits and adds in free transport to/from the airport.

Both cards are cheaper online; otherwise, get them at tourist offices, hotels or transport terminals.

TOURIST INFORMATION

Helsinki City Tourist Office (📞09-3101-3300; www.visithelsinki.fi; Pohjoisesplanadi 19; ⊙9am-

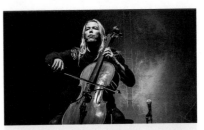

👍 Finnish Music

Finland's music scene is one of the world's richest, and the output of quality musicians per capita is amazingly high, whether a polished symphony orchestra violinist or a headbanging bassist for the next big death-metal band. Summer in Helsinki and across the country is all about music festivals of all conceivable types.

Finland has one of the most storming metal scenes around, and Helsinki is ground zero. The city's biggest exports are HIM with their 'love metal' and darkly atmospheric Nightwish. Catchy light-metal rockers the Rasmus continue to be successful. All genres of metal, as well as a few made-up ones, are represented, including Finntroll's folk metal (blending metal and humppa), the 69 Eyes' Gothic metal, Apocalyptica's classical metal, Children of Bodom's melodic death metal and Stratovarius' power metal.

Local hip-hop, known as Suomirap, also has a dedicated following, thanks to artists such as Elastinen, Heikki Kuula and Pyhimys, and there's always some new underground project.

Jazz is also very big in Helsinki, with dedicated clubs and a huge festival at Espoo each April.

Finnish band Apocalyptica
DOMINIONART/SHUTTERSTOCK ©

6pm Mon-Sat, to 4pm Sun mid-May–mid-Sep, 9am-6pm Mon-Fri, 10am-4pm Sat & Sun mid-Sep–mid-May) Busy multilingual office with a great quantity of information on the city. Also has an

office at the **airport** (www.visithelsinki.fi; Terminal 2, Helsinki-Vantaa Airport; ⏱10am-8pm May-Sep, 10am-6pm Mon-Sat, noon-6pm Sun Oct-Apr).

Strömma (www.stromma.fi; Pohjoisesplanadi 19; ⏱9am-6pm Mon-Sat, to 4pm Sun mid-May–mid-Sep, 9am-6pm Mon-Fri, 10am-4pm Sat & Sun mid-Sep–mid-May) In the city tourist office; sells various tours and local cruises, as well as package tours to Stockholm, Tallinn and St Petersburg. Also sells the Helsinki Card and Helsinki & Region Card.

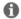 GETTING THERE & AWAY

AIR

Helsinki-Vantaa Airport (www.helsinki-vantaa.fi), 19km north of the city, is Finland's main air terminus. Direct flights serve many major European cities and several intercontinental destinations.

Finnair (☑09-818-0800; www.finnair.fi) covers 18 Finnish cities, usually at least once per day.

BOAT

International ferries sail to Stockholm, Tallinn, St Petersburg and German destinations.

Ferry companies have detailed timetables and fares on their websites. Purchase tickets online, at the terminal, or at ferry company offices. Book well in advance during high season (late June to mid-August) and on weekends.

There are five main terminals: **Katajanokan Terminaali** (Katajanokan), **Makasiiniterminaali** (Eteläranta 7), **Olympia Terminaali** (Olympiaranta 1), **Länsiterminaali** (West Terminal; Tyynenmerenkatu 8) (West Terminal) and **Hansaterminaali** (Provianttikatu 5, Vuosaari).

BUS

Kamppi bus station (www.matkahuolto.fi; Salomonkatu) has a terminal for local buses to Espoo in one wing, while longer-distance buses also depart from here to destinations throughout Finland. From Kamppi bus station, **Onnibus** (www.onnibus.com) runs budget routes to several Finnish cities.

Destinations with several daily departures include the following:

Jyväskylä €30, 4½ hours, up to three hourly

Kuopio €34, six hours, hourly

Lappeenranta €30, 3½ hours, up to three hourly

Oulu €55, 9½ hours, up to 13 per day

Savonlinna €30, 5½ hours, nine daily

Tampere €25, 2½ hours, up to four hourly

Turku €28, 2½ hours, up to four hourly

TRAIN

Helsinki's central **train station** (Rautatieasema; www.vr.fi; Kaivokatu 1) is linked to the metro (Rautatientori stop) and situated 500m east of Kamppi bus station.

The train is the fastest and cheapest way to get from Helsinki to major centres.

Destinations include the following:

Joensuu €44, 4½ hours, three daily

Kuopio €45, 4¼ hours, four daily

Lappeenranta €28, two hours, six daily

Oulu €56, six hours, four daily

Rovaniemi €80, eight hours, four daily

Tampere €21, 1½ hours, two hourly

Turku €20, two hours, hourly

There are also daily trains (buy tickets from the international counter) to the Russian cities of Vyborg, St Petersburg and Moscow; you'll need a Russian visa.

ⓘ GETTING AROUND

○ **Walking** Central Helsinki is compact and easily covered on foot.

○ **Bicycle** Helsinki's shared-bike scheme City Bikes (www.hsl.fi/citybikes) has some 1500 bikes at 150 stations citywide.

○ **Tram** Ten main routes cover the city. Three of these, trams 2, 4 and 6, can double as budget sightseeing tours.

○ **Bus** Buses serve the northern suburbs, Espoo and Vantaa; most visitors won't need to use them.

○ **Metro** Helsinki's single, forked metro line has 17 stations. Most are beyond the centre; the most useful for visitors are in the centre and Kallio.

○ **Ferry** Local ferries serve island destinations, including Suomenlinna.

Where to Stay

Neighbourhood	For	Against
City Centre	As central as it gets, with excellent shopping, major museums and parks.	Drinking and dining options are limited in this small area. Quiet at weekends.
Kamppi & Töölö	Kamppi has plenty of food and drink options and is home to the main bus station. Töölö is leafier and quieter.	Kamppi can be busy and may be noisy. Residential Töölö has very few options.
Kruununhaka & Katajanokka	Katajanokka is handy for the ferry terminal, and accessible to the centre. Mainly residential, Kruununhaka has some standout eateries.	Options are limited on Katajanokka and virtually nonexistent in Kruununhaka.
Punavuori & Ullanlinna	Great cafes, restaurants, bars and shops in Design District hub Punavuori. Peaceful Ullanlinna has parks and open spaces.	Parts of Punavuori close to the centre can be busy and/or noisy. Few options in Ullanlinna.
Kallio	Gentrifying area with hip, creative businesses, vintage shops and cheap bars. Good metro access.	Some areas can be edgy. There are some chain hotels and the usual home-sharing services.

LAKELAND, FINLAND

Lakeland, Finland

Most of Finland could be dubbed 'lakeland', but around here it seems there's more aqua than terra firma. Reflecting the sky and forests as clearly as a mirror, the sparkling, clean water leaves an indelible impression. When exploring the region, it's almost obligatory to get waterborne. On land, there's just as much to do. Architecture buffs from around the globe make the pilgrimage here to visit Alvar Aalto's buildings, opera aficionados arrive en masse to attend the world-famous Savonlinna Opera Festival, and outdoor enthusiasts shoulder their packs. And at day's end, there are always saunas to relax in.

Two Days in Lakeland

Begin in **Savonlinna** (p138)and spend an entire day soaking up its charms; a boat trip, a tour of **Olavinlinna** (p138), and if you're really lucky, you'll be in town for the opera festival. Allow time also for a trip to the Seal Lakes, perhaps on day two, with time also for an exploration of the **New Valamo Monastery** (Valamon Luostari; p140).

Four Days in Lakeland

On day three, explore **Lakeland's churches** (p142) and widely spread museums, do some shopping in **Savonlinna** (p138), and perhaps overnight in **Joensuu** (p147).

Day four is all about **Jyväskylä** (p150), which is one of Scandinavia's most important architectural centres, with the work of Alvar Aalto front and centre. Walking and boat cruises are also recommended.

Arriving in Lakeland

Buses and, to a lesser degree, trains link most cities and towns in the region. Some services are reduced or cancelled on weekends.

Saimaan Laivamatkat Oy (p139) runs cruises between Savonlinna and Kuopio, stopping at Oravi in the **Seal Lakes** (p138) en route. It also sails between Kuopio and **New Valamo** (p140).

Where to Stay

There are sleeping options for every budget in Jyväskylä and Savonlinna, including outstanding boutique choices. Outside these towns, the range of options is limited and less impressive.

Olavinlinna

NIKIFOROV ALEXANDER/SHUTTERSTOCK ©

Savonlinna & the Seal Lakes

The historic frontier settlement of Savonlinna is one of Finland's prettiest towns and most compelling tourist destinations. Nearby, seal-inhabited lakes are a real draw.

Great For...

Don't Miss

The stories told by castle guides – the soldiers, for instance, were partly paid in beer!

Olavinlinna

Built directly on rock in the middle of the lake (now accessed via bridges), this heavily restored 15th-century **fortification** (St Olaf's Castle; ☎029-533-6941; www.kansallismuseo.fi; Olavinlinna; adult/child €9/4.50; ⏰11am-5.15pm Jun–mid-Aug, 10am-3.15pm mid-Aug–May, closed mid-Dec–early Jan) was constructed as a military base on the Swedes' restless eastern border. The currents in the surrounding water ensure that it remains unfrozen in winter, which prevented enemy attacks over ice. To visit the castle's upper levels, including the towers and chapel, you must join a one-hour guided tour. Guides bring the castle to life with vivid accounts of its history.

ℹ **Need to Know**

You can reach Savonlinna by air, boat, bus or train.

✕ **Take a Break**

Savonlinna's very own microbrewery, Huvila (p146) is a lovely spot for a Golden Ale.

★ **Top Tip**

For a list of festivals and events staged in Savonlinna, go to http://visitsavonlinna.fi/en/events-in-savonlinna-region.

Savonlinna Opera Festival

The **Savonlinna Opera Festival** (Savonlinnan Oopperajuhlat; ☏015-476-750; www.operafestival.fi; Olavinkatu 27; ⊘early Jul–early Aug) enjoys an enviably dramatic setting: the covered courtyard of Olavinlinna Castle. Inaugurated in 1912, it stages four weeks of top-class opera performances between early July and early August each year. The atmosphere in town during the festival is reason enough to come: it's buzzing, with restaurants serving post-show midnight feasts, and animated discussions and impromptu arias on all sides.

Seal Lakes

Easily reached from Savonlinna, the watery **Linnansaari** (www.outdoors.fi) and **Kolovesi** (www.outdoors.fi) National Parks are great to explore by canoe and are the habitat of a rare inland seal. See www.nationalparks.fi for information on the parks, and http://visitsavonlinna.fi/en and www.oravivillage.com for transport, accommodation, activities and equipment-hire services in the area.

Take a Cruise

Saimaan Laivamatkat Oy (☏015-250-250; www.mspuijo.fi; Satamapuistonkatu; one-way €95, return by same-day car €130, return with/without overnight cabin €180/150; ⊘mid-Jun–mid-Aug) runs cruises on century-old M/S *Puijo* from Savonlinna to Kuopio on Monday, Wednesday and Friday at 9am (10½ hours), returning on Tuesday, Thursday and Saturday. The boat passes through scenic waterways, canals and locks. On-board meals are available.

New Valamo Monastery

At once rich in history, studded with treasures and filled with a strange spiritual power, the New Valamo Monastery (Valamon Luostari) is deservedly one of Finland's premier attractions.

Great For...

Don't Miss

Take in at least one worship service, whether prayer service, liturgy, matins or vespers.

The Church

Finland's only Orthodox monastery is idyllically located on an island in Juojävi. Visitors are free to roam the site and enter the churches. The first church was made by connecting two sheds; the rustic architecture contrasts curiously with its gilded icons. The modern church has an onion-shaped dome and an incense-saturated interior featuring an elaborate iconostasis. Visitors can follow a 4.5km marked walking trail to a pilgrim's wooden cross located on the lake's edge.

ℹ️ Need to Know

Valamon Luostari (New Valamo, New Valaam; ☎017-570-111; www.valamo.fi; Valamontie 42, Heinävesi; ⊙9am-9pm)

✕ Take a Break

Order a coffee or tea with a sandwich or bun at **Trapesa** (www.valamo.fi; Valamon Luostari; buffet lunch adult/child €14/7; ⊙7.30am-6pm Mon-Thu, to 9pm Fri & Sat) and enjoy it on the front terrace.

★ Top Tip

The most pleasant way to arrive in summer is on the **M/S Puijo** (☎015-250-250; www.mspuijo.fi) from Kuopio.

New Valamo History

The date when the Valamo community was initially established is disputed, but most historians cite the late 14th century. Originally located on Lake Ladoga, it survived the Russian Revolution's aftermath because the original monastery (now in Russian Karelia) fell just within newly independent Finland. This changed during the 1939-40 Winter War, when the region fell to the Soviets. Fortunately, Ladoga froze (a rare occurrence), allowing a hurried evacuation of 190 monks, icons and treasures. The evacuated monks set up a new community here in Heinävesi in 1940, and the original monastery became a Russian military base; it was only in 1989 that a monastic community was re-established there.

Services & Guided Tours

There's a prayer service at noon on Saturday and liturgy at 9am on Sunday. Matins are held at 6am Monday to Saturday and vespers or a vigil at 6pm daily. Guided tours (adult/child €6/3, 75 minutes) of the monastery are offered between 10am and 5pm on Sundays and on other days in high summer.

Sleep Overnight

Valamo (☎017-570-1810; www.valamo.fi; s/d without bathroom €45/66, hotel s/d €80/130; P🛜🐾) is especially peaceful once the day-trippers depart and evening descends. Guesthouses in picturesque wooden buildings provide comfortable, no-frills sleeping with shared bathrooms; there are also hotel rooms with private bathrooms.

Petäjävesi Vanha Kirkko

Lakeland Churches

Churches are such a feature of Finland's Lakeland, and seeking them out will appeal to both architecture buffs and those eager for the soaring complements to all those watery expanses.

Great For...

Don't Miss

A souvenir shop near Lintulan Luostari's entrance sells hand-made candles, supplied to all Finland's Orthodox churches.

Kerimäen Iso Kirkko

Kerimäki may be small (population 5000), but **Kerimäen Iso Kirkko** (Kerimäki Church; www.kerimaenseurakunta.fi; ⊙10am-6pm late Jun & early Aug, to 7pm Jul, to 4pm early Jun & late Aug) **FREE**, its Lutheran church, certainly isn't. Built in 1847, the building was designed to accommodate 5000 and is commonly described as the world's largest wooden church. The building's scale is immense and the grand, light-drenched interior features stained-glass lamps and unusual wood panels painted to resemble marble.

Lintulan Luostari

Finland's only Orthodox convent, **Lintulan Luostari** (Lintula Convent; ☎040-485-7603; www.lintulanluostari.fi; Honkasalontie 3, Palokki; ⊙10am-6pm Jun-Aug) is particularly

Kerimäen Iso Kirkko

PEJO/SHUTTERSTOCK ©

Keitele · Lintulan · Viinijärvi
Jyväskylä · Luostari
Airport · Karvio
Mekaanisen
Musiikin · Varkaus · Orivesi
Petäjävesi · Museo
· Haukivesi
Petäjäveden · Savonlinna
Vanha Kirkko · Airport · Kerimäki
· Kerimäen Iso
Päijänne · Puulavesi · Kirkko

❶ Need to Know

Buses and, to a lesser degree, trains link most cities and towns in the region.

✖ Take a Break

There are cafes in the grounds of Lintulan Luostari and Kerimäen Iso Kirkko.

★ Top Tip

Come in August for decent weather but without the July crowds.

lovely in early summer, when the many flowers in its beautifully tended gardens bloom. The order was founded in Karelia in 1895 and its nuns relocated to this location near New Valamo after WWII. When here, be sure to follow the walking trail from the car park past the small cemetery and down through the forest to the shed-like Chapel of St Paraskeva on the shore of Koskijärvi.

Mekaanisen Musiikin Museo

This extraordinary collection of mechanical **musical instruments** (Mechanical Music Museum; ☎050-590-9297; www.mekaanisenmusiikinmuseo.fi; Pelimanninkatu 8, Varkaus; adult/child €16/8; ◷11am-6pm Tue-Sat, to 5pm Sun Mar–mid-Dec, to

6pm daily Jul) in Varkaus ranges from a ghostly keyboard-tinkling Steinway to a robotic violinist to a full-scale orchestra emanating from a large cabinet. Entry is by multilanguage guided tour that lasts around 75 minutes.

Petäjävesi Vanha Kirkko

Petäjäveden Vanha Kirkko (Petäjävesi Old Church; ☎040-582-2461; www.petajavesi.fi/kirkko; Vanhankirkontie, Petäjävesi; adult/child €6/4; ◷10am-6pm Jun-Aug, reduced hours Sep, other times by appointment), a wonderfully gnarled Unesco–listed wooden church, is located in Petäjävesi, 35km west of Jyväskylä. Finished in 1765, it's a marvellous example of 18th-century rustic Finnish architecture, with crooked wooden pews, a pulpit held up by a rosy-cheeked St Christopher, and a fairy-tale shingle roof.

Savonlinna

Scattered across a garland of small islands strung between Haukivesi and Pihlajavesi lakes, Savonlinna's major attraction is the visually dramatic Olavinlinna Castle (p138), constructed in the 15th century and now the spectacular venue of July's world-famous Savonlinna Opera Festival. In summer, when the lakes shimmer in the sun and operatic arias waft through the forest-scented air, the place is quite magical. In winter, it's blanketed in fairytale-like snow, and its friendly locals can be relied upon to offer visitors a warm welcome.

◎ SIGHTS

Riihisaari Museum
(Lake Saimaa Nature & Culture Centre; ☎044-417-4466; www.savonlinna.fi/museo; adult/child €7/3, incl Olavinlinna €10/4.50; ⊗ 9am-5pm Mon-Fri & 10am-5pm Sat & Sun May, 10am-5pm daily Jun-Aug, 10am-5pm Tue-Sun Sep-Apr) On an island that was once a naval Lakelandport, this museum housed in a handsome 16th-century granary recounts local history and the importance of water transport. It also has a number of exhibits about the history, flora and fauna of Lake Saimaa, including a 12-minute video about the underwater world of Torsti, an endangered ringed seal pup living in the lake. Exhibits on the ground floor are more interesting than those upstairs.

✪ ACTIVITIES

Savonlinna's surrounding area has quiet country lanes and gently sloping hills, and so is terrific for **bicycle touring**. Bikes can be carried on board lakeboats for a small fee.

See http://visitsavonlinna.fi/en for information about canoe and kayak hire in and around the city.

SS Mikko Cruise
(☎044-417-4466; adult/child €15/10; ⊗ Jul) Part of the watercraft collection of the Riihisaari, this 1914 wooden steam barge offers 90-minute cruises on the lake during July.

VIP Cruise Cruise
(☎050-025-0075; www.vipcruise.info/en; Satamapuistonkatu; ⊗Jun-Aug) Operates three historic steamships – S/S *Paul Wahl,* S/S *Punkaharju* and S/S *Savonlinna* – offering 90-minute sightseeing cruises on Lake Saimmaa (adult/child €20/10).

🛍 SHOPPING

Runo Design Design
(☎050-3059-715; www.runodesign.fi; Satamakatu 11; ⊗10am-3pm Mon, to 4pm Tue-Fri) Everything in this gorgeous atelier has been handmade in Savonlinna. Textile designer Mervi Pesonen uses natural materials such as flax, wool, park skirt and cotton marshmallow to make stylish bags, cushions, throws and tea towels.

Studio Marja Putus Clothing
(☎040-526-5129; www.marjaputus.fi; Linnankatu 10; ⊗9am-5pm Mon-Fri, daily during Opera Festival) Artist and fashion designer Maria Putus makes and sells stylish outfits (many made using Marimekko fabric) at her atelier in a timber house in Savonlinna's historic precinct.

✖ EATING

Head for the lakeside kauppatori (market square) for cheap and tasty snacks such as the local speciality, *lörtsy* (turnovers). These come with meat *(lihalörtsy)*, apple *(omenalörtsy)* or cloudberry *(lakkalörtsy)* fillings and cost between €2.50 and €3.50. Savonlinna is also famous for fried *muikku* (vendace, or whitefish, a small lake fish). Restaurants open later during the opera festival; many have reduced hours from September to May and some close altogether.

Kahvila Saima Cafe €
(☎015-515-340; www.kahvilasaima.net; Linnankatu 11; dishes €7-17; ⊗9.30am-5pm Jun-Aug, 10.30am-4.30pm Wed-Sun Sep-May) Set inside a wooden villa with stained-glass windows, and opening to a wide

Savonlinna

terrace out the back, this charmingly old-fashioned cafe is adorned with striped wallpaper and serves home-style Finnish food, including good cakes and baked items. It stays open till 11.30pm on opera days.

Kalastajan Koju — Seafood €

(www.kalastajankoju.com; Kauppatori; fried muikku €9.50, with dip, mayonnaise or remoulade €10.50, with potato & salad €16.90; ⊙11am-10pm Mon-Thu, to midnight Fri & Sat, to 9pm Sun) Owned by a fisherman who heads out on the lake each morning to catch the *muikku* (vendace, or whitefish, a common lake fish) that this place specialises in, Kalastajan Koju is conveniently located on the water by the kauppatori and is particularly busy in summer. The menu also includes fish and chips, bratwurst and fried salmon.

Linnakrouvi — Finnish €€

(☎015-576-9124; www.linnakrouvi.fi; Linnankatu 7; mains €18-33; ⊙noon-10pm or later Mon-Sat, 3-10pm or later Sun late Jun–mid-Aug) Overlooking

Olavinlinna Castle, this summer restaurant employs chefs from Helsinki and serves Savonlinna's most sophisticated food. Unsurprisingly, it's hugely popular during the opera season. There's tiered outdoor seating, an attractive interior and a range of fare running from burgers to freshly caught and beautifully prepared fish from Lake Saimaa. There's a limited but impressive wine list.

🍷 DRINKING & NIGHTLIFE

There are plenty of summer bars and cafes on the lakefront (most opposite the castle), but all of these close outside the summer months. Bars in the town centre open year-round. **Mefisto** (☎029-123-9600; http://kat taasavon.fi; Kauppatori 4-6; cover varies; ⊘10pm-3am Fri & Sat) and **Night & Bar Tamino** (☎015-20-202; http://kattaasavon.fi; Kauppatori 4-6; cover price varies; ⊘11pm-4am Fri & Sat) in the Original Sokos Hotel Seurahuone complex are the only clubbing options.

Huvila Microbrewery
(☎015-555-0555; www.panimoravintolahuvila.fi; Puistokatu 4; mains €24-35, 3-course menu €45-50; ⊘noon-10pm Jun-Aug; 🛜) Sitting across the harbour, Huvila is operated by the Waahto brewery and is a delightful destination in warm weather, when its lakeside deck is full of patrons relaxing over a pint or two of the house brew (try the Golden Ale). There's also an attractive dining area in the old timber house. Sadly, the menu promises more than it delivers.

Olutravintola Sillansuu Pub
(Verkkosaarenkatu 1; ⊘2pm-2am Tue-Sat, to midnight Sun & Mon) Savonlinna's best pub is compact and cosy, offering an excellent variety of international bottled beers, a decent whisky selection and friendly service.

Waahto Bistro & Terrace Bar
(☎015-510-677; www.waahto.fi; Satamapuis-tonkatu 5; mains €19-34; ⊘noon-10pm Mon-Thu, to 11pm Fri & Sat, to 8pm Sun Jun-Aug, 4-10pm Tue-Sat Sep-May) By the kauppatori and harbour, this pub is owned by the local brewery and has a great summer terrace that's perfect for a sundowner. Come here for a drink rather than to eat, as the food is both pricey and disappointing.

Savonlinna harbour

ℹ️ INFORMATION

Savonlinna has no official tourist office, but the ticket desk in the **Riihisaari** (p144) stocks maps and brochures about the city and region. Other information can be accessed via www.savonlinna.fi.

ℹ️ GETTING THERE & AWAY

AIR

Savonlinna Airport (SVL; 📞020-708-8101; www.fi navia.fi; Lentoasemantie 50) is situated 14km north of town, and is predominantly used by charter flights. Finnair flies here during the opera season.

BOAT

Boats connect Savonlinna's **passenger harbour** (Satamapuistonkatu) with many lakeside towns; check www.oravivillage.com for seasonal schedules.

BUS

Savonlinna is not on major bus routes, but buses link the **bus station** (Tulliportinkatu 1) with Helsinki (€30, 5½ hours, up to nine daily), Mikkeli (€20, 1½ hours, up to 14 daily) and Jyväskylä (€30, 3½ hours, up to eight daily).

TRAIN

Punkaharju (€3, 30 minutes, at least four daily) is one of the few destinations that can be accessed via a direct service from Savonlinna. To get to Helsinki (€48, 4¼ hours, up to four daily) and Joensuu (€25, 2¼ hours, up to four daily), you'll need to change in Parikkala. The train station is in the town centre near the kauppatori. Buy your ticket at the machines – there's no ticket office.

ℹ️ GETTING AROUND

Savonlinna airport is 14km northeast; shared **taxis** (📞0500-250-099; www.jsturvataksit.fi) meet flights.

There are car-hire agencies at the airport, and a **Hertz** (📞020-555-2750; www.hertz.fi; Rantakatu 2; ⏰7.30am-9pm Mon-Fri, 9am-9pm Sat & Sun) office in town. Book well ahead.

Several places hire bikes in summer, including **InterSport** (Olavinkatu 52; per day/week €20/70; ⏰9.30am-6pm Mon-Fri, to 5pm Sat, 11am-3pm Sun).

 Alvar Aalto–Designed Buildings

Jyväskylä's (p150) portfolio of Aalto–designed works include the main **university campus** (1953–70); **Alvar Aalto Museo** (📞040-135-6210; www.alvaraalto.fi; Alvar Aallonkatu 7; adult/child €6/free; ⏰ 10am-6pm Tue-Fri Jul-Aug, 11am-6pm Tue-Sun Sep-Jun), built 1971–73; **Keski-Suomen Museo** (Museum of Central Finland; www.jyvaskyla.fi/ keskisuomenmuseo; Alvar Aallonkatu 7; adult/ child €6/free; ⏰11am-6pm Tue-Sun), built 1957–62; the three buildings (1964–82) forming the town's **Administrative and Cultural Centre**; the **Workers' Club Building** (Kauppakatu 30), built 1924–25; the 1962 **Vitatorni Apartment Tower** (Viitaniementie 16) and a scattering of houses in the residential parts of town. For a handy map showing notable architectural works in the town, including all of Aalto's buildings, go to http://visitjyvaskyla.fi/ filebank/1913-arkkitehtuurikartta_2014. pdf. Notable works outside town include the **Säynätsalon Kunnantalo** (Säynätsalo Town Hall; 📞040-197-1091; www.aaltoinfo.com; Parviaisentie 9, Säynätsalo; tours €8; ⏰tours noon-6pm Mon-Fri, 2-6pm Sat & Sun Jun-Sep) **FREE**, built 1949–52, and **Muuratsalon Koetalo** (p153), built 1952–53.

Säynätsalon Kunnantalo
CLAUDIO DIVIZIA/SHUTTERSTOCK ©

Joensuu

At the egress of the Pielisjoki (Joensuu means 'river mouth' in Finnish), North Karelia's capital is a spirited university town, with students making up almost a third of the population. Joensuu was founded by Tsar Nikolai I and

Joensuu

became an important trading port following the 1850s completion of the Saimaa Canal. During the Winter and Continuation Wars, 23 bombing raids flattened many of its older buildings, and today most of its architecture is modern. It's a lively place to spend some time before heading into the Karelian wilderness.

SIGHTS

Carelicum Museum
(www.joensuu.fi; Koskikatu 5; adult/child €5/3; ⊙10am-4.30pm Mon-Fri, to 3pm Sat & Sun) Themed displays – on the region's prehistory, its war-torn past, the Karelian evacuation, the importance of the sauna etc – cover both sides of Karelia's present-day border at this excellent museum. Highlights include a Junkers bomber engine, and local hunting and fishing equipment including a two-century-old crossbow.

Taitokortteli Arts Centre
(☎013-220-140; www.taitokortteli.fi; Koskikatu 1; ⊙10am-5pm Mon-Fri, 10am-3pm Sat year-round, plus noon-4pm Sun Jul) Dating back over a century, these charming wooden buildings are some of the few remaining in Joensuu; some have been relocated here from other parts of town. They now comprise an arts and crafts centre where you can see weavers at

work, browse contemporary art and purchase clothing, toys and homewares by local designers. There's a gallery space as well as cafes and bars.

Orthodox Church of St Nicholas
Church

(Pyhän Nikolaoksen Kirkko; ☎020-610-0590; www.joensuunortodoksit.fi; Kirkkokatu 32; ⏰10am-4pm Mon-Fri mid-Jun–mid-Aug or by appointment) Joensuu's most intriguing church is the wooden Orthodox church, built in 1887 with icons painted in St Petersburg during the late 1880s. Services are held at 6pm Saturday and 10am Sunday; visitors are welcome.

⊙ TOURS

Carriage Ride
Tours

(Koskikatu 5; tours from €20) From the park by the kauppatori you can take a carriage tour in a 19th-century Victorian buggy from June to mid-August. In winter, the operator switches to sled tours.

⊗ EATING

As a student hub, Joensuu has plenty of good, inexpensive places to dine, as well as some higher-end restaurants. At the busy kauppatori food stalls, look for Karelian specialities such as the classic *karjalanpiirakka* (rice-filled savoury pastry) and *kotiruoka* (homemade) soups.

Kahvila & Konditoria Houkutus
Cafe, Bakery €

(www.houkutus.fi; Torikatu 24; small dishes €1.50-5.50, mains €8-17; ⏰7.30am-7pm Mon-Fri, 8.30am-5pm Sat) Houkutus does great coffee and even better cakes (the mint blackcurrant cake is a treat), along with savoury pastries such as quiches, meal-sized salads and filled bread rolls.

Teatteri
Karelian €€

(☎010-231-4250; www.teatteriravintola.fi; Rantakatu 20; lunch buffet €8.60-10.50, mains €18-32, menus €46-65; ⏰11am-10pm Mon & Tue, 11am-11pm Wed & Thu, 11am-midnight Fri, 11.30am-midnight Sat) ✔ Locally sourced ingredients prepared

in innovative ways are served in the town hall's art deco surrounds and on its beautiful summer terrace. Dishes span nettle ricotta with wild herb salad to liquorice-glazed goose with kale pesto; desserts like fennel and apple sorbet with blackberry panna cotta are the icing on the cake. Menus can be accompanied by wine or craft beer pairings.

Ravintola Kielo
Karelian €€€

(☎013-227-874; www.ravintolakielo.fi; Suvantokatu 12; mains €20-29, tasting menu €46, with wine €75; ⏰4-10pm Mon-Sat) At the high end of Karelian cuisine, Kielo's artfully presented miniature starters such as whitefish escabeche with mussel mayo or sugar- and salt-cured Arctic char with smoked sour cream and fennel consommé set the stage for mains like pan-fried pike perch with sautéed forest mushrooms or braised pork belly with caramelised beetroot and roast Lapland potatoes. Wine pairings are superb.

⊗ DRINKING & NIGHTLIFE

The pedestrianised area of Kauppakatu has several late-night bars that get busy on weekends. On the river, boat bars are popular in the summer months; the lakeside Jokiasema is another summer favourite.

Kerubi
Bar, Club

(☎013-129-377; www.kerubi.fi; Siltakatu 1; ⏰bar 11am-2pm Mon, 11am-11pm Tue-Thu, 11am-4am Fri, noon-4am Sat, 2pm-7pm Sun, club 10pm-4am Fri & Sat) Joensuu's best bar/club occupies its own island in the Pielisjoki, linked to the city centre by a bridge. DJs spin techno, trance and electronica on Friday and Saturday; live bands and stand-up comedy take place in the adjacent hall Tuesday to Saturday. Fantastic burgers, salads and steaks are served at its restaurant, which opens to a terrace overlooking the island's beach.

Jokiasema
Bar

(www.jokiasema.fi; Hasanniementie 3; ⏰8am-midnight Jun-Aug; 🛜) Sunsets are spectacular from this bar perched on the Pyhäselkä lake's edge, with a resident peg-leg pirate statue and seating on the terrace

 Savonlinna Opera Festival

The **Savonlinna Opera Festival** (p139) is a key reason to visit Savonlinna in the summertime. The festival's website details the program: there are rotating performances of four or five operas by the Savonlinna company, as well as at least one opera by an international guest company and a few concert performances. The muscular castle walls are a magnificent backdrop to the set and add great atmosphere. There are tickets in various price bands. The top grades (€139 and up) are fine, but the penultimate grades (€85 to €112) put you in untiered seats, so it helps to be tall. The few cheap seats (€55) have a severely restricted view. Buy tickets up to a year in advance online.

DPRM/SHUTTERSTOCK ©

and pier, as well as a sauna in a rustic red timber building.

INFORMATION

Karelia Expert (☑040-023-9549; www.visitkarelia. fi; Koskikatu 5; ☺10am-5pm Mon-Fri; ☜) In the Carelicum, enthusiastic staff handle tourism information and bookings for the region.

GETTING THERE & AWAY

AIR

The **airport** (JOE; www.finavia.fi; Lentoasemantie 30) is 11km northwest of central Joensuu. An airport bus service (one way €5) meets all incoming flights,

and departs from the **bus station** (65 minutes before flight departures) and from the **corner of** Koskikatu and Kauppakatu (one hour before departures). A **taxi** (☑060-110-100; www.taksiitasuomi. fi) costs €25.

Finnair operates several flights a day between Helsinki and Joensuu.

BUS

The bus station is on the eastern side of the river.

Major **Matkahuolto** (www.matkahuolto.fi) services include:

Helsinki (€30, 6½ hours, five express services daily)

Jyväskylä (€30, four hours, five daily)

Kuopio (€29.90, 2¼ hours, three express services daily)

Lappeenranta (€30, 4½ hours, two daily)

Nurmes (€20, two hours, three daily)

Oulu (€40, 6½ hours, two daily)

Onnibus (www.onnibus.com) has cheaper but less frequent services to destinations including Helsinki (€15, 6¼ hours, two daily), Imatra (€5, 2½ hours, one daily) and Lappeenranta (€7, 3¼ hours, one daily).

TRAIN

The **train station** (Itäranta) is east of the river, next to the bus station.

Services include the following:

Helsinki (€44, 4½ hours, four daily)

Lieksa (€14, 1¼ hours, two daily)

Nurmes (€21, two hours, one daily)

Savonlinna (€25, 2¼ hours, four daily); change at Parikkala

Jyväskylä

Vivacious and modern, western Lakeland's main town has a wonderful waterside location, an optimistic feel and an impeccable architectural pedigree. Thanks to the work of Alvar Aalto (p147), who started his career here, Jyväskylä (yoo-vah-skoo-lah) is of global architectural interest. At the other end of the cultural spectrum, petrolheads the world

round know it as a legendary World Rally Championships venue. The large student population and lively arts scene give the town plenty of energy and nightlife.

SIGHTS

For architecture buffs the best visiting days are Tuesday to Friday, as many buildings are closed on weekends and the Alvar Aalto Museum is closed on Monday.

Jyväskylä's museums are all free on Fridays between September and May.

⊕ ACTIVITIES

An enjoyable 12km circuit can be walked or cycled around the lake, and can be cut in half using the road bridge. There are numerous boating options – check http://visitjyvasky la.fi for information, or wander along the pleasant harbour area, where you'll also find boat bars, jet-ski hire, houseboats (www. houseboat.fi) and floating saunas for rent.

Water craft can be hired from www. tavinsulka.com.

Päijänne Risteilyt Hilden Cruise
(☎010-320-8820; www.paijanne-risteilythilden. fi; ☉early Jun–mid-Aug) This cruise operator offers full-day or half-day cruises on the Keitele canal departing daily from the **passenger harbour** (Satamakatu 8) and costing between €40 and €60 for adults, half-price for kids. There's also a weekly Alvar Aalto architectural cruise in July and August, which visits the architect's Säynätsalo Town Hall and returns to Jyväskylä by bus (per person €33, 4½ hours).

✆ EATING

Jyväskylä is a university town, so it's not surprising that there are hipster-style cafes, bars selling pub grub, and vegan and vegetarian eateries here. For fine dining, head to Pöllöwaari (p152), one of the region's most impressive restaurants.

Alvar Aalto Museo (p147)

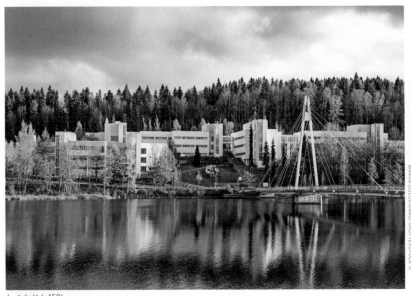

Jyväskylä (p150)

Beans & More Vegan €

(☎050-351-7731; www.beansandmore.fi; Ase-
makatu 11; dishes €10-15; ☉10am-6pm Mon-Fri,
9am-5pm Sat; ✍🖼️) Artek furniture, a vaulted
ceiling and artfully dangling light-fittings pro-
vide a stylish setting at this on-trend vegan
cafe. The friendly staff serve up burgers, sal-
ads piled with kale and other goodies, sand-
wiches on gluten-free bread and vegetarian
snack plates featuring seasonal produce.
Coffee is made with oat, almond or soy milk,
and there's a range of teas to choose from.

Ristorante Rosso Italian €

(☎010-767-5441; Kauppakatu 19; pizzas €13-16,
pastas €12-16; ☉11am-9pm Mon & Tue, to 10pm
Wed & Thu, to 11pm Fri & Sat, noon-9pm Sun) Billing
itself as 'the familiar Italian', this branch of a
popular Finnish chain serves up decent pizza
and pasta in pleasant surroundings (we love
the fresh herbs planted in the tomato-paste
cans). It's located opposite the Kirkkopuisto
and is a good choice for a cheap and *gustoso*
(tasty) meal.

Figaro Winebistro Tapas €€

(☎020-766-9811; www.figaro.fi; Asemakatu 2; lunch
mains €15-18, tapas €3-9, dinner mains €16-28;
☉11am-11pm Mon-Fri, 1-11pm Sat, 2-10pm Sun; 🛜)
The three-course lunch menu (€25) at this
this welcoming wine bar is an excellent deal,
but most regulars head here after work or on
weekends to graze on tapas and order drinks
from the large and top-quality wine and beer
list. It's so pleasant that many choose to stay
on for a steak or burger dinner.

Pöllöwaari Finnish €€€

(☎014-333-900; www.ravintolapollowaari.fi;
Yliopistonkatu 23; mains €22-29; ☉11am-10.30pm
Mon-Fri, 1-10.30pm Sat; 🛜) We're of the view that
Hotel Yöpuu's fine-dining restaurant is the
best in the region. Its menu places a laudable
emphasis on seasonality, and the kitchen's
execution is exemplary. Choose one of the set
menus (€56 to €79, or €84 to €127 with wine
matches) or order à la carte – the main cours-
es are exceptionally well priced considering
their quality. Excellent wine list, too.

🍺 DRINKING & NIGHTLIFE

Head to the eastern end of Kauppakatu to find the main bar strip, or to the harbour for relaxed decktop drinking on a boat bar.

Papu Cafe

(☑050-368-0340; www.paahtimopapu.fi; Yliopistonkatu 26D; ☺10am-6pm Mon & Tue, to 9pm Wed-Fri, noon-6pm Sat) It would be easy to describe Papu as a hipster haunt, but this laid-back cafe doesn't lend itself to easy categorisation. Yes, its baristas have tattooed sleeves and a preference for pour-over coffee, but the loyal customer base is multi-aged and eclectic. The coffee is made with house-roasted organic beans, and there's also espresso tonic and iced chocolate on offer.

Sohwi Pub

(☑014-615-564; www.sohwi.fi; Vaasankatu 21; ☺2pm-midnight Tue-Thu, to 2am Fri, noon-2am Sat, 2-10pm Sun & Mon; 🛜) A short walk from the city centre is this excellent bar with a spacious wooden terrace and plenty of lively student and academic discussion lubricated by a range of good bottled and draught beers. It also has a good menu of snacks and soak-it-all-up bar meals (pizza €15, burgers €12.50 to €17), including vegan options. Great stuff.

ℹ️ INFORMATION

Tourist Office (☑014-266-0113; www.visitjy vaskyla.fi; Asemakatu 7; ☺10am-5pm Mon-Fri, to 3pm Sat Jun-Aug, 10am-4pm Mon-Fri Sep-May) Helpful office where you can source plenty of information. Staff can arrange visits to the **Muuratsalon Koetalo** (Muuratsalo Experimental House; ☑014-266-7113; www.alvaraalto.fi; Melalammentie, Muuratsalo; adult/student €18/9; ☺1.30pm Mon, Wed & Fri Jun, Jul & 1st half Sep, 1.30pm Mon-Fri Aug).

ℹ️ GETTING THERE & AWAY

AIR

The airport is at Tikkakoski, 23km northwest of the city centre. Finnair flies to/from Helsinki.

 Summer Detour

What began as a heathenish medieval habit of pillaging neighbouring villages in search of nubile women has become one of Finland's oddest – and most publicised – events. Get to Sonkajärvi, in the northern Lakeland, for the **Wife-Carrying World Championships** (Eukonkanto; www.eukonkanto.fi) in early July.

It's a race over a 253.5m obstacle course, where competitors must carry their 'wives' through water traps and over hurdles to achieve the fastest time. The winner gets the wife's weight in beer and the prestigious title of World Wife-Carrying Champion. To enter, men need only €50 and a consenting female. There's also a 40-plus and team competition, all accompanied by a weekend of drinking, dancing and typical Finnish frivolity.

Wife-Carrying World Championships in Sonkajarvi
TIMO HARTIKAINEN/AFP/GETTY IMAGES ©

BUS

The bus and train stations share the **Matkakeskus** (Jyväskylä Travel Centre; ☺6am-10pm Mon-Sat, from 8am Sun). Daily express buses connect Jyväskylä to southern Finnish towns, including frequent departures to Tampere (€20, 2¼ hours) and Helsinki (€25 to €30, 3½ to 4½ hours).

TRAIN

The train station is in the **Matkakeskus**. There are regular trains to/from Helsinki (from €32, 3½ hours), many of which travel via Tampere and Hämeenlinna.

THE FAR NORTH
& ARCTIC CIRCLE

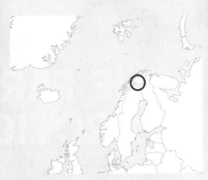

The Far North & Arctic Circle at a Glance...

Scandinavia's Arctic realms rank among the region's most evocative corners, one of few places where reality lives up to the legends that swirl around the destination. This is the land of the Sami and of Santa Claus. Up here, you can get around by dog-sled or snowmobile in winter while the aurora borealis (northern lights) dances across the sky. It is also home to one of northern Europe's most memorable small cities (Tromsø) and landscapes that seem as if they were sculpted by the gods (Lofoten Islands).

Two Days in the Far North

With two days, concentrate on Santa–themed fun and the museums of **Rovaniemi** (p158), before high-tailing it north to divide your time on day two between **Inari** and **Karasjok**. The latter two enable you to immerse yourself in Sami culture in the heart of this ancient people's homeland.

Four Days in the Far North

Tromsø (p160) is worth at least a day of your life (make it day three). The combination of museums and scenery means that you could very easily spend two days diving in. With little time left, fly or drive to the **Lofoten Islands** (p167) for some of the Arctic's most astonishing scenery, and the starting point of a whole new adventure.

Arriving in the Far North

To access this region, you've a long drive north. Alternatively, it is possible to fly from southern Scandinavian capitals into **Rovaniemi** (p158), **Tromsø** (p160) and Bodø (for the Lofoten Islands). Each of these is compact and easy to get around, with taxis and airport buses whisking you into town centres.

Where to Stay

There are excellent places to stay across the region, although as ever in Scandinavia choices are dominated by chain hotels with more comfort than character. Out in the hinterlands of these towns, choices tend to be more intimate, with B&Bs and more personal, family-run hotels.

ROMAN BABAKIN/SHUTTERSTOCK ©

Rovaniemi (Santa Claus Village)

Situated right by the Arctic Circle, the 'official' terrestrial residence of Santa Claus is the capital of Finnish Lapland and a tourism boom town.

Great For...

Don't Miss

Arktikum (p164), one of Finland's finest museums.

Where Arctic Finland begins (or ends), atop the Arctic Circle, the 'official' Santa Claus Village is a complex of shops, activities and accommodation.

Santa Claus Grotto

Santa sees visitors year-round in this impressive **grotto** (www.santaclausvillage.info; Sodankyläntie, Napapiiri; visit free, photographs from €20; ⊙9am-6pm Jun-Aug, 10am-5pm mid-Jan–May, Sep & Nov, 9am-7pm Dec–mid-Jan) FREE, with a huge clock mechanism (it slows the earth's rotation so that Santa can visit the whole world's children on Christmas Eve). The portly saint is quite a linguist, and an old hand at chatting with kids and adults alike.

JOHN BORTHWICK/GETTY IMAGES ©

ℹ Need to Know

Santa Claus Village (www.santaclaus village.info; Tarvantie 2, Napapiiri; ⊙9am-6pm Jun-Aug, 10am-5pm mid-Jan–May, Sep & Nov, 9am-7pm Dec–mid-Jan) FREE

✗ Take a Break

Escape Santa Claus Village and head for Aitta Deli & Dine (p167) for excellent local food.

★ Top Tip

A private chat with Santa is free, but no photos; official photos of your visit start at €20.

Santa Claus Post Office

Within the Santa Claus Village, this **post office** (Sodankyläntie, ⊙9am-6pm Jun-Aug, 10am-5pm mid-Jan–May, Sep & Nov, 9am-7pm Dec–mid-Jan) FREE receives more than half a million letters each year from children worldwide. You can browse a selection, which range from rather mercenary requests for thousands of euros' worth of electronic goods to heart-rending pleas for parents to recover from cancer. Postcards sent from here bear an official Santa stamp; you can arrange to have one delivered at Christmas time. For €7.95 Santa will send you a Christmas card.

Santapark

Built inside a cavern in the mountain, this Christmas–themed **amusement park** (https://santaparkarcticworld.com/santapark; Tarvantie 1; adult/child winter €33/27.50, summer €17.50/15; ⊙10am-6pm late Nov–mid-Jan, to 5pm Mon-Sat mid-Jun–mid-Aug) features an army of elves baking gingerbread, a magic sleigh ride, a carousel, an ice bar, a theatre, a restaurant and, of course, Santa himself. The most intriguing section is the gallery of ice sculpture.

Arctic Cathedral

Cultural Tromsø

Located 400km north of the Arctic Circle, Tromsø bills itself as Norway's gateway to the Arctic. Surrounded by chilly fjords and craggy peaks, it has some fabulous museums and architecture.

Great For...

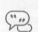 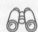 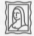

Don't Miss

The summit of Fjellheisen, a cable car that takes you to extraordinary views.

Arctic Cathedral

The 11 triangles of the 1965 **Arctic Cathedral** (Ishavskatedralen; ☑476 80 668; Hans Nilsens veg 41; adult/child 50kr/free, organ recitals 70-170kr; ☺9am-7pm Mon-Sat, 1-7pm Sun Jun–mid-Aug, 3-6pm mid-Aug–mid-May, opens at 2pm Feb), aka Tromsdalen Church, suggest glacial crevasses and auroral curtains. The glowing stained-glass window that occupies the east end depicts Christ descending to earth. The west end is filled by a futuristic organ and icicle-like lamps of Czech crystal.

Polar Museum

Fittingly for a town that was the launchpad for many pioneering expeditions to the Pole, Tromsø's fascinating **Polar Museum** (Polarmuseet; ☑77 62 33 60; www.uit.no/tmu/polarmuseet; Søndre Tollbodgate 11; adult/

Polar Museum

ROALD AMUNDSEN
1872 - 1928

DMITRY CHULOV/SHUTTERSTOCK ©

ARCTIC OCEAN

Lopphavet

Sommarøy • ⊙ Tromsø • Tromsø Airport

Tromsø

• **Lyngseidet**

Skrolsvik • • Finnsnes

ℹ Need to Know

Tromsø's **tourist office** (☎77 61 00 00; www.visittromso.no; Kirkegata 2; ⊙9am-5pm Mon-Fri, 10am-5pm Sat & Sun Jan-Mar & mid-May–Aug, shorter hours rest of year; 🛜) books accommodation and activities, and has free wi-fi, and publishes the *Tromsø Guide*.

✕ Take a Break

Ølhallen (p172) is the brewpub for the famous Mack Brewery. There are 67 ales to try...

★ Top Tip

Tromsø has some of Scandinavia's best nightlife, whatever the weather.

child 60/30kr; ⊙9am-6pm mid-Jun–mid-Aug, 11am-5pm rest of the year) is a rollicking romp through life in the Arctic, taking in everything from the history of trapping to the groundbreaking expeditions of Nansen and Amundsen. There are some fascinating artefacts and black-and-white archive photos; the stuffed remains of various formerly fuzzy, once-blubbery polar creatures are rather less fun. It's in a harbourside building that served as Tromsø's customs house from 1833 to 1970.

Tromsø University Museum

Near the southern end of Tromsøya, this **museum** (☎77 64 50 00; www.uit.no/tmu; Lars Thøringsveg 10; adult/child 60/30kr; ⊙9am-6pm Jun-Aug, 10am-4.30pm Mon-Fri, noon-3pm Sat, 11am-4pm Sun Sep-May) has well-presented and documented displays

on traditional and modern Sami life, ecclesiastical art and accoutrements, and a small section on the Vikings. Downstairs, learn about rocks of the north and ponder a number of thought-provoking themes (such as the role of fire, the consequences of global warming and loss of wilderness).

Mack Brewery

This venerable **institution** (Mack Ølbryggeri; ☎77 62 45 80; www.mack.no; Storgata 5) merits a pilgrimage. Established in 1877, it produces 18 kinds of beer, including the very quaffable Macks Pilsner, Isbjørn, Haakon and several dark beers. At 3.30pm Monday to Friday year-round (plus 2pm, June to August) tours (170kr, including two tastings) leave from the brewery's own Ølhallen Pub (p172). It's wise to reserve in advance.

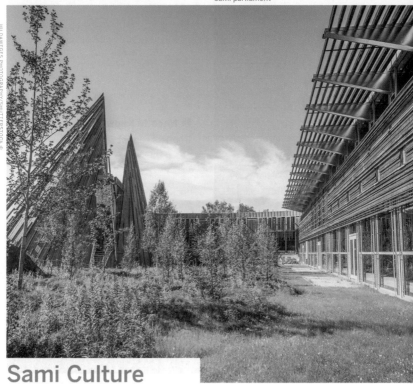

Sami parliament

Sami Culture

When it comes to drawing near to the Sami, two heartlands stand out: Karasjok in Norway and Inari in Finland. Although separated by an international border, they're easy to combine.

Great For...

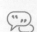

Don't Miss

Karasjok's Sami Parliament is a glorious building, encased in mellow Siberian wood and shaped like a Sami tent.

Siida

One of Finland's most absorbing museums, state-of-the-art **Siida** (www.siida.fi; Inarintie 46; adult/child €10/5; ⊙9am-7pm Jun-Aug, to 6pm Sep, 10am-5pm Wed-Mon Oct-May) offers a comprehensive overview of the Sami and their environment. The main exhibition hall consists of a fabulous nature exhibition around the edge, detailing northern Lapland's ecology by season, with wonderful photos and information panels.

Sajos

The spectacular wood-and-glass Sami **cultural centre** (www.samediggi.fi; Siljotie 4; ⊙9am-5pm Mon-Fri) FREE stands proud in the middle of town. It holds the **Sami parliament** (Sámediggi; ☑78 47 40 00; www.samediggi.no; Kautokeinoveien 50;

Sami woman in traditional dress, Inari

DOUG PEARSON/GETTY IMAGES ©

ℹ Need to Know

Karasjok and Inari are 117km apart by road. There are no border formalities.

✕ Take a Break

In Karasjok **Biepmu Kafeà** (Biepmu Cafe; ☎78 46 61 51; Finlandsveien; mains 140-240kr; ⊙1-8pm), **Aanaar** (☎016-511-7100; www.hotelkultahovi.fi; Saarikoskentie 2; mains €13.50-31.50, 3-/5-course menu €43.50/62, with paired wines €62/85; ⊙11am-2.30pm & 5-10.30pm) ✷ in Inari.

★ Top Tip

Take a tour of Karasjok's Sami Parliament and library (with more than 35,000 volumes) to learn about Sami history.

⊙hourly tours 8.30am-2.30pm Mon-Fri except 11.30am late Jun–mid-Aug, 1pm Mon-Fri rest of year) `FREE` as well as a library and music archive, a restaurant, exhibitions and a craft shop.

Sami National Musuem

Exhibits at the **Sami National Museum** (Sámiid Vuorká Dávvirat, De Samiske Samlinger; ☎78 46 99 50; www.rdm.no; Museumsgata 17; adult/concession/child 90/60kr/free; ⊙9am-6pm mid-Jun–mid-Aug, shorter hours rest of year), also called the Sami Collection, include displays of colourful, traditional Sami clothing, tools and artefacts, and works by contemporary Sami artists. Outdoors, you can roam among a cluster of traditional Sami constructions and follow a short trail, signed in English, that leads past and explains ancient Sami reindeer-trapping pits and hunting techniques.

Sápmi Park

Sami culture is big business here, and this impressive **theme park** (☎78 46 88 00; www.visitsapmi.no; Leavnnjageaidnu 1, off Porsangerveien; adult/child/family 160/80/400kr; ⊙9am-7pm mid-Jun–mid-Aug, 9am-4pm late Aug, 9am-4pm Mon-Fri, 11am-3pm Sat Sep–mid-Dec, 10am-2pm Mon-Fri Jan-May) includes a wistful, hi-tech multimedia introduction to the Sami in the 'Magic Theatre', plus Sami winter and summer camps and other dwellings to explore on the grounds. Reindeers are also often around.

Rovaniemi

Right on the Arctic Circle, Rovaniemi is more than just Santa Claus' home town (p158). There are also excellent museums and it's a fantastic base from which to organise activities.

SIGHTS

Thoroughly destroyed by the retreating Wehrmacht in 1944, the town was rebuilt to a plan by Alvar Aalto, with the major streets in the shape of a reindeer's head and antlers (the stadium near the bus station is the eye). Rovaniemi's concert hall, **Lappia-talo** (☏040-028-2484; www. rovaniementeatteri.fi; Hallituskatu 11; ☺box office 1-5pm Tue-Fri, 11am-1pm Sat & 1hr prior to performances), is one of several buildings in Rovaniemi designed by Alvar Aalto; others include the adjacent library and town hall. Its utilitarian buildings are compensated for by its marvellous riverside location.

Arktikum Museum
(www.arktikum.fi; Pohjoisranta 4; adult/child €12/5; ☺9am-6pm Jun-Aug, 10am-6pm Tue-Sun mid-Jan–May & Sep-Nov, 10am-6pm Dec–mid-Jan) With its beautifully designed glass tunnel stretching out to the Ounasjoki, this is one of Finland's finest museums. One half deals with Lapland, with information on Sami culture and the history of Rovaniemi; the other offers a wide-ranging display on the Arctic, with superb static and interactive displays focusing on flora and fau na, as well as on the peoples of Arctic Europe, Asia and North America. Downstairs, an audiovisual – basically a pretty slide show – plays on a constant loop.

Pilke Tiedekeskus Museum
(www.tiedekeskus-pilke.fi; Ounasjoentie 6; adult/child €7/5; ☺9am-6pm Mon-Fri, 10am-4pm Sat & Sun mid-Jun–Aug, shorter hours rest of year) Downstairs in the Metsähallitus (Finnish Forest and Park Service) building next to the Arktikum, this is a highly entertaining exhibition on Finnish forestry with a sustainable focus. It has dozens of interactive displays that are great for kids of all ages, who can clamber up into a bird house, build a timber-framed dwelling, get behind the wheel of a forest harvester or play games about forest management. Multilingual touch-screens provide interesting background information.

✪ ACTIVITIES

Rovaniemi is a great launching pad for winter and summer activities, offering frequent departures with multilingual guides. You need a driving licence to operate a snowmobile; there's a 50% supplement if you want one to yourself.

Rovaniemi's ski area, **Ounasvaara** (☏044-764-2830; https://ounasvaara.fi; Taunontie 14; winter lift ticket per day €38, ski hire per day €38; ☺winter activities early Nov-late Mar, summer activities late Jun–mid-Aug), is just east of the river.

Bear Hill Husky Dog Sledding
(☏040-760-0020; www.bearhillhusky.com; Sinettäjärventie 22; kennel tours incl sled ride adult/child €59/29, expeditions from €119/59; ☺Jul-Mar) Wintertime husky-pulled sled expeditions start at two hours' duration (prices include transport to/from Rovaniemi). Overnight tours run on Saturdays from late January to March, with accommodation in a traditional wilderness cabin with smoke sauna. If you just want a taster, kennel tours, where you meet the Alaskan huskies, include a 1km ride with their mushers (sled drivers).

Safartica Outdoors
(☏016-311-485; www.safartica.com; Koskikatu 9; ☺3hr reindeer sled tour €148, 4hr mountain-bike tour €121) In addition to reindeer-pulled sled tours and mountain-bike tours, this superb outfit runs river activities such as summer berry-picking trips (three hours €75), midnight-sun lake floating in special flotation suits (three hours €92), ice fishing (2½ hours €89), snowshoe hiking (two hours €69) and a six-hour snowmobile adventure (€192).

Rovaniemi

Konttaniemen Porotila (8km); Husky Point (16km);
Arctic Circle Husky Park (16km);
Bear Hill Husky (23km); Arctic Snow Hotel (27km)

Santapark (7km);
Napapiiri (8km);
Santa Claus Holiday
Village (8km);
(10km)

🕝 TOURS

Rovaniemi Food Walk Food

(📞040-488-7173; www.aittadeli.com; €50,
with drinks €75; ⏰by reservation) Offer-
ing a taster of Lapland cuisine, these
three-hour tours are literally a moveable
feast, starting at street-food restaurant
Roka (📞050-311-6411; www.ravintolaroka.fi;
Ainonkatu 3;

lunch buffet €9.90, street-food dishes €8.50-
12, mains €15.50-23; ⏰10.30am-9pm Mon-
Thu, to 11pm Fri, noon-11pm Sat, noon-9pm
Sun), followed by a contemporary Finnish
main course (such as slow-cooked rein-
deer or whitefish with pickled cucumber)
at Aitta Deli & Dine (p167), and finish-
ing with dessert and a cocktail at Cafe &
Bar 21 (p166).

🛍 SHOPPING

Lauri Tuotteet Arts & Crafts

(www.lauri-tuotteet.fi; Pohjolankatu 25; ⊙10am-5pm Mon-Fri) Established in 1924, this former knife factory in a charming log cabin at the northwestern edge of town still makes knives today, along with jewellery, buttons, felt boots and traditional Sami items like engraved spoons and sewing-needle cases. Everything is handmade from local materials, including reindeer antlers, curly birch and goats willow timbers, and Finnish steel.

Katijuu Fashion & Accessories

(http://katijuu.fi; Rovakatu 11; ⊙10am-4pm Mon-Fri) Reindeer and moose leather, lambskin, and red fox, mink and marten fur are used by Lapland designer Kati Juujärvi to create hats, gloves and mittens, belts and fur collars, as well as clothing for men, women and children such as vests, jackets, dresses and trousers. Seasonal collections are named for places along the Kemijoki river.

Marttiini Arts & Crafts

(www.marttiini.fi; Vartiokatu 32; ⊙10am-6pm Mon-Fri, to 4pm Sat Sep-May, plus noon-3pm Sun Jun-Aug) This former factory of Finland's famous knife manufacturer Marttiini is now a shop open to visitors with a small knife exhibition, and cheaper prices than you can get elsewhere. It's near the Arktikum (p164); there are branches at Santa Claus Village (p159) and at the Rinteenkulma shopping centre in the town centre, as well as one in Helsinki.

🍴 EATING

Cafe & Bar 21 Cafe €

(www.cafebar21.fi; Rovakatu 21; dishes €10-14; ⊙11am-8.30pm Mon & Tue, to 9.30pm Wed & Thu, to 11pm Fri, noon-11pm Sat, noon-8.30pm Sun; 🛜) A reindeer-pelt collage on the grey-concrete wall is the only concession to place at this artfully modern designer cafe-bar. Black-and-white decor makes it a stylish haunt for salads, superb soups, tapas and its house-speciality waffles

Arktikum (p164)

(both savoury and sweet), along with creative cocktails. The bar stays open late.

Aitta Deli & Dine
Finnish, Deli €€

(☎040-488-7173; www.aittadeli.com; Rovakatu 26; lunch buffet €10, platters €10-30, 4-course dinner menu €44, with paired wine or beer €69; ☺restaurant 11am-4pm Mon & Tue, to 10pm Wed-Sat, to 3pm Sun, deli 11am-6pm Mon-Fri, to 3pm Sat) 🍴 Locally sourced, organic food at Aitta includes sharing platters piled high with reindeer heart and tongue, lingonberry and moose stew, bear and nettle sausages, and rye and barley breads. Two- and three-course menus are available at lunch and dinner, but the pick of the dinner offerings is the four-course Taste of Lapland menu paired with natural wines or craft beers.

Nili
Finnish €€

(☎040-036-9669; www.nili.fi; Valtakatu 20; mains €19-35, 4-course menu €56, with paired wines €100; ☺5-11pm Mon-Sat) A timber-lined interior with framed black-and-white photos of Lapland, kerosene lamps, traditional fishing nets, taxidermied bear and reindeer heads, and antler chandeliers gives this hunting-lodge-style spot a cosy, rustic charm. Local ingredients are used in dishes such as Zandar lake fish with tar-and-mustard foam and reindeer with pickled cucumber and lingonberry jam, accompanied by Finnish beers, ciders and berry liqueurs.

Restaurant Sky Ounasvaara
Finnish €€€

(☎016-323-400; www.laplandhotels.com; Juhannuskalliontie; mains €24-36, 5-course menu €69, with wine €127; ☺6-9.30pm Mon-Sat, to 9pm Sun Jun-Apr) For a truly memorable meal, head to the 1st floor of the **Sky Ounasvaara** (d/tr/f/apt from €101/126/135/143; ☺Jun-Apr; P 🛜) hotel, where wraparound floor-to-ceiling glass windows onto the forest outside create the impression of dining in a tree house. Specialities include Lappish potato

🏔️ Exploring the Lofoten Islands

Every traveller in Arctic Scandinavia should consider a detour to the Lofoten Islands, which spread their tall, craggy physique against the sky like some spiky sea dragon. The beauty of this place is simply staggering.

The main islands, Austvågøy, Vestvågøy, Flakstadøy and Moskenesøy, are separated from the mainland by Vestfjorden, but connected by road bridges and tunnels. Each has sheltered bays, sheep pastures and picturesque villages. The vistas, and special quality of the Arctic light, have long attracted artists, represented in galleries throughout the islands.

Sights (unless you count the extraordinary scenery) are few, although there is an excellent **Viking museum** (☎76 15 40 00; www.lofotr.no; adult/child incl guided tour mid-Jun–mid-Aug 200/150kr, rest of year 140/100kr; ☺10am-7pm Jun–mid-Aug, shorter hours rest of year; 🎫), an extraordinary glass-blowing gallery called **Glasshytta** (☎76 09 44 42; www.glasshyttavikten.no; Vikten; ☺10am-7pm May-Aug) and some of the Arctic's prettiest villages. Among the latter are Henningsvær, Nusfjord, Reine and Å.

Svolvær is the gateway to Lofoten, and has the largest selection of accommodation and restaurants. You'll need your own wheels and at least three days to see the best that Lofoten has to offer.

Reine, Lofoten Islands
KENNETH SCHOTH/500PX ©

dumplings with local mushrooms, reindeer tartar with spruce-smoked mayo, Arctic char with sour-milk sauce, and sea-buckthorn meringue with reindeer yoghurt.

🍸 DRINKING & NIGHTLIFE

Paha Kurki Bar

(www.pahakurki.com; Koskikatu 5; ⏰4pm-3am; 📶) Dark yet clean and modern, this rock bar has a fine variety of bottled beers, memorabilia on the walls and a good sound system. A Finnish rock bar is what other places might call a metal bar: expect more Pantera than Pixies.

Kauppayhtiö Bar

(www.kauppayhtio.fi; Valtakatu 24; ⏰11am-9pm Tue-Thu & Sun, to 3.30am Fri, 1pm-3.30am Sat; 📶) Almost everything at this oddball gasoline-themed bar-cafe is for sale, including colourful plastic tables and chairs, and retro and vintage toys, as well as new streetwear and Nordic clothing at the attached boutique. DJs play most evenings and there are often bands at weekends – when it's rocking, crowds spill onto the pavement terrace. Its burgers are renowned. Bonus: pinball machines.

ℹ️ INFORMATION

DISCOUNT CARDS

A Culture Pass combination ticket (adult/child €20/10) offering unlimited access to the three major sights, the **Arktikum** (p164), **Pilke Tiedekeskus** (p164) and **Rovaniemen Taidemuseo** (Korundi; www.korundi.fi; Lapinkävijäntie 4; adult/child €8/4; ⏰11am-6pm Tue-Sun), is valid for a week. Pick it up from the museums or the tourist office.

TOURIST INFORMATION

Metsähallitus (📞020-564-7820; www.metsa.fi; Pilke Tiedekeskus, Ounasjoentie 6; ⏰9am-6pm Mon-Fri, 10am-4pm Sat & Sun mid-Jun–Aug, shorter hours rest of year) Information centre for the national parks; sells maps and fishing permits.

Tourist Information (📞016-346-270; www.visitrovaniemi.fi; Maakuntakatu 29; ⏰9am-5pm Mon-Fri mid-Aug–mid-Jun, plus 10am-3pm Sat mid-Jun–mid-Aug; 📶)) is in the square in the middle of town.

ℹ️ GETTING THERE & AWAY

AIR

Rovaniemi's **airport** (RVN; 📞020-708-6506; www.finavia.fi; Lentokentäntie), 8km northeast of the city, is the 'official airport of Santa Claus' (he must hangar his sleigh here) and a major winter destination for charter flights. Finnair and Norwegian have several flights daily to/from Helsinki.

Airport minibuses (📞016-362-222; http://airportbus.fi) meet arriving flights, dropping off at hotels in the town centre (€7, 15 minutes).

A taxi to the city centre costs €20 to €30 depending on the time of day and number of passengers.

BUS

Daily connections serve just about everywhere in Lapland. Some buses continue north into Norway.

TRAIN

One direct train per day runs from Rovaniemi to Helsinki (€80, eight hours), with two more requiring a change in Oulu (€14, 2¼ hours).

Tromsø

Beautifully sited by the water's edge and in the shadow of mountains, as rich in cultural signposts as great places to eat and drink, Tromsø is one of the Arctic's most desirable urban experiences.

◎ SIGHTS

Around town you'll find a number of interesting churches. **Domkirke** (www.kirken.tromso.no; Storgata; ⏰1-3pm Mon-Fri Jun & Jul, 1-4pm Mon-Fri Aug, 1-5pm Mon-Fri rest of the year) FREE is one of Norway's largest wooden churches. Up the hill is the

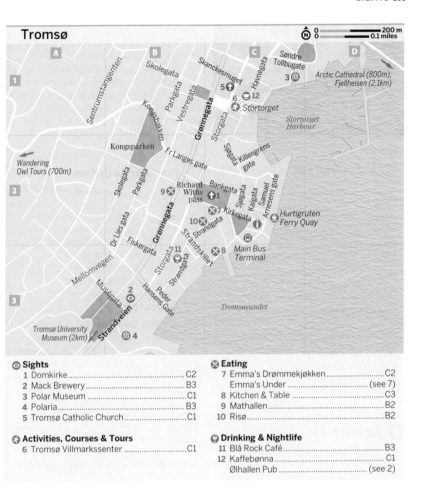

Tromsø

town's **Tromsø Catholic Church** (Storgata 94; ⊙9am-7.30pm) FREE. Both were built in 1861 and each lays claim to be 'the world's northernmost bishopric' of its sect.

You'll find more early-19th-century timber buildings around the town centre, including a stretch of 1830s shops and merchants' homes along Sjøgata.

Polaria Museum, Aquarium
(⊉77 75 01 11; www.polaria.no; Hjalmar Johansens gate 12; adult/child 130/65kr; ⊙10am-7pm mid-May–Aug, 10am-5pm Sep–mid-May) This

Arctic–themed attraction provides a multimedia introduction to northern Norway and *Svalbard*. Kick things off by watching the two films *In the Land of the Northern Lights* and *Spitsbergen – Arctic Wilderness*, then follow the Arctic walkway past exhibits on shrinking sea ice, the aurora borealis, aquariums of cold-water fish and – the big draw – some yapping, playful bearded seals (feeding time is at 12.30pm year-round, plus 3pm in summer or 3.30pm in winter).

Festival Fun

In summer at the Arctic Cathedral, there are Midnight Sun Concerts (adult/child 170/50kr; 11pm June to mid-August) and organ recitals (70kr; 2pm June and July). Experiencing the swelling organ and the light of the midnight sun streaming through the huge west window could be one of the great sensory moments of your trip.

The **Domkirke** (www.kirken.tromso.no; ⊙1-3pm Mon-Fri Jun & Jul, 1-4pm Mon-Fri Aug, 1-5pm Mon-Fri rest of the year) holds half-hour organ recitals (70kr; 5pm June, 3pm July) of classical music and folk tunes.

Domkirke, Tromsø
MAYLAT/SHUTTERSTOCK ©

⊕ ACTIVITIES

For many people, the main reason to visit Tromsø is the chance to hunt for the northern lights. There are lots of companies around town offering aurora-spotting safaris. Go with a small, independent operator, otherwise you might end up with a coach party from one of the city's big hotels.

The tourist office's *Summer Activities in Tromsø* and its winter equivalent provide comprehensive checklists of tours and activities.

⊕ Winter Activities

In and around Tromsø (operators will normally collect you from your hotel), winter activities outnumber those in summer, and include chasing the northern lights, cross-country skiing, Sami encounters, reindeer herding, reindeer- and dog-sledding, snowshoe safaris, ice fishing and snowmobiling. Whale-watching in a variety of boats (including kayaks!) is also an exciting possibility, with the season running from late October to mid-January or into February.

⊕ Summer Activities

Summer activities in the Tromsø hinterland include hiking, fishing, visits to Sami camps, food-centric excursions, boat sightseeing and sea-kayaking. Trips to scenic locations to see the midnight sun and general sightseeing trips are widely available. Wildlife enthusiasts can also go looking for seabirds and seals.

⊕ Operators

Wandering Owl Tours Adventure (☑484 60 081; www.wanderingowl.com; Sommerlystvegen 7a) One of the more creative operators around town, Wandering Owl Tours has excellent summer guided hikes, a trip to a wilderness sauna and scenic driving tours from mid-May to mid-August, with a host of winter activities that include northern lights photography workshops.

Tromsø Villmarkssenter Outdoors (☑77 69 60 02; www.villmarkssenter.no; Stortorget 1, Kystens Hus) Tromsø Villmarkssenter offers dog-sled excursions ranging from a one-day spin to a four-day trek with overnight camping. This booking office is in town; the centre, 24km south of Tromsø on Kvaløya, also offers a range of summer activities such as trekking, glacier hiking and sea-kayaking, as well as seal and seabird safaris.

Tromsø Friluftsenter Adventure Sports (☑907 51 583; www.tromso-friluftsenter.no; Kvaløyvågvegen 669) Tromsø Friluftsenter runs summer sightseeing, boat trips and

a full range of winter activities (including trips to Sami camps). One intriguing possibility is their five-hour humpback whale and orca safari from late November to mid-January. Book online or at Tromsø's tourist office (p161).

✖ EATING

Risø
Cafe €

(📞416 64 516; www.risoe-mk.no; Strandgata 32; mains 95-179kr; ⏰7.30am-5pm Mon-Fri, 9am-5pm Sat) You'll find this popular coffee and lunch bar packed throughout most of the day: young trendies come in for their hand-brewed Chemex coffee, while local workers pop in for the daily specials, open-faced sandwiches and delicious cakes. It's small, and the tables are packed in tight, so you might have to queue.

Emma's Under
Norwegian €€

(📞77 63 77 30; www.emmasdrommekjokken.no; Kirkegata; lunch mains 165-335kr; ⏰11am-10pm Mon-Fri, noon-10pm Sat) Homely and down-to-earth Norwegian cuisine is the order of the day here. You'll find hearty

dishes like fish gratin, king crab and baked *clipfish* (salt cod) on the lunch menu, served in a cosy space designed to echo a traditional kitchen à la grandma. Upstairs is the more formal Emma's Drømmekjøkken, which shares its menu with Emma's Under after 5.30pm.

Emma's Drømmekjøkken
Norwegian €€€

(📞77 63 77 30; www.emmasdrommekjokken.no; Kirkegata; mains 285-365kr, 3-/5-course menu 390/630kr; ⏰6pm-midnight Mon-Sat) Upstairs from Emma's Under, this stylish and highly regarded place pulls in discriminating diners with its imaginative cuisine, providing traditional Norwegian dishes married with top-quality local ingredients such as *lutefisk* (stockfish), blueberry-marinated halibut, ox tenderloin and gratinated king crab. Advance booking is essential.

Kitchen & Table
Norwegian, International €€€

(📞77 66 84 84; www.kitchenandtable.no/tromso; Kaigata 6; mains 235-375kr; ⏰5-10pm

Whale-watching, Tromsø

Reindeer sledding, Tromsø

Mon-Sat, to 9pm Sun) Combining a touch of Manhattan style with Arctic ingredients, chef Marcus Samuelsson serves up some of the freshest and most original tastes in Tromsø – there's reindeer fillet with mango chutney, reindeer ratatouille, burgers with quinoa or kimchi, and even slow-cooked Moroccan lamb.

Mathallen Bistro €€€

(☏77 68 01 00; www.mathallentromso.no; Grønnegata 60; lunch mains 100-210kr, dinner mains from 310kr, 4-course tasting menu 685kr; ☺bistro 11am-11pm Tue-Sat, deli 10am-6pm Mon-Fri, 10am-4pm Sat) With its industrial styling, exposed pipes and open-fronted kitchen, this elegant place wouldn't look out of place in Oslo or Stockholm. It serves some of the best modern Norwegian food in town, majoring in fish and local meats; the lunchtime special is a steal at 100kr. There's a deli next door selling tapenades, cheeses, smoked salmon and *lutefisk* (stockfish).

🍷 DRINKING & NIGHTLIFE

Ølhallen Pub Pub

(☏77 62 45 80; www.olhallen.no; Storgata 4; ☺10am-7.30pm Mon-Wed, 10am-12.30am Thu-Sat) Reputedly the oldest pub in town, and once the hangout for salty fishermen and Arctic sailors, this is now the brewpub for the excellent Mack Brewery (p161). There are 67 ales to try, including eight on tap – so it might take you a while (and a few livers) to work your way through them all.

Blå Rock Café Bar

(☏77 61 00 20; www.facebook.com/Blaarock; Strandgata 14/16; ☺11.30am-2am Mon-Thu, 11.30am-3am Fri & Sat, 1pm-2am Sun) The loudest, most raving place in town has theme evenings, almost 50 brands of beer, occasional live bands and weekend DJs. The music is rock, naturally. Every Monday hour is a happy hour.

Kaffebønna
Cafe

(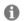77 63 94 00; www.kaffebonna.no; Stortorget 3;
⏰8am-6pm Mon-Fri, 9am-6pm Sat, 10am-6pm Sun)
One of our favourite Tromsø cafes, this cool lit-
tle spot right in the town centre does the city's
best coffee, accompanied by tasty pastries.

ℹ️ INFORMATION

The **Tourist Office** (p161) is in a wooden build-
ing by the harbour, Tromsø's busy tourist office
books accommodation and activities, and has
free wi-fi. It also publishes the comprehensive
Tromsø Guide.

ℹ️ GETTING THERE & AWAY

AIR

Tromsø Airport (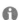77 64 84 00; www.avinor.no/fly
plass/tromso) is about 5km from the town centre,
on the western side of Tromsøya and is the main
airport for the far north. Destinations with direct
Scandinavian Airlines flights to/from the airport
include Oslo, Harstad/ Narvik, Bodø, Trondheim,
Alta, Hammerfest, Kirkenes and Longyearbyen.

Norwegian (www.norwegian.no) flies to and from
most major cities in Norway, plus UK destinations
including London Gatwick, Edinburgh and Dublin.

Widerøe (www.wideroe.no) has several flights
a day to Svolvær and Leknes in the Lofoten
Islands. All flights are via Bodø.

BOAT

Tromsø is a major stop on the Hurtigruten coast-
al-ferry route. All ferries on the route will stop at
the **Hurtigruten ferry quay** (Samuel Arnesens
gate), until the opening of the new terminal (at
the time of research scheduled for autumn 2018).

BUS

The **main bus terminal** (Samuel Arnesens
gate) (also known as Prostneset) is on Kaigata,

 Worth A Trip:
Sommarøy

From Tromsø, this half-day trip is more
for the drive than the destination.
It's an extraordinarily pretty, lightly
trafficked run across Kvaløya, much of
it down at wet-your-feet shore level as
far as the small island of Sommarøy.
If you decide to stay the night, there's
the **Sommarøy Kurs & Feriesenter**
(77 66 40 00; www.sommaroy.no; Skip-
sholmsveien 22, Sommarøy; r 1090-1490kr,
apt from 2300kr, sea house from 3400kr;
P@🛜).

If you're arriving from Senja by the
Botnhamn–Brensholmen ferry (www.
tromskortet.no), the vistas as you cross
Kvaløya, heading westwards for Tromsø,
are equally stunning.

Sommarøy
TRAMONT_ANA/GETTY IMAGES ©

beside the Hurtigruten ferry quay. There are
up to three daily express buses to/from Narvik
(280kr, 4¼ hours) and one to/from Bodø
(410kr, 6½ hours).

Tromskortet (www.tromskortet.no) has a dai-
ly bus on weekdays to Narvik, where there's
a connecting bus to Svolvær (eight hours) in
the Lofoten Islands.

GOTHENBURG, SWEDEN

In this Chapter

Gothenburg, Sweden at a Glance...

Gregarious, chilled-out Gothenburg (Göteborg) has great appeal. Neoclassical architecture lines its tram-rattled streets, locals sun themselves beside canals, and there's always an interesting cultural or social event going on. It's also very walkable. From Centralstationen, shop-lined Östra Hamngatan leads southeast across one of the city's 17th-century canals, through verdant Kungsparken (King's Park) to the boutique- and upscale-bar-lined 'Avenyn' boulevard. The waterfront abounds with all things nautical (ships, aquariums, museums, the freshest fish). To the west, the Vasastan, Haga and Linné districts buzz with creativity and an appreciation of well-preserved history.

Two Days in Gothenburg

Spend a day at **Liseberg** (p183) amusement park, staying for a healthy lunch or dinner. Afterwards, stop for Scandinavian beer at **NOBA Nordic Bar** (p179).

Next day, visit excellent **Konstmuseum** (p182), then visit some independent galleries, like **Galleri Nils Åberg** (p181). Head to **Röda Sten Konsthall** (p182). Continue the art theme with a meal at **Thörnströms Kök** (p188).

Four Days in Gothenburg

On day three, shop in the **Haga district** (p183), stopping for lunch at **En Deli i Haga** (p187). Stroll through Linné district then grab a drink at **Notting Hill** (p190) or any of the comfy pubs in the area.

Next day, take the train to **Mölndals Museum** (p183) for its Swedish cultural artefacts. Grab a tasty shrimp sandwich at **Feskekörka** (p187), or opt for a fancy hot dog at **Gourmet Korv** (p187).

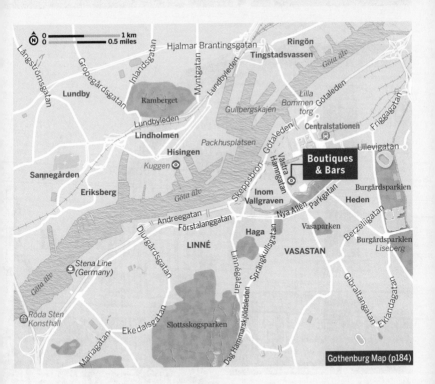

Gothenburg Map (p184)

Arriving in Gothenburg

Göteborg Landvetter Airport (p191) is located 25km east of the city.

Flygbuss (www.flygbussarna.se) runs to Landvetter Airport from Nils Ericson Terminalen every 15 to 20 minutes from 4.20am to 9pm and from the airport to the city between 5am and 11.30pm. Discounts are available for online bookings.

The fixed taxi rate with **Taxi Göteborg** (p193) from the city to the airport is 453kr.

Where to Stay

Gothenburg has a solid range of accommodation in all categories. The majority of hotels offer decent discounts at weekends and during the summer. Check www.goteborg.com for deals. Most hostels are clustered southwest of the centre; all are open year-round.

Haga District

TOMMY ALVEN/SHUTTERSTOCK ©

Boutiques & Bars

Designer boutiques are a Gothenburg speciality, with everything from handmade jewellery to organic honey. Breezy bars, too, are a highlight: seek out a sun-soaked terrace and watch the world go by.

Great For...

Don't Miss

The idiosyncratic small shops in the Haga district.

DesignTorget

This **place** (www.designtorget.se; Vallgatan 14; 10am-7pm Mon-Fri, to 5pm Sat, noon-4pm Sun; 1, 2, 5, 6, 9 Domkyrkan) has cool, brightly coloured, affordable designer kitchenware, jewellery and more from both established and up-and-coming Scandi talent.

J. Lindeberg

This established Stockholm **designer** (www.jlindeberg.com; Korsgatan 17; 11am-6pm Mon-Fri, to 5pm Sat; 1, 6, 9, 11 Domkyrkan) offers slick knitwear, casual shirts and those perfect autumn/winter coats for the discerning gent.

ℹ Need to Know

Shops rarely open before 10am, and some don't get going until noon.

✕ Take a Break

Any bar is good for a mid-shop break.

★ Top Tip

Use the tram (not car) to get around, especially if you're having a few drinks.

Champagne Baren

What's not to like? This **champagne bar** (www.forssenoberg.com; Kyrkogatan; ⏱5-11pm Tue-Thu, 4pm-midnight Fri & Sat; 📶; 🚃1 Domkyrkan) has an idyllic setting on an inner courtyard with uneven cobbles, picturesque buildings and plenty of greenery. Along with glasses of bubbly, there are platters of cheese, oysters and cold cuts. Very popular with the boho-chic set. You can expect some cool background beats, as well as occasional live jazz.

NOBA Nordic Bar

With ye olde maps of Scandinavia on the walls and a glassed-over beer patio with birch tree stumps for stools, this **bar** (www.noba.nu; Viktoriagatan 1A; ⏱4pm-1am Mon-Thu, to 3am Fri & Sat, 5pm-1am Sun; 🚃1, 2, 3, 7, 10 Viktoriagatan) takes its Nordic beers very seriously. From Iceland's Freyja to Denmark's Kärlek, you name it, they've got it. The free-flowing whiskies liven up the scene on weekends.

Ölhallen 7:an

This well-worn Swedish **beer hall** (Kungstorget 7; ⏱11am-midnight Sun-Tue, to 1am Wed-Sat; 🚃3, 4, 5, 7, 10 Kungsportsplatsen), the last remaining from its era, hasn't changed much in more than 100 years. It attracts an interesting mix of bikers and regular folk with its homey atmosphere and friendly service. The illustrations lining the walls are Liss Sidén's portraits of regulars in the old days.

Art & Architecture Walking Tour

Gothenburg has imagination and creativity to spare. Independent galleries brim with up-and-coming talent, and architectural flights of fancy spring up like mushrooms after the rain.

Start Kuggen
Distance 7.5km
Duration 3 hours

START **1**

Myntgatan

Lundbyleden

Göta älv

Göta älv

Oscarsleden

Djurgårdsgatan

1 Take a peek at **Kuggen** (Lindholmsplatsen) for a taste of what 'green' engineering can mean.

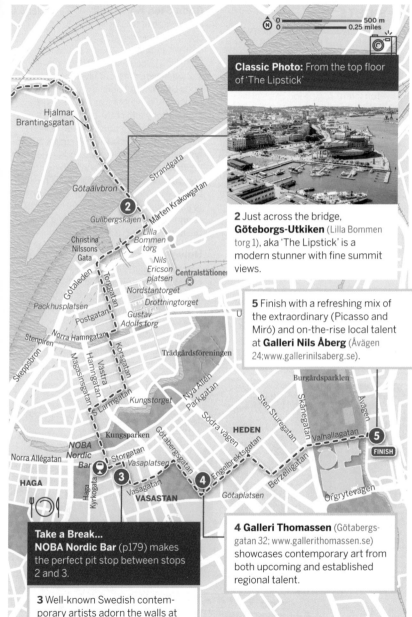

500 m
0.25 miles

N

Classic Photo: From the top floor of 'The Lipstick'

1 SEBASTIAAN KROES/GETTY IMAGES © 2 TRAMINOS/SHUTTERSTOCK ©

2 Just across the bridge, **Göteborgs-Utkiken** (Lilla Bommen torg 1), aka 'The Lipstick' is a modern stunner with fine summit views.

5 Finish with a refreshing mix of the extraordinary (Picasso and Miró) and on-the-rise local talent at **Galleri Nils Åberg** (Åvägen 24; www.gallerinilsaberg.se).

4 Galleri Thomassen (Götabergs-gatan 32; www.gallerithomassen.se) showcases contemporary art from both upcoming and established regional talent.

Take a Break...
NOBA Nordic Bar (p179) makes the perfect pit stop between stops 2 and 3.

3 Well-known Swedish contemporary artists adorn the walls at **Galleri Ferm** (Karl Gustavsgatan 13; www.galleriferm.se), along with some class international acts.

Hjalmar Brantingsgatan

Götaälvbron

Strandgata

Gullbergskajen

Mårten Krakowgatan

Christina Nilssons Gata

Lilla Bommen torg

Nils Ericson platsen

Centralstationen

Götaleden

Torggatan

Nordstantorget

Packhusplatsen

Postgatan

Drottningtorget

Gustav Adolfs torg

Stenpiren

Norra Hamngatan

Västra Hamngatan

Magasinsgatan

Korsgatan

Trädgårdsföreningen

Skeppsbron

Burgårdsparklen

Nya Allén Parkgatan

S Larmgatan

Kungstorget

Södra vägen

Sten Sturegatan

Skånegatan

Åvägen

HEDEN

Valhallagatan

NOBA Nordic Bar

Kungsparken

Storgatan

Götabergsgatan

Engelbrektsgatan

Berzeliigatan

5

FINISH

Norra Allégatan

Vasaplatsen

3

4

HAGA

Haga Kyrkogata

Vasagatan

VASASTAN

Götaplatsen

Örgrytevägen

◉ SIGHTS

Most of the city's sights are located within walking distance of the centre and, after Liseberg, museums are Gothenburg's strongest asset: admission to most is covered by the Göteborg City Card (p191). All the museums have good cafes attached and several have specialist shops.

Konstmuseum
Gallery

(www.konstmuseum.goteborg.se; Götaplatsen; adult/child 40kr/free; ⊙11am-6pm Tue & Thu, to 8pm Wed, to 5pm Fri-Sun; 👶; 🚊4 Berzeliigatan) Home to Gothenburg's premier art collection, Konstmuseet displays works by the French Impressionists, Rubens, Van Gogh, Rembrandt and Picasso; Scandinavian masters such as Bruno Liljefors, Edvard Munch, Anders Zorn and Carl Larsson have pride of place in the **Fürstenburg Galleries**.

Other highlights include a superb sculpture hall, the **Hasselblad Center** with its annual *New Nordic Photography* exhibition, and temporary displays of next-gen Nordic art.

Röda Sten Konsthall
Gallery

(www.rodastenkonsthall.se; Röda Sten 1; adult/child 40kr/free; ⊙noon-5pm Tue, Thu & Fri, to 8pm Wed, to 6pm Sat & Sun; 🚊3 Vagnhallen Majorna) Occupying a defunct power station beside the giant Älvsborgsbron, Röda Sten's four floors are home to such temporary exhibitions as edgy Swedish photography and cross-dressing rap videos by Danish–Filipino artist Lilibeth Cuenca Rasmussen that challenge sexuality stereotypes in Afghan society. The indie-style cafe hosts weekly live music and club nights, and offbeat one-offs like punk bike races, boxing matches and stand-up comedy. To get here, walk towards the Klippan precinct, continue under Älvsborgsbron and look for the brown-brick building.

Universeum
Museum

(www.universeum.se; Södra Vägen 50; adult/child 250/195kr; ⊙10am-6pm, to 8pm Jul & Aug; P 👶; 🚊2 Korsvägen) In what is arguably the best museum for kids in Sweden, you find yourself in the midst of a humid rainforest, complete with trickling water, tropical birds and butterflies flitting through the

Konstmuseum

greenery, and tiny marmosets. On a level above, roaring dinosaurs maul each other, while next door, denizens of the deep float through the shark tunnel and venomous beauties lie coiled in the serpent tanks. In the 'technology inspired by nature' section, stick your children to the Velcro wall.

Haga District Area
(www.hagashopping.se; 🚊25 Hagakyrkan, 🚊2 Handelshögskolan) The Haga district is Gothenburg's oldest suburb, dating back to 1648. A hardcore hippie hang-out in the 1960s and '70s, its cobbled streets and vintage buildings are now host to a cool blend of cafes, trendy shops and boutiques. During some summer weekends and at Christmas, store owners set up stalls along Haga Nygata, turning the neighbourhood into one big market. Check out the charming three-storey timber houses, built as housing for workers in the 19th century.

Trädgårdsföreningen Park
(www.tradgardsforeningen.se; Nya Allén; ⏲7am-8pm; 🚊3, 4, 5, 7, 10 Kungsportsplatsen) Laid out in 1842, the lush Trädgårdsföreningen is a large protected area off Nya Allén. Full of flowers and tiny cafes, it's popular for lunchtime escapes and is home to Europe's largest **rosarium**, with around 2500 varieties. The gracious 19th-century **Palmhuset** (open 10am to 8pm) is a bite-size version of the Crystal Palace in London, with five differently heated halls: look out for the impressive camellia collection and the 2m-wide tropical lily pads.

Liseberg Amusement Park
(www.liseberg.se; Södra Vägen; 1-day pass 455kr; ⏲11am-11pm Jun–mid-Aug, hours vary rest of year; P🚻; 🚊2 Korsvägen) The attractions of Liseberg, Scandinavia's largest amusement park, are many and varied. Adrenalin blasts include the venerable wooden roller coaster Balder; its 'explosive' colleague Kanonen, where you're blasted from 0km/h to 75km/h in under two seconds; AtmosFear, Europe's tallest (116m) free-fall tower; and the park's biggest new attraction, Loke, a

Creative Outskirts

The tiny, creative hub of Kvarnbyn, a district of Mölndal 8km south of Gothenburg, has long attracted architects, designers and artists looking to escape the high rents and pressures of the city. Here, a brooding landscape of roaring rapids gripped by grain mills and historic factories (Mölndal means 'valley of the mills') has been transformed into a dynamic yet low-key cultural centre.

The district's nexus is the smart, interactive **Mölndals Museum** (📞031-431 34; www.museum.molndal.se; Kvarnbygatan 12; ⏲noon-4pm Tue-Sun; P🚻; 🚊752, 756, 🚊Mölndal) **FREE**. Located in an old police station, the museum is like a vast warehouse, with a 10,000-strong collection of local nostalgia that includes a 17th-century clog, kitchen kitsch and a re-created 1930s worker's cottage.

The district also hosts some noteworthy cultural events. On a Saturday in mid- to late April, **Kvarnbydagen** (Kvarnbyn Day; www.kvarnbydagen.se) sees local artists and designers open their studios to the public. In September **Kulturnatt** (http://kulturnatta.goteborg. se/) is a starlit spectacle of open studios and art installations, as well as dance and music performances.

To reach Kvarnbyn from Gothenburg, catch a Kungsbacka–bound train to Mölndal station, then bus 756 or 752 to Mölndals Museum.

fast-paced spinning 'wheel' that soars 42 metres into the air. Softer options include carousels, fairy-tale castles, an outdoor dance floor, adventure playgrounds, and shows and concerts.

🛍 SHOPPING

Gothenburg is right up with Stockholm when it comes to shopping. The Haga

Göteborg (Gothenburg)

Kuggen
(900m)

Gullbergskajen

Lilla
Bommen
torg

Christina
Nilssons Gata

36

Nordstantorget

Nordstan

Östra Hamngatan

Packhusplatsen

Kronhusgatan

Postgatan

Gustav
Adolfs torg

Torggatan

Stenpiren

Norra Hamngatan

Södra Hamngatan

Södra Hamngatan

14

Lilla
Torget

Västra Hamngatan

Korsgatan

Kyrkogatan

29

Stena Line
(Denmark)

Skeppsbron

RFSL
Göteborg

23

21

Magasinsgatan

27

12

Kungsgatan

Vallgatan

13

33

Viktoriapassagen

16

S Larmgatan

Kungstorget

Kungsgatan

15

19

Lilla Korsgatan

Magasinsgatan

Gronsakstorget

Stena Line (Germany) (2.2km);
Röda Sten Konsthall (3km);
Saltholmen (8km)

Rosenlundsgatan

18

Hvitfeldtsplatsen

30

Järntorgsgatan

37

Kungsparken

Parkgatan

Erik Dahlbergsg

25

Järntorget

Andra Långgatan

Södra Allégatan

Kaponjärgatan

Haga Kyrkogata

Storgatan

31

Bengans Skivor
& Café (600m)

32

28

5

Haga Nygata

20

1

7

Tredje Långgatan

11

24

17

HAGA

Vasagatan

VASASTAN

Vegagatan

Nordhemsgatan

Landsvägsgatan

Husargatan

Skansparken

Skanstorget

Brunnsgatan

Föreningsgatan

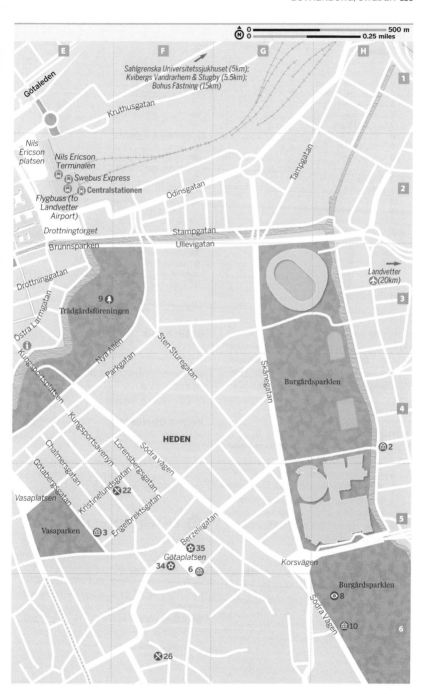

Sahlgrenska Universitetssjukhuset (5km);
Kvibergs Vandrarhem & Stugby (5.5km);
Bohus Fästning (15km)

0 500 m
0 0.25 miles

Götaleden

Kruthusgatan

Nils Ericson platsen

Nils Ericson Terminalen

Swebus Express

Centralstationen

Flygbuss (to Landvetter Airport)

Odinsgatan

Tampgatan

Drottningtorget

Stampgatan

Brunnsparken

Ullevigatan

Landvetter (20km)

Drottninggatan

Trädgårdsföreningen 9

Östra Larmgatan

Kungsportsplatsen

Nya Allén

Parkgatan

Sten Sturegatan

Skånegatan

Burgårdsparklen

Kungsportsavenyn

Lorensbergsgatan

Södra vägen

HEDEN

Chalmersgatan

Göteborgsgatan

Kristinelundsgatan 22

Engelbrektsgatan

Vasaplatsen

Vasaparken 3

Berzeliigatan

35

Götaplatsen

34 6

Korsvägen

Burgårdsparklen

8

Södra vägen

10

26

Göteborg (Gothenburg)

district is good for quirky, small boutiques. At the other end of the scale are designer boutiques and national chains on 'the Avenyn' boulevard. For one-stop shopping head to central Nordiska Kompaniet, a hub of Swedish and international brands.

Nordiska Kompaniet
Department Store

(www.nk.se; Östra Hamngatan 42; ⊙10am-8pm, to 6pm Sat, 11am-5pm Sun; ᪥3,4, 5, 7, 10 Kungsportsplatsen) A local institution since 1971, the four floors of this venerable department store host the likes of Tiger, RedGreen, NK Boutique and Mayla amid its a mix of Swedish and international designers.

Bengans Skivor & Café
Music

(☎031-14 33 00; www.bengans.se; Stigbergstorget 1; ⊙10am-6.30pm Mon-Fri, 10am-4pm Sat, noon-4pm Sun; ᪥3, 9,11 Stigbergstorget) Gothenburg's mightiest music store is set in an old cinema, complete with retro signage and an indie-cool cafe.

Butik Kubik
Clothing

(www.butikkubik.se; Tredje Långgatan 8; ⊙noon-8pm Tue-Fri, to 6pm Sat; ᪥1, 6 Prinsgatan) Run by two young designers, this basement shop is a great place to check out local, bright, flowery threads.

Velour by Nostalgi
Clothing

(www.velour.se; Magasinsgatan 19; ⊙11am-6.30pm Mon-Fri, to 5pm Sat, noon-4pm Sun; ᪥1, 6, 9, 11 Domkyrkan) Revamped flagship store of local label. Stocks slick, stylish streetwear for guys and gals.

✪ ENTERTAINMENT

Widely recognised as Sweden's premier music city, Gothenburg has a lively music scene, as well as one of the country's top opera houses. Check out www.goteborg.com to find out what's on. There are also several annual music festivals, including **Way Out West** (www.wayoutwest.se), which takes place in August and draws fans from all over Europe.

Pustervik — Live Music, Theatre

(www.pusterviksbaren.se; Järntorgsgatan 12; 🚊1, 3, 5, 9, 11 Järntorget) Culture vultures and party people pack this hybrid venue, with its heaving downstairs bar and upstairs club and stage. Gigs range from independent theatre and live music (anything from emerging singer-songwriters to Neneh Cherry) to regular club nights spanning hip-hop, soul and rock.

Göteborgs Konserthuset — Classical Music

(Concert Hall; 📞031-726 53 10; www.gso.se; Götaplatsen; tickets 100-360kr; ⊘closed summer) Home to the local symphony orchestra, with top international guests and some sterling performances.

GöteborgsOperan — Opera

(📞031-13 13 00; www.opera.se; Christina Nilssons Gata; tickets 100-850kr; 🚊5, 10 Lilla Bommen) Designed by architect Jan Izikowitz, the opera house is a striking contemporary glass building with a sloped roof overlooking Lilla Bommen harbour. Performances include classics such as *Phantom of the Opera* as well as contemporary dance by up-and-coming artists.

Göteborgs Stadsteatern — Theatre

(📞031-708 71 00; www.stadsteatern.goteborg.se; Götaplatsen; tickets from 110kr) Stages theatre productions in Swedish.

EATING

Gothenburg's chefs are at the cutting edge of Sweden's Slow Food movement, and the city boasts top-notch restaurants. Happily, there are also more casual options for trying old-fashioned *husmanskost* (home cooking) and a good range of vegan and vegetarian options. Cool cafes, cheap ethnic gems and foodie favourites abound in Vasastan, Haga and Linné districts.

Saluhall Briggen — Market €

(www.saluhallbriggen.se; Nordhemsgatan 28; ⊘9am-6pm Mon-Fri, to 3pm Sat; 🚊1 Prinsgatan) This covered market will have you drooling over its bounty of fresh bread, cheeses, quiches, seafood and ethnic treats. It's particularly handy for the hostel district.

En Deli i Haga — Deli €

(Haga Nygata 15; combo plate weekday/weekend 105/135kr; ⊘8am-7pm Mon-Fri, 10am-5pm Sat & Sun; 🖊; 🚊1, 3, 5, 6, 9 Järntorget) En Deli dishes out great Mediterranean–style salads and meze, as well as good soup and sandwiches. Can't decide? Try some of everything, with the deli plate. An extra perk is the local beer and organic wine to accompany your meal.

Feskekörka — Market €

(www.feskekörka.se; Rosenlundsgatan; salads from 75kr; ⊘9am-5pm Tue-Thu, to 6pm Fri, 10am-3pm Sat; 🚊3, 5, 9, 11 Hagakyrkan) A market devoted to all things that come from the sea, the 'Fish Church' is heaven for those who appreciate slabs of gravadlax, heaped shrimp sandwiches and seafood-heavy salads. The outdoor picnic tables are the ideal place to munch on them.

Da Matteo — Cafe €

(www.damatteo.se; Vallgatan 5; sandwiches & salads 65-95kr; ⊘7.30am-6pm Mon-Fri, 8am-6pm Sat, 10am-5pm Sun; 🚊1, 3, 5, 6, 9 Domkyrkan) The perfect downtown lunch pit stop and a magnet for coffee lovers, this cafe serves wickedly fine espresso, mini *sfogliatelle* (Neapolitan pastries), sandwiches, pizza and great salads. There's a sun-soaked courtyard and a second branch on Viktoriapassagen.

Gourmet Korv — Hot Dogs €

(www.gourmetkorv.se; Södra Larmgatan; dogs 30-40kr, meals 67-95kr; ⊘10am-6pm Mon-Fri, to 4pm Sat, to 3pm Sun; 🚊2, 5, 6, 11 Grönsakstorget) A festival of sausages to sate the hungriest of the carnivorously inclined. Choose from the likes of currywurst, bierwurst and

Fortress Defence

Gamla Älvsborg fortress, standing guard over the river 3km downstream of the centre, is Gothenburg's oldest significant structure and was a key strategic point in the 17th-century territorial wars. The Swedes founded Gothenburg in 1621 to be free of the extortionate taxation rates imposed on their ships by the Danes.

Fearful of Danish attack, the Swedes employed Dutch experts to construct a defensive canal system in the centre. The workers lived in what is now the revitalised Haga area: around a fifth of the original buildings are still standing. Most of Gothenburg's oldest wooden buildings went up in smoke long ago – the city was devastated by no fewer than nine major fires between 1669 and 1804.

Once Sweden had annexed Skåne in 1658, Gothenburg expanded as a trading centre. Boom time came in the 18th century, when merchants such as the Swedish East India Company made huge amounts of wealth from trade with the Far East, their profits responsible for numerous grand houses that are still standing.

Gothenburg was sustained largely by the shipbuilding industry until it went belly up in the 1980s. These days, the lifeblood of Scandinavia's busiest port is heavy industry (Volvo manufacturing in particular) and commerce.

Gamla Älvsborg fortress
GVICTORIA/SHUTTERSTOCK ©

the immensely satisfying, cheese-squirting *käsekrainer* and have it in a bun or with a full spread of salad and mash.

Moon Thai Kitchen Thai €€

(www.moonthai.se; Kristinelundsgatan 9; mains 139-189kr; ⊘11am-11pm Mon-Fri, noon-11pm Sat & Sun; 🚊4, 5, 7, 10 Göteborg Valand) The owners have opted for a 'Thailand' theme and decided to run with it a few miles, hence the kaleidoscopic whirl of tuktuks, flowers and bamboo everything. Luckily, the dishes are authentic, the whimsical menu features such favourites as *som tum* (spicy papaya salad) and the fiery prawn red curry will make you weep with pleasure and gratitude.

Restaurant 2112 Burgers €€

(📞031-787 58 12; Magasinsgatan; burgers 189kr; ⊘4pm-1am, from 2pm Sat; 🚊1, 3, 5, 6, 9 Domkyrkan) Appealing to refined rockers and metalheads, this upmarket joint serves only burgers and beer. But what burgers! These masterpieces range from the superlative Smoke on the Water with its signature Jack Daniels glaze to the fiery Hell Awaits Burger, featuring habanero dressing. The hungriest of diners will meet their match in the 666g monster Number of the Beast.

Thörnströms Kök Scandinavian €€€

(📞031-16 20 66; www.thornstromskok.com; Teknologgatan 3; mains 325-355kr, 4-course menu 675kr; ⊘6pm-1am Mon-Sat; 🛜; 🚊7 Kapellplatsen) Specialising in modern Scandinavian cuisine, owner-chef Håkan shows you how he earned that Michelin star through creative use of local, seasonal ingredients and flawless presentation. Feast on the likes of rabbit with pistachios, pickled carrots and seaweed; don't miss the milk-chocolate pudding with goat's-cheese ice cream. A la carte dishes are available if multicourses overwhelm you.

Smaka Swedish €€€

(📞031-13 22 47; www.smaka.se; Vasaplatsen 3; mains 175-285kr; ⊘5-11pm; 🛜; 🚊1 Vasaplatsen) For top-notch Swedish *husmanskost,*

like the speciality meatballs with mashed potato and lingonberries, it's hard to do better than this smart yet down-to-earth restaurant-bar. Mod–Swedish options might include hake with suckling pig cheek or salmon tartar with pickled pear.

Magnus & Magnus Modern European €€€

(☑031-13 30 00; www.magnusmagnus.se; Magasinsgatan 8; 4-/6-course menu 495/745kr; ☺from 6pm Mon-Sat; ☷1, 2, 5, 6, 9 Domkyrkan) Ever-fashionable Magnus & Magnus serves inspired and beautifully presented modern European dishes in an appropriately chic setting. It's an unpretentious place in spite of its popularity, with pleasantly down-to-earth staff. The menu tantalises with its lists of ingredients (pork belly, king crab, melon, feta cheese), and the courtyard draws Gothenburg's hipsters in summer.

Koka Swedish €€€

(☑031-701 79 79; www.restaurangkoka. se; Viktoriagatan 12C; 3-/5-/7-course meals 480/680/880kr; ☺from 6pm Wed-Sat; ☷1,

2, 3, 7, 10 Vasaplatsen) Stylish Koka is distinguished by its smart, contemporary decor – blond wood, clean lines, mood lighting – and a dedication to conjuring up inspired dishes from the seasonal ingredients of Sweden's west coast. Brace yourself for the likes of mackerel with gooseberries, pork with blackcurrant and chervil ice cream.

🔘 DRINKING & NIGHTLIFE

While Kungsportsavenyn brims with beer-downing tourists and after-work locals, there are some savvier options – in summer, seek out a perch on a sun-soaked terrace and watch the street life go by.

Clubs have minimum-age limits ranging from 18 to 25, and many have a cover charge on popular nights.

Barn Bar

(www.thebarn.se; Kyrkogatan 11; ☺5pm-late Mon-Sat, from 2pm Sun; ☂; ☷1 Domkyrkan) As the name suggests, this bar is all roughly hewn wood and copper taps, and the beer/wine selection is guaranteed to get

Trädgårdsföreningen (p183)

Cafe Santo Domingo

you merry. Excellent cocktails – vouched for by local bartenders. The burgers make fantastic stomach-liners, too.

Notting Hill Pub
(www.nottinghill.se; Nordhemsgatan 19A; ⏱4pm-midnight Mon-Thu, to 2am Fri & Sat; 🚊1, 3, 5, 6, 9 Järntorget) This friendly and pretty local pub between the Haga and Linné districts – on a corner crammed with appealing drinking establishments – looks like it could've dropped in from the Cotswolds. There's a respectable selection of tipples, British and Swedish pub fare (meatballs, fish and chips) and football on the big screen.

Greta's Gay
(📞031-13 69 49; Drottninggatan 35; ⏱9pm-3am Fri & Sat; 🚊1, 3, 4, 5, 6, 9 Brunnsparken) Decked out with Greta Garbo memorabilia, Greta's is Gothenburg's dedicated gay club, featuring flamboyant Tiki parties, DJs and other kitsch-a-licious fun on Friday and Saturday nights.

Nefertiti Club
(www.nefertiti.se; Hvitfeldtsplatsen 6; admission 120-220kr; ⏱Hours vary; 🚊1, 5, 6, 9, 11 Grönsakstorget) Named rather incongruously after an Egyptian goddess, this Gothenburg institution is famous for its smooth live jazz and blues, as well as club nights spanning everything from techno and deep house to hip-hop and funk and a weekly soul night.

Cafe Santo Domingo Bar
(www.cafesantodomingo.se; Andra Långgatan 4; ⏱9am-late; 🚊1, 3, 5, 6, 9 Järntorget) Cafe–record shop serving mean espressos by day turns into a bar with a great array of beers and rowdy live-music sets by night.

ℹ INFORMATION

TOURIST INFORMATION
Cityguide Gothenburg (www.goteborg.com/apps) Info on the city's attractions, events and more, available as an Android and iPhone app. City map available offline.

Tourist Office (www.goteborg.com; Nils Eriksongatan; ⊙10am-8pm Mon-Fri, to 6pm Sat, noon-5pm Sun) Branch office inside the Nordstan shopping complex.

Tourist Office (⊿031-368 42 00; www.goteborg. com; Kungsportsplatsen 2; ⊙9.30am-8pm late Jun–mid-Aug, shorter hours rest of year) Central and busy; has a good selection of free brochures and maps.

RFSL Göteborg (⊿031-788 25 10; www.rfsl.se/ goteborg; Stora Badhusgatan 6; ⊙6-9pm Wed) Comprehensive information on the city's gay scene, events and more.

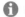 GETTING THERE & AWAY

AIR

Göteborg Landvetter Airport (www.swedavia. se/landvetter; ⊒Flygbuss) has daily flights to/from Stockholm Arlanda and Stockholm Bromma airports, as well as weekday services to Umeå and several weekly services to Borlänge, Falun, Visby and Sundsvall.

Direct European routes include Amsterdam (KLM), Brussels (SAS), Copenhagen (SAS and Norwegian), Frankfurt (Lufthansa), Berlin (Air Berlin), Helsinki (Norwegian and SAS), London (British Airways and Ryanair), Munich (Lufthansa), Oslo (Norwegian) and Paris (Air France and SAS).

BOAT

Gothenburg is a major ferry terminal, with several services to Denmark and Germany.

Stena Line (Denmark) (www.stenaline.se; Danmarksterminalen, Masthuggskajen; foot-passenger one-way from 200kr; ⊠3 Masthuggstorget)

Stena Line (Germany) (www.stenaline.se; Elof Lindälusgata 11; foot passenger one-way/return from 500kr; ⊠3 Jaegerdorffsplatsen)

For a special view of the region, jump on a boat for an unforgettable journey along the **Göta Canal** (www.gotakanal.se/en/). Starting in Gothenburg, you'll pass through Sweden's oldest lock at Lilla Edet, opened in 1607. From there the trip crosses the great lakes Vänern and Vättern through the rolling country of Östergötland and on to Stockholm.

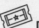 **Discount Cards**

The brilliant **Göteborg City Card** (www. goteborg.com/citycard; 24-/48-/72hr card adult 395/545/695kr, child 265/365/455kr) is particularly worthwhile if you're into intensive sightseeing: it gives you free access to most museums and Liseberg amusement park, discounted and free city tours, unlimited travel on public transport and free parking in a city with infamously dedicated traffic wardens. The card is available at tourist offices, hotels, Pressbyrån newsstands and online.

The **Göteborgspaketet** (http://butik. goteborg.com/en/package; adult from 635kr) is an accommodation-and-entertainment package offered at various hotels, with prices starting at 635kr per person per night in a double room. It includes the Göteborg City Card for the number of nights you stay; book online in advance.

BUS

Västtrafik (⊿0771-41 43 00; www.vasttrafik. se) and **Hallandstrafiken** (⊿0771-33 10 30; www.hlt.se) provide regional transport links. If you're planning to spend some time exploring the southwest counties, a monthly pass or a *sommarkort* offers cheaper travel in the peak summer period (from late June to mid-August).

The bus station, **Nils Ericson Terminalen**, is next to the train station and has excellent facilities including luggage lockers (medium/large up to 24 hours 70/90kr). There's a Västtrafik information booth here, providing information and selling tickets for all city and regional public transport within the Gothenburg, Bohuslän and Västergötland area.

Swebus (⊿0771-21 82 18; www.swebusexpress.com) operates frequent buses to most major towns and cities; non-refundable advance tickets work out considerably cheaper than on-the-spot purchases. Swebus services include:

Day Trip to Marstrand

A quick and rewarding day trip from Gothenburg, Marstrand is a well-known summer retreat, and has been since King Oscar II and co started taking the waters here in the 1880s. Before that, the island enjoyed fame as the herring capital of Europe, and (though the herring come and go) its seafood is still a major draw.

Solitude-seekers beware: dozens of visitors shuffle off and on the ferry linking the mainland to Marstrand island every 15 minutes. But it's easy to ditch the crowds if you follow signs to the nature trail (*'naturstig'*), which leads around the rocky edges to the far side of the island for epic views and secluded sunbathing nooks.

Carlstens Fästning (www.carlsten.se; adult/child 95/50kr; ⊙11am-3pm Apr-May, 11am-5pm Jun & Aug, 10.30am-6.30pm Jul, 11am-3pm Sat & Sun Sep-Oct; 🚗; 🛳Marstrand) fortress was built in the 1660s after the Swedish takeover of Marstrand and Bohuslän and appears to loom over the town. Marstrand's ice-free port was key to trade, so King Karl X Gustav built the fortress to defend it. The port continued to be fought over for decades. Carlstens has also been a prison, known for especially brutal conditions. Admission includes a guided tour. It's worth walking up even if you don't go in: the views of the archipelago are stunning.

Carlstens Fästning

○ Stockholm (from 159kr, 6½ to seven hours, four to five daily)

○ Halmstad (from 109kr, 1¾ hours, five to seven daily)

○ Helsingborg (from 139kr, 2¾ hours, five to eight daily)

○ Copenhagen (from 239kr, 4¾ hours, four daily)

○ Malmö (from 119kr, 3½ to four hours, seven to nine daily)

○ Oslo (from 229kr, 3½ hours, five to 10 daily)

CAR & MOTORCYCLE

The E6 motorway runs north–south from Oslo to Malmö just east of the city centre. There's also a complex junction where the E20 motorway diverges east for Stockholm.

International car-hire companies have desks at Göteborg Landvetter Airport and near the central train/bus stations.

Avis (www.avisworld.com)

Europcar (www.europcar.com)

Hertz (www.hertz-europe.com)

TRAIN

All trains arrive at and depart from Centralstationen, Sweden's oldest railway station and a heritage-listed building. The main railway lines in the west connect Gothenburg to Karlstad, Stockholm, Malmö and Oslo. In the east, the main line runs from Stockholm via Norrköping and Linköping to Malmö. Book tickets online via **Sveriges Järnväg** (SJ; www.sj.se) or purchase from ticket booths at the station.

Left Luggage Luggage lockers (medium/large up to 24 hours 70/90kr) are available at Centralstationen.

GETTING AROUND

BICYCLE

Cyclists should ask at the tourist office for the free map *Cykelkarta Göteborg*, covering the best routes.

Styr & Ställ (www.goteborgbikes.se; per season 75kr) is Gothenburg's handy city-bike system. It involves buying a 'season pass' which then gives

Liseberg (p183)

you unlimited access to bicycles stationed across the city. With the pass, all journeys under half an hour are free, making this ideal for quick trips. (There's a small fee for longer journeys.) You can also download directly onto your smartphone the app allbikesnow.com, which has a city map showing all the bike locales, plus how many bikes are free at any given time.

Cykelkungen (☎031-18 43 00; www. cykelkungen.se; Chalmersgatan 19; per day/wk 200/700kr; ☺10am-6pm Mon-Fri) Reliable spot for longer-term bike hire.

PUBLIC TRANSPORT

Buses, trams and ferries run by Västtrafik (p191) make up the city's public-transport system; there are Västtrafik information booths selling tickets and giving out timetables inside Nils Ericson Terminalen, in front of the train station on Drottningtorget and at Brunnsparken.

The most convenient way to travel around Gothenburg is by tram. Colour-coded lines, numbered 1 to 13, converge near Brunnsparken (a block from the train station). Trams run every few minutes between 5am and midnight; some lines run a reduced service after midnight on Friday and Saturday.

A city **transport ticket** costs 29/22kr per adult/child. One- and three-day **travel cards** (90/180kr, from Västtrafik information booths, 7-Eleven minimarkets or Pressbyrån newsagencies) can work out much cheaper. Holders of the **Göteborg City Card** travel free.

Västtrafik also has a handy app, Västtrafik To Go, which allows you to buy tickets on your phone.

TAXI

Taxi Göteborg (☎031-65 00 00; www.taxigoteborg.se) One of the larger taxi companies.

Taxis can be picked up outside Centralstationen, at Kungsportsplatsen and on Kungsportsavenyn.

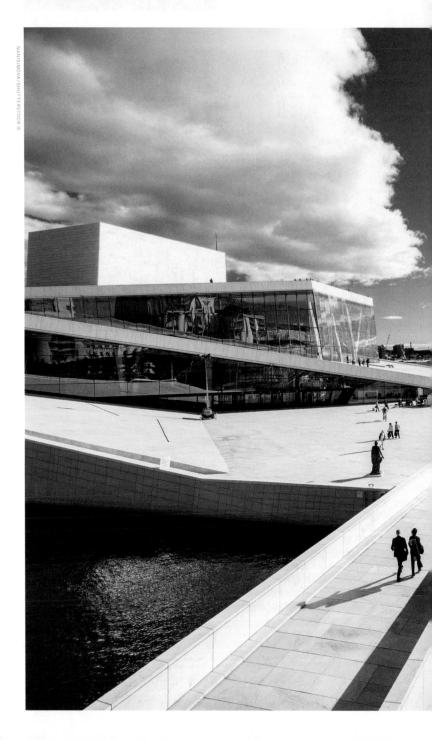

OSLO, NORWAY

Oslo, Norway at a Glance...

Surrounded by mountains and the sea, this compact, cultured, and fun city is Europe's fastest-growing capital with a palpable sense of reinvention. Oslo is also home to world-class museums and galleries to rival anywhere else on the European art trail. But even here Mother Nature has managed to make her mark, and Oslo is fringed with forests, hills and lakes awash with opportunities for hiking, cycling, skiing and boating. Add to this mix a thriving cafe and bar culture, top-notch restaurants and nightlife options ranging from opera to indie rock, and the result is a thoroughly intoxicating place.

Two Days in Oslo

Begin at the **Nasjonalgalleriet** (p202), explore **Akershus Fortress** (p202), then the museums of **Bygdøy (p198)**. Finish your evening in Aker Brygge. On day two, poke around the **Ibsen Museet** (p202), wander **Slottsparken** (p203), take a **Royal Palace tour** (p203) and take in the **Astrup Fearnley Museet** (p203) and the **Tjuvholmen Sculpture Park** (p203). Have dinner and cocktails at Tjuvholmen's **Vingen** (p209).

Four Days in Oslo

Walk the roof of **Oslo Opera House** (p203), then head inside for a tour. A quick tram ride from Central Station will take you to **Frogner** (p206) where you can explore **Frognerparken** (p206) and **Vigelandsanlegget** (p206). Finish your day with Neo Nordic cuisine at **Sentralen Restaurant** (p208).

On your fourth day, climb the **Holmenkollen Ski Jump** (p206) and enjoy the panoramic views. Then head back to hip Grünerløkka for potato bread hot dogs at **Syverkiosken** (p209) followed by a short 10-minute walk to **Torggata Botaniske** (p211) for cocktails.

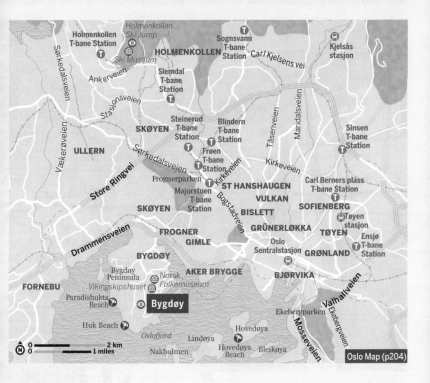

Oslo Map (p204)

Arriving in Oslo

Oslo Gardermoen International Airport The city's main airport, 50km north of the city, is serviced by the high-speed train service **Flytoget** (www.flytoget.no) as well as standard NSB intercity and local trains. The bus service **Flybussen** (www.flybussen.no) also runs directly to the city.

Oslo Sentral All trains from Sweden arrive and depart from here and it's serviced by T-bane, trams, buses and taxis.

Where to Stay

Aker Brygge, the city centre, Opera House, Bjørvika and Bygdøy are the most popular choices – they're close to everything with plenty of attractions, restaurants, cafes etc. Frogner and Western Oslo are serene and close to the Slottsparken and city, while Grüner-løkka and Vulkan are fantastic choices for experiencing local life.

Polarship Fram Museum

History on Bygdøy

Best accessed by ferry, pretty, residential and rural-feeling Bygdøy is home to the city's most fascinating, quintessentially Norwegian museums, featuring Vikings, traditional architecture and modern-day explorers.

Great For...

Don't Miss

The most impressive and ostentatious of the three Viking ships is the *Oseberg*.

Vikingskipshuset

Around 1100 years ago, Vikings dragged two **longships** (Viking Ship Museum; ☎22 13 52 80; www.khm.uio.no; Huk Aveny 35; adult/child 80kr/ free; ⏱9am-6pm May-Sep, 10am-4pm Oct-Apr; 🚌91) from the shoreline and used them as the centrepiece for grand ceremonial burials, most likely for important chieftains or nobles. Along with the ships, they buried many items for the afterlife: food, drink, jewellery, furniture, carriages, weapons and even a few dogs and servants for companionship. Discovered in Oslofjord in the late 19th century, the ships have been beautifully restored and offer an evocative, emotive insight into the Viking world.

Polarship Fram Museum

A **museum** (Frammuseet; ☎23 28 29 50; www. frammuseum.no; Bygdøynesveien 36; adult/child

Norsk Folkemuseum

TRABANTOS/SHUTTERSTOCK ©

Vikingskipshuset Langviksveien Huk Aveny Fredriksborgveien Bygdøynesveien **Polarship Fram Museum** Frognerstranda Bygdøynes Ferry Terminal Hovedøya

❶ Need to Know

Ferry 91 makes the 15-minute run to Bygdøy from Rådhusbrygge 3.

✕ Take a Break

Before catching the ferry to Bygdøy, stop by Pipervika (p209) for a fresh-shrimp baguette.

★ Top Tip

Pre-buy your ferry ticket – and buying a return ticket is far cheaper.

100/40kr, with Oslo Pass free; ⊙9am-6pm Jun-Aug, 10am-5pm May & Sep, to 4pm Oct-May; ⛴91) dedicated to one of the most enduring symbols of early polar exploration, the 39m schooner Fram (meaning 'Forward'). You can wander the decks, peek inside the cramped bunk rooms and imagine life at sea and among the polar ice. There are detailed exhibits complete with maps, pictures and artefacts of various expeditions, from Nansen's attempt to ski across the North Pole to Amundsen's discovery of the Northwest Passage.

Kon-Tiki Museum

A favourite among children, this worthwhile **museum** (☑23 08 67 67; www.kon-tiki.no; Bygdøynesveien 36; adult/child 100/40kr, with Oslo Pass free; ⊙9.30am-6pm Jun-Aug, 10am-5pm Mar-May, Sep & Oct, 10am-4pm Nov-Feb; ⛴91) is dedicated to the balsa raft Kon-Tiki, which Norwegian

explorer Thor Heyerdahl sailed from Peru to Polynesia in 1947. The museum also displays the totora-reed boat Ra II, built by Aymara people on the Bolivian island of Suriqui in Lake Titicaca. Heyerdahl used it to cross the Atlantic in 1970.

Norsk Folkemuseum

Norway's largest open-air **museum** (Norwegian Folk Museum; ☑22 12 37 00; www. norskfolkemuseum.no; Museumsveien 10; adult/ child 130/40kr, with Oslo Pass free; ⊙10am-6pm mid-May–mid-Sep, 11am-3pm Mon-Fri, 11am-4pm Sat & Sun mid-Sep–mid-May; ⛴91) and one of Oslo's most popular attractions is this folk museum. The museum includes more than 140 buildings, mostly from the 17th and 18th centuries, gathered from around the country, rebuilt and organised according to region of origin. Paths wind past old barns, elevated *stabbur* (raised storehouses) and rough-timbered farmhouses with sod roofs sprouting wildflowers. Little people will be entertained by the numerous farm animals, horse and cart rides, and other activities.

Oslo Walking Tour

Once a heavily industrialised port area, Oslo's waterfront has been totally transformed over the last 20 years and is still in the process of rapid change. It makes for a heady mix of the new and the historic, and the industrial and the natural.

Start Ekebergparken
Distance 4.5km
Duration 2.5 hours

Pilestredet

Wergelandsveien

Parkveien

Holbergs gate

Frederiks gate

Pilestredet

Kristian IV's gate

Slottsparken

Karl Johans gate

Henrik Ibsens gate

Nationaltheatret T-bane Station

Stortinget T-bane Station

Munkedamsveien

Dronning Mauds gate

Rådhusplassen

AKER BRYGGE — 5

Kontraskjæret

Frognerstranda

Stranden

Pipervika

Akershus Festning

Tjuvholmen allé

Akershusstranda

6

Kirkegata

Vingen

FINISH

Hovedøya

4

5 At charming **Pipervika** (p209) you can eat this morning's catch straight from the boats.

4 Akerhusstranda makes for a nice waterfront stroll, with the fortress looming above.

6 The city's most-visited stretch of waterfront gives way to the serene sails of Renzo Piano's **Astrup Fearnley Museet** (p203).

Classic Photo Out over Oslofjord from the roof of the Opera House

3 Walk on the luminous marble roof of Oslo's most iconic building, the **Oslo Opera House** (p203) for stunning 360-degree views.

2 Heading down towards the city, fascinating **Bjørvika**, the former port, lies before you.

0 — 400 m
0 — 0.2 miles

Vår Frelsers Gravlund

Oslo Sentralstasjon

Prinsens gate
Tollbugata
Rådhusgata
Schweigaards gate

BARCODE

Dronning Eufemias gate

Trelastgata

Langkaia

Operagata

BJØRVIKA

Bjørvika

Operatunnelen

Oslo gate

Sørengkaia

SØRENGA

Mosseveien

Kongsveien

Take a Break...
Try the airy terrace of historic **Ekeberg Restaurant** (Kongsveien 15; www.ekebergrestauranten.com) or the prime waterfront stools at Vingen (p209) at each end of the walk.

Ekeberg Restaurant

Ekebergparken

1
START

1 For some of Oslo's best views, begin your walk at **Ekebergparken** (Kongsveien 23; https://ekebergparken.com), rich in contemporary art.

◉ SIGHTS

◉ City Centre

Nasjonalgalleriet Gallery

(National Gallery; ☎21 98 20 00; www.nasjonal
museet.no; Universitetsgata 13; adult/child 100kr/
free, Thu free; ⊙10am-6pm Tue, Wed & Fri, to
7pm Thu, 11am-5pm Sat & Sun; ⊕Tullinløkka)
The Gallery houses the nation's largest
collection of traditional and Modern art, and
many of Edvard Munch's best-known cre-
ations are on permanent display, including
his most famous work, *The Scream*.

There's also an impressive collection of
European art, with works by Gauguin, Clau-
del, Picasso and El Greco, plus Impression-
ists such as Manet, Degas, Renoir, Matisse,
Cézanne and Monet. Nineteenth-century
Norwegian artists have a strong showing,
too, including key figures such as JC Dahl
and Christian Krohg.

The gallery is set to relocate in 2020.

Ibsen Museet Museum

(Ibsen Museum; ☎40 02 36 30; www.
ibsenmuseet.no; Henrik Ibsens Gate 26; adult/
child 115/30kr; ⊙11am-6pm May-Sep, to 4pm

Oct-Apr, guided tours hourly; ⊕Slottsparken)
While downstairs houses a small and
rather idiosyncratic museum, it's Ibsen's
former apartment, which you'll need to
join a tour to see, that is unmissable. This
was the playwright's last residence and
his study remains exactly as he left it,
as does the bedroom where he uttered
his famously enigmatic last words 'Tvert
imot!' ('To the contrary!'), before dying on
23 May 1906.

Akershus Festning Fortress

(Akershus Fortress; ⊙6am-9pm; ⊕Christiania
Square) **FREE** When Oslo was named capital
of Norway in 1299, King Håkon V ordered
the construction of Akershus, strategically
located on the eastern side of the harbour,
to protect the city from external threats.
It has, over the centuries, been extended
and modified, and had its defences beefed
up a number of times. Still dominating the
Oslo harbourfront, the sprawling complex
consists of a **medieval castle** (Akershus Cas-
tle; ☎22 41 25 21; www.nasjonalefestningsverk.
no; Kongens gate; adult/child 60/30kr, with Oslo
Pass free; ⊙11am-4pm Mon-Sat, noon-5pm Sun;

Akershus Festning

Christiania Square), fortress and assorted other buildings, including still-active military installations.

Royal Palace Palace

(Det Kongelige Slott; ☎81 53 31 33; www.royal court.no; Slottsparken 1; palace tours adult/child 135/105kr, with Queen Sonja Art Stable 200kr; ⊙guided tours in English noon, 2pm, 2.20pm & 4pm Jun–mid-Aug; ☒Slottsparken) The Norwegian royal family's seat of residence emerges from the wood-like **Slottsparken** (⊙24hr; ☒Slottsparken) **FREE**, a relatively modest, pale buttercup neoclassical pile. Built for the Swedish (in fact, French) king Karl Johan, the palace was never continuously occupied before King Haakon VII and Queen Maud were installed in 1905.

◎ Opera House & Bjørvika

Oslo Opera House Architecture

(Den Norske Opera & Ballett; ☎21 42 21 21; www. operaen.no; Kirsten Flagstads plass 1; foyer free; ⊙foyer 10am-9pm Mon-Fri, 11am-9pm Sat, noon-9pm Sun; ⓣSentralstasjonen) The centrepiece of the city's rapidly developing waterfront is the magnificent Opera House, considered one of the most iconic modern buildings of Scandinavia. Designed by Oslo–based architectural firm Snøhetta and costing around €500 million to build, the Opera House opened in 2008, and resembles a glacier floating in the waters of the Oslofjord. Its design is a thoughtful meditation on the notion of monumentality, the dignity of cultural production, Norway's unique place in the world and the conversation between public life and personal experience.

◎ Aker Brygge & Bygdøy

Astrup Fearnley Museet Gallery

(Astrup Fearnley Museum; ☎22 93 60 60; www. afmuseet.no; Strandpromenaden 2; adult/child 120kr/free; ⊙noon-5pm Tue, Wed & Fri, to 7pm Thu, 11am-5pm Sat & Sun; ☒Aker Brygge) Designed by Renzo Piano, this private contemporary art museum is housed in a wonderful building of silvered wood, with a sail-like glass roof that feels both maritime

Oslo Pass

Oslo Pass (www.visitoslo.com/en/activities-and-attractions/oslo-pass; 1/2/3 days adult 395/595/745kr, child 210/295/370kr), sold at the tourist office, is a good way of cutting transport and ticket costs around the city. The majority of the city's museums are free with the pass, as is public transport within the city limits (barring late-night buses). Other perks include restaurant and tour discounts.

If you're planning to visit just the city-centre museums and galleries, it's worth checking which on your list are free before buying a pass.

RAILELECTROPOWER/GETTY IMAGES ©

and at one with the Oslofjord landscape. While the museum's original collecting brief was conceptual American work from the '80s (with artists such as Jeff Koons, Tom Sachs, Cindy Sherman and Richard Prince well represented), it has in recent times broadened beyond that, with, for example, a room dedicated to Sigmar Polke and Anselm Keifer.

Tjuvholmen
Sculpture Park Sculpture

(http://afmuseet.no/en/om-museet/skulpturparken; Tjuvholmen; ⊙24hr; ☒Aker Brygge) **FREE** Like the Astrup Fearnley Museet that it surrounds, this sculpture park was designed by Renzo Piano and is also dedicated to international contemporary art. Don't miss Louise Bourgeois' magnificent and rather cheeky *Eyes* (1997),

Oslo

A

Vigeland Park
Frognerparken

⊕5

Professor
Dahls gate

⊕16

Kirkeveien

Nordraaks gate

Tidemands gate

Eckersbergs gate

Odins gate

Frognerveien

Løvenskiolds gate

Nobels gate

Thomas Heftyes gate

Gimleveien

Bygdøy allé

FROGNER

Tostrups gate

Gimle terrasse

GIMLE

Sophus Lies gate

Thomas Heftyes gate

Frederik Stangs gate

Gabels gate

Niels Juels gate

Drammensveien

Svoldergata

Frognerstranda

B

Kirkeveien

Maries gate

Middelthuns gate

Neubergata

Majorstuveien

Jacob Aalls gate

Bogstadveien

Ole Vigs gate

Fearnleys gate

Industrigata

Professor Dahls gate

Daas gate

Eilert Sundts gate

Briskebyveien

President Harbitz' gate

Gyldenløves gate

Skovveien

Ridder volds gate

Meltzers gate

Colbjørnsens gate

Frognerveien

Bygdøy allé

Henrik Ibsens gate

Hydroparken

Drammensveien

Observatoriegata

Munkedamsveien

Filipstadveien

Cort Adelers gate

C

Schønings gate

Vibes gate

Roseborggata

Sporveisgata

Hegdehaugsveien

Uranienborgveien

Parkveien

Slottsparken

Uderhaugsveien

Josefines gate

Oscars gate

Wergelandsveien

Slottsparken

⊕13

⊕14

7. Juni Plass

🚉6

Nationaltheatret
T-bane Station

Dronning
Mauds gate

Munkedamsveien

**AKER
BRYGGE**

Filipstadveien

Sjøgata

Stranden

Pipervika

D **ST
HANSHAUGEN**

Stensparken

Pilestredet

Theereses gate

Eugenies gate

Wilhelms gate

Ullevålsveien

Colletts gate

Sofies gate

Bislettgata

BISLETT

Dovregata

Stensberggata

Welhavens gate

Holbergs gate

Edvard
Storms gate

Pilestredet

Frederiks gate

Kristian IV's gate

⊕9

Nationaltheatret
T-bane Station

Fridtjof
Nansens
plass

Eidsvolls
plass

⊕12

Rosenkrantz
gate

Nedre Vollgate

Rådhusplassen

🍴29

Kontraskjæret

Akershus Fortress
Information Centre

Akershusstranda

Kongens gate

Grønnegata

Pilestredet

SOLLIPLASS

Tjuvholmen allé

🏛3

32

⊕15

TJUVHOLMEN

Hovedøya

Bygdøynesveien

🏛7

🏛11

BYGDØY

Vikingskipshuset (1.2km)
Norsk Folkemuseum (1.4km)

1

2

3

4

5

6

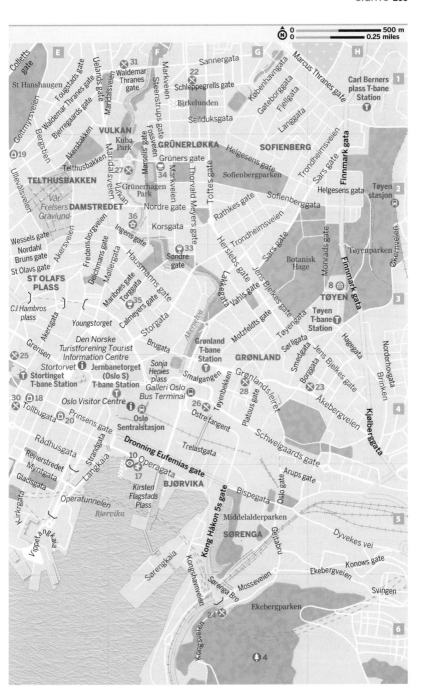

Oslo

Ugo Rondinone's totemic and enchanting *Moonrise. east. november* (2006) and Franz West's bright and tactile *Spalt* (2003). There are also works by Antony Gormley, Anish Kapoor, Ellsworth Kelly, and Peter Fischli and David Weiss. Along with the artwork there are canals and a small child-pleasing pebble beach.

◎ Frogner & Western Oslo

Vigelandsanlegget Park
(Vigeland Sculpture Park; www.vigeland. museum.no/no/vigelandsparken; Nobels gate 32; ⏰Tue-Sun noon-4pm; ⓣBorgen) The centrepiece of Frognerparken is an extraordinary open-air showcase of work by Norway's best-loved sculptor, Gustav Vigeland. Statistically one of the top tourist attractions in Norway, Vigeland Park is brimming with 212 granite and bronze Vigeland works. His highly charged oeuvre includes entwined lovers, tranquil elderly couples, bawling babies and contempt-ridden beggars. Speaking of

bawling babies, his most famous work here, *Sinnataggen* (*Angry Boy*), portrays a child in a mood of particular ill humour.

Frognerparken Park
(ⓣBorgen) Frognerparken attracts westside locals with its broad lawns, ponds, stream and rows of shady trees for picnics, strolling or lounging on the grass. It also contains Vigelandsanlegget, a sprawling sculpture-park-within-a-park. To get here, take tram 12 to Vigelandsparken from the city centre.

◎ Greater Oslo

Holmenkollen Ski Jump Mountain
(☎916 71 947; www.holmenkollen.com; adult/child 130/65kr, with Oslo Pass free; ⏰9am-8pm Jun-Aug, 10am-5pm May & Sep, 10am-4pm rest of year; ⓣHolmen) The Holmenkollen Ski Jump, perched on a hilltop overlooking Oslo, offers a panoramic view of the city and doubles as a concert venue. During Oslo's annual ski festival, held

in March, it draws the world's best ski jumpers. Even if you're not a daredevil ski jumper, the complex is well worth a visit thanks to its **ski museum** (Kongeveien 5; incl Holmenkollen Ski Jump adult/child 130/65kr, with Oslo Pass free; ☺9am-8pm Jun-Aug, 10am-5pm May & Sep, 10am-4pm rest of year; THolmen) and a couple of other attractions.

 ACTIVITIES

Avid skiers, hikers and sailors, Oslo residents will do just about anything to get outside. That's not too hard given that there are over 240 sq km of woodland, 40 islands and 343 lakes within the city limits. And you can jump on a train with your skis and be on the slopes in less than 30 minutes.

The **DNT office** (DNT, Norwegian Mountain Touring Club; www.turistforeningen.no; Storget 3, Oslo; ☺10am-5pm Mon-Wed & Fri, to 6pm Thu, to 3pm Sat; Jernbanetorget), which maintains several mountain huts in the Nordmarka region, can provide information and maps covering longer-distance hiking routes throughout Norway.

🔒 SHOPPING

Oslo's centre and its inner neighbourhoods have a great selection of small shops if you're not into the malls. The city centre's Kirkegaten, Nedre Slottsgate and Prinsens gate are home to a well-considered collection of Scandinavian and international fashion and homewares shops, with Frogner and St Hanshaugen also having some good upmarket choices. Grünerløkka is great for vintage and Scandinavian fashion too.

Norwegian
Rain Fashion & Accessories
(☎996 03 411; http://norwegianrain.com; Kirkegata 20; ☺10am-6pm Mon-Fri, to 5pm Sat; Nationaltheatret) Bergen comes to Oslo! This west coast design superstar creates

what might be the world's most covetable raincoats. This Oslo outpost stocks the complete range as well as creative director T-Michael's woollen suits, detachable collar shirts, leather shoes and bags, not to mention limited editions of Kings of Convenience LPs.

FWSS Fashion & Accessories
(Fall Winter Spring Summer; http://fallwinterspringsummer.com; Prinsens gate 22; ☺10am-7pm Mon-Fri, to 6pm Sat; Øvre Slottsgate) New flagship of this fast-growing Norwegian label, known for its easy basics as well as seasonal collections that combine Scandinavian simplicity with a pretty, playful edge.

Vestkanttorget
Flea Market Market
(Amaldus Nilsens plass; ☺10am-4pm Sat; TMajorstuen) If you're happy sifting through heaps of, well, junk in search of an elusive vintage band T-shirt or mid-century ceramic coffee pot, take a chance here. It's at the plaza that intersects Professor Dahls gate, a block east of Vigeland Park, and it's a more than pleasant way to pass a Saturday morning.

Gutta På Haugen Food & Drinks
(☎22 60 85 12; http://gutta.no/; Ullevålsveien 45; ☺8am-7pm; 37) For picnic or self-catering supplies, head to this well-stocked St Hanshaugen institution. There's a huge cheese selection with both Norwegian and European produce, a lovely array of local sausage and boxes of the must-try Norwegian flatbread. Its fresh produce is the best of the season and you can grab an excellent soft serve to go at its ice-cream van across the road.

⭐ ENTERTAINMENT

Oslo has a thriving live-music scene – it's said that the city hosts more than 5000 gigs a year. Its venues are spread across the city but are concentrated on Møllergata, in Vulkan, Grünerløkka and Grønland. World-class opera or ballet performances are held at the Oslo Opera

B&B in the City

Oslo has plenty of accommodation, including a growing number of small B&Bs and private rentals that offer more character than the chain hotels. Hotels are usually well run and comfortable, but tend towards the bland, and – yes, you guessed it – you'll pay a lot more for what you get compared with other countries. Most hotels have wi-fi access.

B&B Norway (www.bbnorway.com) Lists many of Norway's better-established B&Bs.

House (p203) Book ahead or try for the last-minute 100kr standing seats.

Blå Live Music, Dance
(www.blaaoslo.no; Brenneriveien 9c; ⏰1pm-4am; 🚌54) Blå is all things to everyone, with DJs (it happens to be the city's best spot for hip hop), live gigs and jazz. On Sundays there is a live big band that's been playing every afternoon for years. Or just come early for a drink at one of the pretty riverside tables.

✕ EATING

Oslo's food scene has come into its own in recent years, attracting curious culinary-minded travellers who've eaten their way round Copenhagen or Stockholm and are looking for new sensations. Dining out here can involve a Michelin-starred place, a hot-dog stand, peel-and-eat shrimp, a place doing innovative Neo Nordic small plates or a convincingly authentic Japanese, Italian, French, Indian or Mexican dish.

✕ City Centre

Sentralen Restaurant New Nordic €€
(📞22 33 33 22; www.sentralen.no; Øvre Slottsgate 3; small plates 85-195kr; ⏰11am-10pm Mon-Sat; 🚌Øvre Slottsgate) One of Oslo's best dining experiences is also its most relaxed. A large dining room with a bustling open kitchen, filled with old social club chairs and painted in tones of deep, earthy green, draws city workers, visitors and natural-wine-obsessed locals in equal measure. Small-plate dining makes it easy to sample across the appealing Neo Nordic menu.

Grand Café Norwegian €€
(📞23 21 20 18; www.grand.no; Karl Johans gate 31; mains 145-295kr; ⏰11am-11pm Mon-Fri, from noon Sat, noon-9pm Sun; 🚌Stortinget) At 11am sharp, Henrik Ibsen would leave his apartment and walk to Grand Café for a lunch of herring, beer and one shot of aquavit (alcoholic drink made from potatoes and caraway liquor). His table is still here. Don't worry, though, today you can take your pick from perfectly plated, elegantly sauced cod and mussels, spelt risotto with mushrooms, or cured lamb and potato.

✕ Opera House & Bjørvika

Maaemo New Nordic €€€
(📞22 17 99 69; https://maaemo.no; Schweigaards gate 15; menu 2600kr; ⏰6pm-midnight Wed & Thu, from noon Sat & Sun; 🚌Bussterminalen Grønland) This is not a meal to be taken lightly: firstly, you'll need to book many months in advance, and secondly, there will, for most of us, be the indenting of funds. But go if you can, not for the three Michelin–star accolades, but for Esben Holmboe Bang's 20 or so courses that are one of the world's most potent

culinary experiences and a sensual articulation of what it means to be Norwegian.

Aker Brygge & Bygdøy

Vingen New Nordic €€

(☑901 51 595; http://vingenbar.no; Strandpromenaden 2; mains 145-240kr; ☺10am-9pm Sun-Wed, to midnight Thu-Sat; ☐Aker Brygge) While honouring its role as Astrup Fearnley's (p203) cafe and a super-scenic pit stop, Vingen is so much more. Do drop in for excellent coffee, but also come for lunch or dinner with small, interesting menus subtly themed in homage to the museum's current temporary show. Nightfall brings cocktails, and sometimes DJs and dancing in the museum lobby and, in summer, on the waterfront terrace.

Pipervika Seafood €€

(www.pipervika.no; Rådhusbrygge 4; mains 175-250kr, shrimp per kg 130kr; ☺7am-11pm; ☐Aker brygge) If the weather is nice, nothing beats a shrimp lunch, with fresh shrimp on a baguette with mayonnaise and a spritz

of lemon eaten dockside. The revamped fisherman's coop still does takeaway peel-and-eat shrimp by the kilo, but you can now also relax with a sushi plate, oysters or a full seafood menu including fish burger on brioche or killer fish and chips.

Everything is prepared with daily bounty from the Oslofjord.

Grünerløkka & Vulkan

Syverkiosken Hot Dogs €

(☑967 08 699; Maridalsveien 45; hot dogs from 20kr; ☺9am-11.30pm Mon-Fri, from 11am Sat & Sun; ☐34) It might look like a hipster replica but this hole-in-the-wall *pølser* (hot dogs) place is absolutely authentic and one of the last of its kind in Oslo. Dogs can be had in a potato bread wrap in lieu of the usual roll, or with both, and there's a large range of old-school accompaniments beyond sauce and mustard.

Bass New Nordic €€

(☑482 41 489; http://bassoslo.no; Thorvald Meyers gate 26; dishes 70-175kr; ☺5pm-1am Tue-Sat, 3-8pm Sun; ☐Birkelunden) In what

Holmenkollen Ski Jump (p206)

Vestkanttorget Flea Market (p207)

could be yet another Grunerløkka corner cafe, you'll find one of the city's best small-plate dining options, served beneath vintage seascapes on classic Norwegian ceramics by jovial Løkka locals. Most dishes are what might be called contemporary Norwegian–meets-international – from fried chicken and potato pancakes to deep-sea cod in sorrel butter and death-by-chocolate cake.

Mathallen Oslo　　Food Hall €€
(www.mathallenoslo.no; Maridalsveien 17, Vulkan; ⊙8am-1am Tue-Fri, from 9.30am Sat & Sun; 🚌54) Down by the river this former industrial space is now a food court dedicated to showcasing the very best of Norwegian regional cuisine, as well as some excellent internationals. There are dozens of delis, cafes and miniature restaurants, and the place buzzes throughout the day and well into the evening.

🍷 DRINKING & NIGHTLIFE

The locals definitely don't seem to mind the high price of alcohol: Oslo has a ridiculously rich nightlife scene, with a huge range of bars and clubs, and most open until 3am or later on weekends. The compact nature of the city and its interconnecting inner neighbourhoods means bar-crawling is a joy, if expensive.

Tim Wendelboe　　Cafe
(📞400 04 062; www.timwendelboe.no; Grüners gate 1; ⊙8.30am-6pm Mon-Fri, 11am-5pm Sat & Sun; 🚌Schous plass) Tim Wendelboe is often credited with kickstarting the Scandinavian coffee revolution, and his eponymous cafe and roastery is both a local freelancers' hangout and an international coffee-fiend pilgrimage site. All the beans are, of course, self-sourced and hand-roasted (the roaster is part of the furniture), and yes, all coffees, from an

iced pour over to a regular cappuccino, are world-class.

Torggata Botaniske Cocktail Bar

(☑980 17 830; Torggata 17b; ☺5pm-1am Sun-Wed, to 2am Thu, 2pm-3am Fri & Sat; ⊞Brugata) The greenhouse effect done right, with a lush assortment of indoor plants (including a warm herb-growing area) as well as beautiful mid-century light fittings and chairs, chandeliers, and lots of marble and mirrors. If you're not already seduced by the decor, the drinks will do it, with a list that features the bar's own produce, fresh fruit and good-quality spirits.

Territoriet Wine Bar

(http://territoriet.no/; Markveien 58; ☺4pm-1am Mon-Fri, from noon Sat & Sun; ⊞Schous plass) A true neighbourhood wine bar that's also the city's most exciting. The grape-loving owners offer up more than 300 wines by the glass and do so without a list – talk to the staff about your preferences and – yes this is Norway – budget and they'll find something you'll adore. Beer and gin and tonic orders won't raise an eyebrow, we promise.

ℹ INFORMATION

Oslo Visitor Centre (☑81 53 05 55; www. visitoslo.com; Jernbanetorget 1; ☺9am-6pm; ⊞Sentralstasjon) is right beside the main train station. Sells transport tickets as well as the useful Oslo Pass (p203); publishes free guides to the city.

ℹ GETTING THERE & AWAY

AIR

Oslo Gardermoen International Airport (www.osl.no), the city's main airport, is 50km north of the city. It's used by international carriers, including Norwegian, SAS, Air France and British Airways. It's one of the world's

Arts & Architecture

Norway is one of Europe's cultural giants, producing world-class writers, composers and painters in numbers far out of proportion to its size. Norwegian artists and performers also excel in the realms of popular culture, from dark and compelling crime fiction to musical strands as diverse as jazz, electronica and heavy metal. And when it comes to architecture, Norway is as known for its stave churches as it is for the zany contemporary creations that are also something of a national speciality.

Akrobaten pedestrian bridge
MIROSLAVII0/SHUTTERSTOCK ©

most beautiful airports and has an amazing selection of places to eat and drink as well as Norwegian design shops alongside standard airport shopping.

Some budget flights, including those run by SAS Braathens, Widerøe and Ryanair, operate from Torp International Airport in Sandefjord, some 123km southwest of Oslo. Check carefully which airport your flight is going to. Torp has limited but good restaurants and bars, and extensive parking facilities.

BUS

Long-distance buses arrive and depart from the **Galleri Oslo Bus Terminal** (☑23 00 24 00; Schweigaards gate 8; ⓣSentralstasjon). The

train and bus stations are linked via a convenient overhead walkway for easy connections.

Nor-Way Bussekspress (81 54 44 44; www. nor-way.no) provides timetables and bookings. International services also depart from the bus terminal. Destinations include the following:

Bergen (522kr, 11 hours, three daily)

Stavanger (802kr, seven hours, usually one daily) Via Kristiansand.

TRAIN

All trains arrive and depart from **Oslo S** in the city centre. It has **reservation desks** (Jernbanetorget 1; 6.30am-11pm; Sentralstasjon) and an **information desk** (81 50 08 88; Jernbanetorget 1; Sentralstasjon) that provides details on routes and timetables throughout Norway.

There are frequent train services around Oslofjord (eg Drammen, Skien, Moss, Fredrikstad and Halden). Other major destinations:

Destination	Cost (kr)	Time	Frequency
Bergen via Voss	950	6½ to 7½ hours	four daily
Røros via Hamar	810	five hours	every two hours
Stavanger via Kristiansand	997	40 minutes	six daily
Trondheim via Hamar & Lillehammer	965	6½ to 7½ hours	six daily

ⓘ GETTING AROUND

All public transport is covered off by the Ruter (https://ruter.no/en/) ticketing system; schedules and route maps are available online or at **Trafikanten** (177; www.ruter.no; Jernbanetorget; 7am-8pm Mon-Fri, 8am-6pm Sat & Sun).

○ **Tram** Oslo's tram network is extensive and runs 24 hours.

○ **T-bane** The six-line Tunnelbanen underground system, better known as the T-bane, is faster and extends further from the city centre than most city buses or tram lines.

○ **Train** Suburban trains and services to the Oslofjord where the T-bane doesn't reach.

Astrup Fearnley Museet (p203)

VLADIMIR MUCIBABIC/SHUTTERSTOCK ©

Where to Stay

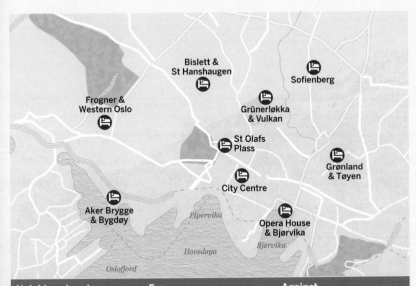

Neighbourhood	For	Against
Aker Brygge & Bygdøy	Scenic, central and close to all the major sites.	Can be a little souless and restaurants are expensive.
City Centre	Close to everything. A wide variety to choose from.	You may not be motivated to explore Oslo's interesting neighbourhoods.
Frogner & Western Oslo	Serene and close to the Slottsparken and city. Very good midrange places.	Restaurants can be expensive and there's little nightlife beyond wine bars.
Grünerløkka & Vulkan	Fantastic choice for experiencing local life, with everything on your doorstep and the city close by.	Not a lot of hotel choice. Can be a little too hipster for some.
Opera House & Bjørvika	Great views, close to everything and increasingly scenic.	Few choices beyond the chains. Not too much neighbourhood life.
Sofienberg, Grønland & Tøyen	Parkland, sights and very down to earth residential neighbourhoods. Close to city and Grünerløkka.	Not a lot of choice beyond private and apartment rentals.
St Olafs Plass, Bislett & St Hanshaugen	Pretty residential areas with an increasing number of places to eat and drink.	Few choices beyond private and apartment rentals. A little further from the main sights.

NORWAY'S FJORDS

Norway's Fjords at a Glance...

If you could visit only one region of Norway and hope to grasp the essence of the country's appeal, this would be our choice. Scoured and gouged by glaciers, western Norway's deep, sea-drowned valleys are covered by steep, rugged terrain. It's a landscape so profoundly beautiful that it's one of the most desirable destinations in the world.

Cool, cultured Bergen is among one of the world's most beautiful cities, with its streets of whitewashed timber cottages climbing steep hillsides from busy Vågen Harbour. It's also the ideal starting point for a journey into splendid Hardangerfjord, or the vast Sognefjorden network.

Two Days in Bergen

Begin with the old port of **Bryggen** (p218) , including **Bryggens Museum** (p222) and the **Torget fish market** (p227). Spend the afternoon exploring stellar art at **KODE** (p219), then dine at **Lysverket** (p227). On day two, take a morning **food tour** (www.bergen foodtours.com), then catch the cable car up **Mt Fløyen** (p223), and hike the trails nearby. For dinner, go traditional at **Pingvinen** (p227).

Four Days in Bergen

With more time, you can extend your sightseeing outside the city centre, with visits to the **Edvard Grieg Museum** (p222) on day three, and a memorable boat trip to the **Ole Bull Museum** (p222) on day four. Restaurants you won't want to miss include the extravagant neo-fjordic cuisine at **Lysverket** (p227), and perhaps for a refined treat, the laid back bistro **Colonialen Litteraturhuset** (p227).

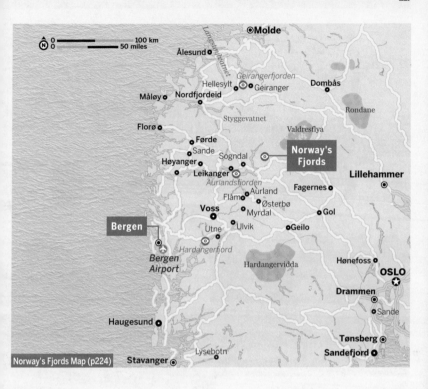

Arriving in Bergen

Bergen is 463km from Oslo via Rv7, and 210km from Stavanger via E39. Bergen Airport is at Flesland, about 18km southwest of the centre.

Where to Stay

Bergen has a reasonably good choice of hotels, but it's very popular and hosts regular conferences and events. It's *always* sensible to book before arriving in town, especially in summer and for festivals.

The tourist office has an accommodation-booking service both online and on-site.

A Day in Bergen

Surrounded by seven hills and seven fjords, Bergen is a beguiling city. Colourful houses creep up hillsides, ferry-boats flit around fjords, and excellent art museums provide a welcome detour.

Bryggen

Bryggen, Bergen's oldest quarter, runs along the eastern shore of Vågen Harbour (*bryggen* translates as 'wharf') in long, parallel and often leaning rows of gabled buildings. The wooden alleyways of Bryggen have become a haven for artists and craftspeople, and there are bijou shops and boutiques at every turn.

Great For...

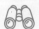 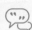

Don't Miss

A tour with Bryggen Guiding (p223) exploring the wharf's colourful history.

Bryggen

Bryggen ◉

Hanseatic
Museum 🏛

❶ Need to Know

Early morning is the best time to visit,
before the crowds arrive.

✕ Take a Break

Det Lille Kaffekompaniet (p229)
makes what could be Bergen's best
coffee.

★ Top Tip

Bergen has notoriously fickle weather –
always carry an umbrella.

Hanseatic Museum

This interesting **museum** (Hanseatisk
Museum & Schøtstuene; Finnegårdsgaten 1a &
Øvregaten 50; adult/child 160/60kr; ⊙9am-
6pm Jul-Aug, 11am-2pm Tue-Sat, to 4pm Sun
Sep-May) provides a window into the
world of Hanseatic traders. Housed in a
rough-timber building dating to 1704, it
starkly reveals the contrast between the
austere living and working conditions of
the merchant sailors and apprentices,
and the comfortable lifestyle of the trade
partners.

KODE

A catch-all umbrella for Bergen's art muse-
ums, **KODE** (☏53 00 97 04; www.kodebergen.
no; Rasmus Meyers allé; adult/child 100kr/free,
includes all 4 museums, valid 2 days) showcases
one of the largest art-and-design collec-
tions in Scandinavia. Each of the four build-
ings has its own focus: **KODE 1** (Nordahl
Bruns gate 9; ⊙11am-5pm) houses a national
silver collection and the renowned Singer
art collection; **KODE 2** (Rasmus Meyers allé
3) is for contemporary exhibitions; **KODE 3**
(Rasmus Meyers allé 7; ⊙10am-6pm) majors in
Edvard Munch; and **KODE 4** (Rasmus Meyers
allé 9; ⊙11am-5pm; 🖼) focuses on modern
art.

Stegastein viewpoint

Exploring the Fjords

A trip around Norway's fjord country has all the hallmarks of being Scandinavia's most beautiful journey. If you allow enough time and plan carefully, you'll leave wondering if this truly is God's own country.

Great For...

Don't Miss

The view from Preikestolen, high above Lysefjord.

Hardangerfjord

Running from the Atlantic to the steep wall of central Norway's Hardangervidda Plateau, Hardangerfjord is classic Norwegian fjord country. There are many beautiful corners, although our picks would take in Eidfjord, Ulvik and Utne, while Folgefonna National Park offers glacier walks and top-level hiking. It's also well-known for its many fruit farms, especially apples – Hardanger is sometimes known as the orchard of Norway.

You can easily explore Hardangerfjord from Bergen; www.hardangerfjord.com is a good resource.

Geirangerfjorden

Well, this is the big one: the world-famous, Unesco–listed, oft-photographed fjord

Folgefonna National Park

MARIUS DOBILAS/SHUTTERSTOCK ©

Geirangerfjorden ⊚

Florø ⊙

Valdresflya

⊚ **Aurlandsfiorden**

Voss ⊙

Fagernes

Bergen ⊙

⊚ **Hardangerfjord**

Bergen Airport ✈

ℹ Need to Know

Norway in a Nutshell (Fjord Tours; ☎81 56 82 22; www.norwaynutshell.com) makes it easy to see the best fjord scenery in a short space of time.

✕ Take a Break

Stalheim Hotel has arguably the best terrace view in Scandinavia.

★ Top Tip

Distances aren't great but travel can be slow due to serpentine roads.

that every visitor to Norway simply has to tick off their bucket list. And in purely scenic terms, it is, quite simply, one of the world's great natural features, a majestic combination of huge cliffs, tumbling waterfalls and deep blue water that's guaranteed to make a lasting imprint on your memory. A ride on the Geiranger–Hellesylt ferry is an essential part of your Norwegian adventure.

Aurlandsfjorden

Branching off the main thrust of Sogneforden, the deep, narrow Aurlandsfjorden runs for about 29km, but is barely 2km across at its widest point – which means it crams an awful lot of scenery into a relatively compact space. The view is best seen from the amazing Stegastein

viewpoint, which juts out from the hillside along the stunning Aurlandsfjellet road.

Aurland and Flåm both sit near the head of the fjord and are the best bases for accommodation and supplies.

Lysefjord

All along the 42km-long Lysefjord (Light Fjord), the granite rock glows with an ethereal light, and even on dull days it's offset by almost-luminous mist. This is the favourite fjord of many visitors, and there's no doubt that it has a captivating beauty. Take a cruise along the fjord, or the four-hour hike to the top of **Preikestolen**, the plunging cliff-face that's graced a million postcards from Norway.

Bergen

Among Scandinavian cities, Bergen has few peers. It's heart-breakingly pretty, dynamic, elegant and cultured, and there's a real buzz that courses through its compact town centre.

◉ SIGHTS

Making time just to wander Bergen's historic neighbourhoods is a must. Beyond Bryggen, the most picturesque are the steep streets climbing the hill behind the Fløibanen funicular station, Nordnes (the peninsula that runs northwest of the centre, including along the southern shore of the main harbour) and Sandviken (the area north of Håkonshallen). It's a maze of winding lanes and clapboard houses, perfect for a quiet wander.

Edvard Grieg Museum Museum
(Troldhaugen; ☎55 92 29 92; http://griegmuse um.no; Troldhaugvegen 65, Paradis-Bergen; adult/child 100kr/free; ☺9am-6pm May-Sep, 10am-4pm Oct-Apr) Composer Edvard Grieg and his wife Nina Hagerup spent summers at this charming Swiss–style wooden villa from 1885 until Grieg's death in 1907. Surrounded by fragrant, tumbling gardens and occupying a semi-rural setting – on a peninsula by coastal Nordåsvatnet lake, south of Bergen – it's a truly lovely place to visit.

Ole Bull Museum Museum
(Museet Lysøen; ☎56 30 90 77; www.lysoen.no; adult/child incl guided tour 60/30kr; ☺11am-4pm mid-May–Aug, Sun only Sep) This beautiful estate was built in 1873 as the summer residence of Norway's first musical superstar, violinist Ole Bull. Languishing on its own private island, it's a fairy-tale concoction of turrets, onion domes, columns and marble inspired by Moorish architecture. Of particular note is the soaring pine music hall: hard not to imagine Bull practising his concertos in here.

Bryggens Museum Museum
(☎55 30 80 30; www.bymuseet.no; Dreggsall-menning 3; adult/child 80kr/free; ☺10am-4pm mid-May–Aug, shorter hours rest of year) This archaeological museum was built on the site of Bergen's first settlement, and the 800-year-old foundations unearthed during its construction have been incorporated into

Edvard Grieg Museum

GOGA812E/SHUTTERSTOCK ©

the exhibits, which include medieval tools, pottery, skulls and runes. The permanent exhibition documenting Bergen circa 1300 is particularly fascinating.

Bergen Kunsthall
Gallery

(📞940 15 050; www.kunsthall.no; Rasmus Meyers allé 5; adult/child 50kr/free, from 5pm Thu free; ⏲11am-5pm Tue-Sun, to 8pm Thu) Bergen's major contemporary-art institution hosts significant exhibitions of international and Norwegian artists, often with a single artist's work utilising the entire space. The cleanly glamorous 1930s architecture is worth a look in itself. The attached venue and bar, Landmark (p228), also hosts video and electronic art, concerts, film, performances and lectures.

🟢 ACTIVITIES

Fløibanen Funicular
Cable Car

(📞55 33 68 00; www.floibanen.no; Vetrlidsalmenning 21; adult/child return 90/45kr; ⏲7.30am-11pm Mon-Fri, 8am-11pm Sat & Sun) For an unbeatable view of the city, ride the 26-degree Fløibanen funicular to the top of Mt Fløyen (320m), with departures every 15 minutes. From the top, well-marked hiking tracks lead into the forest; the possibilities are mapped out on the free *Walking Map of Mount Fløyen,* available from the Bergen tourist office (p229).

Ulriken643
Cable Car

(📞53 64 36 43; www.ulriken643.no; adult/child/family return 170/100/460kr; ⏲9am-9pm May-Sep, 9am-5pm Tue-Sun Oct-Apr) Look up to the mountains from the harbour, and you'll spy a radio mast clad in satellite dishes. That's the top of Mt Ulriken (643m) you're spying, and on a clear day it offers a stunning panorama over city, fjords and mountains. Thankfully, you don't have to climb it: a cable car speeds from bottom to top in just seven minutes.

🟢 TOURS

Bergen Guide Service (📞55 30 10 60; www.bergenguideservice.no; Holmedalsgården 4; adult/child 130kr/free; ⏲office 9am-3pm Mon-Fri) offers guided walking tours of the city year-round, and in summer, **Bryggen Guiding**

🏛 Saving Bryggen

So beautiful and popular is Bryggen that it seems inconceivable that conservationists spent much of the 20th century fighting plans to tear it down.

Fire has destroyed Bryggen at least seven times (notably in 1702 and again in 1955, when one-third of the district was destroyed). The tilt of the structures was caused in 1944, when a Dutch munitions ship exploded in the harbour, blowing off the roofs and shifting the pilings. The explosion and a 1955 fire increased the already considerable clamour to tear down Bryggen once and for all; not only was it considered a dangerous fire hazard, but its run-down state was widely seen as an embarrassment. Plans for the redevelopment of the site included modern, eight-storey buildings, a bus station, a shopping centre and a car park.

What saved Bryggen were the archaeological excavations that took 13 years to complete after the 1955 fire, and which unearthed more than one million artefacts. In 1962 the **Bryggen Foundation** (http://stiftelsenbryggen.no) and Friends of Bryggen were formed; the foundation still oversees the area's protection and restoration, although the buildings are privately owned.

One of the greatest challenges is the fact that Bryggen is actually sinking by an estimated 8mm each year. In 1979 Unesco inscribed Bryggen on its World Heritage list. For more information, visit the **Bryggen Visitors Centre** (p229).

Norway's Fjords

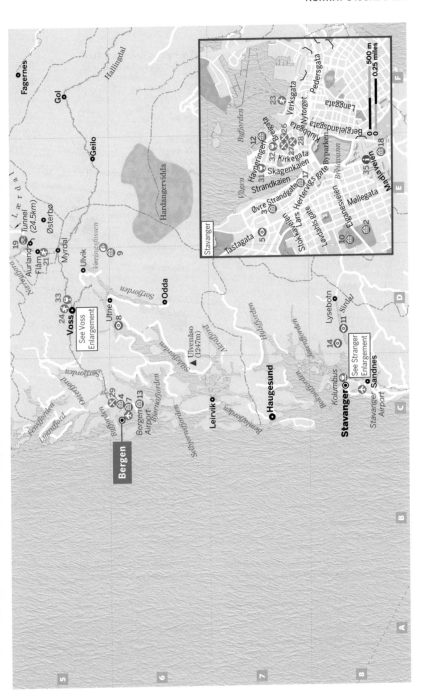

Fagernes

Gol

Geilo

Hallingdal

Hardangervidda

Lærdal

Tunnel (24.5km)

Østerbø

Myrdal

Aurland

Flåm 21

19

Nærøyfjord

Ulvik

Vøringsfossen

9

Utne

8

Odda

Sørfjorden

33

24 Voss

See Voss
Enlargement

Ulvenåso
(1247m)

Sørfjorden

Osterøy

Samnangerfjorden

Sørfjorden

Fensfjorden

Lygrafjord

Osterfjorden

Byfjorden

29

4 7

13 Bergen

Bergen
Airport

Bjørnafjorden

Leirvik

Bømlafjorden

Haugesund

Ålvikfjord

Hylsfjorden

Jøsenfjorden

Boknafjorden

Lysebotn

11 Sirdal

14

Kolumbus

Stavanger

Stavanger
Airport

See Stranger
Enlargement

Sandnes

Stavanger

Stavanger

Byfjorden

Vågen

Tastagata

5

Øvre Strandgate

Haugeringen

31

12

32

23

Verksgata

Pedersgata

Langgata

Bergelandsgata

Nytorget

Klubbgata

26

27

28

Breigata

Kirkegata

Skagenkaien

Strandkaien

Stokkaveien

Lars Hertervigs gate

Løkkeveien

Byparken

Breiavatn

Elganesveien

Madlaveien

35

18

2

10

Møllegata

0 500 m
0 0.25 miles

F

E

D

C

B

A

5

6

7

8

Norway's Fjords

(☏55 30 80 30; www.bymuseet.no; Bryggens Museum, Dreggsallm 3; adult/child 150kr/free) (run by the Bryggen Museum) offers historical walking tours of the Bryggen area.

Fonnafly Scenic Flights
(☏55 34 60 00; www.fonnafly.no; from 5500kr for 3 passengers) This national group will put together a customised sightseeing trip in a helicopter – the aerial views over the fjords are once-in-a-lifetime stuff, but they don't come cheap.

Fjord Tours from Bergen

There are dozens of tours of the fjords from Bergen; the tourist office (p229) has a full list, and you can buy tickets there or purchase them online. Most offer discounts if you have a Bergen Card (p229). For a good overview, pick up the *Round Trips – Fjord Tours & Excursions* brochure from the tourist office, which includes tours with private companies.

Fjord Tours (☏81 56 82 22; www.fjordtours.com) and **Rodne Fjord Cruises** (☏55 25 90 00; www.rodne.no; Torget; adult/child/family 550/350/1250kr; ⊙10am & 2.30pm daily Mar-Oct,

10am Wed-Fri, noon Sat & Sun Nov-Feb) are the key operators.

🛍 SHOPPING

Aksdal i Muren Clothing
(☏55 24 24 55; www.aksdalimuren.no; Østre Muralmenning 23; ⊙10am-5pm Mon-Fri, 10am-6pm Sat) This enticing shop in a historic landmark building has been ensuring the good people of Bergen are warm and dry since 1883. The city's best selection of rainwear includes cult Swedish labels such as Didriksons, big names like Helle Hansen and Barbour, but also local gems such as Blæst by Lillebøe. We can't think of a better Bergen souvenir.

Colonialen Strandgaten 18 Deli
(☏55 90 16 00; www.colonialen.no; Strandgaten 18; ⊙8am-6pm Mon-Fri, 10am-6pm Sat) The latest addition to the Colonialen arsenal, this impeccably cool cafe-deli serves up lavish lunchtime sandwiches, plus an irresistible selection of cold cuts, cheeses, oils, smoked fish and so much more. It's also the best place in town to try baked goodies and breads from Colonialen's own bakery – including their to-die-for cinnamon buns.

ENTERTAINMENT

Bergen has a busy programme of concerts throughout summer, many of them focusing on Bergen's favourite son, composer Edvard Grieg. Most take place at evocative open-air venues such as the Grieg Museum (p222), the **Harald Sæverud Museum** (Siljustøl; 55 92 29 92; www.siljustolmuseum.no; Siljustølveien 50, Råda; adult/child 60kr/free; noon-4pm Sun late Jun–mid-Aug), atop Mt Fløyen and in the park adjacent to Håkonshallen. Bergen Cathedral also offers free organ recitals on Sunday and Thursday from mid-June until August.

Garage
Live Music

(55 32 19 80; www.garage.no; Christies gate 14; 3pm-3am Mon-Sat, 5pm-3am Sun) Garage has taken on an almost mythical quality for music lovers across Norway. They do have the odd jazz and acoustic act, but this is a rock-and-metal venue at heart, with well-known Norwegian and international acts drawn to the cavernous basement. Stop by for their Sunday jam sessions in summer.

Hulen
Live Music

(55 32 31 31; www.hulen.no; Olaf Ryes vei 48; 9pm-3am Thu-Sat) Another minor legend of the Norwegian music scene, this basement club has hosted top rock and indie bands since opening its doors in 1968. *Hulen* means 'cave' and the venue is indeed underground, in a converted bomb shelter.

USF Vertfet
Live Music

(USF; 55 31 00 60; www.usf.no; Georgernes Verft 12; 11am-11pm) This huge arts and culture complex in a renovated warehouse space hosts a varied programme of contemporary art exhibitions, theatre, dance, gigs and other cultural events, and also has an excellent cafe, **Kippers** (USF; Georgernes Verft 12; 11am-11pm Mon-Thu, noon-midnight Fri & Sat, noon-11pm Sun).

EATING

Torget Fish Market
Seafood €

(Torget; lunches 99-169kr; 7am-7pm Jun-Aug, 7am-4pm Mon-Sat Sep-May) For most of its history, Bergen has survived on the fruits of the sea, so there's no better place for lunch than the town's lively fish market, where you'll find everything from salmon to calamari, fish and chips, prawn baguettes and seafood salads.

Pingvinen
Norwegian €€

(55 60 46 46; www.pingvinen.no; Vaskerelven 14; daily specials 119kr, mains 159-269kr; noon-3am) Devoted to Norwegian home cooking, Pingvinen is the old favourite of *everyone* in Bergen. They come for meals their mothers and grandparents used to cook, and the menu always features at least one of the following: fish-cake sandwiches, reindeer, fish pie, salmon, lamb shank and *raspeballer* (sometimes called *komle*) – west-coast potato dumplings. Note that whale is served here.

Colonialen Litteraturhuset
Norwegian €€

(55 90 16 00; www.colonialen.no/litteraturhuset; Østre skostredet 5-7; lunch 145-245kr, dinner 180-280kr; 9-11pm Tue-Fri, 11am-midnight Sat) The more laid-back bistro sister to Colonialen Restaurant, this is a favourite for Bergeners looking for a relaxed but refined lunch. It's a quietly elegant space, with neutral walls and blond-wood tables creating that essential too-cool-for-school Nordic atmosphere, and dishes are full of flavour: leeky fish soup or meat-and-cheese platters for lunch, mountain trout or duck-leg confit for dinner.

Lysverket
Norwegian €€€

(55 60 31 00; www.lysverket.no; KODE 4, Rasmus Meyers allé 9; lunch mains 165-195kr, lunch sharing menu with/without dessert 295/395kr, 4-/7-course menu 745/995kr; 11am-1am Tue-Sat) If you're going to blow the budget on one meal in Norway, make it here. Chef Christopher Haatuft is pioneering his own brand of Nordic cuisine, which he dubs 'neo-fjordic' – in other words, combining modern techniques with the best fjord-sourced produce. His food is highly seasonal, incredibly creative and full of surprising textures, combinations and flavours. Savour every mouthful.

Colonialen Restaurant
Norwegian €€€

(55 90 16 00; www.colonialen.no/restaurant/; Kong Oscars gate 44; 6-/8-course tasting menu 895/1195kr; Mon-Sat 6-11pm) Part of an ever-expanding culinary empire, this flagship

fine-diner showcases the cream of Neo–Nordic cuisine. It's playful and pushes boundaries, sure, but the underlying flavours are classic, and employ the very best Norwegian ingredients, especially from the west coast. Presentation is impeccable – expect edible flowers and unexpected ingredients aplenty. Strange it's on the dingy side of town.

DRINKING & NIGHTLIFE

Bergen has a great bar scene, and locals are enthusiastic drinking companions. Most of them favour the places in the centre or southwest of Øvre Ole Bulls plass. Big, multilevel nightclubs cluster around here, too; they are easy to spot, often fabulously trashy, and only admit those aged over 24.

Landmark
Bar, Cafe

(☎940 15 050; Bergen Kunsthalle, Rasmus Meyers allé 5; ⊙cafe 11am-5pm Tue-Sun, bar 7pm-1am Tue-Thu, to 3.30am Fri & Sat) This large, airy room is a beautiful example of 1930s Norwegian design and is named for architect Ole Landmark. It multitasks: day-time cafe, lecture and screening hall; live-performance space, bar and venue for Bergen's best club nights. It's a favourite with the city's large creative scene. The cafe serves yummy lunches, with a choice of open-faced sandwiches and a weekly melt (995-1295kr).

Terminus Bar
Bar

(Zander Kaaesgate 6, Grand Terminus Hotel; ⊙5pm-midnight) Consistently voted one of the word's best whisky bars, this grand old bar in the Grand Hotel Terminus is the perfect place for a quiet dram. It promises more than 500 different tastes, and the oldest whisky dates back to 1960. The 1928 room looks gorgeous both before and after you've sampled a few.

Altona Vinbar
Wine Bar

(☎55 30 40 00; www.augustin.no/en/altona; C Sundts gate 22; ⊙6pm-12.30am Mon-Thu, to 1.30am Fri & Sat) Set in a warren of vaulted underground rooms that date from the 16th century, Altona's huge, carefully selected wine list, soft lighting and murmured conversation make it Bergen's most romantic bar (particularly appealing when the weather's cold and wet). The bar menu tends towards tasty comfort food, such as Norwegian lamb burgers (190kr).

Fløibanen funicular (p223)

SAMOT/SHUTTERSTOCK ©

Det Lille Kaffekompaniet Cafe
(Nedre Fjellsmug 2; ⊙10am-8pm Mon-Fri, 10am-6pm Sat & Sun) This was one of Bergen's first third-wave coffee places and retains a superlocal feel. Everyone overflows onto the neighbouring stairs when the sun's out, and you're not sure which table belongs to who.

INFORMATION

DISCOUNT CARDS

The **Bergen Card** (www.visitbergen.com/bergencard; adult/child 24hr pass 260/100kr, 48hr 340/1130kr, 72hr 410/160kr) gives you free entrance to most of Bergen's main museums, plus discounted entry to the rest. You also get free travel on public transport, free or discounted return trips on the Fløibanen funicular (p223), depending on the time of year; free guided tours of Bergen; and discounts on city- and boat-sightseeing tours, concerts and cultural performances. It's available from the **tourist office**, some hotels, the bus terminal and online.

TOURIST INFORMATION

Bergen Turlag DNT Office (☎55 33 58 10; www.bergen-turlag.no; Tverrgaten 4; ⊙10am-4pm Mon-Wed & Fri, to 6pm Thu, to 3pm Sat) Maps and information on hiking and hut accommodation throughout western Norway.

Bryggen Visitors Centre (Jacobsfjorden, Bryggen; ⊙9am-5pm mid-May–mid-Sep) Maps and activities in the Bryggen neighbourhood.

Tourist Office (☎55 55 20 00; www.visitbergen.com; Strandkaien 3; ⊙8.30am-10pm Jun-Aug, 9am-8pm May & Sep, 9am-4pm Mon-Sat Oct-Apr) One of the best and busiest in the country, Bergen's tourist office distributes the free and worthwhile *Bergen Guide* booklet, as well as a huge stock of information on the entire region. They also sell rail tickets.

GETTING THERE & AWAY

AIR

Bergen Airport (www.avinor.no/en/airport/bergen-airport) is at Flesland, about 18km southwest of the centre.

Norwegian (www.norwegian.com) Flights to Oslo and Tromsø.

🍽️ Dining Out

In this rural corner of Norway, you'll find lots of fish from the fjords on menus, as well as local meats, game, cheeses and fruits. In times gone by, many communities would have lived a largely subsistence lifestyle, and local dishes reflect that heritage, with lots of pickles and preserves designed to make the summer bounty last through a long, cold winter – most notably in the classic dish of *klippfisk*, a kind of dried, salted cod similar to *bacalao*, which is usually served with a tomato sauce.

Klippfisk in a tomato sauce
SUGAR0607/GETTY IMAGES ©

SAS (www.sas.no) Connects with Oslo and Stavanger.

Widerøe (www.wideroe.no) Flies to Oslo, Haugesund, Stavanger and many coastal destinations as far north as Tromsø.

BOAT

International ferries to/from Bergen dock at **Skoltegrunnskaien**, northwest of the Rosenkrantz tower, while the Hurtigruten coastal ferry leaves from the **Hurtigruteterminalen** (Nøstegaten 30), southwest of the centre.

A number of operators offer express boat services, leaving from the **Strandkaiterminal**.

Norled (☎51 86 87 00; www.norled.no; Kong Christian Frederiks plass 3) offers at least one daily ferry service to Sogndal (1 adult/child 705/353kr, five hours) and Flåm (825/415kr, 5½ hours).

BUS

Flybussen (www.flybussen.no; one way/return adult 90/160kr, child 50/80kr) Runs up to four

Norway's Landscape

Norway's geographical facts tell quite a story. The Norwegian mainland stretches 2518km from Lindesnes in the south to Nordkapp in the Arctic North, with a narrowest point of 6.3km wide. It also has the highest mountains in northern Europe (Norway's highest is Galdhopiggen) and the fourth-largest land mass in Western Europe (behind France, Spain and Sweden). But these are merely the statistical signposts to the staggering diversity of Norwegian landforms, from glacier-strewn high country and plunging fjords to the tundra-like plains of the Arctic North.

Galdhopiggen, Norway's tallest mountain
MOROZOV67/SHUTTERSTOCK ©

times hourly between the airport, the Radisson Blu Royal Hotel, the main bus terminal and opposite the tourist office on Vågsallmenningen.

Bergen's **bus terminal** (Vestre Strømkaien) is located on Vestre Strømkaien. Various companies run long-distance routes across Norway; **Nor-Way** (www.nor-way.no) provides a useful travel planner.

Destination	Departures (daily)	Cost (kr)	Time (hr)
Lillehammer	1	646	8½
Oslo	4	498-577	10
Stavanger	6	475	5½
Voss	1	190	1½

TRAIN

The spectacular train journey between Bergen and Oslo (349kr to 905kr, 6½ to eight hours, five daily) runs through the heart of Norway. Other destinations include Voss (204kr, one hour, hourly) and Myrdal (299kr to 322kr, 2¼ hours, up to nine daily) for connections to the Flåmsbana railway.

Early bookings can secure you some great discounts.

GETTING AROUND

BICYCLE

Sykkelbutikken (www.sykkelbutikken.no; Kong Oscars gate 81; touring bikes per day/week 250/850kr; ⏲10am-8pm Mon-Fri, 10am-4pm Sat) Bicycle hire near the train station.

Bergen Bike (☏400 04 059; www.norwayactive.no; Bontelabo 2; adult per 2hr/day 200/500kr) Rental bikes near the quay.

BUS & TRAM

Skyss (☏177; www.skyss.no) operates buses and light-rail trams throughout Bergen. Fares are based on a zone system; one-trip tickets cost 37kr to 62kr, and can be bought from the machines at tram stops. Ten-trip tickets are also available, and you get free travel with the **Bergen Card** (p229).

Voss

Voss (also known as Vossevangen) sits on a sparkling lake not far from the fjords, and this position has earned it a world-wide reputation as Norway's adventure capital. The town itself is far from pretty, but everyone is here for white-water rafting, bungee jumping and just about anything you can do from a parasail, most of it out in the fjords.

SIGHTS

Vangskyrkja Church

(Uttrågata; adult/child 20kr/free; ⏲10am-4pm Tue-Sat) Voss' stone church occupies the site of an ancient pagan temple. A Gothic–style stone church was built here in the mid-13th century, and although the original stone altar and unique wooden spire remain, the Lutheran Reformation of 1536 saw the removal of many original features. The 1923 stained-glass window commemorates the 900th anniversary of Christianity in Voss. Miraculously, the building escaped destruction during the intense German bombing of Voss in 1940.

Nearby is the important monument of **St Olav's Cross**.

ACTIVITIES

Voss lives for its outdoor activities, and there are loads to choose from. Bookings can be made direct or through the tourist office (p232).

Although normally done from Oslo or Bergen, the Norway in a Nutshell tour run by Fjord Tours (p226) can also be done from Voss.

Voss Vind Skydiving

(401 05 999; www.vossvind.no; Oberst Bulls veg 28; adult/child 765/565kr; 10am-8pm mid-June–mid-Aug, noon-8pm Wed-Sun rest of year) If you've always wanted to feel what it's like to skydive, but the thought of actually hurling yourself out of a plane fills you with mortal terror, then this amazing place can help. It has a wind tunnel that simulates the experience of freefall only without any danger of turning yourself into a cow-pat. There's a minimum age of five.

Nordic Ventures Adventure Sports

(56 51 00 17; www.nordicventures.com; on the water, near Park Hotel; adult/child 1095/750kr; Apr–mid-Oct) Take a guided kayak along the fjords from Voss, or book in for a multinight adventure. They have a floating office on the water near the Park Hotel, as they also run tours out of Gudvangen.

Voss Active Adventure Sports

(56 51 05 25; www.vossactive.no; Nedkvitnesvegen 25; 9am-9pm mid-May–Sep) This outdoors company specialises in organising rafting trips on local rivers including the Stranda, Raundalen and Vosso, but more recently it has branched out into lots of other activities, too, from canyoning and abseiling to fishing, guided hikes and – the kids' favourites – a high-wire rope course.

EATING

Tre Brør Cafe €

(951 03 832; www.trebror.no; Vangsgata 28; sandwiches & light meals 85-185kr; cafe 11am-8pm Mon-Wed, 11am-2.30am Thu-Sat, 11am-8pm Sun;) The 'Three Brothers' is the heart of Voss's social scene, and rightly so – it's everything you want from a small-town cafe. There's super coffee from Oslo's Tim Wendelboe and Ålesund's Jacu Roastery, a

Vangskyrkja

Gamle Stavanger

great range of microbrewed beers from Voss Brewery down the road, and an on-trend menu of salads, soups, wraps, burgers and Asian–tinged dishes. What's not to like?

🍷 DRINKING & NIGHTLIFE

Tre Brør is the centre of the nightlife in Voss.

Voss Bryggeri Microbrewery
(📞975 40 517; www.vossbryggeri.com; Kytesvegen 396; ⊙by appointment) This much-respected brewery has made a real splash on the beer scene in recent years, with standout brews such as their Oregonian pale ale, Natabjødn ('Nut Beer'), an English–style brown beer, and traditional Vossaøl, brewed with juniper tea. It's about 6km north of Voss; guided tours are available by arrangement, otherwise you can taste their beers at Tre Brør.

ℹ️ INFORMATION

Voss Tourist Office (📞406 17 700; www. visitvoss.no; Skulegata 14; ⊙9am-6pm Mon-Sat,

10am-5pm Sun mid-June–Aug, 9am-4pm Mon-Fri Sep–mid-June)

ℹ️ GETTING THERE & AWAY

Voss is about 100km east of Bergen on the E16, and 45km southwest of Gudvangen.

BUS

Buses stop at the train station, west of the centre. Frequent services:

Bergen (186kr, two hours)

Flåm (121kr, 1¼ hours)

Sogndal (149-229kr, three hours) via Gudvangen and Aurland.

TRAIN

Voss has fast and efficient train links. At Myrdal, you can connect with the **Flåmsbåna Railway** (www.visitflam.com/en/flamsbana; adult/child one way 360/180kr, return 480/240kr). Booking ahead can get you some fantastic deals.

Bergen (204kr, one hour, hourly)

Oslo (249kr to 860kr, 5½ to six hours, five daily)

Stavanger

Stavanger's old centre has some of the most beautiful and best-preserved wooden buildings anywhere in Norway, many dating back to the 18th century. It's all very pretty, and in summer the waterfront comes alive in the best port-town style. It's also a perfect launchpad for exploring nearby Lysefjorden, and for tackling the classic hike to Preikestolen (Pulpit Rock).

◉ SIGHTS

Several of Stavanger's museums offer joint admission: one ticket remains valid for the whole day for entry to the **Stavanger Museum** (📞51 84 27 00; www.museumstavanger. no; Muségata 16; adult/child 90/50kr incl other Stavanger museums; ☉10am-4pm daily), the **Stavanger Art Museum**, the Canning Museum, the **Norwegian Children's Museum** (Norsk Barnemuseum; www.stavangermuseum. no/en/samling/samling-norsk-barnemuseum; Muségata 16; adult/child 90/50kr incl other Stavanger museums; ☉10am-4pm; 👪), **Stavanger Maritime Museum** (Sjøfartsmuseet; 📞51 84 27 00; Nedre Strandgate 17-19; adult/child 90/50kr; ☉11am-3pm Tue-Wed & Fri, 11am-7pm Thu, 11am-4pm Sat & Sun), **Breidablikk** (📞51 84 27 00; www.breidablikkmuseum.no; Eiganesveien 40a; adult/child 90/50kr; ☉10am-4pm Sat-Thu) and **Ledaal** (📞51 84 27 00; www.ledaalmuseum. no; Eiganesveien 45; adult/child 90/50kr incl other Stavanger museums; ☉10am-4pm Sat-Thu).

Gamle Stavanger Area

Gamle (Old) Stavanger, above the western shore of the harbour, is a delight. The Old Town's cobblestone walkways pass between rows of late-18th-century whitewashed wooden houses, all immaculately kept and adorned with cheerful, well-tended flowerboxes. It well rewards an hour or two's ambling.

Canning Museum Museum

(📞51 84 27 00; www.museumstavanger.no; Øvre Strandgate 88a; adult/child 90/50kr incl other Stavanger museums; ☉11am-5pm Tue-Fri, 11am-4pm Sat & Sun) Don't miss this museum housed in an old cannery: it's one

Extreme Sports Festival in Voss

The week-long **Extreme Sports Festival** (Veko; www.ekstremsportveko.com; ☉Jun) at the end of June combines all manner of extreme sports (skydiving, paragliding and base jumping) with local and international music acts.

Basejumper near Voss
ANDERS BLOMQVIST/GETTY IMAGES ©

of Stavanger's most entertaining. Before oil, there were sardines, and Stavanger was once home to more than half of Norway's canning factories. By 1922 the city's canneries provided 50% of the town's employment. The exhibits take you through the whole 12-stage process from salting through to threading, smoking, decapitating and packing. Guides are on hand to answer your questions or crank up some of the old machines.

Norsk Oljemuseum Museum

(Oil Museum; www.norskolje.museum.no; Kjeringholmen; adult/child 120/60kr; ☉10am-7pm daily Jun-Aug, 10am-4pm Mon-Sat, to 6pm Sun Sep-May; 👪) Admittedly, an 'oil museum' doesn't sound like the most promising prospect for an afternoon out. But this state-of-the-art place is well worth visiting – both for its striking, steel-clad architecture, and its high-tech displays explaining the history of North Sea oil exploration. Highlights include the world's largest drill bit, simulated rigs, documentary films, archive testimony and a vast hall of oil-platform models. There are also exhibitions on natural history, energy use and climate change.

Sleeping Over

You'll have no trouble finding a place to sleep in this part of Norway; accommodation is plentiful, encompassing the full spectrum from campsites to boutique hotels. Bergen and Stavanger have the largest choice, and both make good bases for exploring, but prices here tend to be a bit higher than elsewhere. Hostels and campsites are widespread, and are a good way of keeping costs down.

The town of Voss has the best selection of accommodation, and there are some good hotels out in the surrounding countryside, too.

 ACTIVITIES

Stavanger is a great launch-pad for adventures in Lysefjord. Boat cruises and sightseeing trips leave from the town's main Fiskespiren Quay.

 EATING

Stavanger has what we suspect is the most expensive dining scene in Norway.

Renaa Matbaren International €€

(📞51 55 11 11; www.restaurantrenaa.no; Breitorget 6, enter from Bakkegata; small dishes 59-125kr, mains 165-395kr; ⊙4pm-1am Mon-Fri, 11am-1am Sat, 2pm-midnight Sun) Run by top chef Sven Erik Renaa, this smart bistro offers a taste of his food at (reasonably) affordable prices. The menu is classic – mussels in beer, rib-eye with rosemary fries, squid with fennel and shallots, all with a Nordic twist. The glass and wood feels uber–Scandi, and the art collection is stellar (yes, that's an Antony Gormley statue).

Renaa Xpress Sølvberget Norwegian €€

(Stavanger Kulturhus; 📞51 55 11 11; www.restaurantrenaa.no; Sølvberggata 2; panini 89-98kr, salads 170kr, pizzas 180-199kr; ⊙10am-10pm Mon-Thu, to midnight Fri & Sat, noon-10pm Sun) One of three Renaa restaurants in Stavanger, this upmarket cafe pretty much corners the lunchtime market. Go for the daily soup deal, tuck into a huge salad, enjoy a panino topped with *Parmaskinke* (Parma ham) or *røkelaks* (smoked salmon), or order a wood-fired, wild-yeasted pizza (available from 3pm). Needless to say, the cake, pastries and coffee are delicious, too.

Egget Bistro €€€

(📞984 07 700; Steinkargata 23; dishes from 800kr; ⊙6-11pm Tue-Sat) In a clapboard building off Steinkargata, this ramshackle, rough-and-ready eatery is small in size, but strong on ambition: the food is modern, creative, and bang on trend, with an emphasis on freshness, seasonality and Asian–inspired flavours. There's no set menu; dishes are chalked above the bar, from wild trout to kimchi, braised ribs or Asian slaws. The only drawback? It's pricey.

DRINKING & NIGHTLIFE

Bøker & Børst Bar

(📞51 86 04 76; www.bokerogborst.webs.com; Øvre Holmegate 32; ⊙10am-2am) With all the decorative chic of a well-worn living room – complete with book-lined shelves, retro floor-lamps and old wallpaper – this lovely coffee bar is a fine spot to while away a few hours. There are plenty of beers on tap, plus pub-type snacks and pastries, and a covered courtyard at the back.

Broremann Bar Bar

(📞406 36 783; www.broremann.no; Skansegata 7; ⊙6pm-2am Tue-Thu & Sun, 4pm-2am Fri & Sat, closed Mon) One of Stavanger's best-loved bars, this low-key shopfront place draws a discerning over-30s crowd and, later, local hospitality staff for post-shift drinks

INFORMATION

Tourist Office (📞51 85 92 00; www.regionstavanger.com; Strandkaien 61; ⊙9am-8pm Jun-Aug, 9am-4pm Mon-Fri, 9am-2pm Sat Sep-May) Local information and advice on Lysefjord and Preikestolen.

Stavanger Turistforening DNT (📞51 84 02 00; www.stf.no; off Muségata; ⊙10am-4pm Mon, Wed, Fri & Sat, 10am-6pm Tue & Thu) Information on hiking and mountain huts.

Norsk Oljemuseum (p233)

ℹ️ GETTING THERE & AWAY

AIR

Stavanger Airport (📞51 65 80 00; https://avinor.no/en/airport/stavanger-airport) is at Sola, 14km south of the city centre. As well as international airlines, there are a number of domestic airline services. Seasonal flights are also available to destinations in the UK and Europe.

Norwegian (www.norwegian.com) Flights to Oslo, Bergen and Trondheim.

SAS (www.sas.no) Services Oslo and Bergen, plus international destinations such as London and Aberdeen.

Widerøe (www.wideroe.no) Flies to Bergen, Kristiansand, Sandefjord, Florø and Aberdeen.

BOAT

International ferries and boat tours of **Lysefjord** (www.norled.no; Lysefjord cruise adult/child/ family 450/280/1100kr, Preikestolen boat-and-bus-ticket 320kr) from Stavanger are available.

Kolumbus (📞81 50 01 82; www.kolumbus.no; Verksgata) also runs an express ferry to Lysebotn (adult/child/car 160/80/567kr, one daily on Monday, Wednesday and Friday), as well as car ferries to several other destinations.

BUS

Destination	Cost (kr)	Time (hr)	Departures
Bergen	475	5½	hourly
Haugesund	241	2	hourly
Kristiansand	406	4½	4 daily
Oslo	742-811	9½	3 daily

TRAIN

Destination	Cost (kr)	Time (hr)	Frequency (daily)
Egersund	177	1¼	hourly
Kristiansand	512	3	5
Oslo	997	8	up to 5

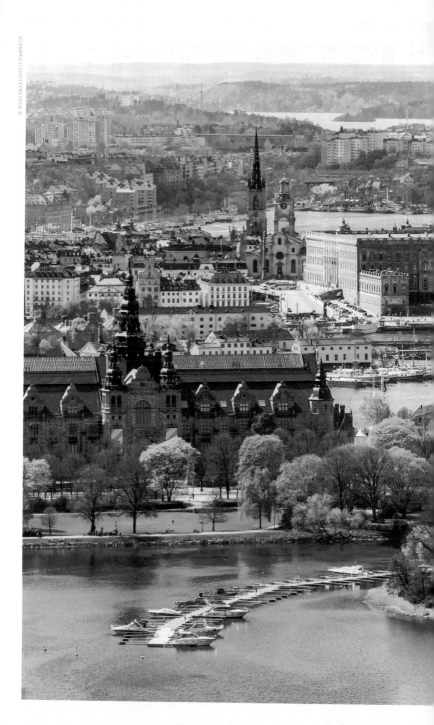

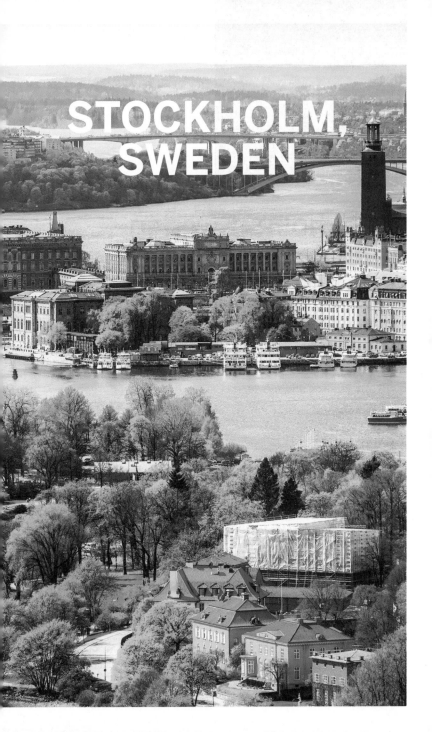

STOCKHOLM,
SWEDEN

Stockholm, Sweden at a Glance...

Stockholmers call their city 'beauty on water'. But despite the well-preserved historic core, Stockholm is no museum piece: it's modern, dynamic and ever-changing. Gamla Stan is a saffron-and-spice vision from the storybooks: one of Europe's most arresting historic hubs, with an imposing palace, looming cathedrals and razor-thin cobblestone streets. Stockholm's beauty and fashion sense are also legendary, with good design a given. Travellers also quickly discover that this is a city of food obsessives. If a food trend appears anywhere in the world, Stockholm is on it. The result is one of Europe's most memorable cities.

Two Days in Stockholm

Begin in Gamla Stan. Tour the royal palace, **Kungliga Slottet** (p246) then lunch at **Chokladkoppen** (p251). Walk to Skeppsholmen, where you'll find **Moderna Museet** (p246). Then, dine on traditional Swedish dishes in **Kryp In** (p252).

On day two, head to Djurgården for **Skansen** (p247), then lunch at **Wärdshuset Ulla Winbladh** (p241). Next, head to nearby **Vasamuseet** (p240), then dine at modern Scandinavian restaurant **Gastrologik** (p254).

Four Days in Stockholm

In Södermalm, begin at **Fotografiska** (p247), then climb to the Söder heights for killer city views. Lunch at **Hermann's Trädgårdscafé** (p253), then walk steep cobbled streets to Medborgarplatsen square. Dine at **Meatballs for the People** (p253), then head to Monteliusvägen for amazing sunset views.

On day four, tour **Stadshuset** (p246). Eat at **Östermalms Saluhall** (p254), study Viking lore at **Historiska Museet** (p250), then shop at **Östermalms Saluhall** (p254) and **Svenskt Tenn** (p251). Dine at **Ekstedt** (p254), then it's to **Monks Porter House** (p255) for a beer.

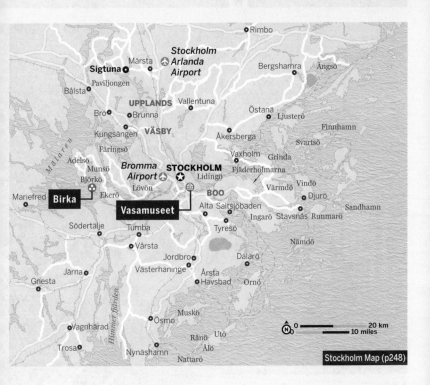

Arriving in Stockholm

Stockholm Arlanda Airport Arlanda
Express runs to Centralstationen every 10
to 15 minutes (20 minutes, one-way adult/
child 280/150kr, summer two people
350kr).

Cityterminalen Local buses go to
Stockholm's neighbourhoods; about 20
minutes to downtown (85kr). Most long
distance buses arrive and depart here
and it's connected to **Centralstationen.**
Trains between the airport and Central-
stationen run every 10 to 15 minutes
5am to 12.30am (less frequently after
9pm), taking 20 minutes.

Where to Stay

Expect high-quality accommodation, al-
though it can be expensive. Major hotel
chains are cheaper booked online and in
advance; rates are also much cheaper in
summer and at weekends.

Stockholm's Svenska Turistförenin-
gen (STF) hostels are affiliated with
Hostelling International (HI); a member-
ship card yields a 50kr discount. Many
have single, double and family rooms.
See Where to Stay (p257) to see
which Stockholm neighbourhood suits
you best.

Vasamuseet

Learn about the short maiden voyage of the massive warship Vasa, which sank within minutes of setting sail. It's one of the most popular museums on Djurgården.

Great For...

Don't Miss

Guided tours, a scale model of the ship, the short film screening, and the upper deck

The Ship

A good-humoured glorification of some dodgy calculations, Vasamuseet is the custom-built home of the massive warship *Vasa*. The ship, a whopping 69m long and 48.8m tall, was the pride of the Swedish crown when it set off on its maiden voyage on 10 August 1628. Within minutes, the top-heavy vessel tipped and sank to the bottom of Saltsjön, along with many of the people on board. The museum details its painstaking retrieval and restoration.

Exhibits

Five levels of exhibits cover artefacts salvaged from *Vasa*, life on board, naval warfare and 17th-century sailing and navigation, plus sculptures and temporary

VICTOR MASCHEK/SHUTTERSTOCK ©

Strandvägen
Ladugårdslandsviken Nordiska Museet -
 Galärvarvsvägen Vasamuseet
 Djurgårdsbrunnsviken
 Vasamuseet Djurgården
 Rosendalsvägen
 Bergbanan
 Hazeliusporten
Skeppsholmen *Saltsjön* Skansen

❶ Need to Know

Vasamuseet (www.vasamuseet.se;
Galärvarvsvägen 14; adult/child 130kr/free;
⊙8.30am-6pm Jun-Aug, 10am-5pm Sep-May;
🅿; 🚌44, 🚢Djurgårdsfärjan, 🚊7)

✕ Take a Break

Outside the museum, **Wärdshuset Ulla
Winbladh** (www.ullawinbladh.se; Rosen-
dalsvägen 8; mains 175-425kr; ⊙11.30am-
10pm Mon, 11.30am-11pm Tue-Fri, 12.30-11pm
Sat, 12.30-10pm Sun) has inviting outdoor
seating.

★ Top Tip

Guided tours in English depart from
the front entrance every 30 minutes in
summer.

exhibitions. The bottom-floor exhibition
is particularly fascinating, using modern
forensic science to re-create the faces
and life stories of several of the ill-fated
passengers. The ship was painstakingly
raised in 1961 and reassembled like a
giant 14,000-piece jigsaw. Almost all of
what you see today is original.

Meanwhile

Putting the catastrophic fate of *Vasa* in
historical context is a permanent multi-
media exhibit, *Meanwhile*. With images of
events and moments happening simulta-
neously around the globe – from China to
France to 'New Amsterdam', from traders
and settlers to royal families to working
mothers and put-upon merchants – it
establishes a vivid setting for the story
at hand.

Scale Model

On the entrance level is a model of the ship at
scale 1:10, painted according to a thoroughly
researched understanding of how the original
would've looked. Once you've studied it, look
for the intricately carved decorations adorn-
ing the actual *Vasa*. The stern in particular
is gorgeous – it was badly damaged but has
been slowly and carefully restored.

Upper Deck

A reconstruction of the upper gun deck
allows visitors to get a feel for what it
might have been like to be on a vessel this
size. *Vasa* had two gun decks, which held
an atypically large number of cannons
– thought to be part of the reason it
capsized.

The Monument of Ansgar

Day Trip to Birka

The historic Viking trading centre of Birka, on Björkö in Lake Mälaren, makes a fantastic day trip. Few places in Scandinavia carry quite as many Viking echoes.

Great For...

Don't Miss

Birka Museum, one of Scandinavia's best Viking museums

A History Lesson

A Unesco World Heritage site, Birka was founded around AD 760 to expand and control trade in the region. The village attracted merchants and craft workers, and the population quickly grew to about 700. A large defensive fort with thick dry-stone ramparts was constructed nearby. Birka was abandoned in the late 10th century when Sigtuna took over the role of commercial centre.

The Cemetery & Around

The village site is surrounded by the largest Viking–era cemetery in Scandinavia, with around 3000 graves. Most people were cremated, then mounds of earth were piled over the remains, but some Christian coffins and chambered tombs have been

Model of Viking settlement, Birka Museum

ANDERS BLOMQVIST/GETTY IMAGES ©

❶ Need to Know

Birka (www.birkavikingastaden.se/en; Björkö; adult/child 395/198kr; ☺May-Sep; ⛴Stromma)

✕ Take a Break

Before setting out from Stockholm, shop for picnic goodies at Östermalms Saluhall (p254).

★ Top Tip

Allow the best part of a day for the excursion.

found. The fort and harbour have also been excavated.

Many of the finds from the excavations are in the Birka Museum.

A Lonely Cross

In 830 the Benedictine monk Ansgar was sent to Birka by the Holy Roman Emperor to convert the heathen Vikings to Christianity; he hung around for 18 months. A cross to his memory can be seen on top of a nearby hill.

Birka Museum

Exhibits at the **Birka Museum** (☎08-56 05 15 40; www.birkavikingastaden.se/en; Björkö; adult/child 100/50kr; ☺hours vary, check schedule online) include finds from the excavations, copies of the most magnificent objects, and an interesting model of the village in Viking times.

Ferry to Birka

Strömma Kanalbolaget (☎08-12 00 40 00; www.stromma.se; Svensksundsvägen 17; 200-400kr) runs round-trip cruises to Birka from Stadshusbron in central Stockholm. The trip takes two hours each way from Stockholm; plan on a full day's outing. Price includes museum admission and a guided English–language tour of the settlement's burial mounds and fortifications. No ferries run during the Midsummer holidays.

Old Town Walking Tour

This exploration of Stockholm's city centre takes you past the best the city has to offer, with a focus on the beguiling old city.

Start Centralstationen
Distance 3km
Duration 2 hours

2 Pop into arts hub **Kulturhuset** (Sergels Torg; www.kulturhuset-stadsteatern.se), with its exhibitions, theatres, cafes and creative spaces.

I-Centralen

Mäster Samuelsgatan

Klarabergsgatan

Brunkebergstorg

Centralplan

START/FINISH

Stockholm Centralstationen

Klara Västra Kyrkogatan

Drottninggatan

Centralbron

Kungsholmen

Hantverkargatan

Tegelbacken

Fredsgatan

Ragnar Ostbergs Plan

Klara Sjö

Vasabron

Norr Mälarstrand

Centralbron

Riddarholmen

Classic Photo The statue of 'Saint George and the Dragon at Köpmantorget

Riddarfjärden

Evert Taubes Terrass

Birger Jarls Torg

Take a Break...
Chokladkoppen (p251) is a long-standing city favourite, right on Stortorget.

6 Källargränd leads southward to **Stortorget**, the cobblestone square where the Stockholm Bloodbath took place (1520).

1 From Centralstationen, head to **Sergels Torg,** a square with frenzied commuters, casual shoppers and the odd demonstration.

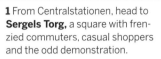

Norrmalmstorg

Hamngatan

Nybroplan

Berzelii Park

Raoul Wallenbergs Torg

Regeringsgatan

Västra Trädgårdsgatan

3 Next, visit the grand and pretty **Kungsträdgården**, originally the kitchen garden for the Royal Palace.

Kungsträdgården

Malmtorgsgatan

Kungsträdgården

Nybroviken

Gustav Adolfs Torg

Karl XII's Torg

Strömgatan

Stallgatan

5 Facing the cathedral across the cobblestone square is **Kungliga Slottet** (p246).

Norrbro

Norrström

Strömbron

Ladugårdslandsviken

Riksgatan

Helgeandsholmen

Slottskajen

Yttre Borggården

Skeppsholmsbron

Skeppsholmsbron

Riddarhustorget

Mynttorget

5

Slottsbacken

Trångsund

4

Köpmantorget

Stora Nygatan

6

Köpmangatan

Chokladkoppen

Gamla Stan

Svartmangatan

4 Head for the city's medieval core, into Storkyrkobrinken and the city's oldest building, **Storkyrkan** (Trångsund 1; www.stockholmsdomkyrk oforsamling.se);

Gamla Stan

Västerlånggatan

Munkbroleden

Kornhamnstorg

7

Österlånggatan

Skeppsbron

Järntorget

Centralbron

Riddarfjärden

Karl Johanstorg

Strömmen

Sjöbergsplan

7 Explore the old town around **Mårten Trotzigs Gränd**, Stockholm's narrowest lane, on your way back to Centralstationen.

Södermalmstorg

Saltsjöbanans Station

Hornsgatan

Stadsgårdsleden

Slussen

Katarinavägen

0 400 m

0 0.2 miles

N

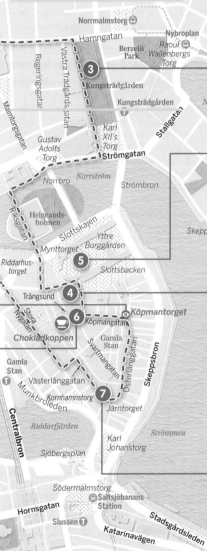

◉ SIGHTS

◎ Gamla Stan

Kungliga Slottet Palace

(Royal Palace; ☎08-402 61 30; www.theroyalpal ace.se; Slottsbacken; adult/child 160/80kr, combo ticket incl Riddarholmen adult/child 180/90kr; ⏱9am-5pm Jul & Aug, 10am-5pm May-Jun & Sep, 10am-4pm Tue-Sun Oct-Apr; ⛴43, 46, 55, 59 Slottsbacken, Ⓜ Gamla Stan) Kungliga Slottet was built on the ruins of Tre Kronor castle, which burned down in 1697. The north wing survived and was incorporated into the new building. Designed by court architect Nicodemus Tessin the Younger, it took 57 years to complete. Highlights include the decadent Karl XI Gallery, inspired by Versailles' Hall of Mirrors, and Queen Kristina's silver throne in the Hall of State.

◎ Kungsholmen

Stadshuset Notable Building

(City Hall; www.stockholm.se/stadshuset; Hantverkargatan 1; adult/child 100/50kr, tower 50kr/free; ⏱9am-3.30pm, ⛴3, 62 Stadshuset, Ⓜ Rådhuset) The mighty Stadshuset domi-nates Stockholm's architecture. Topping off its square tower is a golden spire, and the symbol of Swedish power: the three royal crowns. Entry is by guided tour only; tours in English take place every 30 minutes from 9am until 3.30pm in summer, less frequently the rest of the year. The tower is open for visits every 40 minutes from 9.15am to 4pm, or 5pm from May to September; it offers stellar views and a great thigh workout.

◎ Djurgården & Skeppsholmen

Moderna Museet Museum

(☎08-52 02 35 00; www.modernamuseet. se; Exercisplan 4; ⏱10am-8pm Tue & Fri, to 6pm Wed-Thu, 11am-6pm Sat & Sun; Ⓟ; ⛴65, ⛴Djurgårdsfärjan) **FREE** Moderna Museet is Stockholm's modern-art maverick, its permanent collection ranging from paintings and sculptures to photography, video art and installations. Highlights include works by Pablo Picasso, Salvador Dalí, Andy Warhol, Damien Hirst and Robert Rauschenberg, plus several key figures in the Scandinavian and Russian art worlds

Kungliga Slottet

and beyond. There are important pieces by Francis Bacon, Marcel Duchamp and Matisse, as well as their contemporaries, both household names and otherwise.

Skansen Museum

(www.skansen.se; Djurgårdsvägen; adult/child 180/60kr; ☺10am-6pm, extended hours in summer; ℙ; 🚇69, 🚢Djurgårdsfärjan, 🚋7) The world's first open-air museum, Skansen was founded in 1891 by Artur Hazelius to provide an insight into how Swedes once lived. You could easily spend a day here and not see it all. Around 150 traditional houses and other exhibits dot the hilltop – it's meant to be 'Sweden in miniature', complete with villages, nature, commerce and industry. Note that prices and opening hours vary seasonally; check the website before you go.

Junibacken Amusement Park

(www.junibacken.se; Djurgården; adult/child 159/139kr; ☺10am-6pm Jul-Aug, to 5pm rest of year; 👶; 🚇44, 69, 🚢Djurgårdsfärjan, 🚋7) Junibacken whimsically recreates the fantasy scenes of Astrid Lindgren's books for children. Catch the flying Story Train over Stockholm, shrink to the size of a sugar cube and end up at Villekulla cottage, where kids can shout, squeal and dress up like Pippi Longstocking. The bookshop is a treasure trove of children's books, as well as a great place to pick up anything from cheeky Karlsson dolls to cute little art cards with storybook themes.

ABBA: The Museum Museum

(📞08-12 13 28 60; www.abbathemuseum.com; Djurgårdsvägen 68; adult/child 250/95kr; ☺9am-7pm Mon-Fri Jun-Aug, shorter hours rest of year; 🚇67, 🚢Djurgårdsfärjan, Emelie, 🚋7) A sensory-overload experience that might appeal only to devoted ABBA fans, this long-awaited and wildly hyped cathedral to the demigods of Swedish pop is almost aggressively entertaining. It's packed to the gills with memorabilia and interactivity – every square inch has something new to look at, be it a glittering guitar, a vintage photo of Benny, Björn, Frida or Agnetha, a

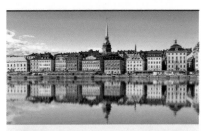

🏙 Navigating Stockholm

Stockholm can seem a baffling city to navigate at first, strewn over 14 islands. Although the city centre and other neighbourhoods are easily walkable, the excellent transport system, comprising trams, buses and metro, is the best way to cover the city's more far-flung sights. Most people start their visit at Gamla Stan, a medieval tangle of narrow alleyways and colourful buildings which, although touristy, is extremely picturesque and home to several truly splendid sights.

Note that very few museums in Stockholm are open before 10am – often not until 11am. Plan to *ta det lugnt* ('take it easy').

Gamla Stan
SCANRAIL/GETTY IMAGES ©

classic music video, an outlandish costume or a tour van from the band members' early days.

◉ Södermalm

Fotografiska Gallery

(www.fotografiska.eu; Stadsgårdshamnen 22; adult/child 135kr/free; ☺9am-11pm Sun-Wed, to 1am Thu-Sat; 🚇Slussen) A stylish photography museum, Fotografiska is a must for shutterbugs. Its constantly changing exhibitions are huge, interestingly chosen and well presented; examples have included a Robert Mapplethorpe retrospective, portraits by indie film-maker Gus Van Sant and an enormous collection of black-and-white photos by Sebastião Salgado. The attached cafe-bar draws a crowd in summer evenings, with

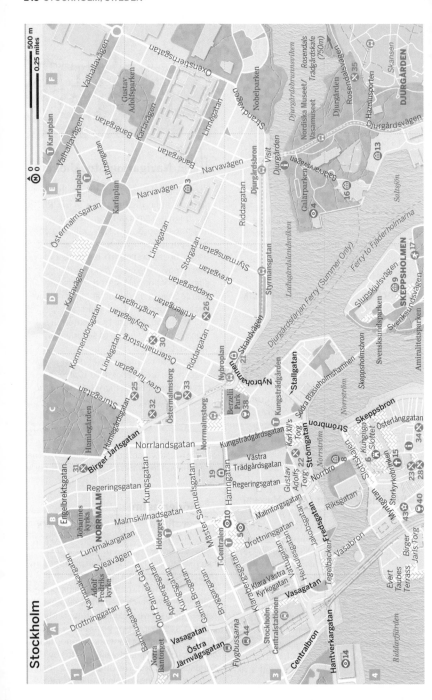

Stockholm

500 m
0.25 miles

DJURGÅRDEN

SKEPPSHOLMEN

NORRMALM

Ferry to Fjäderholmarna

Djurgårdsfärjan Ferry (Summer Only)

Karlaplan

Narvavägen

Östermalmsgatan

Valhallavägen

Oxenstiernsgatan

Gustav
Adolfsparken

Banérgatan

Karlavägen

Lützengatan

Linnégatan

Nobelparken

Strandvägen

Djurgårdsbron

Djurgården

Djurgårdsvägen

Nordiska Museet/
Vasamuseet

Djurgårdsbrunnsviken

Rosendals
Trädgårdskafé
(750m)

Rosendalsvägen

Hazeliusporten

Skansen

Galärvarvsvägen

Galärparken

Saltsjön

Riddargatan

Styrmansgatan

Linnégatan

Storgatan

Grevgatan

Skepparegatan

Artillerigatan

Jungfrugatan

Sibyllegatan

Östermalmstorg

Riddargatan

Kommendörsgatan

Karlavägen

Grev Turegatan

Sturegatan

Humlegårdsgatan

Humlegården

Birger Jarlsgatan

Norrlandsgatan

Engelbrektsgatan

Johannes
kyrka

Kungsgatan

Regeringsgatan

Kungsgatan

Malmskillnadsgatan

Master Samuelsgatan

Norrmalmstorg

Nybroplan

Nybrohamnen

Strandvägen

Stallgatan

Berzelii
Park

Kungsträdgårdsgatan

Kungsträdgårdsgatan

Västra
Trädgårdsgatan

Regeringsgatan

Hamngatan

Gustav
Adolfs
Torg

Karl XII's
Torg

Strömgatan

Norrbro

Strömbron

Skeppsbron

Södra Blasieholmshamnen

Skeppsholmsbron

Norrström

Norrström

Riksgatan

Slottsbacken

Kungliga
Slottet

Österlånggatan

Storkyrkobrinken

Munkbron

Birger
Jarls Torg

Riddarfjärden

Norra
Bantorget

Adolf
Fredriks
kyrka

Barnhusgatan

Kammakargatan

Vasagatan

Östra
Järnvägsgatan

Drottninggatan

Olof Palmes Gata

Apelbergsgatan

Luntmakargatan

Sveavägen

Kungsgatan

Gamla Brogatan

Bryggargatan

Hötorget

T-Centralen

Drottninggatan

Vattugatan

Klarabergsgatan

Klara Västra
Kyrkogatan

Herkulesgatan

Jakobsgatan

Malmtorgsgatan

Fredsgatan

Tegelbacken

Vasabron

Vasagatan

Centralbron

Stockholm
Centralstationen

Flygbussarna

Hantverkargatan

Evert
Taubes
Terrass

Visit
Djurgården

Sights
3
4
13
16
17

26
30
31
33
38

Eating
19
22
23
25
28
31
32
34
35
40
43
44

Drinking & Nightlife
5
6
8
9
10
14
15
21

Stockholm

DJs, good cocktails and outdoor seating. Follow signs from the Slussen tunnelbana stop to reach the museum.

◎ Östermalm & Ladugårdsgärdet

Historiska Museet — Museum

(☎08-51 95 56 20; www.historiska.se; Narvavägen 13-17; ☻10am-5pm Jun-Aug, 11am-5pm Tue-Sun, to 8pm Wed Sep-May; ▤44,56, ▤ Djurgårdsbron, ▤Karlaplan, Östermalmstorg) **FREE** The national historical collection awaits at this enthralling museum. From Iron Age skates and a Viking boat to medieval textiles and Renaissance triptychs, it spans over 10,000 years of Swedish culture and history. There's an exhibit about the medieval Battle of Gotland (1361), an excellent multimedia display on the Vikings, a room of breathtaking altarpieces from the Middle Ages, a vast textile collection and a section on prehistoric culture.

TOURS

Millennium Tour — Walking

(www.stadsmuseum.stockholm.se; per person 130kr; ☻11.30am Sat year-round, 6pm Thu Jul-Sep) Fans of Stieg Larsson's madly popular crime novels (*The Girl with the Dragon Tattoo*) will enjoy this walking tour (in English) pointing out key locations from the books and films. While the Stadsmuseum is closed for renovations, buy tickets online or at the **Medieval Museum** (www.medeltidsmuseet.stockholm.se; Strömparterren; ☻noon-5pm Tue-Sun, to 8pm Wed; ▤62, 65, Gustav Adolfs torg) **FREE**. Tour meeting points are printed on the tickets.

Far & Flyg — Ballooning

(☎070-340 41 07; www.farochflyg.se; 10-person group 25,000kr; ⊗late May–mid-Sep) Float over Stockholm in a hot-air balloon for up to an hour and see the city from a rare vantage point. Note that only groups can book trips, so bring your friends, and reserve well ahead.

SHOPPING

E Torndahl — Design

(www.etorndahl.se; Västerlånggatan 63; ⊗10am-8pm; ®Gamla Stan) This spacious design shop, run by the women of the Torndahl family since 1864, is a calm and civilised oasis on busy Västerlånggatan, offering jewellery, textiles and clever Scandinavian household objects.

Studio Lena M — Gifts & Souvenirs

(www.studiolenam.wordpress.com; Kindstugan 14; ⊗10am-6pm, to 5pm Sat; ®Gamla Stan) This tiny, dimly lit shop is chock-full of adorable prints and products featuring the distinctive graphic design work of Lena M. It's a great place to find a unique – and uniquely Swedish – gift to bring home, or even just a cute postcard.

Svenskt Tenn — Arts, Homewares

(☎08-670 16 00; www.svenskttenn.se; Nybrogatan 15; ⊗10am-6pm Mon-Fri, 10am-4pm Sat; ®Kungsträdgården) As much a museum of design as an actual shop, this iconic store is home to the signature fabrics and furniture of Josef Frank and his contemporaries. Browsing here is a great way to get a quick handle on what people mean by 'classic Swedish design' – and it's owned by a foundation that contributes heavily to arts funding.

NK — Department Store

(☎08-762 80 00; www.nk.se; Hamngatan 12-18; ⊗10am-8pm Mon-Fri, 10am-6pm Sat, 11am-5pm Sun; ®T-Centralen) An ultra-classy department store founded in 1902, NK (Nordiska Kompaniet) is a city landmark – you can see its rotating neon sign from most parts

of Stockholm. You'll find top-name brands and several nice cafes, and the basement levels are great for stocking up on souvenirs and gourmet groceries. Around Christmas, check out its inventive window displays.

ENTERTAINMENT

For an up-to-date events calendar, see www.visitstockholm.com. Another good source, if you can navigate a little Swedish, is the Friday 'På Stan' section of *Dagens Nyheter* newspaper (www.dn.se/pa-stan).

Mosebacke Etablissement — Live Music

(http://sodrateatern.com; Mosebacketorg 3; ⊗6pm-late; ®Slussen) Eclectic theatre and club nights aside, this historic culture palace hosts a mixed line-up of live music. Tunes span anything from home-grown pop to Antipodean rock. The outdoor terrace (featured in the opening scene of August Strindberg's novel *The Red Room*) combines dazzling city views with a thumping summertime bar. It adjoins Södra Teatern and a couple of other bars.

Stampen — Jazz

(☎08-20 57 93; www.stampen.se; Stora Nygatan 5; cover free-200kr; ⊗5pm-1am Tue-Fri & Sun, 2pm-1am Sat; ®Gamla Stan) Stampen is one of Stockholm's music-club stalwarts, swinging to live jazz and blues six nights a week. The free blues jam (currently on Sundays) pulls everyone from local noodlers to the odd music legend.

EATING

Gamla Stan

Chokladkoppen — Cafe €

(www.chokladkoppen.se; Stortorget 18; cakes & coffees from 35kr, mains 85-125kr; ⊗9am-11pm Jun-Aug, shorter hours rest of year; ☎; ®Gamla Stan) Arguably Stockholm's best-loved

 Active City

One thing visitors will notice about Stockholm, particularly during the summer months, is how fit and active the majority of locals are. Outdoor activity is a well-integrated part of the city's healthy lifestyle, and there are numerous ways in which a visitor can get in on the action.

Cycling

Stockholm is a very bicycle-friendly city. Cycling is best in the parks and away from the busy central streets and arterial roads, but even busy streets usually have dedicated cycle lanes. There's also a separate network of paved walking and cycling paths that reaches most parts of the city; these paths can be quite beautiful, taking you through green fields and peaceful forested areas. Tourist offices carry maps of cycle routes. Borrow a set of wheels from **City Bikes** (www.citybikes.se; 3-day/season card 165/300kr).

Swimming

Swimming is permitted just about anywhere people can scramble their way to the water. Popular spots include the rocks around Riddarfjärden and the leafy island of Långholmen, the latter also sporting a popular gay beach.

Rock Climbing

Climbers will find around 150 cliffs within 40 minutes' drive of the city, plus a large indoor climbing centre in Nacka.

cafe, hole-in-the-wall Chokladkoppen sits slap bang on the old town's enchanting main square. It's an atmospheric spot with a sprawling terrace and pocket-sized interior with low-beamed ceilings, custard-coloured walls and edgy artwork. The menu includes savoury treats like broccoli-and-blue-cheese pie and scrumptious cakes.

Under Kastanjen Swedish €€

(☑08-21 50 04; www.underkastanjen.se; Kindstugatan 1, Gamla Stan; mains 182-289kr, dagens lunch 105kr; ⊗8am-11pm Mon-Fri, 9am-11pm Sat, 9am-9pm Sun; ☞; �🚇Gamla Stan) This has to be just about the most picturesque corner of Gamla Stan, with tables set on a cobbled square under a beautiful chestnut tree surrounded by ochre and yellow storybook houses. Enjoy classic Swedish dishes like homemade meatballs with mashed potato; the downstairs wine bar has a veritable Spanish bodega feel with its whitewashed brick arches and moody lighting.

Kryp In Swedish €€€

(☑08-20 88 41; www.restaurangkrypin.nu; Prästgatan 17; lunch mains 135-168kr, dinner mains 198-290kr; ⊗5-11pm Mon-Fri, noon-4pm & 5-11pm Sat & Sun; ☞; 🚇Gamla Stan) Small but perfectly formed, this spot wows diners with creative takes on traditional Swedish dishes. Expect the likes of salmon carpaccio, Kalix roe, reindeer roast or gorgeous, spirit-warming saffron aioli shellfish stew. The service is seamless and the atmosphere classy without being stuffy. The three-course set menu (455kr) is superb. Book ahead.

⊗ Djurgården & Skeppsholmen

Rosendals Trädgårdskafe Cafe €€

(☑08-54 58 12 70; www.rosendalstradgard. se; Rosendalsterrassen 12; mains 99-145kr; ⊗11am-5pm Mon-Fri, to 6pm Sat & Sun May-Sep, closed Mon Feb-Apr & Oct-Dec; 🅿🏊; 🚌44, 69, 76 Djurgårdsbron, 🚋7) 🌿 Set among the greenhouses of a pretty botanical garden, Rosendals is an idyllic spot for heavenly pastries and coffee or a meal and a glass

of organic wine. Lunch includes a brief menu of soups, sandwiches (such as ground-lamb burger with chanterelles) and gorgeous salads. Much of the produce is biodynamic and grown on-site.

Södermalm

Hermans
Trädgårdscafé Vegetarian €€
(☏08-643 94 80; www.hermans.se; Fjällgatan 23B; buffet 195kr, desserts from 35kr; ⏱11am-9pm; 🖉; 🚍2, 3, 53, 71, 76 Tjärhovsplan, 🚇Slussen) 🍃 This justifiably popular vegetarian buffet is one of the nicest places to dine in Stockholm, with a glassed-in porch and outdoor seating on a terrace overlooking the city's glittering skyline. Fill up on inventive, flavourful veggie and vegan creations served from a cosy, vaulted room – you might need to muscle your way in, but it's worth the effort.

Meatballs for
the People Swedish €€
(☏08-466 60 99; www.meatballs.se; Nytorgsgatan 30, Södermalm; mains 179-195kr; ⏱11am-10pm Mon-Thu, to midnight Fri & Sat, limited hours Jul & Aug; 🛜; 🚇Medborgarplatsen) The name says it all. This restaurant serves serious meatballs, including moose, deer, wild boar and lamb, served with creamed potatoes and pickled vegetables, washed down with a pint of Sleepy Bulldog craft beer. It's a novel twist on a traditional Swedish dining experience, accentuated by the rustic decor and delightful waiting staff.

Woodstockholm Swedish €€€
(☏08-36 93 99; www.woodstockholm.com; Mosebacketorg 9, Södermalm; mains 265-285kr; ⏱11.30am-2pm Mon, 11.30am-2pm & 5-11pm Tue-Sat; 🛜🖉; 🚇Slussen) 🍃 This hip dining spot incorporates a wine bar and furniture store showcasing chairs and tables by local designers. The menu changes weekly and is themed, somewhat wackily: think Salvador Dalí or Aphrodisiac, the latter including scallops with oyster mushrooms and sweetbreads with yellow beets and horseradish cream. This is fast becoming one of the city's classic foodie destinations. Reservations essential.

Under Kastanjen

Kvarnen

Östermalm & Ladugårdsgärdet

Sturekatten Cafe €

(☑08-611 16 12; www.sturekatten.se; Riddargatan 4; pastries from 35kr; ☺9am-7pm Mon-Fri, 9am-6pm Sat, 10am-6pm Sun; ☒Östermalmstorg) Looking like a life-size doll's house, this vintage cafe is a fetching blend of antique chairs, oil paintings, ladies who lunch and servers in black-and-white garb. Slip into a salon chair, pour some tea and nibble on a piece of apple pie or a *kanelbulle* (cinnamon bun).

Östermalms Saluhall Market

(www.saluhallen.com; Östermalmstorg; ☺9.30am-7pm Mon-Fri, to 5pm Sat; ☒Östermalmstorg) FREE Östermalms Saluhall is a gourmet food hall that inhabits a delightful many-spired brick building. It's a sophisticated take on the traditional market, with fresh produce, fish counters, baked goods, butcher shops and tea vendors and some top places to grab a meal. For best results, arrive hungry and curious.

Ekstedt Swedish €€€

(☑08-611 12 10; http://ekstedt.nu/en; Humlegårdsgatan 17; 4/6 courses 890/1090kr; ☺from 6pm till late Tue-Thu, from 5pm Fri, from 4pm Sat; ☒Östermalmstorg) Dining here is as much an experience as a meal. Chef Niklas Ekstedt's education in French and Italian cooking informs his approach to traditional Scandinavian cuisine – but only slightly. Choose from a four- or six-course set menu built around reindeer and pike-perch. Everything is cooked in a wood-fired oven, over a fire pit or smoked in a chimney.

The Michelin–starred restaurant is frequently named among the best in the world; reservations are essential.

Gastrologik Swedish €€€

(☑08-662 30 60; www.gastrologik.se; Artillerigatan 14; tasting menu 1595kr; ☺6-11.30pm Tue-Fri, 5-11.30pm Sat; ☒Östermalmstorg) Gastrologik is at the forefront of dynamic and modern Scandinavian cooking. Diners choose from a set three- or six-course menu, which changes frequently, as the chefs work closely with suppliers to deliver the

freshest and most readily available produce with a nod to sustainability and tradition. Reservations are essential.

DRINKING & NIGHTLIFE

Akkurat — Bar

(☑08-644 00 15; www.akkurat.se; Hornsgatan 18; ☺3pm-midnight Mon, to 1am Tue-Sat, 6pm-1am Sun; ⟲Slussen) Valhalla for beer fiends, Akkurat boasts a huge selection of Belgian ales as well as a good range of Swedish–made microbrews and hard ciders. It's one of only two places in Sweden to be recognised by a Cask Marque for its real ale. Extras include a vast wall of whisky, and live music several nights a week.

Kvarnen — Bar

(☑08-643 03 80; www.kvarnen.com; Tjärhovsgatan 4; ☺11am-1am Mon & Tue, to 3am Wed-Fri, noon-3am Sat, noon-1am Sun; ⟲Medborgarplatsen) An old-school Hammarby football fan hang-out, Kvarnen is one of the best bars in Söder. The gorgeous beer hall dates from 1907 and seeps tradition; if you're not the clubbing type, get here early for a nice pint and a meal (mains from 210kr). As the night progresses, the nightclub vibe takes over. Queues are fairly constant but justifiable.

Monks Wine Room — Wine Bar

(☑08-23 12 14; www.monkscafe.se; Lilla Nygatan 2; ☺5pm-midnight Tue-Thu, 4pm-midnight Fri & Sat; ⟲Gamla Stan) Set in atmospheric 17th-century surroundings in the heart of the old town, Monks Wine Room has a well-stocked cellar with hundreds of bottles to choose from. Stop by for a quick glass of wine to recharge the batteries, or take some time to sample a cheese and wine pairing.

Monks Porter House — Pub

(☑08-23 12 12; www.monkscafe.se; Munkbron 11; ☺6pm-1am Tue-Sat; ⟲Gamla Stan) This cavernous brewpub has an epic beer list, including 56 taps, many of which are made here or at the Monks microbrewery in Vasastan. Everything we tried was delicious, especially the Monks Orange Ale – your

 Tickets & Passes

The same tickets are valid on the tunnelbana, local trains and buses within Stockholm County, and some local ferry routes.

Single tickets are available, but if you're traveling more than once or twice it's better to get a refillable Access card. Keep tickets with you throughout your journey.

A single ticket costs 30-60kr and is valid for 75 minutes; it covers return trips and transfers between bus and metro.

A 24hr/72hr/7-day pass costs 120/240/315kr for an adult, and 80/160/210kr for a child. Add another 20kr for a refillable Access card.

Metro station, Stockholm
LAIMONAS CIŪNYS/500PX ©

best bet is to ask the bartender for a recommendation (or a taste). Check online for beer-tasting events.

INFORMATION

DISCOUNT CARDS

Destination Stockholm (☑08-663 00 80; www.stockholmpass.com; adult 1-/2-/3-/5-day pass 595/795/995/1295kr, children half-price) offers the Stockholm Pass, a discount package that includes free sightseeing tours and admission to 75 attractions.

TOURIST INFORMATION

Tourist Center (☑08-550 882 20; www.guidestockholm.info; Köpmangatan 22; ☺10am-4pm Mon-Fri year-round, 11am-2pm Sat & Sun Jun-Sep;

Gamla Stan) Tiny office in Gamla Stan, with brochures and information.

Visit Djurgården (08-667 77 01; www.visit djurgarden.se; Djurgårdsvägen 2; ⊗9am-dusk) With tourist information specific to Djurgården, this office at the edge of the Djurgården bridge is attached to Sjöcaféet cafe (⊘08-660 57 57; www.sjocafeet.se; Djurgårdsvägen 2; ⊗9am-8pm Mon-Tue & Sun, 9am-9pm Thu-Sat), so you can grab a bite or a beverage as you plot your day.

❶ GETTING THERE & AWAY

AIR

STOCKHOLM ARLANDA AIRPORT

Stockholm Arlanda Airport ((ARN); ⊘10-109 10 00; www.swedavia.se/arlanda) Stockholm's main airport, 45km north of the city centre, is reached from central Stockholm by bus, local train and express train. Terminals two and five are for international flights; three and four are domestic; there is no terminal one.

BROMMA AIRPORT

Bromma Airport ((BMA); ⊘010-109 40 00; www.swedavia.se/bromma; Ulvsundavägen; ⊠Brommaplan) Located 8km west of the city centre, Bromma is handy for domestic flights but services only a handful of airlines, primarily British Airways, Brussels Airlines and Finnair.

BUS

Most long-distance buses arrive at and depart from **Cityterminalen** (www.cityterminalen.com; ⊗7am-6pm), which is connected to Centralstationen. The main counter sells tickets for several bus companies, including **Flygbuss** (www.flyg bussarna.se; Cityterminalen; ⊠Centralen) (airport coaches), **Swebus** (www.swebus.se; Cityterminalen) and **Ybuss** (www.ybuss.se; Cityterminalen). You can also buy tickets from Pressbyrå shops and ticket machines. Destinations include:

Malmö from 549kr, 8½ hours, two to four times daily

Gothenburg from 419kr, six hours, eight daily

Uppsala 79kr, one hour, six daily

Jönköping from 269kr, five hours, six daily

Halmstad from 569kr, 12 hours, two daily

Nyköping from 89kr, two hours, eight daily

TRAIN

Stockholm is the hub for national train services run by **Sveriges Järnväg** (SJ; ⊘0771-75 75 75; www.sj.se), with a network of services that covers all the major towns and cities, as well as services to the rest of Scandinavia, including the following destinations:

Malmö from 632kr, five hours, frequent

Kiruna from 795kr, 17 hours, one daily

Uppsala from 95kr, 35 to 55 minutes, frequent

Gothenburg from 422kr, three to five hours, hourly

Gällivare from 795kr, 15 hours, one daily

Jönköping from 696kr, 3½ hours, one daily

Lund from 632kr, 4½ hours, four daily

Oslo from 1000kr, five hours, four daily

Central Station has left-luggage lockers on the lower level (small/large locker for 24 hours 70/90kr).

❶ GETTING AROUND

Storstockholms Lokaltrafik (SL; ⊘08-600 10 00; www.sl.se; Centralstationen; ⊗SL Center Sergels Torg 7am-6.30pm Mon-Fri, 10am-5pm Sat & Sun, inside Centralstationen 6.30am-11.45pm Mon-Sat, from 7am Sun) runs the tunnelbana (metro), local trains and buses within Stockholm county. You can buy tickets and passes at SL counters, ticket machines at tunnelbana stations, and Pressbyrå kiosks. Refillable SL travel cards (20kr) can be loaded with single-trip or unlimited-travel credit. Fines are steep (1500kr) for travelling without a valid ticket.

- **Tunnelbana** The city's underground rail system is efficient and extensive.

- **Bus** Local buses thoroughly cover the city and surrounds.

- **Tram** Tram lines serve Djurgården from Norrmalm.

- **Ferry** In summer, ferries are the best way to get to Djurgården, and they serve the archipelago year-round.

Where to Stay

Neighbourhood	For	Against
Gamla Stan	Central and romantic.	Pricier than other neighbourhoods.
Norrmalm	Handy for trains and buses.	Busier, less atmospheric, sometimes noisy.
Södermalm	Fun, budget-friendly part of town, good for nightlife.	Farther from train and bus stations.
Kungsholmen	Great for exploring restaurants.	A bit out of the way.
Östermalm & Ladugårdsgärdet	Ideal for shopping and nightlife.	Can be expensive.
Suburbs	Some excellent hostels and campgrounds.	Up to an hour from the city centre.
Vasastan	Central enough, but with more of a residential neighbourhood feel.	A little farther from the trains, buses and ferries.
Djurgården & Skeppsholmen	Close to several prime attractions.	Busy and less convenient to trains and buses.

TALLINN, ESTONIA

Tallinn, Estonia at a Glance...

Tallinn is a proud European capital with an allure that's all its own. The city is lively yet peaceful, absurdly photogenic and bursting with wonderful sights – ancient churches, medieval streetscapes and noble merchants' houses. Throw in delightful food and vibrant modern culture and it's no wonder Tallinn is so popular.

Despite the boom of 21st-century development, Tallinn safeguards the fairy-tale charms of its Unesco-listed Old Town – one of Europe's most complete walled cities. And the blossoming of first-rate restaurants, atmospheric hotels and a well-oiled tourist machine makes visiting a breeze.

Two Days in Tallinn

Spend your first day exploring **Old Town**, stopping for lunch in **Chocolats de Pierre** (p274). Spend the afternoon exploring the **Town Hall Square** (p268) and the Estonian History Museum at the **Great Guild** (p267). In the evening, dine at posh Russian restaurant **Tchaikovsky** (p274).

The following day, head to the **Estonian Open-Air Museum** (p263) to explore rural Estonia in an urban location. In the evening, hit the **Rotermann Quarter** (p272).

Four Days in Tallinn

Four days is enough to cover the remainder of central Tallinn's highlights. Round out your days with trips to **St Mary's Lutheran Cathedral** (p268), **Kadriorg Art Museum** (p269) and **Kumu** (p269). Allow some time to wander around super-hip **Telliskivi Creative City** (p268).

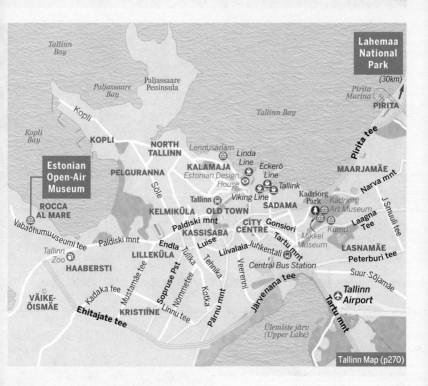

Tallinn Map (p270)

Arriving in Tallinn

From the airport, bus 2 will take you into central Tallinn and then on to the passenger ferry port. A taxi between the airport and the city centre should cost less than €10.

Buses connect the ferry terminals with the city centre. A taxi between the city centre and any of the terminals should cost about €5.

Where to Stay

Tallinn has a good range of accommodation to suit every budget. Most of it is congregated in Old Town and its immediate surrounds, where even backpackers might find themselves waking up in a converted merchant's house. Of course, Tallinn is no secret any more, and it can be extremely difficult to find a bed on the weekend in summer.

Estonian Open-Air Museum

Part folk museum, part architectural showpiece, this fine open-air museum takes rural Estonia and gives it an urban location. As an introduction to the country's traditions, it has few peers.

Great For...

Don't Miss

If you're here on Midsummer's Eve (23 June), come for the traditional celebrations, bonfire and all.

The Museum's Collection

If tourists won't go to the countryside, let's bring the countryside to them. That's the modus operandi of this excellent, sprawling complex, where historic Estonian buildings have been plucked and transplanted among the tall trees. In summer the time-warping effect is highlighted by staff in period costume performing traditional activities among the wooden farmhouses and windmills. There's a chapel dating from 1699 called Kolu Kõrts.

ROCCA
AL MARE
*Kopli
Bay*
*Estonian
Open-Air*
Museum
Vabaõhumuuseumi tee
Paldiski mnt

❶ Need to Know

Estonian Open-Air Museum (Eesti vabaõhumuuseum; ☑654 9101; www.evm. ee; Vabaõhumuuseumi tee 12, Rocca Al Mare; adult/child €9/6 high season, €7/5 low season; ⊙10am-8pm 23 Apr-28 Sep, to 5pm 29 Sep-22 Apr)

✗ Take a Break

Kolu Kõrts, an old wooden tavern, serves traditional Estonian cuisine

★ Top Tip

Combined family tickets include **Tallinn Zoo** (Tallinna loomaed; ☑694 3300; www. tallinnzoo.ee; Paldiski mnt 145, Veskimetsa; adult/child €8/5; ⊙9am-8pm May-Aug, to 7pm Mar, Apr, Sep & Oct, to 5pm Nov-Feb), which is a 20-minute walk away.

Traditional Activities

Some of the activities you can try your hand at include weaving, blacksmithing and traditional cooking. Children love the horse-and-carriage rides (adult/child €9/6), and bikes can be hired (€3 per hour).

Getting to the Museum

To get here from the centre, take Paldiski mnt. When the road nears the water, veer right onto Vabaõhumuuseumi tee. Bus 21 (departing from the railway station at least hourly) stops right out front.

Altja

Lahemaa National Park

Estonia's largest rahvuspark (national park), the 'Land of Bays' is 725 sq km of unspoiled rural Estonia, making it the perfect country retreat from the nearby capital.

Great For...

Don't Miss

Kuusekännu Riding Farm (Kuusekännu Ratsatalu; ☑ 325 2942; www.kuusekannurat satalu.ee; riding per hr €20) arranges trail rides through Lahemaa.

A microcosm of Estonia's natural charms, the park takes in a stretch of deeply indented coast with several peninsulas and bays, plus 475 sq km of pine-fresh hinterland encompassing forest, lakes, rivers and peat bogs, and areas of historical and cultural interest.

Altja

First mentioned in 1465, this fishing village has many restored or reconstructed traditional buildings, including a wonderfully ancient-looking tavern, which was actually built in 1976. Altja's Swing Hill (Kiitemägi), complete with a traditional Estonian wooden swing, has long been the focus of Midsummer's Eve festivities in Lahemaa. The 3km circular Altja Nature & Culture Trail starts at Swing Hill and takes in net sheds, fishing cottages and the stone field known as the 'open-air museum of stones'.

Clock tower and gate of Sagadi Manor

ℹ Need to Know

Lahemaa is best explored by car or bicycle, with limited buses in the park.

✕ Take a Break

In a thatched, wooden building, uber-rustic Altja Kõrts serves delicious traditional fare.

★ Top Tip

The excellent Lahemaa National Park Visitor Centre has information on hiking, accommodation and guides.

Sagadi Manor & Forest Museum

Completed in 1753, this pretty pink-and-white baroque **mansion** (Sagadi Mõis & Metsamuuseum; ☎676 7888; www.sagadi. ee; adult/child €3/2; ◷10am-6pm May-Sep, by appointment Oct-Apr) is surrounded by glorious gardens (which are free to visit), encompassing a lake, numerous modern sculptures, an arboretum and an endless view down a grand avenue of trees. The house ticket includes admission to the neighbouring Forest Museum.

Tammispea Boulder

Over the millennia it has split into several pieces, but this gigantic 7.8m-high erratic boulder is still an impressive sight. It's hidden within a lovely stand of forest. To find it, leave the main coastal road and head through Tammispea village, continuing on to the unsealed road.

Viinistu Art Museum

Viinistu (Kunstimuuseum; www.viinistu. ee; adult/child €4/2; ◷11am-6pm Wed-Sun) houses the remarkable private art collection of Jaan Manitski. It's devoted entirely to Estonian art and pays particularly strong attention to contemporary painting (although you'll also find sculpture, etchings, drawings and more traditional canvasses).

Tallinn's Old Town Walking Tour

Wandering around the medieval streets of Tallinn is one of Scandinavia's most rewarding urban pastimes, and you could spend days in this pleasurable pursuit.

Start Freedom Square
Distance 4km
Duration three hours

Take a Break...
Stop off for down-home Estonian cooking at **Vanaema Juures** (p274).

5 Lower Town Wall (Väike-Kloostri 1) links nine of the 26 remaining towers (there were once 45).

3 Castle Square (Lossi plats) is dominated by the pretty, onion-domed **Alexander Nevsky Orthodox Cathedral** (p269).

4 At **Danish King's Garden**, artists set up their easels in summer to capture the ageless vista over Tallinn's rooftops.

2 From **Linda Hill** (Falgi tee) you can see the remaining medieval elements of **Toompea Castle** (p274).

1 Starting at **Freedom Square** (Vabaduse väljak), take the stairs up into Toompea, noting the famous **Kiek in de Kök** (Komandandi tee 2; www.linnamuuseum.ee) tower on your right.

Baltic Train Station (Balti Jaam)

Rannamäe tee

Toompuiestee

Nunne

Suur-Kloostri

Patkul Lookout

Toompark

TOOMPEA

Rahukohtu

Kohtu

Pikk

Vanaema Juures

Toom-Kooli

Pikk jalg

Dunkri

Piiskopi

Lai

Nunne

Rataskaevu

Niguliste

Toompea Castle

Alexander Nevsky Cathedral

Rüütli

Harju

Paldiski mnt

Falgi tee

Kiek in de Kök

Komandandi tee

START

Toompea

Harjumägi

Hirvepark

Vabaduse väljak

Wismari

Kaarli pst

Kaarli pst

Luise

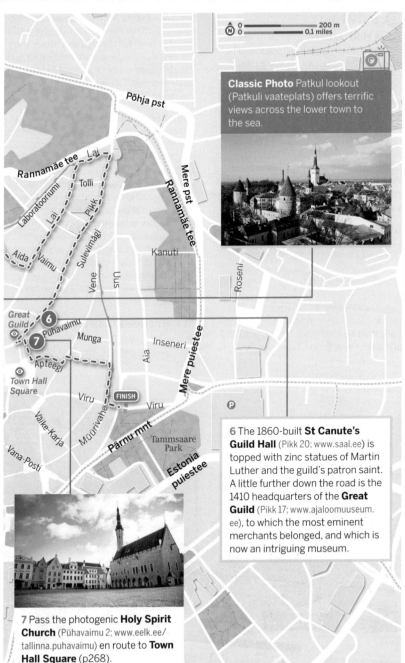

Classic Photo Patkul lookout (Patkuli vaateplats) offers terrific views across the lower town to the sea.

Põhja pst

Rannamäe tee

Tolli

Laboratooriumi

Lai

Pikk

Aida

Vaimu

Sulevimägi

Vene

Uus

Kanuti

Mere pst

Rannamäe tee

Roseni

Great Guild

Pühavaimu

Munga

Inseneri

Aia

Mere puiestee

Apteegi

Town Hall Square

Viru

FINISH

Viru

P

Väike-Karja

Müürivahe

Pärnu mnt

Tammsaare Park

Estonia puiestee

Vana-Posti

6 The 1860-built **St Canute's Guild Hall** (Pikk 20; www.saal.ee) is topped with zinc statues of Martin Luther and the guild's patron saint. A little further down the road is the 1410 headquarters of the **Great Guild** (Pikk 17; www.ajaloomuuseum. ee), to which the most eminent merchants belonged, and which is now an intriguing museum.

7 Pass the photogenic **Holy Spirit Church** (Pühavaimu 2; www.eelk.ee/ tallinna.puhavaimu) en route to **Town Hall Square** (p268).

⊙ SIGHTS

Town Hall Square
Square

(Raekoja plats) In Tallinn all roads lead to Raekoja plats, the city's pulsing heart since markets began setting up here in the 11th century. One side is dominated by the Gothic **town hall** (Tallinna raekoda; ☑645 7900; www.raekoda.tallinn.ee; Raekoja plats; adult/student €5/2; ⊙10am-4pm Mon-Sat Jul & Aug, shorter hrs rest of year; 🖼️), while the rest is ringed by pretty pastel-coloured buildings dating from the 15th to 17th centuries. Whether bathed in sunlight or sprinkled with snow, it's always a photogenic spot.

St Mary's Lutheran Cathedral
Church

(Tallinna Püha Neitsi Maarja Piiskoplik toomkirik; ☑644 4140; www.toomkirik.ee; Toom-Kooli 6; church/tower €2/5; ⊙9am-5pm May & Sep, to 6pm Jun-Aug, shorter hrs/days rest of year) Tallinn's cathedral (now Lutheran, originally Catholic) had been initially built by the Danes by at least 1233, although the exterior dates mainly from the 15th century, with the tower completed in 1779. This impressive building was a burial ground for the rich and titled, and the whitewashed walls are decorated with the elaborate coats of arms of Estonia's noble families. Fit view-seekers can climb the tower.

Telliskivi Creative City
Area

(Telliskivi Loomelinnak; www.telliskivi.eu; Telliskivi 60a; ⊙shops 10am-6pm Mon-Sat, 11am-5pm Sun; 🖼️) Once literally on the wrong side of the tracks, this set of abandoned factory buildings is now Tallinn's most alternative shopping and entertainment precinct, with cafes, a bike shop, bars selling craft beer, graffiti walls, artist studios, food trucks and pop-up concept stores. But it's not only hipsters who flock to Telliskivi to peruse the fashion and design stores, drink espressos and riffle through the stalls at the weekly flea market – you're as likely to see families rummaging and sipping.

St Catherine's Cloister
Church

(www.claustrum.eu; Müürivahe 33; adult/child €2/1; ⊙11am-5pm mid-May–Sep) Perhaps

Kumu

ANDRII ZHEZHERA/SHUTTERSTOCK ©

Tallinn's oldest building, St Catherine's Monastery was founded by Dominican monks in 1246. In its glory days it had its own brewery and hospital. A mob of angry Lutherans torched the place in 1524 and the monastery languished for the next 400 years until its partial restoration in 1954. Today the ruined complex includes the gloomy shell of the barren church (which makes an atmospheric venue for occasional recitals) and a peaceful cloister lined with carved tombstones.

Kadriorg Art Museum Museum

(Kardrioru kunstimuuseum; ☑606 6400; www.kadriorumuuseum.ekm.ee; A Weizenbergi 37, Kadriorg Palace; adult/child €6.50/4.50; ⊙10am-6pm Tue & Thu-Sun May-Sep, to 5pm Thu-Sun Oct-Apr, to 8pm Wed year-round) Kadriorg Palace, a baroque beauty built by Peter the Great between 1718 and 1736, houses a branch of the Estonian Art Museum devoted to Dutch, German and Italian paintings from the 16th to the 18th centuries, and Russian works from the 18th to early 20th centuries (check out the decorative porcelain with Communist imagery upstairs). The pink building is exactly as frilly and fabulous as a palace ought to be, and there's a handsome French–style formal garden at the rear.

Kumu Gallery

(☑602 6000; www.kumu.ekm.ee; A Weizenbergi 34, near Kadriorg Park; adult/student €8/6; ⊙10am-8pm Thu, to 6pm Wed & Fri-Sun year-round, plus 10am-6pm Tue Apr-Sep) This futuristic, Finnish–designed, seven-storey building is a spectacular structure of limestone, glass and copper, nicely integrated into the landscape. Kumu (the name is short for *kunstimuuseum*, or art museum) contains the country's largest repository of Estonian art as well as constantly changing contemporary exhibits. There's everything from venerable painted altarpieces to the work of contemporary Estonian artists such as Adamson-Eric.

 Sweat It Out

Locals attribute all kinds of health benefits to a good old-fashioned sweat and, truth be told, a trip to Estonia just won't be complete until you've paid a visit to the sauna. You won't have to look far – most hotels have one – but Tallinn also has some good public options.

Alexander Nevsky Orthodox Cathedral Cathedral

(☑644 3484; http://tallinnanevskikatedraal.eu; Lossi plats 10; ⊙8am-7pm, to 4pm winter) The positioning of this magnificent, onion-domed Russian Orthodox cathedral (completed in 1900) at the heart of the country's main administrative hub was no accident: the church was one of many built in the last part of the 19th century as part of a general wave of Russification in the empire's Baltic provinces. Orthodox believers come here in droves, alongside tourists ogling the interior's striking icons and frescoes. Quiet, respectful, demurely dressed visitors are welcome, but cameras aren't.

⊕ ACTIVITIES

Harju Ice Rink Ice Skating

(Harju tänava uisuplats; ☑56246739; www.uisuplats.ee; Harju; per hr adult/child €5/3; ⊙10am-10pm Nov-Mar; ♿) Wrap up warmly to join the locals at Old Town's outdoor ice rink – very popular in the winter months. You'll have earned a *hõõgvein*

Tallinn

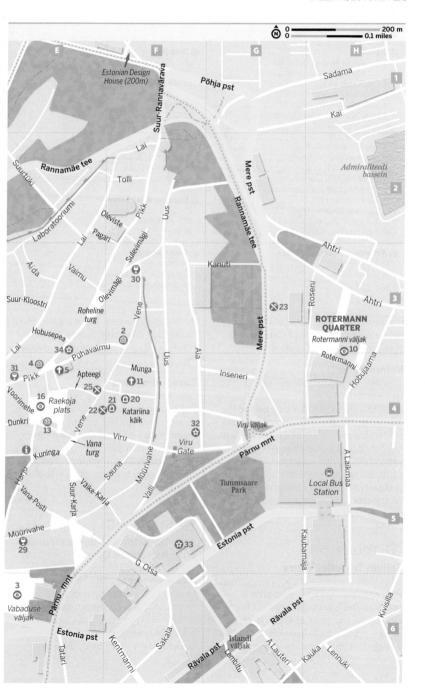

Tallinn

(mulled or 'glowing' wine) in the warm indoor cafe by the end of your skating session. Skate rental costs €3.

Kalma Saun Spa

(☏627 1811; www.kalmasaun.ee; Vana-Kalamaja 9a; €9-10; ☺11am-10pm Mon-Fri, 10am-11pm Sat & Sun) In a grand 1928 building behind the train station, Tallinn's oldest public sauna still has the aura of an old-fashioned, Russian–style *banya* (bathhouse) – flagellation with a birch branch is definitely on the cards. It has separate men's and women's sections (the women's is slightly cheaper), and private saunas are available (per hour €20; up to six people).

☺ TOURS

Tallinn Traveller Tours Tours

(☏58374800; www.traveller.ee) This outfit runs entertaining tours – including a two-hour Old Town walk departing from outside the tourist office (p276) (private groups of 1-15 people from €80, or there's a larger free tour, for which you should tip

the engaging guides). There are also ghost tours (€15), bike tours (from €19), pub crawls (€20) and day trips as far afield as Rīga (€55).

Euroaudioguide Walking

(www.euroaudioguide.com; iPod rental €15) Pre-loaded iPods are available from the tourist office (p276), offering excellent commentary on most Old Town sights, with plenty of history thrown in. If you've got your own iPod, iPhone or iPad you can download the tour as an e-book (€10).

☺ SHOPPING

The city's glitziest shopping precinct is the **Rotermann Quarter** (Rotermanni kvartal; ☏626 4200; www.rotermann.eu; Rotermanni 8), a clutch of former warehouses now sheltering dozens of small stores selling everything from streetwear to Scandinavian–designed furniture, artisanal cheese, good wines, top-notch bread and dry-aged beef. Telliskivi

Creative City (p268) has fewer but more unusual shops, and you'll be tripping over *käsitöö* (handicraft) stores everywhere in Old Town.

Katariina Käik Arts & Crafts
(St Catherine's Passage; www.katariinagild.eu; off Vene 12; ⊘noon-6pm Mon-Sat) This lovely medieval lane is home to the Katariina Guild, comprising eight artisans' studios where you can happily browse the work of 14 female creators. Look for ceramics, textiles, patchwork quilts, hats, jewellery, stained glass and beautiful leather-bound books. Opening hours can vary amongst the different studios.

Masters' Courtyard Arts & Crafts
(Meistrite Hoov; www.hoov.ee; Vene 6; ⊘10am-6pm) Archetypal of Tallinn's amber-suspended medieval beauty, this cobbled 13th-century courtyard offers rich pickings – a cosy chocolaterie/cafe, a guesthouse and artisans' stores and workshops selling quality ceramics, glass, jewellery, knitwear, woodwork and candles.

Balti Jaama Turg Market
(Baltic Station Market; https://astri.ee/bjt; Kopli 1; ⊘9am-7pm Mon-Sat, to 5pm Sun) The gentrification of the train station (p277) precinct is manifest in this sleek new market complex, where niche food vendors trade from tidy huts on the former site of a famed but slightly seedy outdoor market. There's also a supermarket, meat, dairy and seafood halls, greengrocers, fashion retailers, a gym and underground parking.

Estonian Design House Gifts & Souvenirs
(Eesti Disaini Maja; www.estoniandesignhouse. ee; Kalasadama 8; ⊘11am-7pm Mon-Fri, to 6pm Sat & Sun) This slick little store showcases the work of more than 100 Estonian designers – everything from shoes to lamps, furniture to ceramics. Keep an eye out for the 'slow fashion' of local designer

Reet Aus, who creates great clothes for her label out of offcuts from mass-production processes.

😀 ENTERTAINMENT

Find Tallinn's best English–language listings in the bimonthly *Tallinn In Your Pocket* (€2.50, or free at www.inyourpocket.com). There's also *Tallinn This Week* (actually also bimonthly, and free) www.culture.ee, www.concert.ee, www.draamamaa.ee and the ticketing service Piletilevi (www.piletilevi.ee).

Estonia Concert Hall Classical Music
(Eesti Kontserdisaal; ☑614 7771; www.concert.ee; Estonia pst 4) The city's biggest classical concerts are held in this double-barrelled venue, built in the early 20th century and reconstructed after WWII bomb damage. It's Tallinn's most prestigious performance venue, housing both the Estonian National Opera and Ballet (www.opera.ee), and the Estonian National Symphony Orchestra (www.erso.ee).

Chicago 1933 Live Music
(☑627 1266; www.chicago.ee; Aia 3; ⊘noon-midnight Mon & Tue, to 1am Wed & Thu, to 3am Fri, 2pm-3am Sat, 2pm-midnight Sun; 🛜) With a dim, wood-panelled speakeasy vibe, live blues and jazz played by Estonian and international artists most nights, and seriously comfortable horseshoe banquettes amongst the stylish fittings, Chicago is easy to like. There are also bar snacks (sold in bulk – 15 pieces for €21), a good cigar selection and a smoking room in which to enjoy them.

EATING

Vegan Restoran V Vegan €
(☑626 9087; www.vonkrahl.ee; Rataskaevu 12; mains €9-11; ⊘noon-11pm Sun-Thu, to midnight Fri & Sat; 🌱) Visiting vegans are spoiled for choice in this wonderful restaurant. In summer everyone wants one

Visit the Toompea Citadel

Lording it over the lower part of Old Town is the ancient hilltop citadel of **Toompea** (Lossi plats). In German times this was the preserve of the feudal nobility, literally looking down on the traders and lesser beings below. It's now almost completely given over to government buildings, churches, embassies and shops selling amber knick-knacks and fridge magnets, and is correspondingly quieter than the teeming streets below.

YEGOROVNICK/SHUTTERSTOCK ©

of the four tables on the street, but the atmospheric interior is just as appealing. The food is excellent – expect the likes of tempeh and veggies on brown rice with tomato-coconut sauce, and kale and lentil pie with creamy hemp-seed sauce.

Chocolats de Pierre
Cafe €

(☑️641 8061; www.pierre.ee; Vene 6; mains €8-11; ⊙8am-11pm) Nestled inside the picturesque Masters' Courtyard (p273) and offering respite from the Old Town hubbub, this snug cafe is renowned for its delectable (but pricey) handmade chocolates, but it also sells pastries, sandwiches and quiches, making it a great choice for a light breakfast or lunch. As the day progresses, pasta finds its way onto the menu.

Von Krahli Aed
Modern European €€

(☑️58593839; www.vonkrahl.ee; Rataskaevu 8; mains €13-16; ⊙noon-midnight Mon-Sat, to 11pm Sun; 🔊🍴) You'll find plenty of greenery on your plate at this rustic, plant-filled restaurant (aed means 'garden'), beneath the rough beams of a medieval merchant's house. Veggies star here (although all dishes can be ordered with some kind of fleshy embellishment) and there's care taken to offer vegan dishes and gluten-, lactose- and egg-free options.

Vanaema Juures
Estonian €€

(☑️626 9080; www.vonkrahl.ee/vanaemajuures; Rataskaevu 10/12; mains €12-14; ⊙noon-10pm) Food just like your grandma used to make, if she was a) Estonian, and b) a really good cook. 'Grandma's Place' was one of Tallinn's most stylish restaurants in the 1930s, and still rates as a top choice for traditional, homestyle Estonian fare such as blood sausages with lingonberry jam. Antiques and photographs lend the dining room a formal air.

Tchaikovsky
Russian, French €€€

(☑️600 0600; www.telegraafhotel.com; Vene 9; mains €24-25; ⊙noon-3pm & 6-11pm Mon-Fri, 1-11pm Sat & Sun; 🔊) Located in a glassed-in pavilion within the **Hotel Telegraaf** (☑️600 0600; www.telegraafhotel.com; Vene 9; r €225-255; 🅿🌸🔊🏊), Tchaikovsky offers a dazzling tableau of blinged-up chandeliers, gilt frames and greenery. Service is formal and faultless (as is the carefully contemporized menu of Franco–Russian classics) and the experience is capped by live chamber music. The €25 three-course weekday lunch is excellent value and there's terrace seating in summer.

Ö
New Nordic €€€

(☑️661 6150; www.restoran-o.ee; Mere pst 6e; degustation menus €59-76; ⊙6-11pm Mon-Sat, closed Jul) Award-winning Ö (pronounced 'er' and named for Estonia's biggest island, Saaremaa) has carved a unique space in

Tallinn's culinary world, delivering inventive degustation menus showcasing seasonal Estonian produce. There's a distinct New Nordic influence at play, deploying unusual ingredients such as fermented birch sap and spruce shoots, and the understated dining room nicely complements the theatrical but always delicious cuisine.

🍷 DRINKING & NIGHTLIFE

Don't worry about Tallinn's reputation as a stag-party paradise: it's easy to avoid the 'British' and 'Irish' pubs in the southeast corner of Old Town where lager louts congregate (roughly the triangle formed by Viru, Suur-Karja and the city walls).

Levist Väljas Bar
(☑5077372; Olevimägi 12; ☺3pm-3am Mon-Thu, to 6am Fri & Sat, to midnight Sun) Inside this much-loved Tallinn cellar bar (usually the last pit stop of the night) you'll find broken furniture, cheap booze and a refreshingly motley crew of friendly punks, grunge kids and anyone else who strays from the well-trodden tourist path.

The discreet entrance is down a flight of stairs.

No Ku Klubi Bar
(☑631 3929; Pikk 5; ☺noon-1am Mon-Thu, to 3am Fri, 2pm-3am Sat, 6pm-1am Sun) A nondescript red-and-blue door, a key-code to enter, a clubbable atmosphere of regulars lounging in mismatched armchairs – could this be Tallinn's ultimate 'secret' bar? Once the surreptitious haunt of artists in Soviet times, it's now free for all to enter – just ask one of the smokers outside for the code. Occasional evenings of low-key music and film are arranged.

Gloria Wine Cellar Wine Bar
(☑640 6804; www.gloria.ee; Müürivahe 2; ☺noon-11pm Mon-Sat) Set in a cellar beneath the inner face of the town wall, this atmospheric wine bar and shop stocks thousands of bottles across a series of vaulted stone chambers. Credenzas, heavy carpets, antique furniture and walls hung with paintings greet you inside, and the passing life of Tallinn outside, should the weather encourage an alfresco glass.

Chocolats de Pierre

Tourist Information Centre

 INFORMATION

DISCOUNT CARDS

With the **Tallinn Card** (www.tallinncard.ee), you'll pay €25/37/45 for a one/two/three-day adult card (children €14/19/23) and get free entry to more than 40 sights and attractions (including most of the big-ticket ones), unlimited use of public transport and plenty of other discounts on shopping, dining and entertainment. You can buy the Tallinn Card online, from the **Tourist Information Centre**, or from many hotels.

TOURIST INFORMATION

Tallinn Tourist Information Centre (☎645 7777; www.visittallinn.ee; Niguliste 2; ⊙9am-7pm Mon-Sat, to 6pm Sun Jun-Aug, shorter hrs rest of year) A very well-stocked and helpful office. Many Old Town walking tours leave from here.

 GETTING THERE & AWAY

AIR

Tallinn Airport (Tallinna Lennujaam; ☎605 8888; www.tallinn-airport.ee; Tartu mnt 101) is conveniently located just 4km southeast of the city centre and offers air connections with 34 other Baltic and European destinations.

BOAT

Ferries fan across the Baltic from Tallinn to Helsinki, St Petersburg, Mariehamn and Stockholm.

Eckerö Line (☎6000 4300; www.eckeroline.fi; Passenger Terminal A, Vanasadam; adult/child/car from €19/12/19; ⊙ticket office 8.30am-7pm Mon-Fri, to 3pm Sat & Sun) Twice-daily car ferry from Helsinki to Tallinn (2½ hours).

Linda Line (☎699 9331; www.lindaliini.ee; Patarei Sadam, Linnahall Terminal) Operates smaller, faster (and more expensive) hydrofoil connections between Tallinn and Helsinki, from late March to late December.

Tallink (☎631 8320; www.tallink.com; Terminal D, Lootsi 13) Runs multiple daily services between Tallinn and Helsinki, and an overnight ferry to Stockholm, via the Åland islands.

Viking Line (☎666 3966; www.vikingline.com; Terminal A, Varasadam; passenger & vehicle

from €42) At least four daily car ferries between Helsinki and Tallinn (2½ hours).

BUS

Regional and international buses depart from Tallinn's **Central Bus Station** (Tallinna bussijaam; ☎12550; www.bussijaam.ee; Lastekodu 46; ⊙ticket office 7am-9pm Mon-Sat, 8am-8pm Sun), about 2km southeast of Old Town; bus 2 or tram 4 will get you there. The national bus network is extensive, linking Tallinn to pretty much everywhere you might care to go. All services are summarised on the extremely handy Tpilet site (www.tpilet.ee).

TRAIN

The **Baltic Train Station** (Balti Jaam; Toompuiestee 35) is on the northwestern edge of Old Town; despite the name, it has no direct services to other Baltic states. **GoRail** (www.gorail.ee) runs a daily service stopping in Narva (€8.10, 2½ hours) en route to St Petersburg and Moscow.

❶ GETTING AROUND

Tallinn is very compact, with excellent, cheap public transport. If you're staying in or near Old Town, as most visitors do, you may find shoe leather the most efficient means of transport.

Tallinn has an excellent network of buses, trams and trolleybuses running from around 6am to 11pm or midnight. The major **local bus station** is beneath the Viru Keskus shopping centre. All local public transport timetables are online at www.tallinn.ee.

Public transport is free for Tallinn residents, children under seven and adults with children under three. Others need to pay, either buying a paper ticket from the driver (€2 for a single journey, exact change required) or by using the e-ticketing system. Buy a Ühiskaart (a smartcard, requiring a €2 deposit which can't be recouped within six months of validation) at an R-Kiosk, post office or the Tallinn City Government customer service desk, add credit, then validate the card at the start of each journey using the orange card-readers. E-ticket fares are €1.10/3/6 for an hour/day/five days.

🏛 Introducing Estonians

Despite (or perhaps because of) centuries of occupation by Danes, Swedes, Germans and Russians, Estonians have tenaciously held onto their national identity and are deeply, emotionally connected to their history, folklore and national song tradition. The Estonian Literary Museum in Tartu holds more than 1.3 million pages of folk songs, the world's second-largest collection (Ireland has the largest), and Estonia produces films for one of the world's smallest audiences (only Iceland produces for a smaller audience).

According to the popular stereotype, Estonians (particularly the men) are reserved and aloof. Some believe it has much to do with the weather – those long, dark nights breeding endless introspection. This reserve also extends to gross displays of public affection, brash behaviour and intoxication – all frowned upon. This is assuming that there isn't a festival under way, such as Jaanipäev, when friends, family and acquaintances gather in the countryside for drinking, dancing and revelry.

Estonians are known for their strong work ethic, but when they're not toiling in the fields, or putting in long hours at the office, they head to the countryside. Ideal weekends are spent at the family cottage, picking berries or mushrooms, walking through the woods, or sitting with friends soaking up the quiet beauty. Owning a country house with a sauna is one of the national aspirations.

Estonian folk dancers, Tallinn
YEGOROVNICK/SHUTTERSTOCK ©

Stadshuset, Stockholm (p246)

In Focus

Wind turbines, Norway

DRIMAFILM/SHUTTERSTOCK ©

Scandinavia Today

The Nordic nations tend to be table-toppers on global measures of equality, development, sustainability and liveability. Despite the impact of the financial crisis, these countries remain at the forefront of all that is forward-thinking and progressive. The world has come knocking at Scandinavia's door, regardless of its history of isolation, in the shape of immigration and climate change.

Immigration

Exacerbated by the financial crisis, the relatively rapid influx of immigrants to formerly homogeneous Nordic societies has raised tensions in recent years, resulting in anti-immigration and far-right political parties gaining substantial portions of the popular vote. Local opinion has polarised, raising the question of whether the region's famed tolerance was just a veneer. Much of the debate has been focused on the 2017 terrorist attack in Stockholm by a failed asylum seeker cited by politicians across the region as evidence of the need for tighter controls. On the other side, Anders Breivik's 2011 massacre of Norwegian teenagers or Finland's troubled history with guns could be seen as powerful evidence that local extremism is a bigger problem.

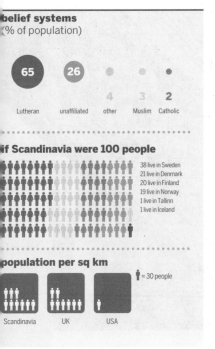

belief systems
(% of population)

65	26	4	3	2
Lutheran	unaffiliated	other	Muslim	Catholic

if Scandinavia were 100 people

38 live in Sweden
21 live in Denmark
20 live in Finland
19 live in Norway
1 live in Tallinn
1 live in Iceland

population per sq km

♦ ≈ 30 people

Scandinavia UK USA

There has always been a divide between Scandinavia's liberal cities and its more conservative countryside, and the settlement of refugees in rural areas has brought global issues to remote doorsteps. For some, particularly older generations, the perception of overwhelming immigration – combined with the sharp decline of churchgoing in recent decades, and plus various technological developments – has led to worries about the loss of traditional values and culture.

Environment

Scandinavia is a model of sustainability, with high – 100% in the cases of Norway and Iceland – renewable electricity output, a firm and long-standing commitment to recycling, stringent environmental certifications and lots of investment in green technology. Firm government commitments have pledged to make most of the Nordic nations carbon neutral within a few years.

Nevertheless, Norway's oil industry is a major contribution to the world's fossil fuels, and dramatically changed weather patterns have already affected the region, with much milder winters and a corresponding decrease in snow cover. The rapid warming of the polar region – some scientists predict that ice-free summers at the North Pole may come as early as 2030 – will have a huge, potentially devastating effect on the Scandinavian ecosystem, impacting everything from fisheries to indigenous rights. Less snow and ice cover means that more heat is absorbed rather than reflected by the earth's surface, exacerbating the rapid warming; the consequent thawing of layers of permafrost will release yet more trapped carbon into the atmosphere. Reindeer herding in the north has already been severely affected.

As members of the Arctic Council (www.arctic-council.org), which strives to protect the northern environment, the Nordic countries are intimately engaged with trying to find solutions. However, questions about the management of resources under the ice cap in Russian and Canadian territories remain unanswered.

The European Union

If the European Union is a house party, then festivities have been badly soured by the economic crisis and immigration issue. Finns grumbled that they were paying for everyone else to have a good time, while Danes and Swedes wanted to tighten up their formerly liberal policies on those some perceived as gate-crashers. Then Britain left in a huff and those remaining have begun to feel that maybe the party isn't so bad after all – it's cold outside and there's a big bear lurking. Meanwhile, friendly neighbour Norway isn't a party person but now wonders if its standing invitation to share the food and beer might be re-evaluated after the commotion of Britain's exit. And Iceland? Still dithering by the doorbell, wondering if the party is worthwhile.

Viking drakkar (Dragon ship)

GOGA18128/SHUTTERSTOCK ©

History

From Vikings to social democrats, through wars, treaties and peace, Scandinavia has had an interesting ride. Innovation has been a constant theme, from longships ploughing furrows across the known world and beyond to wholesale religious change, from struggles for independence to postwar democracies that changed the idea of what it meant to be a citizen of a nation-state. The sparsely populated Nordic lands often punch well above their weight.

12,000–9000 BC

In the wake of the receding glaciers of the last Ice Age, the reinhabiting of Scandinavia begins.

4000 BC

Agriculture begins in Denmark and southern Sweden.

AD 793

The first recorded sacking of an English monastery marks the beginning of the Age of the Vikings.

Petäjävesi Vanha Kirkko (p143)

FEDERICA GENTILE/GETTY IMAGES ©

The Vikings

Our view of the Vikings is often heavily conditioned by accounts written by terrified monks of the plundering of their monasteries by fierce dragonship-borne warriors from across the sea. In fact, though the Norse sagas bear out the fact that they were partial to a bit of sacking and skull-crushing, the portrait of these fascinating Scandinavians is a more complex one.

Developing marvellous seafaring skills, the Vikings, whose era is normally considered to have begun in the late 8th century, became inveterate traders whose influence – and, sometimes, pillaging – eventually extended across much of Europe. Often voyaging on their own account or for local warlords rather than for any ruler, they explored, settled, fought, farmed and mixed with locals right across northern Europe, through the whole Mediterranean, well into modern-day Russia and across the Atlantic, establishing Iceland and reaching America.

As belief in Valhalla's free bar and the end-of-days vision of Ragnarök were superseded by heavenly harps and the Last Judgement, so the Vikings blended gradually into what came afterwards. The best example is the defeat of Harald Hardrada, king of Norway, in England in 1066.

850

Norse settlers begin to take up residence in Iceland.

1000–1170

Christianity takes over the region, with Finland the last to be evangelised.

1397

The Kalmar Union joins much of Scandinavia together under the direction of a common monarch.

The Secrets of Viking World Domination

The main god who provided strength to the Viking cause was Odin (Oðinn), the 'All-Father' who was married to Frigg. Together they gave birth to a son, Thor (Þór), the God of Thunder. The Vikings believed that if they died on the battlefield, the all-powerful Odin would take them to a paradise by the name of Valhalla, where Viking men could fight all day and then be served by beautiful women.

Not surprisingly, it was considered far better for a Viking to die on the battlefield than in bed of old age, and Vikings brought a reckless abandon to their battles that was extremely difficult for enemies to overcome – to die or to come away with loot, the Vikings seemed to say, was more or less the same. Equally unsurprising was the fact that the essential Viking values that emerged from their unique world view embodied strength, skill in weapons, heroic courage, personal sacrifice and a disregard for death.

But the Vikings were as much the sophisticates of the Middle Ages as they were its fearless warriors. Viking ships were revolutionary, fast, manoeuvrable vessels capable of withstanding torrid and often long ocean journeys. Longboats were over 30m long, had a solid keel, a flexible hull and large, square sails, and could travel up to 12 knots (22km/h); they enabled the Vikings to launch and maintain a conquest that would go largely unchallenged for 200 years.

It's often cited as the end of the Viking Age, yet victorious King Harold's forebears were Viking royalty, and the Norman conquerors who defeated *him* at Hastings shortly thereafter took their name from 'Norsemen' and were descended from Vikings who had settled in northwest France.

Danish & Swedish Dominance

For around 600 years from the early 13th to the early 19th centuries, Scandinavia was dominated by the kingdoms of Sweden and Denmark, who signed treaties, broke them, fought as allies and enemies, conquered territory across northern Europe and lost it again. Finland basically became a Swedish possession and was a frequent venue for Sweden's territorial squabbles with Novgorod (Russia), which ended up taking control of Finland after heavily defeating Sweden in 1809. Norway was a junior partner to Sweden, then Denmark, then Sweden again. Iceland fell under Danish control, with Danish merchants establishing a legal monopoly on Iceland's resources that lasted nearly 200 years.

During the second quarter of the 16th century, the Reformation swept through Scandinavia, and Lutheran Protestantism was adopted by royal decrees and force. Catholicism, which had taken over from the Norse gods some five centuries earlier, almost ceased to exist in the region.

By the end of the 19th century, independence movements in Finland, Norway and Iceland were strong, and by 1920 all three were autonomous. The Nordic nations as we know them today were in place.

1517–50	1905	1939–40
The Reformation sweeps across Scandinavia, establishing Lutheran Protestantism as the totally dominant religion.	Norway finally regains independence, followed by Finland (1917) and Iceland (1918, 1944).	Finland is invaded by the Soviet Union, and Denmark and Norway by Germany.

World War II

The Nordic nations all had a different experience of the Second World War. The first to be attacked was Finland, whose heroic but ultimately unsuccessful harsh winter struggle against Soviet invasion began in November 1939. A few months later, in April 1940, Germany occupied Denmark without a struggle and simultaneously invaded Norway, which finally succumbed after bitter fighting from Norwegian and other Allied troops.

Iceland, in a royal union with Denmark, remained free but army-less and soon accepted British, then American troops to prevent this strategically placed North Atlantic island from falling under German control. Meanwhile, Sweden had declared itself neutral and remained so – more or less – throughout the war.

Finland, forced to cede territory to the Soviets and ignored by the other Allies, now looked to Germany for help and soon was at war with Russia again as the Germans launched their doomed invasion. They reclaimed their lands but Russia bounced back in 1944. Finland had to cede more territory and then drive the Germans out. As the Wehrmacht retreated across northern Finland and Norway, they destroyed everything in their path, leaving large parts of Lapland devastated. When peace came, the Danes and Norwegians – whose resistance throughout the war had cost them many lives – celebrated the end of occupation with gusto, Sweden dusted itself down slightly sheepishly, Iceland grabbed full independence and the luckless Finns were left without a big chunk of territory and forced to pay reparations to the Allies.

The Social Democratic Years

After the war it was time to rebuild, and there was a chance for the Nordic countries to ask themselves what sort of country they wanted to construct. Governments across the region began laying the foundations for social democratic states in which high taxes and a socially responsible citizenry would be recompensed with lifelong medical care, free education, fair working conditions, excellent infrastructure, comfortable pensions and generous welfare payments for parents and the unemployed.

These nations became standard-bearers for equality and tolerance, and overall wealth increased rapidly, leaving the privations of the war years to memory. Women achieved significant representation at all levels of society, and forward-thinking in policy was much in evidence.

Though the political consensus for the social democratic model of government has waned in recent decades – taxes have fallen and some benefits have been sheared away – in general Scandinavians are still very well looked after by the state, and inequality here is low.

1989
Beer is legalised in Iceland.

1995
Finland and Sweden join what is now the EU. Denmark had already joined in 1973.

2000
The Øresund Bridge is completed, physically linking Sweden (and hence Norway and Finland) to Denmark and the rest of northern Europe.

Architecture

Scandinavia's architecture has always been an enduring part of the region's appeal, with Norway, Sweden and Denmark in particular leading the way. The story begins with traditional turf-roofed houses and stave churches in Norway, the round churches of Bornholm in Denmark, and gabled wooden structures across the region and progresses to urban style icons that give expression to Denmark and Sweden's passion for design.

Traditional Architecture

Norway

Timber and stone are the mainstays of traditional Norwegian architecture; nowhere is this more evident than in the former mining village of Røros, where many of the colourful timber houses date back to the 17th and 18th centuries. Bergen's waterfront Brygge district is one of the finest examples of maritime architecture in a region famous for the genre.

Tallinn, Estonia

The medieval jewel of Estonia, Tallinn's Old Town (*vanalinn*) is without a doubt the country's most fascinating locality. Picking your way along the narrow, cobbled streets is like strolling into the 15th century. You'll pass the ornate stone facades of Hanseatic merchants' houses, wander into hidden medieval courtyards, and find footworn stone stairways leading to sweeping views of the red-roofed city. It's staggeringly popular with tourists, but manages to remain largely unspoilt: while most historic buildings have helpful bilingual plaques, pleasingly few have been turned into pizza restaurants.

Stave Churches

Seemingly conceived by a whimsical child-like imagination, the stave church is an ingenious adaptation to Norway's unique local conditions. Originally dating from the late Viking era, these ornately worked houses of worship are among the oldest surviving wooden buildings on earth, albeit heavily restored. Named for their vertical supporting posts, these churches are also distinguished by detailed carved designs and dragon-headed gables resembling the prows of classic Viking ships. Of the 500 to 600 that were originally built, only about 20 of the 28 that remain retain many of their original components.

Contemporary Architecture

Denmark

Functional, humanistic, organic and sympathetic are all adjectives that might be used to describe the defining features of classic postwar Danish architecture, best embodied in the work of architects such as Jørn Utzon and Arne Jacobsen. Their usually restrained take on modernism has been superseded since the 1990s, often by a much bolder, brasher, even aggressive type of building.

Here is a handful of Copenhagen's most iconic modern buildings:

Radisson Blu Royal Hotel (Arne Jacobsen) Not content with merely creating a building, Jacobsen designed every item in the hotel, down to the door handles, cutlery and the famous Egg and Swan chairs. Room 606 remains entirely as it was on opening day in 1960.

The Black Diamond (Schmidt, Hammer & Lassen) Completed in 1999, Copenhagen's monolithic library extension offers sharp contrast to the original red-brick building. While the latter sits firmly and sombrely, the black granite extension floats on a ribbon of raised glass, leaning towards the harbour as if wanting to detach and jump in.

Operaen (Henning Larsen) While its squat exterior has drawn comparisons to a toaster, the maple-wood and Sicilian marble interior is a triumph.

Royal Danish Playhouse (Lundgaard & Tranberg) Completed in 2008 and facing Operaen, the award-winning Skuespilhuset is dark, subdued and elegant. Its glasshouse design includes a projected upper floor of coloured glass, a playful contrast to the building's muted-grey, English clay bricks.

Den Blå Planet (3XN) Denmark's National Aquarium made quite a splash with its spiral, whirlpool-inspired design. Hitting the scene in 2013, its gleaming silver facade is clad in shingles – diamond-shaped aluminium plates designed to adapt to the building's organic form.

Norway

Due to the need to rebuild quickly after WWII, Norway's architecture was primarily governed by functionalist necessity (the style is often called *funkis* in the local vernacular)

Northern Lights Cathedral, Alta, Norway

© C RITZ/SHUTTERSTOCK ©

rather than any coherent sense of style. Nowhere is this exemplified more than in the 1950, red-brick **Oslo Rådhus** (Fridtjof Nansens plass; ⊘9am-6pm, guided tours 10am, noon & 2pm Jun–mid-Jul; 🚇Kontraskjæret) **FREE**. As the style evolved, functionality was wedded to other concerns, such as recognising the importance of aesthetics in urban renewal (for example in Oslo's Grünerløkka district), and ensured that the country's contemporary architectural forms once again sat in harmony with Norway's environment and history.

Tromsø's Arctic Cathedral (p160), designed by Jan Inge Hovig in 1964, mimics Norway's glacial crevasses and auroral curtains. Another beautiful example is the Sami Parliament (p162) in Karasjok, where Arctic building materials (birch, pine and oak) lend the place a sturdy authenticity, while the use of lights to replicate the Arctic night sky and the structure's resemblance to a Sami *lavvu* are extraordinary. Alta's **Northern Lights Cathedral** (http://nordlyskatedral.autoweb.no/index.jsp; Løkkeveien; adult/child 50/25kr, incl Borealis Alta show 150/75kr; ⊘11am-9pm Mon-Sat & 4-9pm Sun mid-Jun–mid-Aug, 11am-3pm Mon-Sat rest of year) is weird and wonderful, and the creative interpretation of historical Norwegian shapes also finds expression at the **Viking Ship Sports Arena** (Vikingskipet; ☎62 51 75 00; www.hoa.no; Åkersvikaveien 1; 50kr; ⊘9am-8pm Mon-Fri, 9.30am-5pm Sat & Sun 1-17 Aug, 9am-3pm Mon-Fri mid-Oct–Mar, closed rest of year) in Hamar, while Oslo's landmark new opera house (p203) powerfully evokes a fjord-side glacier.

Sweden

The post-industrial city of Malmö has become a hotspot of design and innovation. The old docks northwest of Gamla Staden (Old Town) were converted into ecologically focused housing for the new century. Its landmark Turning Torso (2005) – a twisting residential tower designed by Catalan architect Santiago Calatrava – is an arresting sight dominating the skyline.

Close by is the Öresund bridge (Georg KS Rotne; 2000) connecting the metropolitan areas of Malmö and Copenhagen. After it reaches the end of the bridge section, the road and rail lines literally disappear into the water.

Within Stockholm, contemporary design and culture found a robust home in 1974 in Kulturhuset, a large modernist pavilion holding a wide range of cultural activities. Designed by Peter Celsing, it's like a big set of drawers offering their wares onto the large plaza outside, Sergels Torg; the *torg* (town square) is the modern heart of Stockholm, and standing at its centre is *Kristallvertikalaccent* (Crystal Vertical Accent), a wonderful, luminescent monument to modernity and glassmaking traditions. Designed by sculptor Edvin Öhrström, it was the result of a 1962 competition.

More recently, the planned suburb Hammarby Sjöstad, just south of Stockholm's centre, has taken shape as a sustainably built, ecoconscious neighbourhood. Its approach to mindful integration of infrastructure, transportation, public spaces and energy conservation has been widely influential in urban planning.

Tore Bruvoll playing at Traenafestival, Norway

Music

Despite their relatively low populations, the Nordic nations' influence on global music has been extraordinary. Scandinavia is a bastion of quality classical music and folk traditions; pop acts ABBA, A-ha and Björk have sold tens of millions of albums internationally; and the region's contribution to the metal scene is legendary. There's an excellent range of music festivals, with everything from chamber music to cutting-edge electronica.

Classical & Traditional

Grieg and Sibelius are the big names in Nordic classical music, and both helped – by their music and by their enthusiastic collaboration with other artists and writers – create a romantic nationalism that was an important factor driving eventual Norwegian and Finnish independence. Across the region, classical music is loved and cared for, with state-of-the-art concert halls, festivals and musical education. Finland, in particular, produces an astonishing number of top-grade classical performers and conductors.

Traditional music includes a range of folk styles. Particularly noteworthy are the Icelandic *rímur*, chants from the sagas that have preserved an ancient form of oral storytelling, and Norwegian folk, which incorporates the distinctive Hardanger fiddle.

The Sami of Lapland use a traditional form called the *yoik* (joik). Part chant, part poem, part song, it is an a cappella invocation or description of a person or place that has huge significance in Sami culture. In recent years, Sami artists have incorporated *yoiking* into various styles of modern music with great success. Artists to look out for include Wimme, Mari Boine and Ulla Pirttijärvi.

Norwegian Folk Music

Folk music is a central pillar of Norwegian music, and the Hardanger fiddle – which derives its distinctive sound from four or five sympathetic strings stretched out beneath the usual four strings – is one of Europe's best-loved folk instruments.

Some of the hottest folk acts include Tore Bruvoll and Jon Anders Halvorsen, who perform traditional Telemark songs *(Nattsang);* the live Norwegian performances of Bukkene Bruse (heavy on the Hardanger fiddle; *Spel);* Rusk's impressively wide repertoire of music from southeastern Norway *(Rusk);* Sigrid Moldestad and Liv Merete Kroken, who bring classical training to bear on the traditional fiddle *(Spindel);* and Sinikka Langeland, whose *Runoja* draws on ancient runic music. In 2009 Alexander Rybak, a Norwegian composer, fiddler and pianist of Belorussian descent, won the Eurovision Song Contest.

Traditional Icelandic Music

Until rock and roll arrived in the 20th century, Iceland was a land practically devoid of musical instruments. The Vikings brought the *fiðla* and the *langspil* with them – both a kind of two-stringed box rested on the player's knee and played with a bow. They were never solo instruments but merely served to accompany singers.

Instruments were generally an unheard-of luxury, and singing was the sole form of music. The most famous song styles are *rímur* (poetry or stories from the sagas performed in a low, eerie chant; Sigur Rós have dabbled with the form), and *fimmundasöngur* (sung by two people in harmony). Cut off from other influences, the Icelandic singing style barely changed from the 14th century to the 20th century; it also managed to retain harmonies that were banned by the church across the rest of Europe on the basis of being the work of the devil.

You'll find choirs around Iceland performing traditional music, and various compilation albums, such as *Inspired by Harpa – The Traditional Songs of Iceland* (2013), give a sampling of Icelandic folk songs or *rímur*.

Sami Music

Several Finnish Sami groups and artists have created excellent modern music with the traditional *yoik* (chant; also *joiks* or *juoiggus*) form. The *yoik* is traditionally sung a capella, often invoking a person or place with immense spiritual importance in Sami culture. Wimme is a big name in this sphere, and Angelit produce popular, dance-floor-style Sami music. One of their former members, Ulla Pirttijärvi, releases particularly haunting solo albums, while Vilddas are on the trancey side of Sami music, combining it with other influences. Look out too for rockier offerings from SomBy and Tiina Sanila, Sami hip-hop artist Ailu Valle and electro-acoustic compositions from Niko Valkeapää.

In Norway, recent Sami artists such as Ingor Ánte Áilu Gaup, Sofia Jannock, Mari Boine and Nils Aslak Valkeapää have performed, recorded and popularised traditional and modern versions of the *yoik*. Boine in particular has enjoyed international air-time and her distinctive sound blends folk-rock with *joik* roots.

Classical Estonia

On the international stage, the area in which Estonia has had the greatest artistic impact is classical music. Estonia's most celebrated composer is Arvo Pärt (b 1935), the intense and reclusive

master of hauntingly austere music many have misleadingly termed minimalist. Pärt emigrated to Germany during Soviet rule and his *Miserere Litany, Te Deum* and *Tabula Rasa* are among an internationally acclaimed body of work characterised by dramatic bleakness, piercing majesty and nuanced silence. He's now the world's most performed living classical-music composer.

The main Estonian composers of the 20th century remain popular today. Rudolf Tobias (1873–1918) wrote influential symphonic, choral and concerto works as well as fantasies on folk song melodies. Mart Saar (1882–1963) studied under Rimsky-Korsakov in St Petersburg but his music shows none of this influence. His songs and piano suites were among the most performed pieces of music in between-war concerts in Estonia. Eduard Tubin (1905–82) is another great Estonian composer whose body of work includes 10 symphonies. Contemporary composer Erkki-Sven Tüür (b 1959) takes inspiration from nature and the elements as experienced on his native Hiiumaa.

Estonian conductors Tõnu Kaljuste (who won a Grammy in 2014 for a Pärt recording), Anu Tali and Paavo Järvi are hot tickets at concert halls around the world.

Pop & Beyond

Bursting onto the scene in the 1970s, ABBA brought Swedish music bang into the international spotlight. Their phenomenal global success paved the way for spiritual followers like Roxette and Aqua and set the trend for Scandinavian artists to sing in English. Singing about love, dancing and normal suburban life, ABBA won the hearts of a generation and beyond.

With the path to stardom from Scandinavia now an easier one, the region has cranked out pop and rock success story after success story in the decades since. A-ha, Europe, Ace of Base, the Cardigans, the Rasmus, the Hives, Robyn and Mando Diao have made it big worldwide. Björk, who almost deserves a musical category to herself, brought lonely Iceland into the picture and has been followed by bands like Sigur Rós and Of Monsters and Men.

Jazz is strong across the region, particularly in Norway and Denmark, with a thriving local scene backed by international festivals. Electronica has also been a strong suit, with '90s dancefloor legends like Darude backed by more recent arrivals such as Avicii, Eric Prydz, Kygo and Galantis. Reykjavík, in particular, has a brilliant scene. Hip hop has also gained traction across the region, especially in Finland and Iceland.

The Heavy Stuff

Though its influence isn't quite what it once was, with many millennials preferring Norwegian electronica or Finnish hip hop, Scandinavian bands have been immensely influential in the harder rock and metal scenes, with several metal subgenres basically invented here.

Norway started the trend in the 1980s, with a thriving black metal scene and outrageous antics. It has continued to produce quality bands, with famous names on the black and death metal side of things including Emperor, Burzum, Mayhem, Darkthrone and Dimmu Borgir.

Finnish metal bands have achieved notable international success, with HIM's 'love metal' and Nightwish's gloriously symphonic variety the most prominent. The 69 Eyes, Apocalyptica (who are classically trained cellists), Children of Bodom and Finntroll all represent different genres. Lordi memorably brought the scene to Eurovision, winning in 2006 with Hard Rock Hallelujah.

Sweden has produced legends like Bathory, who moved from hard black metal to a more melodic style based on Viking mythology, Sabaton, HammerFall, Dark Tranquillity and Therion. Denmark has a thriving scene but its bands haven't, in the main, had quite the same international profile. They can, however, claim Lars Ulrich, the Metallica drummer. The Faroes chip in with Týr's Viking metal, and Iceland's most famous metallists are Sólstafir.

Arctic fox, Norway

ONDREJ PROSICKY/SHUTTERSTOCK ©

Nature

The real soul of Scandinavia resides in its glorious natural landscapes. Some of Europe's wildest places are here. From soaring fjord walls in Norway to Iceland's volcanic brutality, from autumn's forest palette to charming Baltic islands, from sparkling summer lakes to Arctic snowscapes, there's a feast of distinct beauty spots, populated by a range of intriguing creatures.

Landscapes

Scandinavia's diverse scenery encompasses gentle pastoral landscapes in the south to untamed canvases wrought by nature's forces in the north. Wild, rugged coasts and mountains, hundreds of kilometres of forest broken only by lakes and the odd cottage, and unspoilt Baltic archipelagos make up a varied menu of uplifting visual treats.

Flat Denmark in the south doesn't have the mountainous magnificence of Norway or the volcanoes of Iceland but has a charming coastal landscape across its hundreds of islands. Offshore Bornholm, and the Baltic archipelagos of Sweden and Finland present a fascinating patchwork where charmingly rural farms alternate with low rock polished smooth by the glaciers of the last Ice Age.

Norway's phenomenal coastline is famous for a reason; the fjords here take your breath away, while the northern mountains are heart-achingly beautiful. Inland, much of mainland Scandinavia is taken up with forests. The region has some of the world's highest tree cover, and the woods – largely managed for forestry, some wild – stretch for hundreds of kilometres. Mainly composed of spruce, pine and birch, these forests are responsible for the crisp, clean, aromatic northern air and are dotted with lakes.

Iceland, thrown up in the middle of the Atlantic by violent geothermal activity, offers a very distinct landscape, with bleak and epic scenery that is at once harsh and gloriously uplifting. The juxtaposition of frozen glaciers and boiling geysers make it a wild scenic ride.

Iceland's Volcanoes

Thin crust and grating plates are responsible for a host of exciting volcanic situations in Iceland. The volcanoes are many and varied – some are active, some extinct, and some are dormant and dreaming, no doubt, of future destruction. Fissure eruptions and their associated craters are probably the most common type of eruption in Iceland. The still-volatile Lakagígar crater row around Mt Laki mountain is the country's most extreme example. It produced the largest lava flow in human history in the 18th century, covering an area of 565 sq km to a depth of 12m.

Several of Iceland's liveliest volcanoes are found beneath glaciers, which makes for dramatic eruptions as molten lava and ice interact. The main 2010 Eyjafjallajökull eruption was of this type: it caused a *jökulhlaup* (flooding caused by volcanic eruption beneath an ice cap) that damaged part of the Ring Road, before throwing up the famous ash plume that grounded Europe's aeroplanes. Iceland's most active volcano, Grímsvötn, which lies beneath the Vatnajökull ice cap, behaved in a similar fashion in 2011.

Recent eruptions in Iceland have tended to be fairly harmless – they're often called 'tourist eruptions' because their fountains of magma, electric storms and dramatic ash clouds make perfect photos but cause relatively little damage. This is partly due to the sparsely populated land, and partly because devastating features such as fast-flowing lava, lahars (mudslides) and pyroclastic surges (like the ones that obliterated Pompeii and Herculaneum) are usually absent in this part of the world. As of 2016, the volcanoes to watch are Katla and Hekla, both well overdue for eruption.

Norway's Fjords

Norway's signature landscape, the fjords rank among the most astonishing natural landforms anywhere in the world. The Norwegian coast is cut deeply with these inlets distinguished by plunging cliffs, isolated farms high on forested ledges and an abundance of ice-blue water extending deep into the Norwegian interior.

Norway's fjords are a relatively recent phenomenon in geological terms. Although Norwegian geological history stretches back 1.8 billion years, the fjords were not carved out until much later. During the glacial periods over this time, the elevated highland plateaus that ranged across central Norway subsided at least 700m due to an ice sheet up to 2km thick. The movement of this ice, driven by gravity down former river courses, gouged out the fjords and valleys and created the surrounding mountains by sharpening peaks and exposing high cliffs of bare rock. The fjords took on their present form when sea levels rose as the climate warmed following the last Ice Age (which ended around 10,000 years ago), flooding into the new valleys left behind by melting and retreating glaciers. Sea levels are thought to have risen by as much as 100m, creating fjords whose waters can seem impossibly deep.

In 2005 Unesco inscribed Geirangerfjord and Nærøyfjord on its World Heritage List because they 'are classic, superbly developed fjords', which are 'among the most scenically outstanding fjord areas on the planet'.

Wildlife

Vast tracts of barely populated land away from the bustle of central Europe make Scandinavia an important refuge for numerous species, including several high-profile carnivores, myriad seabirds and lovable marine mammals.

Estonia

Estonia has 64 recorded species of land mammals, and some animals that have disappeared elsewhere have survived within the country's extensive forests. The brown bear faced extinction at the turn of the 20th century but today there are more than 600 in Estonia. The European beaver, which was also hunted to near extinction, was successfully reintroduced in the 1950s, and today the population is around 20,000.

While roe deer and wild boar are present in their tens of thousands, numbers are dwindling, which some chalk up to predators – though these animals are hunted and appear on the menu in more expensive restaurants (along with elk and bear). Estonia still has grey wolves (thought to number around 135) and lynx (more than 750), handsome furry cats with large, impressive feet that act as snowshoes. Lynx, bears, wolves and beavers are just some of the animals that are hunted each year, although a system of quotas aims to keep numbers stable.

Estonia also has abundant birdlife, with 363 recorded species. Owing to the harsh winters, most birds here are migratory. Although it's found throughout much of the world, the barn swallow has an almost regal status in Estonia and is the 'national bird'; it reappears from its winter retreat in April or May. Another bird with pride of place in Estonia is the stork. While their numbers are declining elsewhere in Europe, white storks are on the increase – you'll often see them perched on the top of lamp posts in large round nests. Black storks, on the other hand, are in decline.

Iceland

Apart from birds, sheep and horses, you'll be lucky to have any casual sightings of animals in Iceland. The only indigenous land mammal is the elusive Arctic fox, best spotted in remote Hornstrandir in the Westfjords – wildlife enthusiasts can apply in advance to monitor these creatures while volunteering at the Arctic Fox Center (www.arcticfoxcenter. com). In East Iceland, herds of reindeer can sometimes be spotted from the road. Reindeer were introduced from Norway in the 18th century and now roam the mountains in the east. Polar bears very occasionally drift across from Greenland on ice floes, but armed farmers make sure they don't last long.

In contrast, Iceland has a rich marine life, particularly whales. On whale-watching tours from Húsavík in northern Iceland, you'll have an excellent chance of seeing cetaceans, particularly dolphins, porpoises, minke whales and humpback whales. Sperm, fin, sei, pilot, orca and blue whales also swim in Icelandic waters and have been seen by visitors. Seals can be seen in the Eastfjords, on the Vatnsnes Peninsula in Northwest Iceland, in the Mýrar region on the southeast coast (including at Jökulsárlón), in Breiðafjörður in the west, and in the Westfjords.

Norway

Norway is home to some of Europe's most charismatic fauna, and tracking them down can be a highlight of your trip. While Norway's unique settlement pattern spreads the human population thinly and limits wildlife habitat, the country more than compensates with its variety of iconic northern European species including musk oxen, reindeer, Arctic fox and elk on the mainland and polar bears and walruses on Svalbard. And offshore, whales have survived the best efforts of hunters to drive them to extinction.

Sweden

Sweden's big carnivores – the bear, wolf, wolverine, lynx and golden eagle – are all protected species. Wolf hunting was banned in the 1970s, after the wolf population had been driven nearly to extinction, but in 2010 the Swedish parliament authorised a cull to bring the newly resurgent species' numbers back down. Most of the country's wolf population is in Dalarna and Värmland.

The wolverine, a larger cousin of the weasel, inhabits high forests and alpine areas along the Norwegian border. There are an estimated 680 in Sweden, mostly in Norrbotten and Västerbotten.

Brown bears were persecuted for centuries, but recent conservation measures have seen numbers increase to about 3200. Bears mostly live in forests in the northern half of the country but are spreading south.

Another fascinating forest dweller is the lynx, which belongs to the panther family and is Europe's only large cat. Sweden's 1200 to 1500 lynx are notoriously difficult to spot because of their nocturnal habits.

Not all of Sweden's wild creatures are predatory, of course. The iconic elk is a gentle, knob-by-kneed creature that grows up to 2m tall. Though they won't try to eat you, elk are a serious traffic hazard, particularly at night: they can dart out in front of your car at up to 50km/h.

Around 260,000 domesticated reindeer roam the northern areas under the watchful eyes of Sami herders. Like elk, reindeer can be a major traffic hazard.

Lemmings are famous for their extraordinary reproductive capacity. Every 10 years or so the population explodes, resulting in denuded landscapes and thousands of dead lemmings in rivers and lakes and on roads.

Norway's Wild Reindeer

Wild *reinsdyr* (reindeer) exist in large herds across central Norway, usually above the treeline and sometimes as high up as 2000m. The prime viewing areas are on the Hardangervidda Plateau, where you'll find Europe's largest herd (around 7000). Sightings are also possible in most national parks of central Norway, as well as the inland areas of Trøndelag.

The reindeer of Finnmark in Norway's far north are domestic and owned by the Sami, who drive them to the coast at the start of summer, then back to the interior in winter.

National Parks

It is an indication of how the Nordic nations value their natural environments that the region has well over a hundred national parks, conserving everything from jewel-like Baltic archipelagos to glaciers and snowy wastes. As well as being crucial drivers of conservation, many of these parks also offer the best chance to appreciate Scandinavia's deep nature.

Some of Europe's best hiking can be done on the short- and long-distance trails in the national parks of Finland, Sweden, Norway and Iceland. These trails offer excellent facilities, including reliable waymarking, well-maintained campsites with firewood and shared cabins where you can sleep. Rules are strict so that the impact from visitors is minimised.

Standout parks for trekking include **Jotunheimen** (www.jotunheimen.com; 17km SW of Lom), **Jostedalsbreen** (Jostedalsbreen Nasjonalparksenter; www.jostedalsbre.no; Oppstryn; adult/child 80/40kr; 10am-4pm or 6pm May–mid-Sep), **Hardangervidda** (53 67 40 00; www.hardangerviddanatursenter. no; Øvre Eidfjord; adult/child 130/65kr; 9am-7pm mid-Jun–mid-Aug, 10am-6pm Apr–mid-Jun & mid-Aug–Oct) and Rondane in Norway; Abisko, **Padjelanta** (Badjelánnda National Park), Skuleskogen, **Sarek** in Sweden; Urho Kekkonen in Finland, Pallas-Yllästunturi, **Oulanka** (Oulangan; www.nationalparks. fi) and Lemmenjoki in Finland; **Snæfellsjökull** and Vatnajökull in Iceland (the wonderful hiking around Þórsmörk is perhaps soon to be national-park covered); and **Mols Bjerge** (http://eng. nationalparkmolsbjerge.dk) in Denmark.

Geirangerfjord, Norwa (p220)y

Survival Guide

Directory A–Z

Accommodation

Scandinavia has a wide range of accommodation, from hostels to boutique hotels and self-catering cottages. Booking ahead in summer is a good idea and is essential year-round in Iceland, where the tourist boom has squeezed accommodation availability.

Hotels Generally bland, chain options. Outside major cities, you can often get discount rates in summer and on weekends.

Camping Grounds Very popular. Most have good-value cabins.

Hostels Great network in Sweden and good options in other countries.

Self-catering From urban apartments to wilderness cottages, this is an excellent option across the region.

B&Bs, Guesthouses & Hotels

● B&Bs, where you get a room and breakfast in a private home, can often be real bargains. Pensions and guesthouses are similar but usually slightly more upmarket.

● Most Scandinavian hotels are geared to business travellers and have prices to match. But excellent hotel discounts are often available at certain times (eg at weekends and in summer in Finland, Norway and Sweden) and for longer stays. Breakfast in hotels is usually included in the price of the room.

● If you think a hotel is too expensive, ask if it has a cheaper room. In non-chain places it can be easy to negotiate a discount in quiet periods.

Camping

● Camping is immensely popular throughout the region. The Camping Key Europe card (www.campingkey.com) offers good benefits and discounts.

● Camping grounds tend to charge per site, with a small extra charge per person. Tent sites are often cheaper than van sites.

● National tourist offices have booklets or brochures listing camping grounds all over their country.

● In most larger towns and cities, camping grounds are some distance from the centre. If you've got no transport, the money you save by camping can quickly be outweighed by the money spent commuting in and out of town.

● Nearly all mainland Scandinavian camping grounds rent simple cabins – a great budget option if you're not carrying a tent. Many also have more upmarket cottages with bedrooms, bathrooms and proper kitchens, perfect for families who want to self-cater.

● Camping other than in designated camping grounds is not always straightforward but in many countries there's a right of common access that applies. Tourist offices usually stock official publications in English explaining your rights and responsibilities.

Hostels

Hostels generally offer the cheapest roof over your head. In Scandinavia hostels are geared to budget travellers of all ages, including families, and most have dorms and private rooms.

Most hostels are part of national Youth Hostel Associations (YHA), known collectively throughout the world as Hostelling International (www.hihostels.com).

You'll have to be a YHA or HI member to use some affiliated hostels (indicated

Book Your Stay Online

For more accommodation reviews by Lonely Planet authors, check out http://hotels.lonelyplanet.com. You'll find independent reviews, as well as recommendations on the best places to stay. Best of all, you can book online.

by a blue triangle symbol) but most are open to anyone. Members get substantial discounts; it's worth joining, which you can do at any hostel, via your local hostelling organisation or online. There's a particularly huge network of HI hostels in Denmark and Sweden.

Comfort levels and facilities vary markedly. Some hostels charge extra if you don't want to sweep your room out when you leave.

Breakfast Many hostels (exceptions include most hostels in Iceland) serve breakfast, and almost all have communal kitchens where you can prepare meals.

Bookings Some hostels accept reservations by phone; they'll often book the next hostel you're headed to for a small fee. The HI website has a booking form you can use to reserve a bed in advance – but not all hostels are on the network. Popular hostels in capital cities can be heavily booked in summer, and limits may be placed on how many nights you can stay.

Linen You must use a sleep-sheet (ie a cotton or silk sleeping bag) or linen in hostels in most Scandinavian countries; regular sleeping bags are not permitted. It's worth carrying your own sleep-sheet or linen, as hiring these at hostels is comparatively expensive.

Travellers with disabilities Specially adapted rooms for visitors with disabilities are common, but check with the hostel first.

Self-Catering

○ There's a huge network (especially in Norway, Sweden, Denmark and Finland) of rental cottages that make excellent, peaceful places to stay and offer a chance to experience a traditional aspect of Scandinavian life.

○ Many Scandinavians traditionally spend their summers in such places. Renting a cottage for a few days as part of a visit to the region is highly recommended.

Customs Regulations

From non-EU to EU countries For EU countries (ie Denmark, Sweden, Finland and Estonia), travellers arriving from outside the EU can bring duty-free goods up to the value of €430 without declaration. You can also bring in up to 16L of beer, 4L of wine, 2L of liquors not exceeding 22% vol or 1L of spirits, 200 cigarettes or 250g of tobacco.

Within the EU If you're coming from another EU country, there is no restriction on the value of purchases for your own use.

Åland islands Arriving on or from the Åland islands (although technically part of the EU) carries the same import restrictions as arriving from a non-EU country.

Other Nordic countries Norway, Iceland and the Faroe Islands have lower limits.

Discount Cards

Seniors Cards Discounts for retirees, pensioners and those over 60 (sometimes slightly younger for women; over 65 in Sweden) at museums and other sights, public swimming pools, spas and with transport companies. Make sure you carry proof of age around with you.

Student Cards If you are studying in Scandinavia, a local student card will get you megadiscounts on transport and more.

Camping Key Europe (www.campingkeyeurope.com) Discounts at many camping grounds and attractions, with built-in third-party insurance. In Denmark and at some Swedish camping grounds, it's obligatory to have this or a similar card. Order through regional camping websites, or buy from camping grounds throughout the region (this is sometimes cheaper). It costs around €16 depending on where you get it.

Camping Card International (www.campingcardinternational.com) Widely accepted in the region, this camping card can be obtained from your local camping association or club.

European Youth Card (www.eyca.org) If you're under 30, you can pick up this card in almost any European country (some specify a maximum

age of 26 though). It offers significant discounts on a wide range of things throughout the region. It's available for a small charge to anyone, not just European residents, through student unions, hostelling organisations or youth-oriented travel agencies.

Hostelling International (www.hihostels.com) The HI membership card gives significant discounts on accommodation, as well as some transport and attractions.

International Student Identity Card (www.isic.org) Discounts on many forms of transport, reduced or free admission to museums and sights, and numerous other offers – a worthwhile way of cutting costs. Check the website for a list of discounts by country. Because of the proliferation of fakes, carry your home student ID as back up. The same organisation also issues an International Youth Travel Card for under-30s, and the International Teacher Identity Card.

Oslo Pass (www.visitoslo.com/en/activities-and-attractions/oslo-pass; 1/2/3days adult 395/595/745kr, child 210/295/370kr), sold at the tourist office, is a good way of cutting transport and ticket costs around the city. The majority of the city's museums are free with the pass, as is public transport within the city limits (barring late-night buses). Other perks include restaurant and tour discounts. If you're planning to visit just the city-centre museums and galleries, it's worth checking

which on your list are free before buying a pass.

Electricity

Type C
220V/50Hz

Type F
230V/50Hz

Etiquette

Greetings Shake hands with men, women and children when meeting them for the first time.

Shoes Take them off when entering someone's home.

Saunas Naked is normally the way to go.

Gifts Bring flowers, pastries, wine or chocolate when invited to someone's house.

LGBT Travellers

Denmark, Finland, Iceland, Norway and Sweden are very tolerant nations, although public displays of affection are less common in rural areas, particularly Lapland.

Health

Travel in Scandinavia presents very few health problems. The level of hygiene is high and there are no endemic diseases.

The extreme winter climate poses a risk; you must be aware of hypothermia and frostbite. In summer, biting insects, such as mosquitoes, are more of an annoyance than a real health risk. Always dress warmly when temperatures are low, and heed weather local warnings.

Before You Go

Health Insurance

Citizens of the European Economic Area (EEA) are covered for emergency medical treatment in other EEA countries (including Denmark, Finland, Iceland, Norway and Sweden) on presentation of a European Health Insurance Card (EHIC), though they may be liable to pay a daily or per-appointment fee as a local would. Enquire about EHICs at your health centre, travel agency or (in some countries) post office well in advance of travel.

Citizens from countries outside the EEA should find out if there is a reciprocal arrangement for free medical care between their country and the country visited. If not, travel health insurance is recommended.

Availability & Cost of Health Care

The standard of health care is extremely high and English is widely spoken by doctors and medical-clinic staff. Even if you are covered for health care here, you may be required to pay a per-visit fee as a local would. This is likely to be around €30 to €100 for a doctor or hospital visit.

Internet Access

● Wireless (wi-fi) hotspots are rife. Numerous cafes and bars, and nearly all hostels and hotels offer the service for free. A number of towns and cities in the region have free public wi-fi across the centre.

● Data is cheap. Buy a local SIM card, pop it in an unlocked phone, laptop or USB modem, and away you go. Deals may mean you pay as little as €15 to €20 for a month's unlimited access.

● Internet cafes are increasingly uncommon, but libraries provide free or very cheap internet service.

Money

ATMs Widespread, even in small places. This is the best way to access cash in Scandinavia. Find out what your home bank will charge you per withdrawal before you go as you may be better off taking out larger sums.

Cash cards Much like debit or credit cards but are loaded with a set amount of money. They also have the advantage of lower withdrawal fees than your bank might otherwise charge you.

Changing money All Scandinavian currencies are fully convertible.

Charge cards These include cards like American Express and Diners Club. Less widely accepted than credit cards because they charge merchants high commissions.

Debit and credit cards Scandinavians love using plastic, even for small transactions, and you'll find that debit and credit cards are the way to go here.

Foreign currencies Easily exchanged, with rates usually

Government Travel Advice

The following government websites offer travel advisories and information for travellers.

Australian Department of Foreign Affairs & Trade (www.smartraveller.gov.au)

Canadian Department of Foreign Affairs & International Trade (www.voyage.gc.ca)

French Ministère des Affaires Étrangères et Européennes (www.diplomatie.gouv.fr/fr/conseils-aux-voyageurs)

Italian Ministero degli Affari Esteri (www.viaggiaresicuri.mae.aci.it)

New Zealand Ministry of Foreign Affairs & Trade (www.safetravel.govt.nz)

UK Foreign & Commonwealth Office (www.gov.uk/foreign-travel-advice)

US Department of State (www.travel.state.gov)

Exchange Rates

		Denmark (DKK)	Finland (€)	Iceland (ISK)	Norway (NOK)	Sweden (SEK)
Australia	A$1	4.99	0.67	85.10	6.28	6.37
Canada	C$1	5.11	0.69	87.19	6.44	6.53
Eurozone	€1	7.45	–	126.98	6.37	6.51
Japan	¥100	5.63	0.76	95.94	7.08	7.19
New Zealand	NZ$1	4.55	0.61	77.53	5.72	5.81
UK	£1	8.47	1.14	144.46	10.67	10.82
US	US$1	6.24	0.84	106.30	7.85	7.96

For current exchange rates, see www.xe.com.

slightly better at exchange offices rather than banks. Avoid exchanging at airports if possible; you'll get better rates downtown. Always ask about the rate and commission before handing over your cash.

Tax A value-added tax (VAT) applies to most goods and services throughout Scandinavia. International visitors from outside the European Economic Area can claim back the VAT above a set minimum amount on purchases that are being taken out of the country. The procedure for making the claim is usually pretty straightforward.

Travellers cheques Rapidly disappearing but still accepted in big hotels and exchange offices.

Tipping

Tipping isn't very usual or required in Scandinavia. Rounding up a bill or cab fare is about as far as most locals go. Tips will be gratefully received, however.

Safe Travel

Scandinavia is a very safe place to travel, with very low crime rates.

○ Extreme winter temperatures must be taken seriously: wear proper protective clothing when outdoors.

○ In northern Scandinavia, biting insects can be a major annoyance in summer.

Telephone

To call abroad dial 🕿00 (the IAC, or international access code from Scandinavia), the country code (CC) for the country you are calling, the local area code (usually dropping the leading zero if there is one) and then the number.

Emergencies The emergency number is the same throughout Scandinavia: 🕿112.

Internet Calling via the internet is a practical and cheap solution for making international calls, whether from a laptop, tablet or smartphone.

Mobile phones Bring a mobile that's not tied to a specific network (unlocked) and buy local SIM cards.

Phone boxes Almost nonexistent in most of Scandinavia.

Phonecards Easily bought for cheaper international calls.

Reverse-charge (collect) calls Usually possible, and communicating with the local operator in English should not be much of a problem.

Roaming Roaming charges for EU phones within the EU have been abolished and are low for other European Economic Area (EEA) countries.

Mobile Phones

○ Local SIM cards are cheap and widely available. You need an unlocked phone.

○ Data packages are cheap and easy.

○ Normal tariff for EU SIM cards in EU countries.

○ Otherwise roaming rates.

Telephone Codes

Country	Country Code (CC)
Denmark	45
Finland	358
Iceland	354
Norway	47
Sweden	46
Estonia (Tallinn)	372

All countries use 00 as an International Access Code (IAC). Use the country code to call into that country. Use the international access code to call abroad from that country.

Time

Scandinavia sprawls across several time zones. The 24-hour clock is widely used. Note that Europe and the US move clocks forward and back at slightly different times. The following table is a seasonal guide only.

City	Time in Winter	Time in Summer
New York	11am (UTC -5)	noon (UTC -4)
Reykjavík	4pm (UTC)	4pm (UTC; no summer time)
London	4pm (UTC)	5pm (UTC +1)
Oslo	5pm (UTC +1)	6pm (UTC +2)
Copenhagen	5pm (UTC +1)	6pm (UTC +2)
Stockholm	5pm (UTC +1)	6pm (UTC +2)
Helsinki, Tallinn	6pm (UTC +2)	7pm (UTC +3)

Toilets

Public toilets are usually good, but often expensive; they can cost €1 or €2 or equivalent to enter.

Tourist Information

Facilities Generally excellent, with piles of regional and national brochures, helpful free maps and friendly employees. Staff are often multilingual, speaking English and perhaps other major European languages.

Locations Offices are at train stations or centrally located (often in the town hall or central square) in most towns.

Opening hours Longer office hours over summer, reduced hours over winter; smaller offices may open only during peak summer months.

Services Will book hotel and transport reservations and tours; a small charge may apply.

Websites Most towns have a tourist information portal, with good information about sights, accommodation options and more.

Travellers with Disabilities

○ Scandinavia leads the world as the best-equipped region for travellers with disabilities. By law, most institutions must provide ramps, lifts and special toilets for people with disabilities; all new hotels and restaurants must install disabled facilities. Most trains and city buses are also accessible by wheelchair.

○ Some national parks offer accessible nature trails, and cities have ongoing projects in place designed to maximise disabled access in all aspects of urban life.

○ Iceland is a little further behind the rest of the region – check access issues before you travel. Scandinavian tourist office websites generally contain good information on disabled access.

○ Before leaving home, get in touch with your national support organisation – preferably the 'travel officer' if there is one. They often have complete libraries devoted to travel and can put you in touch with agencies that specialise in tours for the disabled. One such agency in the UK is Can Be Done (www.canbedone. co.uk).

● Download Lonely Planet's free Accessible Travel guide from http://lptravel.to/ AccessibleTravel.

Visas

● Denmark, Estonia, Finland, Iceland, Norway and Sweden are all part of the Schengen area. A valid passport or EU identity card is required to enter the region.

● Most Western nationals don't need a tourist visa for stays of less than three months. South Africans, Indians and Chinese, however, are among those who need a Schengen visa.

● A Schengen visa can be obtained by applying to an embassy or consulate of any country in the Schengen area.

Transport

Getting There & Away

Scandinavia is easily accessed from the rest of Europe and beyond. There are direct flights from numerous destinations into Sweden, Norway, Denmark and Finland. There

Climate Change & Travel

Every form of transport that relies on carbon-based fuel generates CO_2, the main cause of human-induced climate change. Modern travel is dependent on aeroplanes, which might use less fuel per kilometre per person than most cars but travel much greater distances. The altitude at which aircraft emit gases (including CO_2) and particles also contributes to their climate change impact. Many websites offer 'carbon calculators' that allow people to estimate the carbon emissions generated by their journey and, for those who wish to do so, to offset the impact of the greenhouse gases emitted with contributions to portfolios of climate-friendly initiatives throughout the world. Lonely Planet offsets the carbon footprint of all staff and author travel.

is less choice to Iceland. Estonia is serviced by 11 European airlines to Tallinn year-round, with additional routes added in summer.

Denmark, Sweden and Norway can be accessed by train from Western Europe, while Baltic and North Sea ferries are another good option for accessing these Nordic countries.

Flights, cars and tours can be booked online at lonelyplanet.com/bookings.

Air

As well as the many national carriers that fly directly into Scandinavia's airports, there are several budget options. These routes change frequently and are best investigated online.

Airports & Airlines

The following are major hubs in Scandinavia:

Stockholm Arlanda Airport (www.swedavia.com/arlanda) Sweden

Helsinki Vantaa Airport (www.helsinki-vantaa.fi) Finland

Copenhagen Kastrup Airport (www.cph.dk) Denmark

Reykjavík Keflavík Airport (www.kefairport.is) Iceland

Oslo Gardermoen Airport (www.osl.no) Norway

Tallinn Airport (www.tallinn-airport.ee) Estonia

SAS (www.flysas.com) is the national carrier for Sweden, Norway and Denmark, **Finnair** (www.finnair.com) for Finland and **Icelandair** (www.icelandair.com) for Iceland. Other important regional airlines include **Norwegian** (www.norwegian.com). Estonian Air (www.estonian-air.ee) flies between Tallinn and Vilnius four times per week, while **airBaltic** (www.airbaltic.com) runs multiple daily flights between Tallinn and Rīga.

Land

Bus

Without a rail pass, the cheapest overland transport from Europe to Scandinavia

Departure Tax

Departure tax is included in the price of a ticket.

is the bus, though a cheap flight deal will often beat it on price. Eurolines (www.euro lines.com), a conglomeration of coach companies, is the biggest and best-established express-bus network, and connects Scandinavia with the rest of Europe. Advance ticket purchases are usually necessary and sometimes cheaper.

Car & Motorcycle

Driving to Scandinavia means either driving into Denmark from Germany (and on to Sweden via the bridge-tunnel), going through Russia or taking a car ferry.

Train

○ Apart from trains into Finland from Russia, the rail route into Scandinavia goes from Germany into Denmark, then on to Sweden and then Norway via the Copenhagen–Malmö bridge-tunnel connection. Hamburg and Cologne are the main gateways in Germany for this route.

○ See the exceptional Man in Seat 61 website (www. seat61.com) for details of all train routes.

○ Contact **Deutsche Bahn** (www.bahn.com) for details of frequent special offers and for reservations and tickets.

○ For more information on international rail travel (including Eurostar services), check out www. voyages-sncf.com.

Sea

Services are year-round between major cities: book ahead in summer, at weekends and if travelling with a vehicle. Many boats are amazingly cheap if you travel deck class (without a cabin). Many ferry lines offer 50% discounts for holders of Eurail, Scanrail and InterRail passes. Some offer discounts for seniors, and for ISIC and youth-card holders; enquire when purchasing your ticket. There are usually discounts for families and small groups travelling together. Ferry companies have detailed timetables and fares on their websites. Fares vary according to season.

Ferry Companies

The following is a list of the main ferry companies operating to and around Scandinavia, with their websites and major routes. See websites for contact telephone numbers, times, durations and sample fares.

BornholmerFærgen (www. faergen.com) Denmark (Bornholm)–Sweden, Denmark (Bornholm)–Germany.

Color Line (www.colorline.com) Norway–Denmark, Norway–Germany, Norway–Sweden.

DFDS Seaways (www. dfdsseaways.com) Denmark–Norway, Sweden–Lithuania, Sweden–Estonia.

Eckerö Line (www.eckeroline. fi for Finland–Estonia, www. eckerolinjen.se for Finland–Sweden) Finland (Åland)–Sweden, Finland–Estonia.

Finnlines (www.finnlines.com) Germany–Sweden, Sweden–Finland, Germany–Finland.

Fjord Line (www.fjordline. com) Denmark–Norway, Norway–Sweden.

Linda Line (www.lindaline.fi) Finland–Estonia.

Polferries (www.polferries.pl) Sweden–Poland.

St Peter Line (www.stpeterline. com) Sweden–Russia, Finland–Russia, Estonia–Russia.

Scandlines (www.scandlines. com) Denmark–Germany.

Smyril Line (www.smyrill-ine.com) Denmark–Faroe Islands–Iceland.

Stena Line (www.stenaline. com) Denmark–Norway, Denmark–Sweden, Sweden–Germany, Sweden–Poland, Sweden–Latvia.

Syltfähre (www.syltfaehre.de) Denmark–Germany (Sylt).

Tallink/Silja Line (www. tallinksilja.com) Finland–Sweden, Finland–Estonia, Sweden–Estonia, Sweden–Latvia.

TT-Line (www.ttline.com) Sweden–Germany, Sweden–Poland, Denmark (Bornholm)–Poland.

Unity Line (www.unityline.eu) Sweden–Poland.

Viking Line (www.vikingline. com) Sweden–Finland, Finland–Estonia.

Wasaline (www.wasaline.com) Finland–Sweden.

Baltic Countries

There are numerous sailings between Tallinn, Estonia and

Helsinki, Finland, operated by Eckerö Line, Linda Line (fast boats), Tallink/Silja Line and Viking Line. Tallink/ Silja also sails from Tallinn to Stockholm via Mariehamn, and DFDS Seaways runs from Paldiski (Estonia) to Kapellskär (Sweden).

Stena Line runs from Nynäshamn, Sweden to Ventspils, Latvia. Tallink/ Silja does a Stockholm to Riga run.

DFDS operates between Karlshamn (Sweden) and Klaipėda (Lithuania).

Germany

Denmark BornholmerFærgen runs between the island of Bornholm and Sassnitz, in eastern Germany. Scandlines runs from Rødby to Puttgarden, and between Gedser and Rostock. There's also a service from Havneby, at the southern tip of the Danish island of Rømø, to List on the German island of Sylt; this is run by Syltfähre.

Finland Finnlines runs from Helsinki to Travemünde.

Norway Color Line runs daily from Oslo to Kiel.

Sweden Stena Line runs Trelleborg to Rostock, Trelleborg to Sassnitz and Gothenburg to Kiel. TT-Line runs Trelleborg to Travemünde and Trelleborg to Rostock. Finnlines runs Malmö to Travemünde.

Poland

Denmark TT Line runs between the island of Bornholm and Świnoujście.

Sweden Polferries runs Ystad to Świnoujście, as does Unity Line, while TT-Line runs

Trelleborg to Świnoujście. Polferries also links Nynäshamn with Gdańsk. Stena Line runs between Karlskrona and Gdynia.

Russia

St Peter Line runs from St Petersburg, Russia to Helsinki, Tallinn, and Stockholm, Sweden.

Getting Around

Getting around Scandinavia's populated areas is generally a breeze, with efficient public transport and snappy connections. Remote regions usually have trustworthy but infrequent services.

Bus Comprehensive network throughout region; only choice in many areas.

Train Efficient services in the continental nations, none in Iceland.

Car Drive on the right. Hire is easy but not cheap. Few motorways, so travel times can be long. Compulsory winter tyres.

Ferry Great-value network around the Baltic; spectacular Norwegian coastal ferry, and service to Iceland via the Faroe Islands.

Bike Very bike-friendly cities and many options for longer cycling routes. Most transport carries bikes for little or no charge. Hire widely available.

Planes Decent network of budget flights connecting major centres. Full-fare flights comparatively expensive.

Air

Flights are safe and reliable. Can be expensive, but often cheaper than land-based alternatives for longer journeys, and can save days of travelling time.

There are reduced rates for internet bookings on internal airline routes. The main budget operators in the region are Ryanair and Norwegian.

Good bus and train networks between airports and city centres.

Bicycle

Scandinavia is exceptionally bike-friendly, with loads of cycle paths, courteous motorists, easy public transport options and lots of flattish, picturesque terrain.

Bike shops Widespread in towns and cities.

Hire Often from train station bike-rental counters, tourist offices, camping grounds; in some cases it's possible to return hire bikes to another outlet so you don't have to double back. Several cities have bike-sharing schemes accessible for a small fee.

No-nos Cycling across the Øresund bridge between Denmark and Sweden is prohibited. A new summer-only bike ferry opened in 2017 as an alternative.

On public transport Bikes can be transported as luggage, either free or for a small fee, on slower trains and local buses in Scandinavia.

Theft Not uncommon in big cities; take a decent lock and use it when you leave your bike unattended.

Boat

Ferries are a major part of Scandinavian travel, connecting islands and countries on both the Baltic and North Sea sides.

Ferry

You can't really get around Scandinavia without using ferries extensively. The shortest routes from Denmark (Jutland) to Norway and from southern Sweden to Finland are ferry routes. Denmark is now well connected to mainland Europe and Sweden by bridges.

Ferry tickets are cheap on competitive routes, although transporting cars can be costly. Bicycles are usually carried free. On some routes, train-pass holders are entitled to free or discounted travel.

Weekend ferries, especially on Friday night, are significantly more expensive. Teenagers are banned from travelling on some Friday-night ferries due to problems with drunkenness.

Denmark–Faroe Islands–Iceland Smyril Line runs the popular *Nörrona* ferry from Hirtshals, Denmark to Seyðisfjörður, Iceland via Tórshavn on the Faroe Islands.

Denmark–Norway There are several connections. From Hirtshals, Fjord Line sails to Bergen, Kristiansand, Langesund and Stavanger. Color Line goes to Kristiansand and Larvik. From Frederikshavn, Stena Line goes to Oslo. From Copenhagen, DFDS Seaways goes to Oslo.

Denmark–Sweden Stena Line runs the connections from Grenaa to Varberg and Frederikshavn to Gothenburg. The short Helsingør to Helsingborg crossing is covered by Scandlines, while BornholmerFærgen goes from Rønne on Bornholm to Ystad.

Norway–Sweden Fjord Line and Color Line connect Strömstad, Sweden, with Sandefjord, Norway.

Sweden–Finland Connections from Stockholm to Helsinki or Turku via Åland are operated by Tallink/Silja and Viking Line. Eckerö Line runs from Grisslehamn to Eckerö on Åland, Finnlines runs Kapellskär to Naantali, while further north, Wasaline connects Umeå with Vaasa.

Steamer

○ Scandinavia's main lakes and rivers are served by boats during summer, including some historic steamers. Treat these as relaxing, scenic cruises; if you view them merely as a way to get from A to B, they can seem quite expensive.

○ Sweden has numerous routes. Most leave from Stockholm and sail east to the Stockholm archipelago and west to historic Lake Mälaren. You can also cruise the Göta Canal, the longest water route in Sweden.

○ The legendary *Hurtigruten* ferry provides a link between Norway's coastal fishing villages.

○ In Finland, steamships ply the eastern lakes, connecting the towns on their shores.

Bus

Buses provide a viable alternative to the rail network in Scandinavian countries, and are the only option in Iceland and parts of northern Sweden, Finland and Norway.

Cost Compared to trains, they're usually cheaper and slightly slower. Connections with train services (where they exist) are good.

Advance reservation Rarely necessary. But you do need to pre-purchase your ticket before you board many city buses, and then validate your ticket on board.

International routes There are regular bus services between Denmark and Sweden, and Sweden and Norway. Services between Finland and Norway run in Lapland, and you can change between Swedish and Finnish buses at the shared bus station of the border towns of Tornio/Haparanda.

Car & Motorcycle

Travelling with a vehicle is the best way to get to remote places and gives you independence and flexibility.

Bringing Your Own Vehicle

Documentation Proof of ownership of a private vehicle should always be carried (this is the Vehicle Registration Document for British–registered cars). You'll also need an insurance document valid in the countries you are planning to visit. Contact

your local automobile association for further information.

Border crossings Vehicles crossing an international border should display a sticker showing their country of registration. The exception is cars with Euro-plates.

Safety It's compulsory to carry a warning triangle in most places, to be used in the event of breakdown, and several countries require a reflective jacket. You must also use headlamp beam reflectors/converters on right-hand-drive cars.

Driving Licences

An EU driving licence is acceptable for driving throughout Scandinavia, as are North American and Australian licences, for example. If you have any other type of licence, you should check to see if you need to obtain an International Driving Permit (IDP) from your motoring organisation before you leave home.

If you're thinking of going snowmobiling, you'll need to bring your driving licence with you.

Fuel

Fuel is heavily taxed and very expensive in Scandinavia. Most types of petrol, including unleaded 95 and 98 octane, are widely available; leaded petrol is no longer sold. Diesel is significantly cheaper than petrol in most countries. Usually pumps with green markings deliver unleaded fuel, and black pumps supply diesel.

Car Hire

Cost Renting a car is more expensive in Scandinavia than in other European countries. Be sure you understand what's included in the price (unlimited or paid kilometres, injury insurance, tax, collision damage waiver etc) and what your liabilities are. Norway is the most expensive so it may pay to rent a car in neighbouring Sweden and take it across.

Insurance Decide whether to take the collision damage waiver. You may be covered for this and injury insurance if you have a travel-insurance policy: check.

Companies The big international firms – Hertz, Avis, Budget and Europcar – are all present. Sixt often has the most competitive prices. Using local firms can mean a better deal. Big firms give you the option of returning the car to a different outlet when you've finished with it, but this is often heavily charged.

Booking Pre-booking always works out cheaper. Online brokers often offer substantially cheaper rates than the company websites themselves.

Fly/drive combination SAS and Icelandair often offer cheaper car rentals to their international passengers. Check their websites for deals.

Border crossings Ask in advance if you can drive a rented car across borders. In Scandinavia it's usually no problem.

Age The minimum rental age is usually 21, sometimes even 23, and you'll need a credit card for the deposit.

Practicalities

Smoking Widely forbidden in public spaces, but some countries have dedicated smoking rooms in hotels and smoking areas in bars. Vaping laws depend on the country.

Weights & Measures The metric system is used across the region, though old local miles are still sometimes referred to.

Motorcycle and moped rental Not particularly common in Scandinavian countries, but possible in major cities.

Insurance

Third-party motor insurance A minimum requirement in most of Europe. Most UK car-insurance policies automatically provide third-party cover for EU and some other countries. Ask your insurer for a Green Card – an internationally recognised proof of insurance (there may be a charge) – and check that it lists all the countries you intend to visit.

Breakdown assistance Check whether your insurance policy offers breakdown assistance overseas. If it doesn't, a European breakdown-assistance policy, such as those provided by the AA or the RAC, is a good investment. Your motoring organisation may also offer reciprocal coverage with affiliated motoring organisations.

Road Conditions & Hazards

Conditions and types of roads vary widely across Scandinavia, but it's possible to make some generalisations.

Iceland Specific challenges include unsealed gravel roads, long, claustrophobic single-lane tunnels, frequent mist and the wild, lonely, 4WD-only F-roads. See the videos at www.drive.is for more info.

Main roads Primary routes, with the exception of some roads in Iceland, are universally in good condition. There are comparatively few motorways.

Minor roads Road surfaces on minor routes are not so reliable, although normally adequate.

Norway Has some particularly hair-raising roads; serpentine examples climb from sea level to 1000m in what seems no distance at all on a map. Driving a campervan on this kind of route is not recommended.

Tolls In Norway, there are tolls for some tunnels, bridges, roads and entry into larger towns, and for practically all ferries crossing fjords. Roads, tunnels, bridges and car ferries in Finland and Sweden are usually free, although there's a hefty toll of €56 per car on the Øresund bridge (www.oresundsbron.com) between Denmark and Sweden.

Winter Snow tyres are compulsory in winter, except in Denmark. Chains are allowed in most countries but almost never used.

Livestock on roads Animals is motion, including sheep, elk, horses and reindeer, are a potential hazard. If you are involved in an animal incident, by law you must report it to the police.

Road Rules

◉ Drive on the right-hand side of the road in all Scandinavian countries.

◉ Seatbelts are compulsory for driver and all passengers.

◉ Headlights must be switched on at all times.

◉ In the absence of give-way or stop signs, priority is given to traffic approaching from the right.

◉ It's compulsory for motorcyclists and their passengers to wear helmets.

◉ Take care with speed limits, which vary from country to country.

◉ Many driving infringements are subject to on-the-spot fines in Scandinavian countries. In Norway these are stratospheric. Drink-driving regulations are strict.

Train

There are no trains in Iceland nor in far-north Finland and Norway.

Costs Full-price tickets can be expensive; book ahead for discounts. Rail passes are worth buying if you plan to do a reasonable amount of travelling. Seniors and travellers under 26 years of age are eligible for discounted tickets in some countries, which can cut fares by between 15% and 40%.

Reservations It's a good idea (sometimes obligatory) to make reservations at peak times and on certain train lines, especially long-distance trains. In some countries it can be a lot cheaper to book in advance and online.

Express trains There are various names for fast trains throughout Scandinavia. Supplements usually apply on fast trains and it's wise (sometimes obligatory) to make reservations at peak times and on certain lines.

Overnight Trains

These trains usually offer couchettes or sleepers. Reservations are advisable, particularly as sleeping options are generally allocated on a first-come, first-served basis.

Couchettes Basic bunk beds numbering four (1st class) or six (2nd class) per compartment are comfortable enough, if lacking a little privacy. In Scandinavia, a bunk costs around €25 to €50 (on top of the train fare) for most trains, irrespective of the length of the journey.

Sleepers The most comfortable option, offering beds for one or two passengers in 1st class and two or three passengers in 2nd class.

Food Most long-distance trains have a dining car or snack trolley – bring your own nibbles to keep costs down.

Car Some long-distance trains have car-carrying facilities.

Train Passes

There is a variety of passes available for rail travel within

Scandinavia, or in various European countries including Scandinavia. There are cheaper passes for students, people under 26 and seniors. Supplements (eg for high-speed services) and reservation costs are not covered by passes, and terms and conditions change – check carefully before buying. Pass-holders must always carry their passport on the train for identification purposes.

Eurail Passes

Eurail (www.eurail.com) Offers a good selection of different passes available to residents of non-European countries; should be purchased before arriving in Europe.

Eurail Scandinavia Pass Gives a number of days of travel in a two-month period, and is valid for travel in Denmark, Sweden, Norway and Finland. It costs €215 for three days in 2nd class, up to €353 for eight days. There are also single-country passes.

Eurail Global Pass Offers travel in 28 European countries – five or seven days in a month, 10 or 15 days in a two-month period or unlimited travel from 15 days up to three months. It's much better value for under 28s, as those older have to buy a 1st-class pass.

Select Pass Gives a number of days of travel in a two-month period; you can choose up to four adjoining countries.

Discounts Most passes offer discounts of around 25% for under 28s, or 15% for two people travelling together. On most Eurail passes, children aged between four and 11 get a 50% discount on the full adult fare. Eurail passes give a 30% to 50% discount on several ferry lines in the region; check the website for details.

InterRail Passes

If you've lived in Europe for more than six months, you're eligible for an InterRail (www.interrail.eu) pass. InterRail offers two passes valid for train travel in Scandinavia.

InterRail One Country Pass Offers travel in one country of your choice for three/four/six/eight days in a one-month period, costing €119/150/201/241 in 2nd class for Denmark or Finland, and €175/199/259/300 for Sweden or Norway.

Global Pass Offers travel in 30 European countries and costs from €267 for five days' travel in any 15, to €632 for a month's unlimited train travel.

Discounts On both the above passes, there's a discount of around 20% for under 28s. InterRail passes give a 30% to 50% discount on several ferry lines in the region; check the website for details.

Behind the Scenes

Acknowledgements

Climate map data adapted from Peel MC, Finlayson BL & McMahon TA (2007) 'Updated World Map of the Köppen-Geiger Climate Classification', Hydrology and Earth System Sciences, 11, 163344.

This Book

This guidebook was researched and written by Anthony Ham, Alexis Averbuck, Belinda Dixon, Carolyn Bain, Oliver Berry, Cristian Bonetto, Peter Dragicevich, Catherine Le Nevez, Virginia Maxwell, Hugh McNaughtan, Becky Ohlsen, Andy Symington and Donna Wheeler.

This guidebook was produced by the following:

Destination Editors Gemma Graham, James Smart

Product Editor Genna Patterson

Senior Cartographer Valentina Kremenchutskaya

Book Designer Gwen Cotter

Assisting Editors Michelle Bennett, Jennifer Hattam, Charlotte Orr, Susan Paterson, Sam Wheeler

Cover Researcher Naomi Parker

Thanks to Egill Bjarnason, Mark Elliott, Shona Gray, Sandie Kestell, Kate Kiely, Craig McLachlan, Doug Rimington, Angela Tinson, Mara Vorhees

Send Us Your Feedback

We love to hear from travellers – your comments keep us on our toes and help make our books better. Our well-travelled team reads every word on what you loved or loathed about this book. Although we cannot reply individually to postal submissions, we always guarantee that your feedback goes straight to the appropriate authors, in time for the next edition. Each person who sends us information is thanked in the next edition, the most useful submissions are rewarded with a selection of digital PDF chapters.

Visit lonelyplanet.com/contact to submit your updates and suggestions or to ask for help. Our award-winning website also features inspirational travel stories, news and discussions.

Note: We may edit, reproduce and incorporate your comments in Lonely Planet products such as guidebooks, websites and digital products, so let us know if you don't want your comments reproduced or your name acknowledged. For a copy of our privacy policy visit lonelyplanet.com/privacy.

Index

A

B

C

Symbols & Map Key

Look for these symbols to quickly identify listings:

- ◉ Sights
- ✪ Activities
- ✪ Courses
- ✪ Tours
- ✪ Festivals & Events
- ✪ Eating
- ✪ Drinking
- ✪ Entertainment
- ✪ Shopping
- ✪ Information & Transport

These symbols and abbreviations give vital information for each listing:

- 🍃 Sustainable or green recommendation
- FREE No payment required
- ☏ Telephone number
- ⊙ Opening hours
- P Parking
- ⊝ Nonsmoking
- ❄ Air-conditioning
- @ Internet access
- 🛜 Wi-fi access
- 🏊 Swimming pool
- 🚍 Bus
- 🚢 Ferry
- 🚊 Tram
- 🚆 Train
- 🍽 English-language menu
- ✔ Vegetarian selection
- 👪 Family-friendly

Find your best experiences with these Great For... icons.

 Art & Culture

 Beaches

 Budget

 Cafe/Coffee

 Cycling

 Detour

Drinking

 Entertainment

Events

 Family Travel

Food & Drink

 History

Local Life

 Nature & Wildlife

 Photo Op

 Scenery

 Shopping

 Short Trip

Sport

 Walking

Winter Travel

Sights

- 🏖 Beach
- 🐦 Bird Sanctuary
- 🛕 Buddhist
- 🏰 Castle/Palace
- ✝ Christian
- ☯ Confucian
- 🕉 Hindu
- ☪ Islamic
- Jain
- ✡ Jewish
- Monument
- 🏛 Museum/Gallery/ Historic Building
- Ruin
- ⛩ Shinto
- 🪯 Sikh
- ☯ Taoist
- 🍷 Winery/Vineyard
- 🦓 Zoo/Wildlife Sanctuary
- ◉ Other Sight

Points of Interest

- 🏄 Bodysurfing
- ⛺ Camping
- ☕ Cafe
- 🛶 Canoeing/Kayaking
- ● Course/Tour
- 🤿 Diving
- 🍸 Drinking & Nightlife
- ✗ Eating
- ✪ Entertainment
- ♨ Sento Hot Baths/ Onsen
- 🛍 Shopping
- ⛷ Skiing
- 🛏 Sleeping
- 🤿 Snorkelling
- 🏄 Surfing
- 🏊 Swimming/Pool
- 🚶 Walking
- 🏄 Windsurfing
- ✪ Other Activity

Information

- 🏦 Bank
- Embassy/Consulate
- ➕ Hospital/Medical
- @ Internet
- Police
- ✉ Post Office
- ☏ Telephone
- 🚻 Toilet
- ❶ Tourist Information
- ● Other Information

Geographic

- 🏖 Beach
- ⊶ Gate
- 🏠 Hut/Shelter
- 🔦 Lighthouse
- 🔭 Lookout
- ▲ Mountain/Volcano
- 🌴 Oasis
- ❶ Park
-)(Pass
- 🍴 Picnic Area
- 💧 Waterfall

Transport

- ✈ Airport
- Ⓑ BART station
- ⊗ Border crossing
- Ⓣ Boston T station
- 🚍 Bus
- Cable car/Funicular
- Cycling
- Ferry
- Ⓜ Metro/MRT station
- Monorail
- P Parking
- Petrol station
- Ⓢ Subway/S-Bahn/ Skytrain station
- 🚕 Taxi
- Train station/Railway
- Tram
- ⊜ Tube Station
- Ⓤ Underground/ U-Bahn station
- ● Other Transport

Telegraph (UK) and *Corriere del Mezzogiorno* (Italy). Instagram: rexcat75.

Belinda Dixon

Belinda has been (gleefully) travelling, researching and writing for Lonely Planet since 2006. Belinda is also an adventure writer and a trained radio journalist. See her VideoBlog posts at belindadixon.com

Peter Dragicevich

With a background in newspaper and magazine publishing, Peter turned to travel writing. Over the last decade he has written literally dozens of guidebooks for Lonely Planet on an oddly disparate collection of countries, all of which he's come to love. He calls Auckland, New Zealand his home – although his current nomadic existence means he's often elsewhere.

Catherine Le Nevez

With a Doctorate of Creative Arts in Writing, Masters in Professional Writing, and postgrad qualifications in Editing and Publishing, Catherine has written scores of Lonely Planet guides and articles covering Paris, France, Europe and far beyond. Her work has also appeared in numerous online and print publications. Topping Catherine's list of travel tips is to travel without any expectations.

Virginia Maxwell

Although based in Australia, Virginia spends at least half of her year updating Lonely Planet destination coverage in Europe and the Middle East. Though the Mediterranean is her major area of interest – she has covered Spain, Italy, Turkey, Syria, Lebanon, Israel, Egypt and Morocco for LP guidebooks – Virginia also writes LP guides to Finland, Armenia, Iran and Australia. Follow her @maxwellvirginia on Instagram and Twitter.

Hugh McNaughtan

A former English lecturer, Hugh swapped grant applications for visa applications, and turned his love of travel intro a full-time thing. Having done a bit of restaurant-reviewing in his home town (Melbourne) he's now eaten his way across four continents. He's never happier than when on the road with his two daughters. Except perhaps on the cricket field.

Becky Ohlsen

Becky is a freelance writer, editor and critic based in Portland, Oregon. She writes guidebooks and travel stories about Scandinavia, Portland and elsewhere for Lonely Planet. She has a master's degree in journalism from NYU's Cultural Reporting and Criticism program.

Andy Symington

Andy has written or worked on over a hundred books and other updates for Lonely Planet (especially in Europe and Latin America) and other publishing companies, and has published articles on numerous subjects for a variety of newspapers, magazines, and websites.

Donna Wheeler

Donna has written guidebooks for Lonely Planet for over ten years, including the Italy, Norway, Belgium, Africa, Tunisia, Algeria, France, Austria and Australia titles. She became a travel writer after various careers as a commissioning editor, creative director, digital producer and content strategist. Born and bred in Sydney, Australia, Donna travels widely (and deeply) in Europe, North Africa, the US and Asia. She loves cities, mountains and the sea.

Our Story

A beat-up old car, a few dollars in the pocket and a sense of adventure. In 1972 that's all Tony and Maureen Wheeler needed for the trip of a lifetime – across Europe and Asia overland to Australia. It took several months, and at the end – broke but inspired – they sat at their kitchen table writing and stapling together their first travel guide, *Across Asia on the Cheap*. Within a week they'd sold 1500 copies. Lonely Planet was born. Today, Lonely Planet has offices in Franklin, London, Melbourne, Oakland, Dublin, Beijing, and Delhi, with more than 600 staff and writers. We share Tony's belief that 'a great guidebook should do three things: inform, educate and amuse'.

Our Writers

Anthony Ham

Anthony is a freelance writer and photographer who specialises in Spain, East and Southern Africa, the Arctic and the Middle East. When he's not writing for Lonely Planet, Anthony writes about and photographs Spain, Africa and the Middle East for newspapers and magazines in Australia, the UK and US.

Alexis Averbuck

A travel writer for over two decades, Alexis has lived in Antarctica for a year, crossed the Pacific by sailboat and written books on her journeys through Asia, Europe and the Americas. She's also a painter – visit www.alexisaverbuck.com – and promotes travel and adventure on video and television.

Oliver Berry

Oliver Berry is a writer and photographer from Cornwall. He has worked for Lonely Planet for more than a decade on more than 30 guidebooks. He is also a regular contributor to many newspapers and magazines, including *Lonely Planet Traveller*. His latest work is published at www.oliverberry.com.

Carolyn Bain

A travel writer and editor for more than 20 years, Carolyn has lived, worked and studied in various corners of the globe, including Denmark, London, St Petersburg and Nantucket. She moved from Melbourne to Reykjavík recently and writes about travel and food for a range of publishers; see carolynbain.com.au for more.

Cristian Bonetto

Cristian has contributed to over 30 Lonely Planet guides to date, including New York City, Italy, Venice & the Veneto, Naples & the Amalfi Coast, Denmark, Copenhagen, Sweden and Singapore. Lonely Planet work aside, his musings on travel, food, culture and design appear in numerous publications around the world, including *The*

More Writers

STAY IN TOUCH LONELYPLANET.COM/CONTACT

AUSTRALIA The Malt Store, Level 3, 551 Swanston St, Carlton, Victoria 3053
03 8379 8000,
fax 03 8379 8111

IRELAND Digital Depot, Roe Lane (off Thomas St), Digital Hub, Dublin 8, D08 TCV4, Ireland

USA 124 Linden Street, Oakland, CA 94607
510 250 6400,
toll free 800 275 8555,
fax 510 893 8572

UK 240 Blackfriars Road, London SE1 8NW
020 3771 5100,
fax 020 3771 5101

 twitter.com/
lonelyplanet

 facebook.com/
lonelyplanet

instagram.com/
lonelyplanet

 youtube.com/
lonelyplanet

 lonelyplanet.com/
newsletter